WILLY RONIS
BY *Willy Ronis*
THE MASTER PHOTOGRAPHER'S
UNPUBLISHED ALBUMS

WILLY RONIS
BY *Willy Ronis*

THE MASTER PHOTOGRAPHER'S
UNPUBLISHED ALBUMS

Flammarion

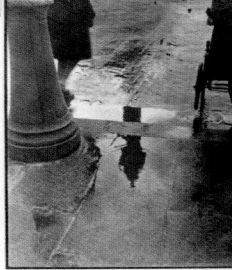

P17-11

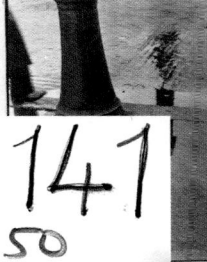

Contact sheet 141 and corresponding file, 24 × 36-mm film, nos. 45–50; East Germany, October 1967.

Illustrated sheet no. 5/3, containing seven 2¼ × 2¼-in. (6 × 6-cm) photographs from 1947 on the theme of the Vendôme Column, plus one 2¼ × 2¼-in. (6 × 6-cm) image from 1949 and one 24 × 36-mm from 1959.

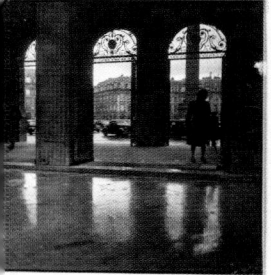

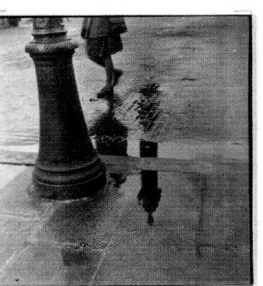
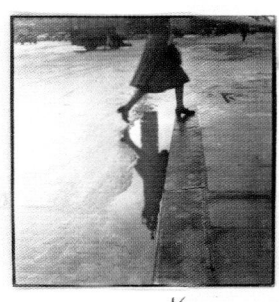

THE ALBUMS OF WILLY RONIS

"The photojournalist is not well prepared for handling the pen. First, because it is not his everyday tool. Second, because the rhythms of expression of the man who wields a camera and the man who wields a pen are fundamentally different, even in the field of journalism, where these two men rub elbows. And yet, today it is a photographer who is writing. He does so, in any case, taking care not to say anything that is not verified by his own experience and that of his colleagues whose words he has recalled here and there."[1]

A LIFE IN PHOTOGRAPHY

Throughout these pages, the reader will watch an oeuvre of 590 photographs, along with comments by their author, unfold. By turns reporter, industrial photographer, and photographic illustrator, Willy Ronis is a prominent figure in French twentieth-century photography who between the 1930s and the 2000s focused on the French, treading the streets of Paris and the South of France with never fading pleasure. A photographer of "slices of ordinary life,"[2] Willy Ronis intimately linked his personal experience to his work.

A socially committed man and a member of the Communist party, Ronis captured the great struggles of his time, such as the strike at the Javel factories in 1938 (photos 17 and 18), the return of prisoners of war in 1945 (photos 27 and 475), and the funeral of the victims of the Charonne massacre in 1962 (photo 497). His images of the underprivileged, of picket lines, and of trade union activists do not revel in despair, but are the fruit of genuine solidarity with the workers' struggle and an active engagement with the disadvantaged. His photographs appeared in the press of the time, notably in the Communist magazine *Regards*. As a photographic illustrator, Willy Ronis also regularly published his images in books on Paris, alongside other photographers of the Groupe des XV, including Robert Doisneau and René-Jacques. His first personal book, *Belleville Ménilmontant*,[3] published by Arthaud in 1954 with a preface by Pierre Mac Orlan, is devoted to a district of Paris that had been little photographed at the time. This professional already stood up for his work and his vision of his craft in the many articles he published in magazines aimed at amateur and professional photographers such as *Photo-Cinéma*, *Photorama*, and *FOCAgraphie*.

In Paris as in Gordes in the Vaucluse, where the Ronis family bought a house in 1948, his wife, Marie-Anne,[4] his son, Vincent, and his friends became his first subjects. He observed them with candor and gentleness. Each day, the moments of daily life—games, a bath, a nap—gave the photographer images that have become iconic.

Multilingual and curious, Willy Ronis looked abroad very early, traveling through Italy in the 1930s and, after the war, in England and the United States, and in Moscow, Berlin, and Prague during the Cold War. Rarely driven by commissions, his travels often provided an opportunity for sharing his work through exhibitions or lectures, as with his invitations from John Heartfield to East Berlin in 1960[5] or to Moscow in 1968.[6] In 1951, Ronis's work was celebrated by Edward Steichen, who made him one of his *Five French Photographers* alongside Brassaï, Henri Cartier-Bresson, Robert Doisneau, and Izis at the Museum of Modern Art in New York. The American curator, passing through Paris, chose

1. Manuscript of an article published under the title "Devoir de vacances d'un reporter-photographe" for the magazine *Camera* in 1954.
2. Willy Ronis quoted by Marta Gili in the press pack of the exhibition *Willy Ronis, Une poétique de l'engagement*, La Monnaie/Jeu de Paume, Paris 2010 [http://www.jeudepaume.org/pdf/PetitJournal_WillyRonis.pdf, accessed February 20, 2018].
3. Willy Ronis, Pierre Mac Orlan, *Belleville Ménilmontant* (Paris: Arthaud, 1954).
4. Willy Ronis met the painter Marie-Anne Lansiaux while hiding in the Free Zone during the occupation.
5. Lecture, "La liberté de la presse en France," 1960.
6. Lecture, "L'influence du reportage et de l'illustration dans la conception de la photographie publicitaire," 1968.

Vincent and the model aircraft taken in Gordes in 1952 (photo 129), for the exhibition *The Family of Man*, presented in 1955 in New York.[7] Two years later, Willy Ronis received the gold medal at the Mostra Internazionale Biennale di Fotografia in Venice.

This early recognition was undermined by the unfavorable situation photographers of his generation faced during the following decade. In the mid 1960s, he opened up to those close to him, such as Naf Avnon,[8] about the difficulties he had in finding new clients. From 1968, he added a string to his bow by joining the IDHEC film school,[9] then the École de Vaugirard, where he taught photography and its principles.

In 1972, as his photographic commitments shrunk more and more, he left Paris to settle first in Gordes, then L'Isle-sur-la-Sorgue in the Vaucluse. Developing a method of teaching photography through images, he lectured on the subject at the University of Aix-en-Provence and the École des Beaux-Arts in Avignon until 1977.[10] Those years in the South of France allowed him to take a fresh look at his archives and to present his work in a new light.

In France, Ronis had to wait until 1970 to be rediscovered by young critics including Bertrand Éveno, Jean-Claude Gautrand, and Guy Mandery. In 1979 he received the Grand Prix National des Arts et des Lettres, and participated in the exhibition *10 photographes pour le patrimoine* (10 Photographers for the Fatherland) at the Centre Georges Pompidou.[11] The Rencontres d'Arles photography festival chose him as guest of honor the following year. With the help of Pierre-Jean Amar, Claude Nori, and Guy Le Querrec, he published his second book, which became a milestone in his bibliography: *Sur le fil du hasard* (On Chance's Edge). Containing 113 photographs, this publication marked the return of Willy Ronis to the spotlight when it received the Nadar prize in 1981.

A PHOTOGRAPHIC DONATION

As early as 1979, at the Rencontres d'Arles festival,[12] Pierre Barbin, the head of the photographic heritage at the Ministry of Culture, spoke to Willy Ronis about the possibility of a donation to the State.

The photographer did not respond at first, but issues with his health and that of his wife, Marie-Anne, made him reconsider the matter in 1982. He opened up about his decision in a letter to Raymond and Barbara Grosset dated January 25, 1983: "But with advancing age, the prospect of staying here alone after one of our deaths seeming impossible, I agreed to make this donation in return for an apartment in Paris until the death of the surviving spouse."[13] This home in the capital provided by the French State, as for André Kertész the following year, allowed Ronis to come back to live in Paris after years spent in the south, and to return to the neighborhoods of his youth.

On June 16, 1983, Jack Lang, the Minister for Culture, accepted Willy Ronis's donation to the French State of all his photographic work since 1927.[14] This included all of his negatives on glass plate and on film, in both black and white and color, as well as all the prints in his possession. Inundated with projects, the photographer wanted to continue to explore his work; he therefore retained the usufruct of both his prints and his negatives. The donation took place in a formal setting that delighted the photographer: "The minister paid me the honor of receiving me alone for some time before signing the act, after which his prolonged presence concluded this ceremony in a relaxed and good humored atmosphere, which we will remember vividly for a long time."[15]

From the moment of signature, it was necessary to consider the transfer of the photographic collection, which was then kept in the south. At the same time, several exchanges took place between the photographic heritage team (Sylvie Cohen and Pierre Barbin) and the photographer to define the couple's housing needs. The apartment would need to be 860 square feet (80 square meters), provide both Willy and Marie-Anne with workspaces, and include a small room that could be transformed into a darkroom in which to develop films and make prints. The location of the apartment was also important: it had to be in a central neighborhood but "not in a beautiful neighborhood,"[16] as Willy Ronis wanted to get back to the

7. *The Family of Man* exhibition traveled around the world over the course of a decade, attracting nine million visitors.
8. Letter from Willy Ronis to Naf Avnon, April 18, 1966: "However, for over one year, work has not been going well, and I wonder how it is going to turn out" (MAP, Willy Ronis archive).
9. Institut des Hautes Études Cinématographiques, Paris.
10. Letter from Willy Ronis to Inge Bondi, February 1, 1978.
11. Letter from Jean-Philippe Lecat, Minister of Culture, to Willy Ronis, August 24, 1979; letter from Christian Pattyn, Director of Heritage, to Willy Ronis, September 6, 1979.
12. Patrick Roegiers, *Façons de voir* (Pantin: Le Castor Astral, 1992), 111.
13. In the same letter, he ensured that his working relationship with the Rapho agency, which Raymond Grosset founded, would remain unchanged until his death (MAP, Willy Ronis donation file).
14. In 1983, Jacques Henri Lartigue completed the donation to the State he had made in 1979. In his speech to welcome the Willy Ronis donation of June 16, 1983, Jack Lang, Minister for Culture, defined a policy of safeguarding photographic heritage with these words: "The interest in heritage is indeed one of the elements of the coherent and diversified policy relating to photography that the Ministry of Culture is committed to implement. This interest has been reflected in a very real way in the past few months: two new donations, those of Jacques Henri Lartigue's recent works, and the one given to us by Mr. Ronis today, have been received" (MAP, Willy Ronis donation file).
15. Letter from Willy Ronis to Pierre Barbin, June 18, 1983 (MAP, Willy Ronis donation file). In this exchange, the photographer lamented, however, that "the press had been poorly represented" during the ceremony following the signature.
16. Letter from Willy Ronis to Sylvie Cohen, March 1, 1983.

lively working-class areas that did so much for his reputation. At the end of 1983, the Ronises settled on rue Beccaria, in the twelfth arrondissement.

It was in 1982, during the correspondence between Willy Ronis and Pierre Barbin, that the idea of the albums came about.[17] Since the photographer kept his prints and negatives at home, "a specialized archivist will need to build up a catalog containing reference prints accompanied by technical comments for subsequent and historical prints of each of the photographs."[18] In the minds of each of the protagonists, it was clear that Ronis's work would enter the public collections only after his death; it was therefore necessary to come up with a medium that would symbolically mark the entry of the work into public collections and open up opportunities for further study.

On the occasion of the exhibition marking the first donation—*Willy Ronis par Willy Ronis*, presented in 1985 at the Palais de Tokyo[19]—four reference albums containing 350 prints were made up. Each print, usually 7 7/8 × 10 in. (20 × 25 cm), was accompanied by very detailed comments by the photographer about the circumstances of each exposure, the equipment used, the method to be employed for printing, and any potential printing difficulties. The production of these albums required many exchanges between Ronis and the photographic heritage team over the course of some two years. This led to the creation of four beige canvas albums, each measuring 15 3/4 × 16 1/2 in. (40 × 42 cm). The prints are mounted on the right-hand page, on double sheets in which windows are cut to show the framing of the images. The commentary is inscribed on the left-hand page opposite each image. The sheets are then mounted on a tab. The success of the Palais de Tokyo exhibition led Pierre Barbin to propose to Ronis that he publish a book including about eighty images, accompanied by the commentary from the albums. Due to a lack of funding, this project never saw the light of day.

In 1989, when the owner of the rue Beccaria apartment gave notice to Ronis, Marie-Anne's health was deteriorating. The need to change apartments revived the correspondence between the Ministry and the photographer, and the idea of a complementary donation then came about. For six years, the photographer had continued to survey all the neighborhoods he had visited in his early career. He therefore felt, as did the representatives of the photographic heritage department, that these images should join the first corpus. A new donation was signed on June 22, 1989: it included all the negatives Willy Ronis had produced since 1983—some six thousand images. A new album was made on this occasion, which included 120 new photographs.

In 2004, the collection of photographers' work assembled by the photographic heritage department was assigned to the Médiathèque de l'Architecture et du Patrimoine (MAP), which had been created a few years earlier. In 2006, at the request of its director, Jean-Daniel Pariset, and of his colleague Anne de Mondenard, who was responsible for the early photography collections, Willy Ronis made a new selection from his negatives, which allowed for a final album to be made, also including 120 photographs.[20] This album was officially presented by the photographer to Renaud Donnedieu de Vabres, Minister of Culture and Communication, during a visit to the MAP at the Fort de Saint-Cyr.

The will drafted by Willy Ronis confirmed all his donations, and enriched them with his archives and his library. Agendas, notebooks, travel journals, book dummies, manuscripts and typescripts of articles and lectures, personal correspondence with some of his colleagues, including Brassaï and Doisneau, audio and video recordings, and both handwritten and printed professional and personal documentation would all help to illuminate his work from its first conception to the different states of the photographic image: contact prints, work prints, press prints, test prints, exhibition prints. An important resource for understanding his practice (such as his tests and issues of retouching and reframing), the archives became an invaluable tool for researchers and curators.

In order for these sets to be shown and fully exploited by the institution that conserved them, Ronis also gave up all commercial rights to his images. To ensure that his work and the commitments that marked his career were respected, he entrusted the exercise of moral rights to four of his friends: Jean Guerry, Daniel Karlin, Roland Rappaport,

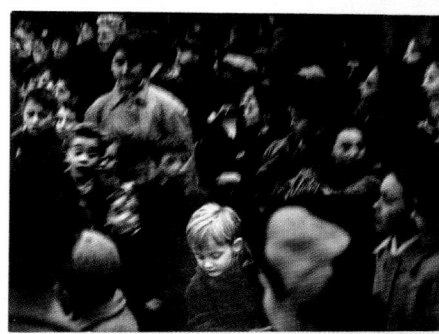

Album 2, photo 160, showing Ronis's annotations.
Photo Christophe Frontera, MAP.

17. Previously, in 1968, in response to the requirements of legal deposit and mindful of being represented in national collections, the photographer had given the print department of the Bibliothèque Nationale one hundred 11 3/4 × 15 3/4-in. (30 × 40-cm) prints to be mounted as an album. (These prints were not commented on frame by frame.) This donation was important for the photographer, who included it in some biographies he distributed to publishers and exhibition venues that showed his works after the 1970s (BnF, EP- 35-BOX FOL).

18. "Note concerning the donation of the photographic work of Mr. Willy Ronis," by Pierre Barbin, coordinator for the photographic heritage department, addressed to Christian Pattyn, Director of Heritage (MAP, Willy Ronis donation file).

19. The exhibition spaces in the Palais de Tokyo were at that time assigned to the Centre National de la Photographie, run by Robert Delpire.

20. The prints in the sixth album were made by Hervé Hudry, Ronis's official printer at the Publimod laboratory.

and Gerard Uféras. Ronis's death in September 2009 opened a period of succession that ended on October 5, 2016, with the official allocation of the entire collection to the MAP. His last wishes, which related to maintaining the integrity of his work, are thus fully respected by the State.

Currently held at the Fort de Saint-Cyr, in Montigny-le-Bretonneux, Yvelines, the Willy Ronis archive contains 108,000 negatives, mostly film in 2 ¼ × 2 ¼-in. (6 × 6-cm) and 24 × 36-mm formats, as well as nine thousand slides. To this body of work is attached a series of contact sheets and contact prints—five binders for the 2 ¼ × 2 ¼-in. (6 × 6-cm) negatives (1,250 contact sheets); fifty-three binders for the 24 × 36-mm negatives (four thousand contact sheets); and 20,317 prints by the photographer—forming a unique ensemble that spans his entire career. Thus researchers can see Ronis's first exhibition prints, such as the montage entitled *Work for the war*, presented in 1934 at the exhibition *Documents de la vie sociale* at the Gallery de la Pléiade in Paris; his press prints from the 1930s, which bear the "Roness" stamp; prints of images published in the three following decades; and the many examples made for press and publishers until the 2000s. This part of the archive is also enriched with many exhibition prints from the years 1980–2000, which reflect the photographer's recognition after his donations.

NAVIGATING THE ALBUMS

"This selection is the photographer's own, and is therefore subjective, which determines both its merits and its limitations."[21]

The albums, which for a long time were the only material sign of the donation to come, provided Willy Ronis with the opportunity to define his photographic work. For each image he selected, he gives the place, the date, and the context of the photograph. In the first five albums, he also often provides important remarks on the framing and printing of his images, pointing out the difficulties posed by some of them. Made over the course of twenty years, the albums are also a reflection of the trends and the evolution of the gaze of a photographer who, until the end of his life, continued to question his work. In his three introductions, Willy Ronis emphasizes the difficulty he faced in choosing the images that defined his work, since he is subject to "pangs of doubt, distortions of subjectivity, [and] the fear of self-betrayal."[22]

For the first four albums, Ronis notes the almost total absence of industrial and advertising photographs, but does not elaborate on the few images from the beginning of his career. Since his monograph *Sur le fil du hasard* (1980) was still fresh in his mind, the images it contains are almost all selected once more in the first four albums: 108 photographs out of a total of 113. His other major book, *Belleville Ménilmontant*, is widely represented in the albums, the sequencing of prints sometimes even following the layout of the book published by Arthaud.

The fifth album, donated in 1991, opens with a review of Ronis's work since the beginning of his career. Indeed, as the photographer was still rediscovering images in his archives through the editorial assignments that he received, he took advantage of compiling this new selection to introduce photos that he had rejected with regret a few years earlier, defining them as "not a collection of second choices, but rather, if I may say so, an overflow that has been saved."[23] He also took the opportunity to introduce thirty of his recent creations, influenced by his pleasure in rediscovering the streets of Paris.

The final selection of a photographer who worked throughout the century, the sixth album contains many rediscoveries and additions. In a sign that the use to which photographs were put, and the manner in which they were shown, were changing, Ronis chose, for some shots taken with the Rolleiflex, to respect the square frame of the negative, as in the images of prisoners being repatriated (photos 27 and 475) or those showing Marie-Anne and Vincent playing in the snow, a subject he presented once more, but this time full frame (photos 118 and 487). This album was also the opportunity to show many nude photographs, as he was preparing a book on the subject with the publisher Terre Bleue.[24]

21. Willy Ronis, introduction to album 6.
22. Ibid.
23. Willy Ronis, introduction to album 5.
24. Willy Ronis and Philippe Sollers, *Nues* (Paris: Éditions Terre Bleue, 2008).

A rare record among photographers, the archive also gives those who have chosen to preserve and highlight Ronis's work essential information about the classification of negatives and the reference numbers that he attributed to the images as he went along. As with many of his fellow photographers, Ronis's strategy of storing negatives was carefully conceived: he needed to be able to respond quickly to publishers or art directors and provide them with the image they needed. He therefore assigned each image a reference number that was then copied onto the back of the prints, which he organized by theme.

In addition, the characteristics of different photographic media also had to be taken into account. Medium-format images, such as those made with a Rolleiflex 2 ¼ × 2 ¼-in. (6 × 6-cm) camera, can easily be cut into individual exposures. Ronis began to number his work in 1930, the year in which he began his career as a photojournalist, and continued until 1955,[25] following which he conducted his assignments with a 24 × 36-mm SLR camera. He gave his images the code "R," followed by the number assigned to the year of the report, the number of the report in that year, and the number of the negative in the series. To give an example, the photograph *The return of the prisoners* (photo 27) bears the number R15/03/156, meaning that it is the 156th negative of the third report of that year, taken in the fifteenth year of his photographic career.[26] This series includes mainly projects produced for weeklies such as *Regards*, *Point de vue*, *Cavalcade*, or images intended for institutional sponsors, as with the *Air France* magazine. It includes nearly 380 photo stories—about 11,500 negatives—and represents a significant part of Willy Ronis's best-known work. In the albums, ninety-six photographs from this series were selected.

In parallel, Ronis began a second series devoted to his industrial and commercial projects and identified by the code "I". It follows the same principle as the previous one.[27] However, because he thought that these images, produced within a specific context, would not be reused in the future, or because the contract provided temporary exclusivity to the sponsor, the photographer was more lax about its organization. Therefore, many reports not assigned a number in the "Industry" series in fact represent about eighty assignments, or roughly four thousand negatives. It is interesting to note that this grouping includes all of his industrial sponsors, including Schlumberger, the Société Alsacienne d'Industrie Cotonnière, and the Ateliers de Construction Schwartz-Hautmont. Only four of these photographs are included in the albums. Nevertheless, among them are two major works by Willy Ronis, which have received a lot of attention: *The broken thread* (photo 102) and *The forge, Renault factories* (photo 103).

The photographer created two other series, preceded by the codes "F" and "P," which were used to organize photographs of which France and Paris formed the principal subject. Most of these were not the product of assignments, but rather the result of the photographer's wanderings. Intended for illustration purposes, these shots, unlike those of the two previous series, are classified not by a report number but by year. In his contact sheets, Ronis favored thematic groupings as a way of presenting them (photo 19). Finally, the photographer created several small series that cover very defined bodies of work, such as his images of snow made in the 1930s (code "N"), the photographs published in the book *Belleville Ménilmontant* (code "BM"),[28] photographs of manual trades (code "M"), and images taken in a family context and nudes, classified under "Divers" ("miscellaneous"; code "D"). Some series followed a specific logic, as he explains at length in the album commentary (see photo 61 for the series "BM," for example).

The use of an SLR camera from 1955 required Ronis to implement another strategy, since the film format meant that negatives could not be cut up into individual exposures. He therefore had to adapt his numbering system, introducing one based on the number of the contact sheet and the position of the shot in the selected strip. For Ronis, this change also went hand in hand with a reconsideration of his photos' ultimate purpose. Just as the SLR camera was becoming a necessity for him, he was receiving fewer industrial, advertising, and editorial commissions. The small format of the 24 × 36-mm cameras allowed him to photograph more freely and to embark on a hunt for images that he pursued until the year 2000. True to his habits, the photographer nonetheless still used a letter to determine the theme of his series of

Willy Ronis's six albums.
Photo Christophe Frontera, MAP.

25. Although the series continued until 1958, at the end of 1955 Ronis traded in his Rolleiflexes for his 24 × 36-mm cameras; from that point on, he used medium format only for infrequent commissions (see photo 488).

26. When in 1930 Ronis created his "P" series, covering images of Paris, he began to number his works, beginning with "00." His first photo story dates to 1933 and thus is labeled "R03."

27. The reportages from the "I" series were interpolated into those from the series labeled "R." Only the identifier changed.

28. The "BM" series grew with the different editions of the book, of which there are four; a reissue of the 1992 edition was even published in 2011.

photographs, even though it was no longer necessary for the classification. As a final point, it is worth noting that Ronis did not attribute any specific reference number to his color slides—just as they are absent from the albums.

PHOTOGRAPHIC STORIES

"The text–image relationship is almost always that of the horse and the rider. But who will be the horse and who will be the rider?"[29]

The long entries in the albums that accompany each chosen image illustrate Willy Ronis's attachment to the texts that always appeared alongside his photographs when they were published. We must go back to the photographs taken on Mediterranean cruises (photos 21, 357, 358, and 474) in 1938 to uncover the fundamental link between the photographer's images and the text that should accompany them. Penniless, Ronis had managed to get himself hired as a photographer on a liner, where he responded to the demand of cruise passengers for souvenir photos. He took part in another journey on a freighter in September that same year. As his biographer Françoise Denoyelle explains,[30] he took advantage of stopovers to take photographs for himself, in order to bring back to Paris a significant body of work. On the advice of Robert Capa, he grouped his Mediterranean photographs into a single report and gave them a political angle, connecting them to the situation in the Balkans on the eve of the war. With Capa, he wrote a text about the geopolitics of the region, although the photographs are primarily touristic and picturesque. Each image was then distributed to newspapers and news agencies with a caption written by the photographer.[31]

Throughout his career, Ronis made sure that the titles of his published images did not distort the meaning he wanted to give them, echoing Edward Steichen's words: "A photograph is worth ten thousand words, provided it is accompanied by ten words."[32] Since the liberation, *Life* magazine had assigned him several reports in France, such as that covering the great mining strikes of 1948 in Saint-Étienne, but an English magazine cropped one of his images from the story and rewrote the caption that accompanied it.[33] Thus the union delegate who faces the workers, themselves described in the magazine as "petit bourgeois," was amputated from the *Rue Saint-Amand* photograph (photo 101), whereas in fact in the photographer's mind the image illustrated the workers' support for the unions. American magazines "paid handsomely, but captions were rewritten in New York. I did not like it."[34] In a lecture titled "Le reporter et ses batailles" (The Reporter and his Battles),[35] given at the Société Française de Photographie, Ronis set out as early as 1948 the virtues necessary for the photojournalist, among which he emphasized the "right to refuse a job that goes against one's sensitivity or opinions."[36] Following several other mishaps related to the misrepresentation of the meaning of his images, he gave up working for the English-speaking press, and *Life* in particular.

Rather than placing his work in the context of the history of photography, Ronis often chose to tell the story of his images. The chronological nature of the albums creates a powerful illustrated account of the photographer's career. His decision to comment on each of the images is not insignificant. For Ronis, this exercise, practiced by many photographers of his generation, went back to the magazines to which he contributed from the 1950s, such as *Photorama*[37] (in which commentary on two or three photographs appeared next to the table of contents in each issue[38]). In his many articles, after a writing a general introduction Ronis provided a reading of his images related to their theme. These readings focused on the technique, the framing, or the lighting of the subject. However, as in the later albums, the anecdote behind the photograph was never forgotten. The technical comments already foreshadowed those that appear in the albums; Ronis even reused some texts, such as that for *The broken thread* (photo 102), originally published at the end of an article on industrial photography.[39] In another article, "Le photographe devant la réalité" (The Photographer in Front of Reality), seven of the eight published images are included in the albums (photos 56, 101, 120, 161, 169, 171, and 485).[40]

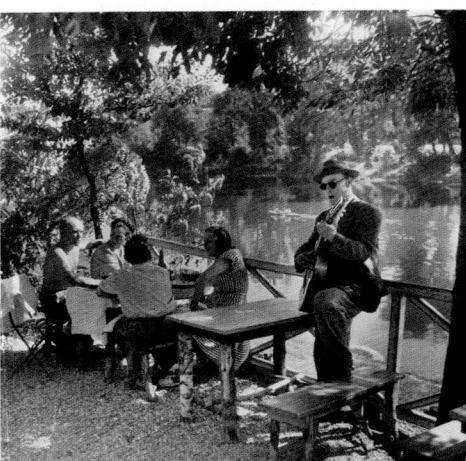

29. Willy Ronis, "Une vieille maison dans un vieux village," *Photorama* (December 1958), 613.
30. Françoise Denoyelle, *Le Siècle de Willy Ronis* (Paris: Éditions Terre Bleue, 2012), 67–70.
31. Robert Capa and Willy Ronis, "Les Balkans de nouveau en danger," typescript (MAP, Willy Ronis archive).
32. Quoted by Willy Ronis in Ronis, "Une vieille maison," 613.
33. Interview with Willy Ronis filmed in spring 2009 to promote the retrospective exhibition presented in Arles in July 2009 [http://www.jeudepaume.org/?page=article&idArt=2865, accessed on February 20, 2018].
34. Ibid.
35. "Le reporter et ses batailles," *Le Photographe*, no. 665 (February 5, 1948); typescript of the original lecture given at the Société Française de Photographie (MAP, Willy Ronis archive).
36. Ronis gave various accounts of his break with *Life* magazine. For other *Life* commissions, see Denoyelle, *Le Siècle de Willy Ronis*.
37. The magazine *Photo-service*, which became *Photorama* in 1952, was published from 1944 until the end of the 1950s by Gevaert in Antwerp, Belgium. Alongside Belgian and Dutch photographers, many French photographers contributed, including members of the Groupe des XV such as Daniel Masclet, René-Jacques, Marcel Bovis, and Willy Ronis.
38. These were the illustrations on the cover, the inside cover, and, from December 1951, the back cover.
39. "À propos de photo industrielle," *Photorama*, vol. 2, no. 11 (January 1958).
40. "Le photographe devant la réalité," *Photorama*, vol. 2, no. 4 (July 1956).

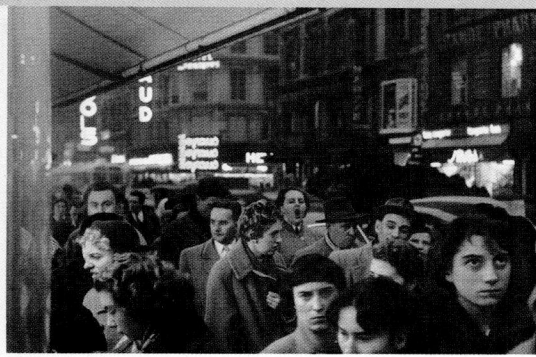

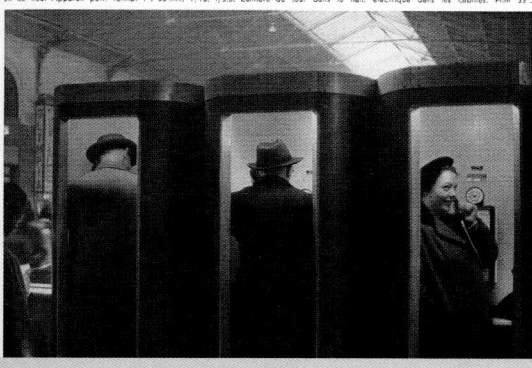

———— Willy Ronis, "The Photographer in Front of Reality," *Photorama* (Antwerp: Gevaert), vol. 2, no. 4 (July 1956).

Similarly, during the summer of 1960 Ronis was planning a new book, at the request of the publisher Paul Montel, on the theme of candid photography.[41] As he explained to his friend Herman Craeybeckx,[42] Ronis worked by reusing the text he had written for articles and conferences in previous years. He addresses himself to an audience of enlightened amateur practitioners—the context in which he was most comfortable. In the thick manuscript for the book, following a lengthy introduction that includes many passages published in *Photorama* or *Photo-Cinéma*, he comments on images covering five themes that reflect the main lines of his photographic work up until that point: the city, interiors, outdoors, children, and work. He introduces a new dimension to his publications by commenting at length on fifteen images at the end of each section, in which he specifies the context of the shot, relates an anecdote, and notes the cameras and film that had been used. However, even though the commentaries on certain images, such as the photograph *The beguinage, Bruges* (photo 110), were already almost fixed, any details relating to his personal life are completely absent. At the end of the 1970s, while Robert Doisneau encouraged Ronis to take up the pen to write a sequel to Beaumont Newhall's history of photography,[43] Ronis preferred to leave this task to a photographer like Pierre-Jean Amar, whose experience was more academic, in order to concentrate on his re-emerging career and on writing *Sur le fil du hasard*. Focusing on the images, the captions of this publication are very short, buried at the back, and Ronis chose to introduce the book with a text that was only autobiographical. It was not until Ronis's first four albums were compiled that the comments relating these images, which were almost all included, reappeared. In the majority of the publications that followed, the photographer left, with undisguised pleasure, the task of writing on his images to critics such as Bertrand Éveno, filmmakers like Daniel Karlin, or writers including Régine Deforges and Didier Daeninckx. However, he pursued his educational work in the form of interviews, documentaries, and lectures, and he continued to discuss his oeuvre by means of his photographs.

The texts of the first five albums had been put together around fifteen years earlier, but two other writing projects occupied the photographer between 2000 and 2006. In 2001, Ronis collaborated with Lionel Hoebeke for his series called *Derrière l'objectif de* (Behind the Lens of), devoted to the stories of individual photographers. Having provided a short introduction, Ronis went on to provide commentaries for some 222 photographs and contact sheets. While some of these texts were taken from his work done for the Ministry of Culture, others, such as that for *The children's barge* (photo 242),[45] are completely different and give the reader a fresh perspective on images that had been published many times. Furthermore, Ronis commented not only on individual images, but also on contact sheets or series of photographs. With the release of *Ce jour-là* (That Day) in 2006,[46] the relationship between text and image was reversed. Here, the photographer, offering a full autobiographical narrative, chose only fifty-four images, detailing, in a very literary manner, the story behind the moment each photo was taken. The text reads like a novel: horse and rider have swapped places. The photographer was a writer all along.

Matthieu Rivallin
Head of Collections, Photography Department,
Médiathèque de l'Architecture et du Patrimoine, Charenton-le-Pont

41. In the early 1950s, the Parisian publisher Paul Montel had released two books by Willy Ronis, *Photo-reportage et chasse aux images* (1951) and *Belles photos à la mer* (1953).

42. Between June and September 1960, Willy Ronis sent six long letters to Herman Craeybeckx (MAP, Willy Ronis archive).

43. Letter from Willy Ronis to Robert Doisneau, March 19, 1979 (MAP, Willy Ronis archive).

44. Willy Ronis, *Sur le fil du hasard* (Paris: Contrejour, 1980).

45. This photo, however, had been the subject of a full critical analysis in an article for *Photo-magazine* (July–August 1985).

46. Willy Ronis, *Ce jour-là* (Paris: Mercure de France, 2006).

EDITORIAL NOTE

Out of respect for Willy Ronis's work, we have reproduced the albums in their entirety and integrity. His texts have been kept as close as possible to the originals, with only slight harmonization and spelling and typographic corrections. Errors of identification and omissions are unchanged. The photographs are presented in the order in which they appear in the albums, with a chronological reset for the fifth (photos 351–470) and sixth albums (photos 471–590). The prints delivered by Ronis were digitized with their framing and possible imperfections intact. The majority of the photographs from albums 1 to 5 do not have titles, which constitutes a break with the photographer's usual practice. We have proposed simple titles, constructed, as much as possible, in the spirit of the author's own publications: generally a short description, followed by the location and the year. Ronis's habits regarding titles have varied. Nonetheless, the titles of some series do appear in his work (*Christmas week*, *Busker*, *The lovers of...*, *Subject seen from...*); they are applied as a matter of principle. For place names, we have preferred denominations as they were at the time of shooting (Leningrad, for example). All information has been verified by cross-checking different sources (personal diaries, contact sheets, etc.) that are sometimes at odds with the photographer's account of shooting conditions as he recalled them. Finally, the dimensions and reference numbers of the negatives as recorded by Ronis have been retained, with corrections where necessary.

Ronan Guinée, Head of Collections, Willy Ronis archive,
Médiathèque de l'Architecture et du Patrimoine, Charenton-le-Pont

DONATION 1
1985

ALBUM_01 : PHOTOGRAPHS 1 > 89
ALBUM_02 : PHOTOGRAPHS 90 > 179
ALBUM_03 : PHOTOGRAPHS 180 > 269
ALBUM_04 : PHOTOGRAPHS 270 > 350

The total number of photographs in these albums amounts to 350 images. The selection extends from 1926—the year when I received my first camera as a gift (I was fifteen and a half)—to 1983, the year in which the certificate of donation was signed. My selection is not the result of an arithmetic operation; in other words, the number of images representing the various topics covered is in no way proportional to the number of negatives that were devoted to them. Paris, where I lived and worked for most of my life, is represented by only 45 percent of the photographs. There are few industrial photographs, let alone fashion and advertising ones. My choice was guided solely by the value of the images (in my eyes) and the conception I have built of their consistency with my nature. The precision I bring to the commentary of some old photos may seem surprising, but I have kept almost all of my diaries since my adolescence. Sometimes finding a few words on a specific date is enough to release a host of memories, which until then had lain dormant in my mind. The photographs are presented in chronological order, which leads to a number of repetitions. That was inevitable. Readers are not expected to have studied everything that precedes the period or the types of images that interest them and it was important to avoid duplicating cross-references.
To present the summary of such a long career is neither easy nor risk-free—it was done in the throes of doubt, the distortions of subjectivity, the fear of betraying oneself. Without the efficient help of Sylvie Cohen of the Association Française pour la Diffusion du Patrimoine Photographique (AFDPP), who calmly handled my outbreaks of indecision and tempered my nervousness, and the supervision of my young colleague Gilles Walusinski, I would still be struggling with my soul-searching. I sincerely thank them for the quality of their advice, as well as for their great patience.

Willy Ronis
August 1984

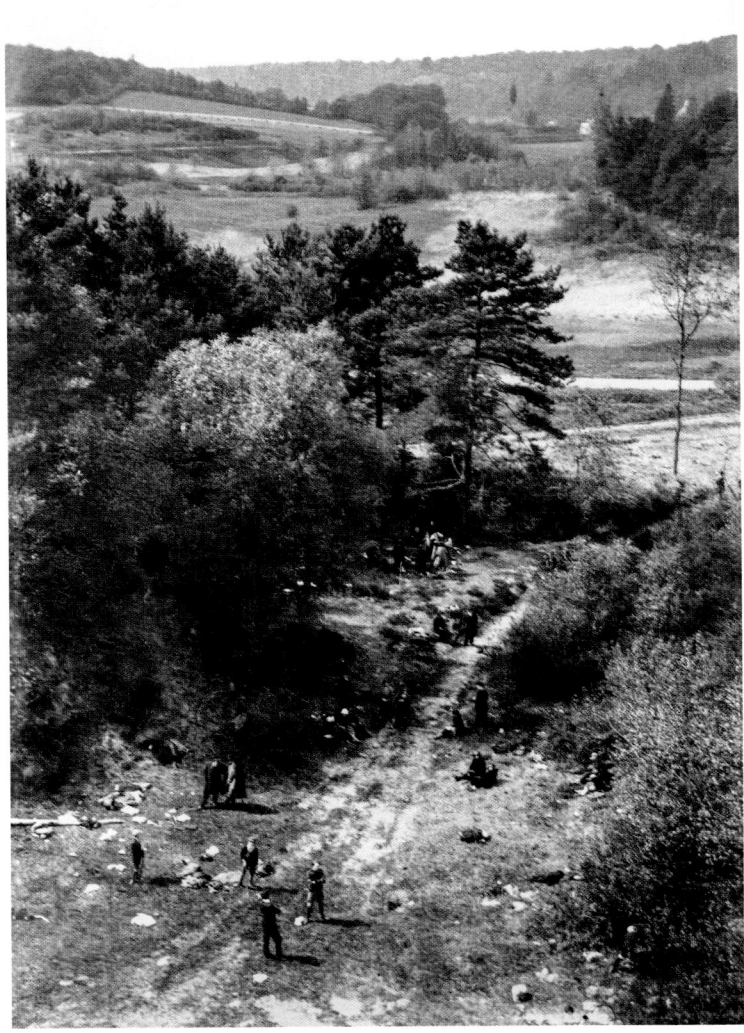

**Chevreuse Valley, Seine-et-Oise,
photo from my first roll, 1926**
NEGATIVE: 2½×4¼ IN. (6.5×11 CM) _ F06/1
— 1

I took this photograph in the spring, during one of my many outings with a group of young people, visiting châteaux or going on excursions near Paris. I had just received my first camera: a 2 ½ × 4 ¼-in. (6.5 × 11-cm) Folding Kodak. This is the only photograph from that roll to have survived. I destroyed the rest a long time ago, because they did not seem very interesting to me. That may have been a mistake. On the technical side, nothing special to report. It's a blurry photograph, but I was not yet sixteen and it was my first roll, so I think we can be a little forgiving! The framing is shortened in the sky.

**Savoie, photo taken with
my first camera, 1926**
NEGATIVE: 2½×4¼ IN. (6.5×11 CM) _ F06/3
— 2

This photograph was taken near Chambéry in Savoie, where I was at a summer camp. I had brought my brand-new 2 ½ × 4 ¼-in. (6.5 × 11-cm) camera. This photograph is to be printed full frame, without any specific indications.

**Carpenters from Corrèze,
summer vacation photo,
Cornil, 1928**

NEGATIVE: 2½×4¼ IN. (6.5×11 CM) _ F08/1

— 3

This is also a vacation photograph, taken
in Cornil, Corrèze, where, for several
years, my mother, younger brother,
and I spent our summer vacation.
The man in the center is the owner of the
boarding house where we stayed. He also
owned a sawmill. Here he is preparing
a frame with his son-in-law (right) and a
tradesman (left). This is a posed photograph.
A souvenir photograph, but I like it anyway.
Full frame.

Self-portrait in the family apartment, Paris, 1929
NEGATIVE: 2½×4¼ IN. (6.5×11 CM) _ D09/1
— 4

A self-portrait taken in the dining room of the apartment where I was born: 8 cité Condorcet in the ninth arrondissement, Paris, spring 1929. Understandably, this photograph moves me because I see myself in a way that I cannot recall in my memory. It's also a proclamation of my love for music. It is very difficult to print: the negative has probably been overdeveloped and the values are overly contrasted. At that time, I often developed my own films in my father's laboratory and I made mistakes. What's more, it may be that this frame was overexposed: I was still just an amateur. Slightly cropped framing compared to the full 2½ × 4¼-in. (6.5 × 11-cm) frame.

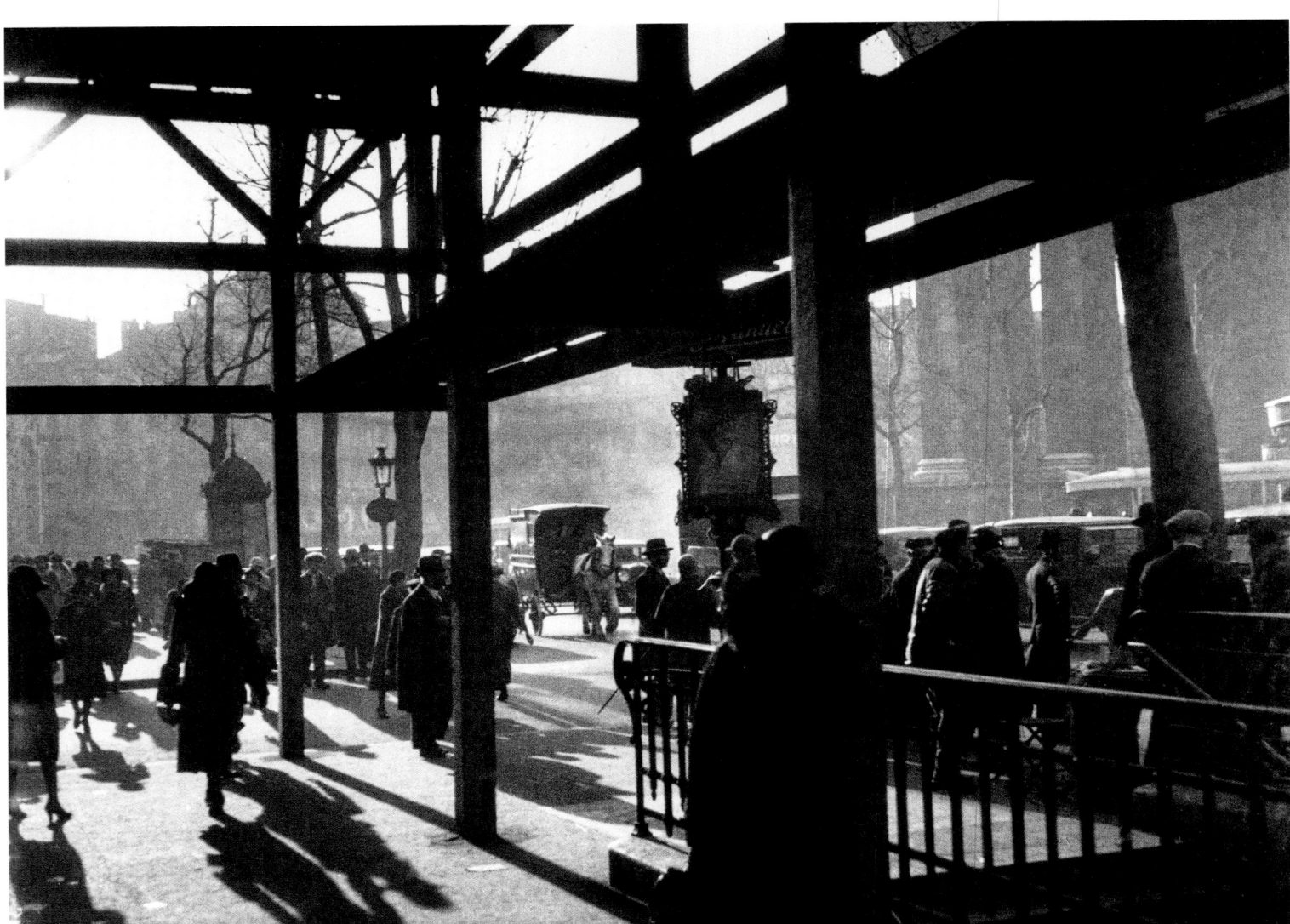

Construction of the Trois Quartiers department store, boulevard de la Madeleine, Paris, 1930
NEGATIVE: 1 1/8 × 1 5/8 IN. (3 × 4 CM) _ PO/63

Place de la Madeleine. I always liked backlight, even when I was still an amateur photographer. I was protected from direct sunlight by the scaffolding of the Trois Quartiers. I waited and then, suddenly, a horse-drawn carriage went past. There were not that many still in use in 1930. From the beginning, I used several cameras. The 2 1/2 × 4 1/4-in. (6.5 × 11-cm) camera my father gave me in 1926 soon turned out to be inadequate. It used film with eight exposures, so it needed to be reloaded often and was expensive; 2 1/2 × 4 1/4 in. (6.5 × 11 cm) is already a large format. There were cameras for sale in the window of my father's shop and, from time to time, he lent me one, if I promised to take good care of it. I had adopted two cameras: a 1 5/8 × 2 1/4 in. (4.5 × 6 cm) and a 1 1/8 × 1 5/8 in. (3 × 4 cm). The 1 5/8 × 2 1/4 in. (4.5 × 6 cm) allowed for sixteen 1 5/8 × 2 1/4-in. (4.5 × 6-cm) exposures on a roll of 2 1/4 × 3 1/4-in. (6 × 9-cm) film; it had a focal length of 75 mm. It was a folding Ikonta camera with bellows. The 1 1/8 × 1 5/8-in. (3 × 4-cm) camera, another Ikonta, also allowed for sixteen 1 1/8 × 1 5/8-in. (3 × 4-cm) exposures on a roll of 2 1/4 × 3 1/4-in. (6 × 9-cm) film. I sometimes borrowed a 2 1/4 × 3 1/4-in. (6 × 9-cm) Ikonta camera with an excellent Tessar f/4.5 lens. This photograph is to be printed full frame.

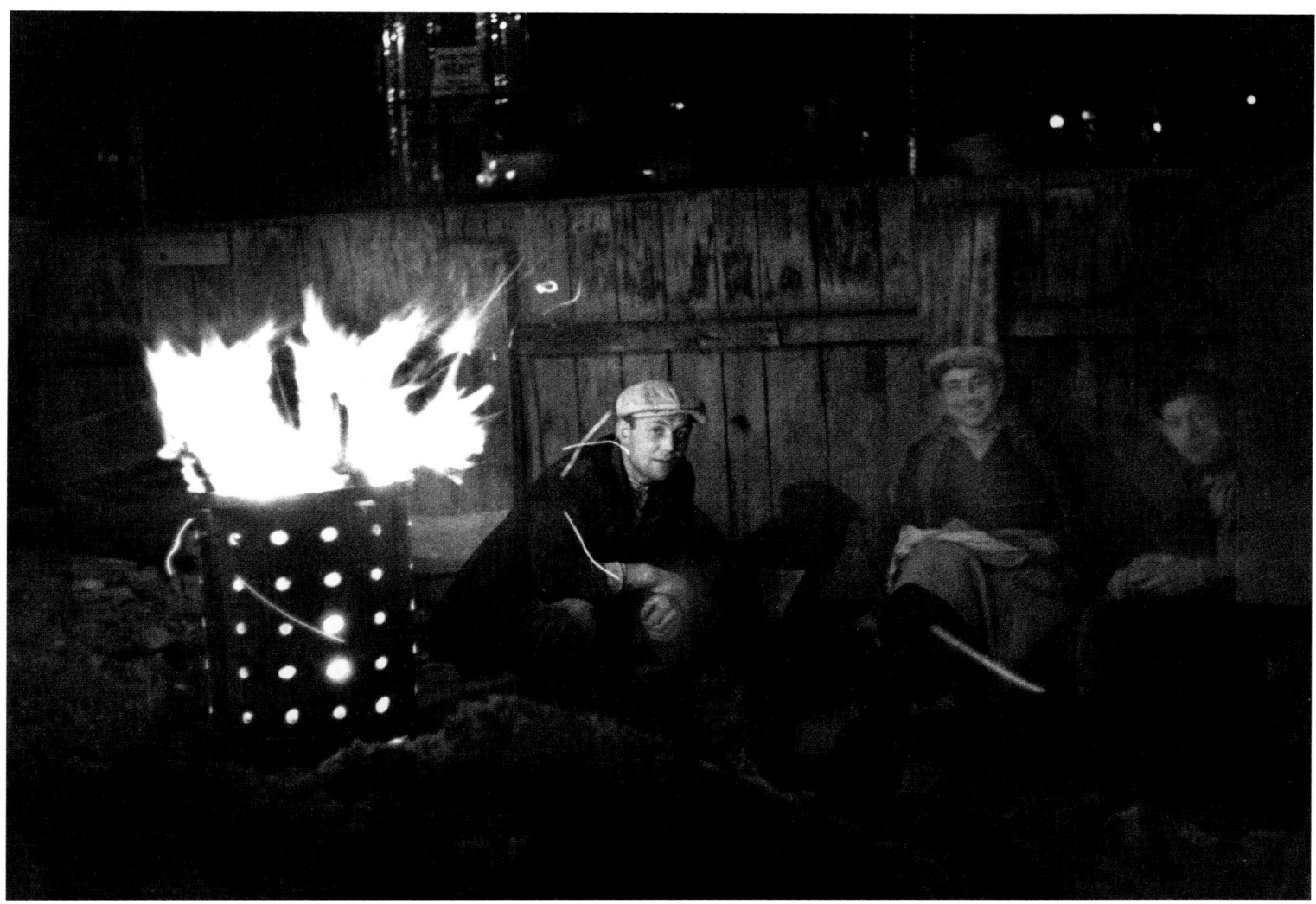

Construction site by night in Paris, 1931
NEGATIVE: 24×36 MM _ P1/0111 [OR P2/64]

— 6

Photograph taken with a 35-mm camera, which was highly unusual for me at the time, that is to say late 1931. It was taken during military leave. One of my father's clients was a young Polish man who was studying in France. Passionate about photography and from an affluent family, he had been given a 35-mm Contax. We became friends and he sometimes lent me his camera.
I think this is around a one-second exposure shot while leaning against a tree, because I don't believe I used a tripod. Looking at the photograph, I now remember throwing a handful of straw into the brazier to create the flame I needed to light up my subjects (normally a brazier does not produce a flame).
The film was Agfa Superpan, around 40 ASA. The negative is quite difficult to print from as the bright highlights need to be balanced with the areas that remained in the shadows. I do not remember the location at all. It must have been during one of my nocturnal walks in Paris. The people are probably the site watchmen. I had not asked them to move.

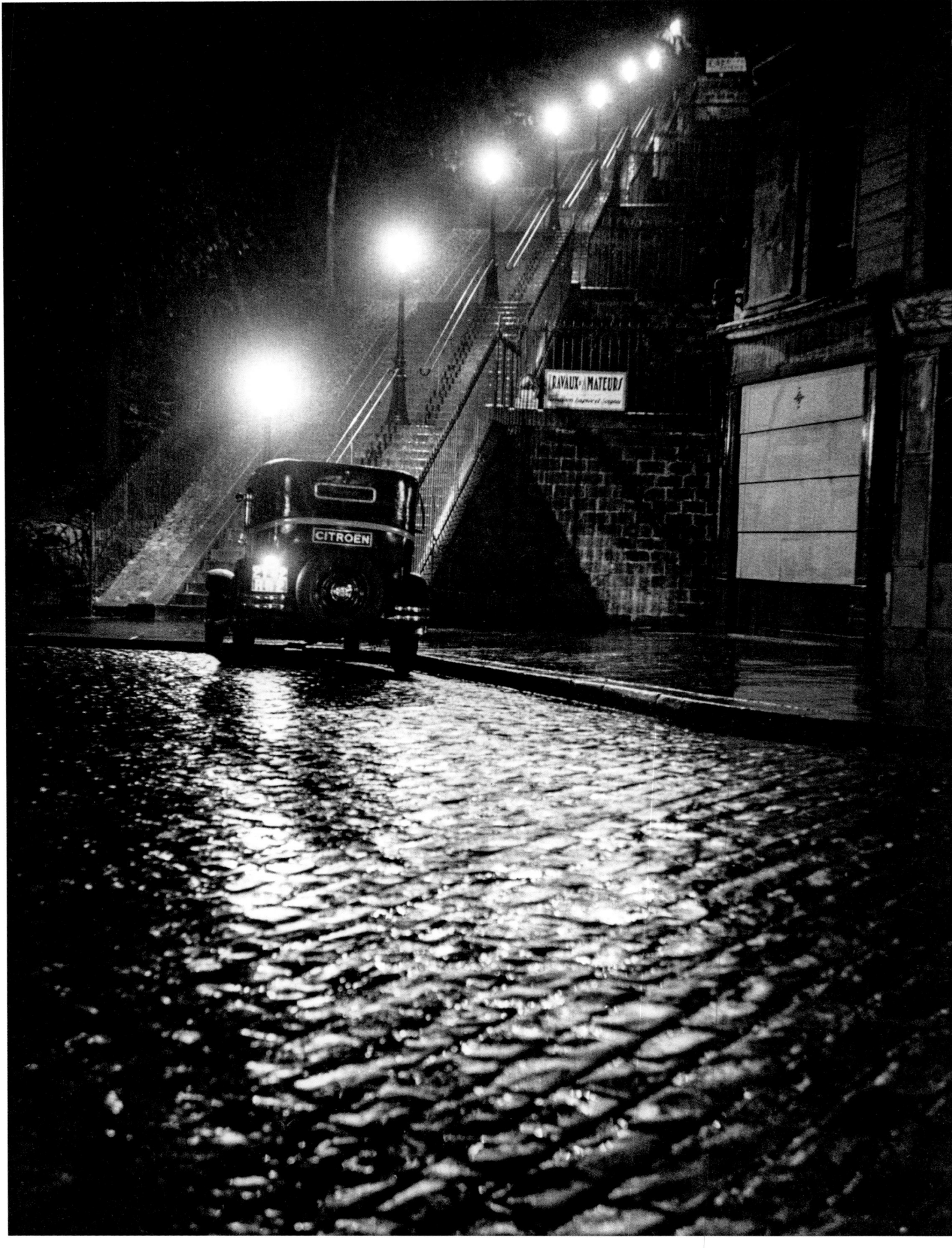

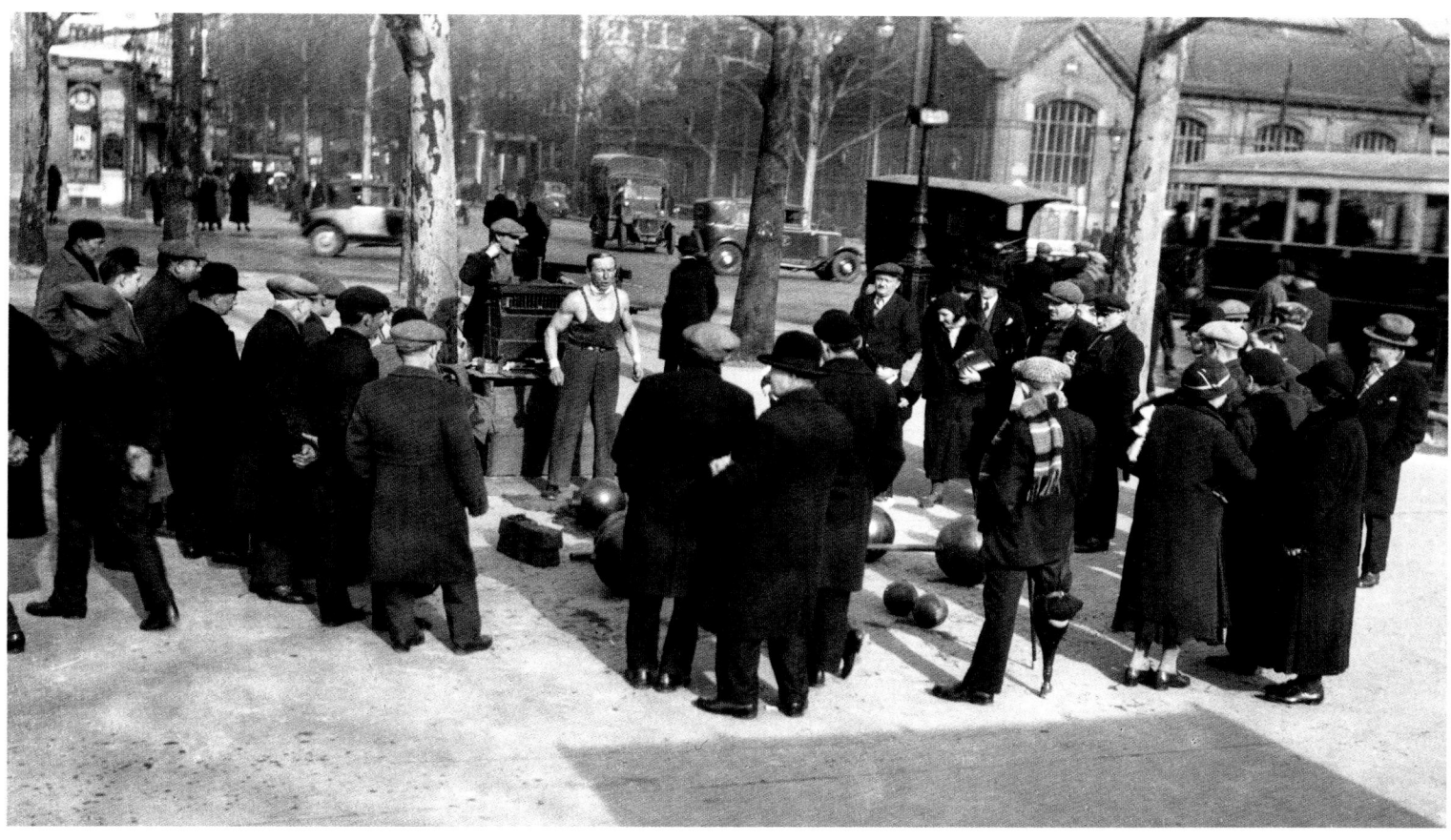

On the slopes of the Butte Montmartre, from the top of rue Muller, Paris, 1934
NEGATIVE: 1⅝×2¼ IN. (4.5×6 CM) _ P4/15
__ 7

At that time, I was not aware that there was another photographer, a dozen or so years older than me, who also roamed through Paris at night with a tripod and whose name was Brassaï. I only met Brassaï much later on, in 1945 (see photo 163). Like all lovers of night photography in cities, I particularly liked the rainy days because of the reflections.
This photograph is to be printed full frame.

Weightlifting, quai de la Râpée, near the Pont d'Austerlitz, Paris, 1934
NEGATIVE: 2½×4¼ IN. (6.5×11 CM) _ P4/52
__ 8

This is a place where acrobats often went before the war. For reasons I cannot explain today, I used to pick up the 2½ × 4¼-in. (6.5 × 11-cm) camera once in a while. Did my father think I borrowed the other cameras from the store too often? In 1932, after returning from military service, I was forced to help my father who had fallen very ill. So, despite myself, I became a professional photographer, but I really disliked being at the studio-store. I took comfort outside, by taking photographs like this one that were more to my taste, either on Sundays, when my father was on duty, or on Fridays, when the store was closed. Moreover, this photograph required some research, since it is taken from a high angle. I must have climbed up onto a parapet. Today, this area is a parking lot. The 2½ × 4¼-in. (6.5 × 11-cm) camera must have had a focal length of 115 or 120 mm. This is the only camera I owned in my own right until my father died in 1936.

**Under the Pont d'Austerlitz,
Paris, 1935**

NEGATIVE: 2¼×3¼ IN. (6×9 CM) _ P5/43

___ 9

I took this photograph on the banks of the Seine, one of my favorite places to walk. The character seen from the back is a homeless man walking along the quai de la Râpée, which is now a road along the riverbank. This photograph is slightly cropped. The difficulty is to make the clouds in the sky appear without losing any detail in the shadows on the right and at the bottom.

**Night at the cottage,
Todtnauberg, Germany, 1935**

NEGATIVE: 2¼×3¼ IN. (6×9 CM) _ N5/58

___ 10

A personal photograph: a friend in a chalet in the Black Forest, after a dinner of cold cuts, slices of buttered brown bread, and café au lait, according to a German custom. Single lighting: the oil lamp that can be seen on the table. It is not too difficult to print, although there are strong differences between the highlights and the shadows. Slightly cropped on the left side, after the pitcher, to remove unnecessary detail.

**Place de la République,
Paris, 1935**

NEGATIVE: 2¼×3¼ IN. (6×9 CM) _ P5/62

___ 11

This photograph was taken at place de la République, close to my father's shop, which was located at 15 boulevard Voltaire. I like this photograph to be printed a little gray, as suggested by the winter light. Full frame.

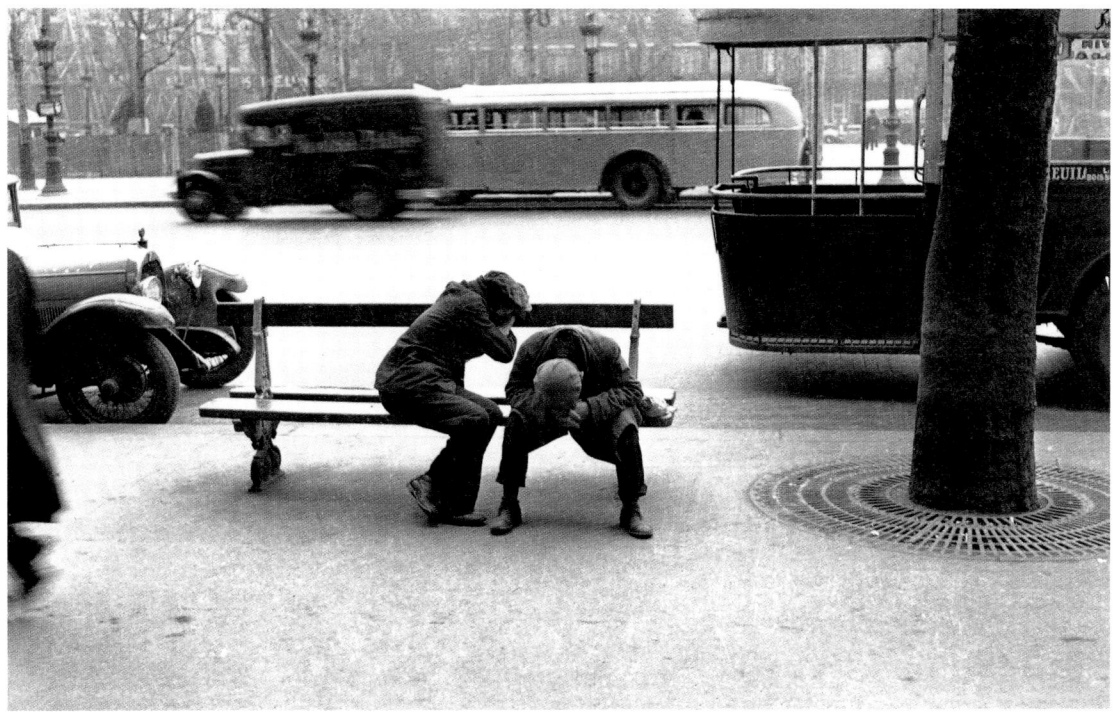

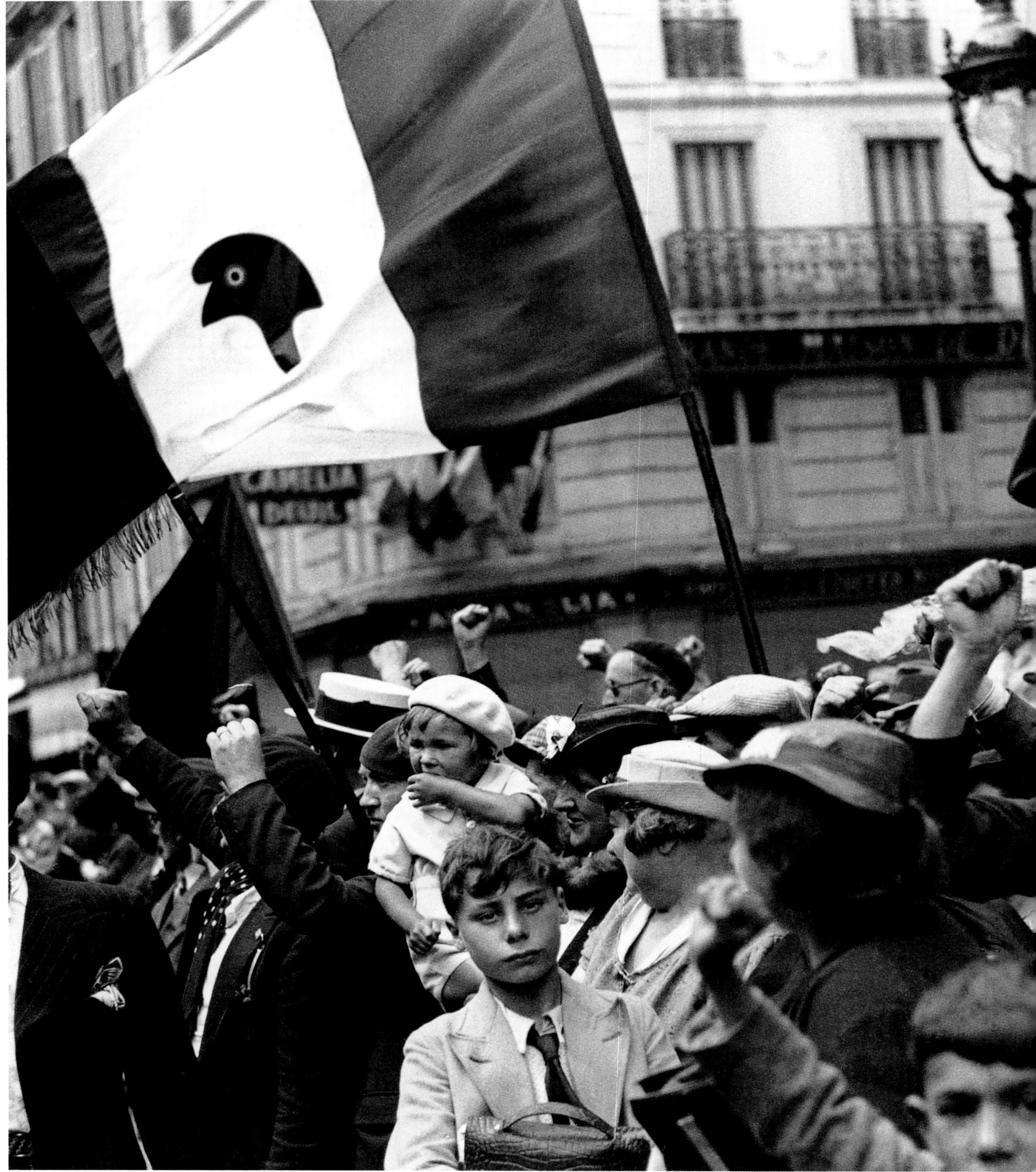

During the Popular Front victory parade, rue Saint-Antoine, Paris, July 14, 1936
NEGATIVE: 2¼×3¼ IN. (6×9 CM) _ R6/10/[2]

This is the Popular Front, and the jubilant crowd on the march that went from the Bastille to Nation. Here, we are on rue du Faubourg-Saint-Antoine. I already preferred to photograph the sidelines rather than events themselves. I had been amused by this little girl in the Phrygian cap, echoing that of the flag, who was raising her fist without really knowing why. On the technical side, no specific instructions. Cropped negative.

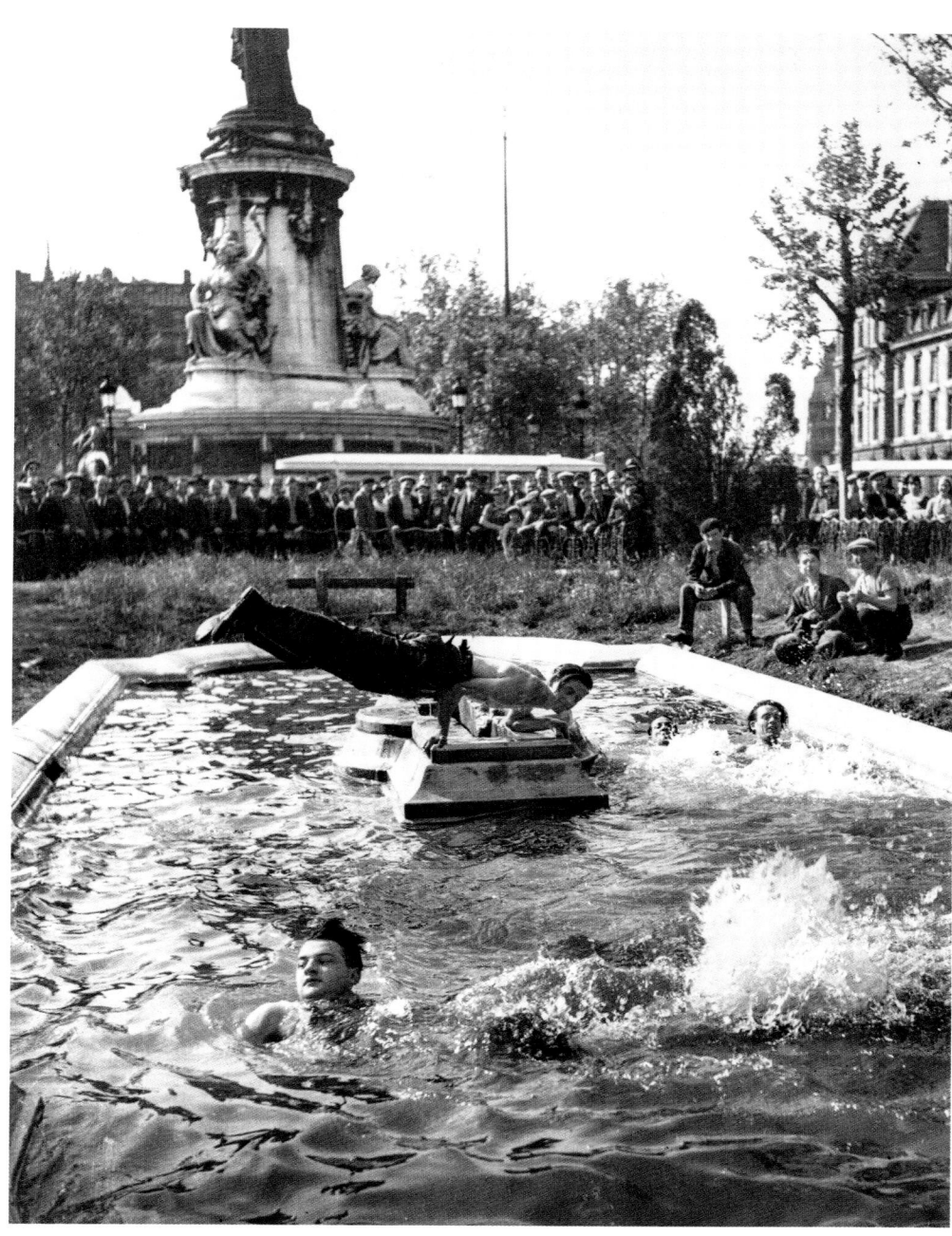

Place de la République, Paris, 1937
NEGATIVE: 2¼ × 2¼ IN. (6 × 6 CM) _ P7/156
— 14

In the spring of that year, I finally bought the 2¼ × 2¼-in. (6 × 6-cm) Rolleiflex with the Tessar f/3.5 lens that I had coveted for such a long time. I bought it from a German refugee. Many refugees who were fleeing Nazism sold items they had brought to France—especially Leica, Contax, or Rolleiflex cameras—in order to survive. I used this camera until the end of 1954, and occasionally later on, for some industrial or studio photography. In 1937 (one year after my father's death), the store had already been sold, but my mother, brother, and I still lived at 117 boulevard Richard-Lenoir, close to the place de la République where this photograph was taken. On May 25, in the late afternoon, I was returning from a shoot at Expo 37 when I chanced upon this scene. It had been exceptionally hot for a few days and workers at a nearby site had found a good way to cool off. I took five photographs and my diary entry for the next day reads: "took 4 photos swimming Pl. Rep. to *Ce Soir*." This is a different image to the one that was published, in 10¼ × 11-in. (26 × 28-cm) format, in the new issue dated May 28. Highly contrasted negative. Lateral cropping.

Val-d'Isère, Savoie, 1937
NEGATIVE: 1⅝ × 2¼ IN. (4.5 × 6 CM) _ N7/90
— 13

Photograph taken in Val-d'Isère, which at that time was no bigger than a hamlet. I had gone to this slope using skis with climbing skins to save money on the cable car. That way, I could stay a few more days. The negative is to be printed full frame.

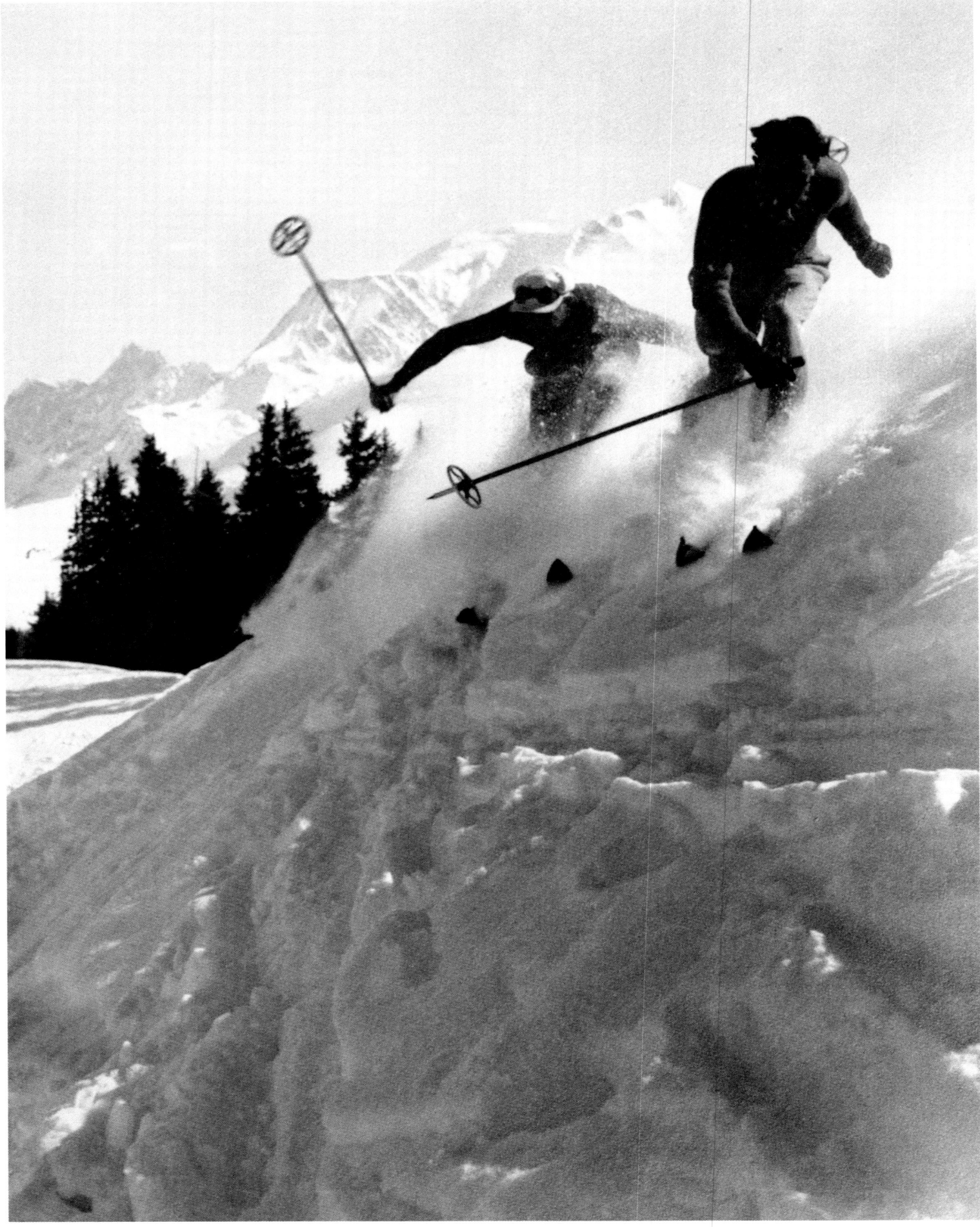

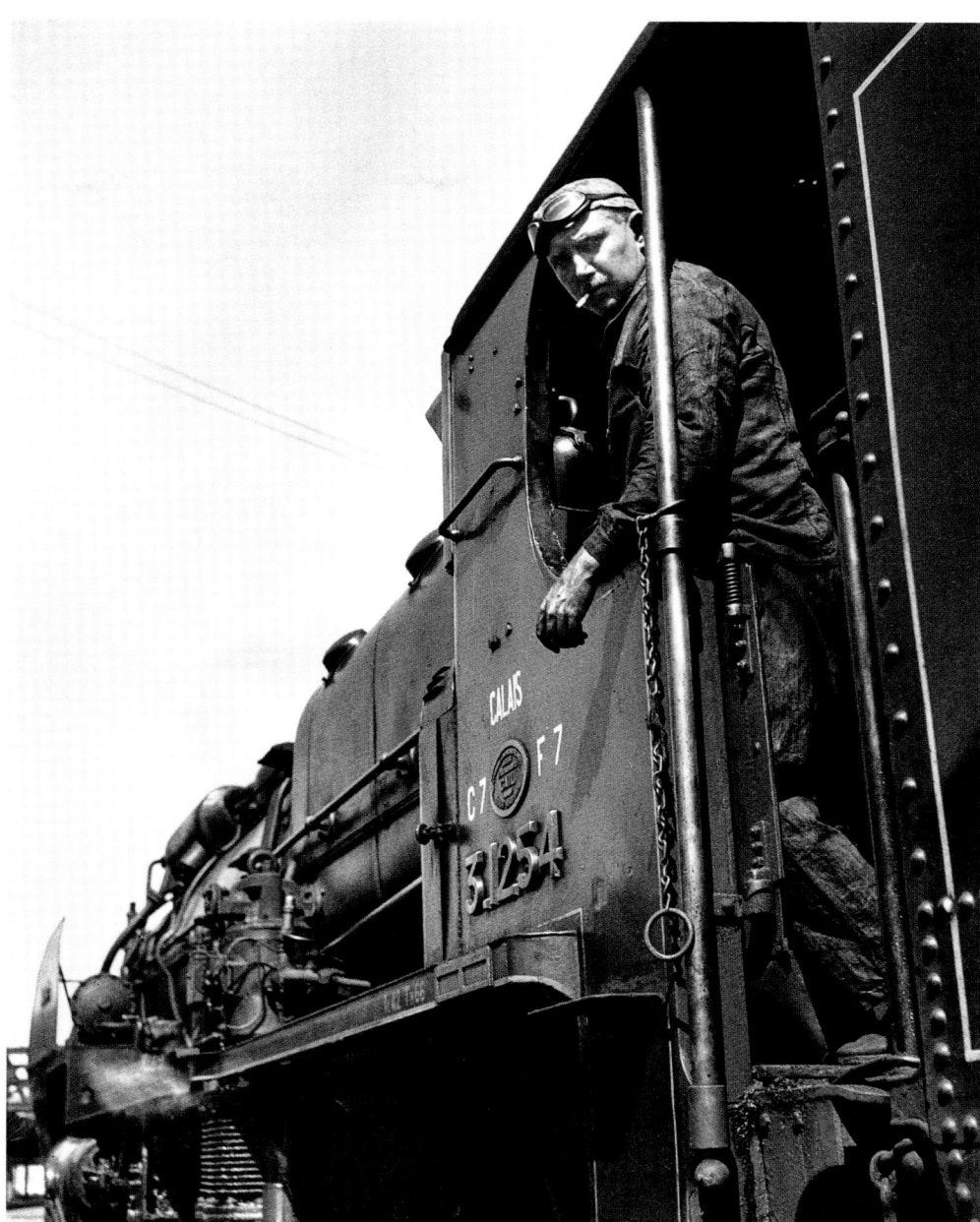

Mont d'Arbois, above Megève, Haute-Savoie, 1938
NEGATIVE: [2¼ × 2¼ IN. (6 × 6 CM) ORIGINAL] _
2¼ × 3¼ IN. (6 × 9 CM) DUPLICATE _ N8/221
—— 15

Two years after my father's death, I had become something of a specialist in snow and winter sports photography. The store had been auctioned off due to debts that I could not pay in those times of crisis. It was sold in late 1936. I did not take anything away from it, except freedom. A very hypothetical freedom since I needed to find work. I had a great passion for winter sports and, since returning from military service, I took my vacation in the off-season, that is to say at the end of January, beginning of February. It was a pretty dreadful season for us, especially in those years of serious economic crisis, while in the summer we developed a lot of amateur work, which was a big boost. During this vacation, I had gradually built up real archives. What's more, I had met a fellow of my age, André Ledoux, who had founded a ski school and a winter sports travel agency. This photograph shows two of his instructors. It was taken on February 23, 1938. I found the clipping of the December 27, 1938, issue of the newspaper *Le Jour-Écho de Paris* where it appeared, in 7½ × 9½-in. (19 × 24-cm) format, to inform readers of the international exhibition of snow photography at the Grand Atelier on rue Lafayette, a gallery belonging to the camera store and importer Tiranty, which no longer exists. The 2¼ × 2¼-in. (6 × 6-cm) negative was lost shortly afterward by an editor (a mishap that would happen to me again several times). Fortunately, I had a good print from which I was able to make a good 2¼ × 3¼-in. (6 × 9-cm) duplicate after the war. This print was made from that new negative. An alternative version of this photograph, from the same session but with a single skier, was published before the war as a poster for the French tourist board with the title *Neige de France* (France's Snow).

The Pacific 231 steam locomotive, Gare du Nord, Paris, 1938
NEGATIVE: 2¼ × 2¼ IN. (6 × 6 CM) _ P8/108
—— 16

It was only on April 30, 1939 (according to my diary), that I saw Jean Renoir's *La Bête humaine* (The Human Beast) at the Gaumont Palace. But I always liked locomotives and I often wandered the platforms of the Gare de l'Est after leaving the network's advertising offices, with which I worked frequently. The mechanic knew I was taking his picture. I probably asked him to look at me. Lateral cropping.

**Union delegate Rose Zehner
during a strike at Citroën-Javel,
Paris, 1938**
NEGATIVE: 2¼×2¼ IN. (6×6 CM) _ R8/10/2
___ 17

This photograph is taken from a report for the weekly *Regards* during a strike at the Citroën-Javel factories. My diary entry for March 25, 1938, reads, "7:30 a.m. Citroën Javel. Reportage with Léveillé and L. Guerin"— no doubt an editor and a union delegate—and then, "Took and brought 26 photos to *Regards* [5 p.m.]," on the same day. However, the full story contains forty-six negatives. I must have chosen those that, at first sight, seemed the most interesting and the easiest to print. The negative of Rose Zehner is very underexposed and I suppose I did not have the right grade of paper on hand. It was therefore neither printed nor, of course, presented. I found it while preparing my book *Sur le fil du hasard* (On Chance's Edge), in L'Isle-sur-la-Sorgue in 1979. When it was published in late 1980, this is the photograph which was most often reproduced in the daily, weekly, or monthly press. A friend of Rose Zehner, having recognized her in the photograph published in *L'Humanité*, told her immediately. Rose wrote to the paper, which sent me the letter—a magnificent letter. Thus began a written and then telephone correspondence, until the following summer when I received Patrick Barbéris, a young filmmaker who was visiting my home to make a short film. Talking about this and that after the shoot, I told him this story. He found it so extraordinary that he immediately decided to meet this woman. Then the phone rang: it was Rose Zehner! This is how a second film was born, relating my reunion with the former Citroën union member in September 1982 in Paris. Lateral cropping.

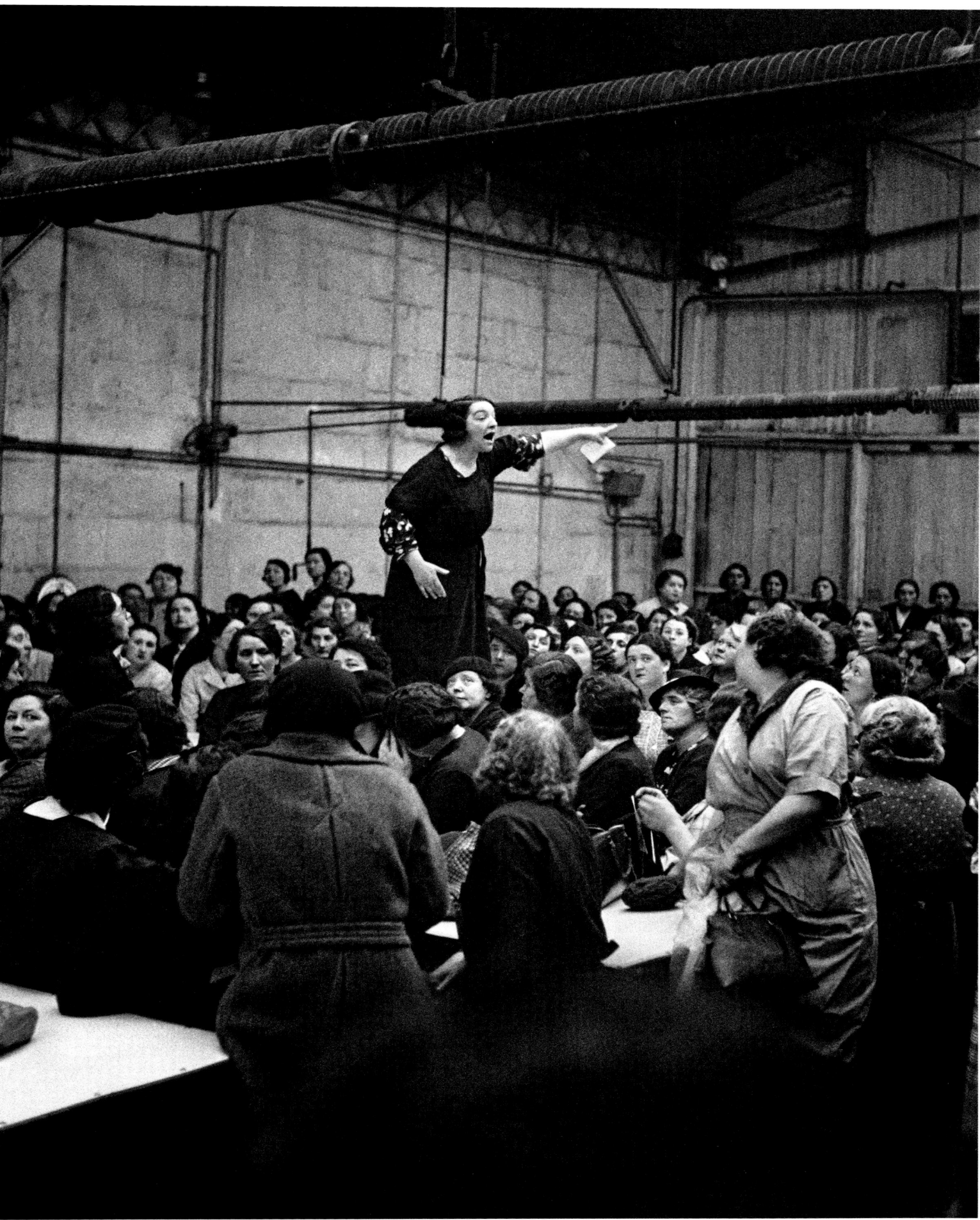

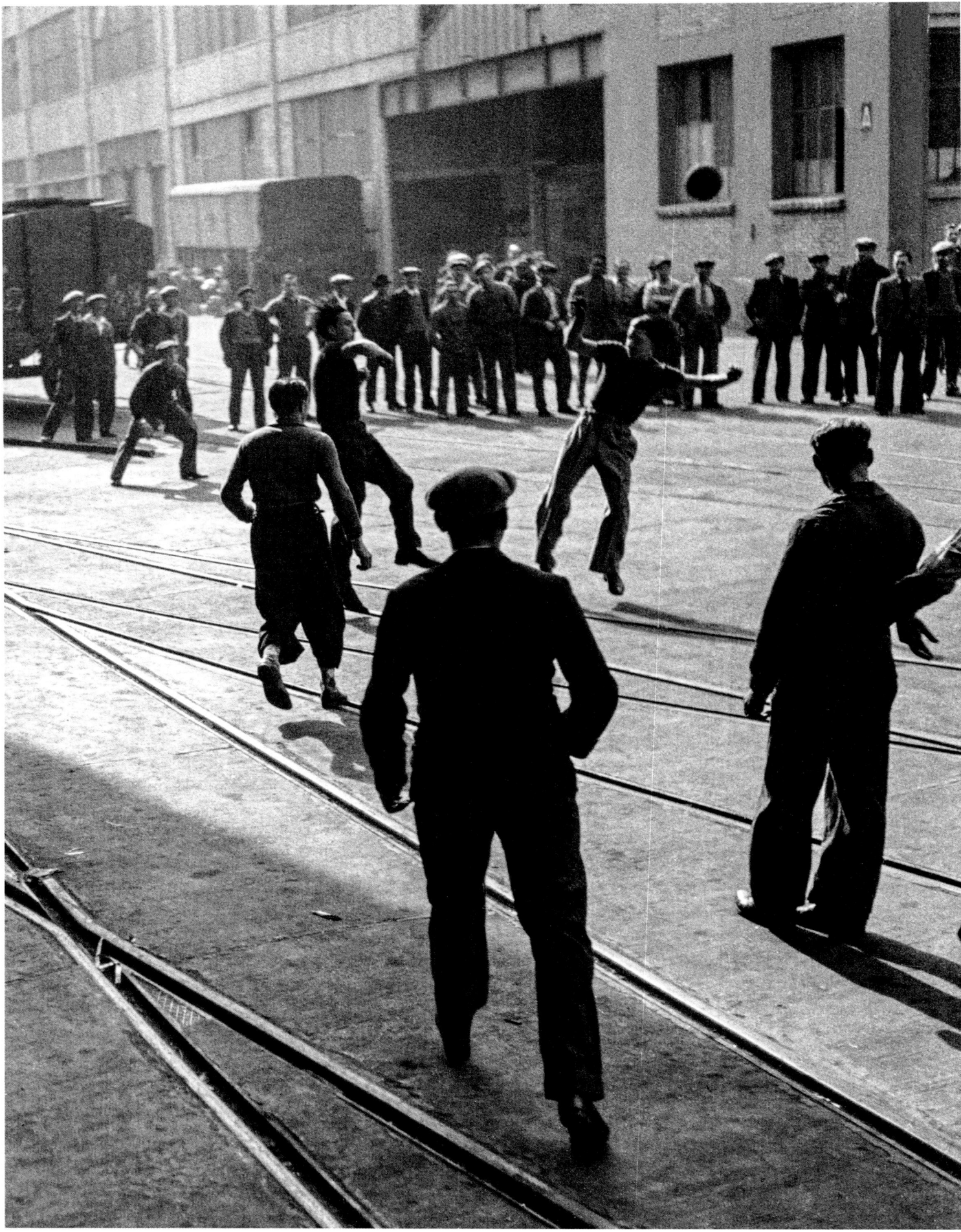

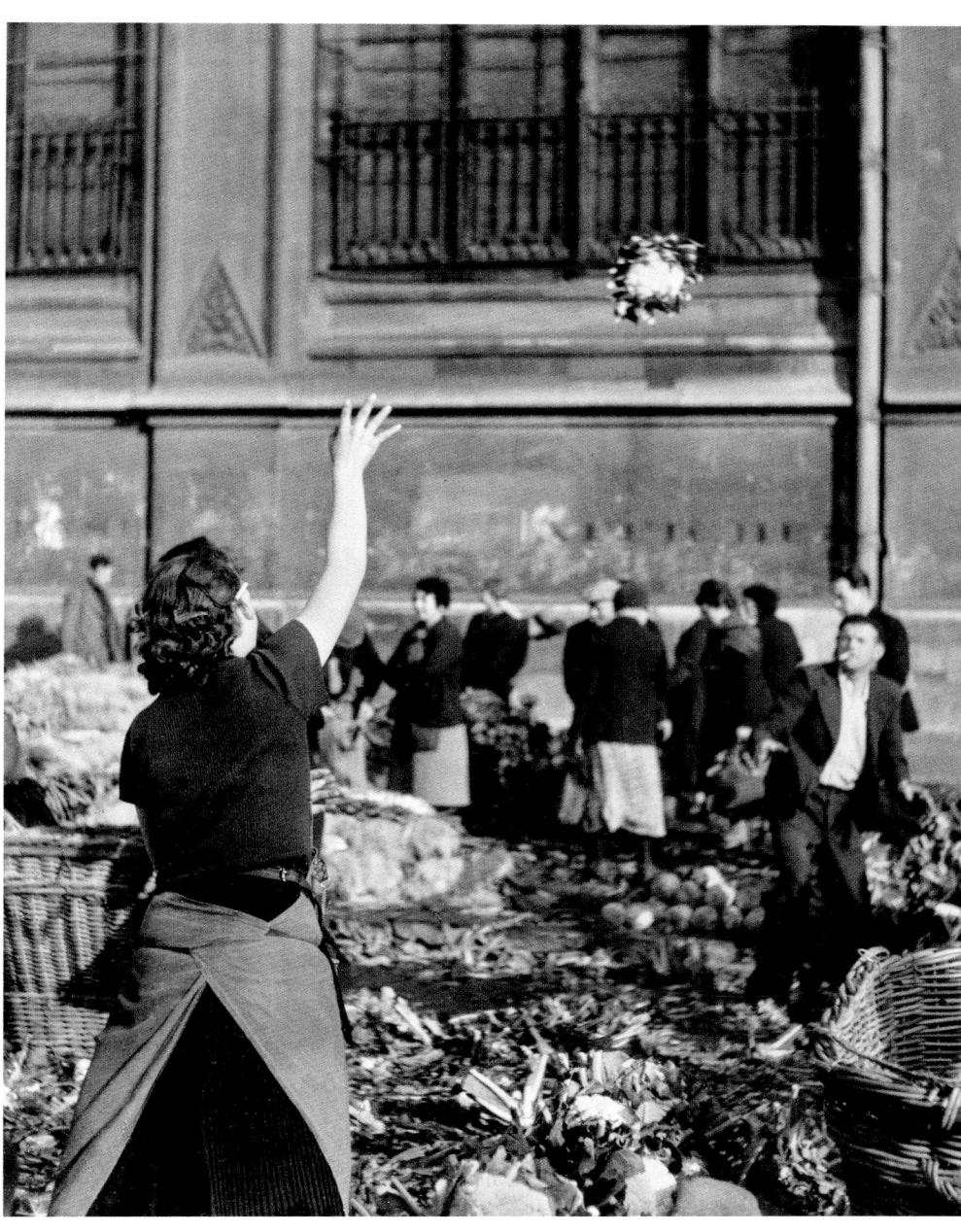

Workers in the yard during the strike at the Citroën-Javel factory, Paris, 1938
NEGATIVE: 2¼×2¼ IN. (6×6 CM) _ R8/10/6
___ 18
This photograph is from the same story as the previous one. It shows the workers playing soccer in the yard during the strike. This negative, highly underexposed and poorly composed during the shoot, is heavily cropped.

Closing of the market between architect Victor Baltard's Les Halles and Saint-Eustache church, Paris, 1938
NEGATIVE: 2¼×2¼ IN. (6×6 CM) _ P8/148
___ 19
It's the end of a morning market at Les Halles, in front of Saint-Eustache church. I think that the woman was throwing the cauliflowers to her colleague so that he could put them away because, as a Parisian who frequented markets regularly, I don't remember customers being served in this way. The negative is cropped but retains almost the full height of the 2¼ × 2¼ in. (6 × 6 cm).

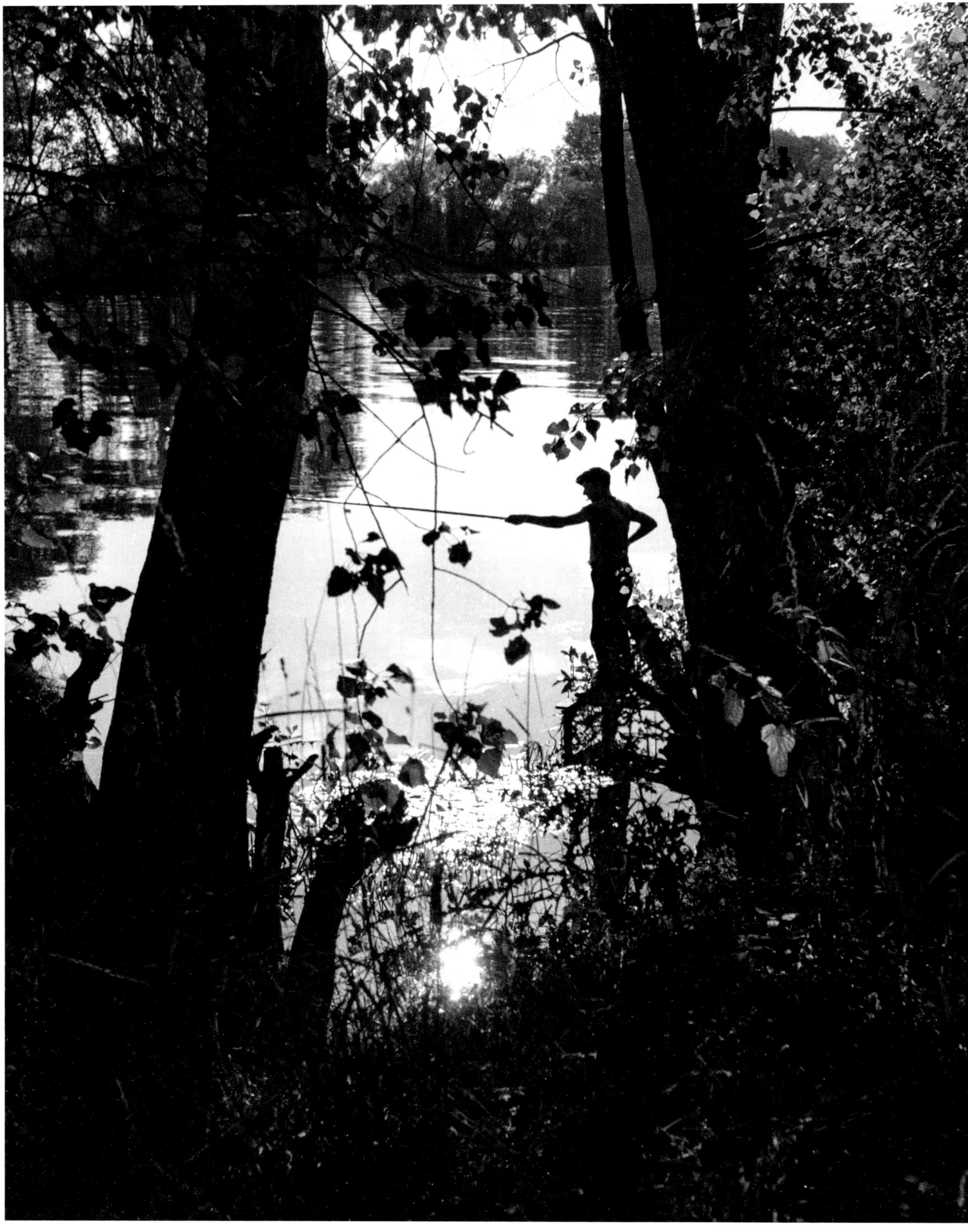

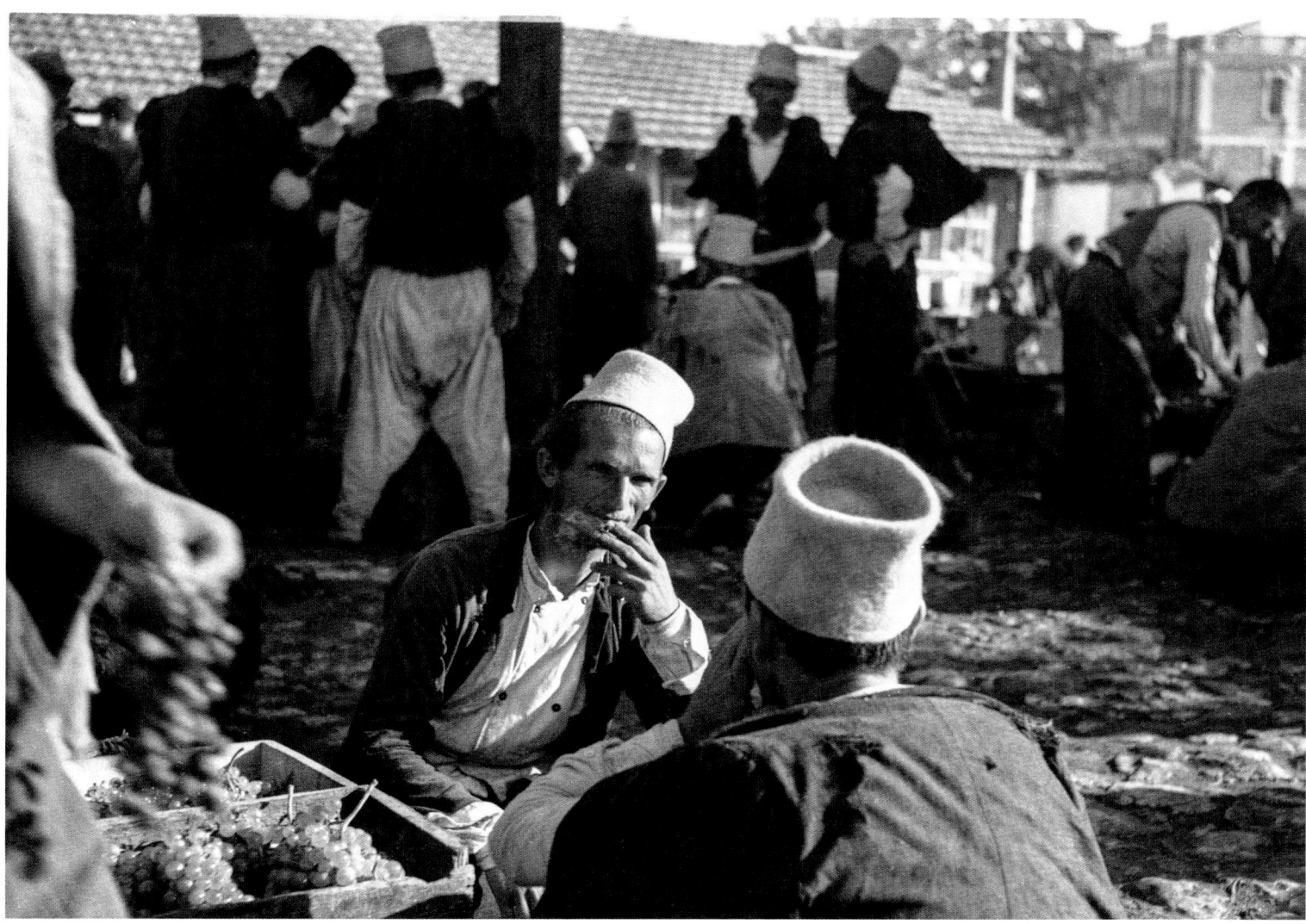

**Fisherman on the Marne river,
Faÿ-le-Bac, Seine-et-Marne, 1938**
NEGATIVE: 2¼×2¼ IN. (6×6 CM) _ Z8/36
__ 20

On a weekend (Sunday, August 7), I had been invited by a high-school friend to his parents' property near La Ferté-sous-Jouarre. I couldn't resist the backlight; it was as if a backlight-master was calling his dog-photographer. At the whistle, the animal runs up, eye switched on and camera loaded for a new image. Still, for the ear to perk up, the backlight needs to outline a subject. Here, the subject is a worker fishing at the edge of the Marne. I say a worker, because before the war the way people dressed characterized them much more than now, and the cap was really a hallmark of the male working class. Some never took it off, except to sleep. Photograph cropped on both sides.

**At the Durrës market,
Albania, 1938**
NEGATIVE: 2¼×2¼ IN. (6×6 CM) _ B8/258
__ 21

Why Albania? Why Durrës? Of course, in 1938 I didn't have the means to treat myself to a cruise. A friendly and enterprising fellow who I got to know during a military period had offered to take me on a Yugoslavia-Albania-Greece cruise in exchange for work, reserving the right to use my photographs for his advertising, without exclusivity. I could also take portraits of the passengers on the boat and ashore, photographs that I developed at night to deliver them the next day (a big success). This photograph was taken during a stopover at the Durrës market. The negative must be cropped, because of a problem in winding on the film (two overlapping negatives). This framing does not quite satisfy me, but I think I captured the scene well.

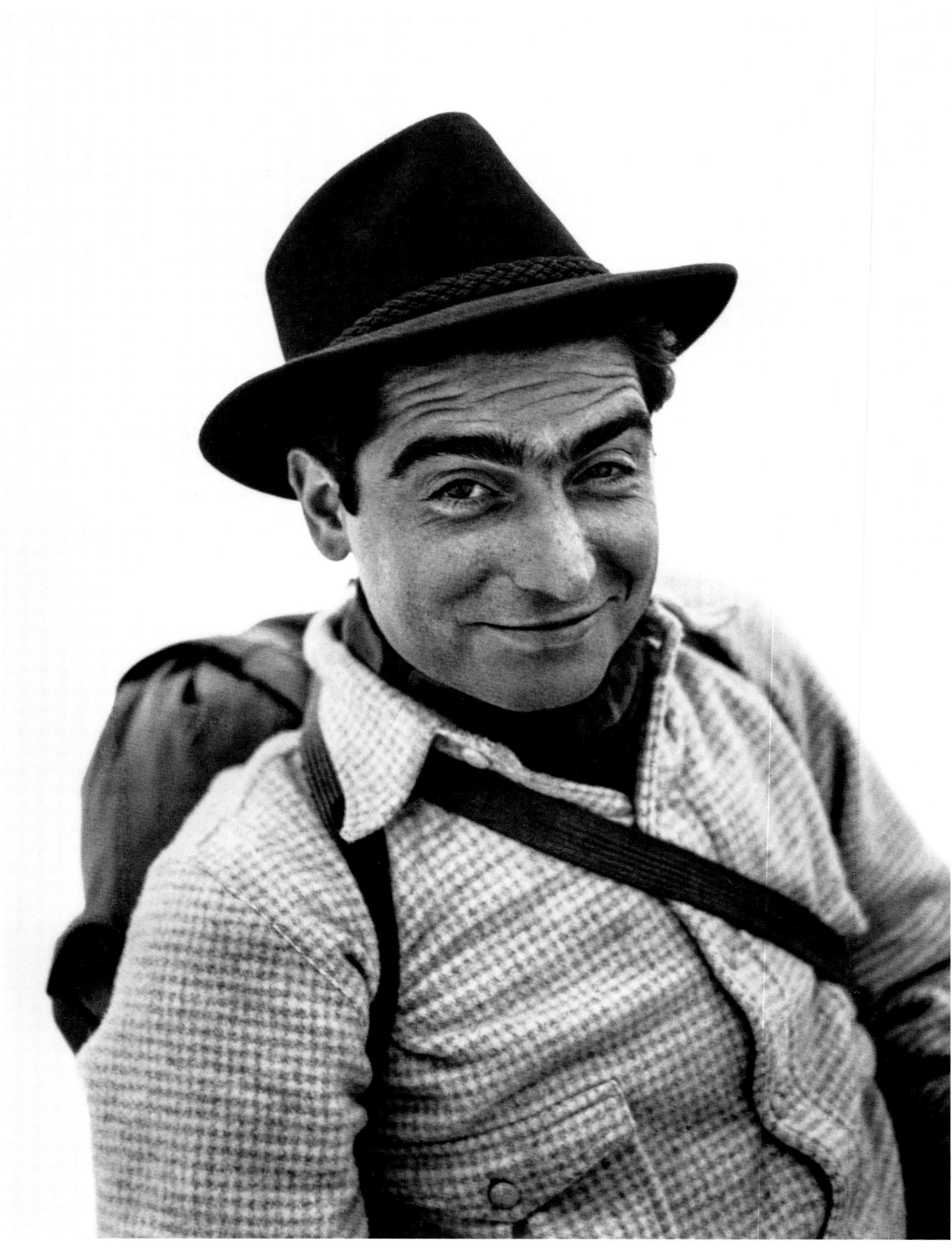

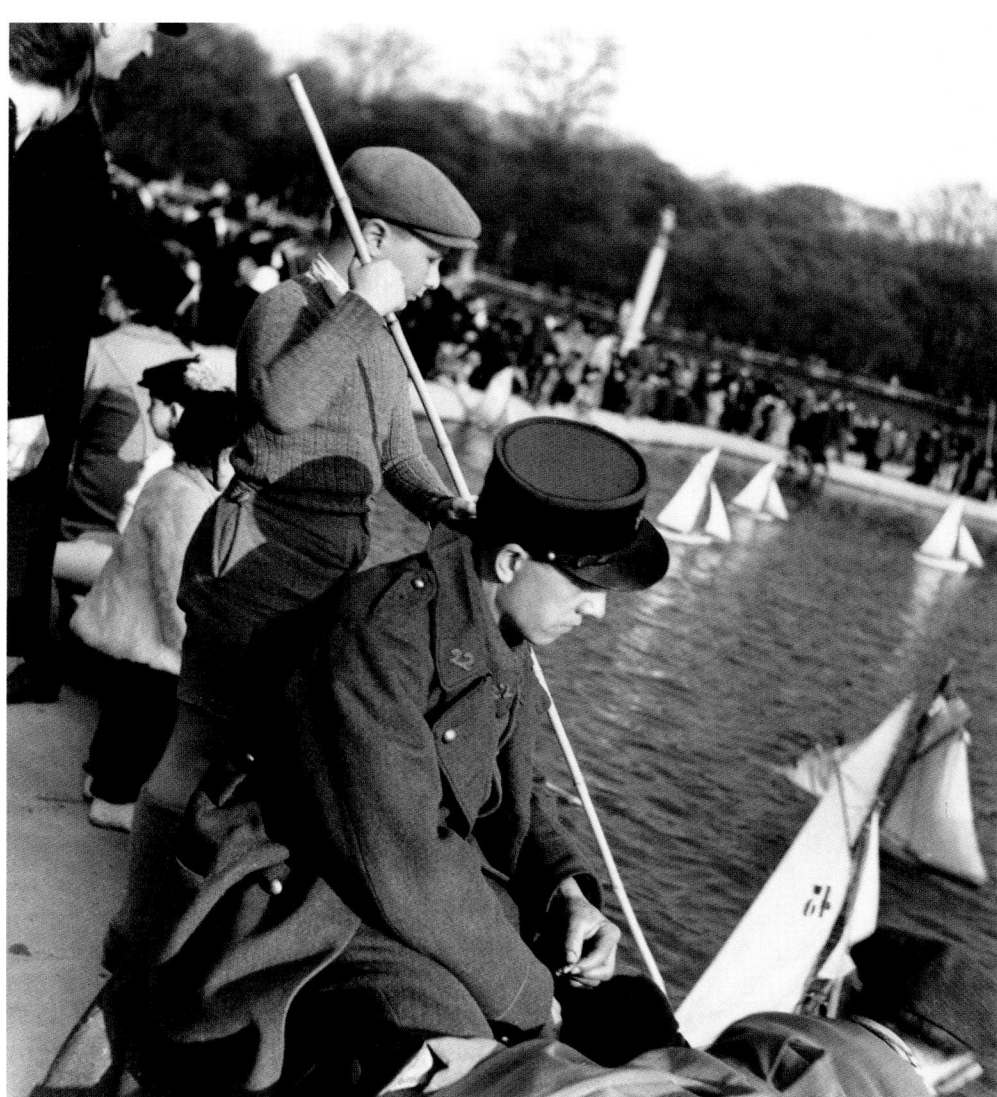

**Robert Capa, Megève,
Haute-Savoie, 1939**
NEGATIVE: 2¼×2¼ IN. (6×6 CM) _ 2¾×4 IN. (7×10 CM)
DUPLICATE _ N9/316 OR DN9/316
— 22

An impromptu portrait of Robert Capa.
I had returned to Megève in the spring of 1939, for a commission from the sports travel agency mentioned in photo 15, and, by chance, on the afternoon of April 7, I ran into Capa on the slopes of Mont-Joux. I had known him for three years already and we were very close. Amused by this chance encounter, we photographed each other. When Capa died in 1954, I remembered only very vaguely having photographed him in 1939. Moreover, I know through Pierre Gassmann and Romeo Martinez that there are few photographs of him, strange as that may seem.
I found the negative while preparing my book *Sur le fil du hasard* (On Chance's Edge), in 1979. It had been damaged and had never been reproduced before. Since the Pictorial laboratory made a duplicate from a carefully retouched print, printing it is no longer a problem.

By the edge of the fountain in the Luxembourg Gardens on the eve of war, Paris, mid-June 1939
NEGATIVE: 2¼×2¼ IN. (6×6 CM) _ P9/120
— 23

Since the end of 1936, having become a freelance photographer, I had been systematically building up my archives, encouraged by the favorable reception that they had received from the French tourist board and the SNCF railroad company, among others. But, in 1939, I added images linked to current events to my general interest photographs: hence the sad and pensive face of this soldier, reflecting the drama about to unfold.

The framing of this photograph is tilted. It was fashionable then. I didn't give myself over to this trend very often because I was wary of stylistic affectations and already aware that they could make images feel dated. But in this case, I found that the framing accentuated the despondent expression of this fellow, who was not so much younger than me, as in 1939 I was twenty-nine years old.

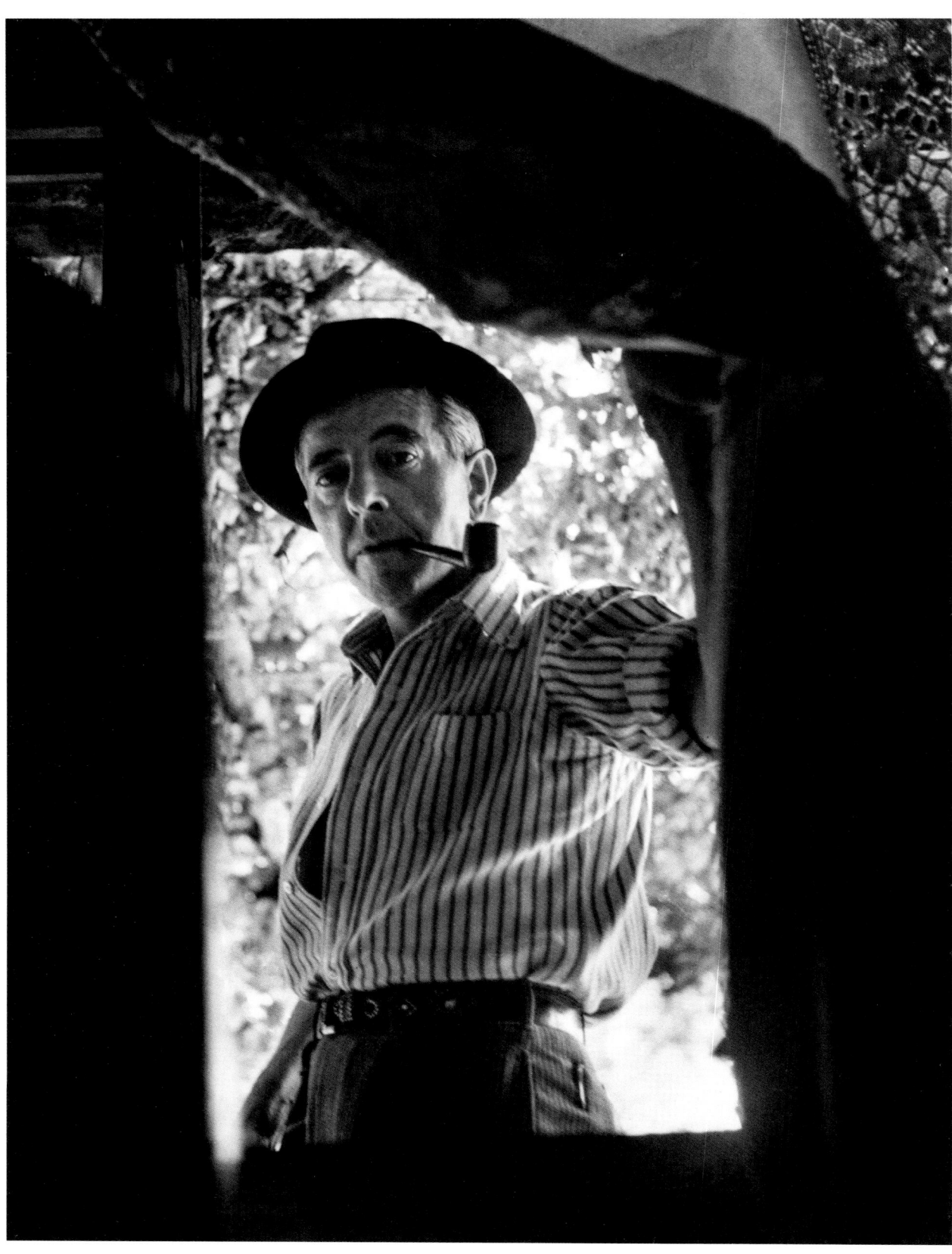

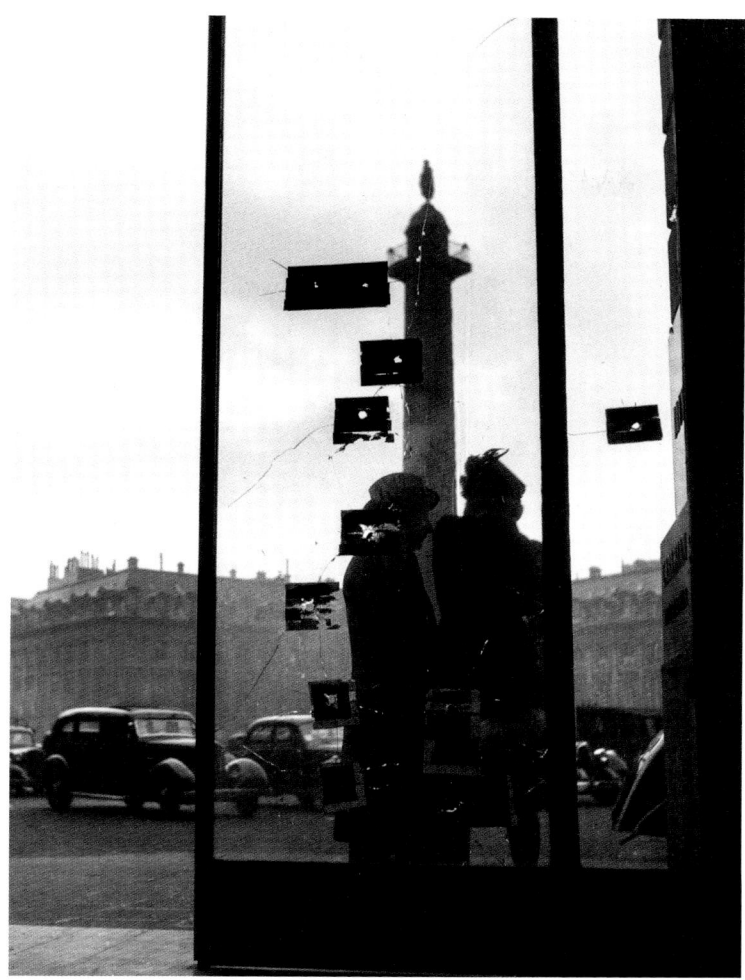
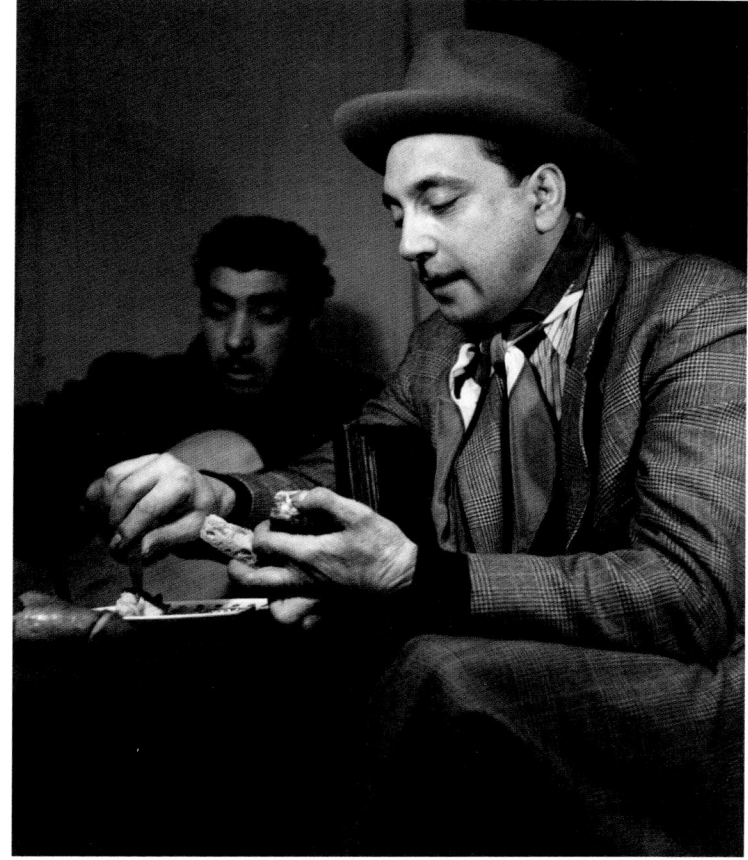

Jacques Prévert at Tourrettes-sur-Loup, Alpes-Maritimes, 1941
NEGATIVE: 2¼ × 2¼ IN. (6 × 6 CM) _ [D]11/5
___ 24

In 1941, I had left Paris for Nice, where I worked with Marcel Duhamel in a traveling theater company, taking care of stage management and set maintenance. Marcel Duhamel was part of the Bande à Prévert group. That is how I met the Prévert brothers, with whom I immediately became friends. Jacques was then living in Tourrettes-sur-Loup, and one day when he had invited me over with some friends, I photographed him as he lifted the curtain to enter the room. Cropped photograph.

Vestiges of the liberation at place Vendôme, Paris, 1945
NEGATIVE: 2¼ × 2¼ IN. (6 × 6 CM) _ P15/61
___ 25

With this photograph, we make a four-year leap in my life because I did not take many pictures during the occupation, except for a few snapshots that are only of interest to me and my family. This photograph dates from winter 1945 and is part of a report retracing the footsteps of the occupation and the struggles of the liberation, commissioned by *Point de vue* magazine. I wanted to draw attention to the bullet holes in the glass door of a fashion house on place Vendôme. The flow of cars and the two characters chatting calmly on the sidewalk create a much livelier image than if the space had remained empty.

Django Reinhardt, with his brother Joseph in the background, Paris, 1945
NEGATIVE: 2¼ × 2¼ IN. (6 × 6 CM) _ R15/2/15
___ 26

I had met a certain Charles Delaunay at Saint-Cyr fort in 1931, during my military service. Housed in the same room, we became friends, united by a passion for jazz. Having later become president of the Hot Club de France federation and the director of *Jazz Hot* magazine, he arranged a meeting for me with the great guitarist-composer. Django had just been playing for a long while. His brother Joseph, in the background, is still improvising. It is February 19, 1945, in a ground-floor apartment on avenue Frochot, and it is cold. Additional lighting with two floodlights. Lateral cropping.

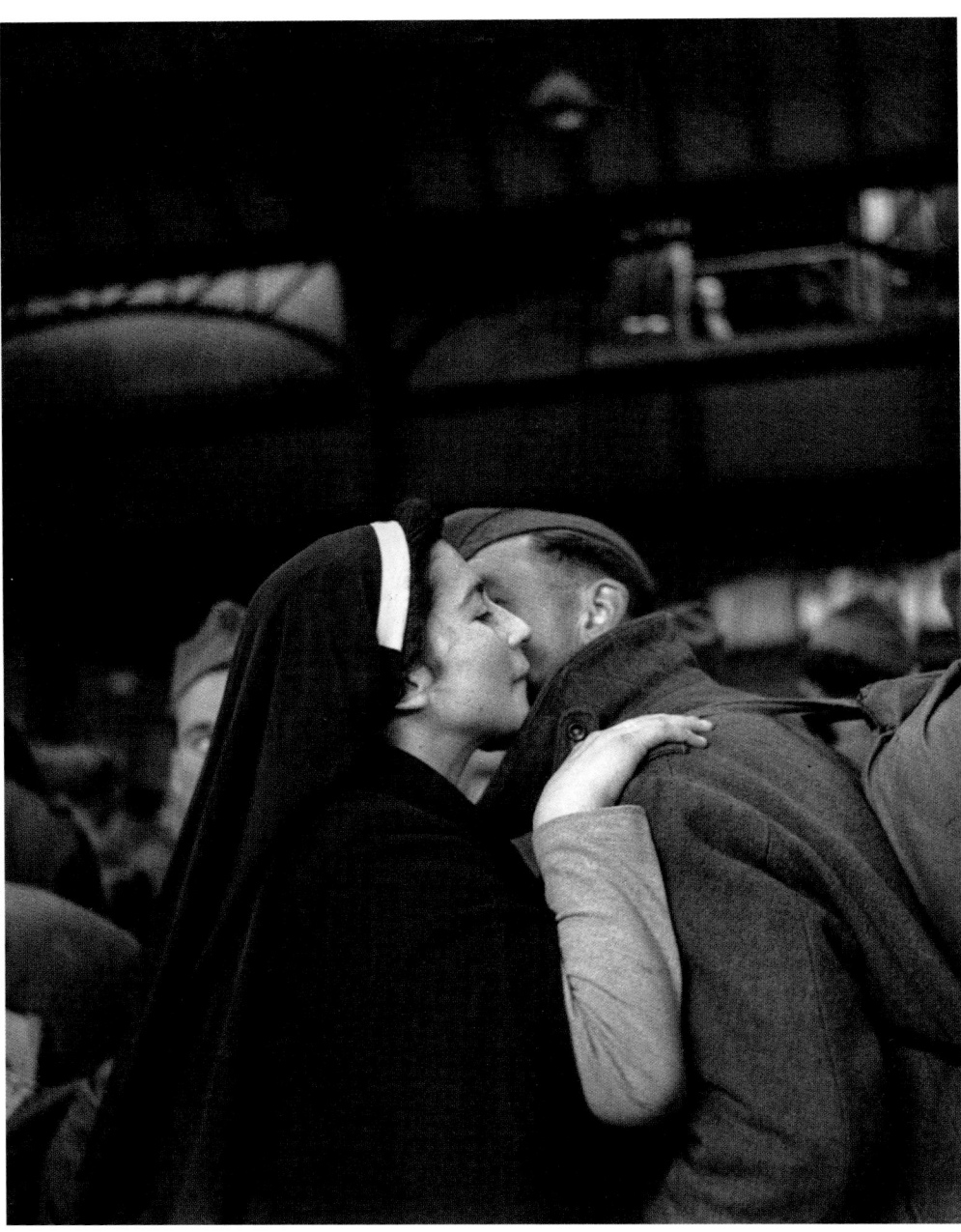

**Prisoners' return,
Gare de l'Est, Paris, 1945**
NEGATIVE: 2¼×2¼ IN. (6×6 CM) _ R15/3/156
___ 27

Back in Paris at the end of 1944, I had to make a place for myself again in the profession. It wasn't too difficult because there was a great need for images: the illustrated press was putting itself back together and those who knew how to work easily found takers. I had also been to see my pre-war clients: the tourist board, the SNCF, the travel agencies, and the illustrated magazines. This photograph is taken from a major story commissioned by the SNCF on the French railroad's efforts for the repatriation of prisoners. The story had kept me occupied through the second half of April and many of its images were used by various publications. I did not give this photograph to the client at the time; I felt it was too intimate. Today, time has passed and it no longer matters. I also included it in my book *Sur le fil du hasard* (On Chance's Edge). Lateral cropping.

**Victory Day, Grands Boulevards,
Paris, May 8, 1945**
NEGATIVE: 2¼×2¼ IN. (6×6 CM) _ R15/4/5
___ 28

It is "V-day," May 8, 1945, on the Grands Boulevards in Paris: an American tank full of jubilant Parisians passes by. That day, I had a number of non-commissioned photographs. I must have placed a few, but there were so many photographers to "cover" this event that, of course, no one was counting on me; for that matter I do not remember if this photo was reproduced. There is only one technical aspect that I would like to point out: the tank was driving quite fast. So, I knowingly used a shutter speed that was not too fast to allow for a slight blur in the trees in the background, which precisely renders the impression of movement. The print is a little tricky to make because the bottom of the image is underexposed. Care must be taken not to lose detail in the shadows. Lateral cropping.

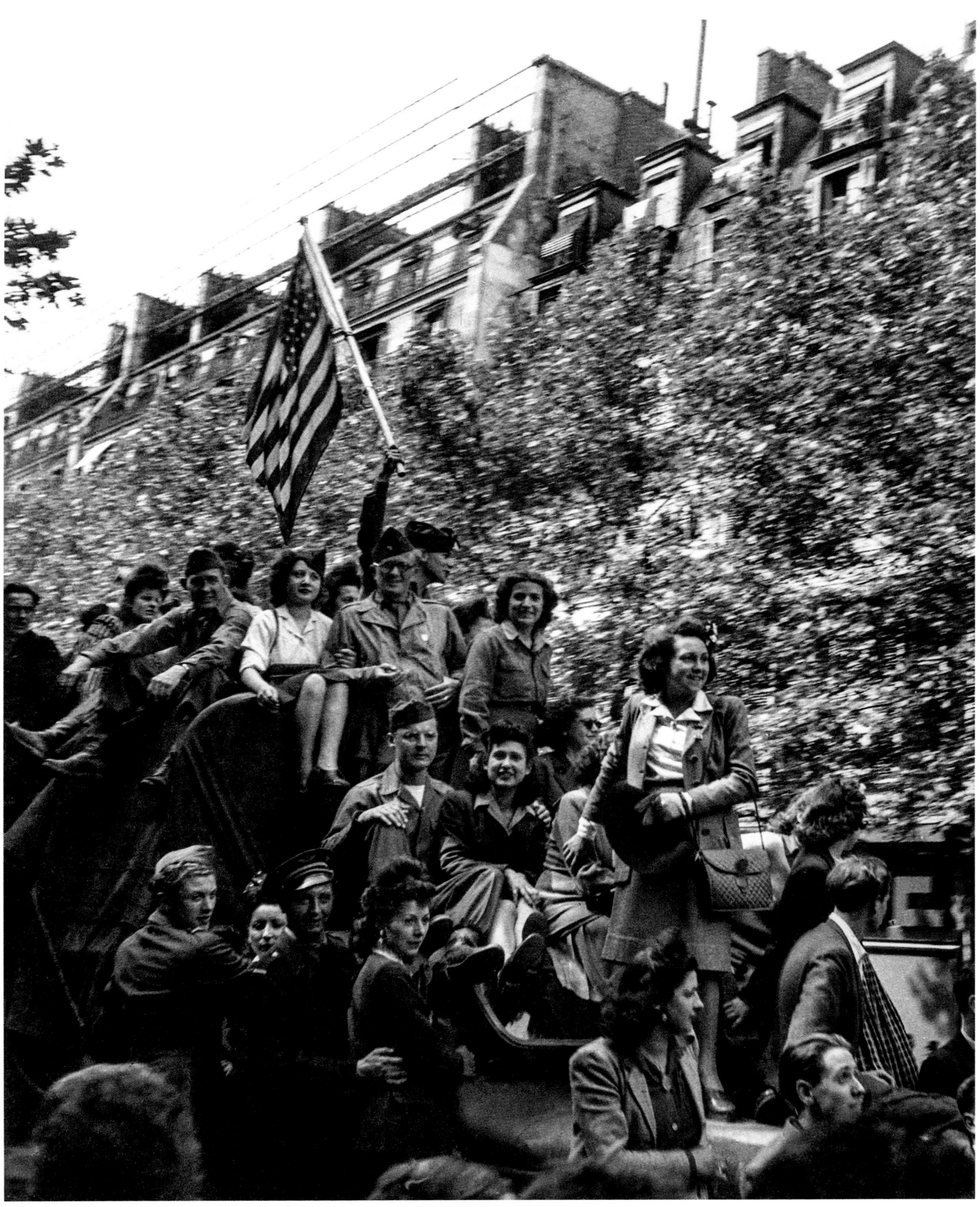

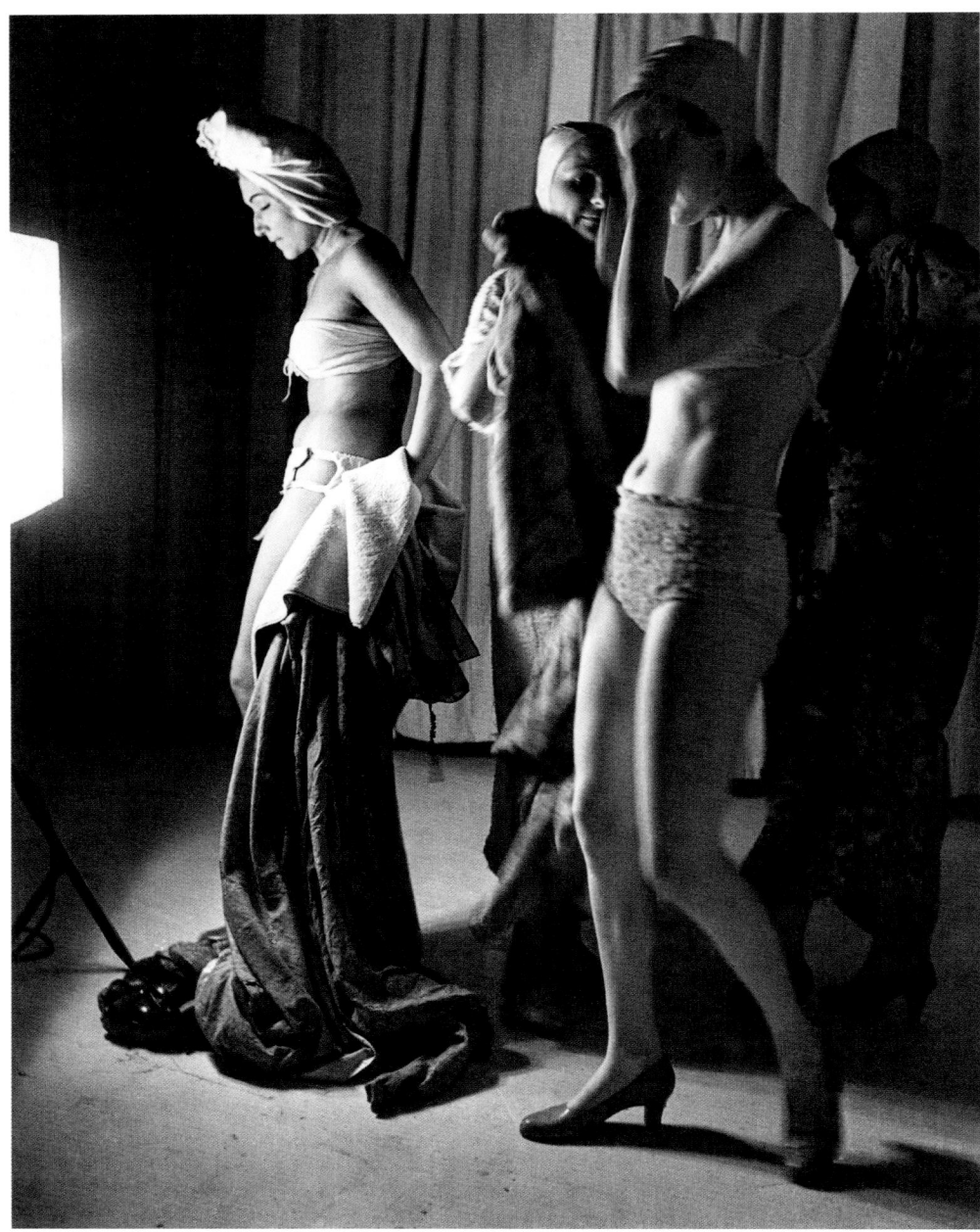

A break on set, Joinville-le-Pont studios, Seine, 1945
NEGATIVE: 2¼×2¼ IN. (6×6 CM) _ R15/10/22
___ 29

Photograph taken from a story commissioned by *Point de vue* magazine on the shooting of a movie entitled *Le Roi des resquilleurs* (The King of the Free-Riders). The music hall girls, who had done the previous scene and had remained motionless for a long time, were warming themselves under the spotlight during a break in filming. I was not a film set photographer. I was supposed to shoot the movie as it was being made: the preparation, the rehearsals, the backstage, and so on. As a matter of fact, I have always preferred to photograph the sidelines of the main subject, rather than the event itself. Light cropping of the negative.

The Girondin winemaker, Cavignac, 1945
NEGATIVE: 2¼×2¼ IN. (6×6 CM) _ F15/257
___ 30

It was during the summer vacation. We had joined my wife Marie-Anne's parents in a village in the Gironde. They knew this winemaker who made very good wine and, during a visit, I thought he had such an amazing "mug" that I photographed him. I have several photographs of him in fact, but this is the most distinctive one. The man died soon after, having failed to observe the diet prescribed by his doctor: no more than three quarts (three liters) a day. He drank seven. Photograph cropped on the sides.

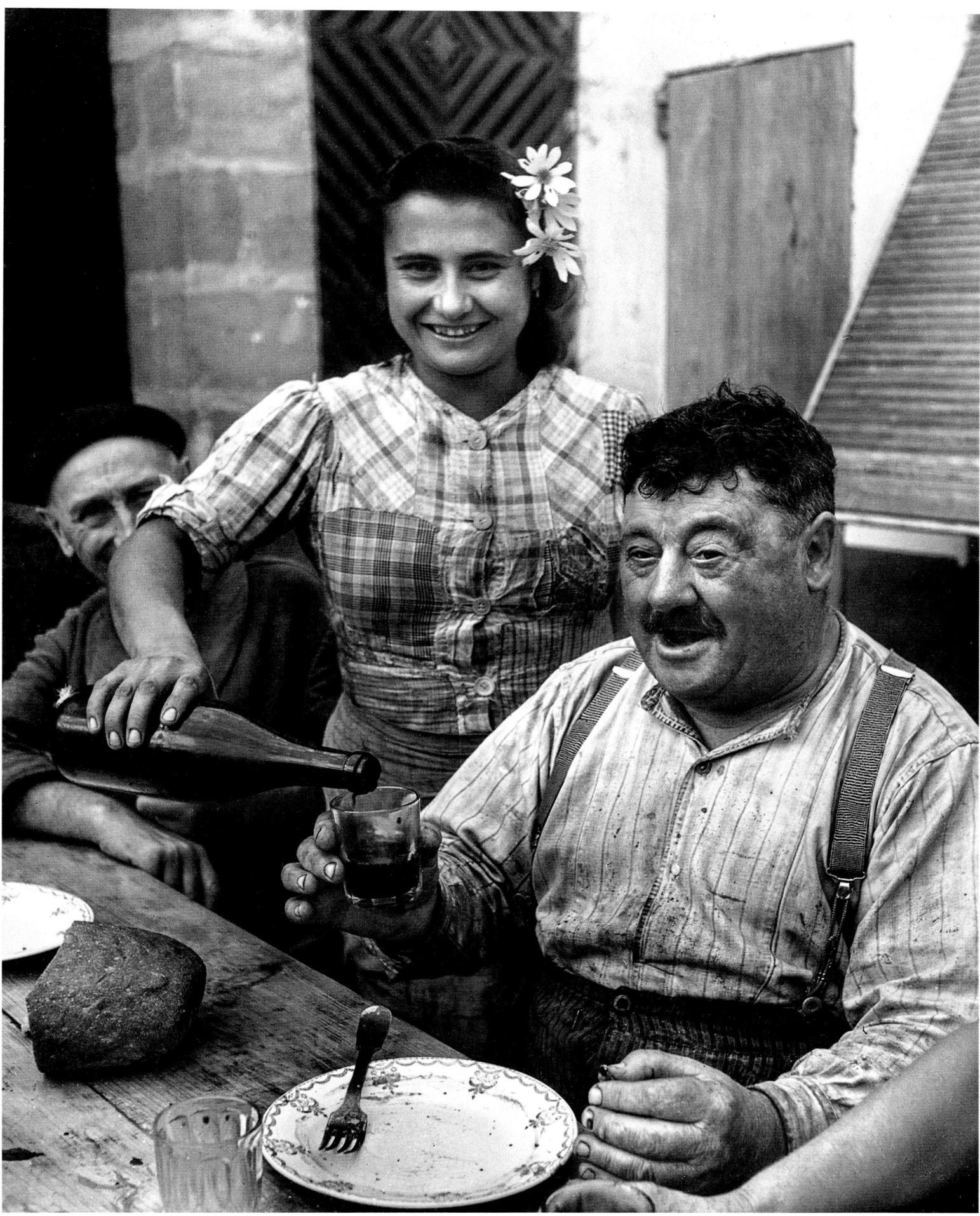

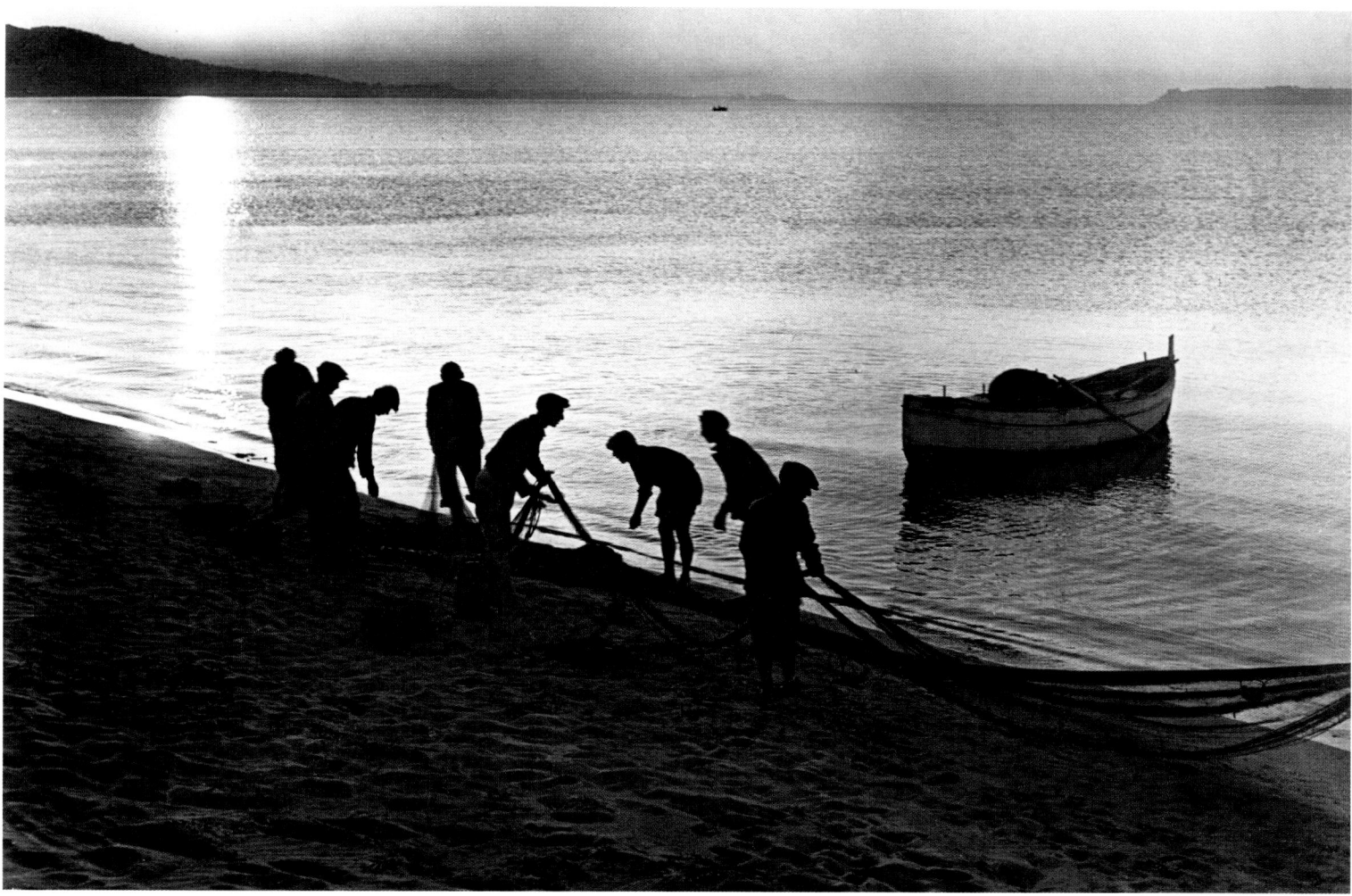

Fusion, Cogolin, Var, 1945
NEGATIVE: 2¼×2¼ IN. (6×6 CM) _ FD15/5 [OR D15/5]
— 31

A view of Cogolin, a small village in the Var. This is obviously a very special landscape, since it is deformed by a fusion of the gelatin emulsion. In these times of scarcity, I used leftover film from the American surplus, reconfigured to 2¼ × 2¼-in. (6 × 6-cm) dimensions and reconditioned in homemade laboratories. These emulsions were often either out of date or altered in some way by time. They melted easily and I experienced this kind of accident in several instances, sometimes even on entire rolls.
This phenomenon and its funny effects had amused Prévert: shortly afterward he composed a poem entitled "The Mysteries of the Dark Room" which, accompanied by four fused photographs including this one, appeared in the review *Quadrige* of May 1946. This poem also appears in the collection *Soleil de nuit* (Night Sun) (Gallimard, 1980). Subsequently, I intentionally caused the emulsion to fuse by heating film immediately after washing it.

Fishermen, La Bocca, Cannes, Alpes-Maritimes, 1945
NEGATIVE: 2¼×2¼ IN. (6×6 CM) _ F15/15
— 32

That same summer, we left the Gironde for the south of France by motorbike, since we did not yet have a car. In fact, in 1945, the manufacture of automobiles had only just resumed, and second-hand cars were selling for top dollar. I photographed these fishermen in the vicinity of Cannes, in La Bocca. I have a great fondness for this photograph. I totally recognize in it my taste for on-the-spot composition. A few seconds later, I shot the same scene in total chaos. I wonder if I didn't do it on purpose, to show that one or two seconds is enough to destroy or rebuild harmony.
It's a very difficult photograph to print. The negative was damaged during development, most likely by clumsiness. Negative heavily cropped on all four sides, because I was located a little far from the scene, on a dike.

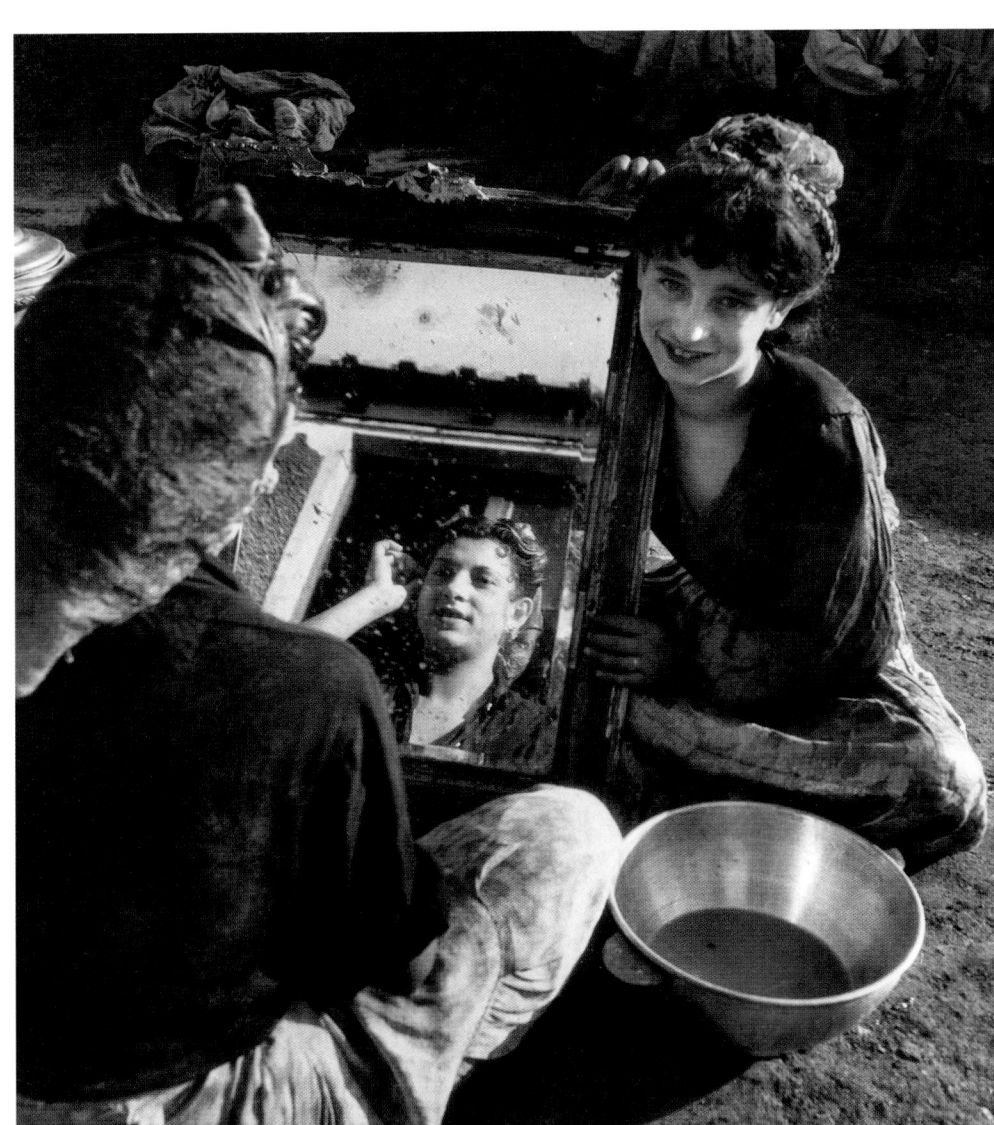

With the Roma of Montreuil, Seine, 1945
NEGATIVE: 2¼ × 2¼ IN. (6 × 6 CM) _ R15/29/3
__ 33

Uncommissioned series of photos, taken in October 1945, about a group of settled Roma who worked in tinplating in Montreuil, near Paris. The series was published in part in *France Illustration* shortly thereafter. I had surprised these two girls doing themselves up. One of them looked up at me. Is that regrettable? I do not deny a certain complicity between the photographer and the person being photographed (see photograph 16).

With the Roma tinplaters of Montreuil, Seine, 1945
NEGATIVE: 2¼ × 2¼ IN. (6 × 6 CM) _ R15/29/19
__ 34

I went back to Montreuil two or three times. The report took some time to get going, but I was patient and diplomatic enough to be able to photograph freely. I brought Marie-Anne along and she had her palm read by an old woman from the community, which made shooting easier. The man on the left is working on tinplating a cooking pot for a hospital kitchen. Virtually full frame.

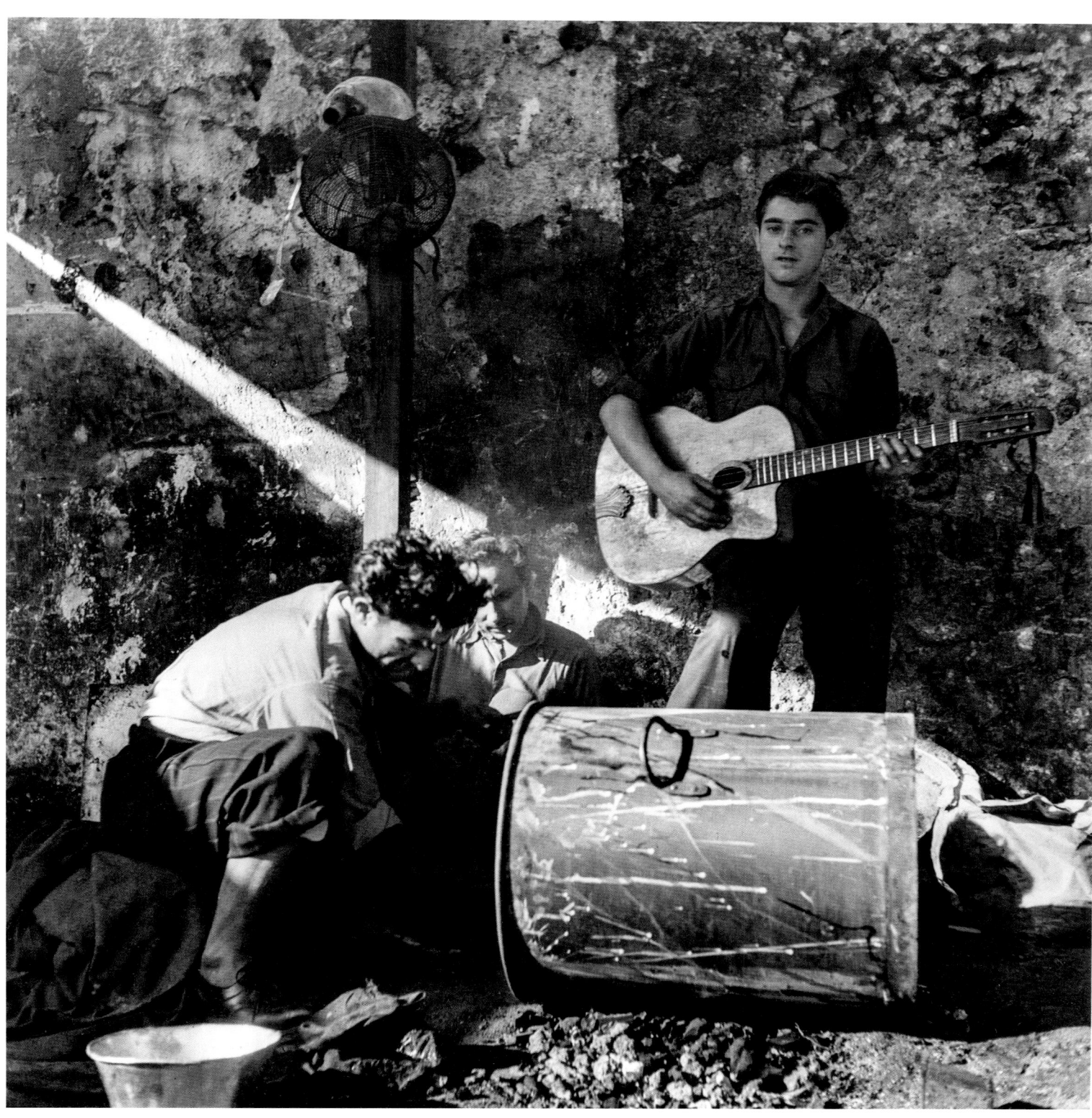

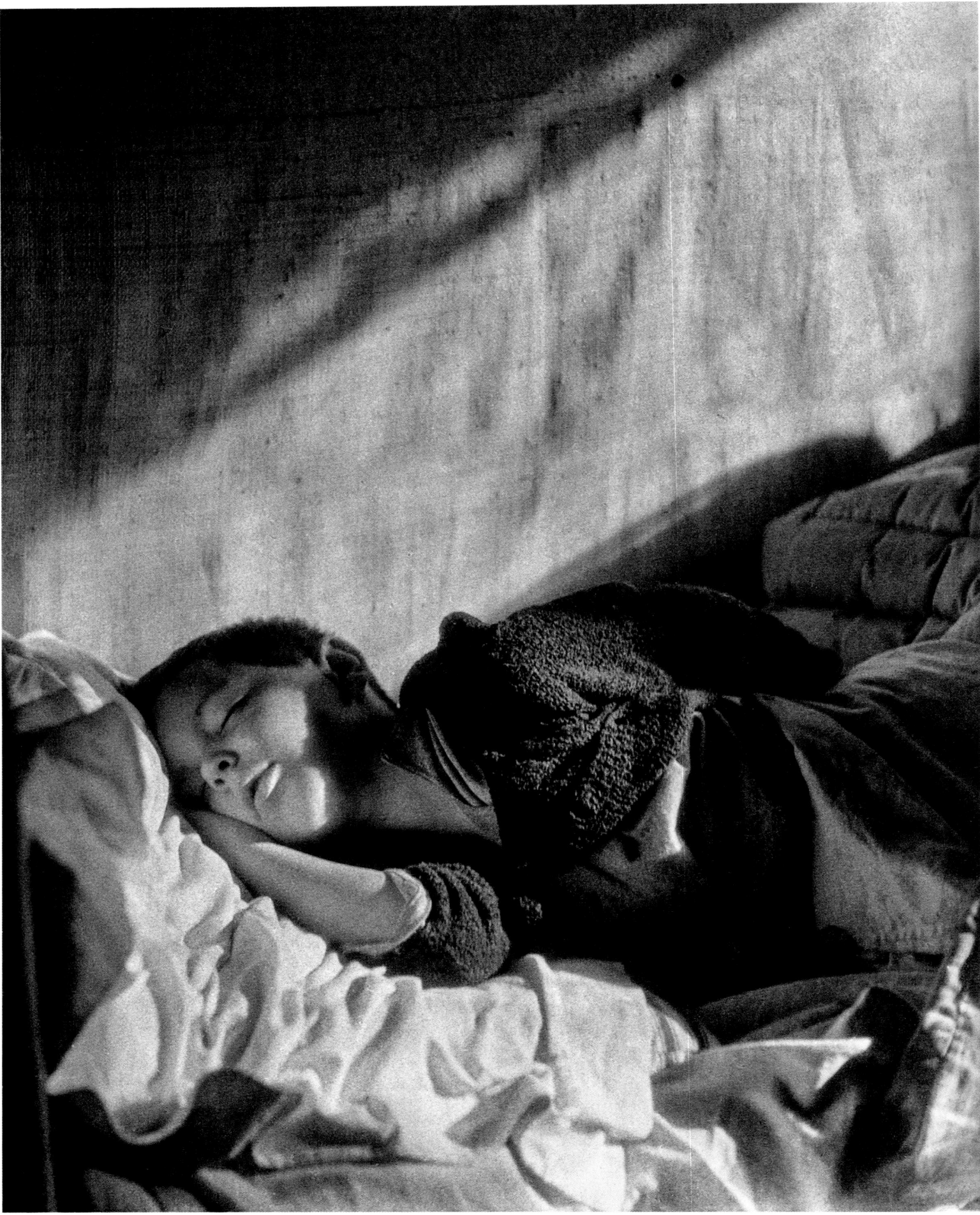

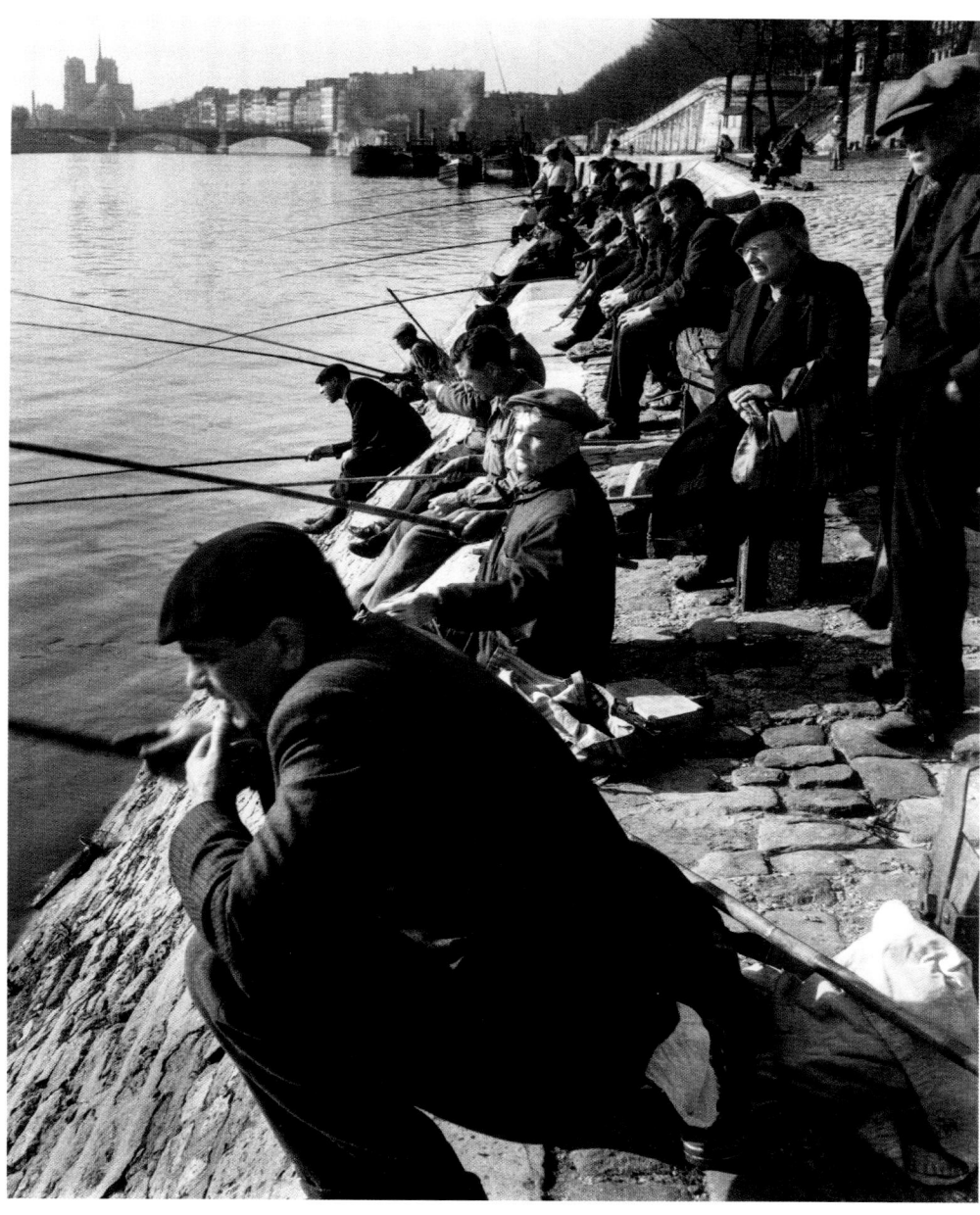

Vincent asleep, Paris, 1946
NEGATIVE: 2¼×2¼ IN. (6×6 CM) _ E16/10 BIS
__ 35
A winter morning on boulevard Richard-Lenoir. Marie-Anne had just opened the curtains. I had to be quick, before the shock of this royal ray of sun roused Vincent from his sleep. Lateral cropping.

Fishermen, quai Henri IV, Paris, 1946
NEGATIVE: 2¼×2¼ IN. (6×6 CM) _ P16/122
__ 36
Quai de la Râpée. I walked along the Seine, one of my favorite photographic expeditions. Since the fish weren't biting, the fishermen were enjoying a little sun on this chilly spring day. This bank is now closed off to them: cars stream along it at full speed, hurried by the passing time.

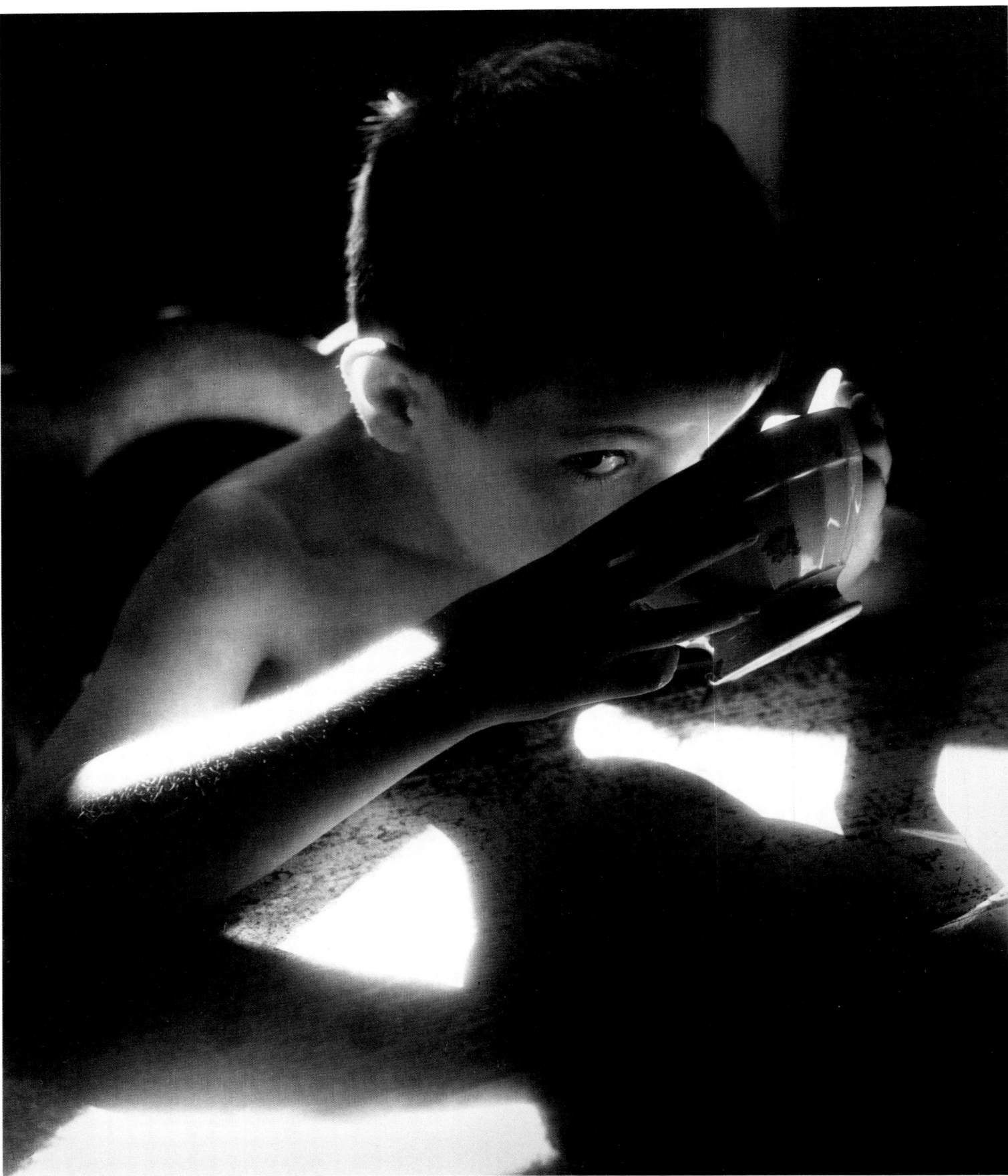

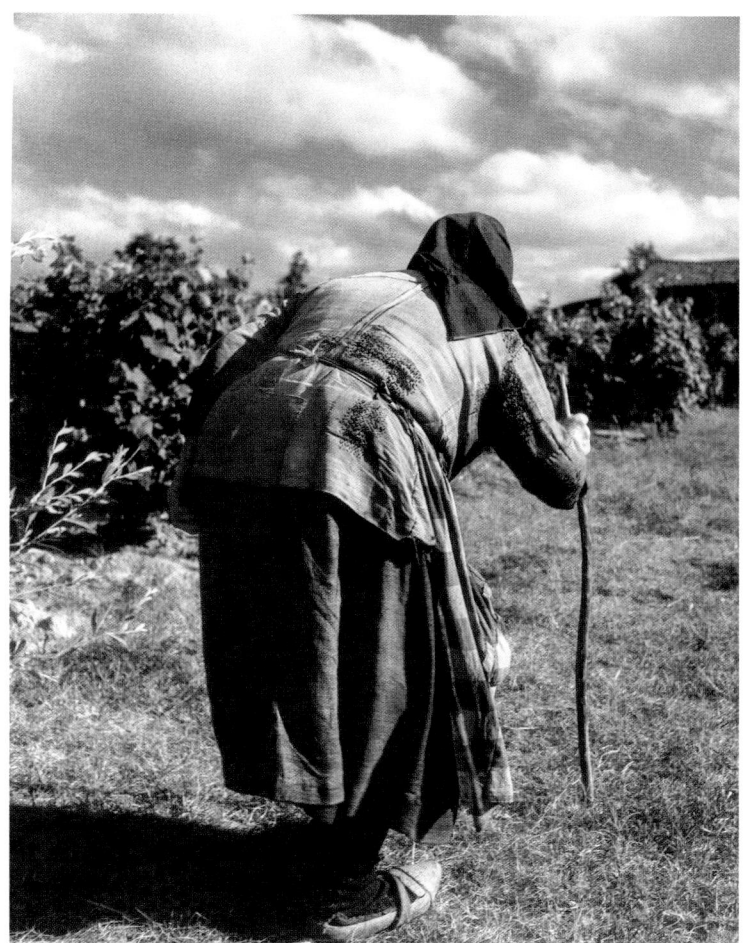
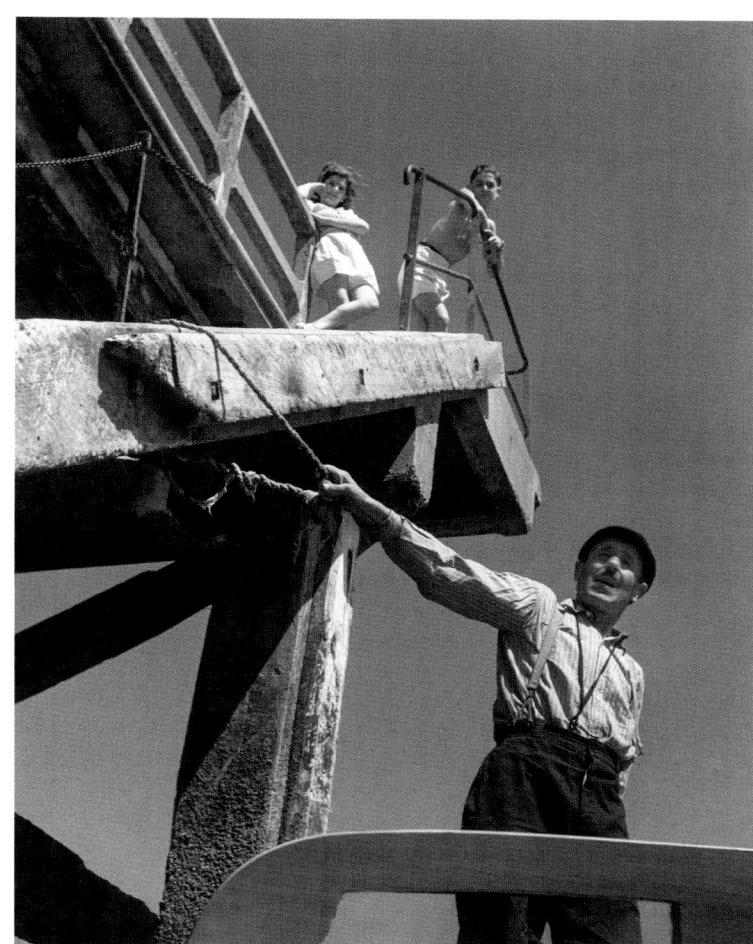

Vincent with a bowl, Cavignac, Gironde, 1946
NEGATIVE: 2¼×2¼ IN. (6×6 CM) _ E16/29
__ 37

During the summer, in the Girondin village mentioned previously, Vincent was having breakfast in my parents-in-law's home. I took this photograph in a similar way to the one of Vincent asleep (photo 35). All of a sudden, the light was so beautiful, so amazing, that I jumped on my camera to seize this fleeting moment. This undertaking was all the more difficult because Vincent, knowing that he was being watched, could very well jeopardize the result, either from embarrassment or by playing to the camera. What was important to retain from that moment was the reflection of the sun from inside the bowl. Here is an anecdote about this image: during the 1960s, I was showing this photograph, among many others, to an advertising agency when the "art buyer" took it and asked me:
"Do you know this child?"
"Yes, very well."
"Can we photograph him?"
"Yes, but he is doing his military service."
She then kept this photograph to show to an art director. When it was returned a few months later, I saw the same image taken by another photographer advertising a food product. I immediately called this colleague, who is an excellent photographer and a good friend, and he knew nothing about this story. He was probably told, "We would like to have a child drinking, with the sun behind him," and given a sketch. That is advertising. Or at least, it is much of the time!

Countrywoman, Cavignac, Gironde, 1946
NEGATIVE: 2¼×2¼ IN. (6×6 CM) _ F16/246
__ 38

In the same region. Marie-Anne and I followed this old peasant woman who invited us to her home. The only memory I have left, besides the rugged good nature of the person, is the invitation to drink a glass of red at her place. Which we did in glasses as bottomless as soldiers' cups. Lateral cropping.

Jetty on Arcachon bay, Gironde, 1946
NEGATIVE: 2¼×2¼ IN. (6×6 CM) _ F16/330
__ 39

Fruitful summer. The launch we have just boarded will take us onto Arcachon lake. I took this low-angle shot just before casting off. The Rollei lens was probably fitted with a medium orange filter, hence the darkened sky.
No particular printing difficulties. Cropping on both sides.

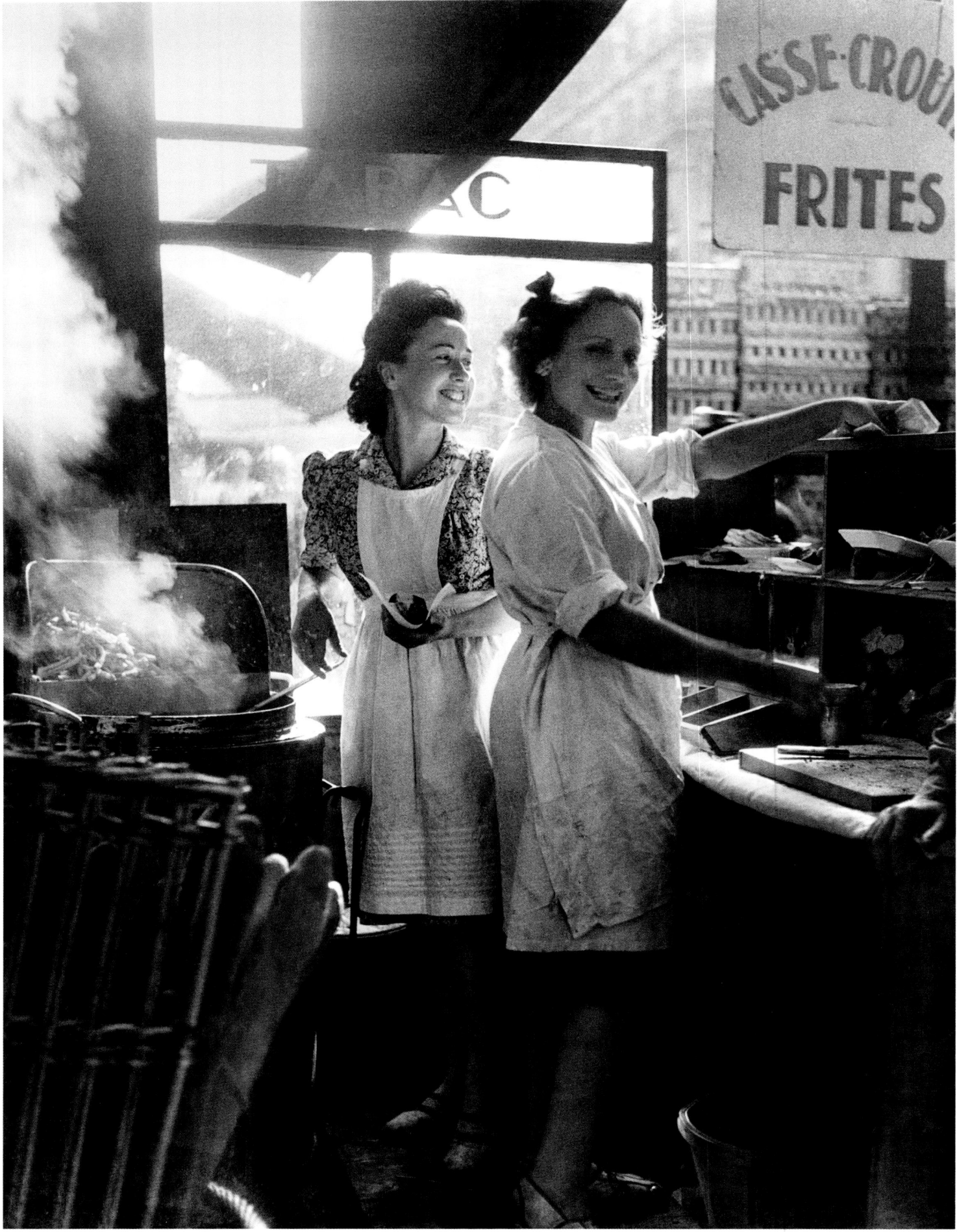

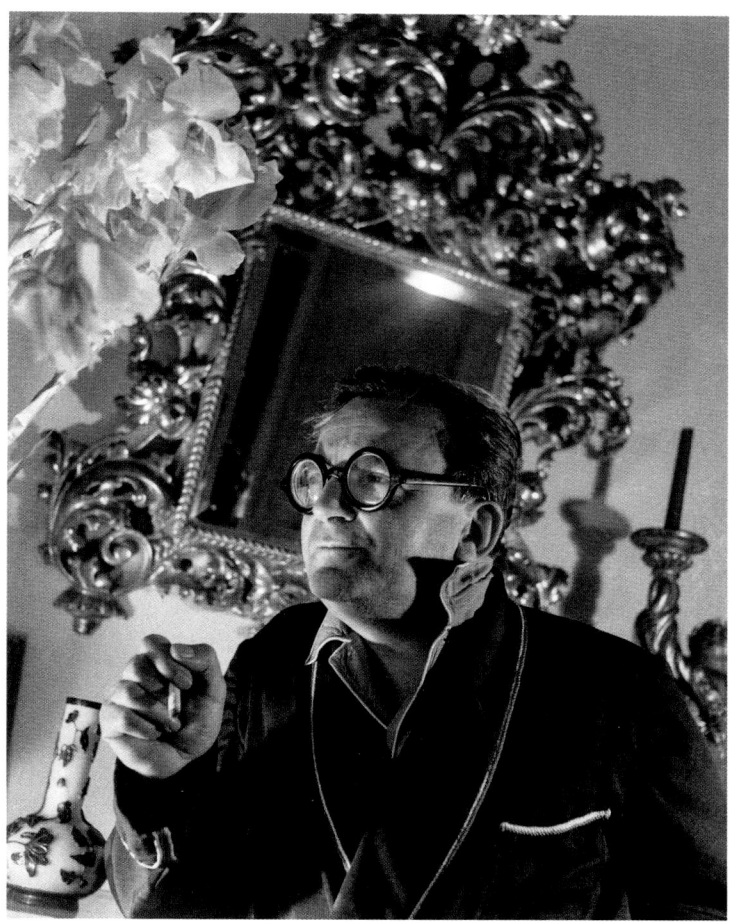

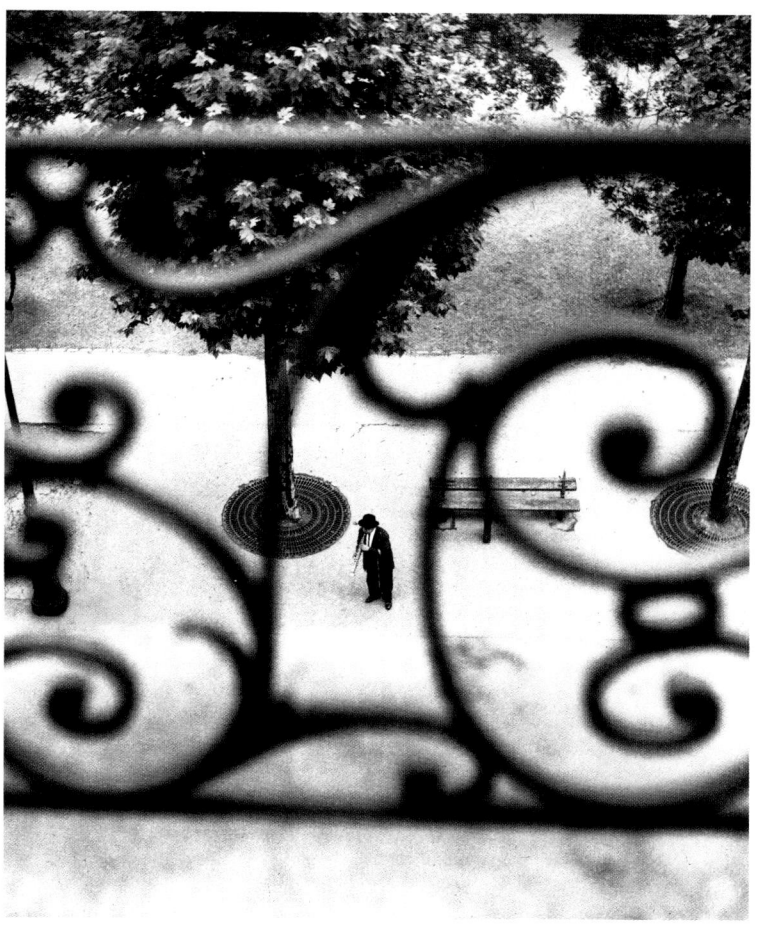

Selling fries, rue Rambuteau, Paris, 1946
NEGATIVE: 2¼×2¼ IN. (6×6 CM) _ P16/232
— 40

This scene took place on rue Rambuteau, in front of Les Halles market, in the corner of a café. It is backlit just as I like it: a nice shot of sun. The opportunity was there to be seized. This photograph is not easy to print because there are underexposed areas and other very dense areas on the film.

Marcel Achard, Paris, 1946
NEGATIVE: 2¼×2¼ IN. (6×6 CM) _ R16/22/2
— 41

September in Paris. The Rapho agency had sent me to do a short story about the writer Marcel Achard in his apartment. Artificial lighting, using two floodlights on light stands.
Easy to print. Lateral cropping.

Busker, boulevard Richard-Lenoir, Paris, 1946
NEGATIVE: 2¼×2¼ IN. (6×6 CM) _ DUPLICATE* _ P16/251
— 42

From the window of our apartment at the time, on the fourth floor of 117 boulevard Richard-Lenoir. One morning, I heard music coming from outside. From my office, framed by the wrought-iron detailing supporting the balcony handrail, I saw a busker playing his soprano saxophone. That is how I captured the memory of that little scene.
This photograph is cropped at the sides only. The print requires a lot of retouching since the negative has a number of flaws whose cause I cannot remember.

* In 1984, a number of original negatives, very hard to print for various reasons, were replaced by duplicates made from carefully retouched prints, including the above image, and the following photographs: 68, 79, 94, 108, 112, 129, 131, 136, 176, 199, and 242.

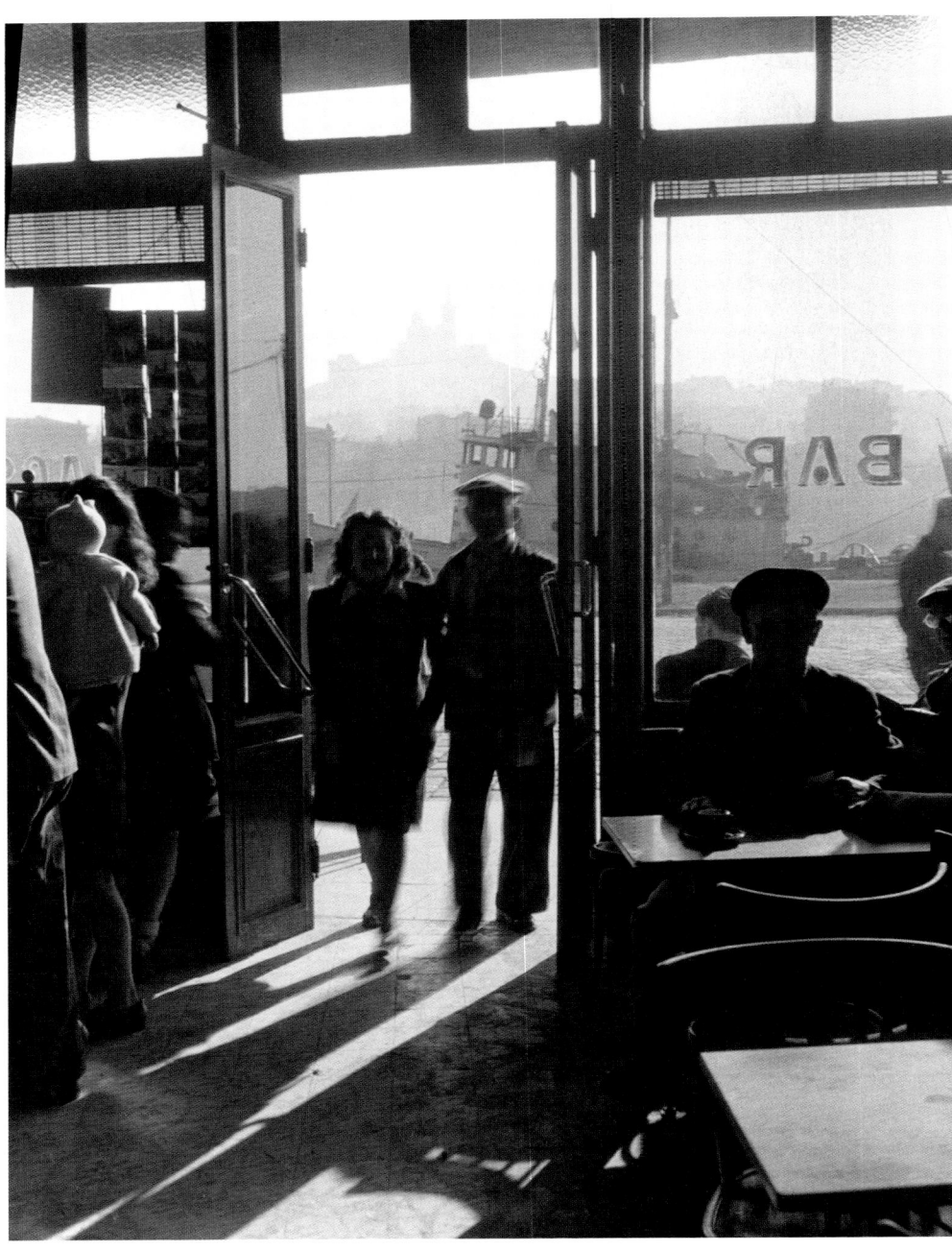

Bistro at the Old Port, Marseille, Bouches-du-Rhône, 1946
NEGATIVE: 2¼×2¼ IN. (6×6 CM) _ F16/753
___ 43

In November of that year, the great American magazine *Collier's* had commissioned me through Rapho to do a story on the Foreign Legion in Marseille. Of course, alongside this story, I took a lot of photographs for myself in the sunny city. We are in a bistro in the Old Port; the atmosphere is just like Marcel Pagnol's *Marius*. The couple's shadow is heavily slanted. My line of sight was north–south; therefore the photograph was taken in the afternoon (southwest sun). Moreover, a cup of coffee can be seen on the right-hand table. Partial cropping.

Couple at the Old Port, Marseille, Bouches-du-Rhône 1946
NEGATIVE: 2¼×2¼ IN. (6×6 CM) _ F16/764
___ 44

Marseille, November 1946. These young people were in tender conversation beside the Lacydon where the Old Port was built. I was out in the open and they would have seen me working. I preferred to ask permission to photograph them. I do not remember ever having been refused. The number of this photograph, F16/764, indicates that it was made after the previous one (753). The direction of the shadow being roughly north–south, this photograph must have been taken around noon on the following day.

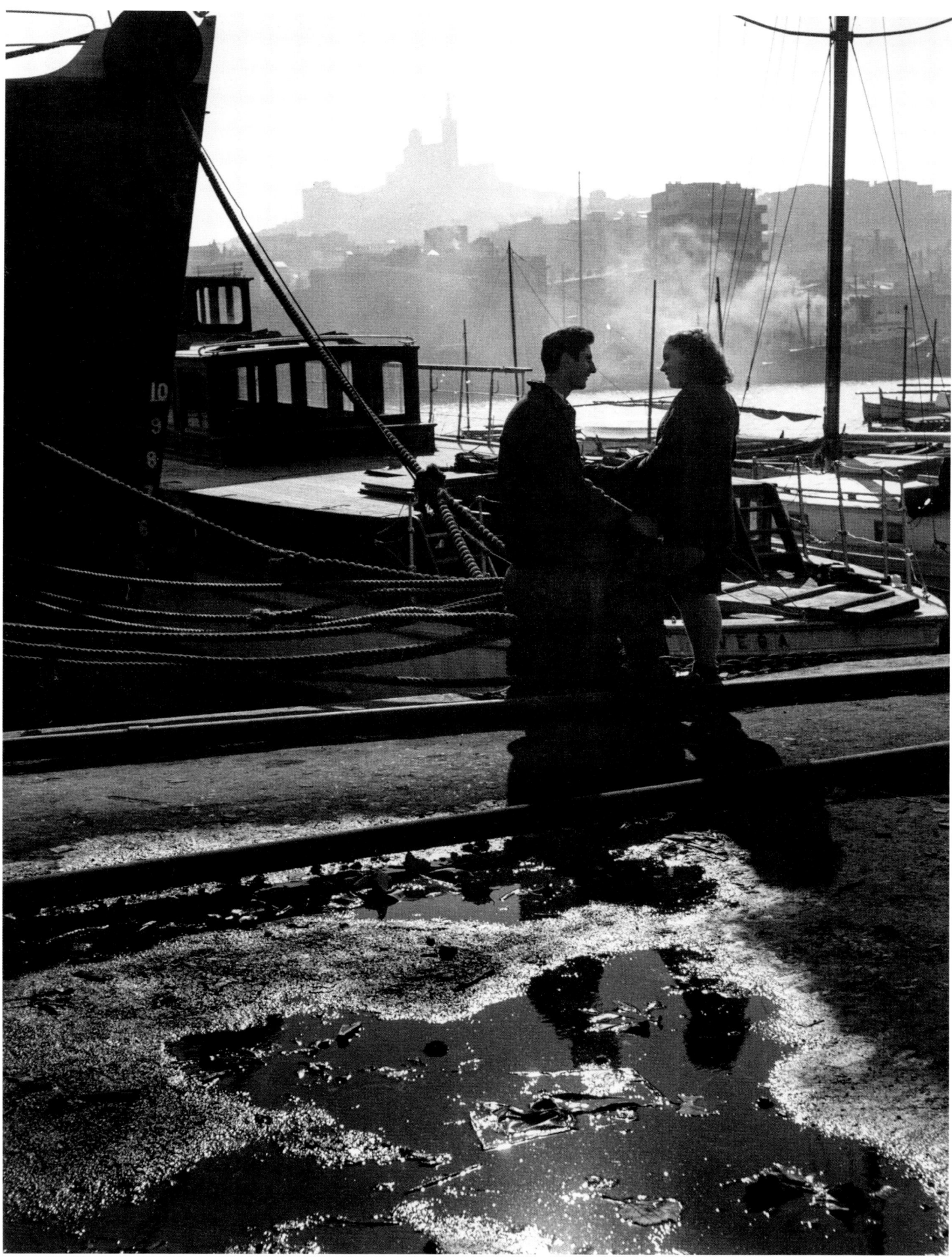

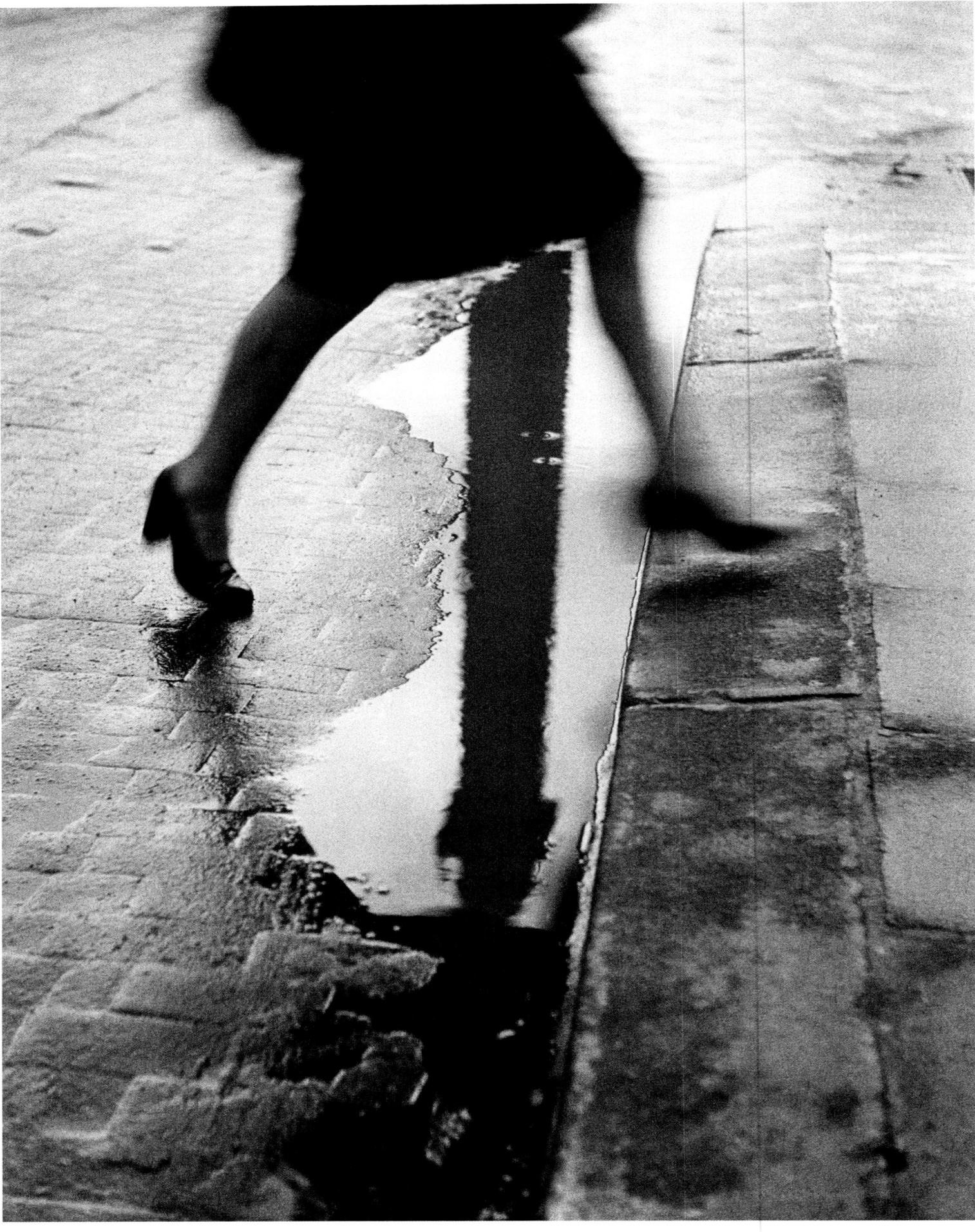

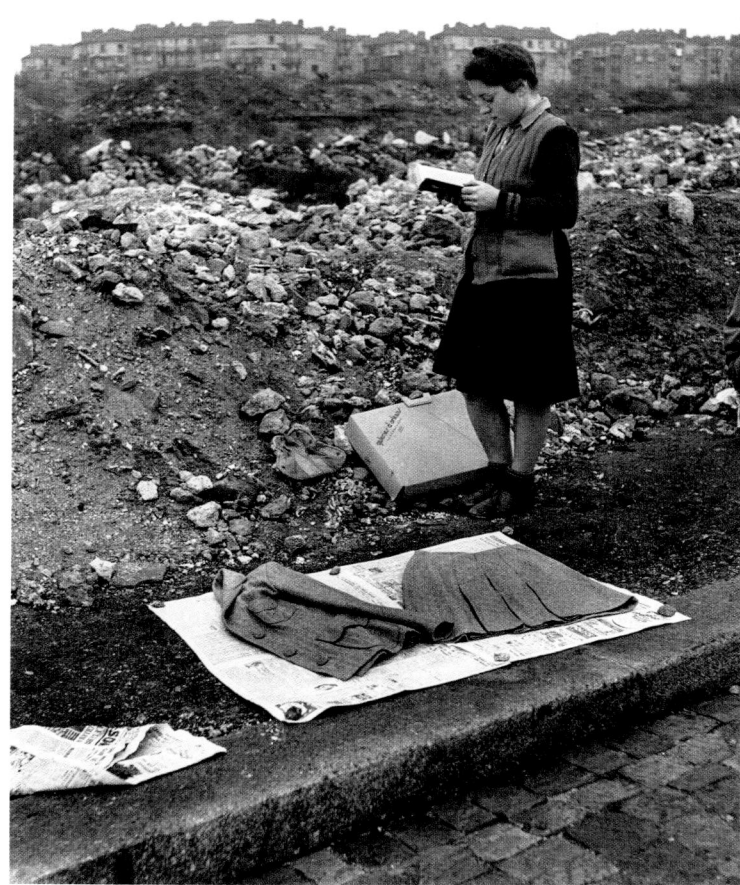
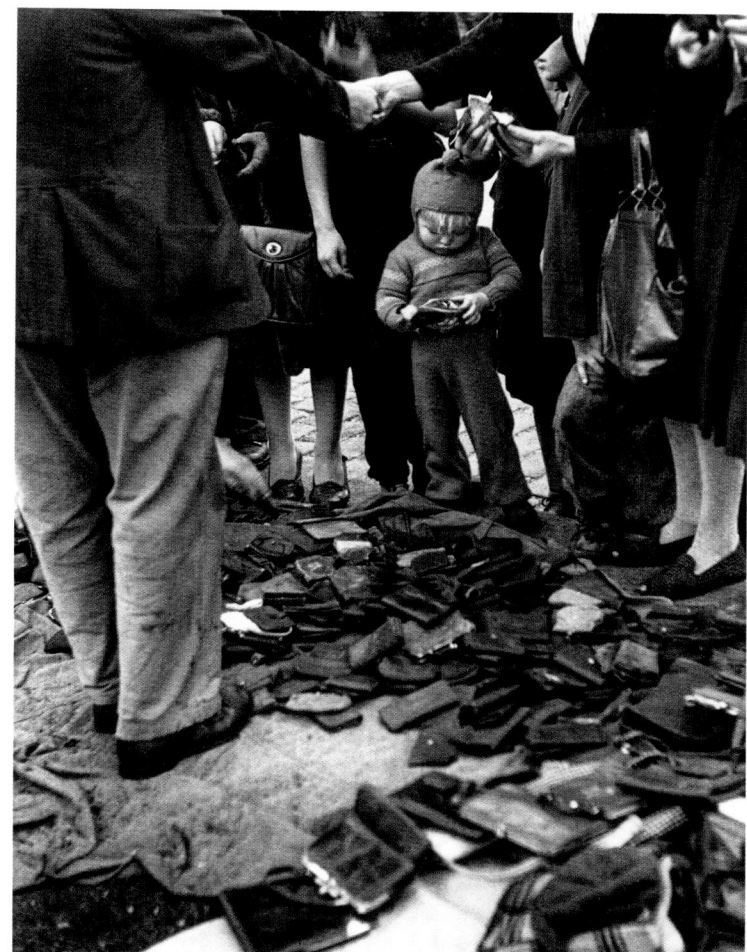

**Rain on place Vendôme,
Paris, 1947**
NEGATIVE: 2¼×2¼ IN. (6×6 CM) _ P17/13
___ 45

Place Vendôme in Paris on a rainy day, probably in the first quarter of 1947.
A chance photograph. I was hanging around the area. I may have been coming back from the Rapho agency, whose offices were nearby. I must have seen a woman stepping over that puddle and noticed that the Vendôme column was reflected in it. As luck would have it, just at that moment, a cohort of girls was let out for lunch from the neighboring fashion houses. I recorded several jumps: this one was the most successful.
A good example of what is known as a previsualized photograph.
To print this photograph, it is useful to keep the upper pavement areas light and to push the black of the clothing.

**Porte de Vanves flea
market, Paris, 1947**
NEGATIVE: 2¼×2¼ IN. (6×6 CM) _ P17/55
___ 46

Only three years after the liberation. We still lacked a lot of things in our household and we were flea-market fanatics. We often went either to Clignancourt, to the iron and ham fairs on boulevard Richard-Lenoir, or to porte de Vanves where this photograph was taken. I found this scene so moving: a young girl, a student no doubt, reading while waiting to sell her outfit.
I remember showing this photograph to Jean-Pierre Chabrol. We were both working for *Regards* at the time, and it was with him that I did the story on a gang of youths in Belleville in 1955, which appears later in this collection (photo 165). When he saw this photograph, he thought there was a whole story to be told about it. He may have done so.
Slightly cropped photograph.

**Porte de Vanves flea
market, Paris, 1947**
NEGATIVE: 2¼×2¼ IN. (6×6 CM) _ P17/57
___ 47

At the Vanves flea market, probably on the same day. A pile of wallets and used purses spread out on a blanket. A deal has just been struck between adults. The child apparently already knows what money is. As for framing, I crop a part of the negative on top and on the sides, to focus the attention on the essential.

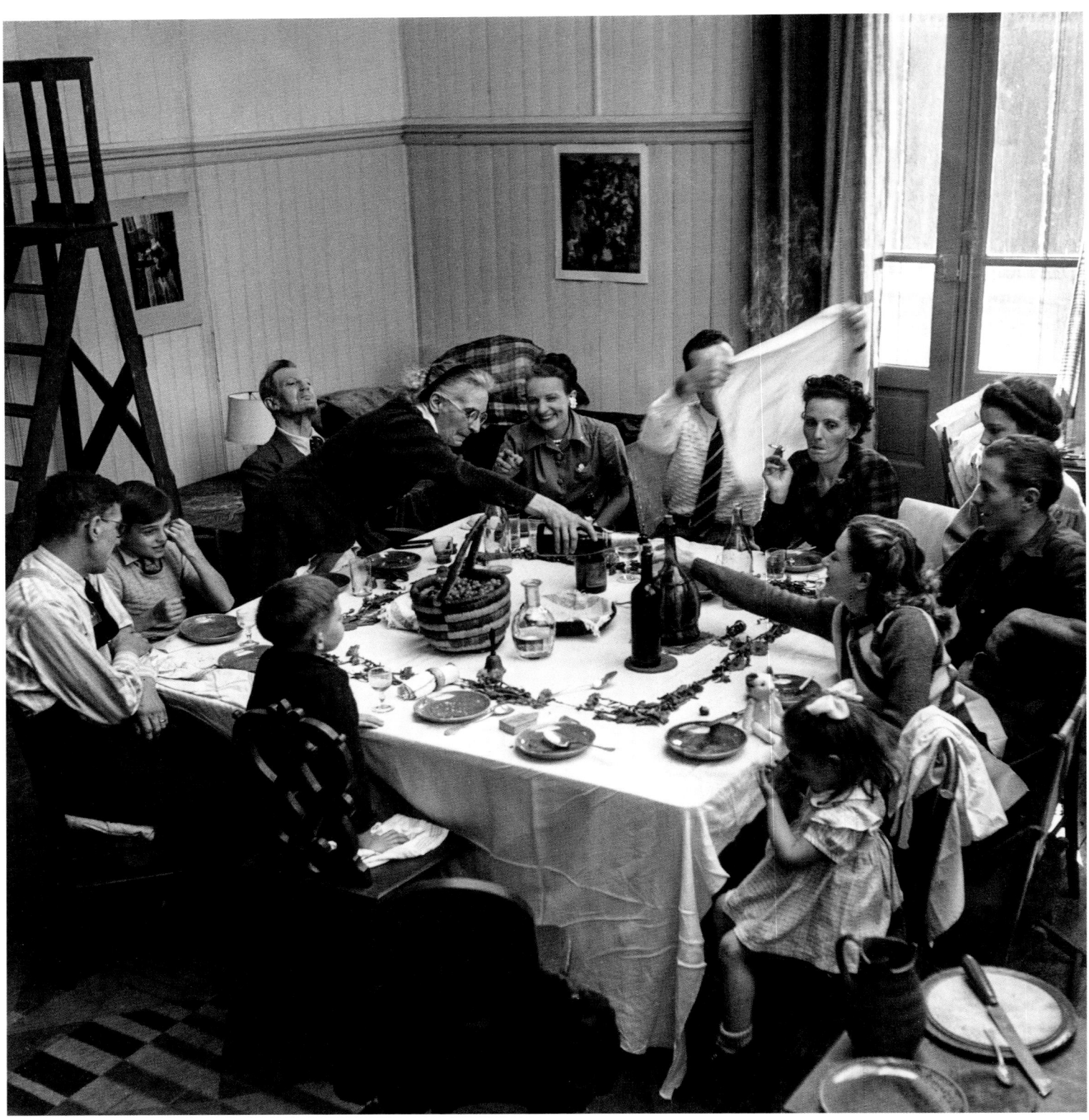

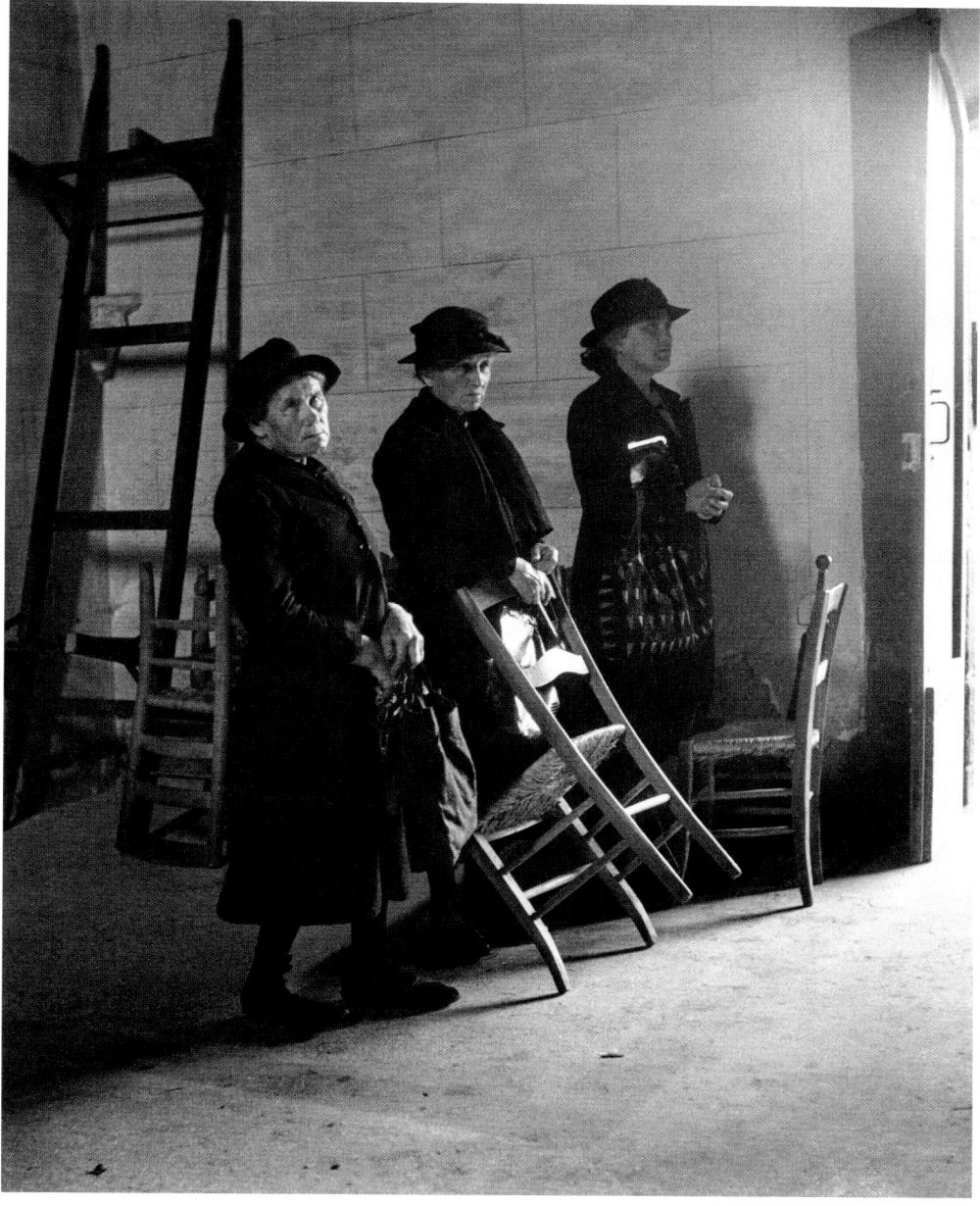

The family lunch, Paris, 1947
NEGATIVE: 2¼×2¼ IN. (6×6 CM) _ R17/2/1
— 48

February 1947, just two months after moving into the little house with the artist's studio on passage des Charbonniers in the fifteenth arrondissement. Marie-Anne's parents (they appear with her on the top corner of the table) came to see us, and we organized a big family meal. I do not like taking photographs in these situations, or when we go out with friends. But here the atmosphere was so pleasant, and as it was rare for so many of us to get together, I wanted to keep a memento of this day. The winter light was coming in from the veranda and, having climbed up on a stool, I took advantage of a favorable moment and took a good amateur photograph.
Full negative.

The three devotees during a pilgrimage to Espis, Moissac, Tarn-et-Garonne, 1947
NEGATIVE: 2¼×2¼ IN. (6×6 CM) _ R17/18/78
— 49

In professional terms, 1947 was an extraordinary year. In fact, the entire period from 1945 to 1952 was very good. There was a huge demand for photographs. What's more, it was always possible to place uncommissioned stories. The situation became more difficult around the mid-fifties, especially for independent photographers. In June of 1947 *Point de vue* commissioned me to do a story on a pilgrimage that had taken place near Moissac, in the southwest. Young women devotees from a village called Espis claimed to have seen the Virgin in a small wood nearby. These appearances were highly contested and the clergy remained cautious in this case. That had led to a kind of revolution in the village, and soon many people from the surrounding area and even farther away came to visit the site, often in organized groups. My report covered a full day of the pilgrimage on June 13, 1947. In order not to miss anything, I had gone into the woods before dawn. I even remember shaving at the edge of a stream. I worked until nightfall and I used around twenty rolls of 2¼ × 2¼-in. (6 × 6-cm). I did not hide at any time. I introduced myself and explained that I was there to witness the event. That way, I had no trouble. (I only ever hid once, in July 1946, for a photograph of General de Gaulle, unbeknownst to his personal guard.) Once more, this photograph focuses on the sidelines of the event: three old women praying in the church of Espis, before traveling to the pilgrimage site. There is almost nothing on two-thirds of the negative. The film was not very fast, the place quite dark, and I did not have a tripod for the camera. With the Rolleiflex open to f/3.5 I probably took a 1/5-second exposure, leaning against a column. The negative is cropped on the sides.

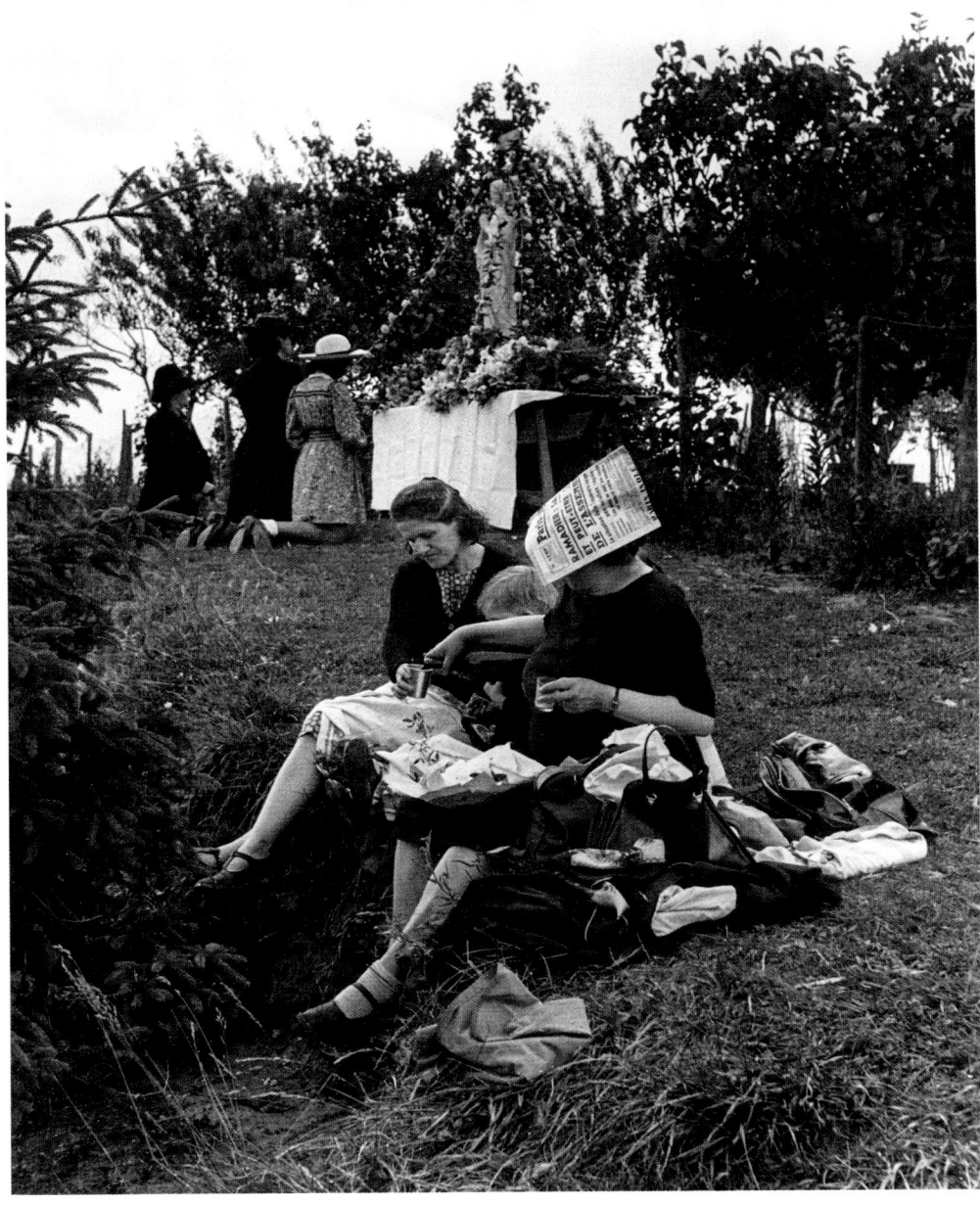

During a pilgrimage to Espis, Moissac, Tarn-et-Garonne, 1947
NEGATIVE: 2¼×2¼ IN. (6×6 CM) _ R17/18/68
___ 50

This photograph is part of the same story as the previous one. Between noon and two o'clock some women had something to eat, while others prayed in front of a statue of the Virgin. This photograph can be dated by the headline of the newspaper, which one of the women is wearing on her head to protect herself from the sun. Underexposed, gray negative.

The painter André Lhote framing the valley of Apt, Gordes, Vaucluse, 1947
NEGATIVE: 2¼×2¼ IN. (6×6 CM) _ F17/385
___ 51

The painter André Lhote in Gordes in the Vaucluse on August 21, 1947. In early July, the director of the Rapho agency, Raymond Grosset, asked me to make use of my trip to the south of France to do a story on André Lhote and his summer school at Mirmande in the Drôme. So, I left Marie-Anne and Vincent to go down south without me, while I headed to Mirmande on my motorbike, which I picked up from the train in Montélimar. The project was very pleasant and relaxed. At the end of it, André Lhote suggested that I complete the job in August in his other summer school in Gordes, which I did with Marie-Anne. Before leaving, I asked him to pose with this empty frame in front of the countryside, as if to illustrate his *Traité du paysage* (Treaty of the Landscape). He was very amused by this photograph. It subsequently appeared in *Harper's Bazaar* and elsewhere. It is also in my book *Sur le fil du hasard* (On Chance's Edge, page 132). I should also mention that this is how we discovered Gordes, and the following year we bought a ruin there. This is a very difficult photograph to print, because it is highly underexposed. For reasons that escape me, I had very slow, ultrafine-grain film in my Rollei. In addition, to darken the sky, I had an orange filter on my lens, which decreased the film sensitivity by two stops. Full frame.

Game of pétanque, Aubagne, Bouches-du-Rhône, 1947
NEGATIVE: 2¼×2¼ IN. (6×6 CM) _ F17/405
___ 52
We were spending our summer vacation near Aubagne, where I photographed this pétanque player. It is an ordinary scene, but I found the man very colorful in his postures. Photograph cropped on three sides.

La Ciotat port, Bouches-du-Rhône, 1947
NEGATIVE: 2¼×2¼ IN. (6×6 CM) _ F17/412
___ 53
Apart from my story on André Lhote (July and August), I had traveled a lot around the south on my motorcycle with Marie-Anne (notably for a book project on Sainte-Baume), and then in the southwest, adding to my archives a number of subjects encountered along the way. In my diary for that year, the entry for September 2, the day after our return, reads: "Started to develop my 52 rolls!" This is La Ciotat. There, I saw these two kids diving from the chains of a ship. This photograph was published many times. Printed at full height, only cropped on the sides.

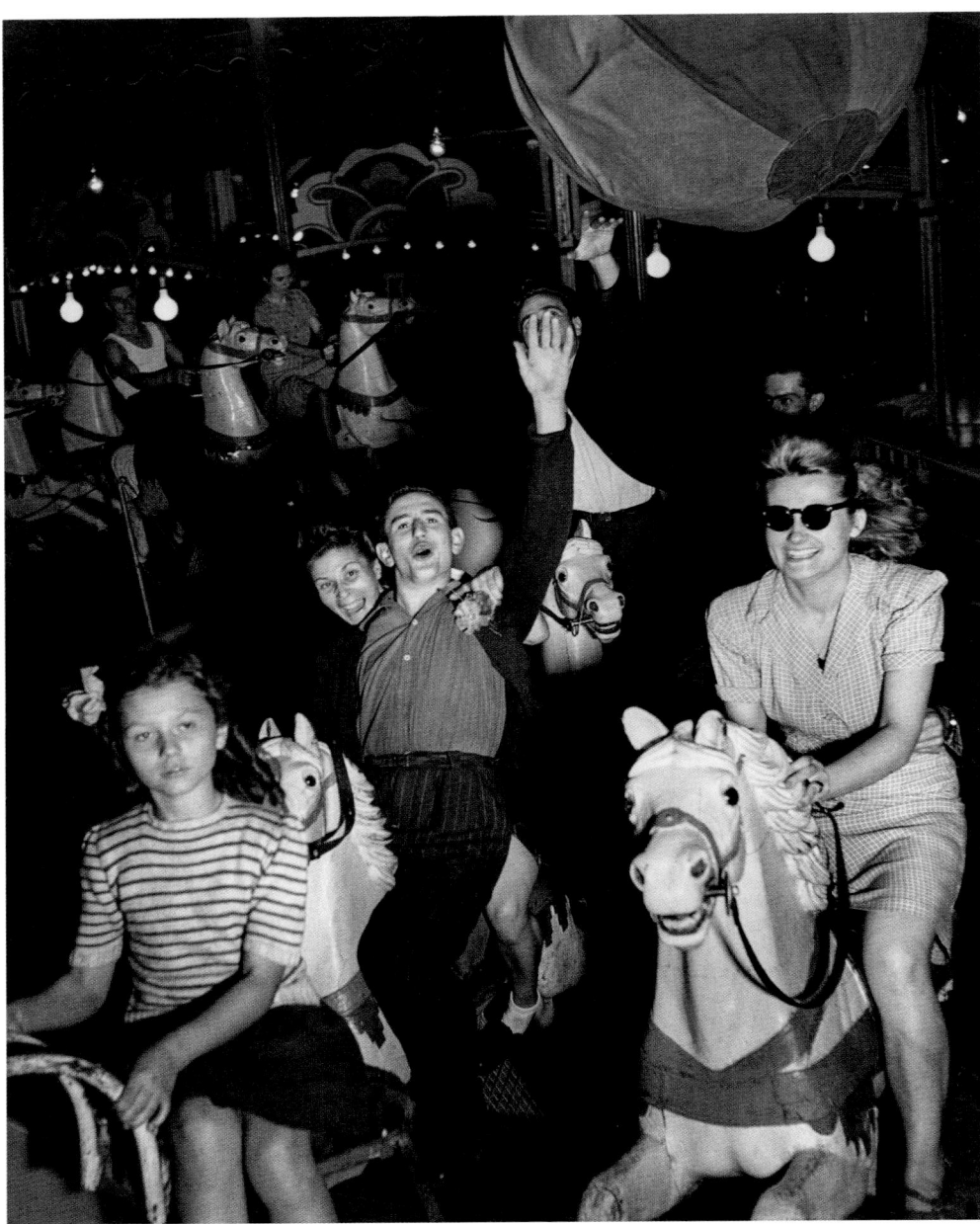

At the fairground, boulevard Garibaldi, Paris, 1947
NEGATIVE: 2¼×2¼ IN. (6×6 CM) _ R17/20/7
___ 54

In 1947 Raymond Grosset (the director of the Rapho agency) returned from a trip to the United States with the first camera with an electronic flash. The Americans were already using it, but in France it was almost unknown. It weighed twenty-six pounds (twelve kilos) and was not very powerful, but it was still great and Raymond entrusted it to the photographers of the agency.
In 1947, I lived on passage des Charbonniers, near boulevard Garibaldi, where a fairground was set up twice a year, at Easter and in September, between Cambronne and Pasteur, partially under the elevated metro line. I sat facing backward on a wooden horse that I was holding tight between my knees, with the heavy lightning generator pulling on my shoulder. The flash illuminated from the front since I had to hold it close to the camera. It's a practice that I disapprove of, but I had no choice. I took a lot of photographs at the fair, but I went only for that purpose, because it's an atmosphere that makes me feel blue. Fortunately, the camera protects me.
This photograph was chosen as the cover of the French edition of my book *Sur le fil du hasard* (On Chance's Edge). For the cover of the Italian edition, the photograph on page 56 (the bistro on rue Montmartre) was used. It appears here under number 189.

An open-air dance at Chez Maxe, Joinville-le-Pont, Seine, 1947
NEGATIVE: 2¼×2¼ IN. (6×6 CM) _ R17/25/1
___ 55

As part of a story for the quarterly magazine *Album du Figaro*, Louis Ferrand, the artistic director, had commissioned me to do a major series on the *guinguette* (open-air) dance halls on the banks of the Marne. I took a lot of photographs on this subject, including this one on September 14, in Nogent, which Marie-Anne and I had visited by motorbike. This photograph is the culmination of a series that covers an entire roll of 2¼ × 2¼-in. (6 × 6-cm) film, that is twelve frames, on these same characters: a guy dancing with two girls. I found this trio fascinating and, after the fifth shot, I climbed up on a chair to have a slightly elevated view with the seated couple, blurred in the foreground, who obviously did not suspect that I was also photographing them. The guy danced like a god. When the music stopped, he walked away with a slight limp: he had a clubfoot. This photograph is not totally serendipitous, since he had understood that I was photographing him. At a certain point, I signaled to him, from the top of my chair, to come a little closer with his two partners, so that he would be better positioned in my shot. This photograph has been published many times.

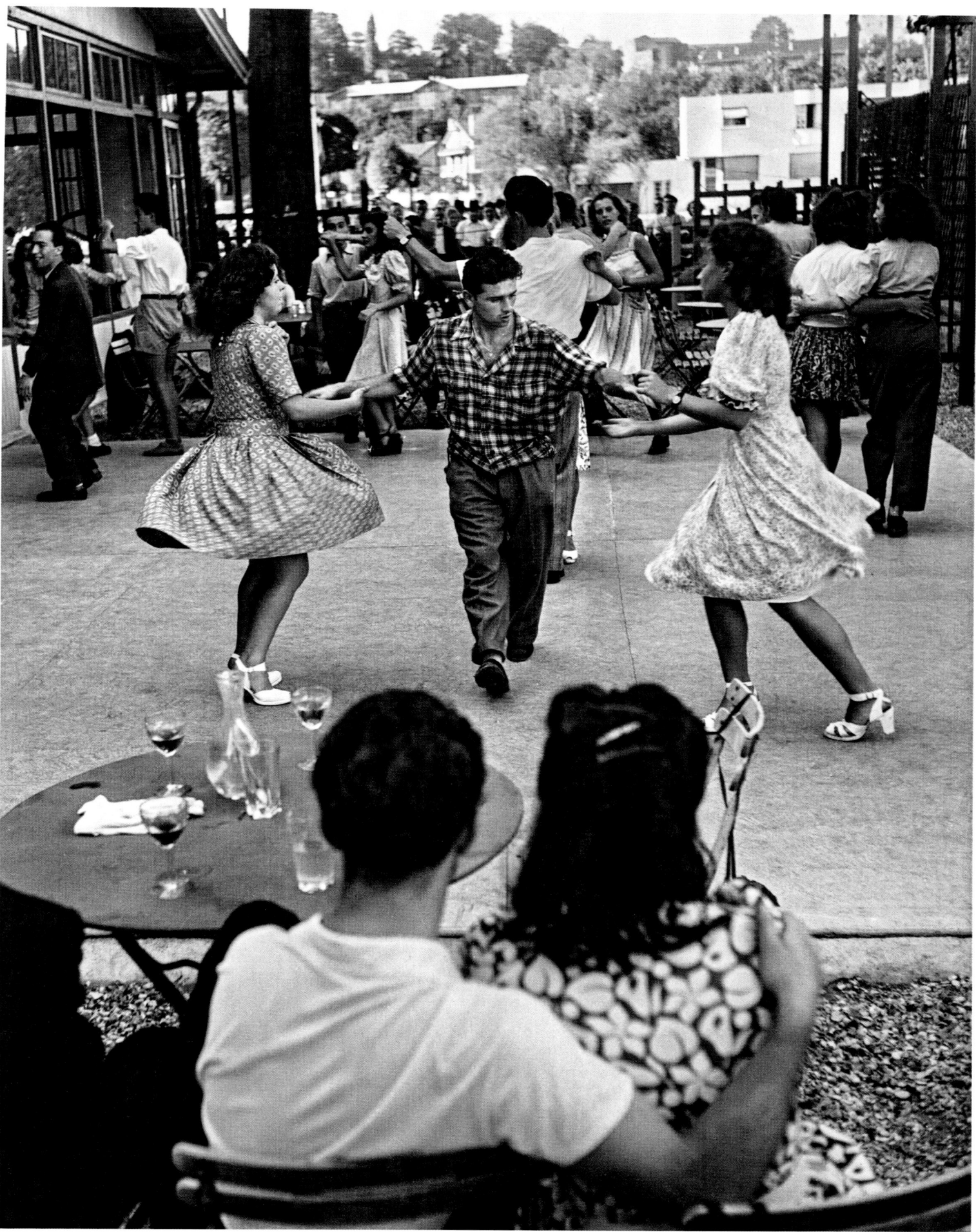

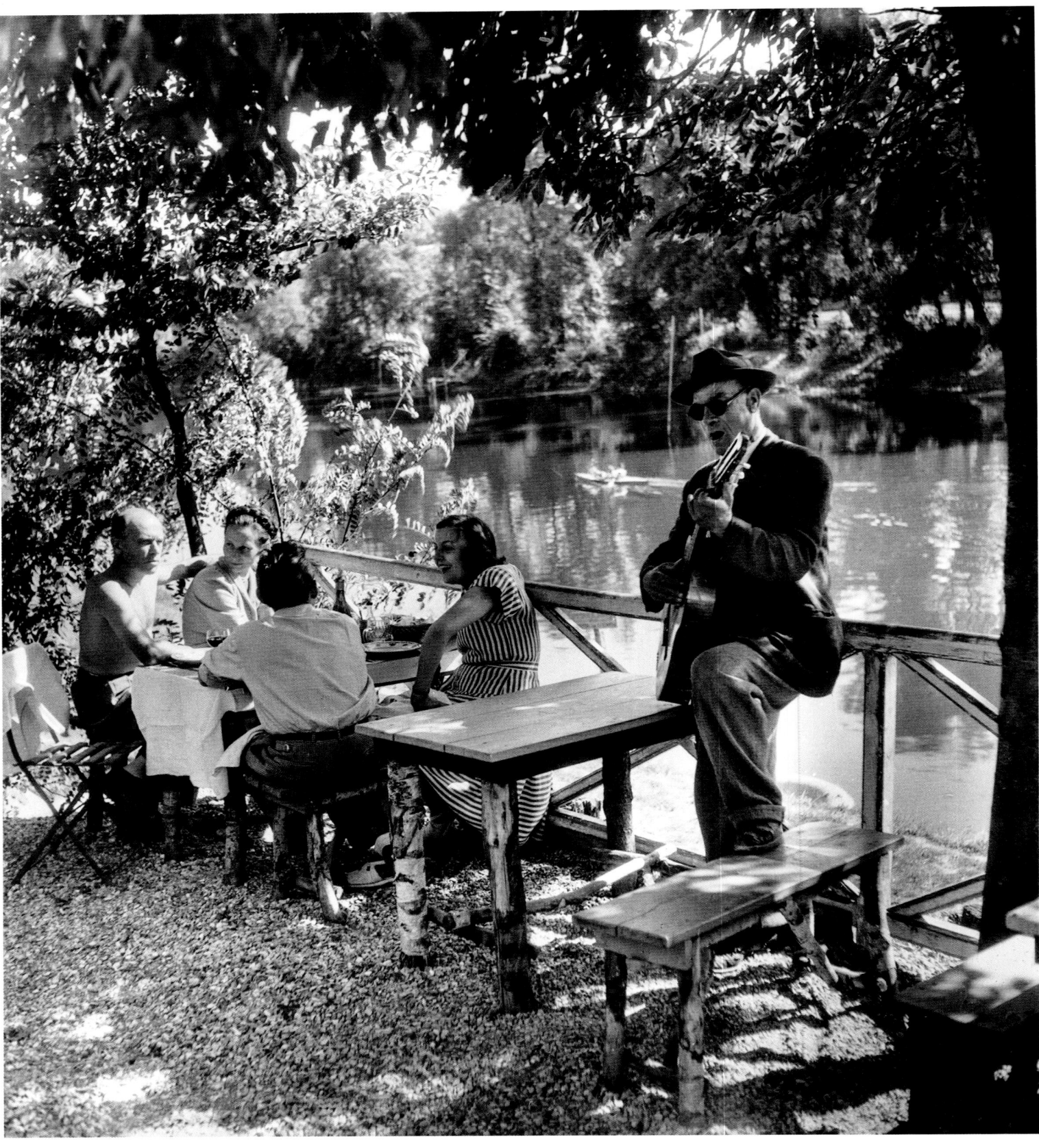

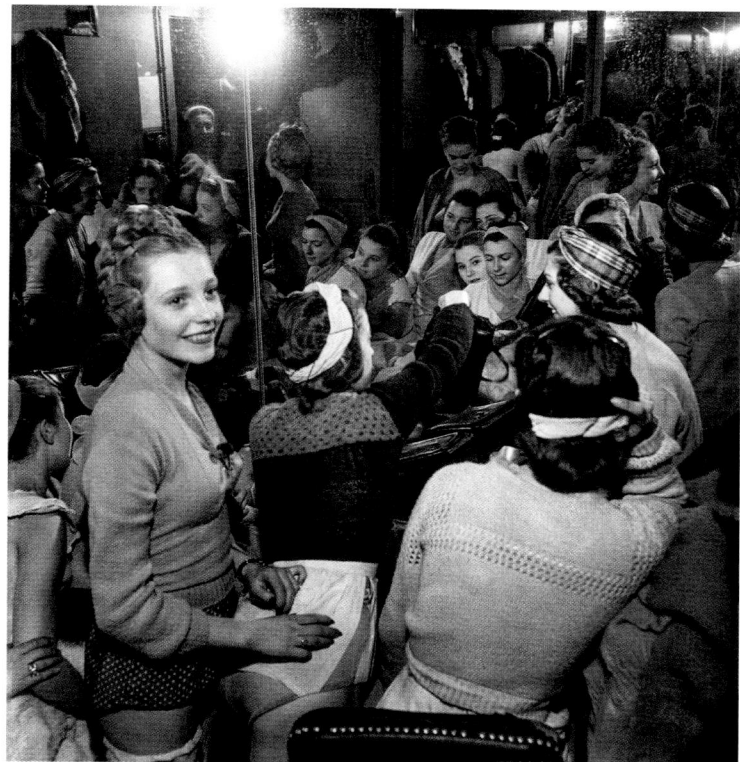

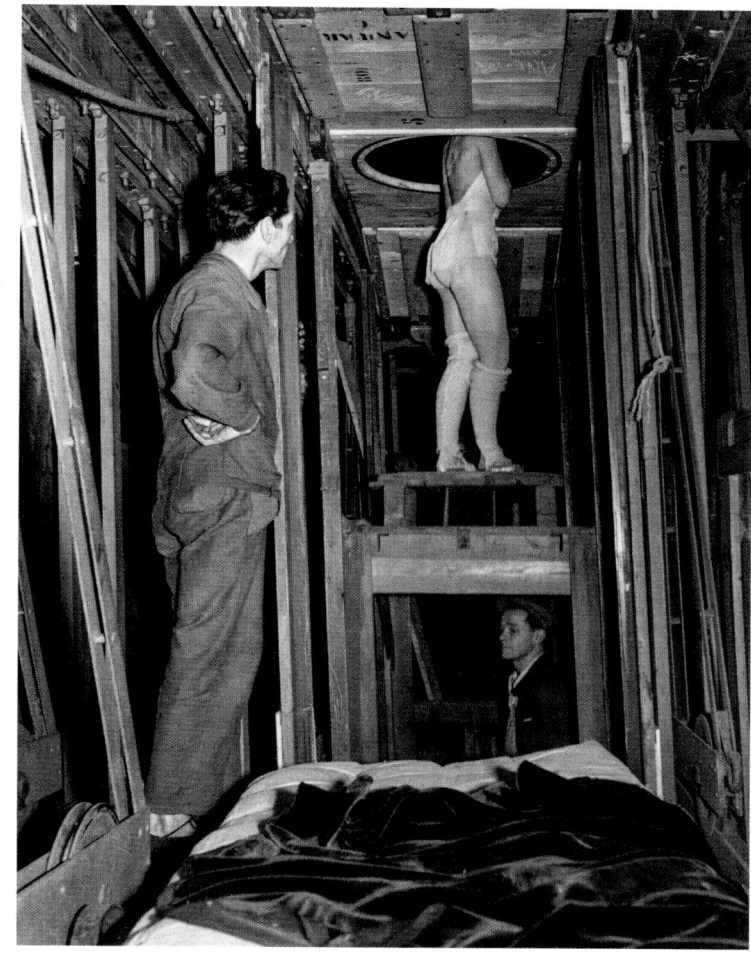

The Beau-Rivage guinguette, Champigny-sur-Marne, Seine, 1947
NEGATIVE: 2¼×2¼ IN. (6×6 CM) _ R17/25/26
__ 56

Same story as the previous photograph. A blind guitarist plays in a *guinguette* in Champigny. In terms of composition, I made two or three photographs of this scene. I chose this negative because of the canoe which, of course, I had been waiting for. It isn't just about what is happening in the foreground and motivated the image, there is this little extra detail that enriches the story. To print almost full frame.

Dressing room at the Opéra Garnier, Paris, 1947
NEGATIVE: 2¼×2¼ IN. (6×6 CM) _ R17/34/22
__ 57

This photograph is taken from a story done in October 1947 on the backstage of the Opéra Garnier. It had been commissioned by *Cavalcade*, one of the many weeklies I worked for at that time. The image was taken in the dressing room of the Opéra's *petits rats* (the young students from the Opéra's dance school). I had climbed up on a chair and set off the flash as high up as possible, because of the mirrors all around the room. These mirrors multiply the reflections of the dancers. Because the ceiling was quite low, I could not avoid the flash bouncing back off one of the mirrors. The negative has therefore been burned at the top of the image, making it quite difficult to print. Full frame.

Secrets of the Opéra, Paris, 1947
NEGATIVE: 2¼×2¼ IN. (6×6 CM) _ R17/34/32
__ 58

Same project as the previous photograph. This was a trapdoor test. You can see the stagehands, an elevator, and the dancer in her work clothes rehearsing an appearance on stage. I was there by chance, it was absolutely not prepared. In fact, as I was nosing about everywhere, I often witnessed unexpected scenes. Framing to the full height of the negative. Cropping on the sides only. Difficult to print, due to strong lighting differences. Electronic flash.

Strike ballot distribution at SNECMA, Paris, 1947
NEGATIVE: 2¼×2¼ IN. (6×6 CM) _ R17/42/10
__ 59
Distribution of leaflets at the gates of the strike at the SNECMA-Kellermann factory in Paris, in December 1947.

During a strike at SNECMA, Paris, 1947
NEGATIVE: 2¼×2¼ IN. (6×6 CM) _ R17/42/20
__ 60
Same project. A worker stands on duty in the workshop during the strike at the SNECMA-Kellermann factory to prevent theft or damage to machinery. There were a number of them, but I isolated him in the corner he had been assigned. This photograph is taken without flash, in low existing light. Film sensitive enough to take photographs like this one already existed, provided a suitable developer was used. This story was commissioned by *Life* magazine. American reporters for this publication were often not accepted on the site of social conflicts; the cold war had begun. Therefore, *Life* regularly commissioned French photographers for this kind of work. One of the photographs in this series also made the cover of *Regards*.

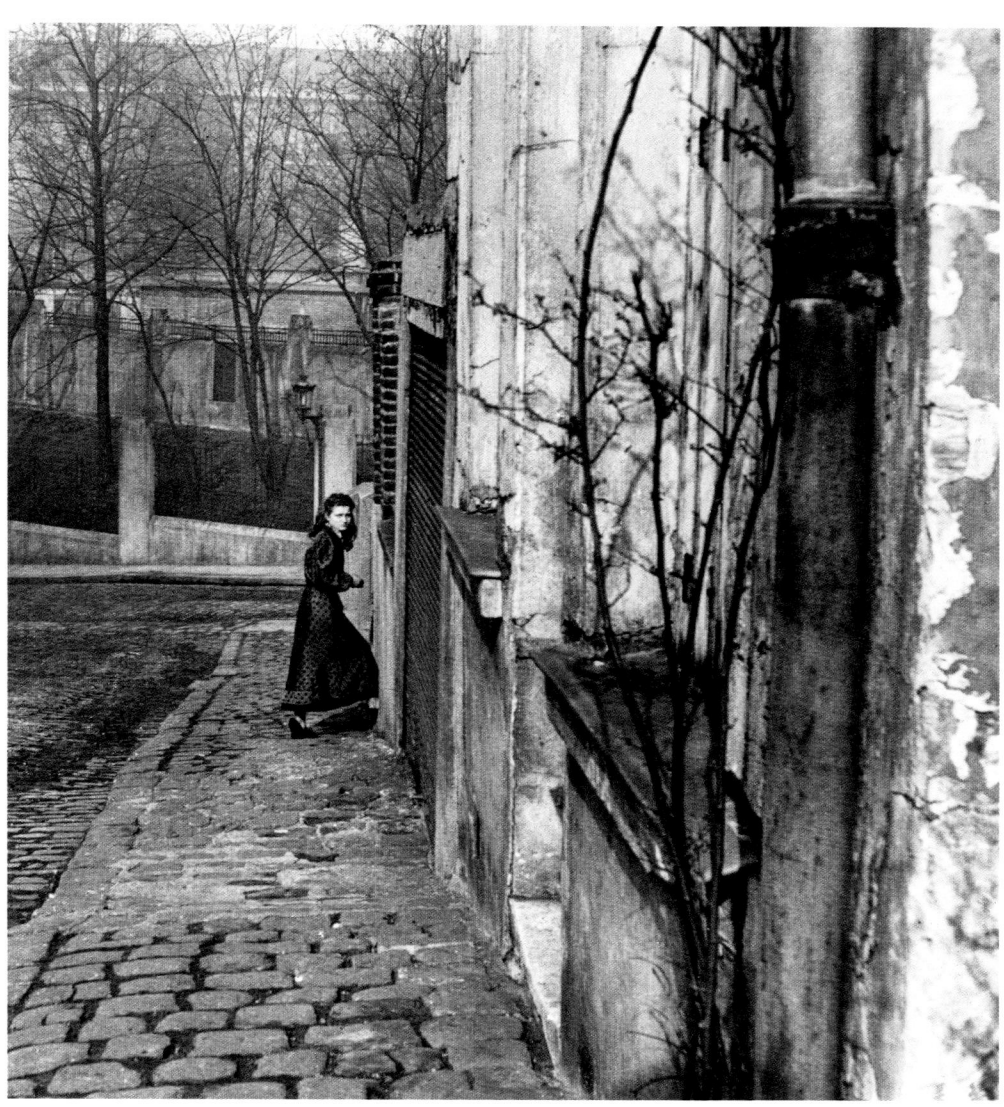

Ménilmontant station on the Petite Ceinture railroad, view from rue Henri-Chevreau, Paris, 1948
NEGATIVE: 2¼×2¼ IN. (6×6 CM) _ BM/1 [BM2/1]
— 61

Published by Arthaud in 1954, my book *Belleville Ménilmontant* opens with this photograph. This is Ménilmontant station taken from the railings that used to line the corner of rue des Couronnes and rue Henri-Chevreau (see photo 64). This area has now been built up. A train had just passed by and the locomotive's steam mingled with the morning mist. There are nineteen photographs taken here, seventeen of which were reproduced in the book. I am not certain of the dates. I found a list of eighteen photographs which, in July 1948, I gave to Pierre Mac Orlan who had kindly written the preface and captions for my book. It appears that the photograph of the station, as well as those that follow under numbers 68, 71, 72, 76, and 77 are from 1948. In fact, my campaign had started with two sessions in November 1947. The rest—around 350 negatives in total—were spread out until early 1951. There are two editions of the book. The first, dating from 1954, used a numbering system with the letters BM followed by the page number, e.g. BM/39: *The bistro on rue des Cascades*. The layout was modified for the second edition published in 1984. The prints that have been made since bear the new page number but preceded by BM2/. That is to say, BM/31 became, for example, BM2/29 etc.

Rue de la Cloche, Paris, 1948–50
NEGATIVE: 2¼×2¼ IN. (6×6 CM) _ BM/3 [BM2/3]
— 62

I had happened upon this girl going into her home on rue de la Cloche, near place Martin-Nadaud. I admit that I did not ask her permission. I don't know if I should regret that—because I rarely performed this kind of "kidnapping" of images—or rejoice at having captured what appeared in front of my eyes. This is one of the contradictions that arise from time to time when practicing this profession. Negative printed almost full frame.

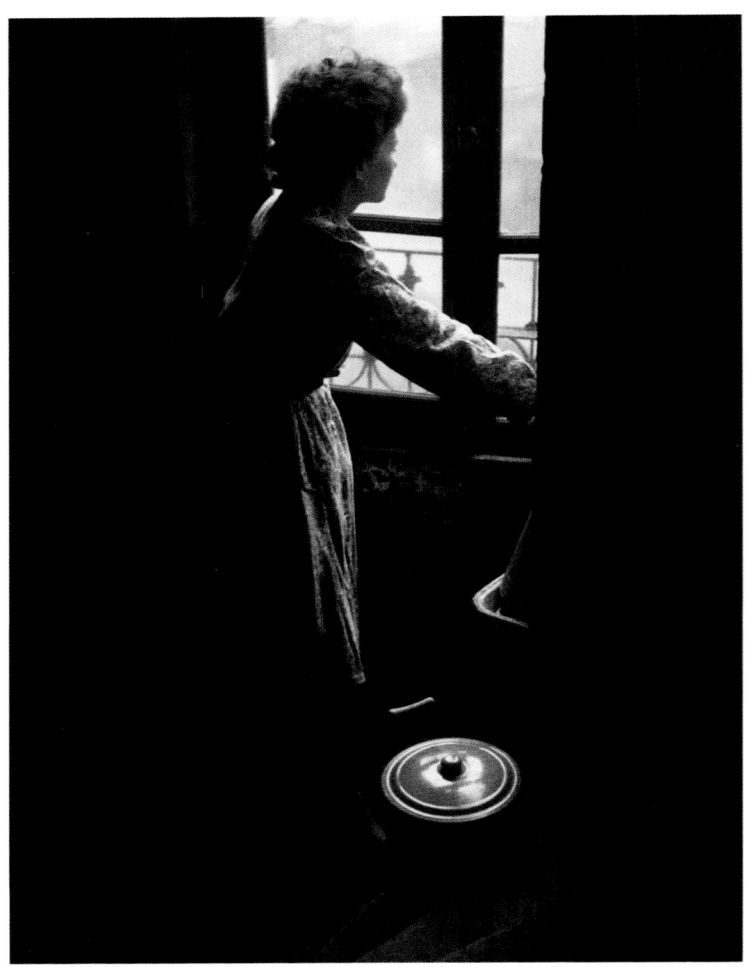
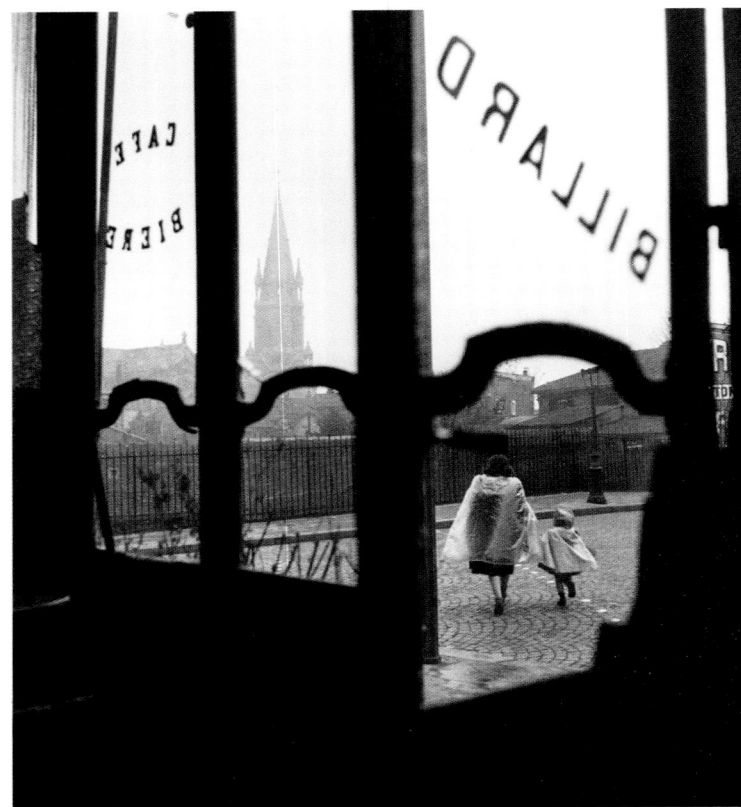

In a furnished hotel on rue Henri-Chevreau, Paris, 1948–50

NEGATIVE: 2¼×2¼ IN. (6×6 CM) _ BM/5 [BM2/4]

__ 63

Furnished room. The service sink was between floors and this young woman was using it to fill her pitcher. She sees from a little higher up what can be seen from the café in the next photograph. Cropping on the sides. Underexposed negative, as is often the case with interiors with a window in the shot.

Café on the corner of rue des Couronnes and rue Henri-Chevreau, Paris, 1948

NEGATIVE: 2¼×2¼ IN. (6×6 CM) _ BM/9 [BM2/25]

__ 64

I had seen this café from the sidewalk, at the railings where photograph 61 was taken, and I thought there would be an interesting point of view from inside, including the steeple of Ménilmontant church and the pedestrians on the crosswalk. I half-opened the door to break the lower black band, took the time to frame carefully, and waited. As I already mentioned in my commentary on photograph 45 (place Vendôme), this is a previsualized image. There is no contradiction between candid photographs and previsualization. It is a question of opportunity. Impromptu things occur, or there is a sense that by setting up in a certain spot and with some patience, something will surely happen. Negative cropped on the left.

A café on rue Saint-Blaise with a reflection of the rue du Clos, Paris, 1948–50

NEGATIVE: 2¼×2¼ IN. (6×6 CM) _ BM/20 [BM2/38]

__ 65

The late-afternoon sun picturesquely brought out the reflection of the low houses on rue du Clos. Just as I released the shutter, this woman appeared on the edge of the frame. This type of composition with a strong element in a corner is quite unusual for me. I would have liked the woman to be four or five inches to the right. Never mind! I like this image as it is. Full frame.

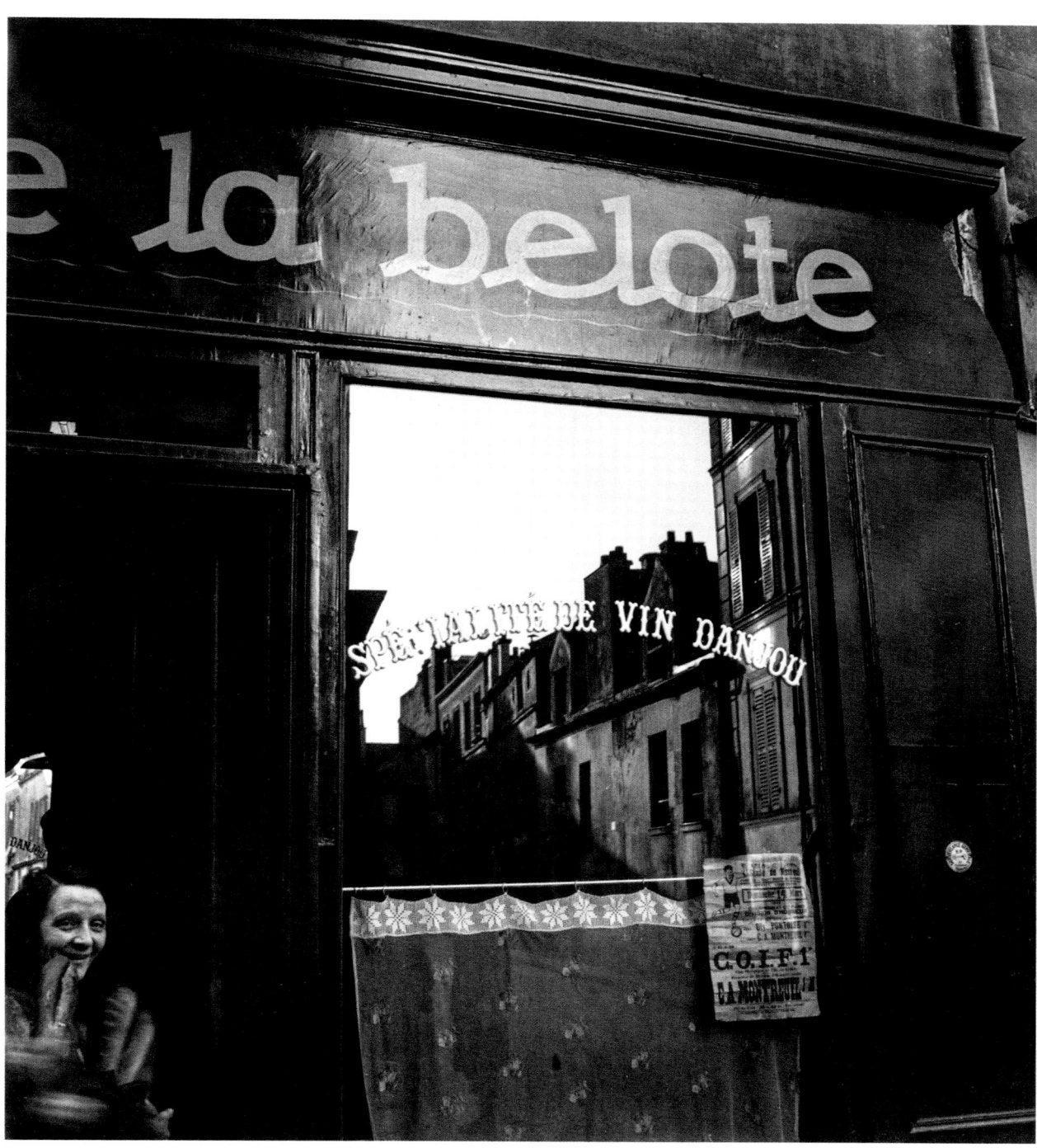

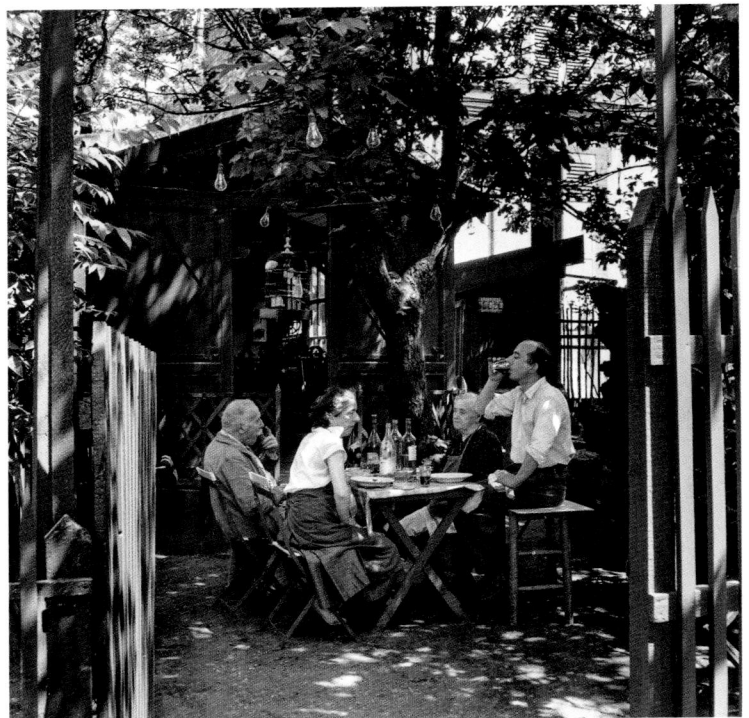

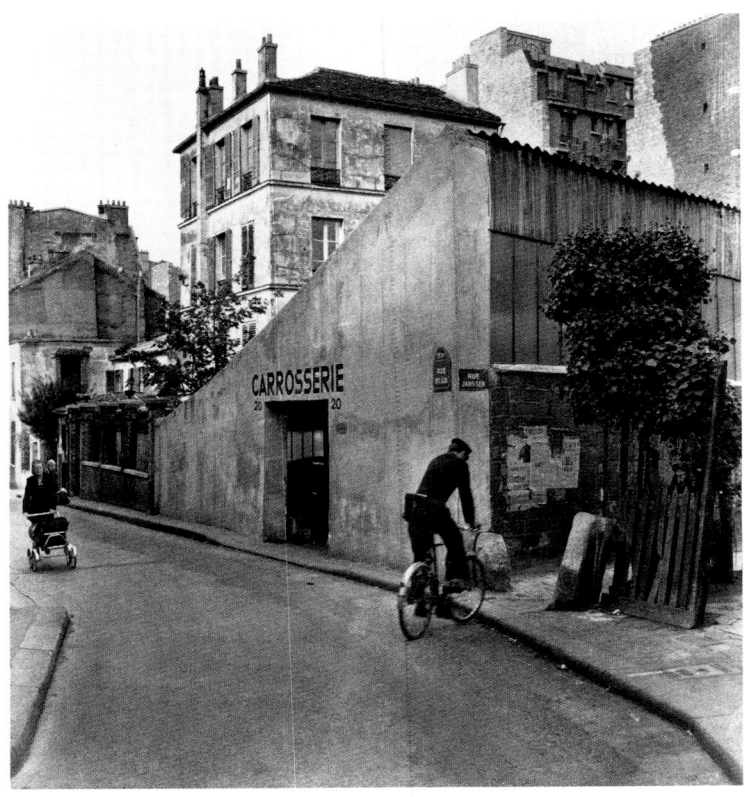

Rue de Belleville, Paris, 1948–50
NEGATIVE: 2¼ × 2¼ IN. (6 × 6 CM) _ BM/25 [BM2/9]
— 66
In a garden at the top of rue de Belleville, in summer. The small cottage houses a mechanical workshop. I lost my work notes: I imagine that the father and son worked there. The framing must be rectified because, inexplicably, my shot is crooked.

The telegram boy, on the corner of rue des Lilas and rue Janssen, Paris, 1948–50
NEGATIVE: 2¼ × 2¼ IN. (6 × 6 CM) _ DUPLICATE _ BM/33 [BM2/31]
— 67
Small-town Paris. Going to the intersection of these two streets today with this photograph in hand, one has to wonder if it is the same city. It's a shame that I released the shutter a tenth of a second too soon: I would have caught the front wheel rearing up. Highly difficult printing, very gray negative. I produced a duplicate to facilitate the process. Full frame.

The bistro on rue des Cascades, Paris, 1948
NEGATIVE: 2¼ × 2¼ IN. (6 × 6 CM) _ DUPLICATE _ BM/39 [BM2/37]
— 68
This street is on the hillside of Ménilmontant and the bistro was spread over three levels. Upstairs, level with the street, was the bar with its counter. A staircase descended to the room shown in the photograph. Down below, there was a garden with trees and other rooms full of life at the end of the week. Today, it is a pile of ruins.
Cropped on both sides.

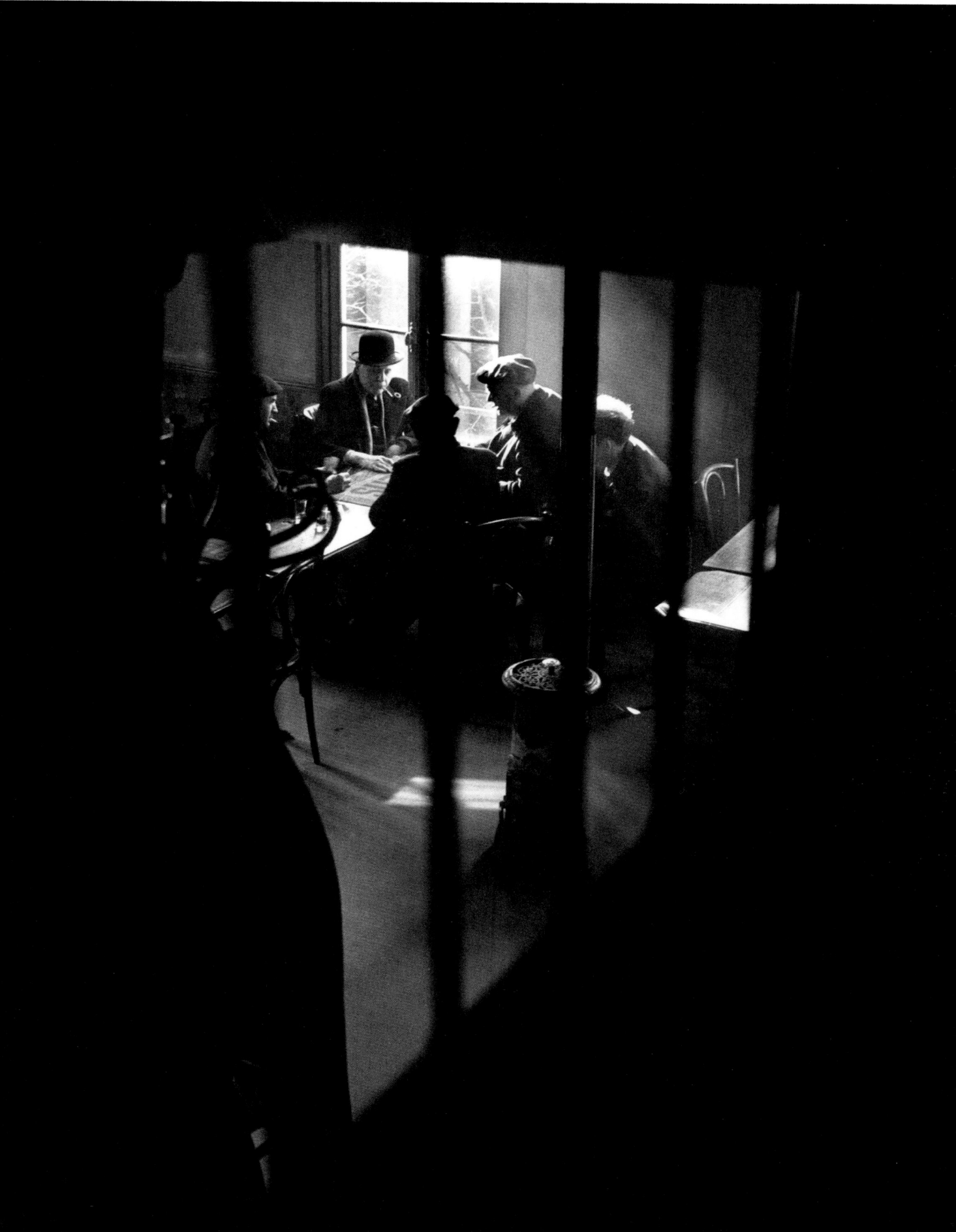

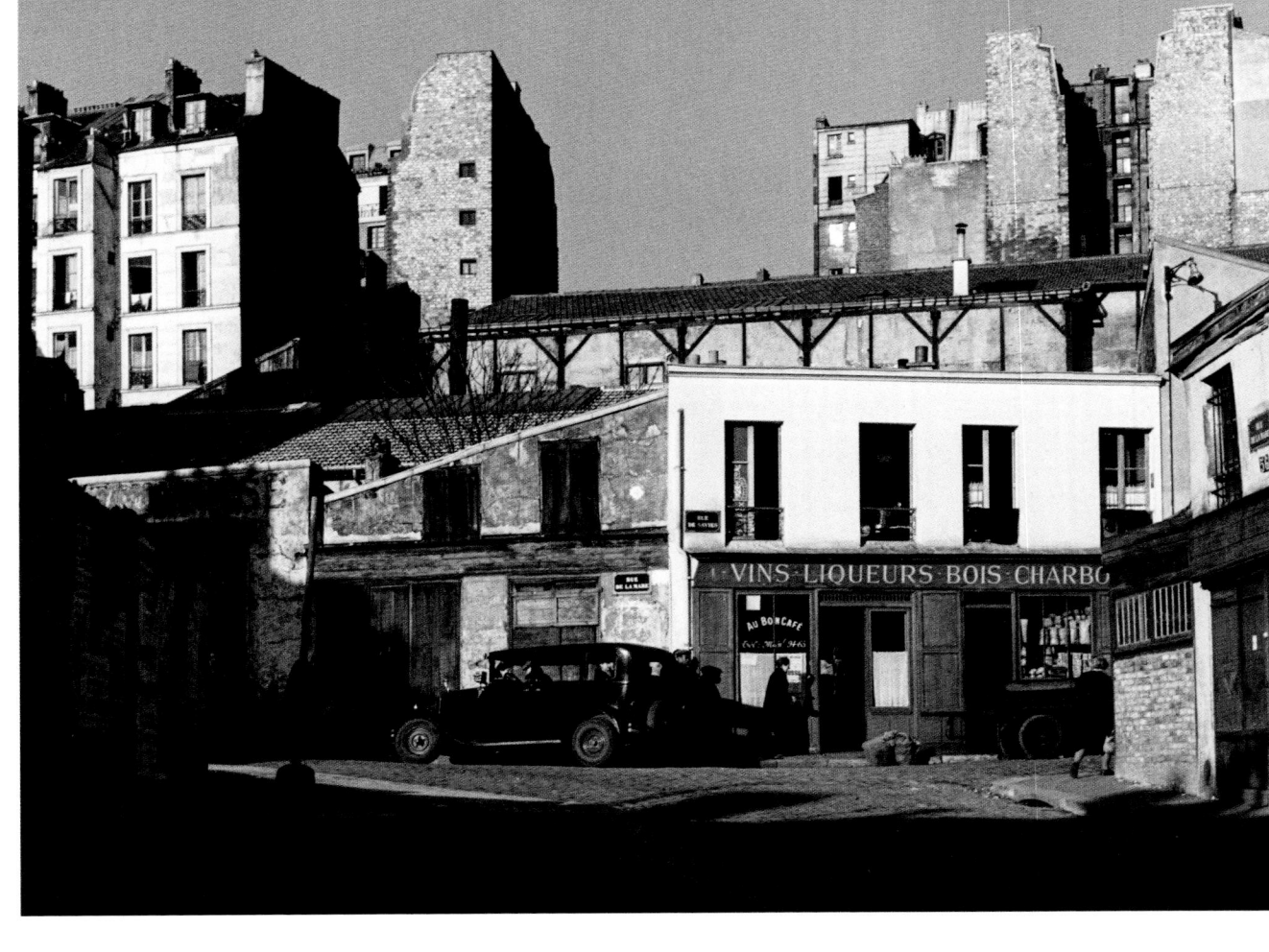

Intersection of rue de la Mare and rue de Savies, Paris, 1948–50
NEGATIVE: 2¼×2¼ IN. (6×6 CM) _ BM/43 [BM2/35]
__ 69

The intersection where the rue de la Mare turns off to the left and, on the right, runs into the rue de Savies, which descends abruptly from the rue des Cascades. Late-afternoon sun. The location is still recognizable, but under renovation.
The print is slightly corrected, to reduce the convergence of the vertical lines caused by shooting from a low angle. Cropping of a large section of the ground and a little sky.

Villa du Parc, near Les Buttes-Chaumont, Paris, 1948–50
NEGATIVE: 2¼×2¼ IN. (6×6 CM) _ WB/44 _ BM2/8
__ 70

The location did not make me want to preserve it for the future—the child in his stroller was the reason for this shot. He slept soundly, while, to the left, some tenants probably woke at night wondering how they would be able to keep their homes.
The surroundings are more appealing today, something unusual enough to be worth a mention. The cobblestones are the same, but the central island is lined with ivy and other trees have been planted there. Full frame.

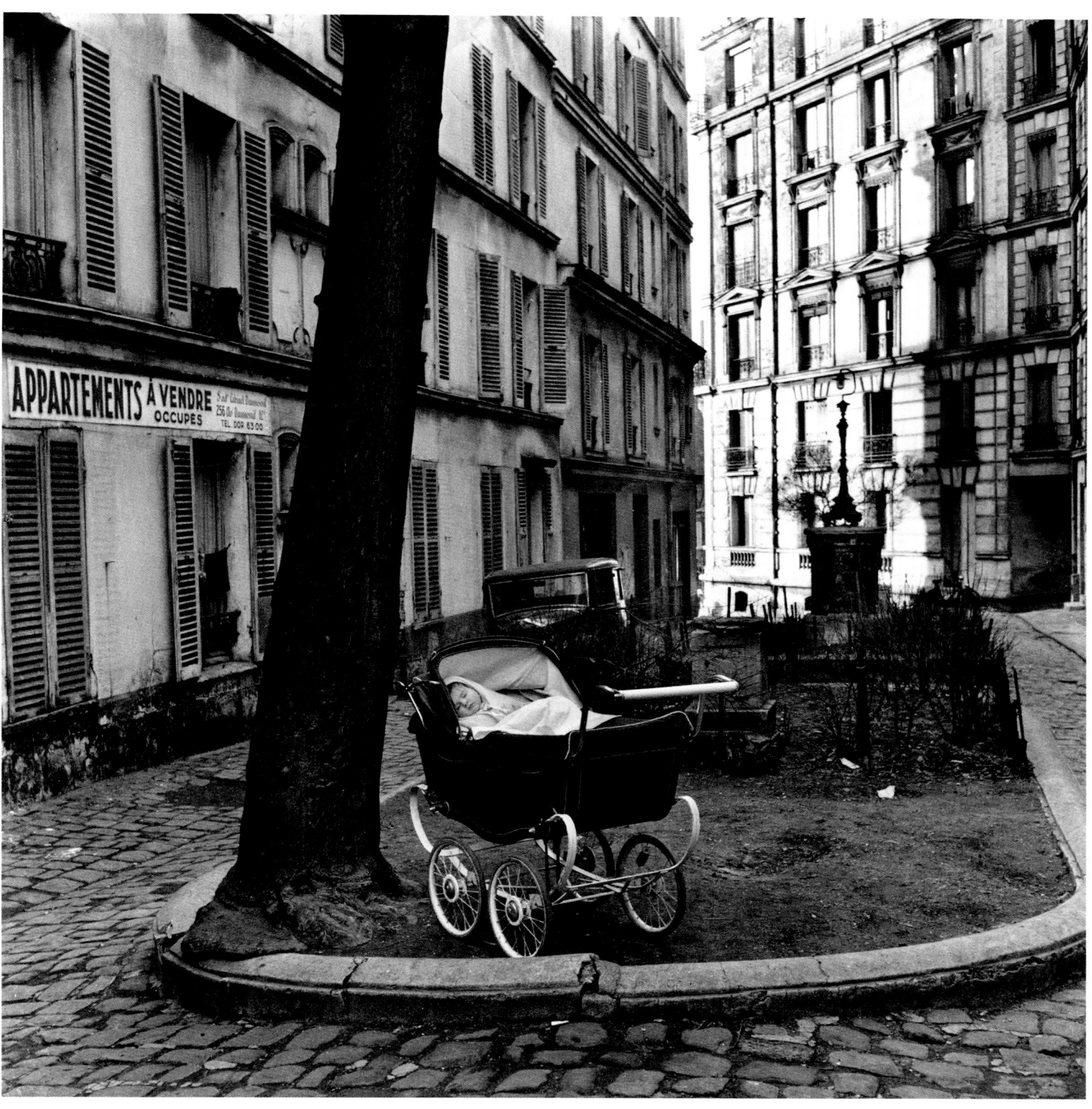

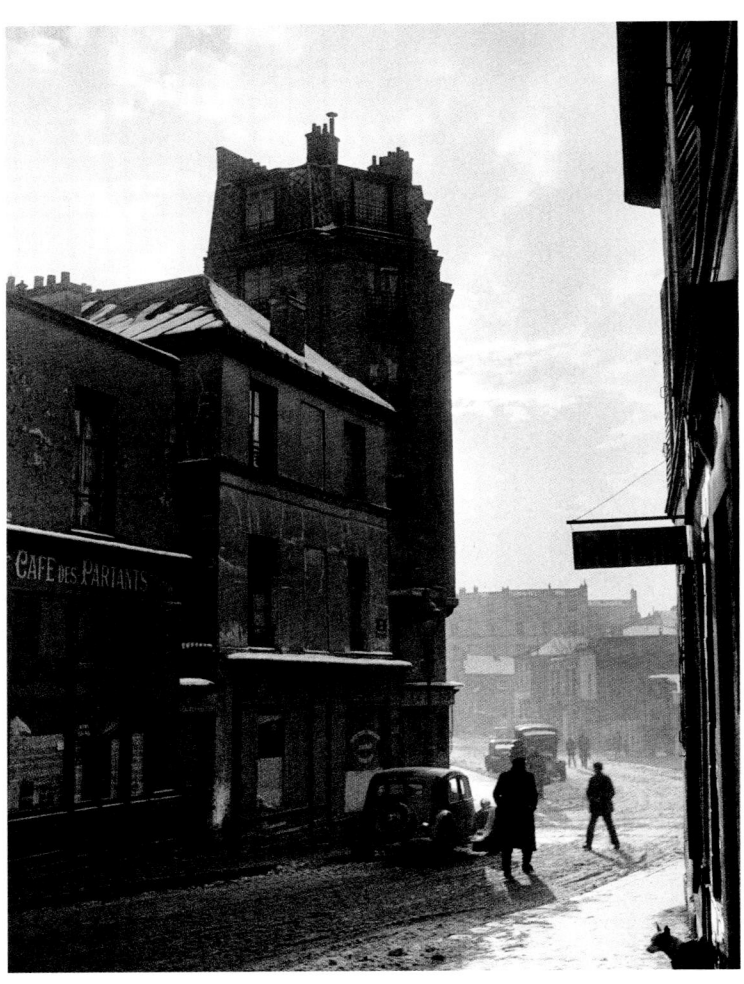

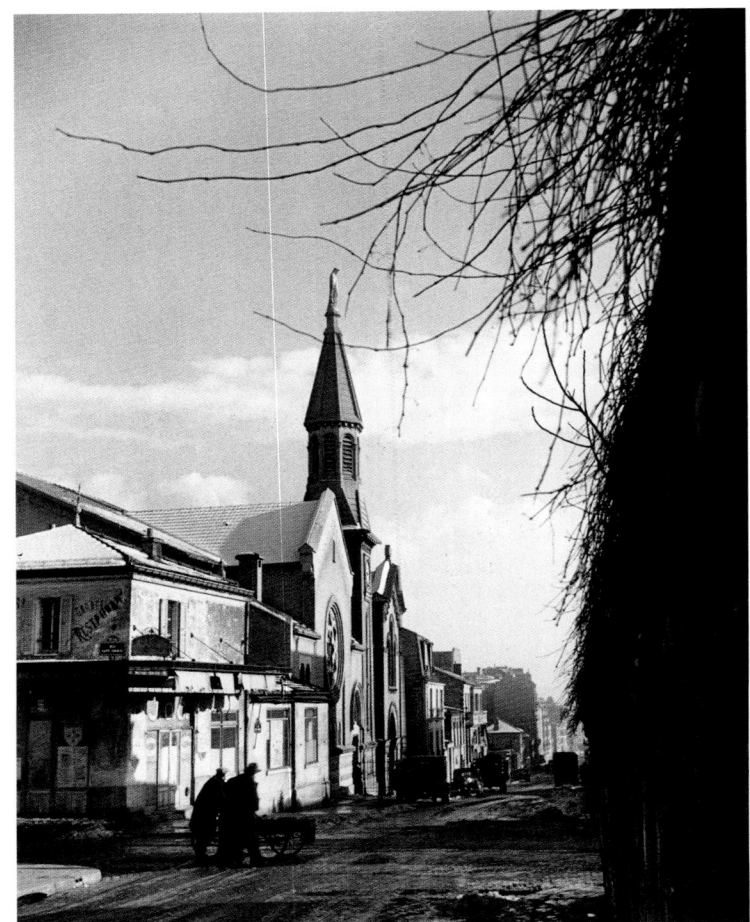

The lower end of rue des Partants, Paris, 1948–50
NEGATIVE: 2¼×2¼ IN. (6×6 CM) _ BM/50 [BM2/45]
—— 71

The quality of the light made me take this photograph: a sunny backlight the night after it had snowed. I waited for some passersby to occupy the space in a satisfactory way. A wait that can be brief, long, or despairing. And so—I speak for the photographer who on principle requires a human presence—either one arms oneself with patience, or else one looks for something else; but in this case, one left with bitter regret. Complicated printing: a classic problem with this kind of backlight. Cropping mainly on the right.

Pelleport–Saint-Fargeau intersection, Paris, 1948
NEGATIVE: 2¼×2¼ IN. (6×6 CM) _ BM/53 [BM2/49]
—— 72

It must have been the same winter as in the previous photograph, and maybe even the same day.
I have very few comments to add to what can be seen in the image. The light was superb and I found the right spot. My two characters stand out well.
It is not a question of lamenting the charms of the past. Even if the landscape had remained unchanged, the street would now have inherited one or even two unbroken lines of parked cars. The point of these photographs is due, in large part, to the not insignificant fact that the war had only just ended and Paris had fewer cars than in 1939. That was about to be put right.

The courtyard of a housing project on boulevard Sérurier, Paris, 1948–50
NEGATIVE: 2¼×2¼ IN. (6×6 CM) _ BM/69 [BM2/66]
—— 73

Neapolitan atmosphere, with the hanging laundry and the dark-haired girls in the foreground. A kid shows off nonchalantly on a big touring bike. While taking this photograph, I was thinking of the Italian neorealist films of the time. And today, the mysterious double gesture of the two children on the balcony—one of them fired a shot, but at whom?—is like a *Blow-Up* still from my memory. Easy print. Major cropping to the top and on the right. In the second edition of the book, following the designer's suggestion, the negative is shown in its entirety, with another little boy on the right. I also accept this way of viewing this photograph.

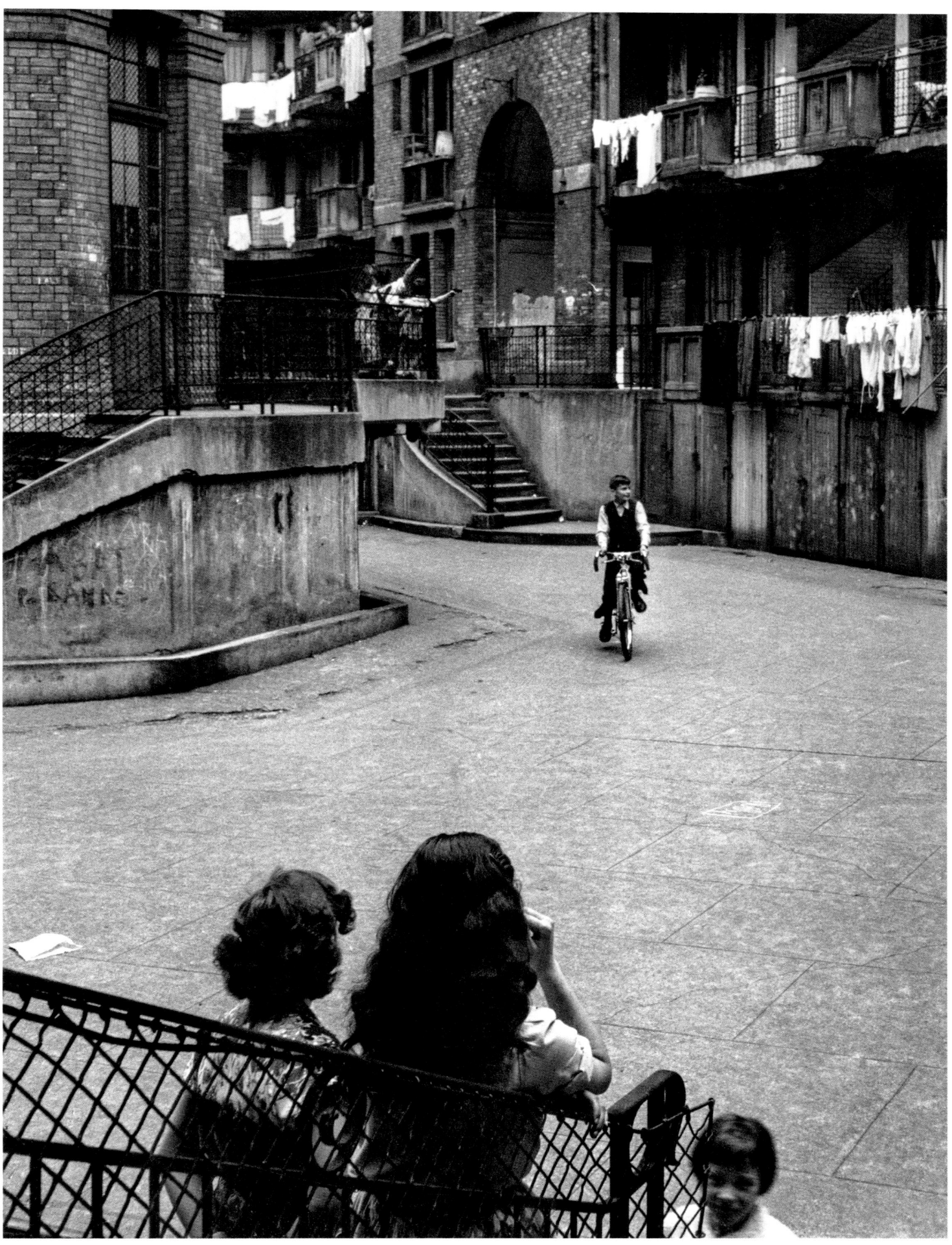

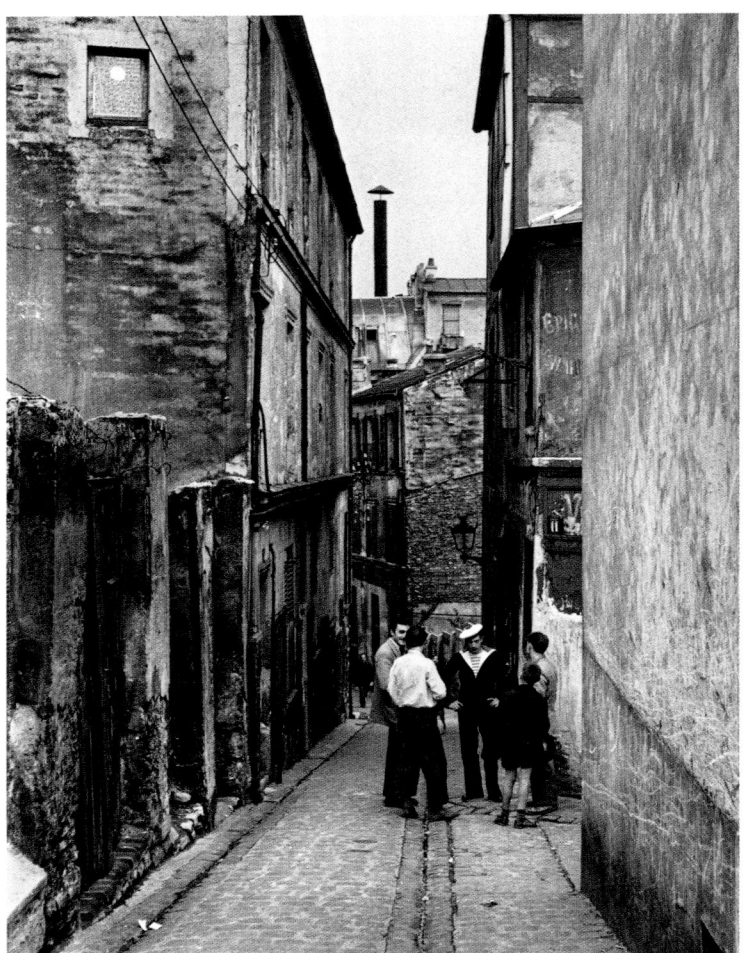

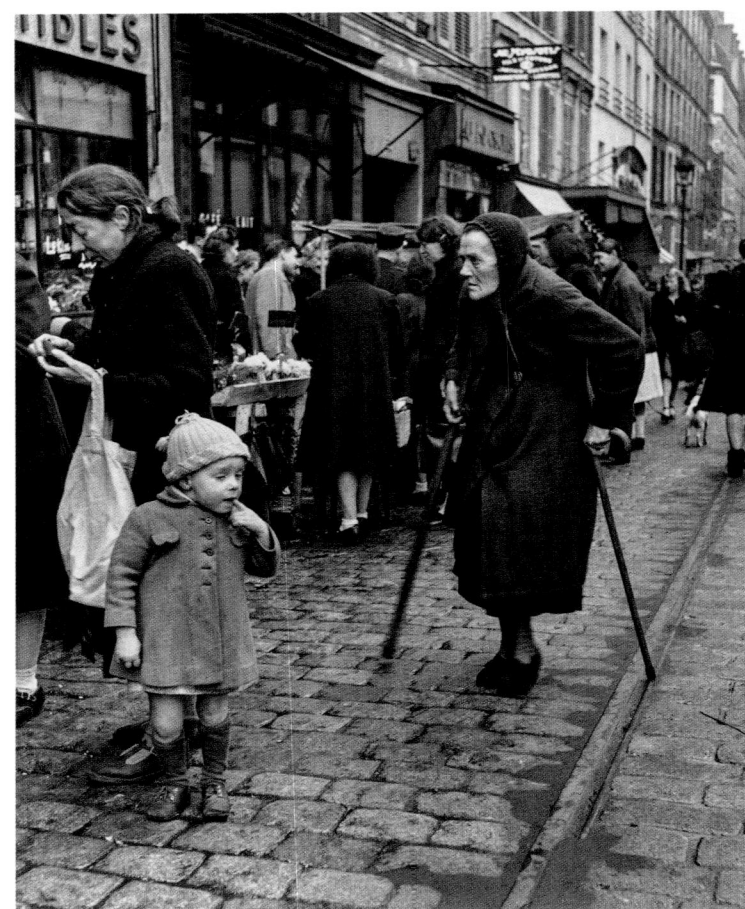

Passage Notre-Dame-de-la-Croix, Ménilmontant, Paris, 1948–50

NEGATIVE: 2¼×2¼ IN. (6×6 CM) _ BM/75 [BM2/58]
— 74

It's funny how a detail can direct the imagination onto unsuspected paths: all of a sudden, there's a sailor in the shot and we're in Toulon. In truth, it was a block of slums and there is no reason to regret its passing. Easy print, as is usually the case for negatives obtained in gray weather. Cropping on top and to the right.

The fruit and vegetable market, rue de Ménilmontant, Paris, 1948–50

NEGATIVE: 2¼×2¼ IN. (6×6 CM) _ BM/79 [BM2/75]
— 75

No superfluous comments. Of course, it was the old woman with two canes—a "Bruegelian" silhouette—who had caught my attention. The housewife counting her money and the daydreaming child help to establish the planes of the image. Easy print. Cropping mainly to the bottom and to the right. Negative printed in full for the new edition.

Glazier on rue Laurence-Savart, Paris, 1948

NEGATIVE: 2¼×2¼ IN. (6×6 CM) _ BM/82 [BM2/22]
— 76

A glazier slowly climbing rue Laurence-Savart, in the moving backlight of this winter afternoon. His voice had made me leave rue du Retrait, where I couldn't find a subject, and run toward him. Just as the photographer on the hunt looks for the best place to stand, when he is able to, to wait for the unexpected (see the commentary for photo 64), when something suddenly arises, it is essential that he conducts a quick scan of the surroundings in order to integrate into the shot one or several elements likely to emphasize the main subject. Here, it was the reflection of the puddle on the sidewalk and also the gutter, which balances the sky and the windows that our man was carrying. Relatively easy print. Avoid over-correcting the top to retain the glare. Cropped a little on all four sides.

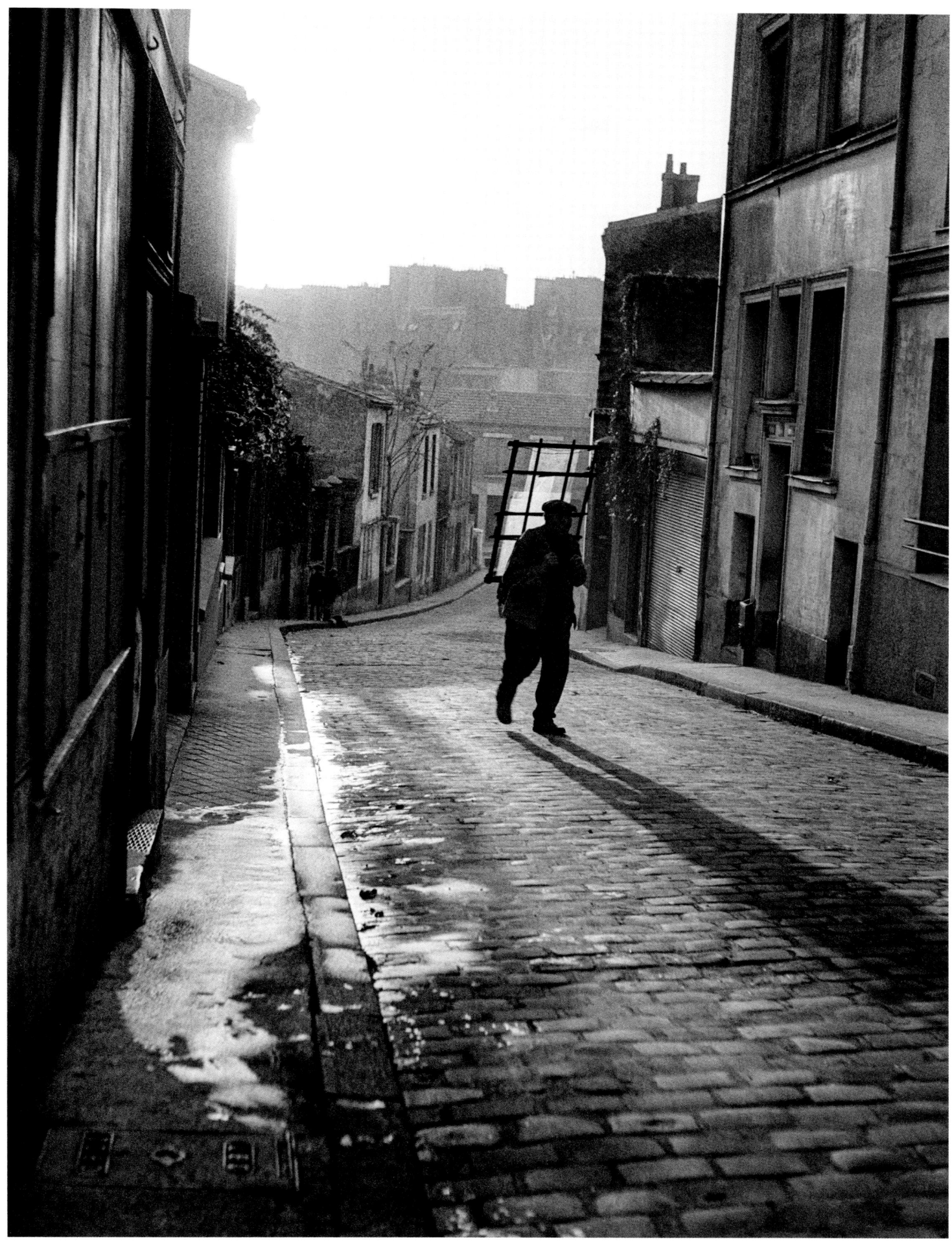

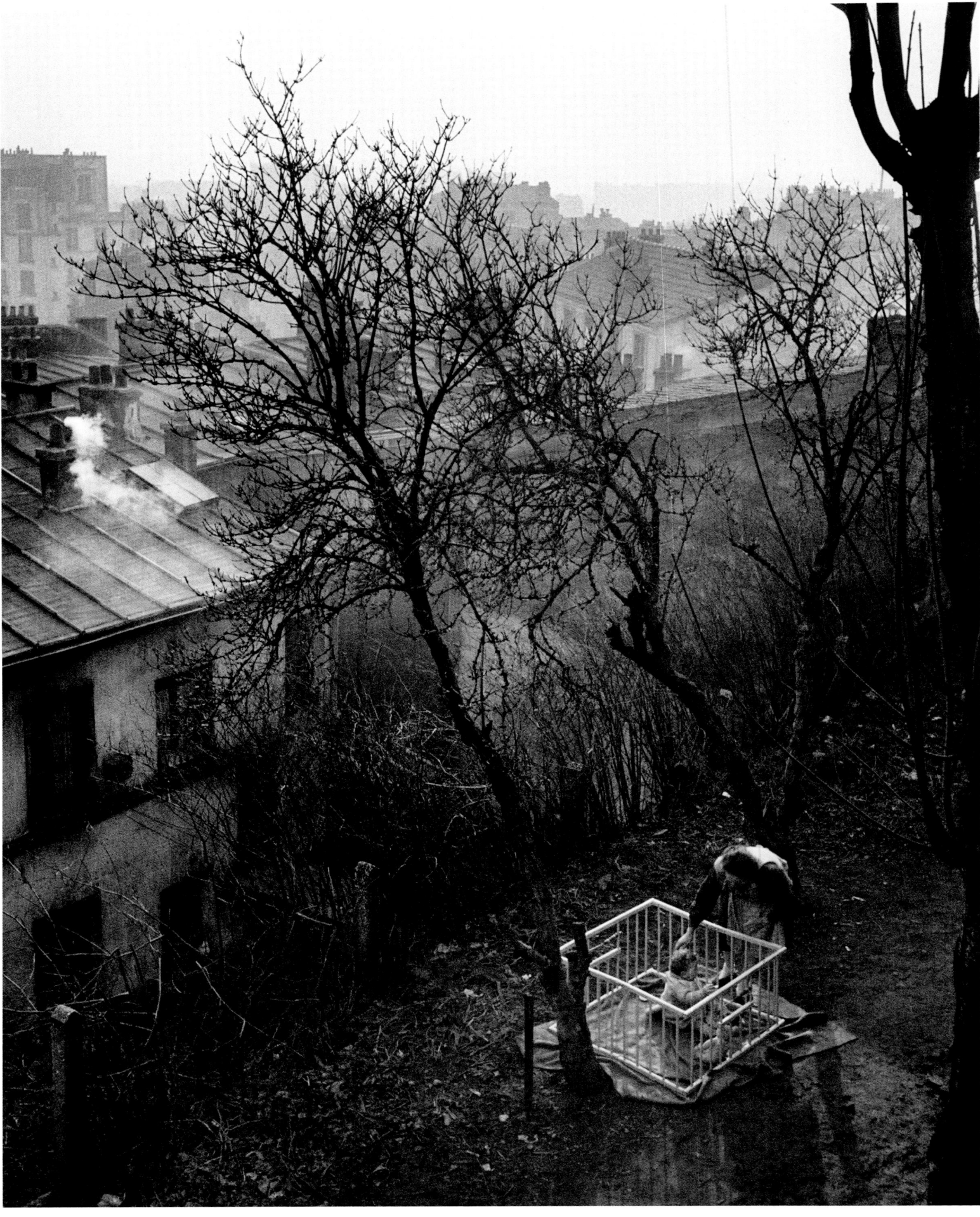

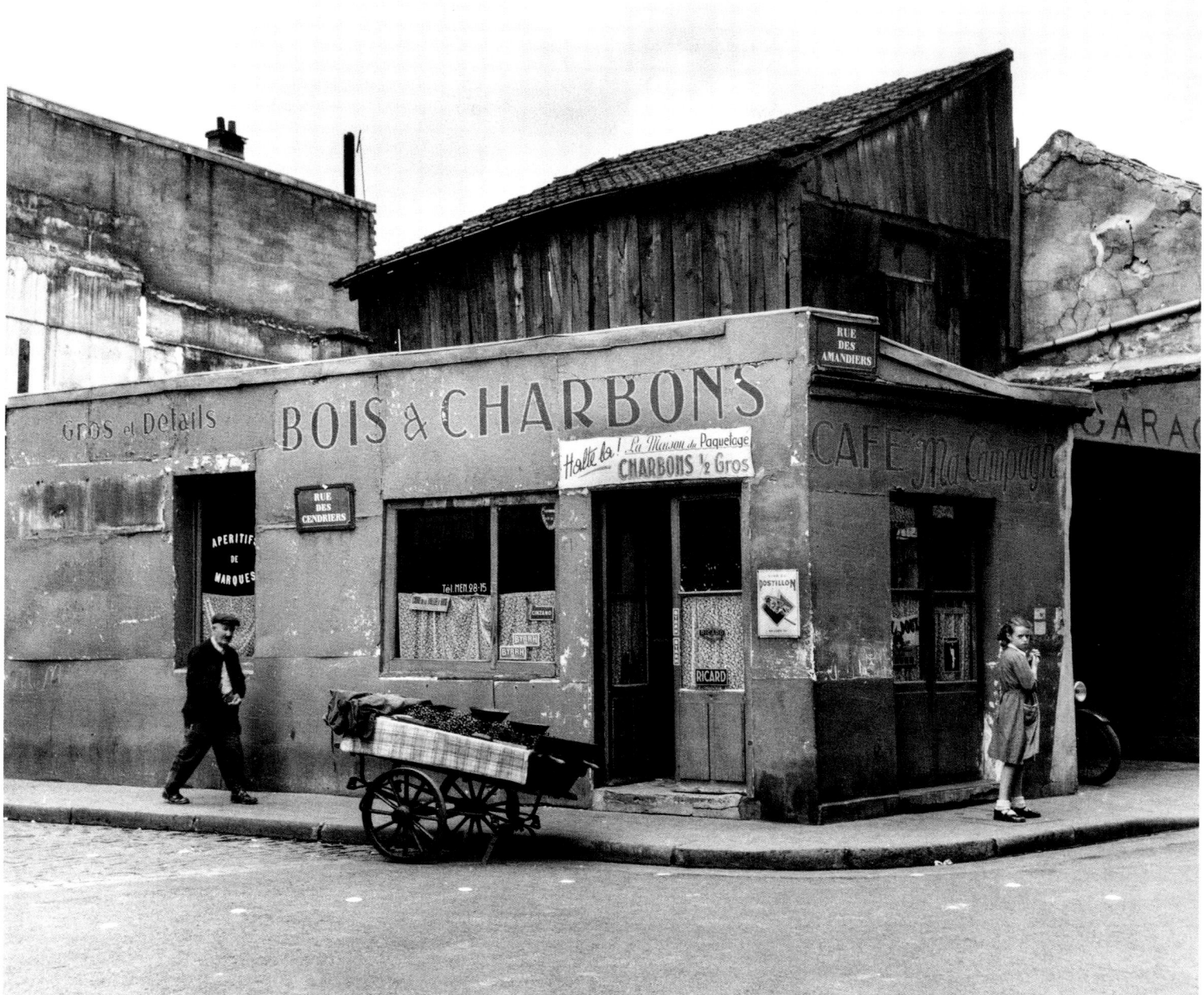

Yard on rue Piat, Paris, 1948
NEGATIVE: 2¼×2¼ IN. (6×6 CM) _ BM/83 [BM2/79]
__ 77

Rue Piat is high enough up on the Belleville hill, and I had been sniffing around the courtyards and small gardens that flank the houses on the odd-numbered side of the street for some time. Of all the images that I brought back, this is one of those that I prefer. An iron balcony level with rue Piat ran along the hidden side of the house and I had time to compose my shot to include the smoking chimney on the left, in addition to the trees. Light cropping on the left. The negative is difficult enough to balance when printing to retain detail in the foreground and in the distance.

A café-bougnat (coalmerchant and bar) in Ménilmontant, on the corner of rue des Cendriers and rue des Amandiers, Paris, 1948
NEGATIVE: 2¼×2¼ IN. (6×6 CM) _ BM/100 [BM2/21]
__ 78

Neither this photograph, nor the next one, appeared in the first edition of *Belleville-Ménilmontant*; they appear in the 1984 edition. I have included them both in *Sur le fil du hasard* (On Chance's Edge). This is an exemplary location of the old working-class Paris. It is a shame that there isn't anyone on the doorstep of the *café-bougnat*. I could have waited, but I liked this journeyman carpenter (with the typical trousers of the trade); the little girl, a little intimidated by my Rollei, balances out the composition. It's a gray Paris day in June (the little cherry cart). Easy print. Cropping to top and bottom.

**Avenue Simon-Bolivar,
from the staircase of rue
Barrelet-de-Ricou, Paris, 1950**
NEGATIVE: 2¼×2¼ IN. [6×6 CM] _ DUPLICATE _ BM/125
[BM20/125 OR BM2/77]

—— 79

A winter afternoon.
I have rarely included so many elements in the same photograph. The mother carrying her child is the pivot of the composition. There is the dray pulled by its horse, which was no longer common in Paris at that time, and the worker repairing the traffic lights. Behind him a couple pushes a baby carriage, and in front of him a mother does the same. On the right, the cobbler chats to someone (a pharmacist perhaps) as they look on at something that we will never know. Further on lies rue Lauzin and its workshops, now replaced by buildings that are quite pleasing to the eye (allée Louise-Labé, etc.). I took new photographs in the same place, but not in the same season. To avoid saying that they aren't as good, I would say that they are different. Average difficulty in printing. Very slight cropping on both sides.

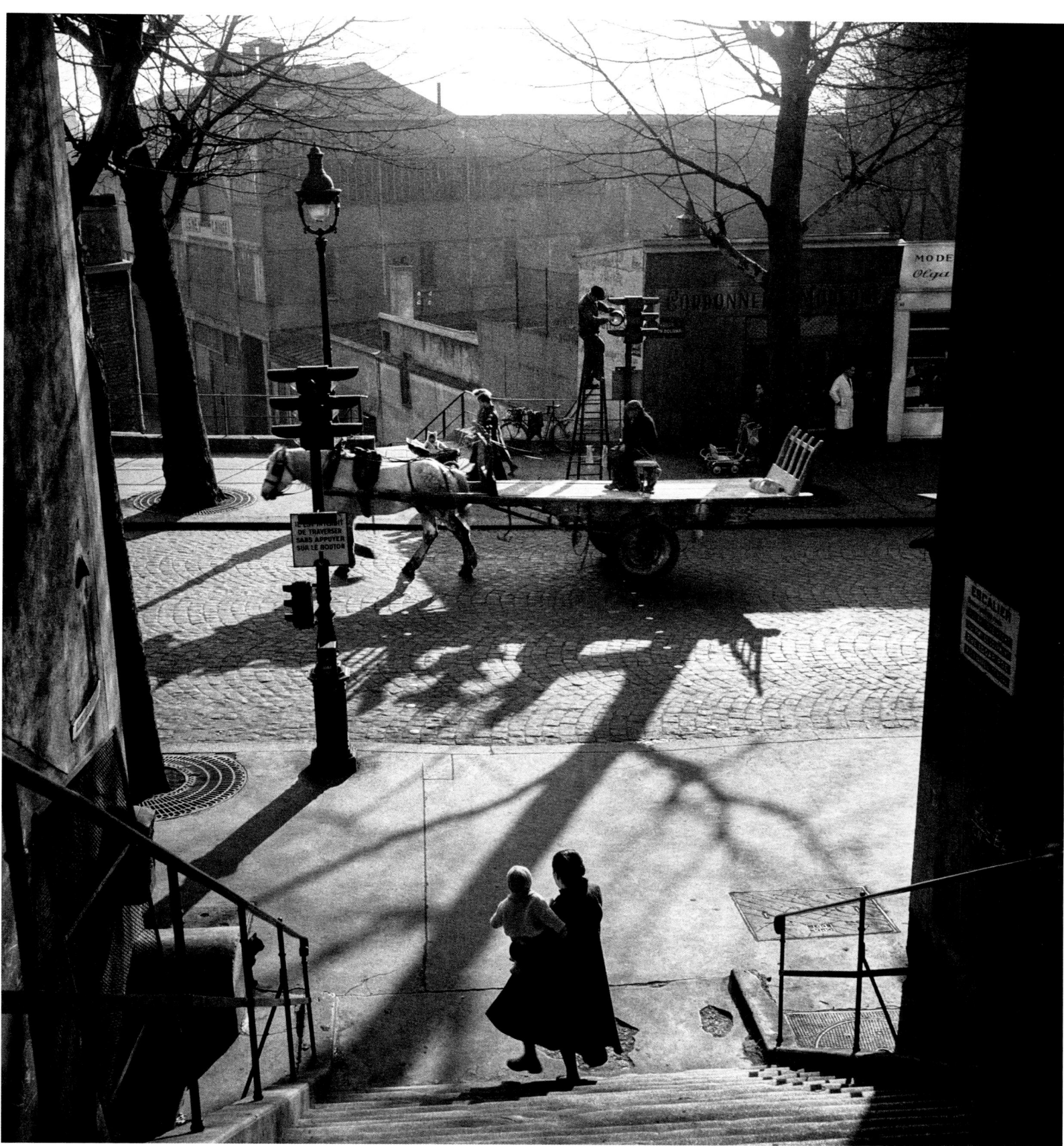

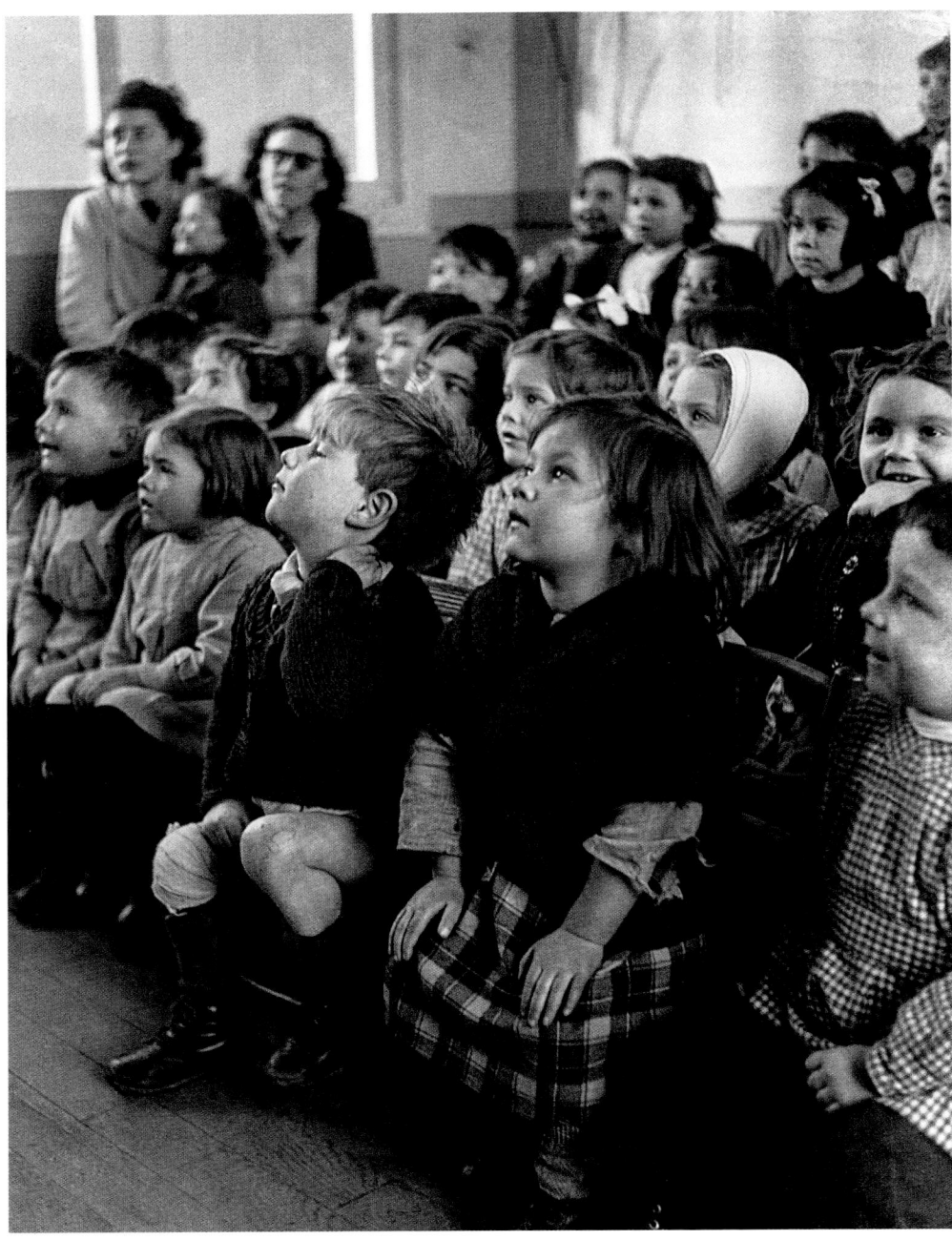

Puppet show at school, Aubervilliers, 1948
NEGATIVE: 2¼×2¼ IN. (6×6 CM) _ R18/7/10
___ 80

My diary for 1948 enables me to date this photograph with precision: February 20, 1948. On that day, I was doing a report on a school in Aubervilliers where Marie-Anne had made a mural decoration. Alongside my documentary work, I took photographs for myself. These children are watching a puppet show put on by a visiting artist. I had been attracted by the two little characters in the front row. It's so easy to imagine the little girl later on in life, selling vegetables at the market with a black pleated skirt. She's already a little woman. The framing retains the full height of the negative and crops a part on the left.

Sèvres-Babylone intersection, Paris, 1948
NEGATIVE: 2¼×2¼ IN. (6×6 CM) _ P18/136
___ 81

I probably took this photograph while going to the Duffort lab, near Sèvres-Babylone. The position of the sun, in the axis of rue de Sèvres, tells me that it was taken in the afternoon. As a photographer who often works outdoors, I was very interested in cosmography. So, whatever the city, I know before going to the location, just by reading a map, at what time of day I will find the best lighting—if the sun turns up, of course. The backlight (it's crazy how much backlight fascinates me!) made me choose this spot, to have the awning on the left and the veiled sun in front. I had taken two shots with little enthusiasm and then, suddenly, this woman appeared out in the open! Jubilation was immediately followed by a twinge of unease, as is always the case in these delicate situations: had I pressed the shutter at the crucial moment? Lateral cropping, mainly on the right.

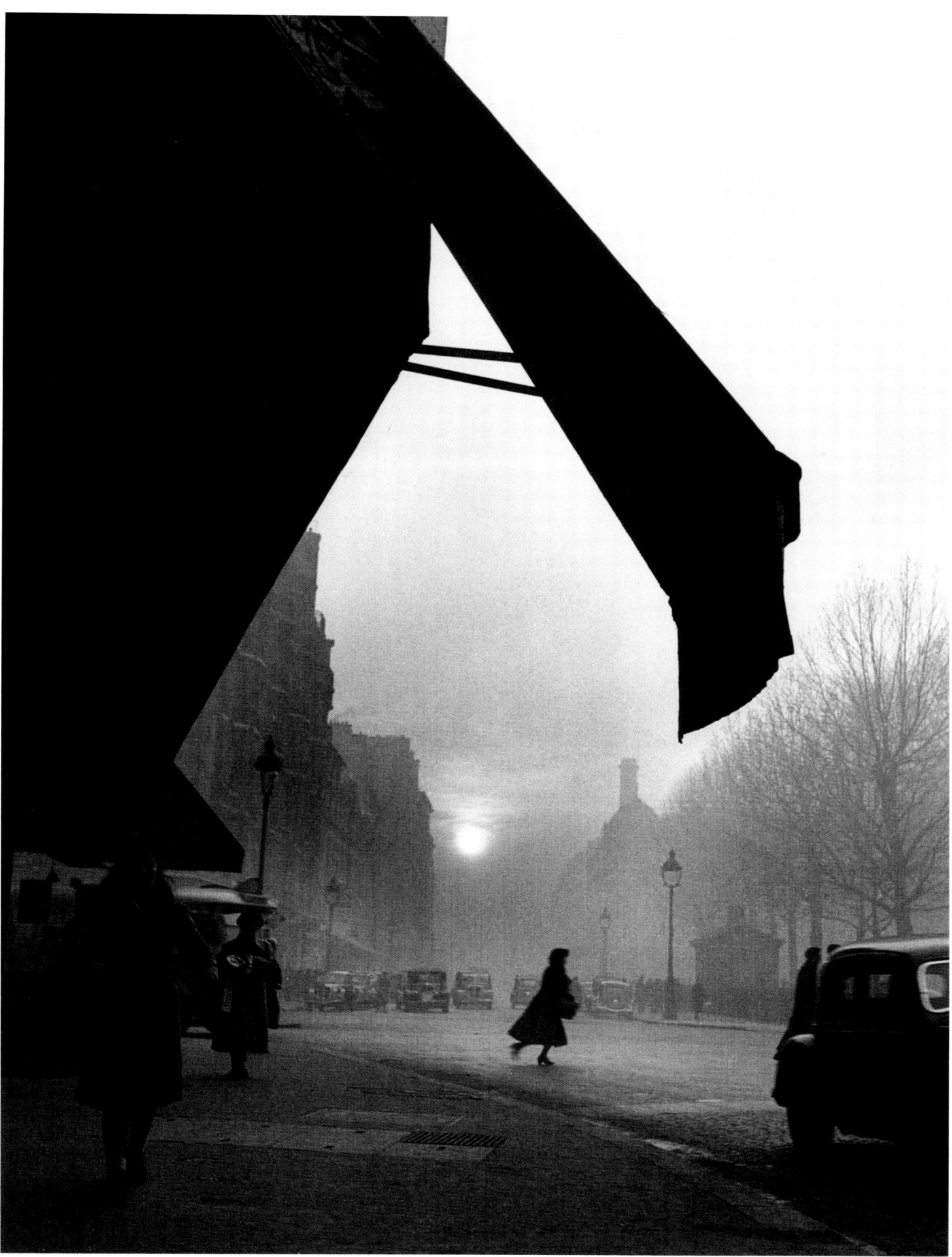

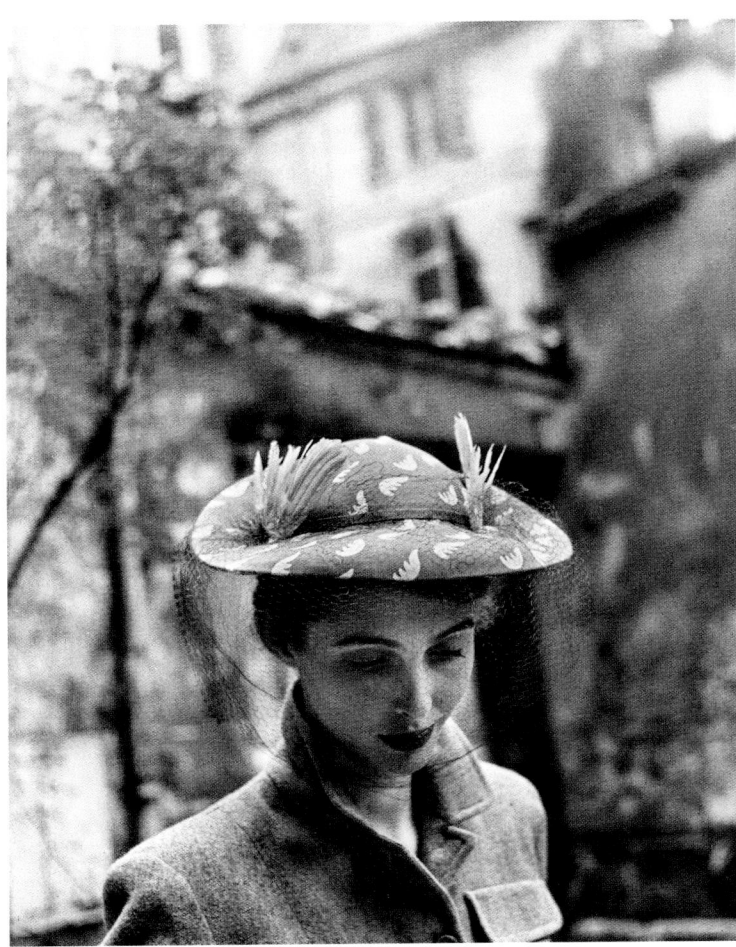

Caroline Reboux hat, Paris, 1948
NEGATIVE: 2¼×2¼ IN. (6×6 CM) _ R18/25/6
— 82

In April of that year, Louis Ferrand, the artistic director of *Album du Figaro* (already mentioned in the commentary for photo 55), commissioned six stories from me for the following issue. One of them needed to illustrate Paris chic through the milliner and fashion designer Caroline Reboux's hats. I decided to photograph my model, the very young Mrs. William Klein, at different picturesque Parisian sites. In 1948, I still rode a motorcycle and so it was with Jeanne seated sidesaddle on the Tan-Sad [auxiliary seat] of my vehicle that we headed off, with the two hatbox ties slung around her forearms. We headed to Ménilmontant (of course), the quays, cour de Rohan, Île Saint-Louis, and place des Vosges. Toward the end of the journey, I drove a little too fast on rue de Rivoli and could not avoid a pothole. The jolt to our crew caused the ties to break, and the boxes rolled underneath the tires of a bus that was following us closely. The blood drained from our faces and we stopped along the sidewalk. Struck by the tires but not crushed, the boxes had opened but the hats were unscathed. We picked them up, shaken by nervous laughter. We still had Montmartre and the Canal Saint-Martin to go. The bulk of our work was done. Basically, we could comfortably slow the pace.
Misty backlight. Soft print.
Cropping on both sides.

René Gruau, Paris, 1948
NEGATIVE: 2¼×2¼ IN. (6×6 CM) _ R18/27/4
— 83

Another one of these six stories focused on the great fashion illustrators. Gruau was already famous. When I do a portrait, I like to place the model in a setting that is familiar to them. I positioned the two articulated lamps to get both grazing and reflected light. I wanted the artist to hold his pencil in a natural but plainly visible way. The sketch in progress (the style was already defined), although purposefully left blurry in order to suggest the separation of planes, identifies its author unequivocally.
Side cropping. Print offset to reduce the lamp halos.

Rail tragedy, Arbresle, Rhône, 1948

NEGATIVE: 2¼ × 2¼ IN. (6×6 CM) _ R18/32/39

— 84

France-Dimanche had asked me to cover for a colleague who had fallen ill and, as the subject interested me, I accepted, despite the relatively limited regard I had for this weekly. I remember that I had been given this story at the same time as another to be done in Lyon on the operations of children with blue baby syndrome. A locomotive had lost control for reasons unknown to me. To stop the train, which probably would have derailed or crashed into a station, the engineer and his driver did not hesitate to sacrifice their lives. I took this photograph a few minutes before the body was placed in the coffin. It was not published. The photograph selected also showed the mechanic's widow, placing her handkerchief on the face of the deceased as a final kiss: a very moving photograph, but in my opinion much less beautiful than this one, for which I have a great fondness. It is of course horrible to have to take photographs in this kind of situation, but I think I did so with the utmost discretion and respect. The blurry elements that can be seen on the right are the leaves of decorative palm trees. In the print they must be hidden by overexposing them. Apart from that, the negative is well exposed and presents no difficulty. It is cropped.

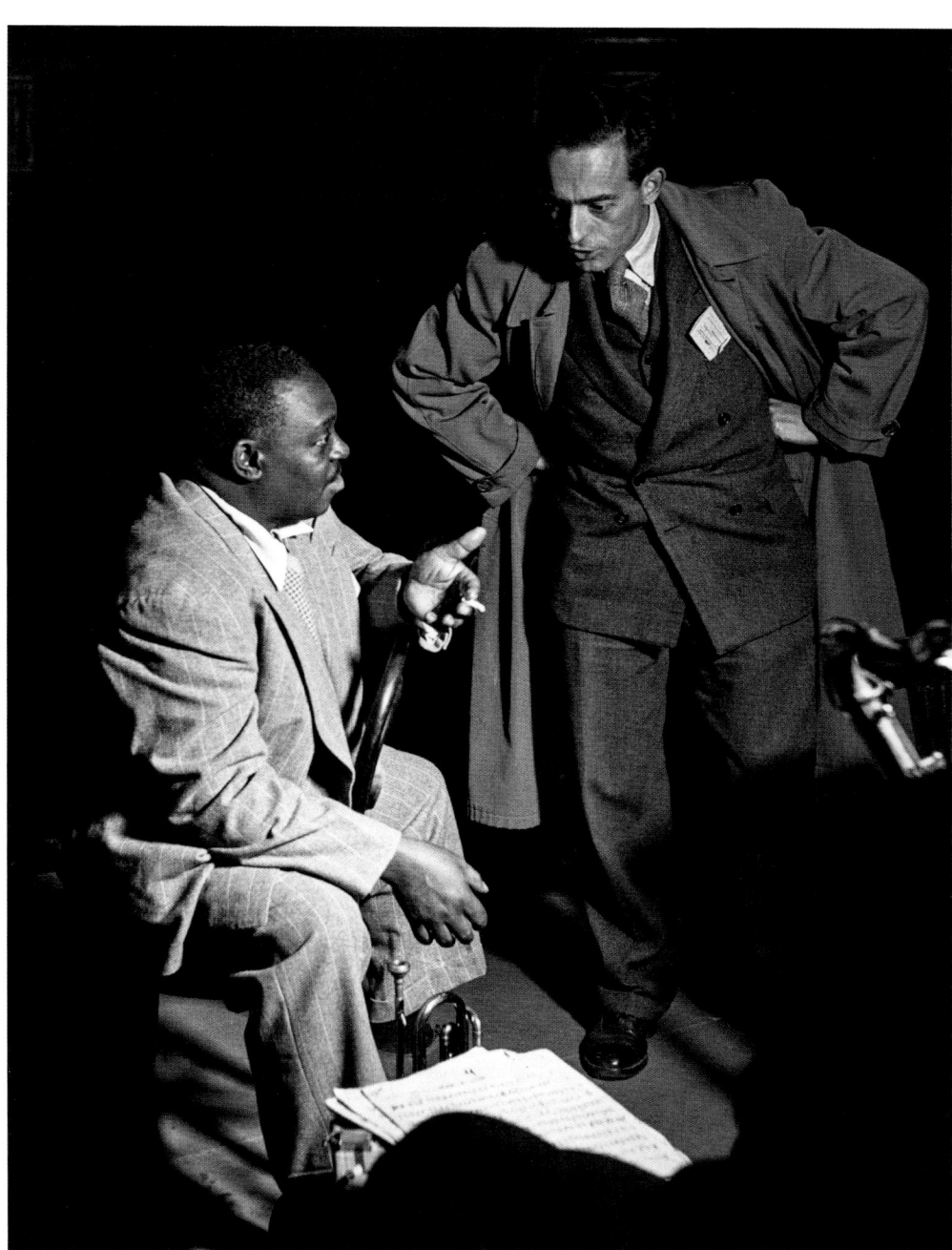

The attic, Gordes, Vaucluse, 1948
NEGATIVE: 2¼×2¼ IN. (6×6 CM) _ F18/788
__ 85

It was the beginning of summer vacation in Gordes. In the previous year we had bought the ruin where I would take, one year later, *The Provençal nude* (photo 94) and, three years later, *Vincent and the model aircraft* (photo 129). Vincent had come into our bed to look through a picture book. He was eight years old at the time. We slept in the attic because the other rooms were under construction. With wood found in the house, I had cobbled together the chair that can be seen to the right of the image. The morning sun hits the gypsum floor violently and the bottom of the photograph requires heavy overexposure when printed. Slight cropping on both sides.

Rex Stewart and Charles Delaunay, Paris, 1948
NEGATIVE: 2¼×2¼ IN. (6×6 CM) _ R18/44/1
__ 86

Story commissioned by *Regards* during the trumpet player Rex Stewart's visit to Paris. This is a break during a rehearsal. Rex is speaking with Charles Delaunay, the president of the Hot Club de France federation and the director of *Jazz Hot* magazine. I knew Charles Delaunay well, because we had been roommates during my military service in 1931, united by a shared passion for jazz (see photo 26). This photograph was lit by the stage lights. It's not hard to print; there is no detail in the background, which remains black.

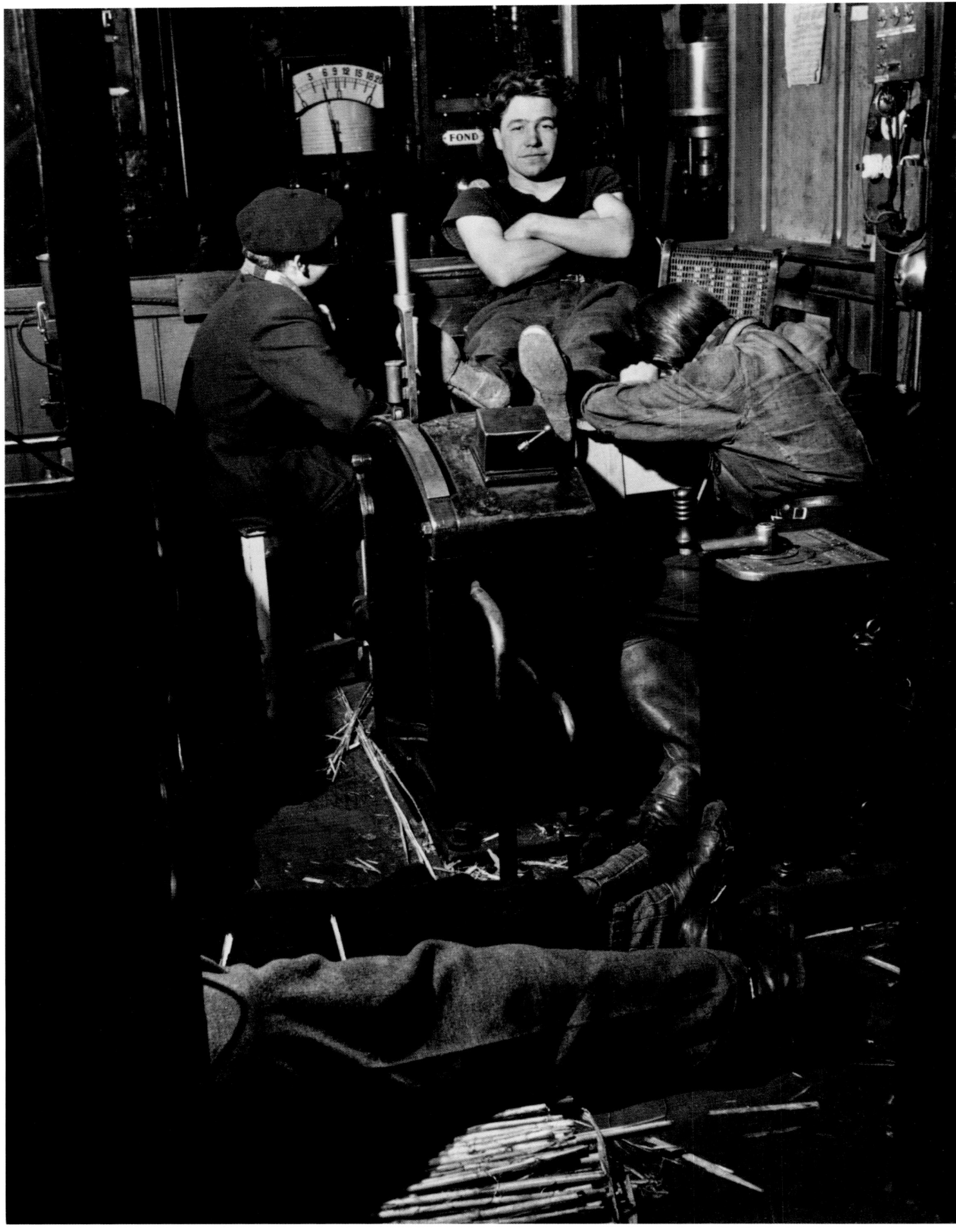

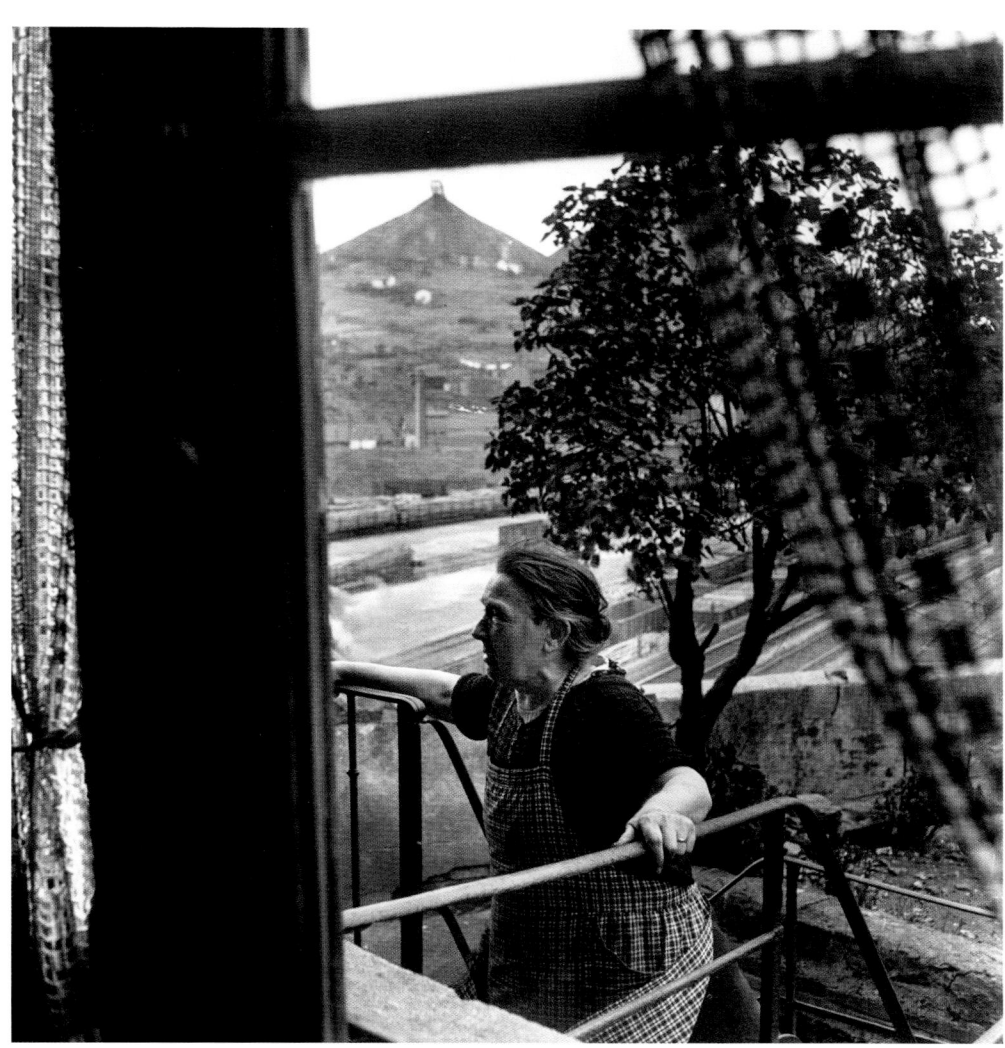

Night watch during a miners' strike in Saint-Étienne, Loire, 1948
NEGATIVE: 2¼×2¼ IN. (6×6 CM) _ DUPLICATE 4×5 IN. (10×12.5 CM) _ R18/45/100
—— 87

This was a commission from *Life* on a miners' strike in Saint-Étienne. I took this picture of the workers on watch in the elevator cabin at night with a magnesium flash bulb. So as not to change the actual lighting of the cabin, I had set the flash up on an extension beside the light bulb that normally lit the scene. The negative was lost during the preparation of my book *Sur le fil du hasard* (On Chance's Edge). Perhaps one day I will find it while looking for something else. Meanwhile, we print from a very good, larger-format duplicate, made by the Pictorial lab.

Miner's wife, Saint-Étienne, Loire, 1948
NEGATIVE: 2¼×2¼ IN. (6×6 CM) _ R18/45/103
—— 88

From the same project as the previous photograph. I was invited to a miner's home and, through the window, I saw his wife climbing the stairs, but I did not have my camera in hand. During our very cordial conversation, I asked her to kindly repeat her arrival to have it in the frame of my Rollei with the slag heap in the background. It is therefore a composed photograph. I set it up without any reservations: this woman took these stairs several times a day, so there is no distortion of the truth, and I often did this during my commissioned projects. However, during unsolicited hunts, on the fly, I would never intervene. If I arrived too late, if I thought I had missed the picture, too bad—I looked for something else. Full frame.

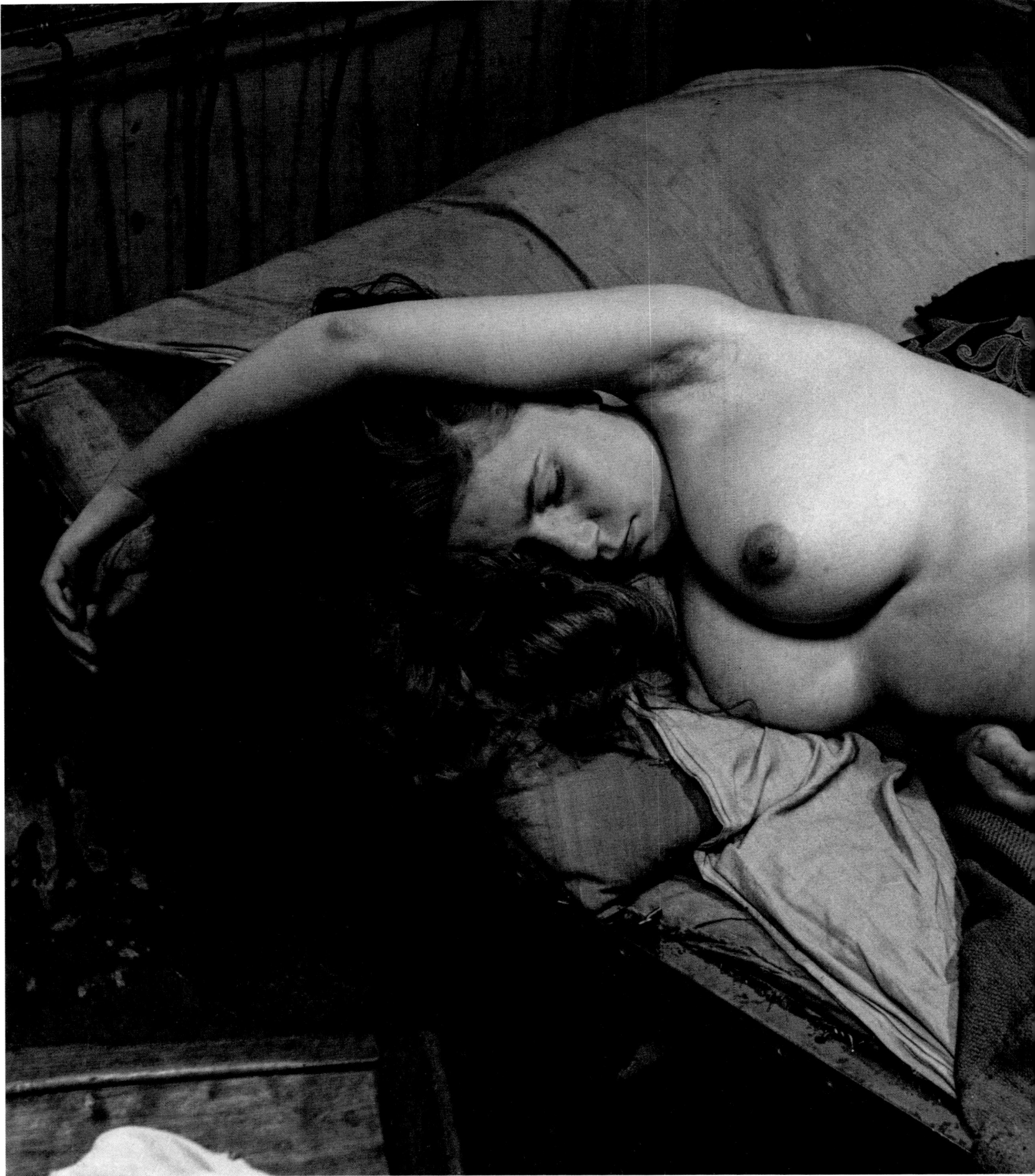

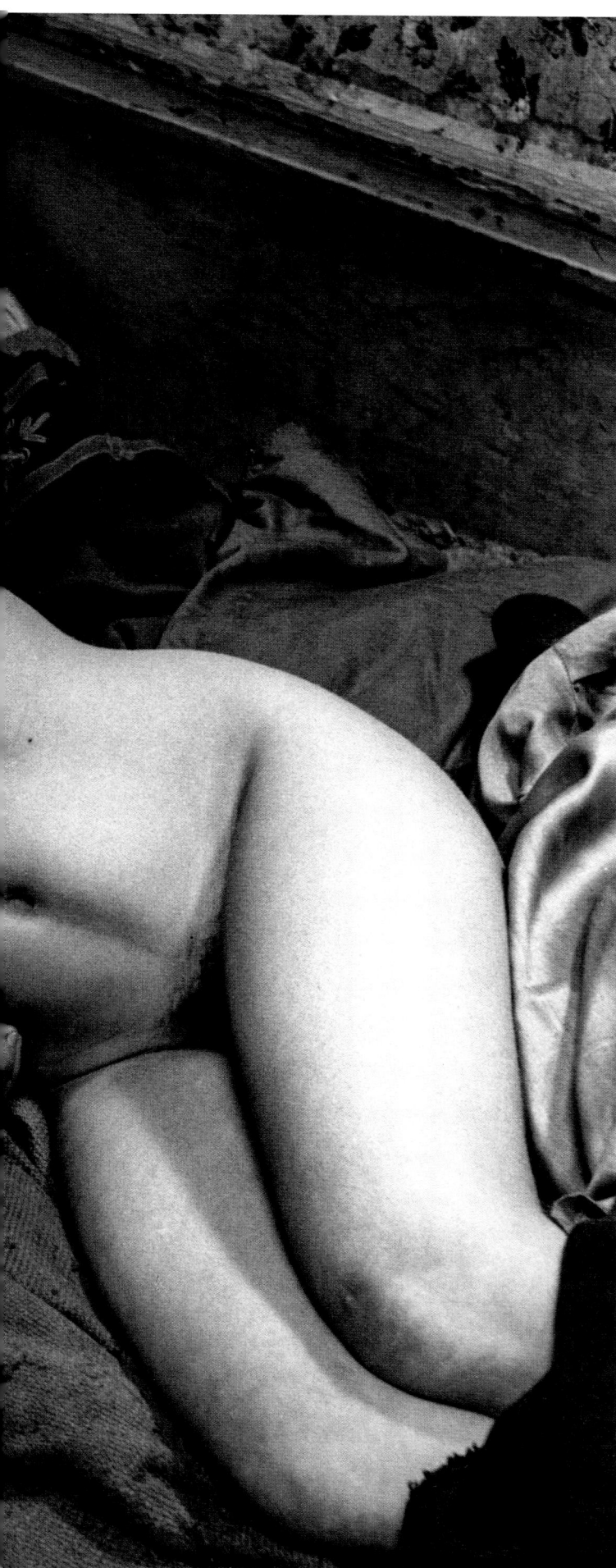

Poor nude, Paris, 1949
NEGATIVE: 2¼ × 2¼ IN. (6×6 CM) _ D19/5/12
— **89**

This is a nude photograph that has often been reproduced and exhibited. It was not at all planned. In February 1949, I had the opportunity to do a story on the Unitarians: an American charitable organization that took care of those left with nothing after the war in different European countries. In this case, I was to photograph a family in the Marais district in Paris. The family was made up of the parents and their two daughters. During our initial conversation, I learned that the elder daughter posed for sculptors. This is how I got her to pose for me a few days later in the same house where I had done my commission. For lighting, I did not use a flash but electric lamps. The series features around fifteen photographs. This is the picture that I prefer.

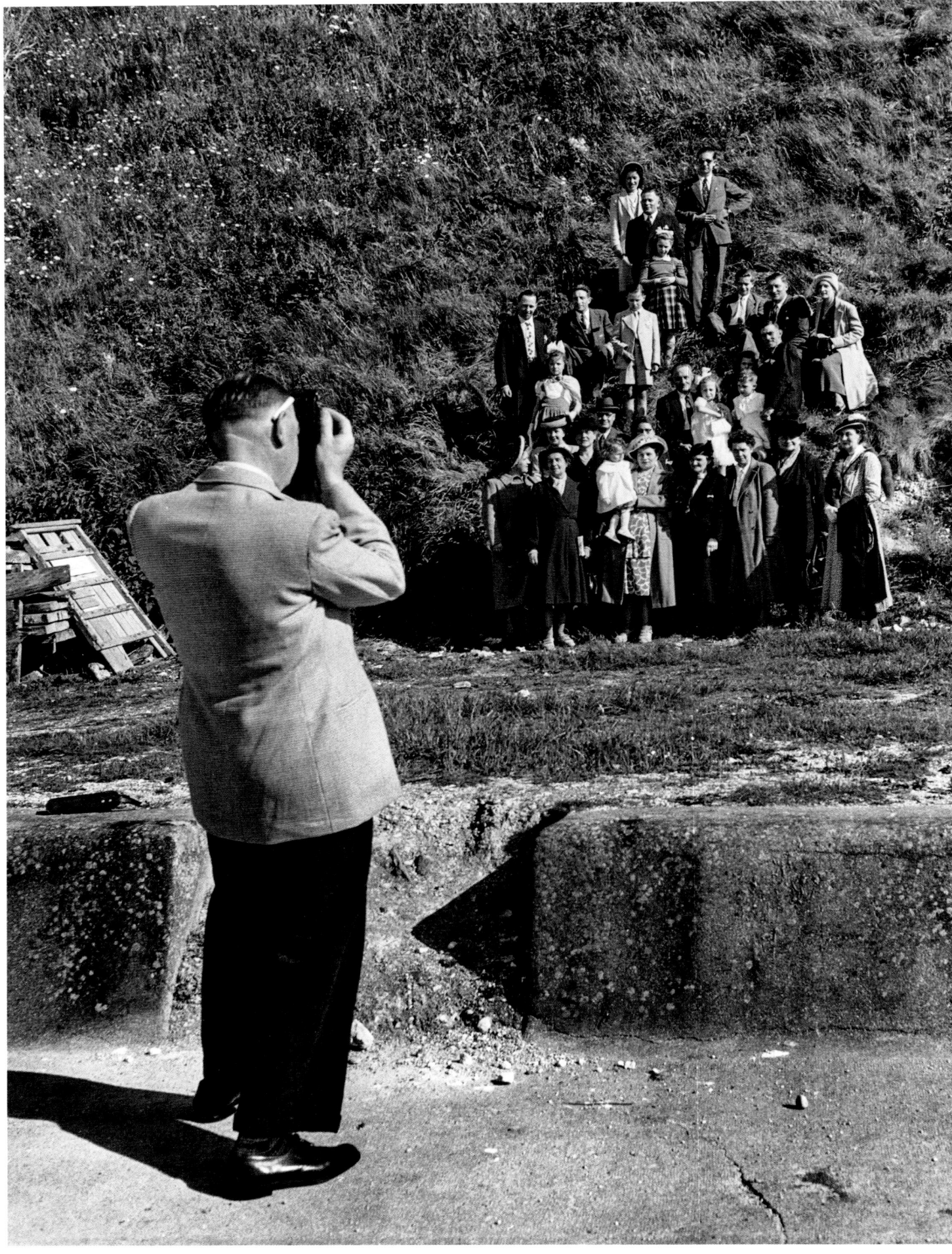

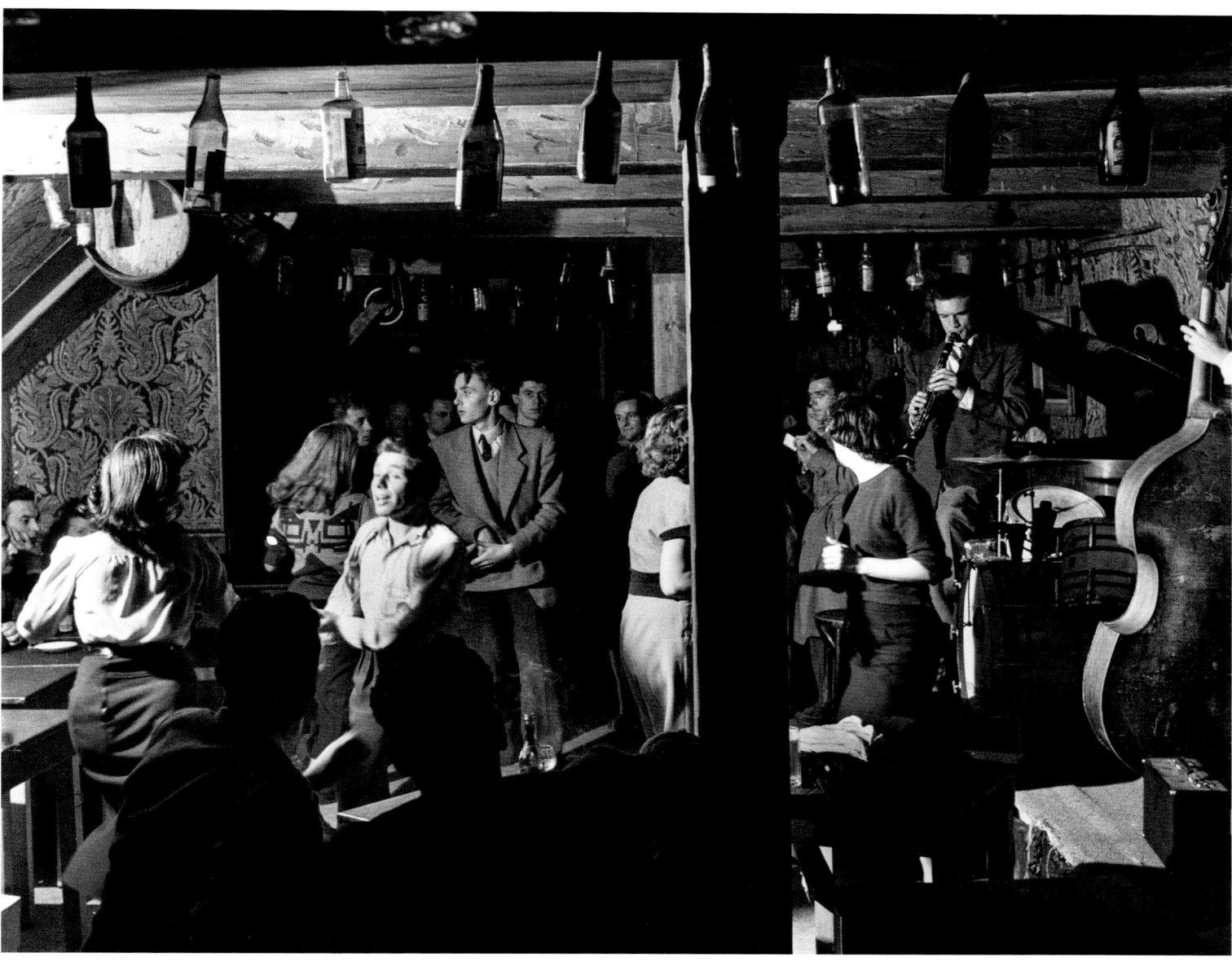

Sunday in Étretat, Seine-Inférieur (now Seine-Maritime), 1949
NEGATIVE: 2¼×2¼ IN. (6×6 CM) _ F19/310
— 90

During a family weekend at Easter by the seaside at Étretat, I came across this group in their Sunday best, probably coming back from a baptism. I found it amusing to photograph the photographing photographer.

The Vieux-Colombier club, Paris, 1949
NEGATIVE: 2¼×2¼ IN. (6×6 CM) _ R19/14/28
— 91

The Saint-Germain club, one of the favorite spots for foreign tourists. A story commissioned by *Time* magazine entitled "Americans in Paris." In the background, Claude Luter can be seen playing clarinet with his band, the New Orleans Jazz Band. This photograph was taken with a left-sided magnesium flash, and I remember that it was held at the end of a long wire by my colleague Paul Facchetti, whom I had met that night in front of the Café de Flore. Given the size of the cellar, the flash was too close to the couple on the left and relatively far from the back, making the print quite difficult to balance. In terms of composition, I was interested in the characters in the foreground, the double bass, and the line of bottles hanging from the ceiling.

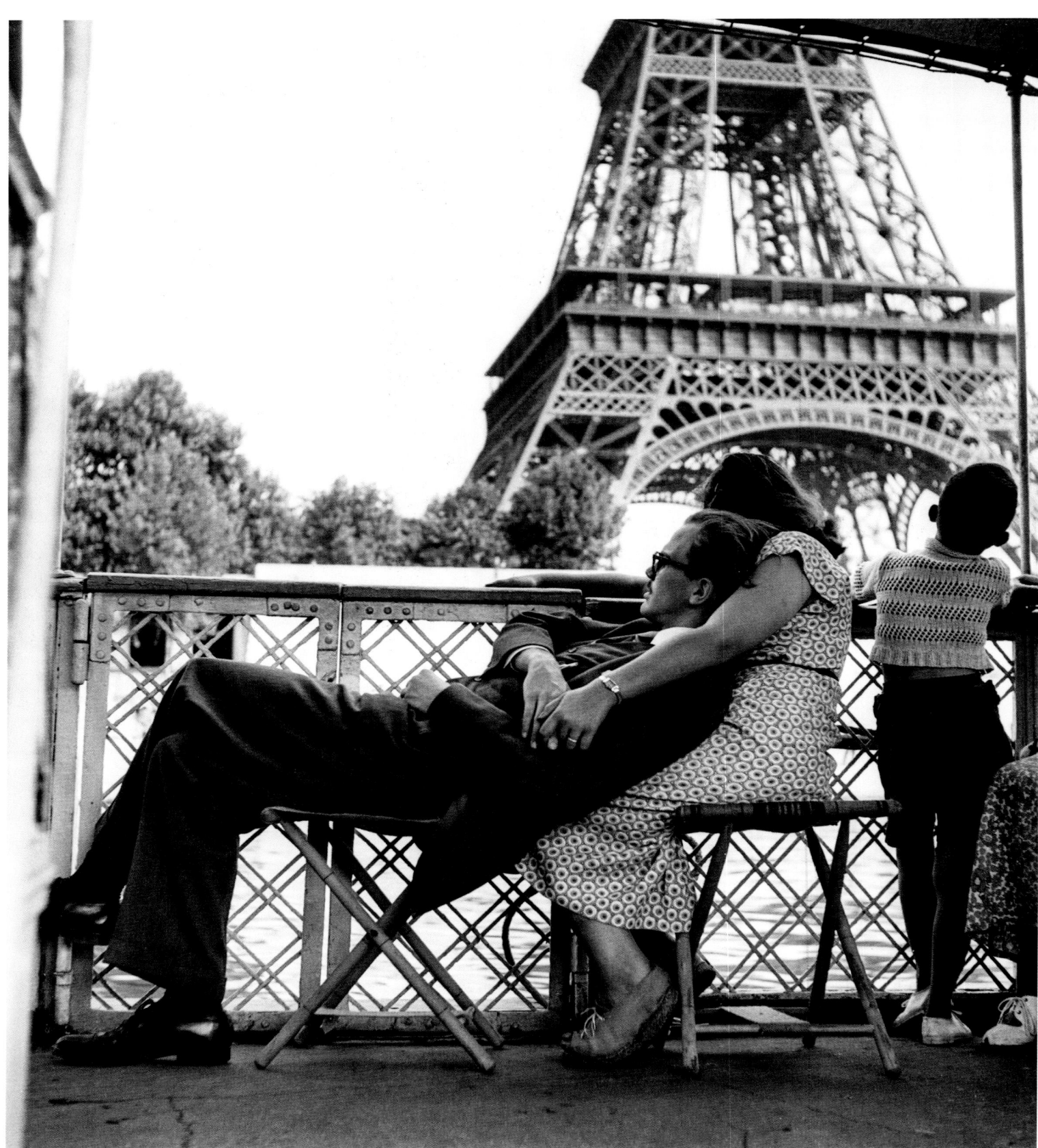

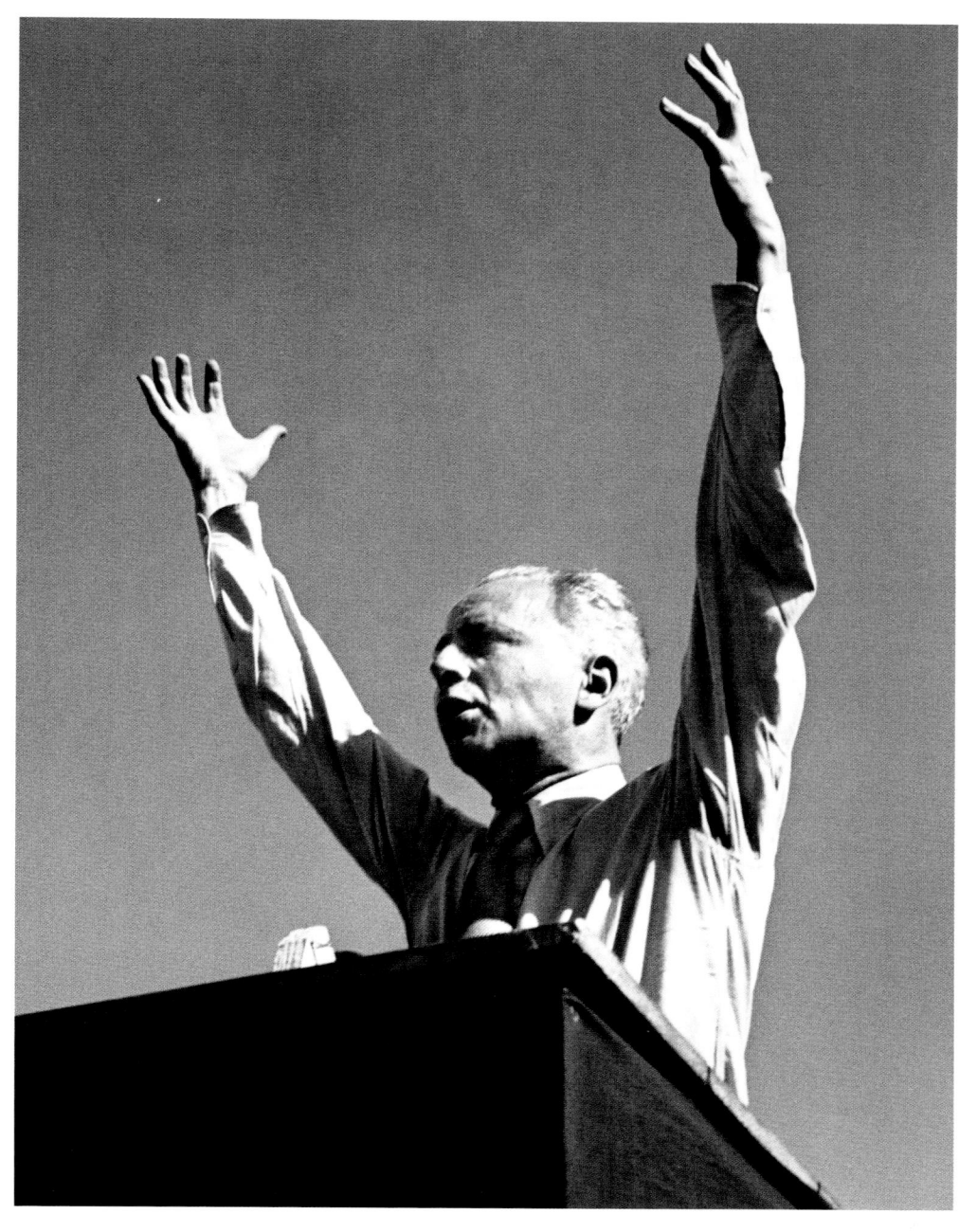

Louis Aragon, Notre-Dame-de-Lorette national necropolis, Pas-de-Calais, 1949
NEGATIVE: 2¼×2¼ IN. (6×6 CM) _ R19/27/53
— 93

The bateaux-mouches riverboat, Paris, 1949
NEGATIVE: 2¼×2¼ IN. (6×6 CM) _ R19/26/51
— 92

Excerpt from a story for the weekly *Action* on the passengers of the *bateaux-mouches*. A very relaxed young married couple—the husband in particular. Framing a little trimmed to the left.

Louis Aragon had commissioned a report from me for the weekly *Les Lettres françaises*, of which he was the director. A crowd had gathered in Arras to commemorate both the dramatic episode during which members of the Resistance had been shot in the city's ditches and the dead of World War I in the Lorette cemetery. The photograph depicts Aragon in Vimy-Lorette, reciting a poem outside in front of an immense audience. He had very much liked this portrait, as had his wife Elsa Triolet, and later they asked me for it for themselves. It is cropped on all four sides: I was in the middle of the crowd, much farther away than it appears on the photograph, and I did not have the freedom to move as I pleased.

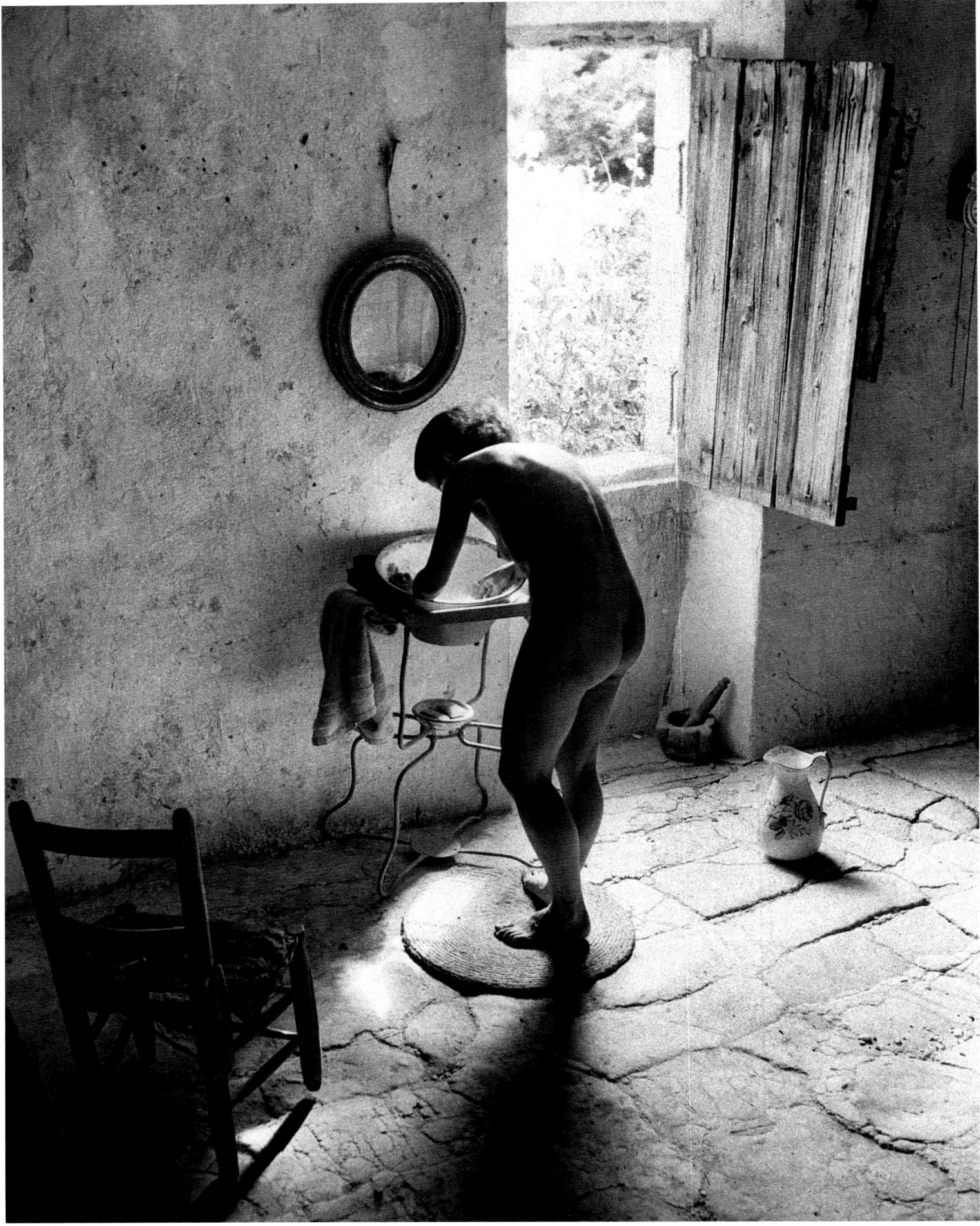

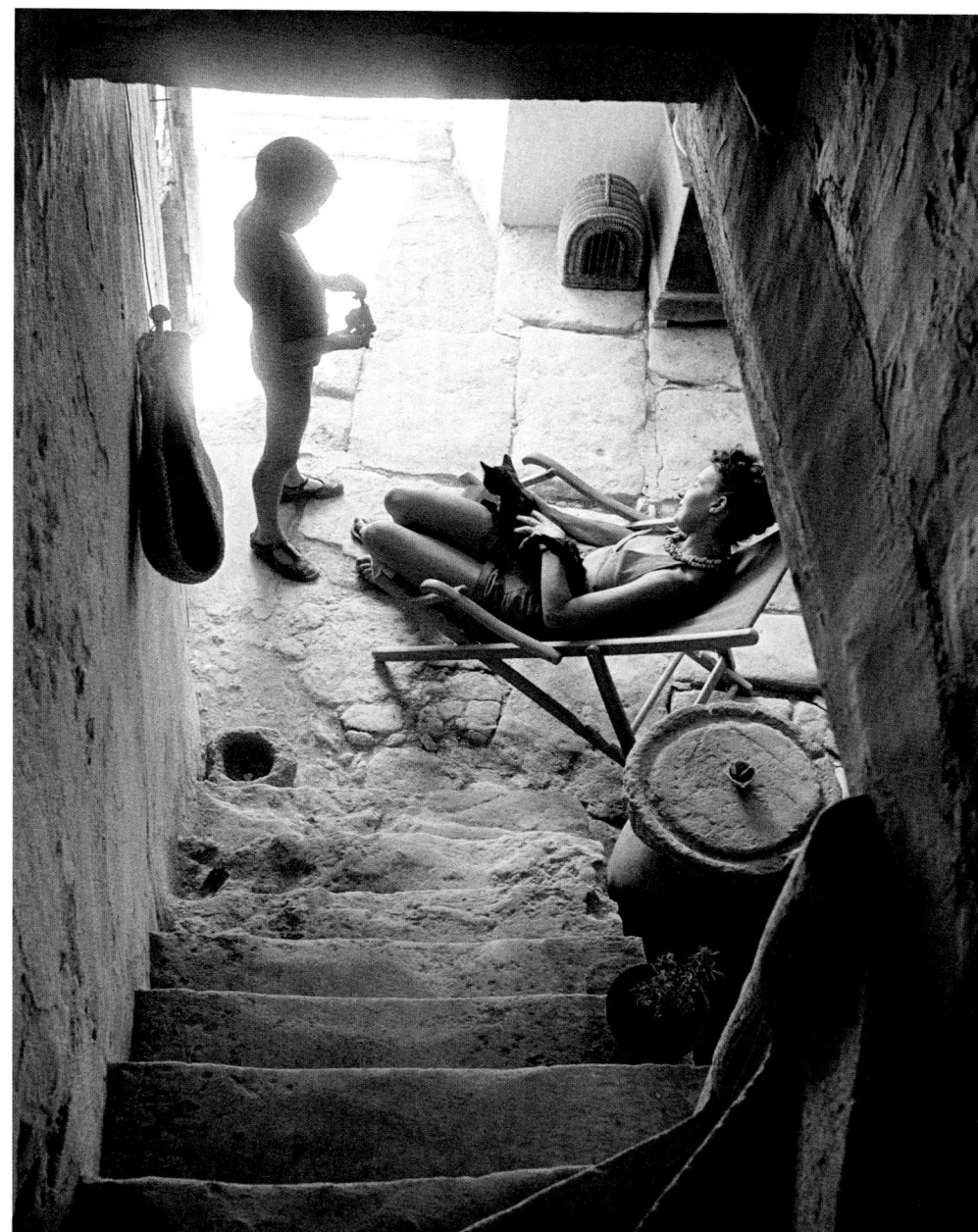

The Provençal nude, Gordes, Vaucluse, 1949
ORIGINAL NEGATIVE: 2¼×2¼ IN. (6×6 CM) _ DUPLICATE _ D19/10
— 94

In July 1947, I informed the Rapho agency that we were spending the month of August in the south. It was good timing: there was a story to be done on the painter André Lhote and his cosmopolitan summer schools. After making my way to the school in the Drôme alone, I took my wife on a motorcycle to the one in the Vaucluse. The village fascinated us and, the following year, we found a ruin there for future vacations. The summer of 1949 was particularly hot. I was tinkering around in the attic. Vincent, nine years old now, was sleeping in his room. To get a tool that I needed from downstairs, I took the stone staircase that went through our room. Marie-Anne, who had just woken up from her nap, was refreshing herself with water from the basin, because running water was only to be had at the washhouse. I told her, "Stay as you are," and grabbed my camera from the chest, went up a few steps, and released the shutter three times. Then I forgot about it, because there were many more photos taken during this vacation, which had only just begun. Back in Paris, it was a nice surprise when I printed the contact sheets, but the outcome of this picture still surprises me. The negative, mistakenly overdeveloped, was very difficult to print. I made a duplicate that put things in order.

The nap, Gordes, Vaucluse, 1949
NEGATIVE: 2¼×2¼ IN. (6×6 CM) _ F19/220
— 95

Same summer, same house, high-angle shot of Vincent, Marie-Anne, and Sophie, the cat. No particular comment.
The print is quite easy to make, as long as care is taken to extend the exposure time on the child, so as to maintain the dazzling effect. Cropping on both sides.

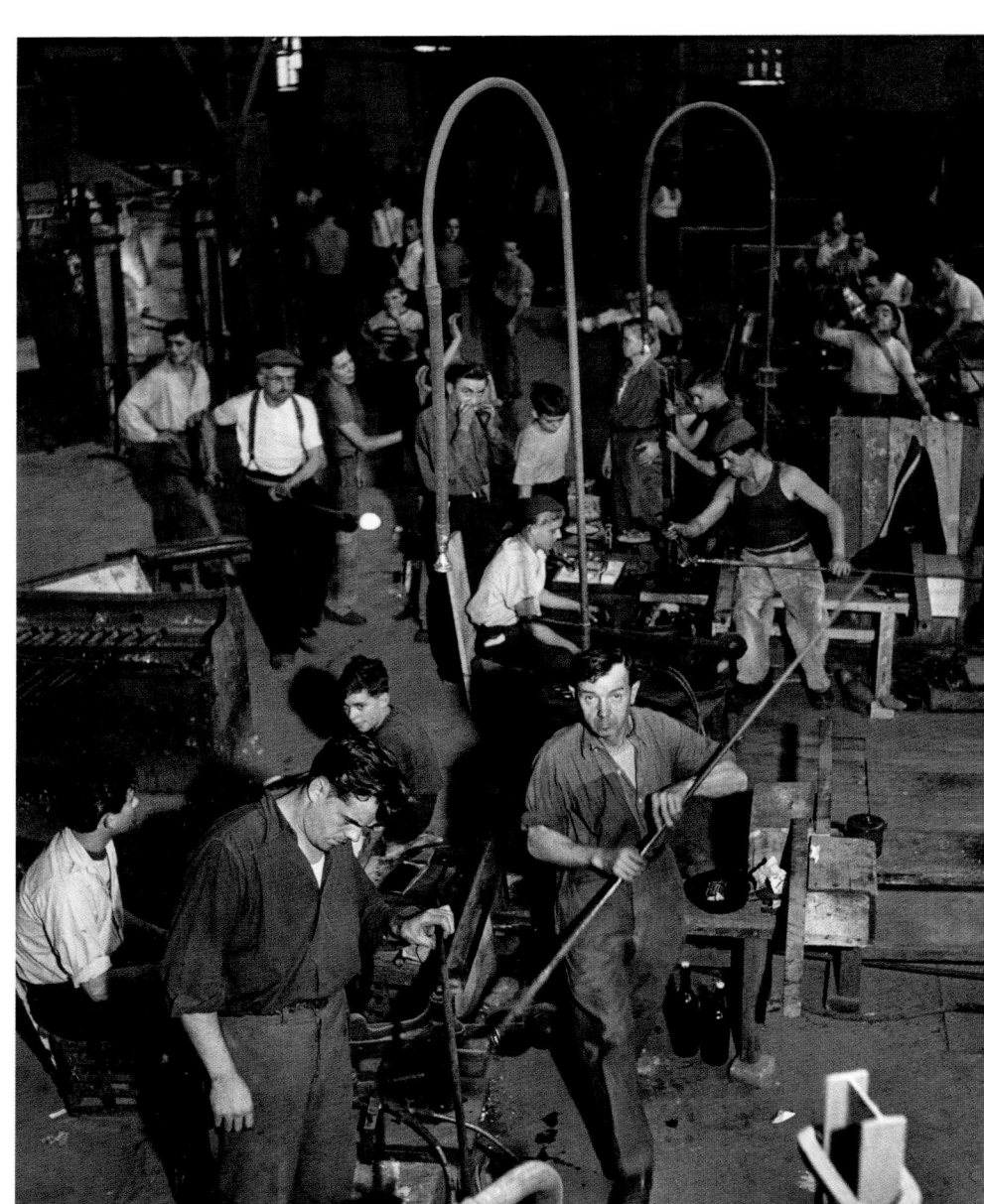

In the hall of ovens at Baccarat, Meurthe-et-Moselle, 1949
NEGATIVE: 2¼×2¼ IN. (6×6 CM) _ I19/62
— 96
In October 1949, an American publication (I could not find which one) sent me and an editor to work for three days in the famous crystal factory. I made use of a ladder to get this high-angle point of view. Mixed lighting: softened direct magnesium flash superimposed on the daylight coming in from the glass roof located further on. Relatively easy print. Lateral cropping.

A Sunday morning at the Zavattas' place, Paris, 1949
NEGATIVE: 2¼×2¼ IN. (6×6 CM) _ R19/30/161A
— 97
Image taken from a huge commission for a book on the famous circus family. Verbal commission, on trust, without a contract. In the end, the publisher pulled out. I worked for weeks for nothing. That taught me a lesson! The room was poorly lit. I bounced a magnesium flash off the ceiling, which distributed the light evenly on this wonderfully nice quintet. Full picture.

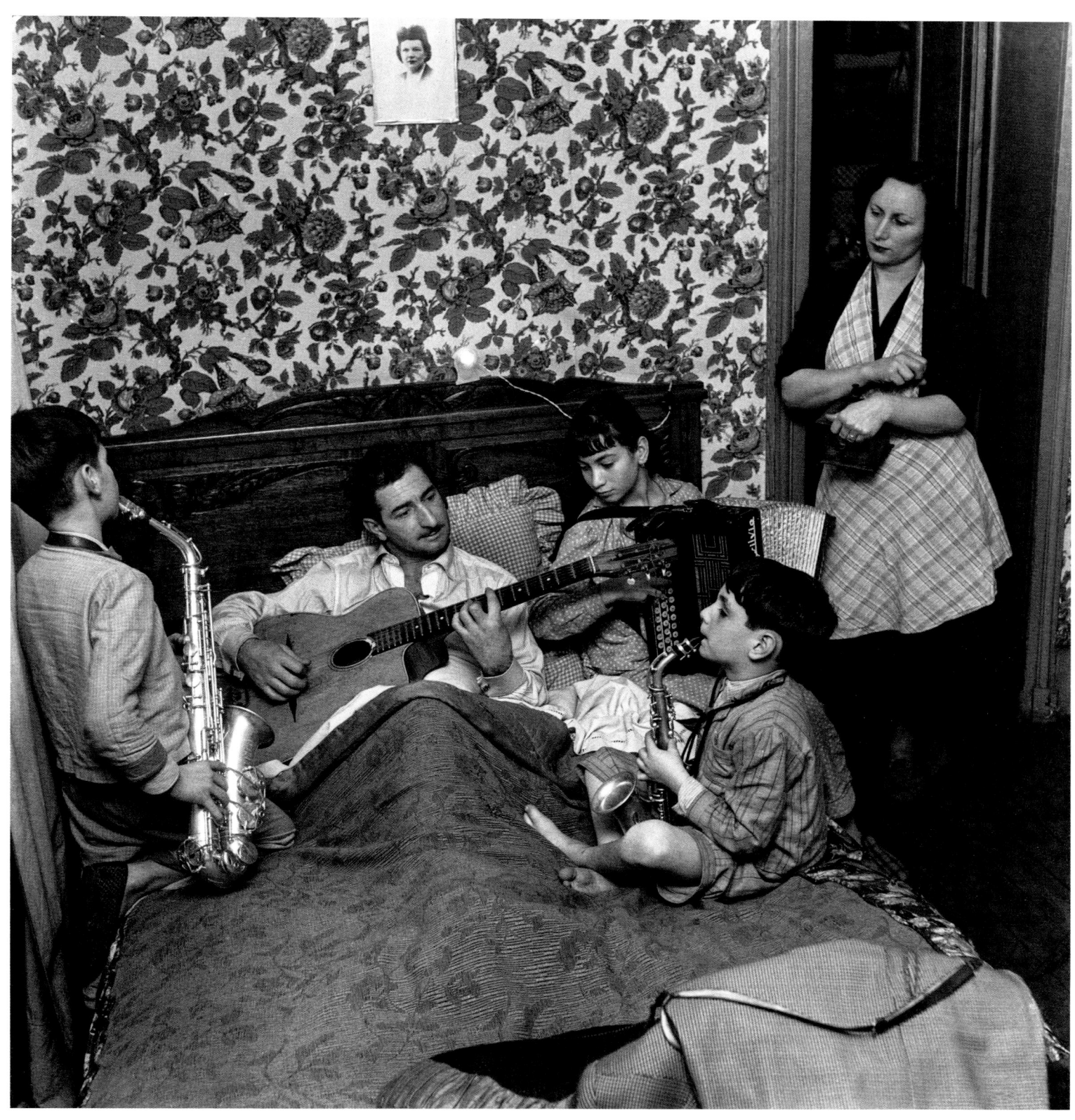

**Achille Zavatta's Zoo-Circus,
Porte d'Ivry, 1949**
NEGATIVE: 2¼×2¼ IN. (6×6 CM) _ R19/30/139
___ 98

Same project. The Zavatta Zoo-Circus at the gates of Paris. Standing on a stool, I had seen the two riders preparing for their act. I felt it would be interesting to include the croups of the horses in the shot. The backlight turned the young women into butterflies. I made them run to accentuate the effect. Generally, for images like this one, several shots are necessary. In this case, time was running out: I only made two. I was lucky. Almost full frame.

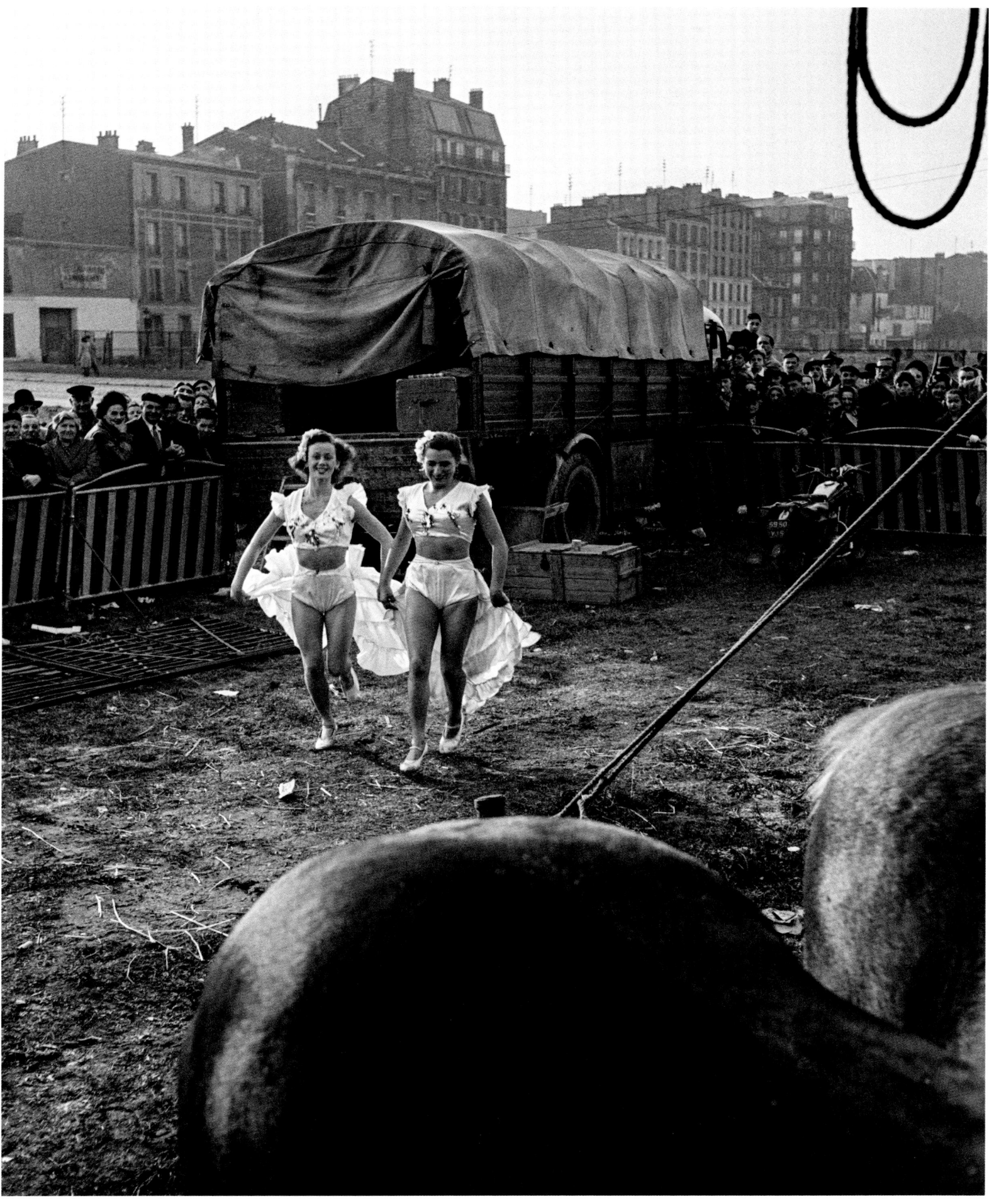

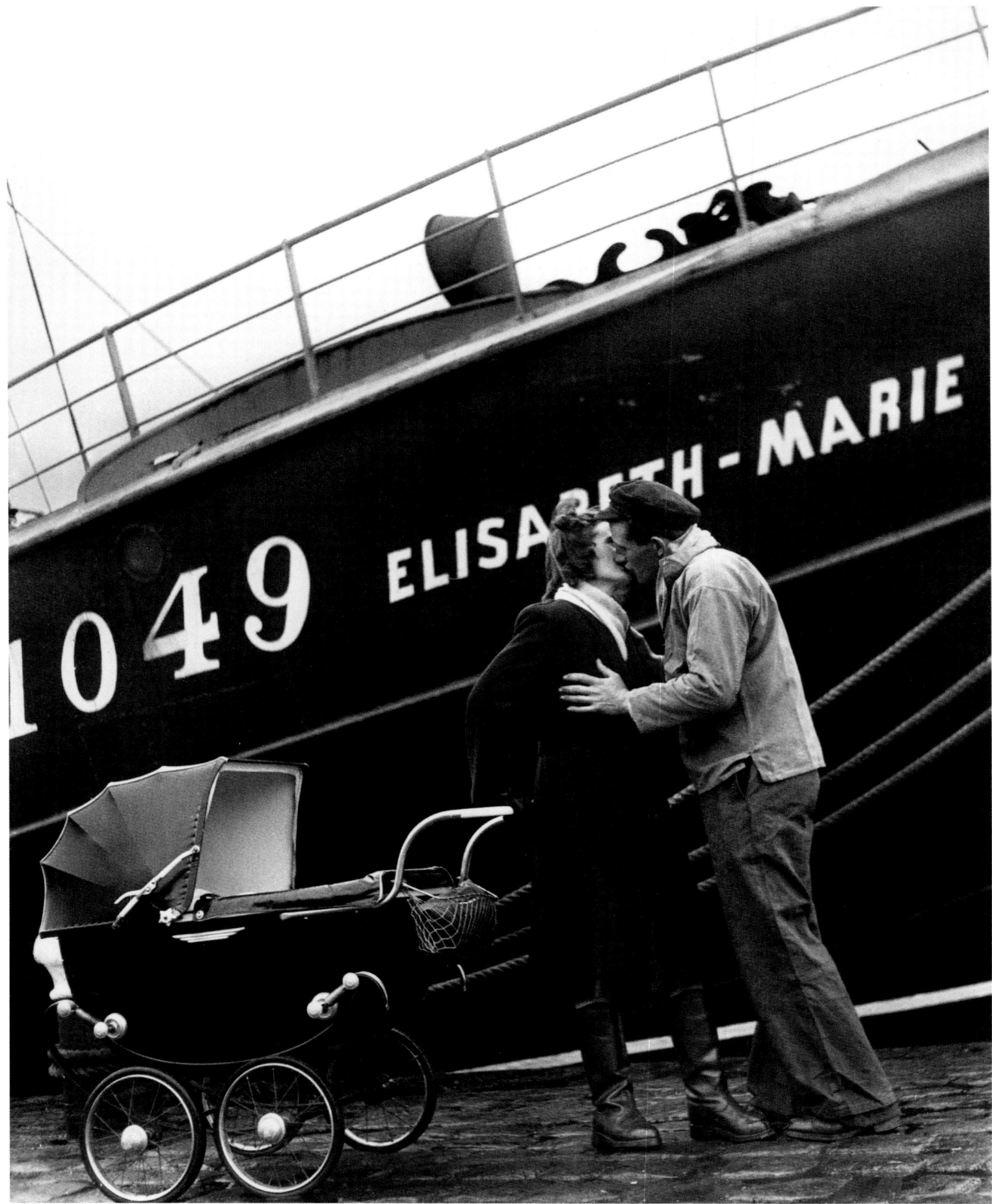

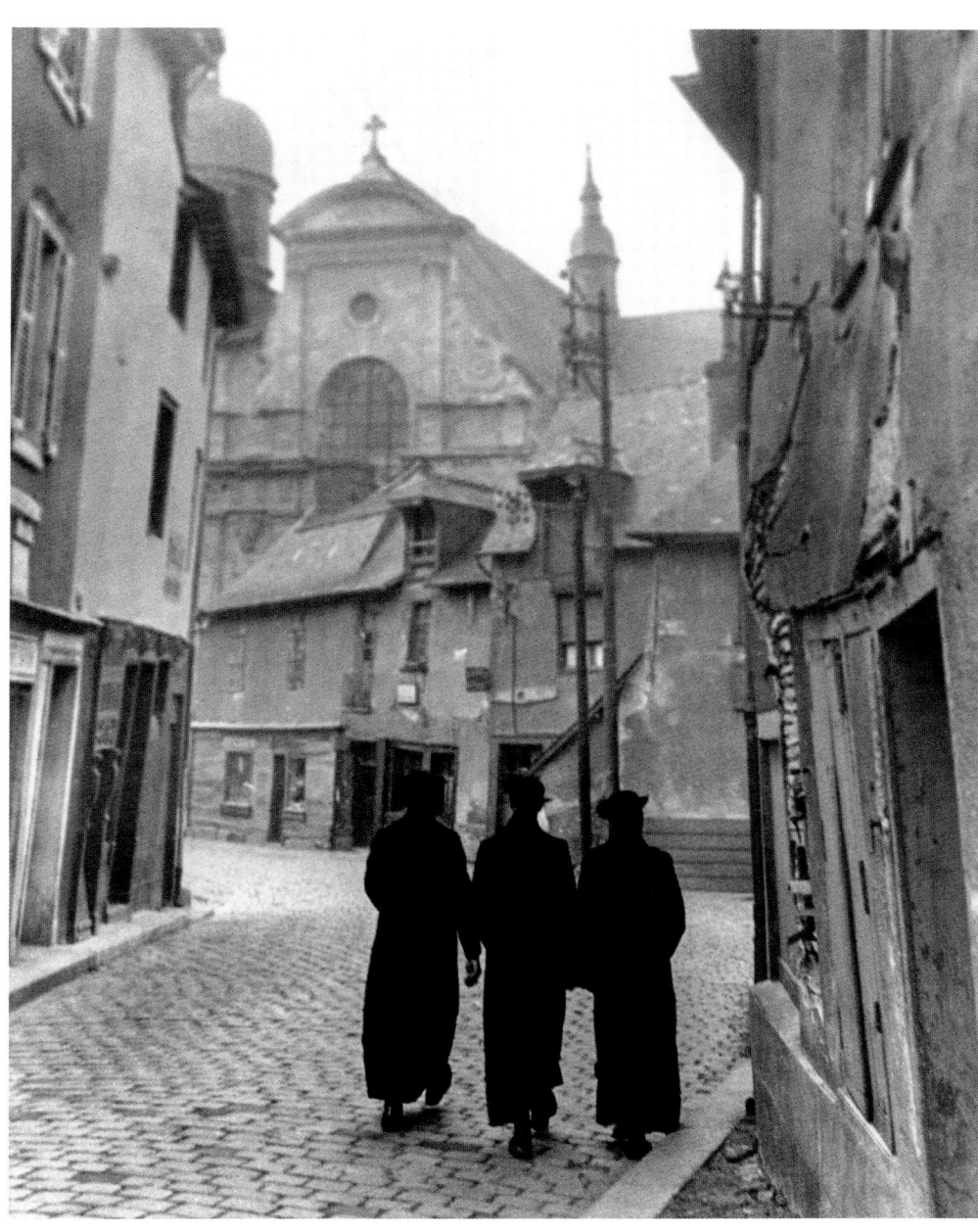

Cod fishermen departing from Fécamp, Seine-Inférieur (now Seine-Maritime), 1949
NEGATIVE: 2¼ × 2¼ IN. (6 × 6 CM) _ R19/32/15
___ 99

In November 1949, *Regards* commissioned me to do a short photo story at Fécamp, as the sailors left for Newfoundland. This photograph illustrates the moment of separation. The printing is a little difficult, because of the rather harsh backlight in overcast weather. The sky must be heavily overexposed to reveal the rail and the top of the hull. Light cropping on the right.

In Rennes, Vilaine, 1949
ORIGINAL NEGATIVE: 2¼ × 2¼ IN. (6 × 6 CM) _
DUPLICATE 2¼ × 3¼ IN. (6 × 8 CM) _ F19/272
___ 100

An irrelevant story had brought me to Rennes. All the shooting had taken place in interiors. On my way to the train station for the return train, I ran into these three priests. I had time to release the shutter twice. The negative had been lent to a publisher at the printer's request, under the pretext that the rotogravure results are better when the original print is available. The gravure was done and the negative was lost. I print from a duplicate made from a decent test print. There is no need to crop since the new negative (about 2¼ × 3¼ in. [6 × 8 cm]) was made from a test print cropped on the sides.

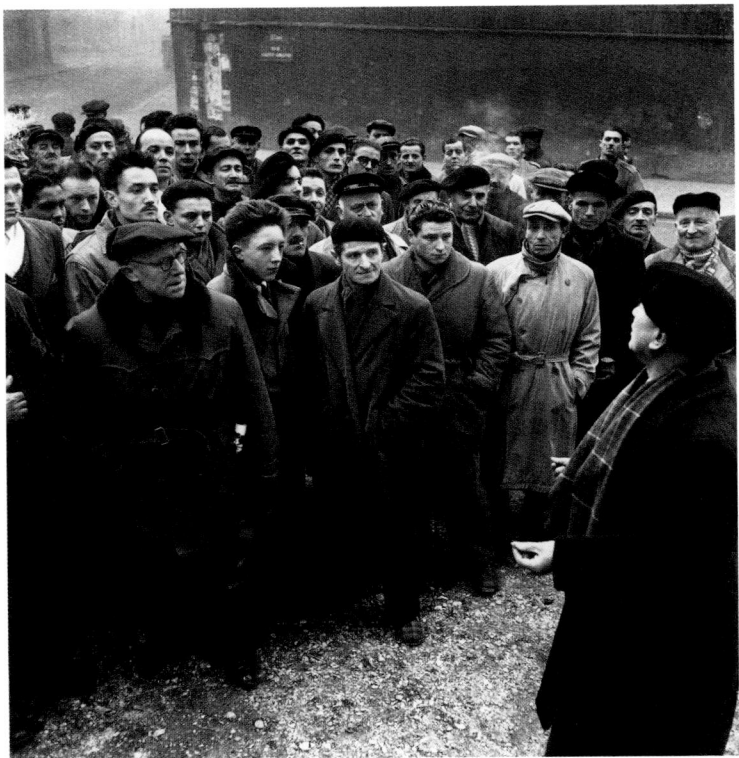

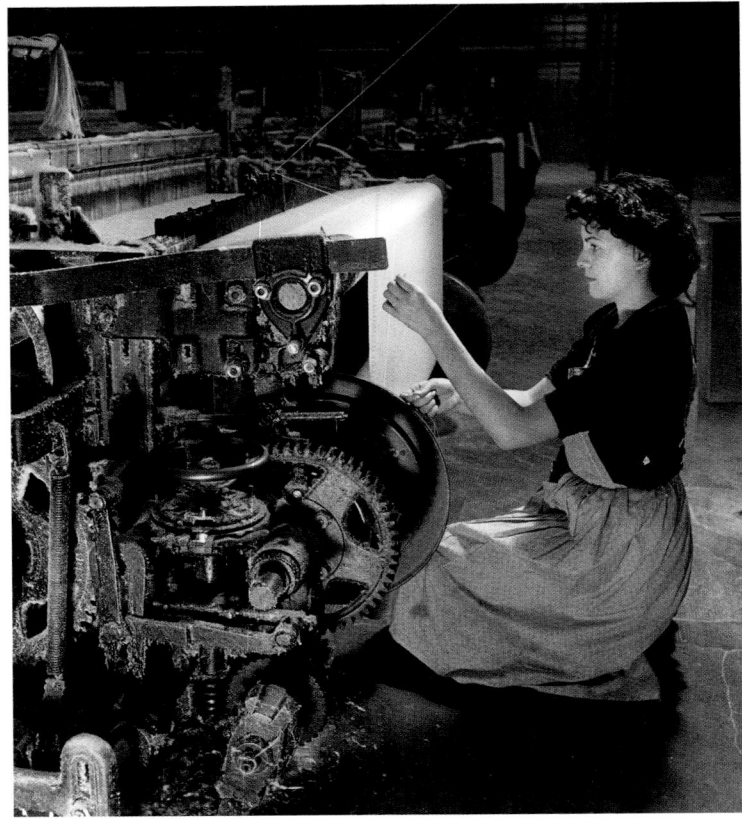

The broken thread, FTB factory, Haut-Rhin, 1950
NEGATIVE: 2¼×2¼ IN. (6×6 CM) _ FTB20/74 I20/74
___ 102

In 1950, I was responsible for a series of reports on behalf of a group of industrial firms in the Haut-Rhin department. With an engineer from this weaving firm as my guide, during the ritual tour of the workshops to identify the subjects to photograph I suddenly saw this young woman tying a broken thread. The attitude and the gesture were so graceful that I begged her to give me a minute to look for two lightweight standing-lamps. I arranged the first, low enough to my immediate left, to light the details of the machine and the left side of the worker. The second lamp, high up, clipped on the telescopic neck of the base (a detail of it can be seen on the extreme right edge of the picture), was designed to illuminate the weaver's hair and arms and the central part of the machine. By principle, but also for my own pleasure, I constantly interrupted the imposed schedule of images to be taken, even if, at the time, my guides reacted with skepticism or signs of impatience. In every case, when it was time to hand in the test prints, some of these unplanned images were picked, so as to embellish the selection. No printing issues, except to strongly overexpose the upper right corner (lamp halo). Almost full frame.

The delegate, carpenters' strike, Paris, 1950
NEGATIVE: 2¼×2¼ IN. (6×6 CM) _ R20/3/29
___ 101

In early March 1950, there was a strike and pictured here are a group of workers from a carpentry company on rue Saint-Amand in the fifteenth arrondissement in Paris. The union delegate had just spoken to inform his comrades of the state of negotiations, and I could see very little as the wall of a house made it impossible to back up. I then saw a bike, securely attached to a pipe running down this wall. Held up by one of the strikers, I climbed onto the bike frame and, facing the scene, I got this bird's-eye view. Two very similar shots were taken. I prefer this one: the delegate's posture appears more natural. Misty backlight: underexposure of dark clothes that makes printing difficult enough to balance. Almost full frame.

The forge, Renault factories, Boulogne-Billancourt, Seine, 1950
NEGATIVE: 2¼×2¼ IN. (6×6 CM) _ I20/31
___ 103

In early 1950, seven photographers were entrusted by Renault to provide a general picture of the company. The final goal was a book entitled *L'Automobile de France*. We were each simply asked to choose a sector, so that we would not be working in the same area. Apart from that, we had total freedom. I had concentrated my efforts on the foundry and the forge. This photograph was rejected: it was not flattering enough for the company's brand image.
Partial lateral cropping. Overexpose the upper left of the image during printing, to bring out some details in the light.

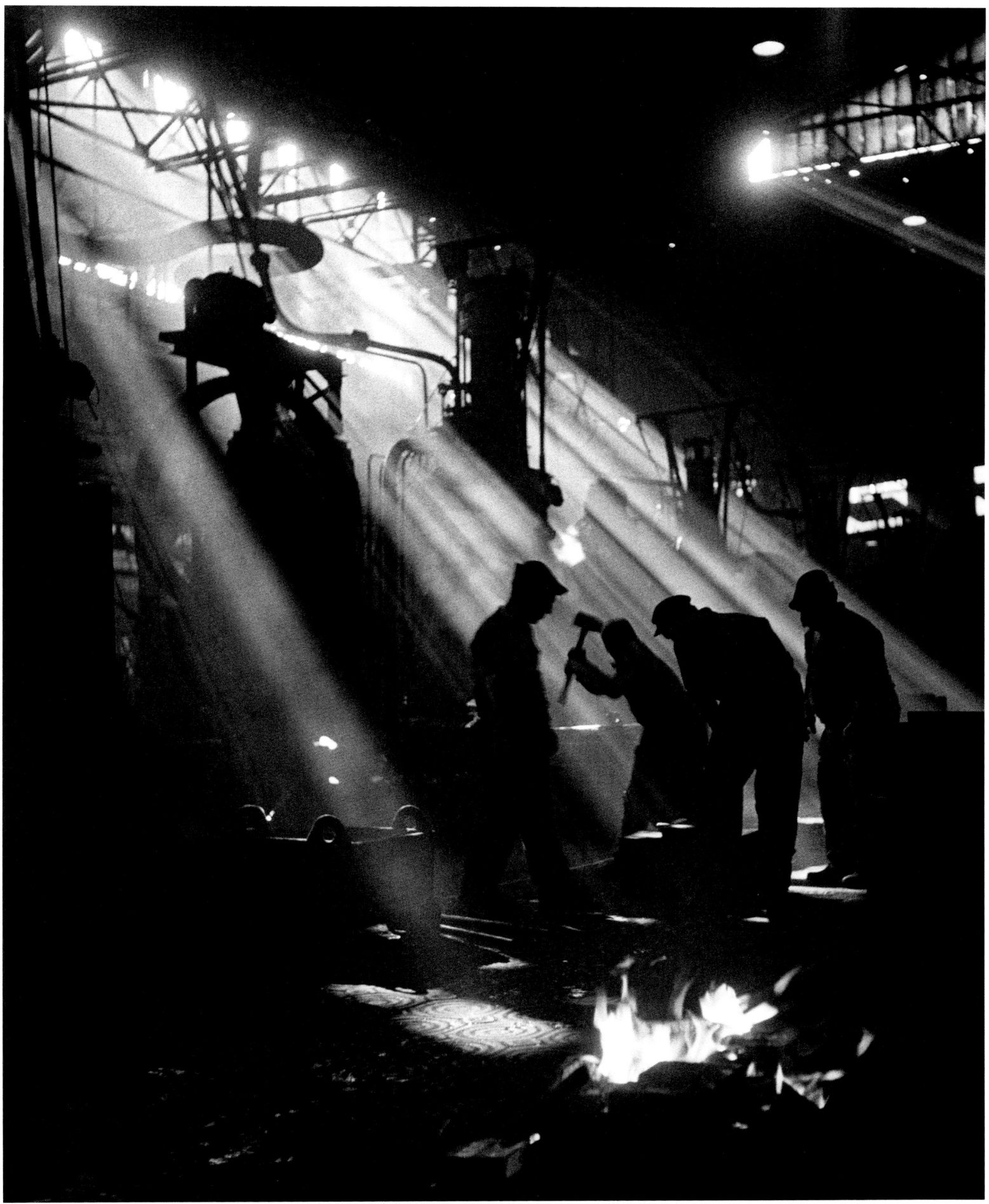

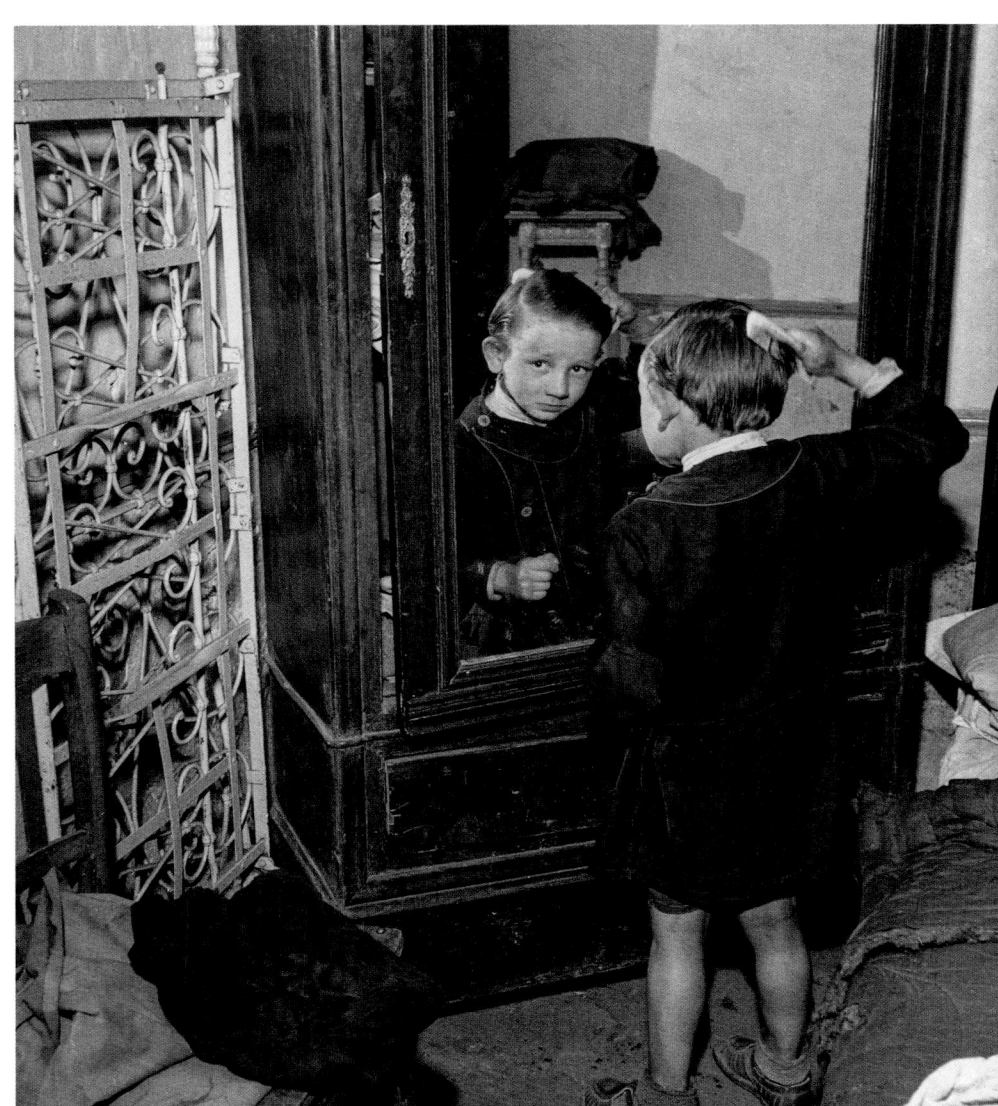

The children of Aubervilliers, Seine, 1950
NEGATIVE: 2¼×2¼ IN. (6×6 CM) _ R20/8/34
___ 104

In May 1950, *Regards* commissioned me to do a report on the children of Aubervilliers. A short while before, the documentary *Aubervilliers* (directed by Eli Lotar, narrated by Jacques Prévert, music by Joseph Kosma) had been a success. The child shown in this photograph is finishing getting ready. He is alone: his parents are already at the factory. Single lighting: a magnesium flash held in the left hand, a little above the camera and without a reflector. It illuminates the whole shot and, reflecting in the mirror, the boy's face and left fist, as well as the wall behind me with a pedestal table and a pile of clothes. Easy printing. Light lateral cropping.

Pool of L'Isle-Adam, Seine-et-Oise, 1950
NEGATIVE: 2¼×2¼ IN. (6×6 CM) _ R20/12/3
___ 105

The weekly *Cavalcade* (I suppose, the name having been omitted on the sleeve containing the negatives) had asked me to bring back some images of an afternoon in June 1950 when the L'Isle-Adam swimming pool had been reserved for the ballet corps of the Opéra. There were, of course, a lot of press photographers there. I found it amusing to include in the same shot three ballerinas relaxing and a Japanese reporter. The sky was overcast but light, which helps to shape the volumes. Bilateral cropping.

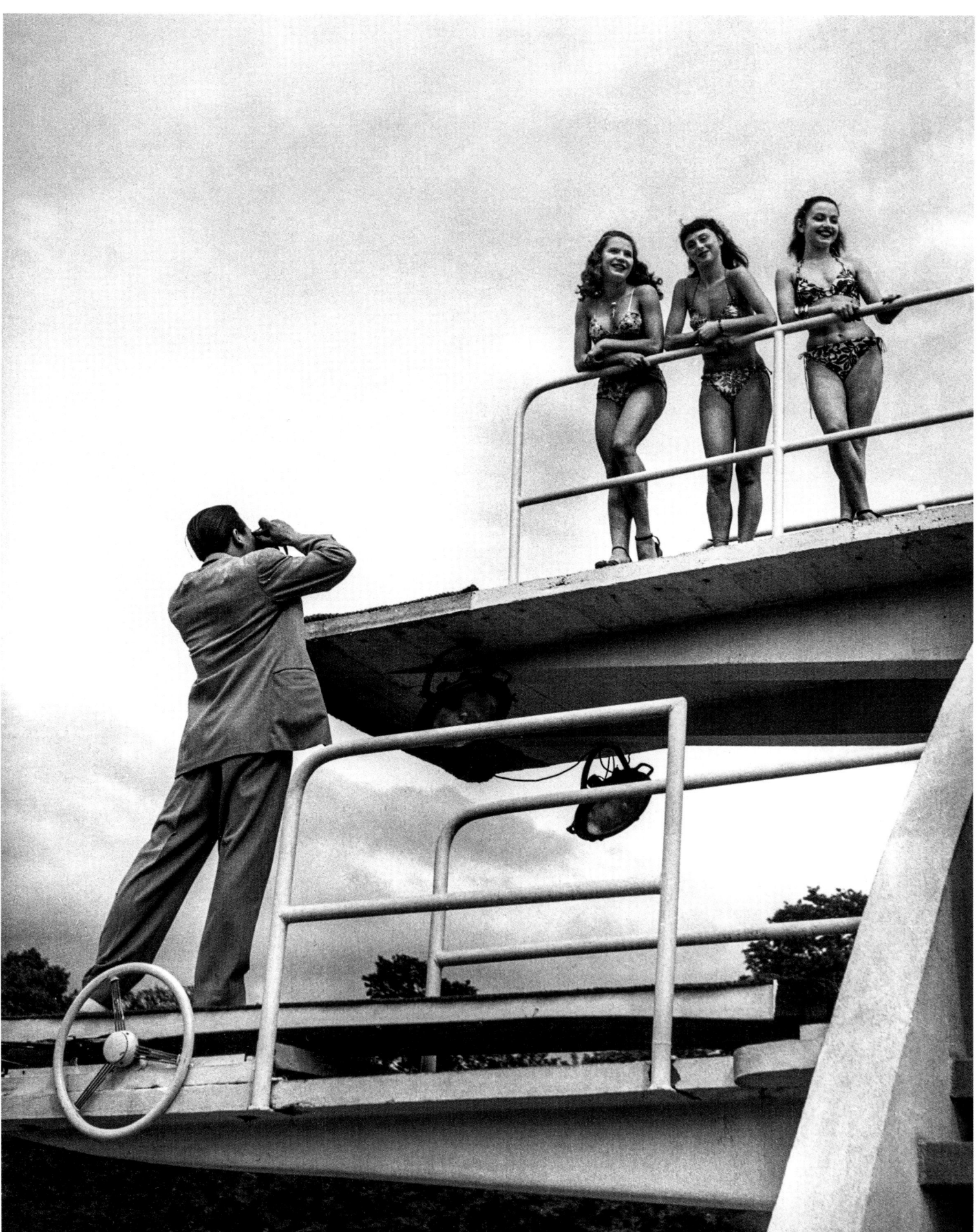

**The old town of Nice,
Alpes-Maritimes, 1950**

NEGATIVE: 2¼×2¼ IN. (6×6 CM) _ F20/129
—— 106

This photograph was taken in dark backlight on a sloping street in the old town of Nice, alongside a commissioned story (see next photograph). Two teenagers are repairing a boat.
I like it for the quality of the light and the attitude of the characters, but I have nothing more to say.
Bilateral cropping.

**Pablo Picasso, Vallauris,
Alpes-Maritimes, 1950**

NEGATIVE: 2¼×2¼ IN. (6×6 CM) _ R20/24/36
—— 107

Regards, aware that I was on vacation in Gordes (Vaucluse), assigned me to cover the International Youth Meeting in Nice. Picasso was living in Vallauris at the time, and he actively participated in a few key moments of the event. A journalist and I were allowed to accompany him home. Here, he can be seen climbing the stairs of his house. It is also here that I took the portrait that, in 1971, I posterized (see photo 305). Relatively easy to print. Cropped on the top and sides, to exclude the characters in the background.

Pit 10 at Courrières, Billy-Montigny, Pas-de-Calais, 1951
NEGATIVE: 2¼×2¼ IN. (6×6 CM) _
DUPLICATE _ F21/417 [R21/1/17]
___ 108

Extract from a story on "The Land of Mines" and the opening at the Maison du Peuple in Lens of an exhibition by painter André Fougeron with the same title, in January 1951.
I do not remember the exact reasons for the presence of these children. I imagine they were accompanying the group (it must have been a Saturday) that I had joined to visit the typical sites of the region; here, pit 10 in Courrières. This photograph is the first of the 111 plates presented in my book *Sur le fil du hasard* (On Chance's Edge). The printing is difficult to the extent that it is important to bring out the overcast sky. Bilateral cropping top and bottom. Due to serious issues with the original negative a duplicate was made.

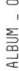

Miner with silicosis, near Lens, Pas-de-Calais, 1951
NEGATIVE: 2¼×2¼ IN. (6×6 CM) _ R21/1/10
— 109
Same project as the previous photograph. I was taken to the home of a miner named Émile Fontaine, a pensioner severely affected by silicosis. He was to die a few months later, at forty-seven years old. I made several photographs, inside and outside his home. In my eyes, this one has the merit of also showing, although with an intentional blur, one of the slag heaps, those mountains of the flat country that are seen in mining areas. Easy printing. Tilted framing.

The beguinage, Bruges, Belgium, 1951
NEGATIVE: 2¼×2¼ IN. (6×6 CM) _ R21/6/11
— 110
June 1951. Marie-Anne and I decided to visit Belgium to get to know the country and to visit some dear friends. On a gray morning, we visited the Bruges beguinage. Suddenly I heard a light, continuous squeaking. I turned around; it was the sound made by the shoes of a group of beguines returning home after a service. I ran: they were not far from their house and I wanted to keep an empty space in front of the line. I even had time to include the tree in the foreground, on the left, to balance the values of the image and help to establish the planes. It goes without saying that this kind of decision is made on instinct. Photographers who work spontaneously have collected, in their head, a complex bundle of graphical construction patterns, resulting from their artistic culture, experience, and sensitivity. Intuition and quick reflexes do the rest. Difficult print to balance properly. It is necessary to ensure a progressive lightening from the ground to the top of the image and to slightly darken the clothes of the beguines. Cropping to the sides and bottom.

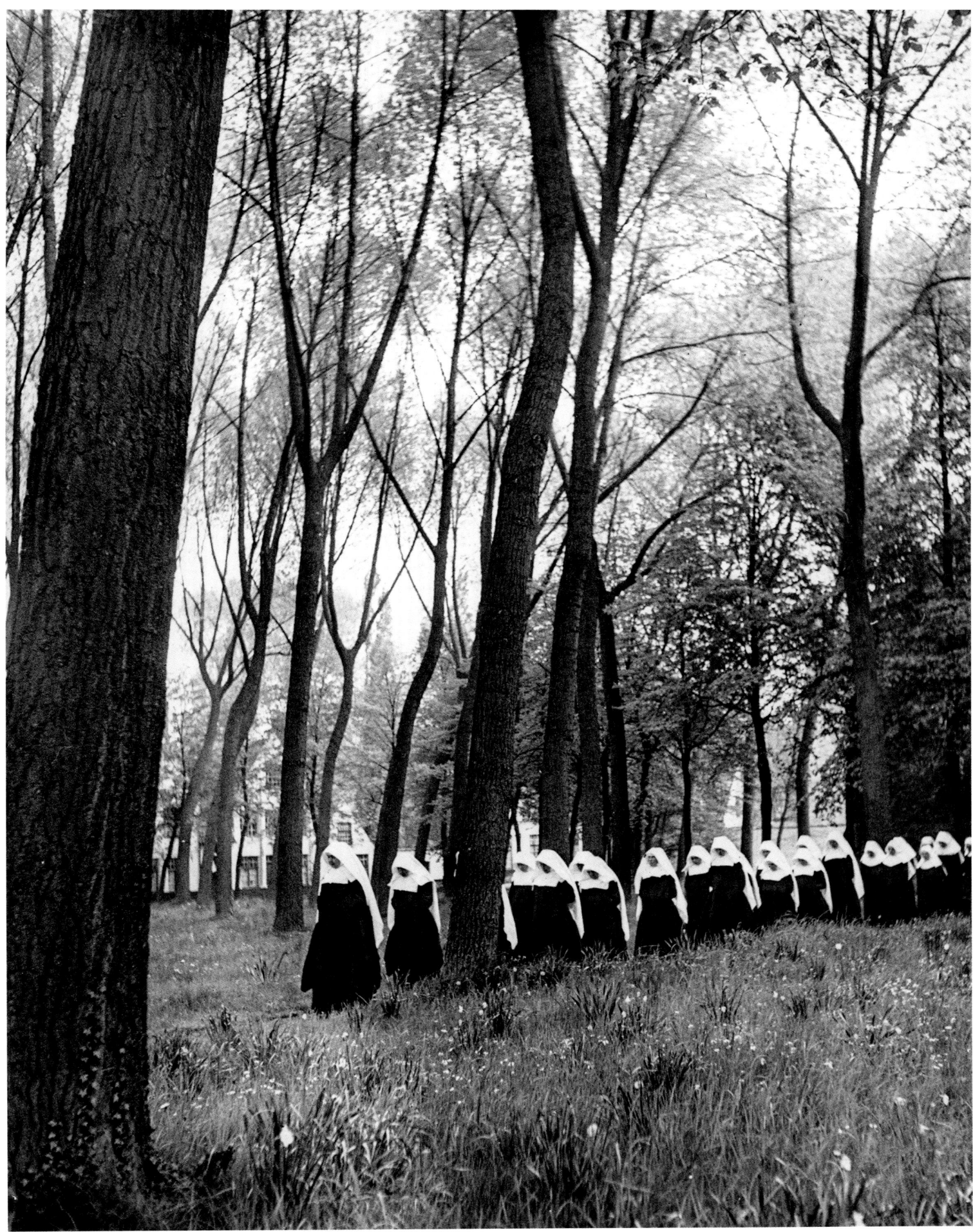

**Self-portrait with flashes,
Paris, 1951**
NEGATIVE: 2¼×2¼ IN. (6×6 CM) _ D21/1
—— 111

Flash is, like the tongues served in Aesop's fable, the best and the worst of things. So often the worst, based on its effects, that as soon as I started using it I decided to study how I could make it an obedient assistant (leading to a few articles on the issue).

In 1951, I had the idea of adding to the set of illustrations I had already amassed a self-portrait made with two flashes, my person being available at will and the mirror fulfilling the role of sketch, model, and operator of the experiment. Unlike current devices, where the flash is controlled by the pressure of the finger on the release, the indirect systems of old had the controls on the power-pack strobe (there is no room here to go into more technical details). In this photograph, one side of the face and the corresponding side of the torso are lit by the flash of a small magnesium bulb, softened, moreover, by some tracing paper (because of the proximity of the light source). The hand in the air holds the auxiliary lamp holder (stronger bulb) which violently illuminates the ceiling and provides indirect lighting of the entire field (as well as the ground glass of the Rolleiflex whose viewfinder lens sends the illumination back toward us). Print requiring slight rebalancing (overexpose the illuminated side of the face). Bilateral cropping.

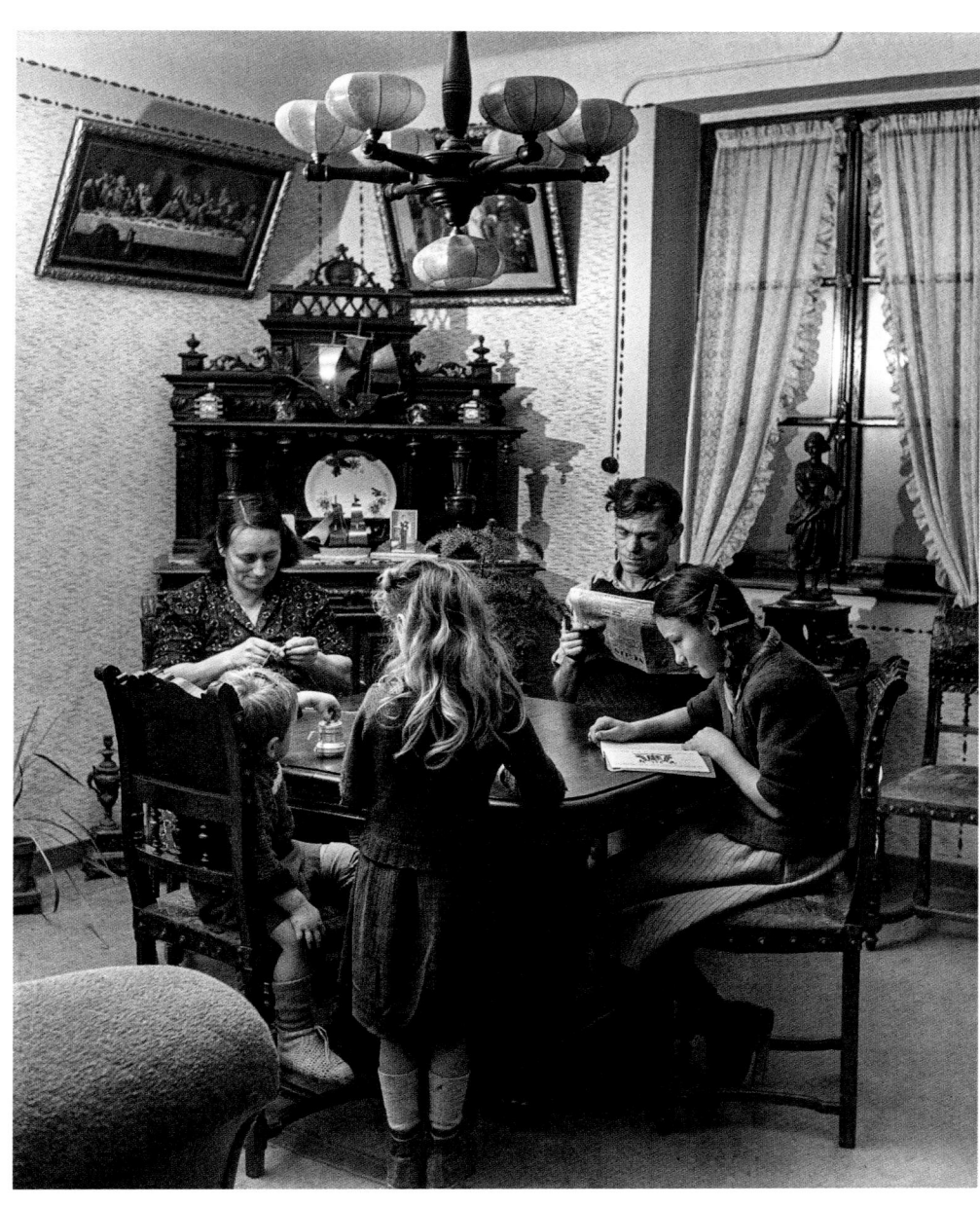

Sélestat, Alsace, 1951
NEGATIVE: 2¼×2¼ IN. (6×6 CM) _ F21/175
— 113
New series on the industrial sector in Alsace, in the north this time. Visit to a family working in the textile industry in Sélestat. Evening, around the table. Magnesium flash with mixed results. The general lighting is reflected back from the ceiling, but the lamp holder—clipped to the top of a door near the left corner—is slightly tilted forward, which produces shadows at the top of the image but helps to increase the illumination of the ceiling over its entire surface. Printing is quite difficult. The lighting disparities need to be reduced by overexposure, mainly at the top, on the wall to the left of the window, and on the window itself, whose central panes reflect the light back into the camera. Cropping on the sides.

The surprised cat, Gordes, Vaucluse, 1951
NEGATIVE: 2¼×2¼ IN. (6×6 CM) _ DUPLICATE _ F21/261
— 112
Summer 1951 in Gordes. I was coming back from an exploratory walk on the hill in front of our house. Suddenly, I turned around and saw this. I could not move: my position was too unstable and the slightest movement would have caused the feline to flee. The camera was hanging under my arm. Released the shutter without checking any settings. The animal then leaped out of view. I checked: the previous photograph had been taken at a similar distance. Good news. The shutter speed and aperture settings would lead to overexposure: not a big problem. That leaves the framing: no way of knowing. I aimed from the hip, like a machine gun (no experience of machine guns). The development in Paris the following month reassured me. It's hard to print, but not impossible: here's the proof! Light lateral cropping.

During a hunt in the Yonne (?), 1951
NEGATIVE: 2¼×2¼ IN. (6×6 CM) _ R21/27/2
___ 114

On a weekend in November 1951, I accompanied my colleague and friend Marcel Amson on a hunt in the Yonne. In the center of this clearing planted with spaced-out trees, I saw my hunter calmly walking home. Because night was falling, I took the risk of setting the speed to 1/5 second and fully opening my lens to f/3.5, blocking his silhouette at the center of the crosshairs of my sports viewfinder (this type of picture is not made with a ground-glass viewfinder, which is too imprecise in low light). I know that if I succeed, I will get a horizontal motion blur on anything that is stationary, that is to say the landscape. I like this effect, which is part of the photographic language and no other. The great unknown is how to compensate the subject's movement by a suitable angular displacement of the camera, even if that compensation cannot be absolute, as legs move in a more complex way. Difficult to print. The sky is strongly overexposed and must be overexposed during printing to reveal the details of the branches. As a result, the bottom of the trunks of the nearest trees must also be overexposed, in order to equalize their values against both the ground and the sky. Lateral and lower cropping.

Author's note: The large number of photographs that are difficult to print is noteworthy. The negative does not have the capacity to record the multiplicity of sensations that the eye (the brain) collects. The printer needs to reproduce these impressions as closely as possible by carefully adjusting the way in which the various elements of the original negative are rendered. That is sometimes very difficult. But who said photography was easy?

Winter velodrome, thirty-fourth anniversary of the October Revolution, Paris, 1951
NEGATIVE: 2¼×2¼ IN. (6×6 CM) _ R21/20/10
___ 115

A political meeting at the Vel d'Hiv velodrome on the occasion of the thirty-fourth anniversary of the October Revolution. The moment chosen for this photograph was when, at the end of one of the speakers' speeches, almost all the faces were turned toward the platform. Thanks to my press card, I was able to choose my location and circulate freely. I worked that night without an assignment, for my archives. Straightforward printing. Cropped top and bottom.

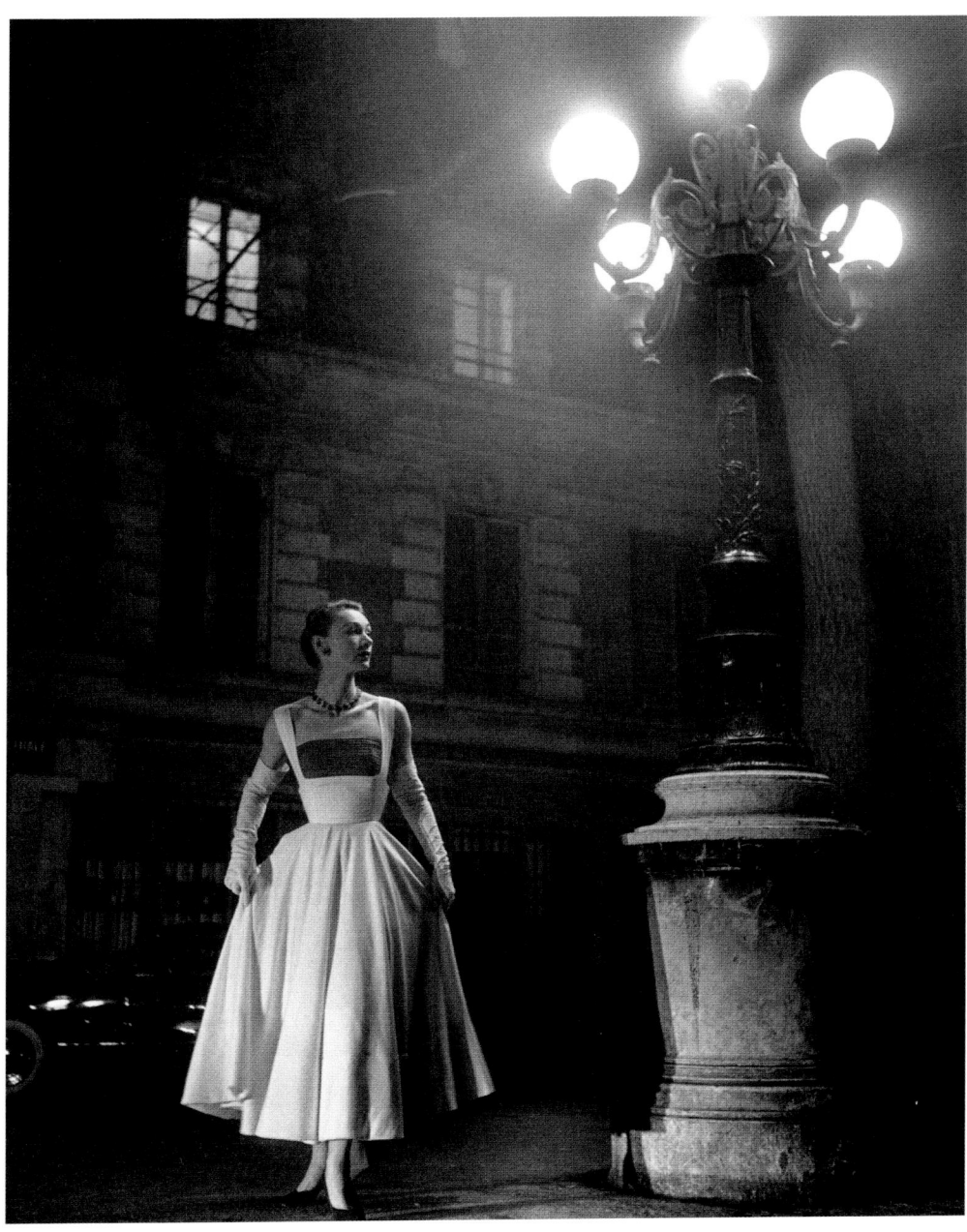

**Place de Fürstenberg,
Paris, 1952**
NEGATIVE: 2¼×2¼ IN. (6×6 CM) _ R22/8/1
___ 120

Lucien Vogel, the renowned director of *Jardin des modes* (and the creator of other equally famous publications), entrusted me with the task of shooting an evening dress worn by Sophie, a star model of the time. Where was I going to take this photograph? I proposed place de Fürstenberg, by night. They agreed. We were to meet there on February 25. It was February 22 and I had the time to do my scouting; a theoretical exercise because it could all change depending on the position of the illuminated windows. The only obligation I gave myself was for the lamppost to appear in shot. I had been told that a (rented) luxury car had to be in the background. On this point, things didn't work out as planned because the flash bulbs did not want to go off (a problem with the connection to the shutter). Nonetheless, the photograph was appreciated and was given a full page. Mixed lighting. Sophie's face, upper body, and left arm are illuminated by the lamppost (probably 1/2 second at f/4). The bottom of the dress and the base of the street lamp were lit by my car's dimmed headlights. Naturally, the camera was on a tripod.
Strong oppositions; the print must reveal the details of the house in the background.

**The Grand Palais kitchens during the Salon des Arts Ménagers,
Paris, 1952**
NEGATIVE: 2¼×2¼ IN. (6×6 CM) _ R22/11/1
___ 121

March 1952. I was at the Salon des Arts Ménagers (Household Arts Fair) without an assignment actually because I was personally interested, but I had my camera just in case. From a gallery, I could see the kitchens of the restaurant where all the staff were working. I just needed to wait for the characters to spread out evenly. Difficult image to print well because it is necessary, and important, to bring out the details on the kitchen's back wall. The left side of the window frame also needs to be overexposed, to emphasize its volume. And then the oblique staircase needs to be pulled back to avoid it darkening too much. That's a lot to do; proof that printing is a delicate exercise. The creation of laboratories for professionals after the liberation undoubtedly met a genuine need, but the result was that many photographers no longer knew how to print, which is a shame, especially for their own critical faculties. They say that while they slave away in the laboratory, they are missing out on the opportunity to take new photographs. But it isn't the quantity that counts. This debate is ongoing and has taken a new turn, since, over the last few years, there has been a renewed interest in the art of printing among young photographers. Lateral cropping.

Weekend with Marie-Anne and Vincent, Chambry, Seine-et-Marne, 1952
NEGATIVE: 2¼×2¼ IN. (6×6 CM) _ R22/7/3
__ 118

During a weekend in Seine-et-Marne, on February 17, 1952. To warm up, Marie-Anne and Vincent had a snowball fight. The weather was gray but bright: it was almost impossible to make out the ground. Some shrubs marked the edge of a small wood. All that was left for me to do was to compose a grid through which the protagonists of this scene would appear. Shot performed with a fairly wide aperture, in order to contrast the blur of the foreground with the sharpness of the middle ground. It is useful to push the contrast during printing. Lateral cropping.

Square Gabriel-Pierné, rue de Seine, Paris, 1952
NEGATIVE: 2¼×2¼ IN. (6×6 CM) _ P22/3
__ 119

Rue de Seine on a beautiful afternoon in the winter of 1952. I had just left Romeo Martinez, whose studio-apartment was located in the same street, when I saw the gentleman sitting in the small square Gabriel-Pierné at the intersection of rue de Seine and rue Mazarine, just behind the Institut de France. The man seemed very interested in what was going on across the street. I went into the square and took this photograph. All that was needed to round things off was for the painters to be whistling the latest hit songs; transistor radios didn't exist yet. During printing, be careful to bring out the detail in the painters' clothes and the other light areas, while ensuring good overall contrast. Lateral cropping.

The harpist Louise Charpentier playing for the elderly in a hospice, Rueil-Malmaison, Seine-et-Oise, 1952
NEGATIVE: 2¼×2¼ IN. (6×6 CM) _ R22/4/52
—— 116

During the summer of 1949 or 1950, I had heard the harpist Louise Charpentier play in Gordes, when she was passing through. Meanwhile, having acquired a more comfortable motorhome, she traveled through France and neighboring countries, accompanied by a friend who was her impresario, manager, and driver. For public relations purposes, she asked me to do a few reports in different places. *Point de vue – Images du monde* published one of them.

This image was taken in a retirement home in Rueil-Malmaison. I was on a stool (again!) to establish the image planes and clearly detach the artist from the middle ground. I also positioned myself to have the old lady, who could probably no longer hear and was living in another world, in the foreground. Magnesium flash on the ceiling. Some light areas require overexposure as they reflected too much light. Almost full frame.

Paul and Dominique Éluard, 1952
NEGATIVE: 2¼×2¼ IN. (6×6 CM) _ R22/5/29
—— 117

"The snow plane."
On February 2, 1952, I had to fly to Geneva, accompanied by a sporty and pretty young woman. The client: *Air France revue*. The subject of the assignment: a packed weekend in the snow of Megève, which we reached quickly thanks to a new bus service that had recently been set up for this purpose. In the boarding area before the flight, I had exchanged a few words with Paul Éluard, whom I already knew as I had photographed him a few times, and who was on his way to Switzerland for a series of lectures. During the flight, a veiled ray of sunlight illuminated the poet for just a moment with superb lighting. I took this shot of him with his wife Dominique at his side. As for the assignment, it was never published for reasons that remain unknown to me. Cropped top and bottom.

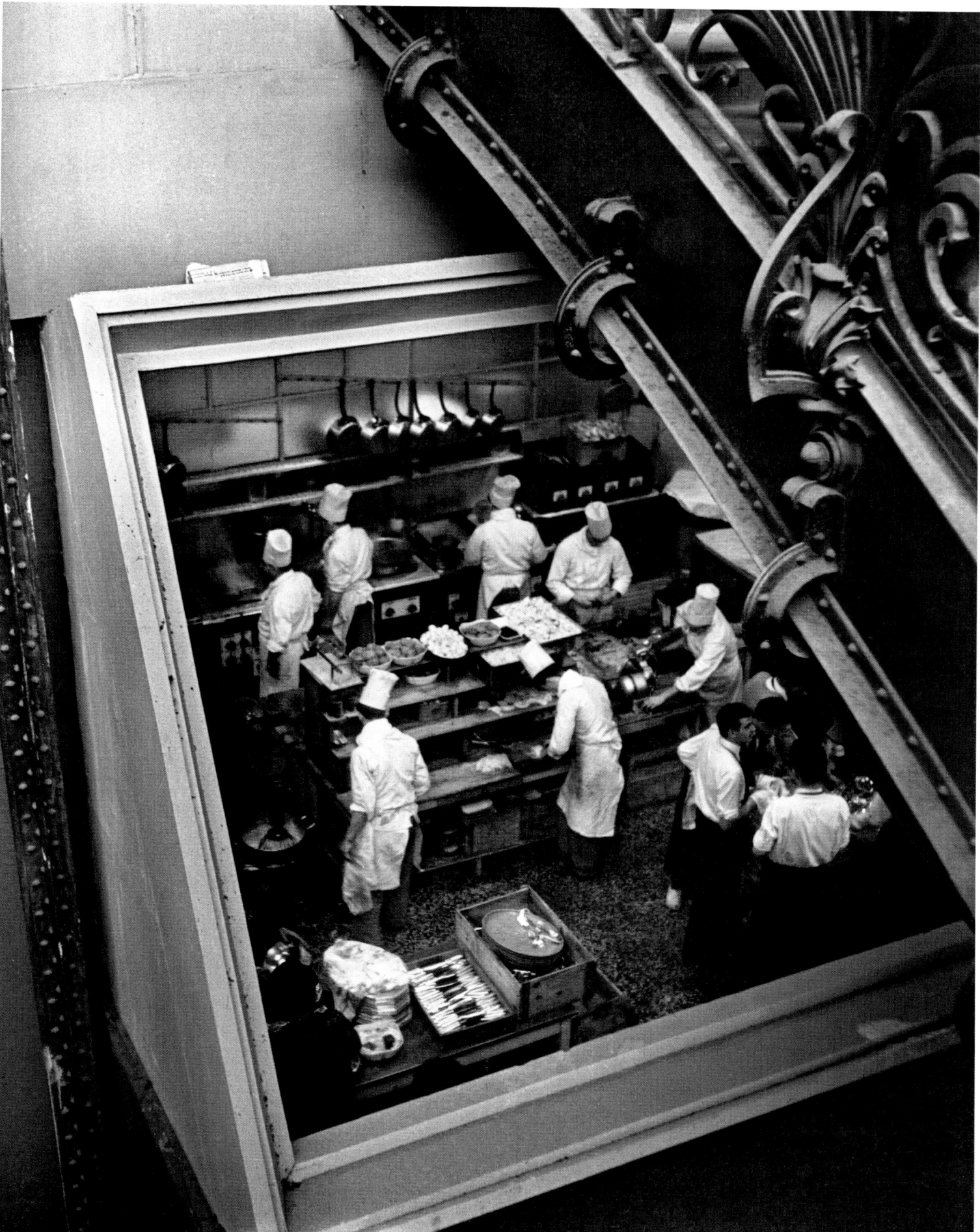

Place de la Concorde, Paris, 1952
NEGATIVE: 2¼×2¼ IN. (6×6 CM) _ P22/5
___ 122

An afternoon at the end of winter, place de la Concorde. Before disappearing, the sun filters through the clouds and sensually outlines the curve of the parked cars. A fleeting effect, which needs to be captured on the spot. The Paris sky is—in the eye of this Parisian—one of the most beautiful and varied in the world, perhaps because of the relative proximity of the English Channel. But that doesn't mean it is beautiful all the time. Furthermore, we must never neglect special moments when they present themselves. Many of the images in this collection are the result of dismissing so-called good reasons such as, "I'll do this some other time, I'm late, that's enough for today," and, worst of all, "So, what am I going to use that for?" Easy print. Cropping top and bottom.

Mont Saint-Michel, Manche, 1952
NEGATIVE: 2¼×2¼ IN. (6×6 CM) _ F22/305
___ 123

Easter vacation at Mont Saint-Michel. It's mild. The window of the hotel where Marie-Anne and I are staying overlooks the ramparts. The camera, loaded, is always kept in an easily accessible place. Another nice little stroke of luck. Relatively easy print, as the light from the overcast sky covered everything. Cropping on all four sides: I was a little too far away for the ideal framing.

At the fairground, boulevard Garibaldi, Paris, 1952
NEGATIVE: 2¼×2¼ IN. (6×6 CM) _ R22/12/5
__ 124

Fairground in spring under the elevated metro, between the Sèvres-Lecourbe and Cambronne stations. A strong man is about to smash the target far behind him, by launching the rocket on wheels with a violent semicircular movement. His smile, tense with effort, is customary for an athlete in this kind of performance. To suitably embrace the situation, I stood (I suppose) on a box or a stepladder, revealing an admiring little boy, a true supporter of the sportsman in his moment of truth. It was mid-afternoon and the mixed crowd was thinning. Notice the light blur of the percussive tool. I knew that at that moment the climax of the effort would be painted on the young man's face. Relatively easy print. Bilateral framing.

Aligre Market, Paris, 1952
NEGATIVE: 2¼×2¼ IN. (6×6 CM) _ R22/14/26
__ 125

At the beginning of April 1952, a journalist suggested that I do a report on the highly picturesque market on rue and place d'Aligre. There was no lack of material and I spent several mornings there (at the time an authoritarian clanging bell brought all activity to a halt on the stroke of noon). I particularly like this photograph, first of all for the clarity of the scene it depicts: the square at the top, with its nineteenth-century building for the weighers. But also for all the activity in the close-ups: a man selling carpet by the yard cuts off a section for a client who cannot be seen. All the characters are serious: the merchant handling his scissors in a sacrificial gesture, the woman furthest away who is expertly testing the quality of the carpet, the man with the trench-coat lost in his eminently serious thoughts, and, closer in, the woman half-turned toward us, hesitating, while a man seems to encourage her; finally, at the bottom, the black-gloved hand holding a sample which weighs heavy under a gaze from outside the frame. Probably in a bid to get the maximum detail possible, I went with 1/10 second at f/22, braving the risks of underexposure, which are difficult to make up during printing and that is the case.
As it is, this image is one of my favorites for the balance it provides between its readability, the internal tension of its composition, and the escape it offers my imagination.
I don't think the story was used by the intended publication. Nevertheless, I included this image in my Italian monograph published by FabbrI in Milan in July 1983, as well as in the book *Mon Paris* (My Paris).

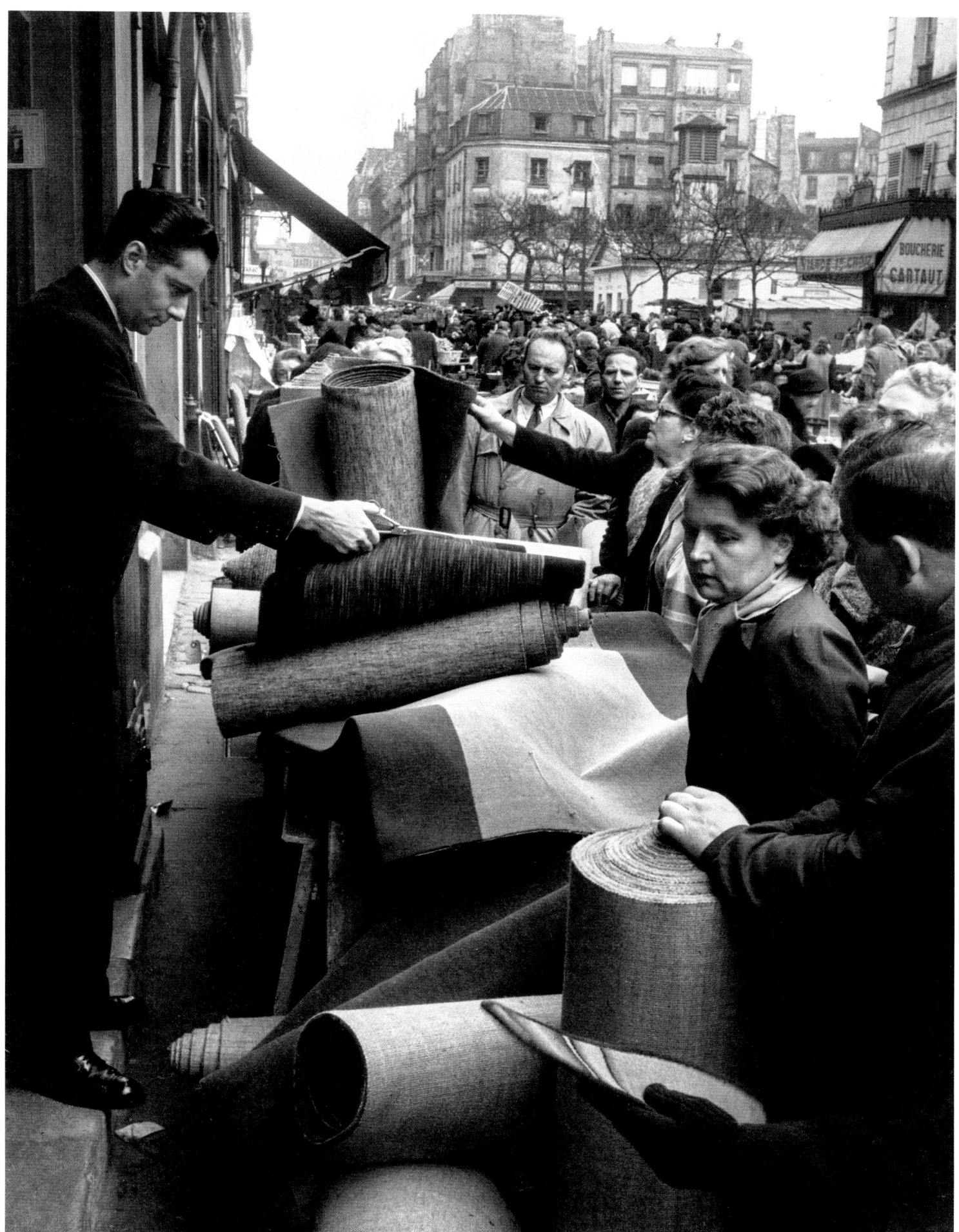

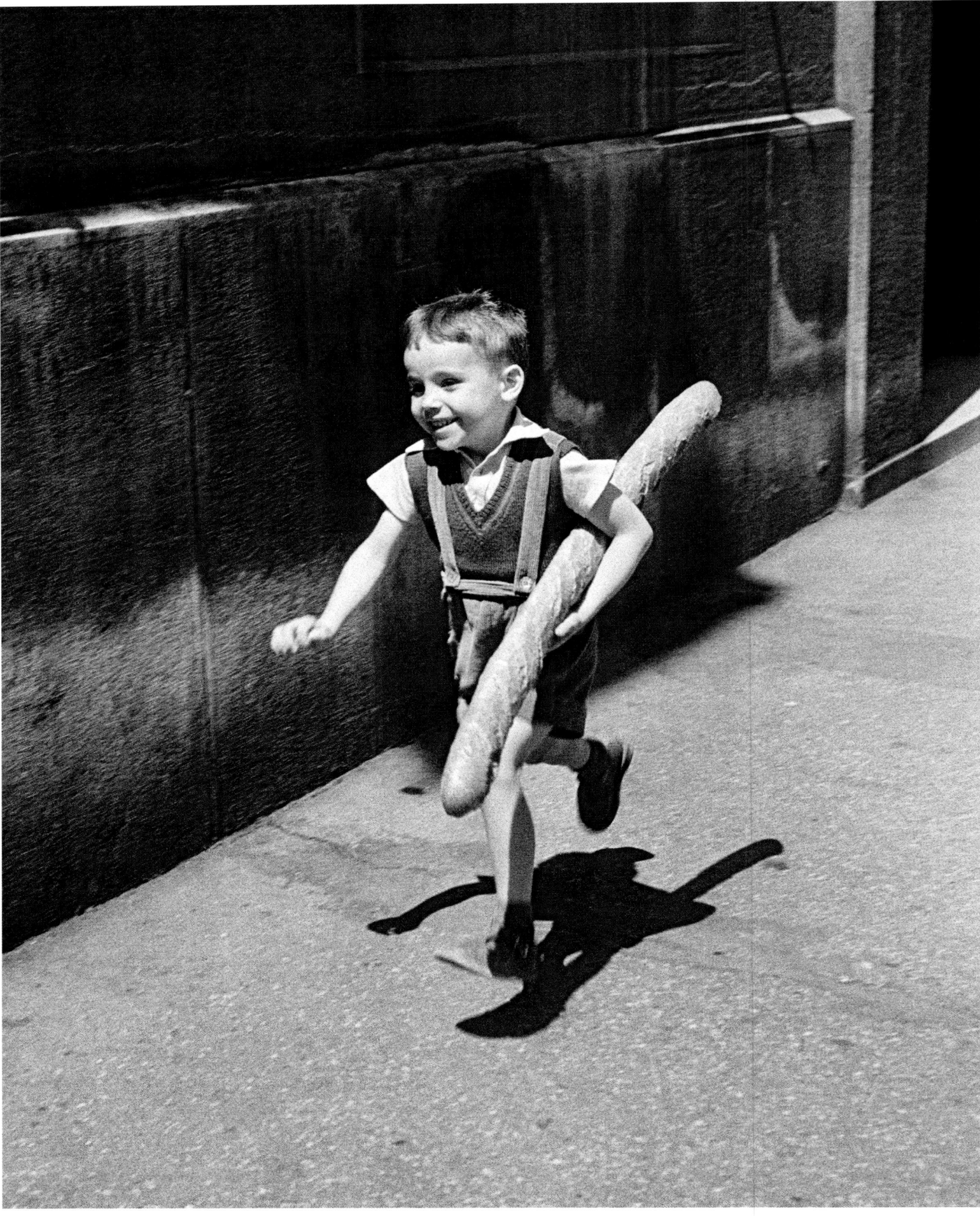

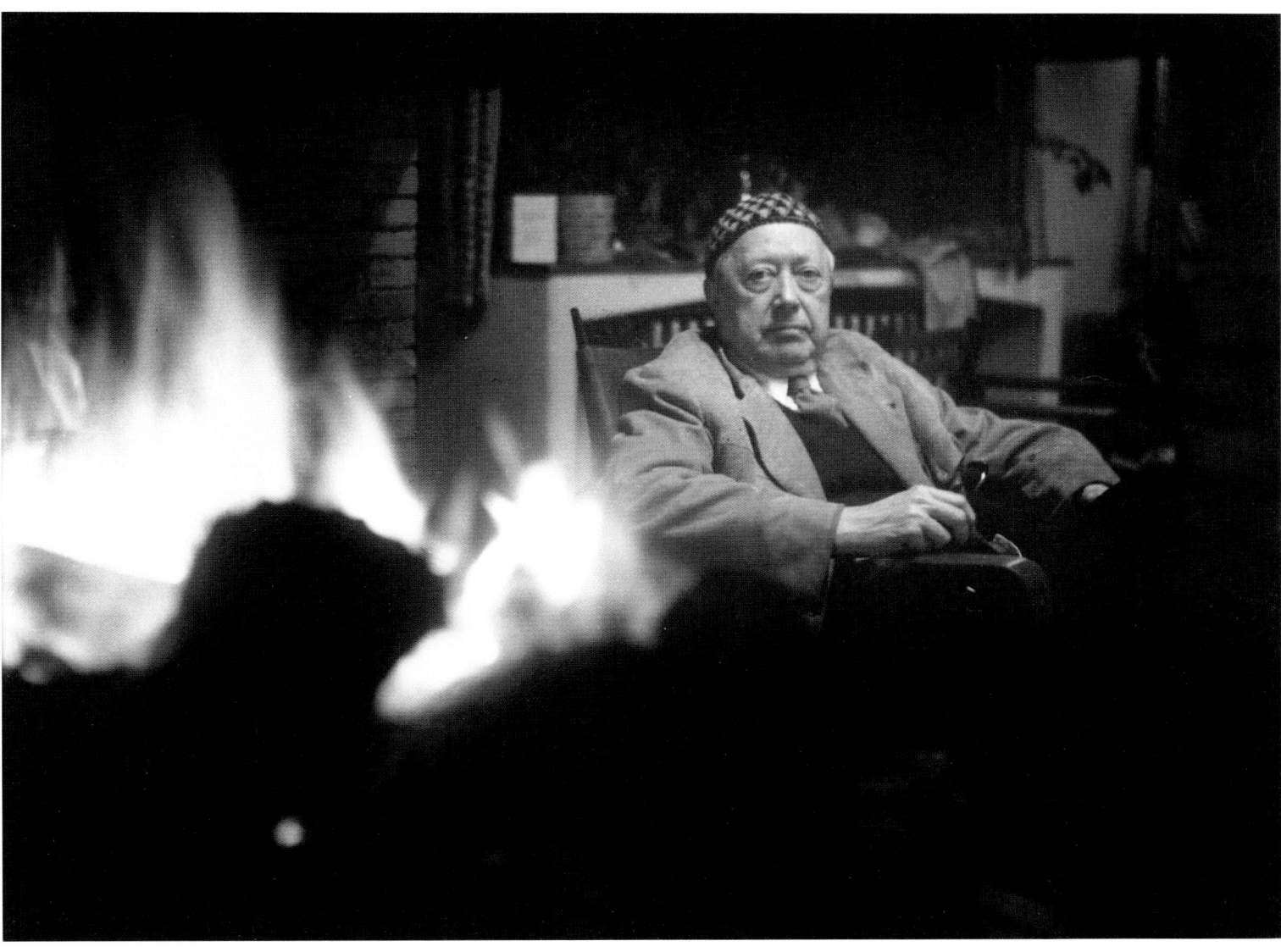

The little Parisian, 1952

NEGATIVE: 2¼ × 2¼ IN. (6 × 6 CM) _ R22/19/19

— 126

In May 1952, a women's magazine entrusted me with an assignment entitled "Seeing Paris Again." A journalist returning to Paris after twenty-five years of absence rediscovers with joy everything that, in his eyes, bears the signature of his hometown. The photographs to be taken—most of them did not require the models' complicity—included an average Frenchman sipping his coffee, an insurer with his napkin, the goat cheese merchant with his flock near the porte de Versailles. Others could be improved at the cost of a little acting direction. This was the case for a *grisette* watering her flowers (which is not included in this collection) and for this image. I had of course set up near a bakery at peak hour and, after a few attempts, I was not sure I had the right image. Then I noticed a boy, seriously counting his pennies while waiting for his turn, and I explained what I needed from him: exit the bakery in a hurry with the loaf held tilted under his left arm. The first attempt was too tense, the second was perfect. We went back into the bakery to eat a chocolate treat together. Contrary to what a number of my friends thought, it is not Vincent. Relatively easy print. Cropping on all sides.

Lucien Vogel, Achères, Seine-et-Oise, 1952

NEGATIVE: 2¼ × 2¼ IN. (6 × 6 CM) _ R22/20/19

— 127

With the affable manners of a great dandy, Lucien Vogel invited me to his residence in the Faisanderie in Achères for the afternoon, where I was responsible for executing, after dark, a number of fashion shots with one or more models. The atmosphere was relaxed and the hospitality courteous, without ostentation. A central fireplace weakly illuminated the master of the house. A photographer's modest and deferential tribute to the great pioneer of modern photojournalism. Relatively easy print. Cropping, top and bottom.

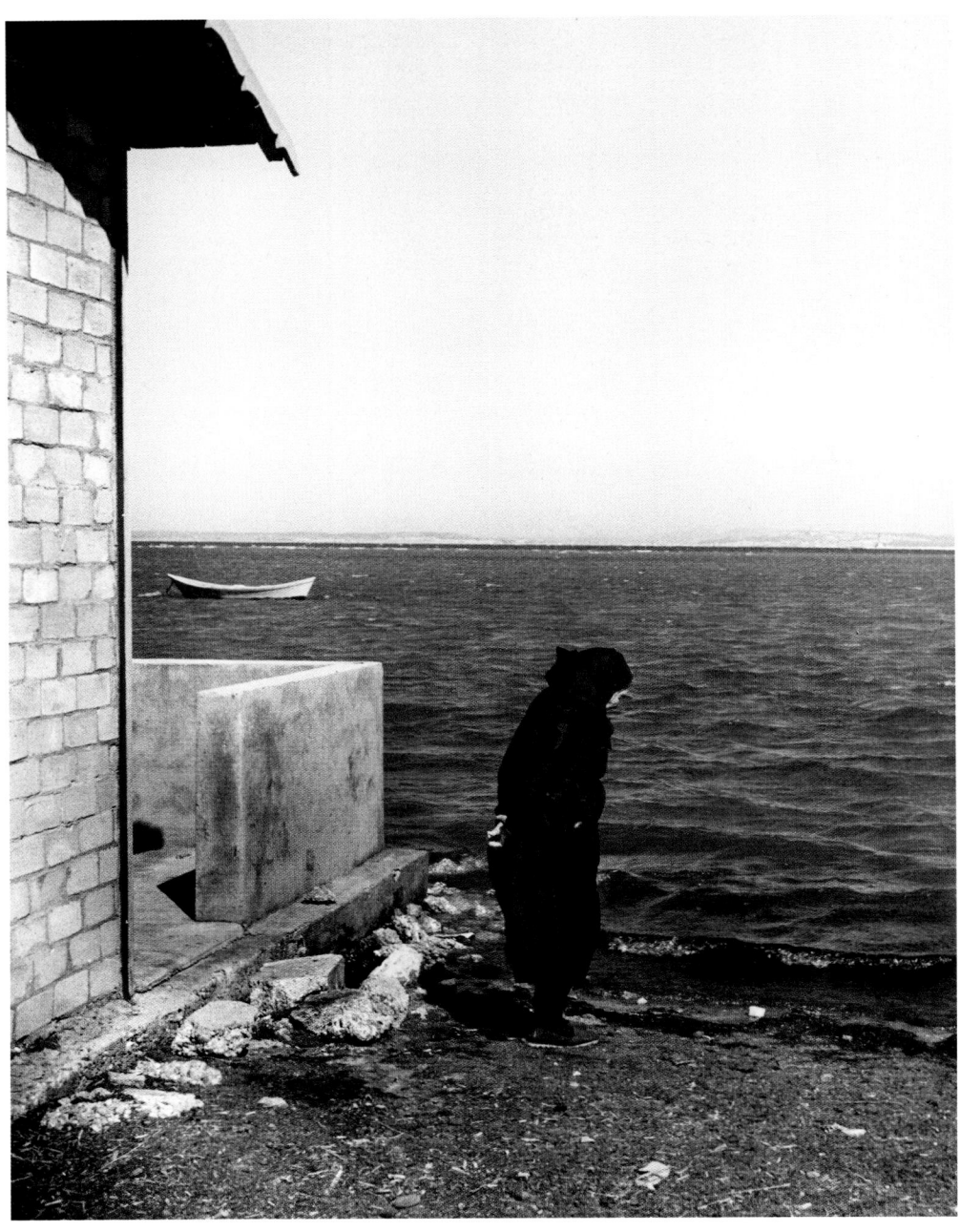

Port-Saint-Louis-du-Rhône, Bouches-du-Rhône, 1952

NEGATIVE: 2¼×2¼ IN. (6×6 CM) _ F22/126
___ 128

Since I took my vacations in the south, I made a series of shots retracing the efforts of the MRU (Ministry of Reconstruction and Urbanism). Some hypocrisy: vacations are too important to be peppered with professional obligations. Bygones. Hanging around at dusk on the shores of the Golfe de Fos, which would experience such profound upheavals, my eyes came to rest on the severe silhouette of this fisherman's wife, at the foot of the run-down shack, resembling a character from a Greek tragedy. The slightly harsh light seemed to mineralize the shore, giving it the appearance of the trompe-l'oeil canvases painted for the workshops of naive photographers. The boat has Puvis de Chavannes' strict line. This may all just be fiction. I was just passing; it's the impression of that evening that I bring back to you and that this image revives, whenever I see it.

Vincent and the model aircraft, Gordes, Vaucluse, 1952

NEGATIVE: 2¼×2¼ IN. (6×6 CM) _ DUPLICATE _ F22/208
___ 129

Summer 1952 in Gordes. From the window of the kitchen-living room, I admired Vincent making the last adjustments to a newly built model, which he would launch later on, in the empty field of some farming friends. The window from which I contemplated this scene is exactly below that which appeared, three years earlier, in *The Provençal Nude*. I previsualized the image in my head while calculating the risks of the operation, because we both knew that a launch in this closed-in site could end very badly. I took the lead and promised him a nice gift in case of a glitch. I added that I would limit myself to two shots. An agreement was reached. A first throw of the plane was badly framed, and I understood better how to go about it. Thankfully, there were no breakages. Growing in confidence, we did several trial throws, following a very specific course, and the second launch (as far as I could tell in the very demanding conditions of the planned framing) seemed good for the image. Unfortunately, there was some damage, which we repaired on the spot in good humor. It was in 1952 that the great Edward Steichen did a world tour of photographers to prepare for his major exhibition *The Family of Man*. He came to see me on September 24 and immediately selected this photograph, asking me to send him more, which I neglected to do, taking his request for a simple courtesy. It was silly; he went on to exhibit *Four French Photographers* at the Museum of Modern Art in New York: Brassaï, Boubat, Doisneau, and Ronis,* presenting thirty photographs each.
A few last words on this photograph. Note the position of the left-hand window, to emphasize the depth. Note also the wooden bowl with its chopper and the papers pushed to the right. This is not an abstract place, but a house where three people live. And the natural elements, in previsualized photography, are often the result of staging.

* In fact, it was *Five French Photographers*: Brassaï, Cartier-Bresson, Doisneau, Izis, and Ronis.

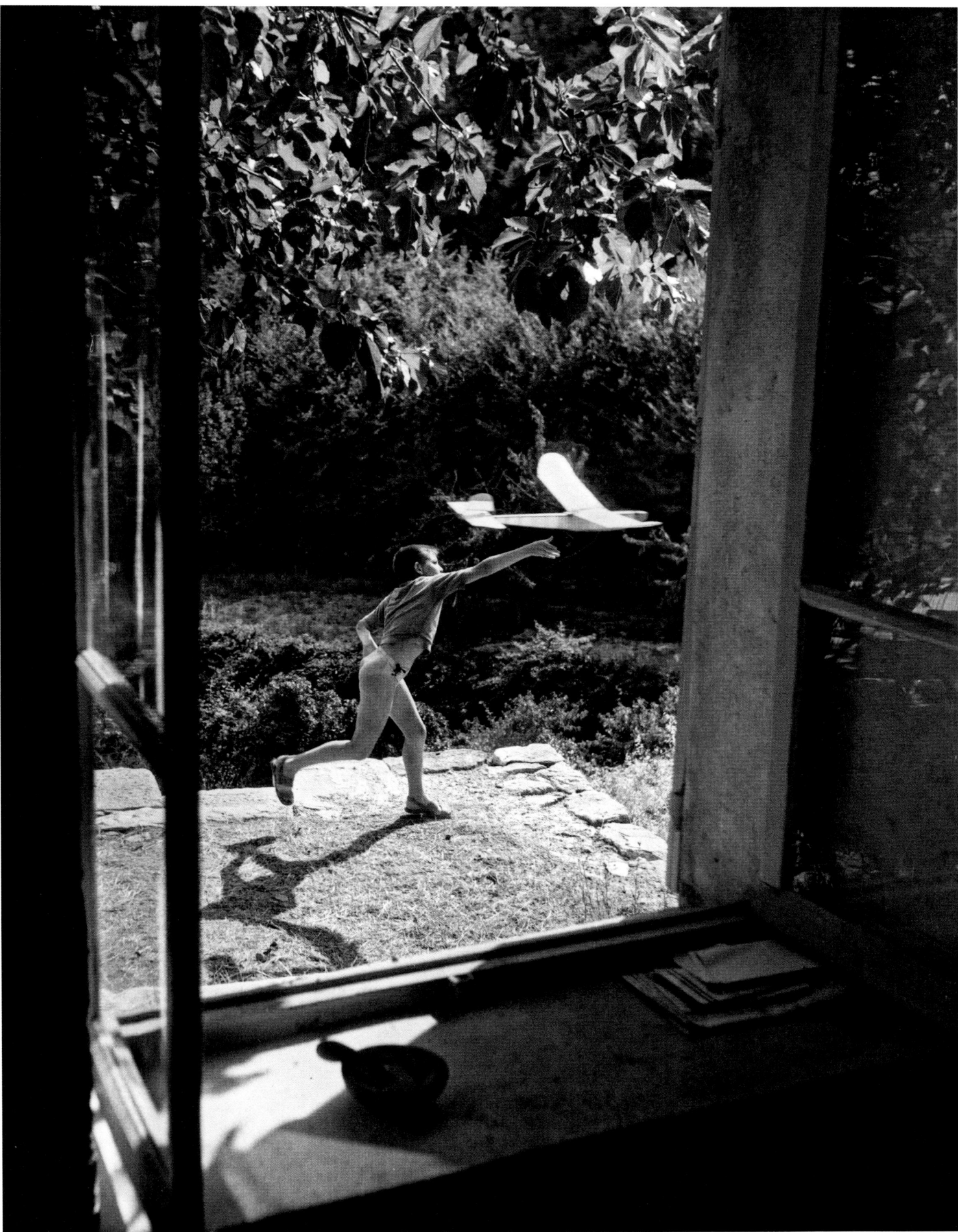

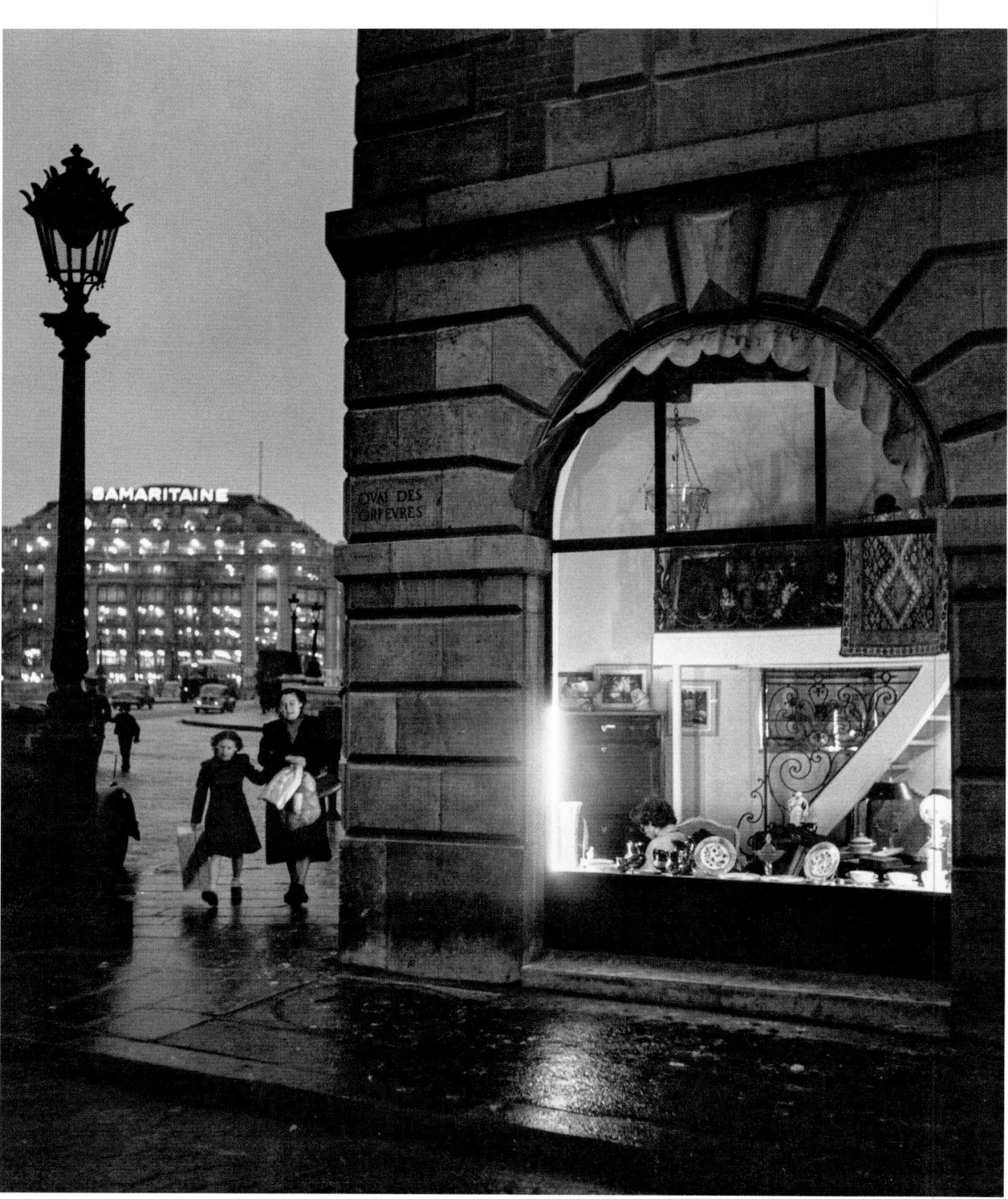

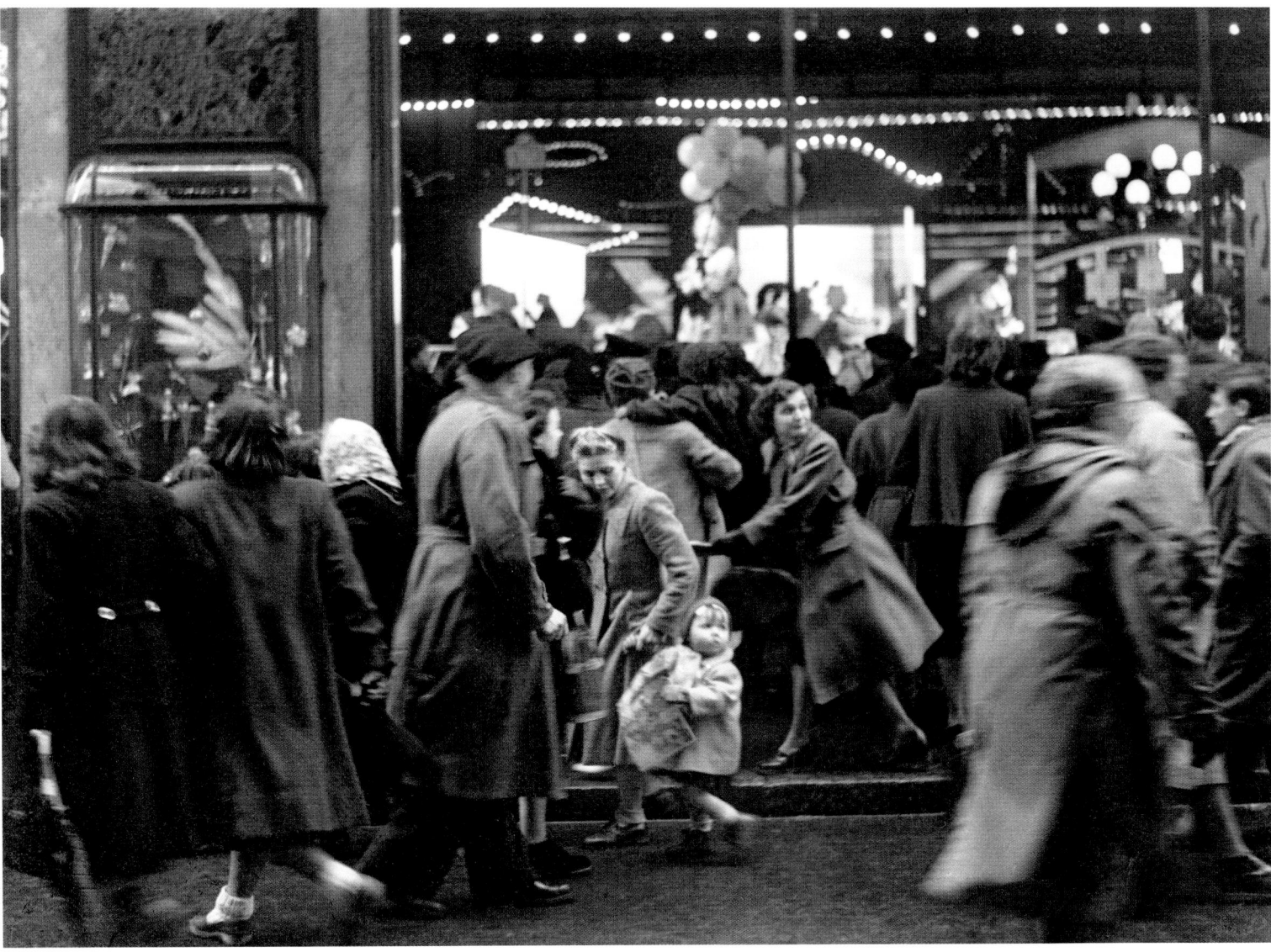

**Christmas week,
rue de Mogador, Paris, 1952**
NEGATIVE: 2¼×2¼ IN. (6×6 CM) _ DUPLICATE _ R22/40/24
___ 131

Île de la Cité, Paris, 1952
NEGATIVE: 2¼×2¼ IN. (6×6 CM) _ P22/92
___ 130

End of fall in Paris. I had noticed these two characters hurrying by from afar. To polish my composition and include the lamppost (I was furious that it was not yet lit), I backed up into the road of quai des Orfèvres. When taking photos at dusk, the sky is always overexposed. It is therefore necessary, during printing, to darken it to restore the impression of reality to the image. Almost full frame.

As an inveterate onlooker, the atmosphere that precedes the end-of-year festivities has always held a particular fascination for me. Here, on rue de Mogador, the road had been pedestrianized for the customers of Galeries Lafayette. For this kind of shot, it goes without saying that I never used the ground-glass viewfinder, but aimed through the cross-linked metal frame that is brought up by folding the hood of the Rollei. That gives a direct vision of the actual image size, and even reveals the immediate surroundings of the frame.

The comings and goings of the crowd ebbed and flowed, beneath the prettily rhythmic decoration of the bulbs and balloons in the window. The moment to remember revealed itself by the simultaneous passing by of the young woman looking behind her and the child (of another mother) apparently attracted by the same thing. There is a good distribution of light and shadow, and the movements are interesting. The print is quite difficult to harmonize. Cropping top and bottom, slightly tilted to the left, to emphasize the instability of the situation.

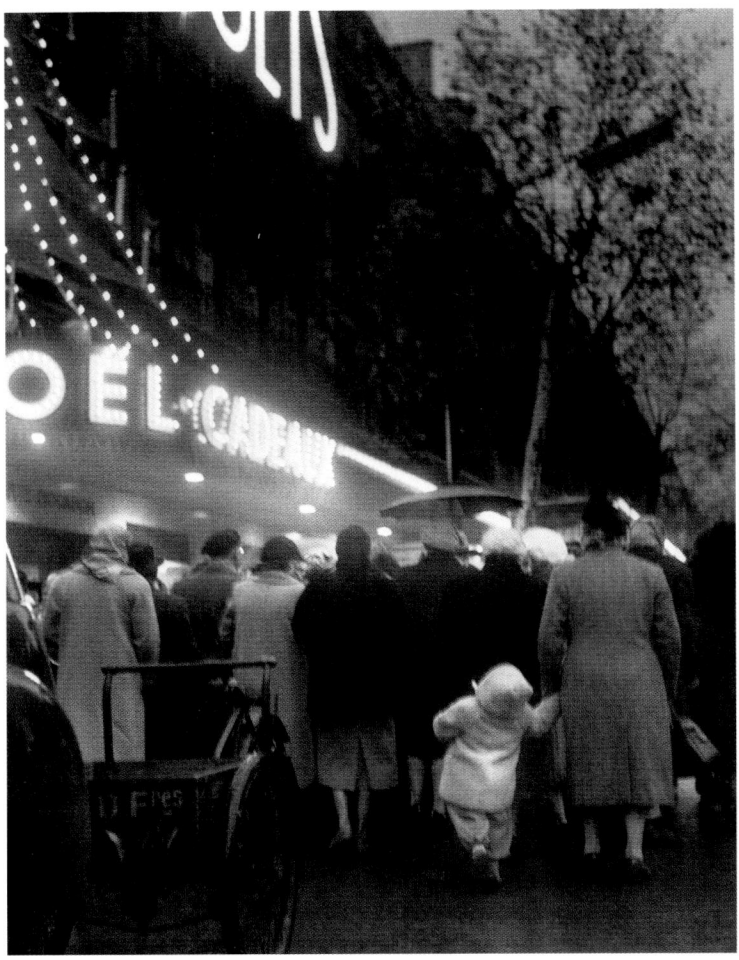
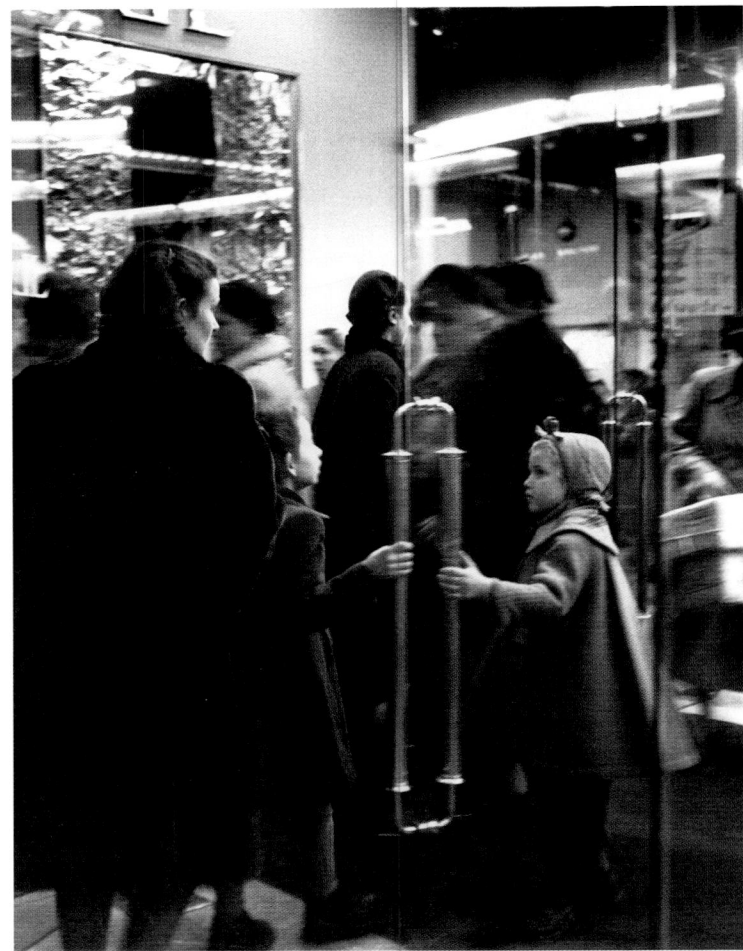

Christmas week, boulevard Haussmann, Paris, 1952
NEGATIVE: 2¼×2¼ IN. (6×6 CM) _ R22/40/34
__ 132
From the same series on Christmas, boulevard Haussmann. Twilight was approaching, it was raining; the crowd was waiting for the end of the flow of cars to cross. The little child in white stared at the fairy lights and hopped up and down impatiently: he wanted to see the animated window displays. That's it; you had to be there, to dare 1/10 second, even 1/5, handheld, in the rain. The rest is the sport's great uncertainty. The print requires overexposure on the word "CADEAUX" (gifts), just enough for the word to remain legible but suggest dazzle. Bilateral cropping. Darken the sky.

Christmas week, boulevard Haussmann, Paris, 1952
NEGATIVE: 2¼×2¼ IN. (6×6 CM) _ R22/40/53
__ 133
A girl pushed the door: she was leaving the store, her features calm. Her counterpart pulled the door toward her, excited by the coming show. That's all, and, well, that's enough. Lateral cropping. Overexposure needed for the top lights.
In this series, none of the photographs chosen here (among many others) was part of an assignment. Shown later, the series led to commissions on similar topics.

In front of a store window, Christmas week, boulevard Haussmann, Paris, 1952
NEGATIVE: 2¼×2¼ IN. (6×6 CM) _ R22/40/55
__ 134
Last photograph of the series. Close-up on a fairytale window display. This is the kind of photograph that is taken on impulse, on the edge of technique, where the emotional tug meets the click of the shutter in the hope that the latter will reflect the former. And sometimes it works. Quite a tight crop: the crowd of children kept me a little further away. Slightly underexposed negative. Partial enlargement of the negative.

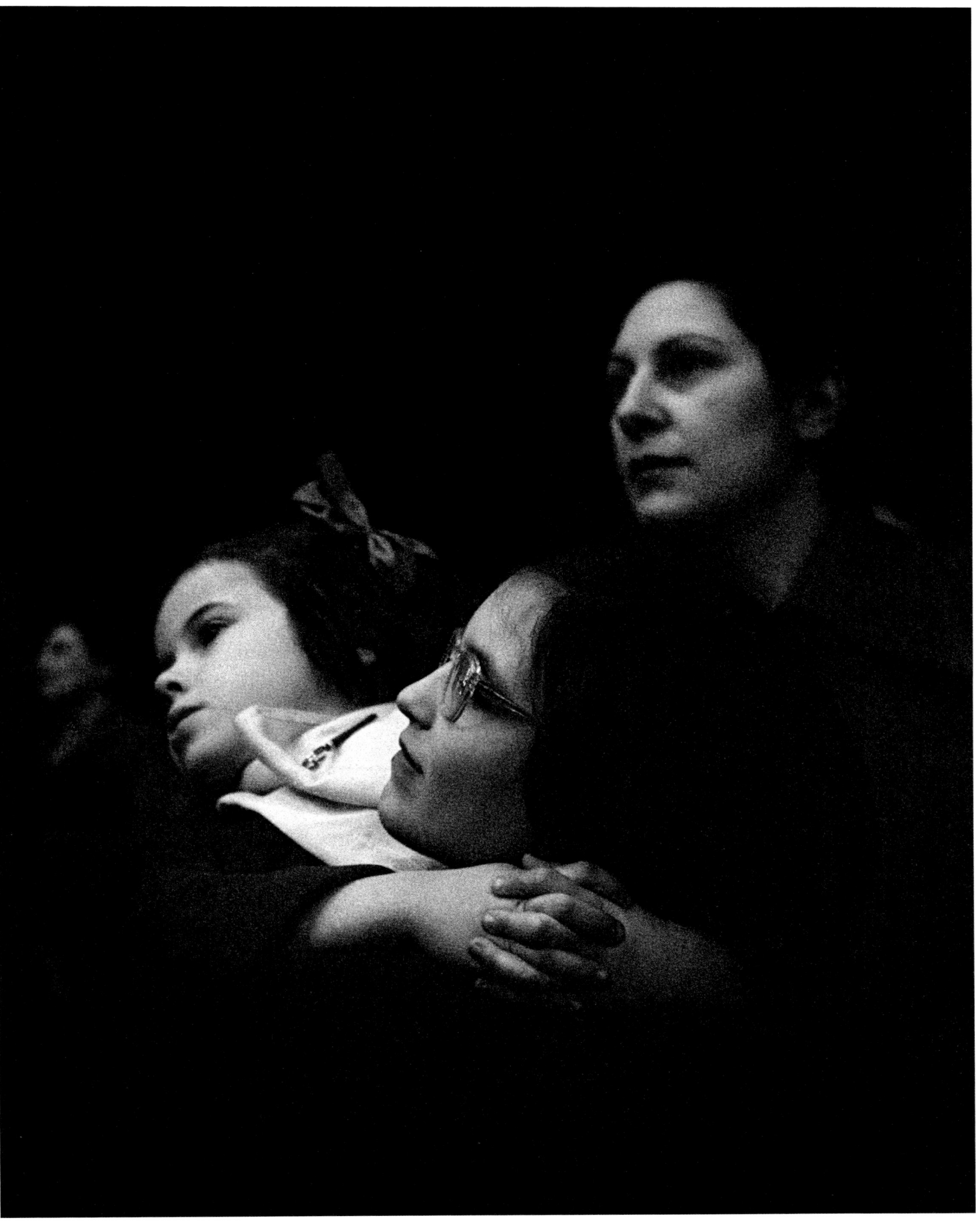

**Lovers on quai des Tuileries,
Paris, 1953**
NEGATIVE: 2¼×2¼ IN. (6×6 CM) _ P23/113
___ 135

"Free man, you will always cherish the sea" (Charles Baudelaire). Lovers, you will always cherish calm waters—my modest addition. Photographing couples on the banks of the Seine in springtime—what a cliché! But why deprive yourself of the pleasure? Every time I encounter a pair of lovers, my camera smiles; let it do its job. Here, the couple is double—the tree slanting through the image unites rather than divides. The sunshine must be pulled back on the left edge. Bilateral cropping.

**"April in Paris," lovers on
quai des Tuileries, Paris, 1953**
NEGATIVE: 2¼×2¼ IN. (6×6 CM) _ DUPLICATE _ P23/116
___ 136

"April in Paris," that sweet ballad sung by Ella Fitzgerald and Louis Armstrong: I cannot dissociate this image from the melody that those wonderful musicians taught me. One afternoon (the incidence of the sun is revealed by the shadows), my steps had led me to the quai des Tuileries. The flowers of the chestnut trees were pleasantly spread through this field of green. How well things are composed when we choose the best place to contemplate them from! The boy is making a barely perceptible move toward the girl: everything is said. The framing is cropped on the right through the trunk of the tree, closing the image in on the essential.

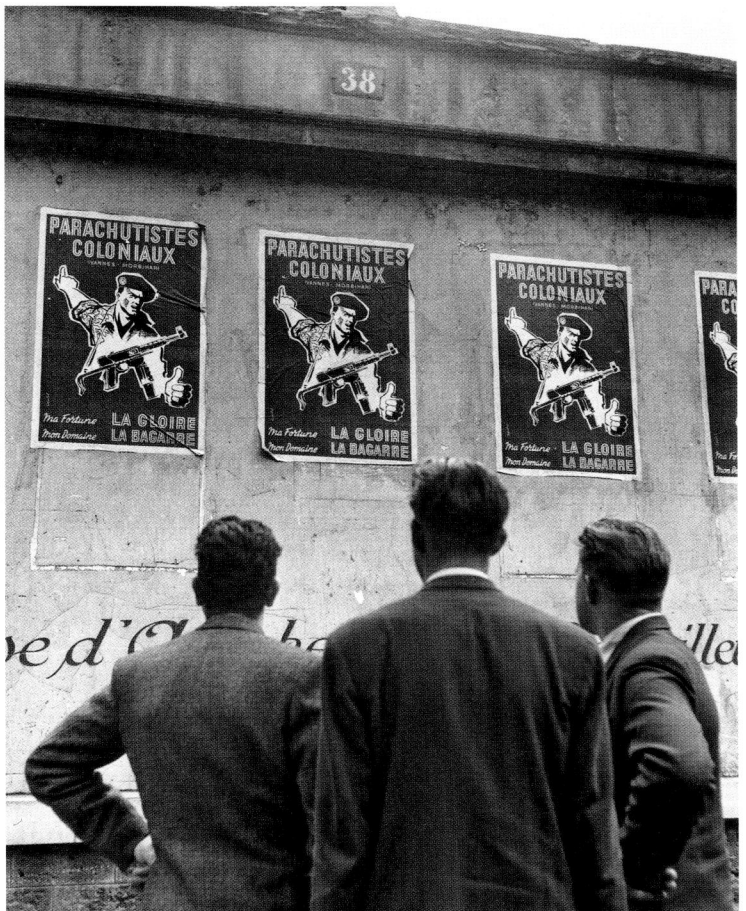

Boulevard de la Tour-Maubourg, Paris, 1953
NEGATIVE: 2¼×2¼ IN. (6×6 CM) _ R23/11/1
___ 137

June 1953. One morning, my travels took me along the outside wall of the barracks at La Tour-Maubourg. Call for legal violence. Three young men hesitating at the crossroads of their fate. I did not judge. I transcribed. Average print. Lateral cropping.

After a rainstorm, at the château of Chaumont-sur-Loire, Loire-et-Cher, 1953
NEGATIVE: 2¼×2¼ IN. (6×6 CM) _ F23/346
___ 138

Summer 1953 in Touraine, with friends. A sudden storm momentarily trapped us in the château of Chaumont. The rain splashed violently against the windows, but the sun returned and it was through the refraction of the drops that the trees reappeared, and beyond, confusedly, the Loire, with an island: a vision derived from an impressionist painting. Nature imitating art. Due to the framing, the visible edges of the window frame converge upward. Any confirmed printer will bring them back in parallel.

At the fairground, boulevard Garibaldi, Paris, 1953
NEGATIVE: 2¼×2¼ IN. (6×6 CM) _ R23/23/37
__ 139

The biannual fair, under the elevated metro near our home on passage des Charbonniers. This was the autumn fair, but the energy was the same as at Easter, if not livelier. A group of cheerful friends stopped in front of my camera, wanting to capture an unforgettable moment of this evening. Rather than disparage them, I positioned them near the lights of the neighboring booths. It was weak. With a bit of luck, my shutter wide open to f/3.5, and my back wedged against a post, I took a deep breath and released the shutter for 1/5 second between two heartbeats. Two clicks. This one is the best. The blurry streaks in the background are just right. In short, one must know how to be daring. And despite these technical imperfections, for me few images portray as much of the truth of the present moment as this one. Full frame.

Midnight Mass at Les Baux-de-Provence, Bouches-du-Rhône, 1953
NEGATIVE: 2¼×2¼ IN. (6×6 CM) _ R23/34/32
__ 140

Mass was over. In the light of the candles, the cart with the lamb was being taken around. The image inspires fervor and serenity. In fact, I was stuck in a crowd that reminded me of Richelieu-Drouot station at 6 p.m.—it was impossible to frame at eye level. I held the Rollei on my head and released the shutter three times, guessing the shot but remembering to wind the film on (with the old model, accidental overprinting was a constant risk).
A photograph of this kind, if it is successful, is the reward for an unshakeable persistence, a visceral bet to bring back something at all costs. And then, while scrutinizing the contacts, you realize that no click, even the most unfortunate, is ever made without a reason.
Slight cropping of the 2 ¼ × 2 ¼-in. (6 × 6-cm) negative.

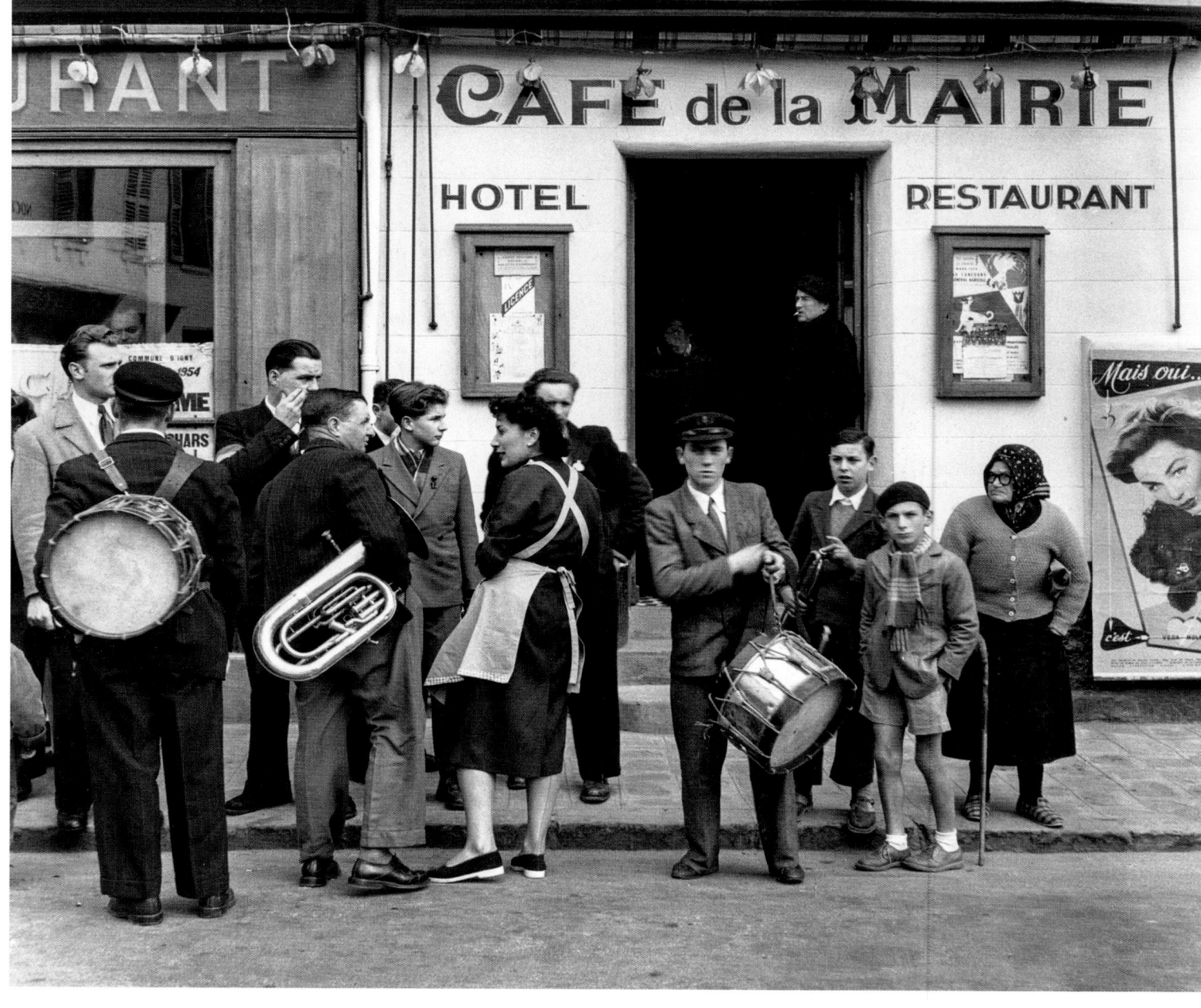

**Mi-Carême (Mid-Lent) in Igny,
Seine-et-Oise, 1954**
NEGATIVE: 2¼ × 2¼ IN. (6 × 6 CM) _ R24/11/10
— 141

The Mi-Carême festival (the third Thursday
in Lent) in Igny, Essonne, in March 1954.
The carnival was getting under way, and
I enjoyed taking this quiet outtake from the
series, in front of the bistro where onlookers
of all ages and musicians were waiting for
the rest of the program to be announced.
Voluntarily frontal view: it presents
the show, from the front, as in
Italian theater. Many of my images
are constructed in this way.
Easy print. Cropping top and bottom.

Going to school, Moselle, 1954
NEGATIVE: 2¼ × 2¼ IN. (6 × 6 CM) _ F24/40
— 142

March 15, 1954. Early in the morning
I was driving through the Lorraine
countryside toward the iron and steel plant
in Richemont where work beckoned me.
I overtook these kids and then, further on,
I braked to let them overtake me. I silently
opened my door and, catching up with
them stealthily, I released the shutter twice.
I'd see the results later, back at home.
Difficult print: push the black of
the hooded capes; hold back the
landscape. Cropping on three sides.

**Mulhouse suburbs,
Haut-Rhîn, 1954**

NEGATIVE: 2¼×2¼ IN. (6×6 CM) _ F24/68

—— 143

An end-of-spring afternoon in the Mulhouse suburbs. Half a dozen kids devote themselves to their beloved sport. The ball is in the air, and this is the emotional moment when they have some crucial decisions to make. Easy print. Cropping top and bottom.

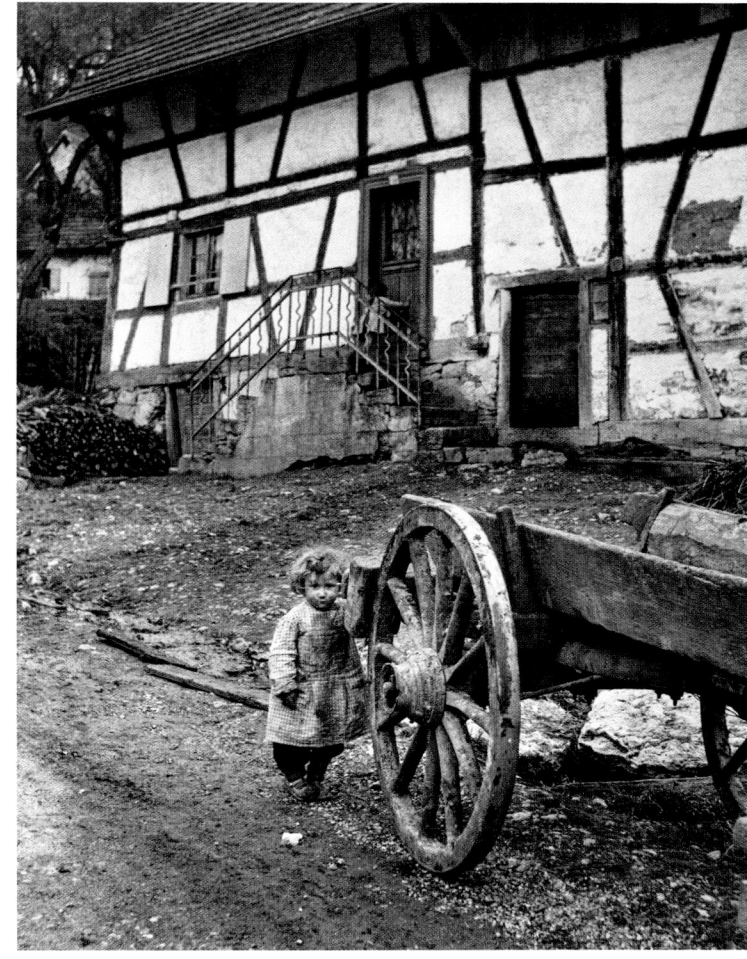

Around Altkirch, Haut-Rhîn, 1954
NEGATIVE: 2¼ × 2¼ IN. (6 × 6 CM) _ F24/70
___ 144

Alongside the same industrial photography tour of the east, this is from a weekend in Sundgau, a province in the far south of Alsace, on the Swiss border.
Three young bike tourists were taking a well-deserved rest and digging in to their snacks on the edge of a small river: another of those encounters with the number three that are scattered throughout my photographic journey.
A calm photograph: the sky can only be seen in its reflection, in the peaceful current that blurs the silhouettes. Another frontal composition, broken by the striking verticality of the tree on the water's edge. Bilateral cropping.

Vieux-Ferrette in Sundgau, Haut-Rhîn, 1954
NEGATIVE: 2¼ × 2¼ IN. (6 × 6 CM) _ F24/82
___ 145

Same region, same day, surely; March 17, 1954, in the village of Vieux-Ferrette. The adults were out in the fields. Having seen me approach, this child fearfully sought refuge behind the cart wheel. The landscape is poor, the ground muddy, the house a little dilapidated. The absence of sky accentuates the weight of things. I would find an echo of this moment, less the deprivation, in a photograph I took in Greece twenty-eight years later (see photo 347).

Ilya Ehrenburg, Paris, 1954
NEGATIVE: 2¼×2¼ IN. (6×6 CM) _ R24/14/1
—— 146

May 12, 1954. I had an appointment with Ilya Ehrenburg on quai de Bourbon, at the apartment of Pierre Cot, a friend of the Soviet writer and a great connoisseur and defender of French culture. I did this portrait-report on the balcony in the late morning. The western tip of the Île Saint-Louis can be seen, where Julio Cortázar later situated the key episode of his story *Las babas del diablo* (The Drool of the Devil), a very free version of which became famous thanks to the film *Blow-Up*. An arm of the Seine bypasses the eastern tip of Île de la Cité, after grazing the Hôtel de Ville de Paris, this Paris that Ilya Ehrenburg explained affectionately to his astonished Parisian friends, having wandered through it at such length.
Full frame.

**A quiet nap, quai de
la Mégisserie, Paris, 1954**
NEGATIVE: 2¼×2¼ IN. (6×6 CM) _ P24/158
—— 147

Perhaps a little weighed down by a heavy meal, this Parisian had fallen asleep on a bench, not at all bothered by the noise of the buses zipping along behind him. It was the beginning of the summer of 1954 and the plane trees were already losing their most fragile leaves. The name of a restaurant, which can be read through the bus windows, specifies the location of the scene. Almost full frame.

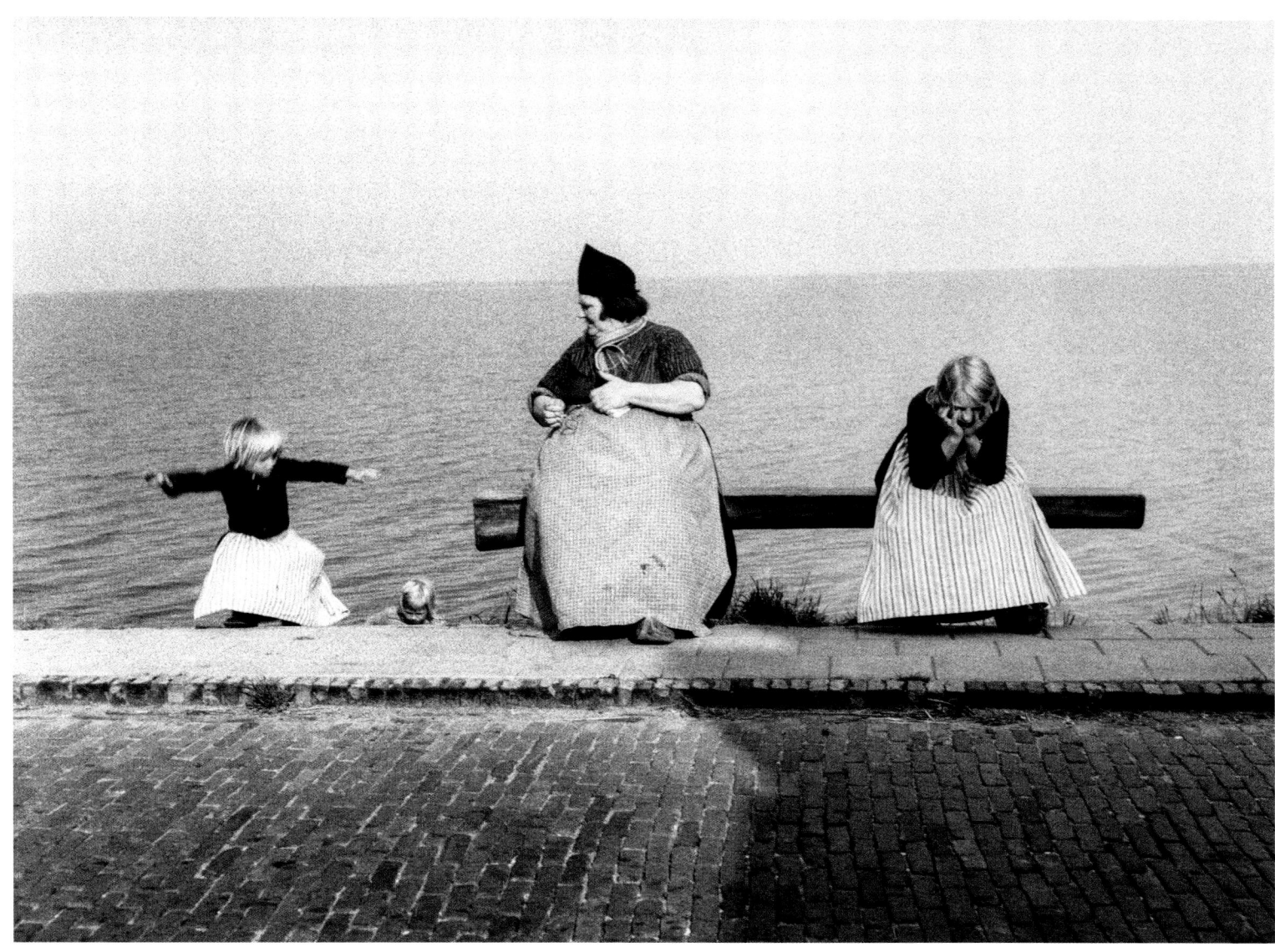

Quai de la Mégisserie, Paris, 1954
NEGATIVE: 2¼×2¼ IN. (6×6 CM) _ P24/161
___ 148

Probably on the same day. I crossed the road to the side the stores were on: seed sellers, nurseries, plants, and animals of all kinds. Aquariums overflowed onto the sidewalk, at an angle. I had fun positioning myself so as to overlay the fish and the pedestrians. Full frame.

On the dike at Volendam, Netherlands, 1954
NEGATIVE: 2¼×2¼ IN. (6×6 CM) _ H24/185
___ 149

July 1954. Our trusty 2CV was one year old and Marie-Anne and I took it for a spin in Holland. That evening, we explored the Volendam dike, on foot of course. These two women interested me: the thin one lost in thought, the larger one serenely resting on her broad rump. What would I do? Suddenly, the little girl with the black sweater burst onto the scene, off balance at the end of her climb, arms spread to shift her weight forward. The perfect parallel with the women's bench, her arms were the signal for me to release the shutter. It was only later, during printing, that I discovered the other little blonde head at the edge of the dike. Print to be balanced between the differently lit sections of the road. Cropping top and bottom.

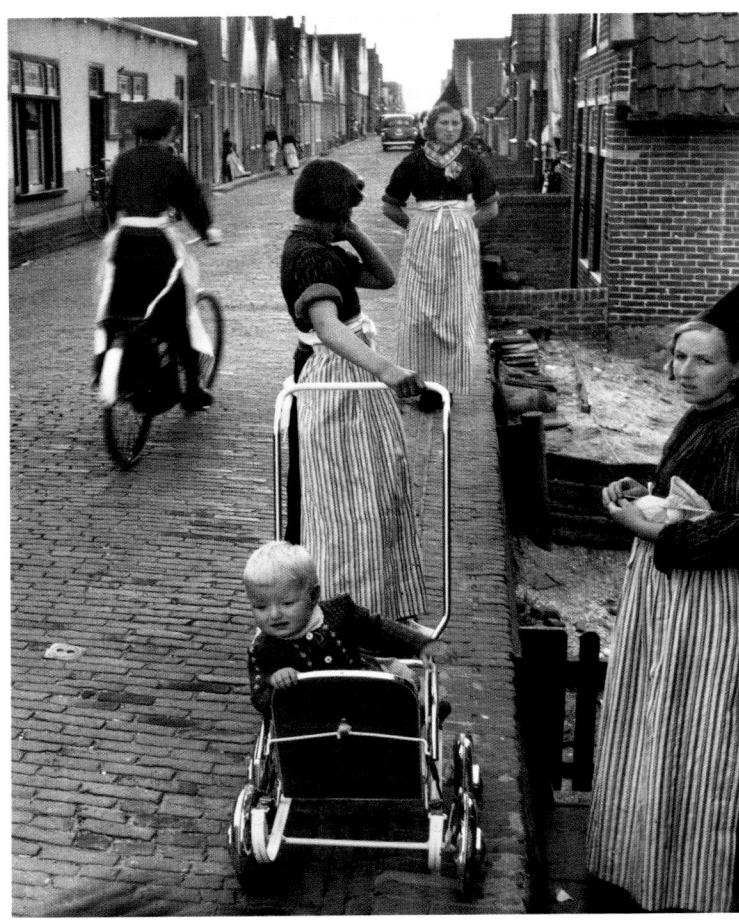

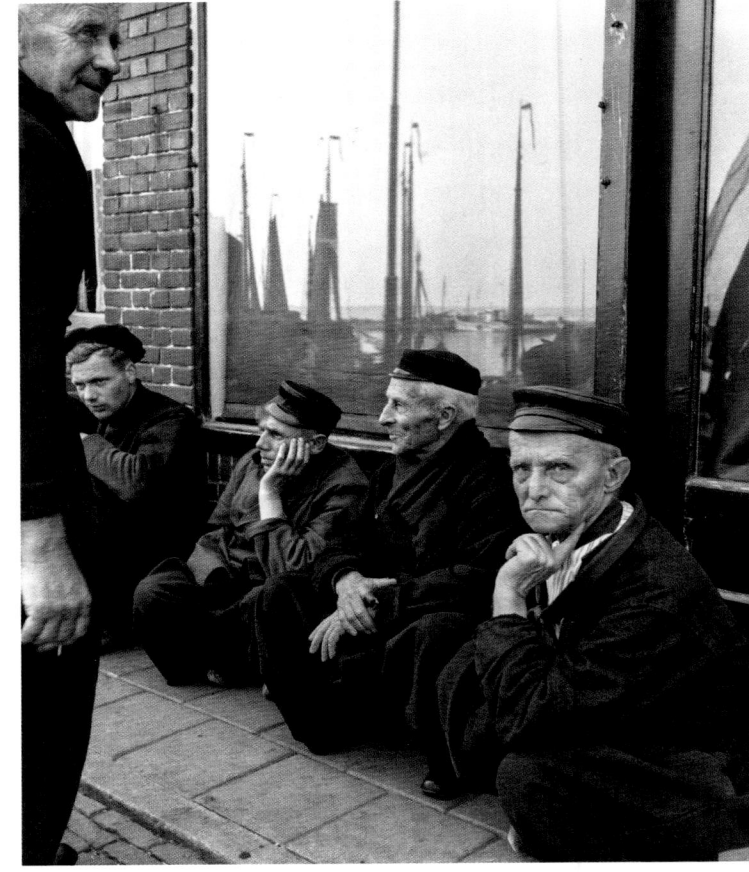

Evening on the dike at Volendam, Netherlands, 1954

NEGATIVE: 2¼×2¼ IN. (6×6 CM) _ H24/190

___ 150

Same place, same day, at dusk. These long vertically striped aprons were somehow fascinating in their shifting repetition. The three women were in conversation, each in front of her garden. The parallelism was emphasized by the chrome of the child's stroller and the gables of the houses in the distance. The empty space on the left was suddenly filled in perfectly by the cyclist riding at full tilt. A moment of unspeakable joy. Perhaps I had just made my day. I would only have my answer later. The small aperture chosen (f/16) ensured a great depth of field. The same need to fill a void on the left, after a long wait, would be satisfied fifteen years later, in Venice in *Calle della Bissa* (see photo 246). Cropping on the left.

Fishermen in Volendam, Netherlands, 1954

NEGATIVE: 2¼×2¼ IN. (6×6 CM) _ H24/192

___ 151

Volendam, the following day. The men's corner: this is the kind of photograph that I have difficulty commenting on. I was asked to include it in my selection, which I would not have done naturally. Which means that the author is not always the best judge of what he produces: a very troubling finding. Light cropping on the right.

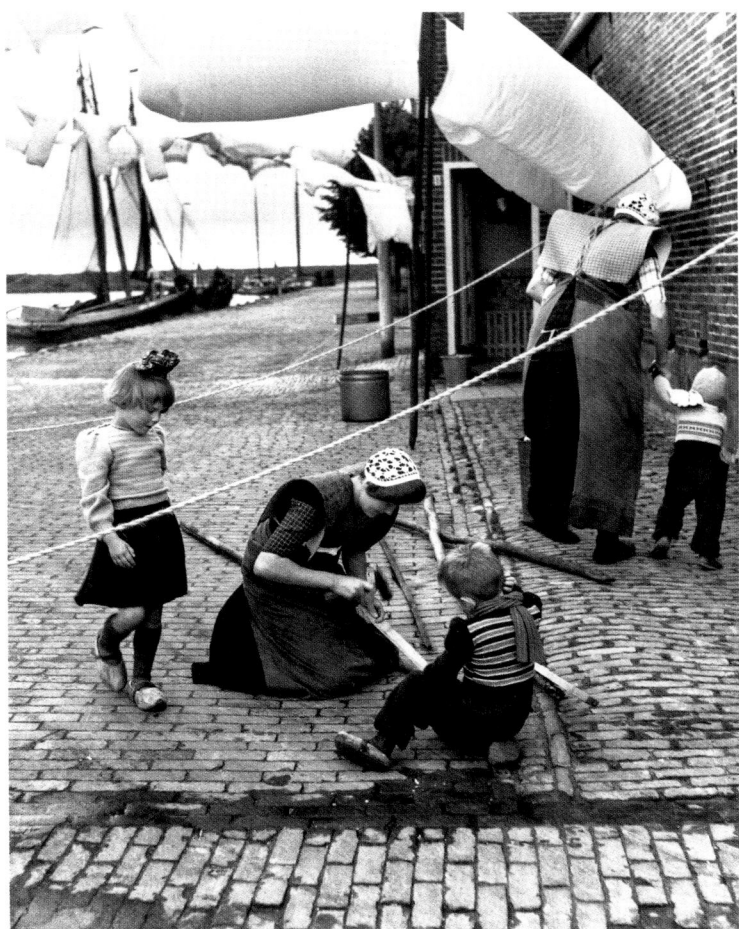

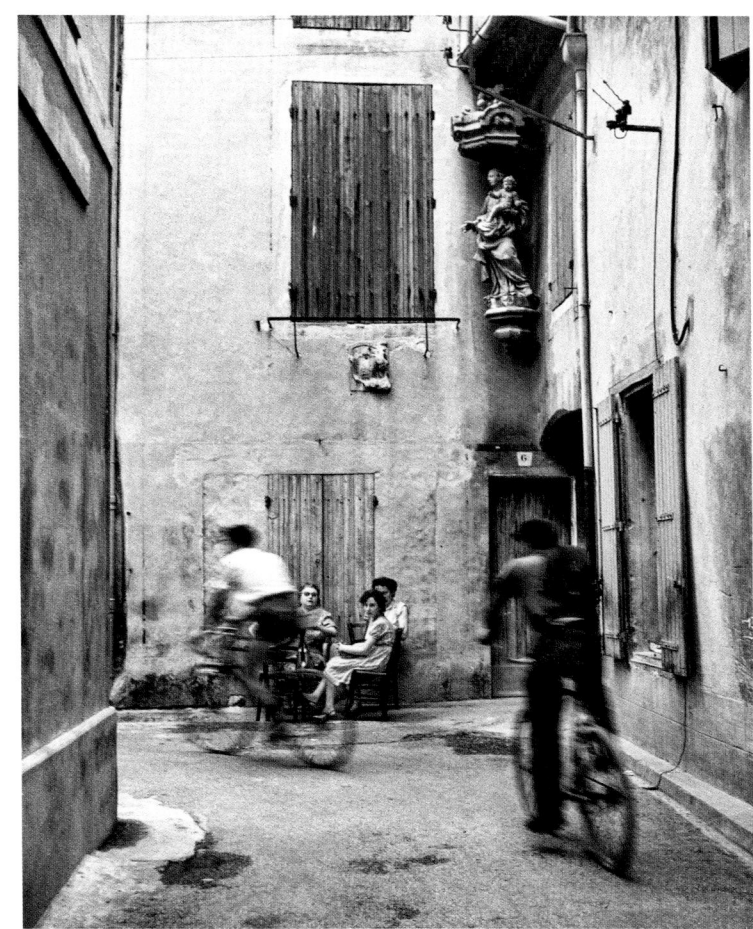

Spakenburg, Netherlands, 1954
NEGATIVE: 2¼×2¼ IN. (6×6 CM) _ H24/225
___ 152

Spakenburg: a small port encountered by chance to which we have returned many times, if only because it is located out of the way and is little visited. The wind was blowing the laundry, and a mother was putting together a toy for her little boy. The positioning of the five characters was suddenly so well organized that the photograph almost took itself. Lateral cropping.

Bollène, Vaucluse, 1954
NEGATIVE: 2¼×2¼ IN. (6×6 CM) _ F24/485
___ 153

This roll is marked "September 12, 1954." On this day we left Gordes to see friends in Bollène. During another little walk in the quiet old town, two cyclists suddenly overtook us, projecting into the frame, their silhouettes blurred by their speed (low light required a 1/25 second shutter speed, which is just fine). I have already mentioned my predilection for the mixture of sharpness and the blur of movement—a very evocative means of expression "invented" by photography and specific to its syntax. We have already seen this combination, deliberately produced in the photograph of the hunter at dusk (photo 114) and, later, in the child in a crowd (photo 160); or freely accepted in place Vendôme (photo 45) or at the fairground (photo 139). We will see it again later, in Venice, with the dockworkers passing by (photo 250), and in the breakdown on the highway (photo 281). It is not a question of using a certain device to appear modern, but of admitting that beyond its primary function—letting light pass through it for a given time—the shutter can fulfill an expressive function. In this case, without any warning—I was only going to photograph the three women on the street corner—my two cyclists appeared, incorporated thanks to a fortunate reflex, injecting this calm photograph with unexpected zest.

The office of the writer Georges Borgeaud, Gordes, Vaucluse, 1954

NEGATIVE: 2¼×2¼ IN. (6×6 CM) _ F24/519

___ 154

I had been to visit the writer Georges Borgeaud in the retreat near Gordes that had been lent to him by friends, and I found it to be very evocative of the calm environment where one should feel comfortable enough to create an artwork. The cat, a silent but merciless judge, mysteriously completed this composition in which I had almost nothing to alter. A shutter closed to f/22 (and a very stable piece of furniture used in lieu of a tripod) ensured a depth of field ranging from the first inkwell to the cat itself. All that was left to do was to press the button. The print is difficult to balance between the underexposed foreground and the sun in the distance. Lateral cropping.

Dog cemetery, Île d'Asnières, Seine, 1954

NEGATIVE: 2¼×2¼ IN. (6×6 CM) _ F24/872

___ 155

I was working relentlessly on an assignment on the islands of Paris. But the parameters of the project remained unclear, and as I gradually delivered images, a difference of opinion between me and the editor in the project's conception became apparent, too vast to ever resolve. Anticipating that the assignment would lead to a book that no longer interested me but too committed to back out, I decided to simultaneously conduct my own adventure, with no specific goal, between Le Perreux-sur-Marne and Le Port-Marly, since I was fascinated by my scouting trips. I did not imagine it would last three years. This image was taken on All Saints Day at the dog cemetery on the Île d'Asnières. Lateral cropping.

A meadow on Île Saint-Denis, Seine, 1954

NEGATIVE: 2¼×2¼ IN. (6×6 CM) _ F24/888

___ 156

In the course of the same project, I found myself in the late afternoon on Île Saint-Denis—that huge strip of land that was three quarters wasteland at that time. Out of the almost total solitude, in the distance, emerged the little silhouette of a girl picking flowers. I approached and framed the shot so that the factory chimneys clearly emphasized the identity of the place. The backlight illuminated the whole scene nicely, with its already heavily slanted rays. Be careful to keep details in the clouds. Cropping top and bottom.

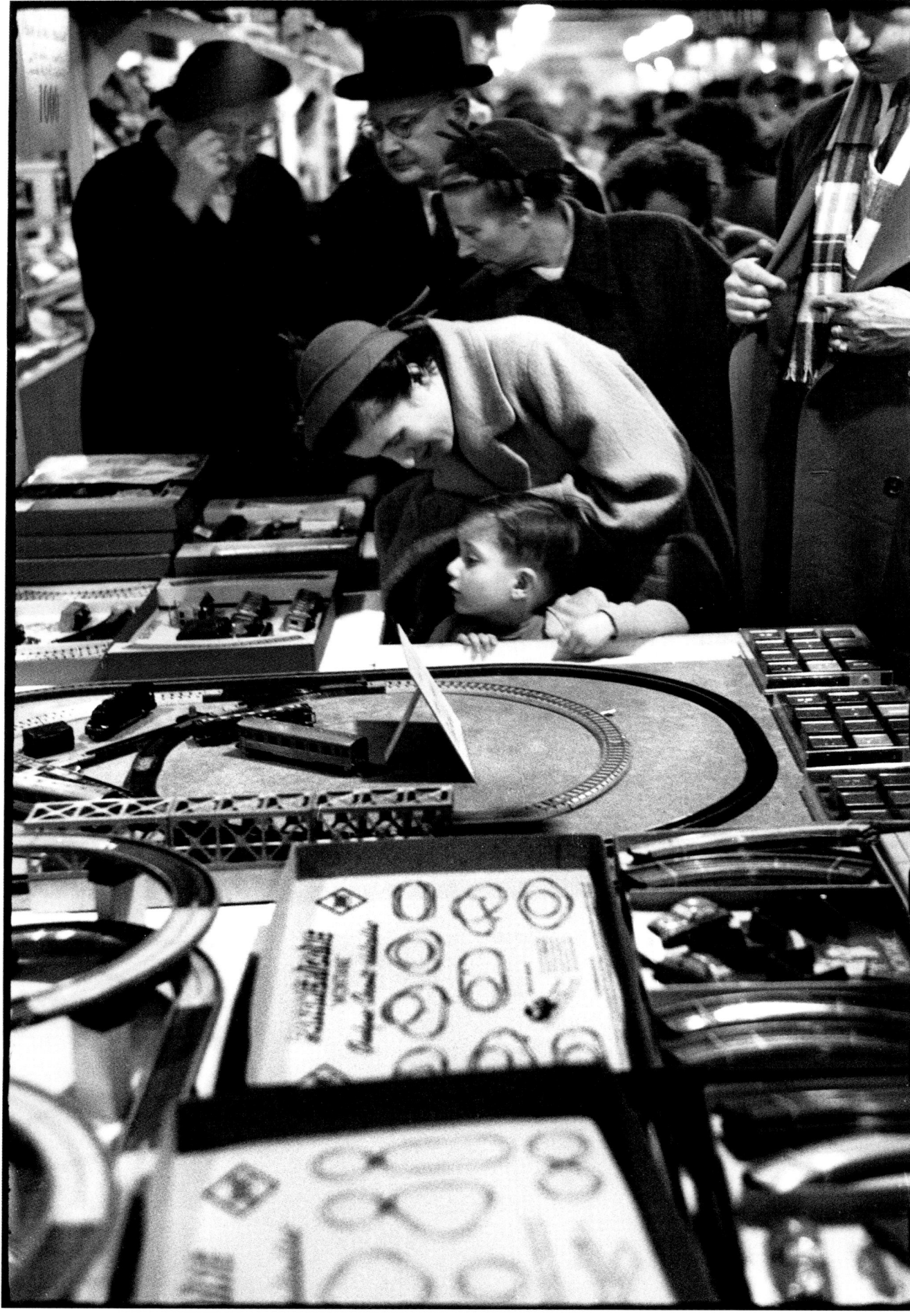

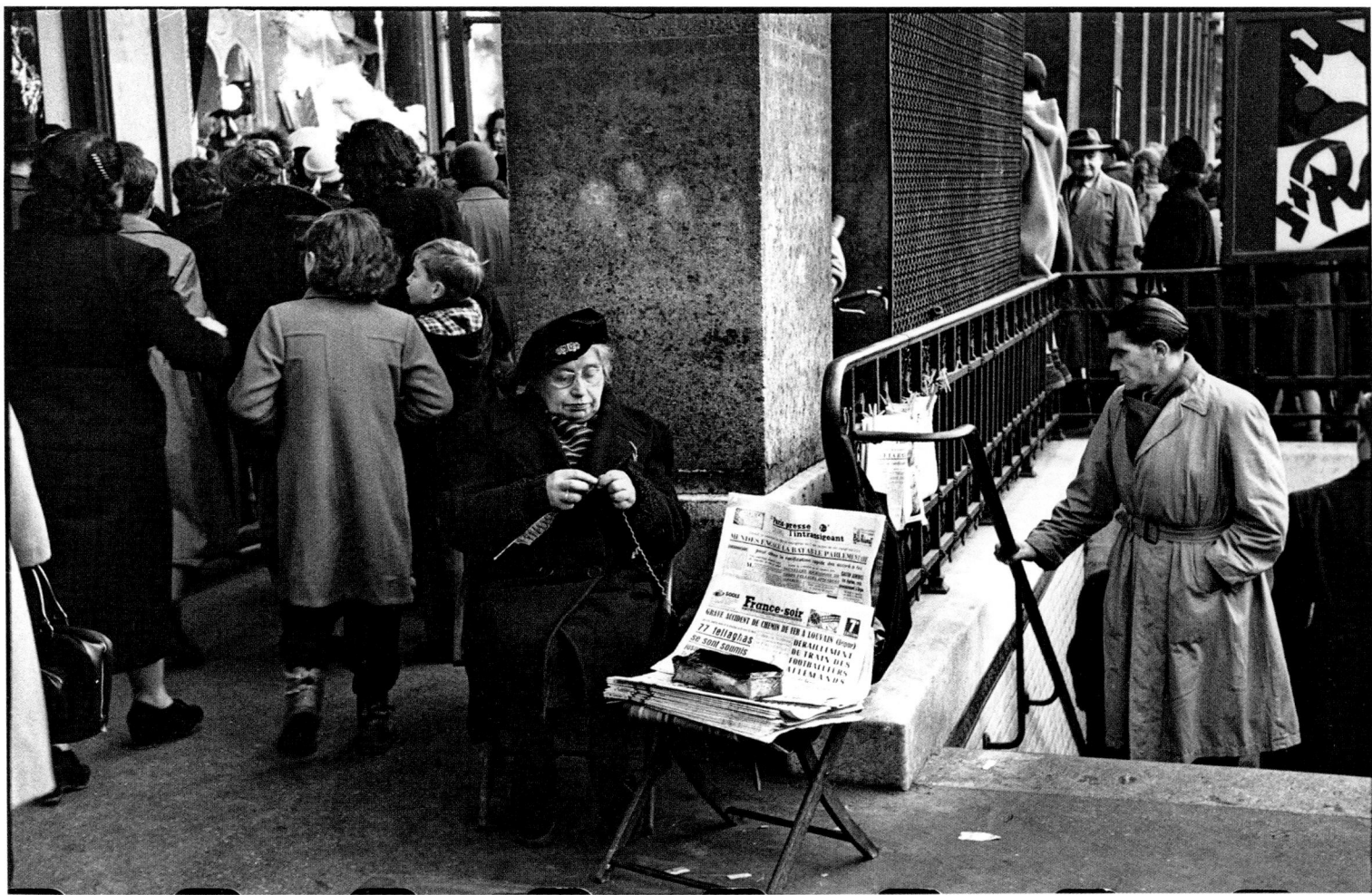

Christmas week, in a department store, Paris, 1954
NEGATIVE: 24×36 MM _ R1/1531
— 157

This photograph marks the beginning of the period in which I abandoned the 2¼ × 2¼-in. (6 × 6-cm) format for 35-mm film (let's disregard the few negatives made with a Contax in 1930, which were only an accident), on the combined authority of Chim, Capa, and Cartier-Bresson. I cautiously began with borrowed cameras. It was really in March 1955 that I acquired one after another, following a very generous deal negotiated with Optique et Précision de Levallois: three Foca bodies, with the five basic lenses and the turret viewfinder, a Foca SLR body with a 105-mm macro lens with a 1:1 magnification ratio, plus a 200-mm lens; the 105-mm for reproduction work and portraits, the 200-mm for occasional use (see photos 233 to 236). The few 24 × 36-mm format photographs that are shown here follow on from a series started in 2¼ × 2¼-in. (6 × 6-cm) format before Christmas 1954. I both felt more at ease with the new format and faced new problems: the choice of vertical versus horizontal, the ethical tendency toward full framing, the new way of viewing the shot through an optical device (turret viewfinder), etc. Not to mention the interchangeability of the lenses, which would only take place gradually. The photograph on the facing page was made in one of the three department stores that I had chosen: Galeries Lafayette, Printemps, and Grands Magasins du Louvre. To print this negative (another backlight!) the highlights and shadows must be respected, without favoring one over the other. Full frame.

Christmas week, Palais-Royal metro, Paris, 1954
NEGATIVE: 24×36 MM _ R1/1813
— 158

Around the central axis composed of the knitting newspaper seller, a traveler emerges on the right from underground and is immediately engrossed in the news, while on the left a crowd gathers in front of the Louvre department store windows. The girl with the light-colored coat and her mother wearing a dark one appear head-on in the lower left corner of the next photograph. Difficult print to balance, high contrast. Full frame.

Christmas week, place du Palais-Royal, Paris, 1954
NEGATIVE: 24×36 MM _ R1/1815
___ 159

This photograph is one of my most reproduced images. It is not up to me to analyze it. It is proof at least of my determination to master the "global vision" of the frame picked up in the viewfinder, from a completely unstable situation. My longstanding habit of framing at eye level with the sports viewfinder of the 2 ¼ × 2 ¼-in. (6 × 6-cm) allowed me to fall on my feet with 35-mm. Almost full frame, except slight cropping to the right.

NB: When I do not mention the lens, it's the standard 50 mm.

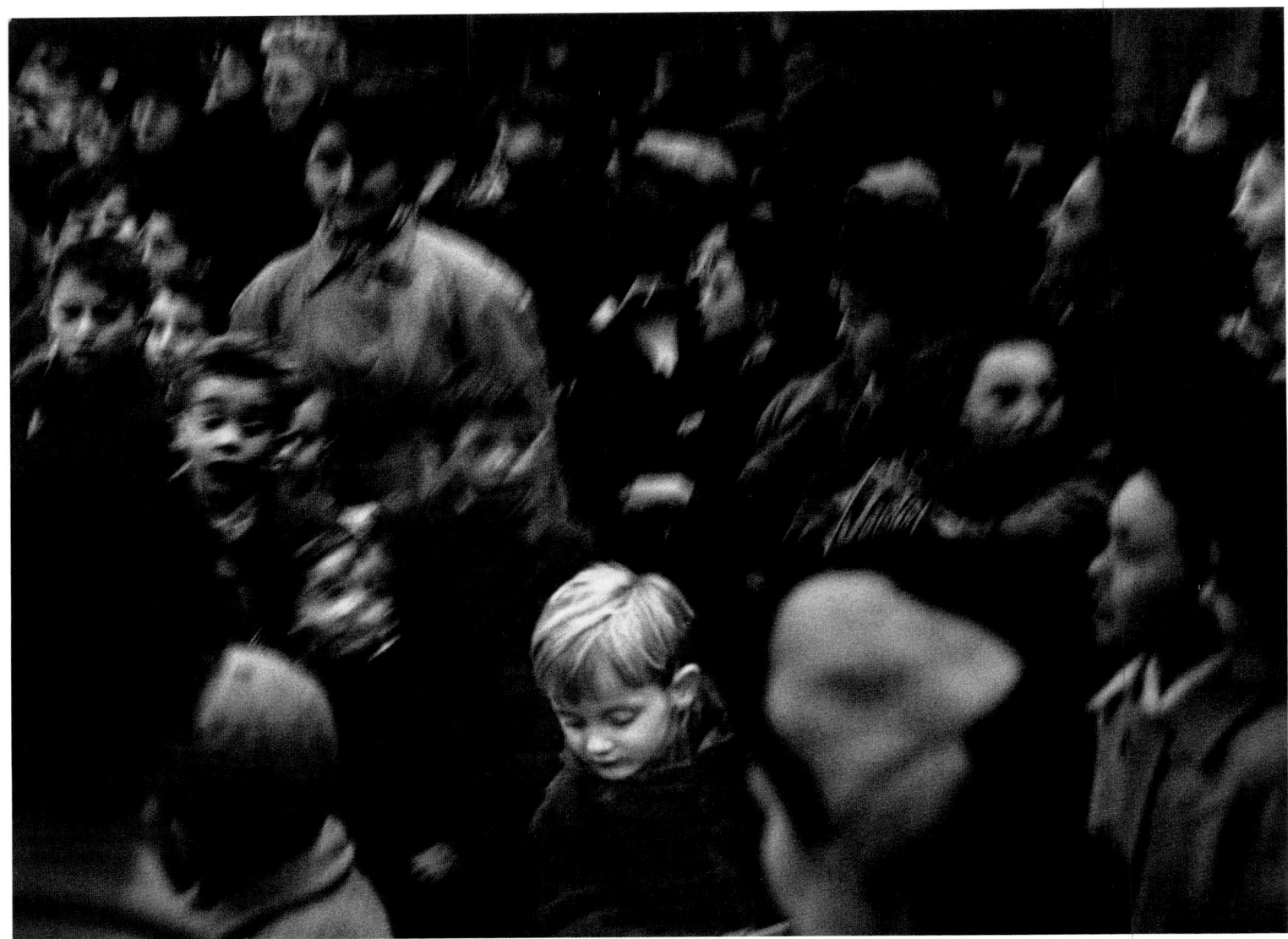

Christmas week, Paris, 1954
NEGATIVE: 24×36 MM _ R1/2303
—— 160

The same day or the following day. A risky kind of photograph, as it requires blocking the movement of a chosen character by following him scrupulously in the viewfinder for 1/5 second so that his image is frozen on the negative while everything else is part of a more or less marked blur. We have already seen a simpler example with the photograph of the hunter at dusk (photo 114). And as it is often impossible to repeat the experience immediately, failures are hard felt. Almost full frame.

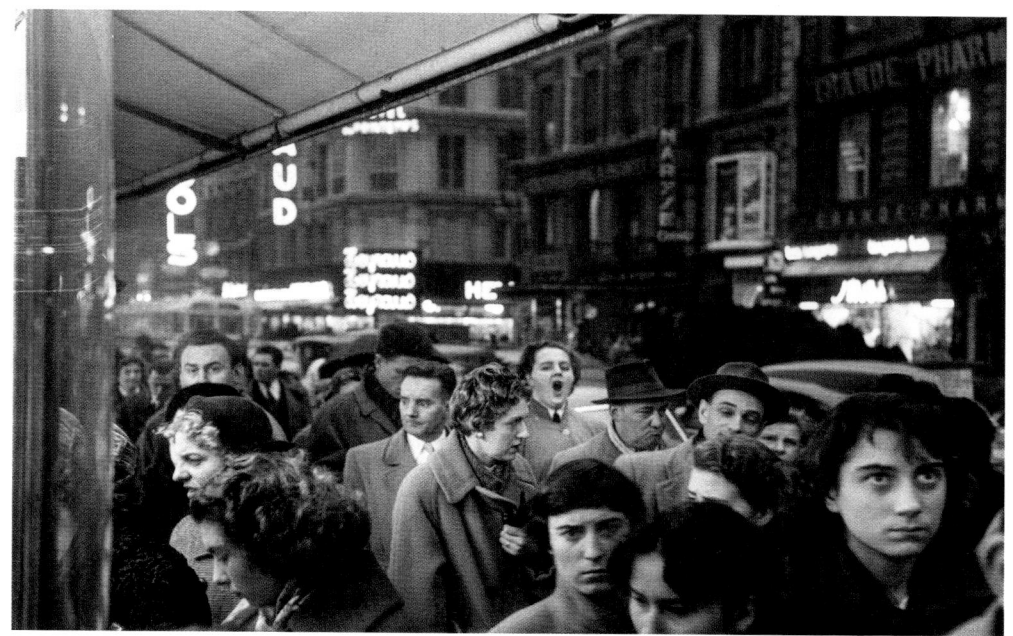

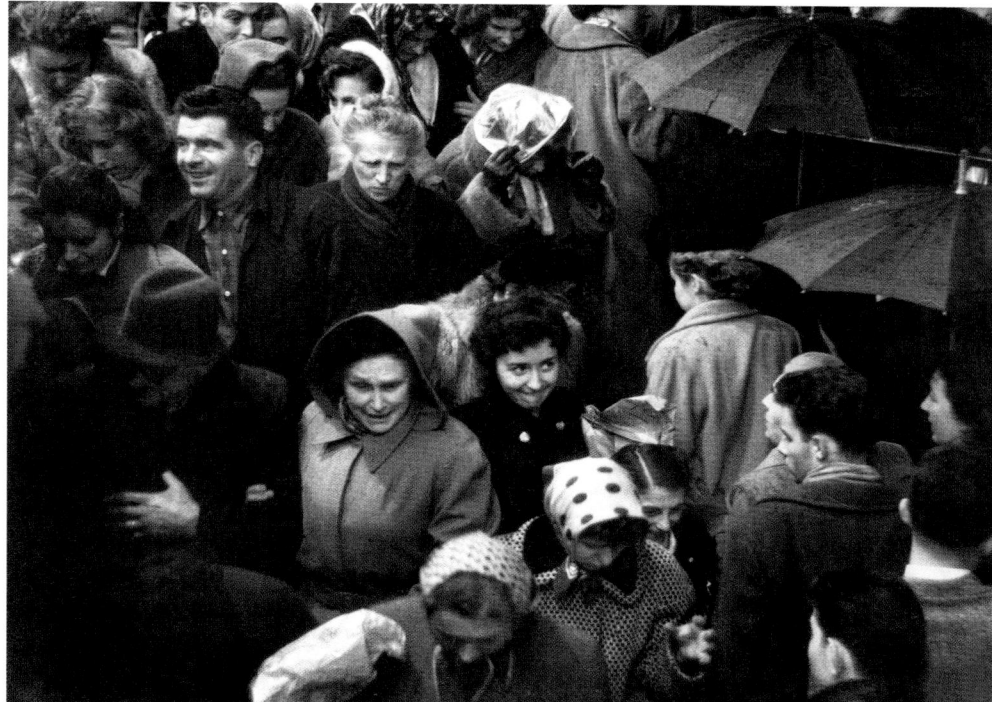

**Office-quitting time,
rue du Havre, Paris, 1954**
NEGATIVE: 24×36 MM _ P1/2702
—— 161

Rue du Havre at 6 p.m., in December. People were leaving the office and on the face of each individual could be discerned their individual concerns, including weariness. The unchecked yawn of the young woman in the center motivated me to release the shutter. Here again, in order to overlook the scene I found a little improvised lookout. When you are only 5 ft. 6 in. (1.68 m) tall this is a constant concern. Full frame.

Entering Havre-Caumartin metro station on a rainy evening, Paris, 1954
NEGATIVE: 24×36 MM _ P2/1114
—— 162

Entering and exiting the metro, probably Havre-Caumartin. It was raining, people were hurrying, glances were exchanged. Curiously, there was a certain relaxed atmosphere which, a few seconds later, could easily have turned to aggression. That is the inevitable haphazardness of any random slice of time. Above all, don't draw conclusions. Almost full frame.

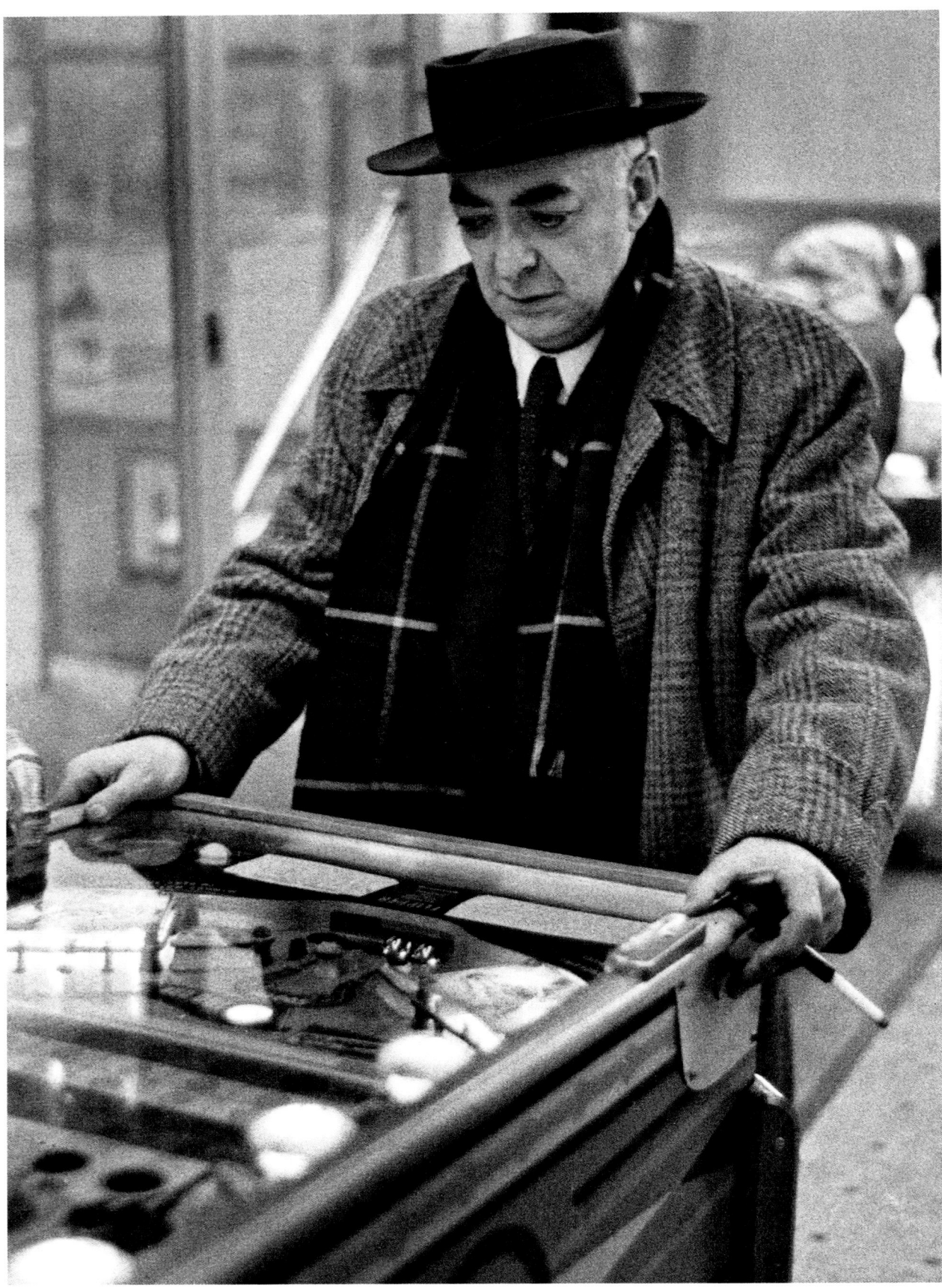

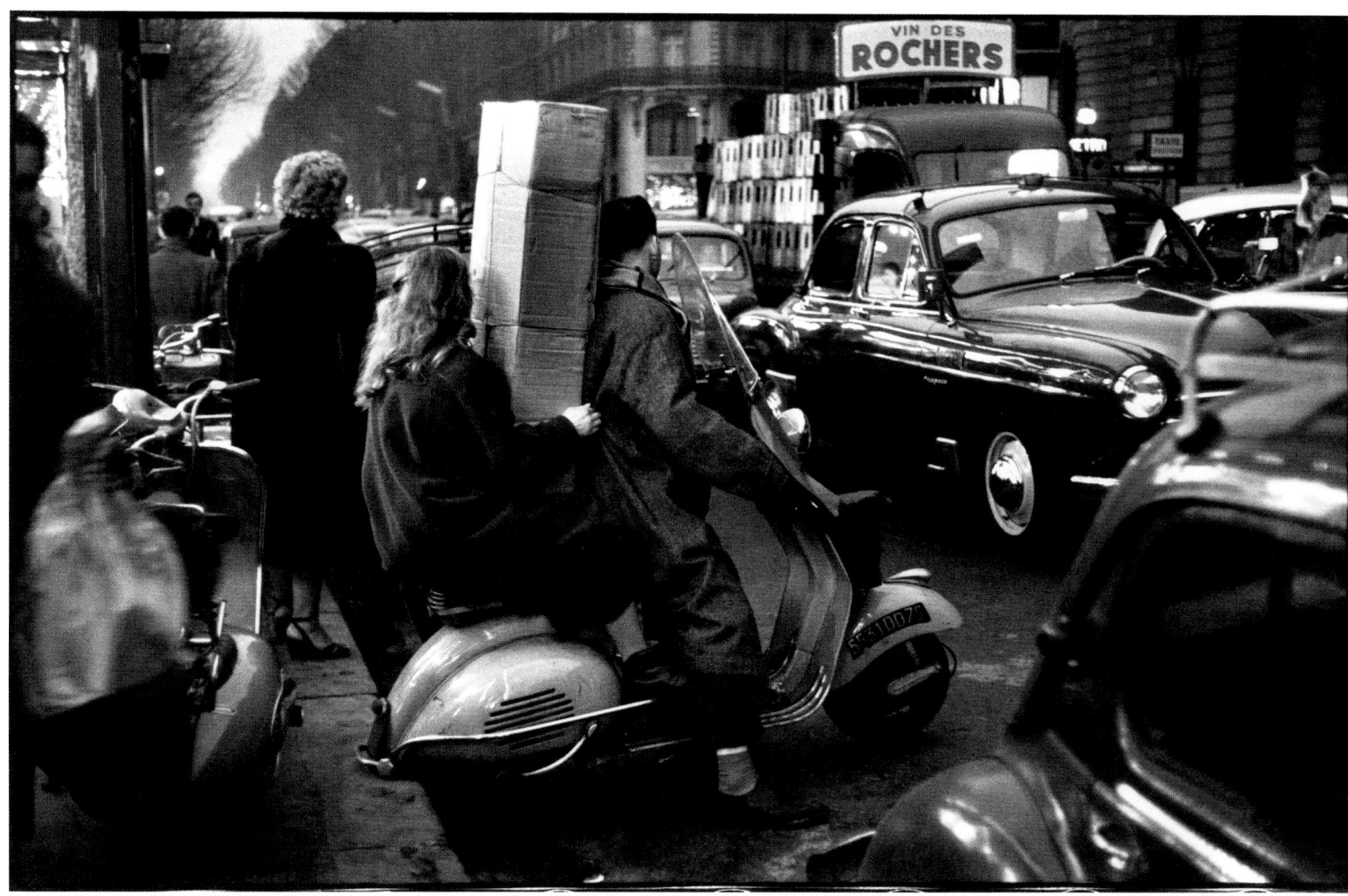

Brassaï, Paris, 1954
NEGATIVE: 24×36 MM _ 2/1509
___ 163

Brassaï and I had just left a photographers' meeting and we took our mind off things by trying our hand at pinball in a neighboring bistro. Always very well dressed, his umbrella hanging on the edge of the machine so as not to lose sight of it, a cigarette securely anchored in a long cigarette holder in his left hand, he weighed up his chances with the amused seriousness that he brought to everything. Almost full frame.

Christmas week, boulevard Haussmann, Paris, 1954
NEGATIVE: 24×36 MM _ P2/2121
___ 164

December 1954 was a prolific month. My excitement was triggered both by the electric Christmas atmosphere and by my enthusiasm for a new tool, which I was only just beginning to get a handle on. It was twilight on boulevard Haussmann; this couple on a scooter was trying to squeeze into the traffic. That peculiarly Parisian bustle of traffic during rush hour. A typical little Parisian scene. Print to be balanced according to the areas of over- and underexposure. Full frame.

**Meeting of young people in a
cellar in Belleville, Paris, 1955**
NEGATIVE: 24×36 MM _ R3/1512
— 165

Jean-Pierre Chabrol had just flipped through
my book *Belleville Ménilmontant*. As he
was a freelance journalist for *Regards* and
I was a freelance photographer for the same
weekly, we would sometimes meet up. He
suggested doing something together on a
group of young people who met regularly
in a cellar in Belleville. This was January
1955. At the time, power outages were
common and there was always a pack of
candles in the cupboard. And so it was
solely by candlelight that this part of the
report took place. This image, taken from
the same report, was published in my book
Sur le fil du hasard (On Chance's Edge).
All the photos showing the group
as a whole were taken with 35-mm,
because of the lack of space and to
ensure maximum depth of field.
During printing, the top of the candles
and the flames need to be overexposed,
without going overboard, to mitigate
the halo effects. Full frame.

**Chez Victor, bistro-guinguette,
impasse Compans in Belleville,
Paris, 1955**
NEGATIVE: 24×36 MM _ R3/2138
— 166

At the far end of impasse Compans there
was a bistro-*guinguette* with a view across
the north of the Parisian suburbs, from
the Sacré-Coeur basilica to the skyscrapers
of Bobigny. It was called Chez Victor. Our
report continued a few days later. Egged
on by Jean-Pierre, one of the youngsters
got up and sang a fashionable song (his
head can just be seen in the mirror at
the back, all the way on the left). A local
tradesman listened on, while the owner
busied herself behind the bar. The Parisian
daylight lit up the place, and I wanted
to capture the familiar atmosphere of
bistros like this one, which still existed
all around this working-class area.
Shot with a 35-mm lens, framing a little
cut off to the left, probably because
of my index finger inadvertently
encroaching on the lens.

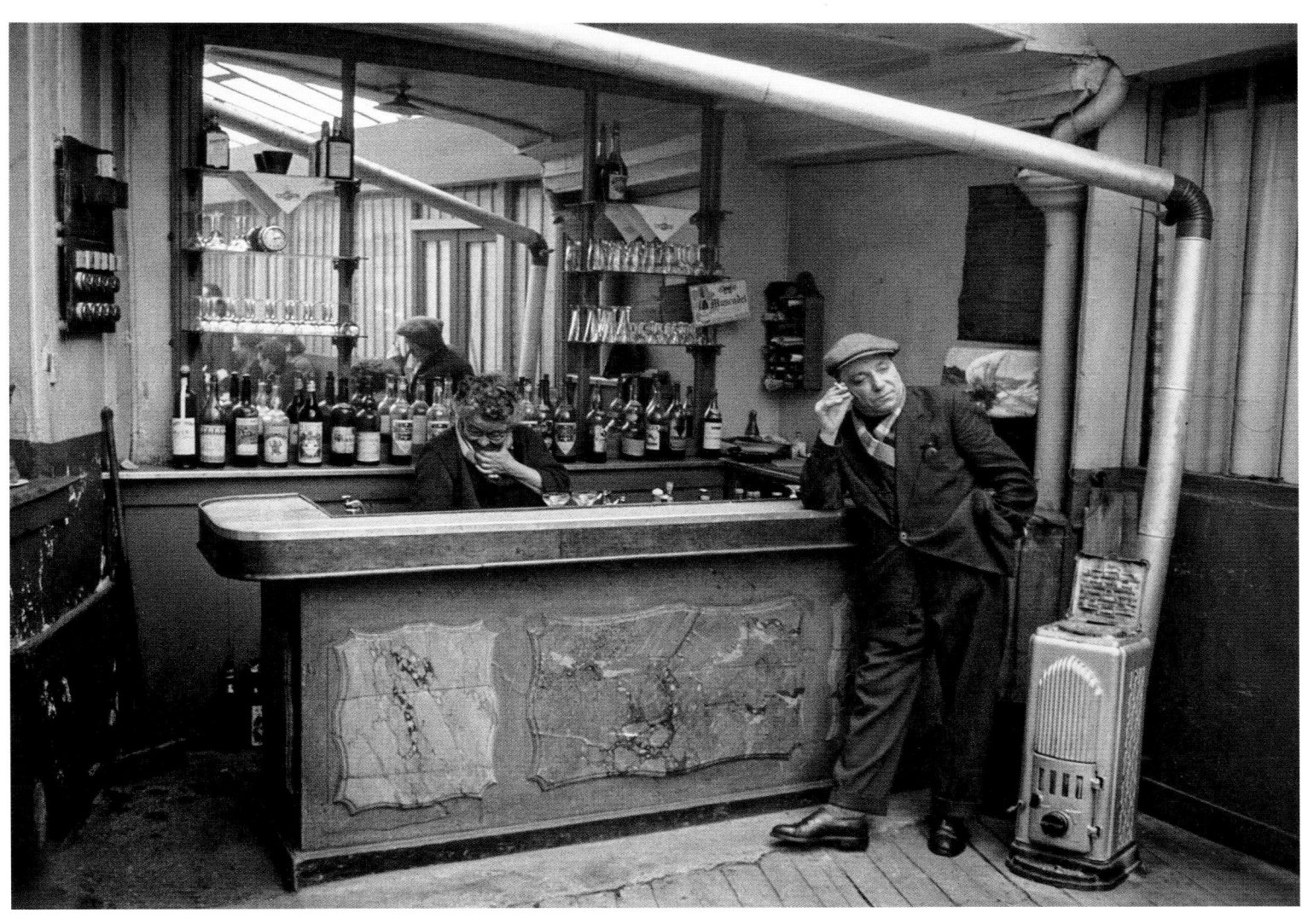

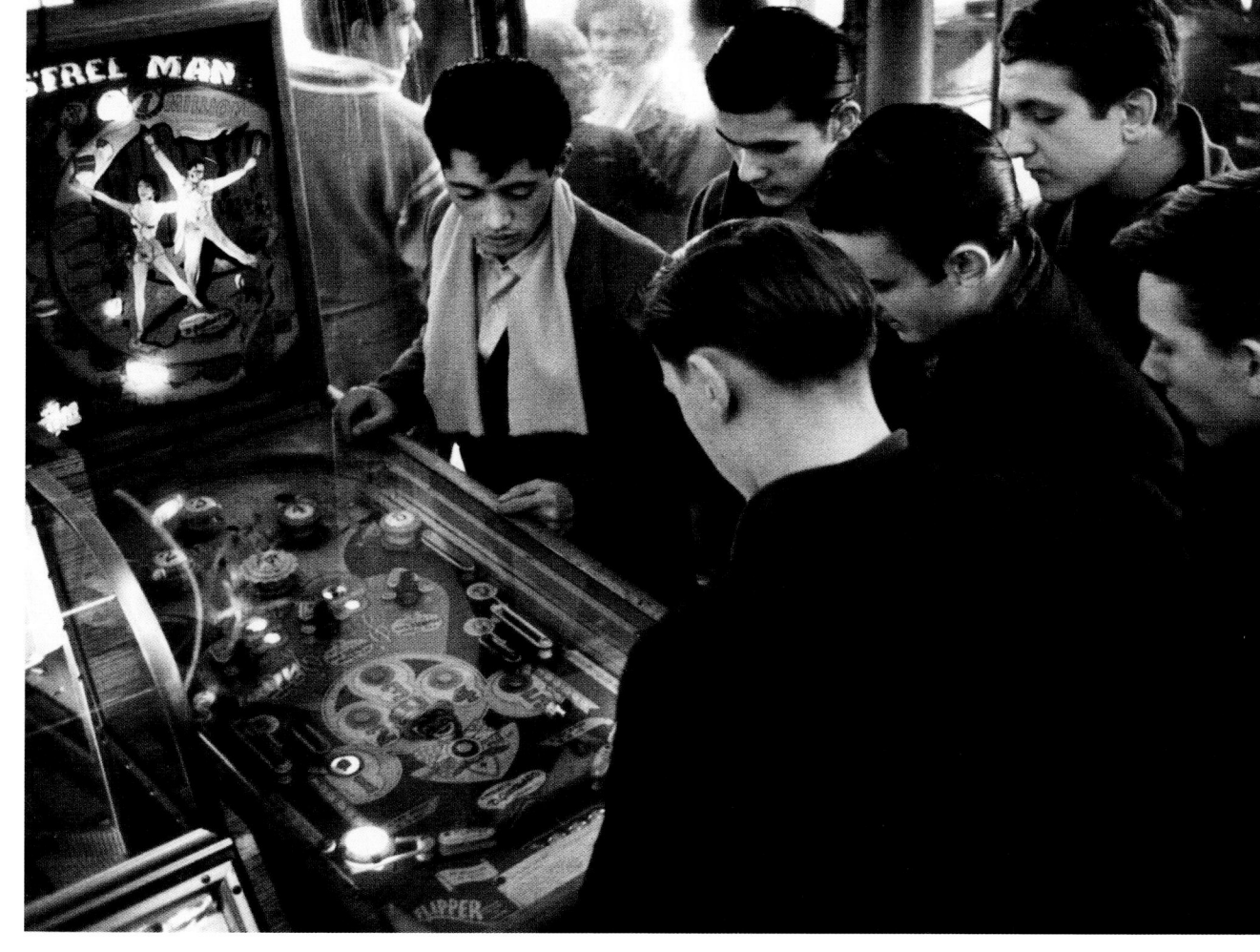

In a bistro on rue de Belleville, Paris, 1955
NEGATIVE: 24×36 MM _ R3/2135
___ 167

Same project, back in a bistro on rue de Belleville. Some girls had come to join the group. There were not many; apparently they were merely tolerated and only then at specific times. 35-mm lens. I'm probably perched on a crate of beer. Print to be balanced: mixture of interior electric light and outside daylight. Almost full frame.

Café on rue Mouffetard, Paris, 1955
NEGATIVE: 24×36 MM _ P4/1002
___ 168

From one bistro to another. I could easily be mistaken for a barfly, which would be an error: I find them practical for relaxed meetings and, above all, I love watching them from the outside, like looking at fish in an aquarium. The only thing I know about this café is that I encountered it in February 1955 on rue Mouffetard. At the same time, thanks to my contact sheet I know I climbed five or six floors of an old house, from where I took a panorama of rooftops with which I was not satisfied, since the same panorama with a better composition appears on my contact sheet for May 5, 1958; it can be seen in photograph 232. Extremely difficult print because of the heavy underexposure of the details of the façade (the same difficulty comes up when printing the café in photo 266).

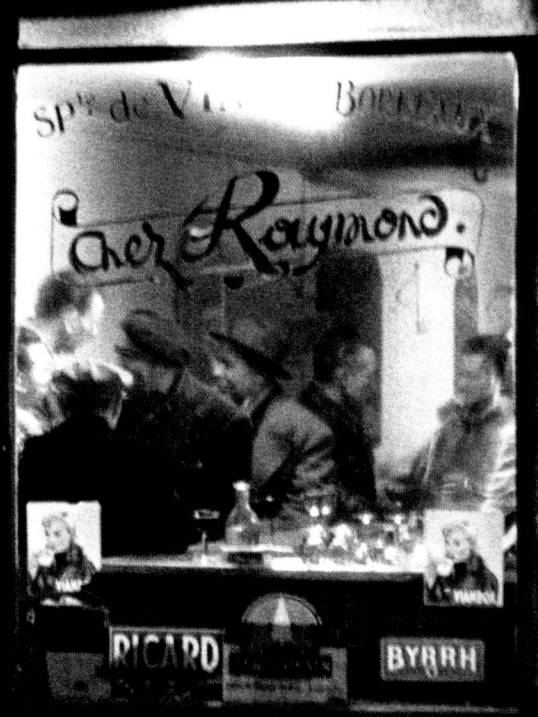

Concourse at Saint-Lazare station, Paris, 1955
NEGATIVE: 24×36 MM _ R4/2609
___ 169

Extract from a project produced in March 1955 for the magazine *Arts Ménagers*. I have forgotten what the subject was. Among others, it required a photograph of someone in a public phone booth. This one taken in the concourse of Saint-Lazare station was suitable. The woman was an editor of the publication, the men were unwitting actors. Because of the men—at once so dissimilar and so typical—this photograph was used (without the woman) on the cover of a spy novel by Noël Behn, published in paperback. It also forms part of my large, randomly composed collection of pictures based on the number three (although I do not usually realize it until after the fact). Quite difficult to print. The film I used then—Ferrania 32—was very sensitive but had an unfortunate tendency to strongly increase in contrast. Full frame.

Music store on boulevard Saint-Michel, Paris, 1955
NEGATIVE: 24×36 MM _ R4/3030
___ 170

Same project, same month. At that time there were establishments—dating back to before the war—where, by means of tokens bought from employees walking along the aisles, one could listen to records (78s) referenced in chunky catalogs. This music box was located on boulevard Saint-Michel, as you walk up, on the left sidewalk, just below rue Soufflot. Full frame.

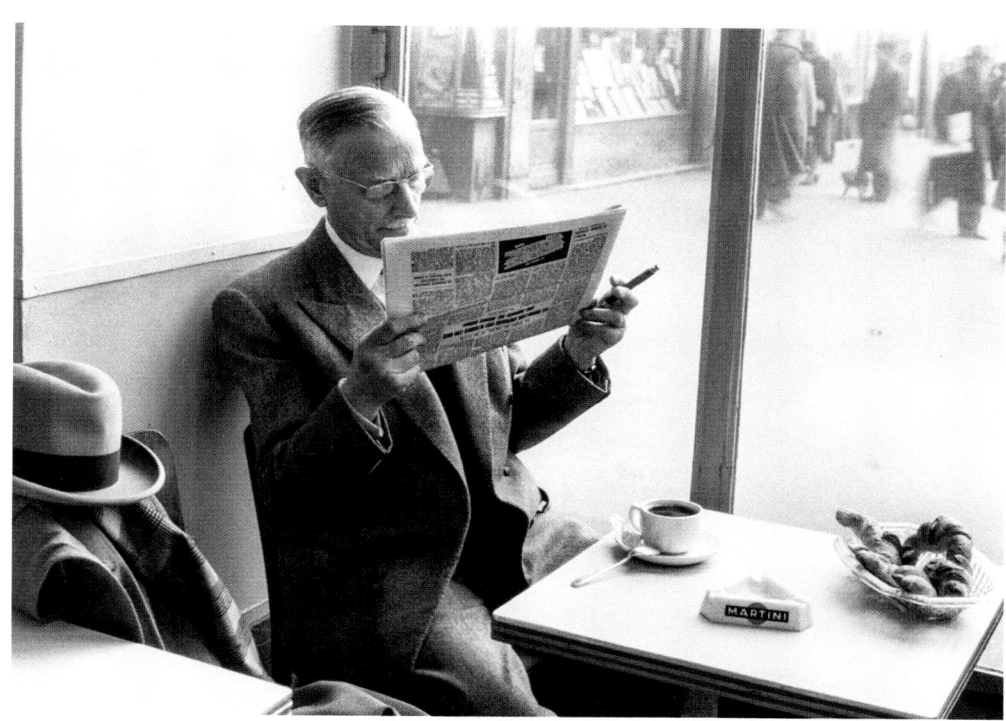

Le Colibri café, place de la Madeleine, Paris, 1955
NEGATIVE: 24×36 MM _ P5/0413
— 171

Same project, same month. An average Frenchman. This is not an impromptu image. The gentleman knew that he was being photographed. As he was naturally photogenic, it was easy. The café is called Le Colibri, located at place de la Madeleine, on the corner opposite Durand musical publishing house. I believe it still exists. Nothing to report. Almost full frame.

Cherry blossoms between Lacoste and Ménerbes, Vaucluse, 1955
NEGATIVE: 24×36 MM _ F7/0218
— 172

Look, a landscape! I say that because it's quite uncommon in my published work. We were on vacation in Gordes, and I had probably been to visit the photographer Denis Brihat that morning, in Bonnieux. Of course, I had dawdled and I imagined Marie-Anne and Vincent torn between worry and hunger pangs. So, I was driving back fast when suddenly, on a bend, not far from Ménerbes, this spectacle hit me in the gut. I was faced with a dilemma, and this is pretty much how my conflicting ideas argued:

- It's too late, I'll come back tomorrow.
- Oh no, tomorrow we are busy.
- It may rain the day after tomorrow, or the mistral could flatten everything to the ground.
- It's damn beautiful, for goodness sake, but I can't stop on a bend, and I'm already way past it. And then,
- Oh, too bad, I'll be late. I'll get yelled at, but so what?

I braked sharply on the straight, locked the 2CV, and with my Foca bag and accessories under my arm, ran back nine hundred feet (300 m), took my photograph—with a 90-mm lens to cut out the sky—resumed my race back toward the car and, for once pleased with myself and without any remorse, finished the drive home at a moderate pace. Not every successful photograph is the fruit of a battle against the odds, or a comical or pathetic struggle. But few good photographs are made by themselves, and that's also what makes this damn job interesting. Printing is a little difficult because of the backlight caused by the insufficient lens hood. Almost full frame.

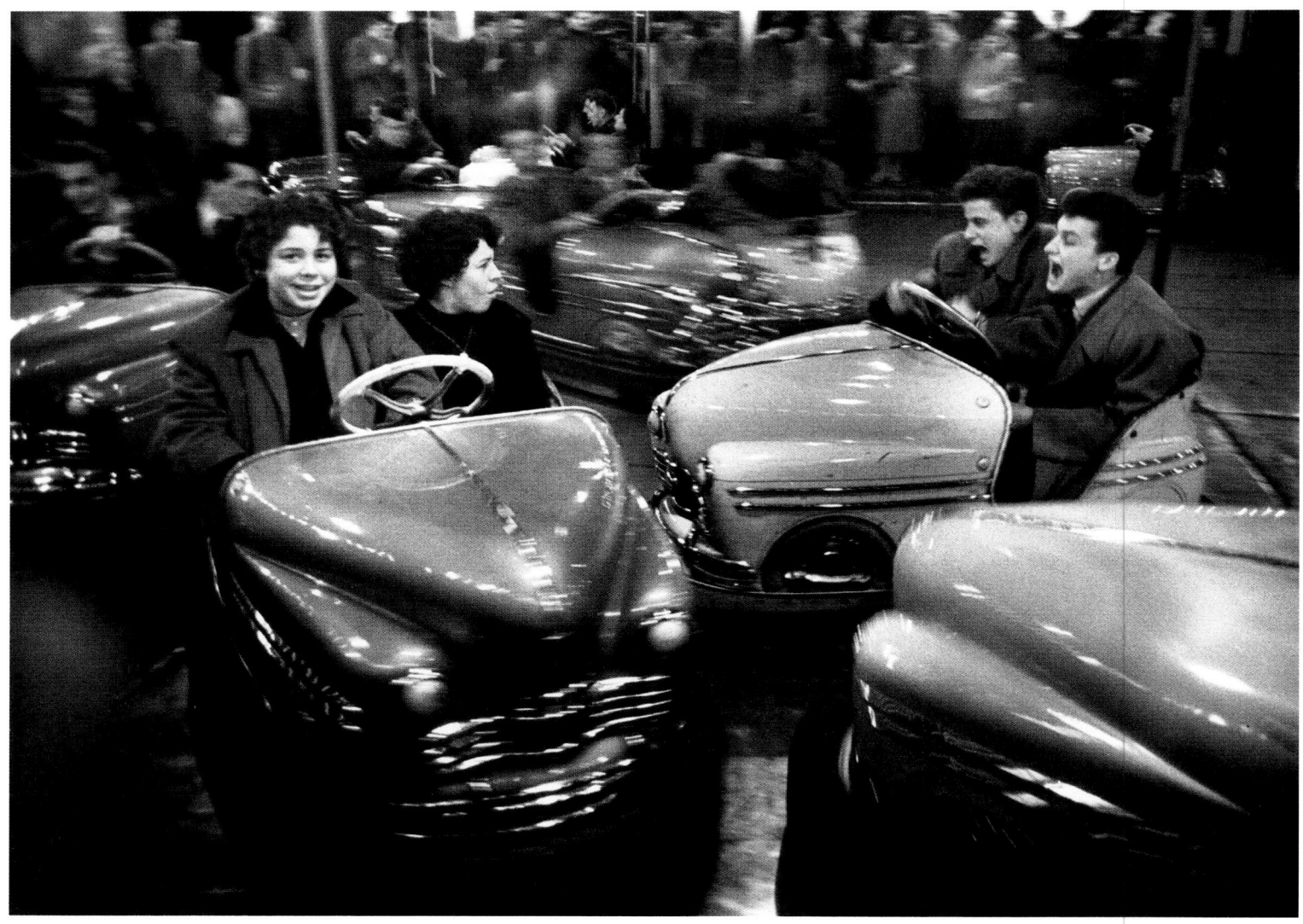

At the fairground, boulevard Garibaldi, Paris, 1955
NEGATIVE: 24×36 MM _ P7/1315
—— 173

Once again at the fair in my fifteenth arrondissement. No more Rollei—now it's the small format, with a 35-mm and a 28-mm lens, depending on the occasion. April 1955, artificial fair lighting. 28-mm. Almost full frame.

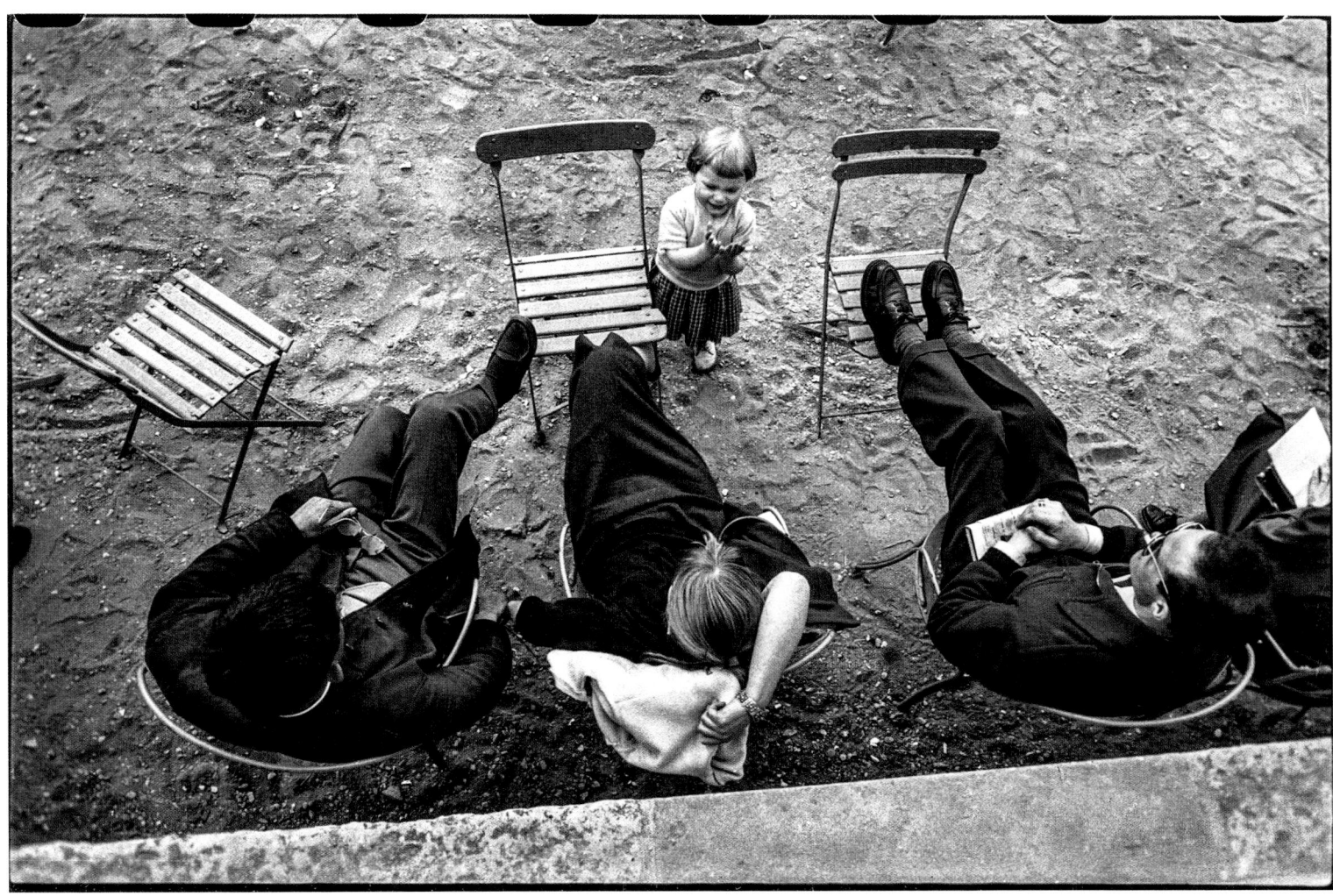

In the Luxembourg Gardens, Paris, 1955
NEGATIVE: 24×36 MM _ P7/2235
—— 174

View from the upper level in the Luxembourg Gardens on a cloudy April afternoon. I had done a lot of work around the fountain and was looking for something else. 28-mm. No particular printing difficulties. Full frame.

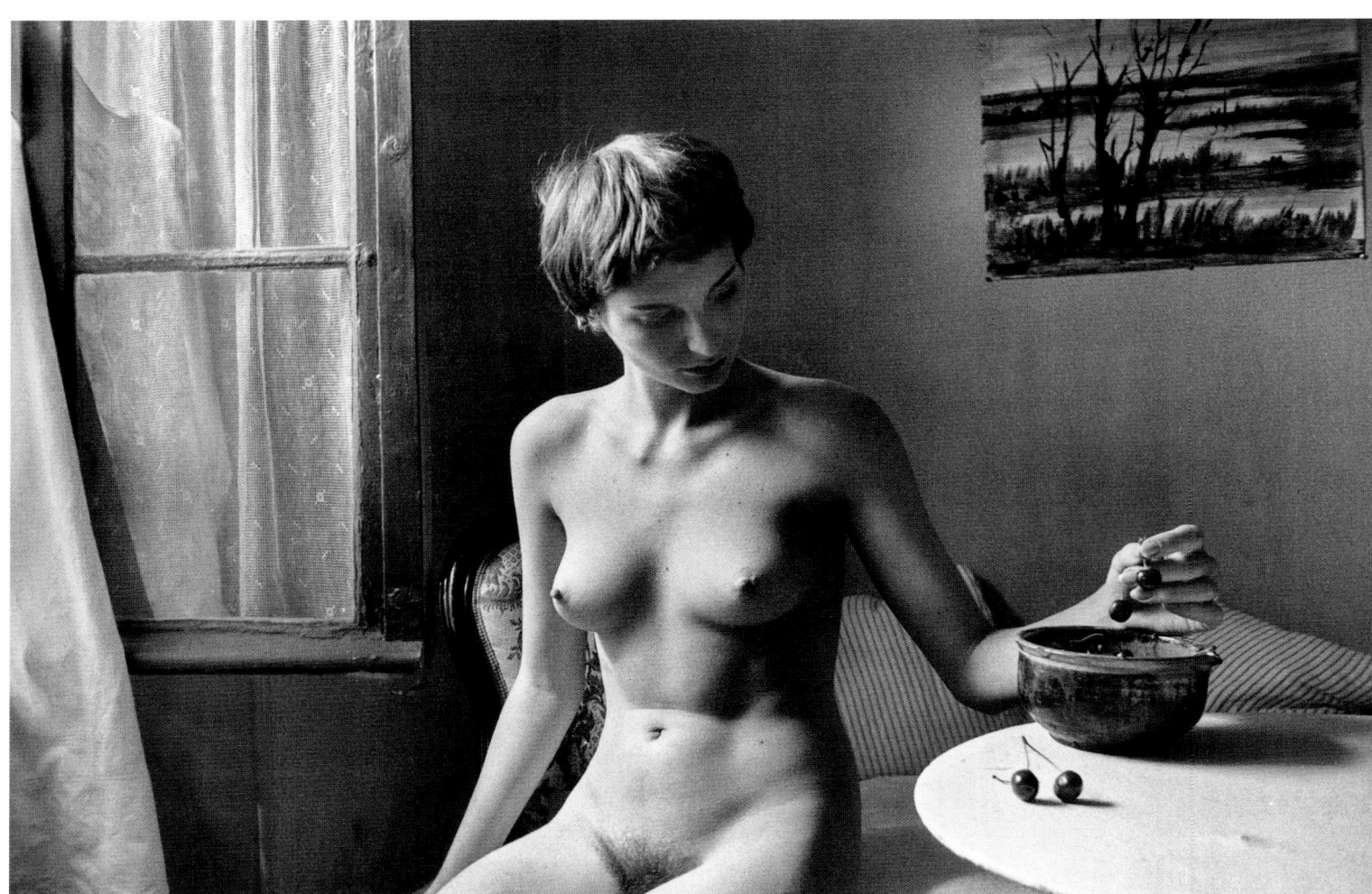

Nude, Sceaux, Seine, 1955

NEGATIVE: 24×36 MM _ D9/0725

__ 175

Two colleagues had recommended this young woman—the wife of a commercial executive, who was herself a freelance journalist—to me. Her exceptional beauty allowed her a significant additional source of income by sitting for photographers. The session took place on May 25, 1955, in the old-fashioned atmosphere of a suburban house, well lit by daylight. Almost full frame.

Nude from the back, Sceaux, Seine, 1955

NEGATIVE: 24×36 MM _ DUPLICATE _ D9/0728

__ 176

Same place, same day, same model. The lighting is more complex. I had stretched a tablecloth across the window, up to a few inches above the top of the frame. Direct sunlight hit the top of her head, the left shoulder, part of the back of the chair, and part of the white bedspread, which is visible in the bottom right corner. It is the reflection of this last ray of sun on the bedspread that faintly lights the small of the model's back as well as the bottom of the armchair. Her left side and thighs are illuminated by the sun filtering through the tablecloth, on which the projected shadow of the window railing can be seen. Difficult print: detail is required in the tablecloth-curtain and the bottom third of the negative must not be drowned in darkness. Almost full frame.

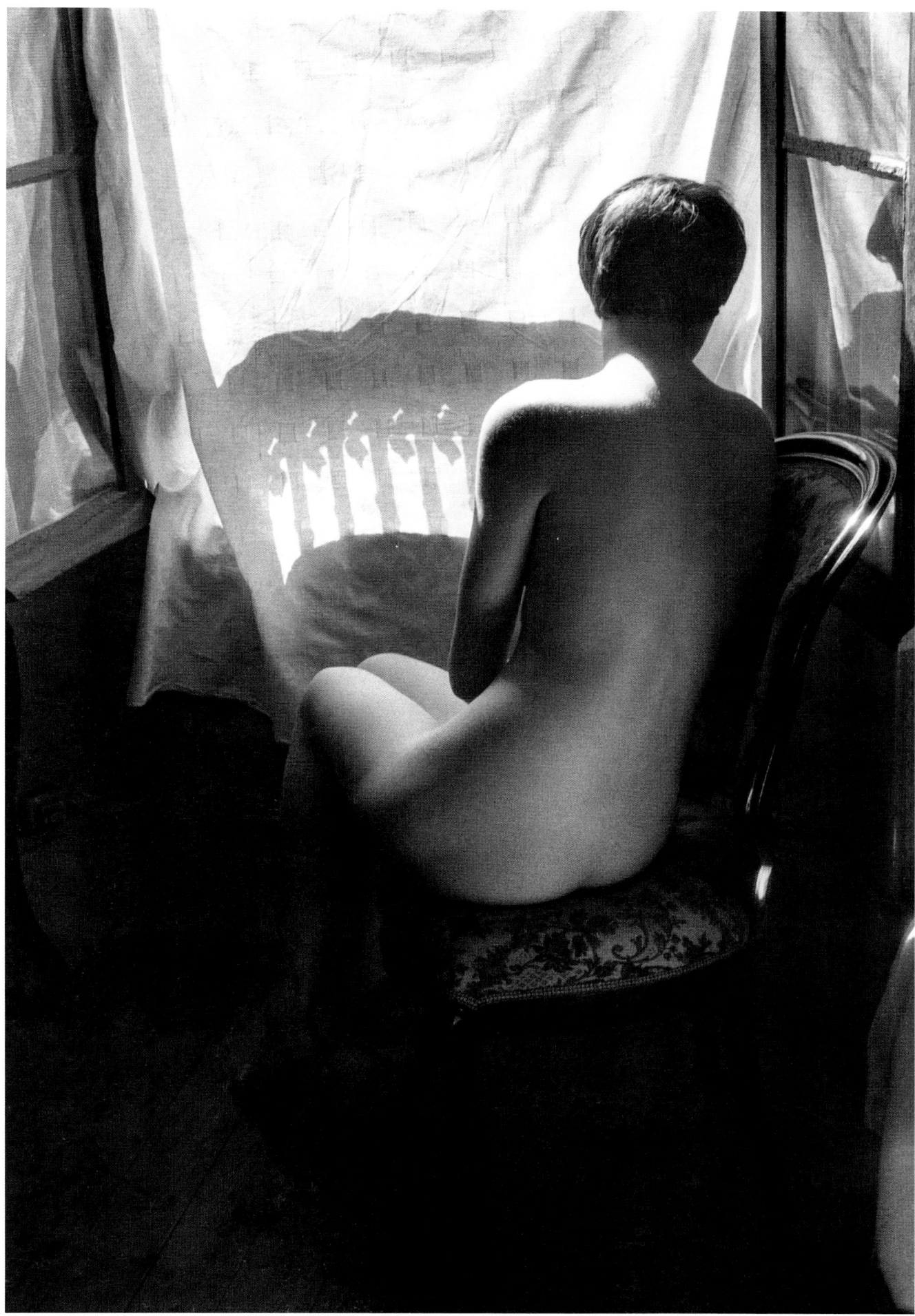

Mont-de-Marsan, Landes, 1955
NEGATIVE: 24×36 MM _ F10/1233
___ 177

In 1955, *Sciences et Vie* commissioned me to do an important story in black and white and in color on military pilots' jet aircraft training. This work took me to the Ministry of Air in Paris, to Mont-de-Marsan—a training base for the Fouga Magister jet—and through the flight test center in Brétigny. Photographs were taken on the ground and in the air. During a break—probably on a Saturday morning—I was taken into the lively center of Mont-de-Marsan (it was May). Once again, I perched on a wall in order to overlook the scene, and the sight immediately brought familiar extra-photographic artistic reminiscences to mind: a fugue for multiple voices by Johann Sebastian Bach and a genre scene by Bruegel the Elder. It is in this musical–pictorial context that my intuitions express themselves best. The values must be balanced out between the areas in the shade and in the sun. Full frame on three sides, slightly cropped to the right.

**Picasso exhibition at the Pavillon
de Marsan, Paris, 1955**
NEGATIVE: 24×36 MM _ R12/0301
—— 178

July 1955, major retrospective exhibition of Picasso's work at the Pavillon de Marsan in the Louvre. Of all the images I accumulated on that day, without any particular assignment, I have selected this one as it amuses me, nothing more. Everyone will read it in their own way. Difficult print, underexposed negative. Slight cropping.

**The night of Bastille Day,
Saint-Germain-des-Prés, Paris, 1955**
NEGATIVE: 24×36 MM _ P12/0807
___ 179

July 14, 1955, on boulevard Saint-Germain, at the corner of the Odéon traffic island: one of those many scenes that emerge, evolve very quickly, and disappear, like soap bubbles. Being present; positioning oneself in the right place; avoiding the confusion of planes; showing that something is happening, whatever it is: this is not cinema and there is no need for a central theme to follow. You need to move around constantly in order to sensitize yourself to the uninterrupted succession of surprises. Balance the print well. Almost full frame.

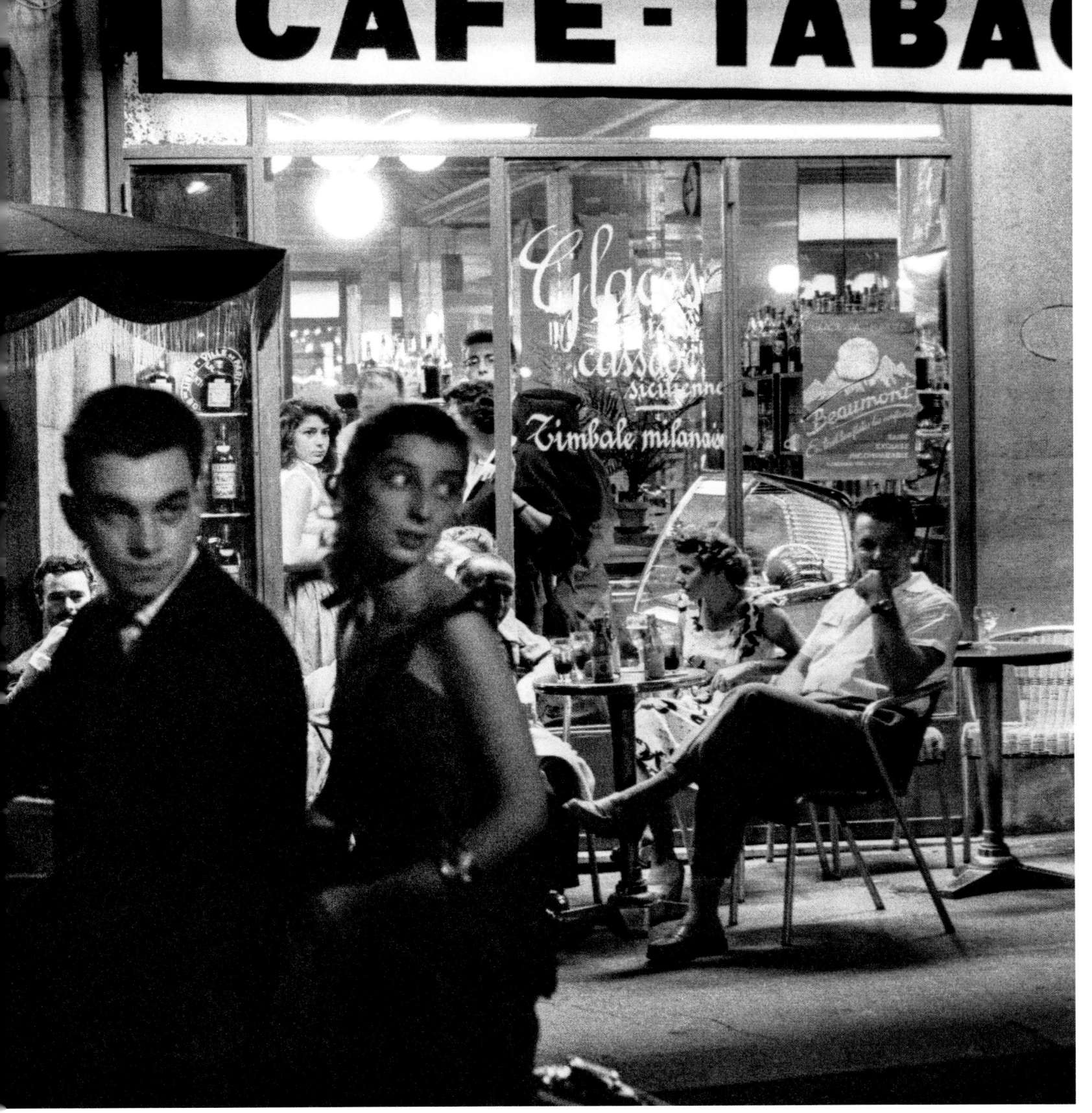

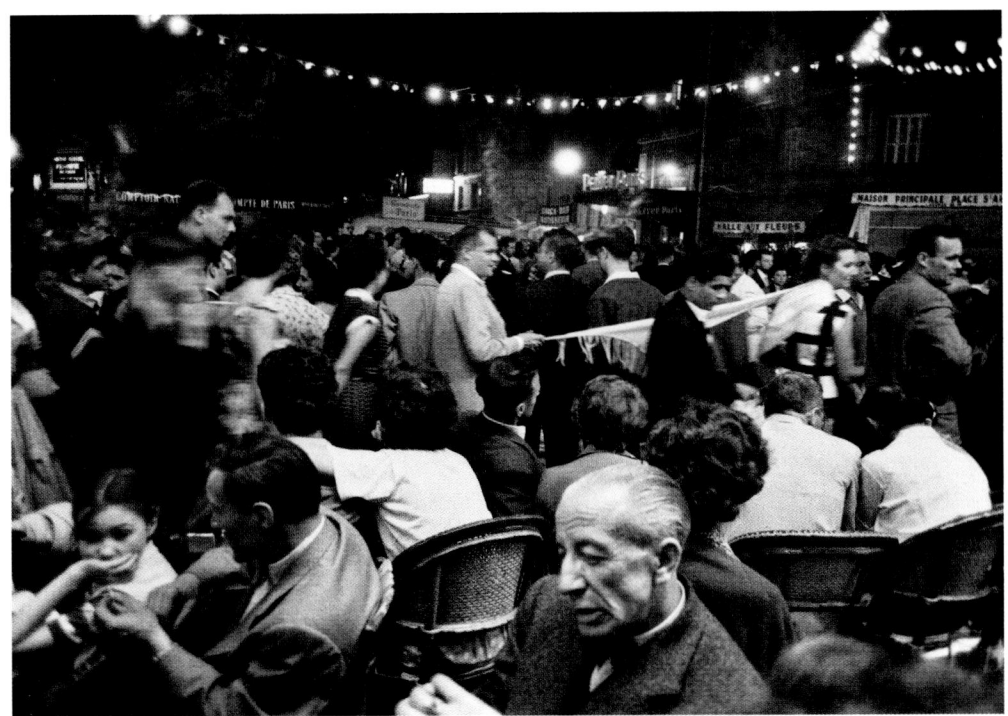

The night of July 14, place Saint-Germain-des-Prés, Paris, 1955
NEGATIVE: 24×36 MM _ R12/1234
—— 180

Same story, same night. I positioned myself in the Royal Saint-Germain café, one step up from the sidewalk. I swapped the 50-mm for the 28-mm. The relatively abundant ambient light allowed me to use an aperture of f/5.6 at 1/10 second, resulting in a remarkable depth of field and little risk of movement, because the dense crowd was moving quite slowly. Relatively easy print, but the light areas (dense on the negative) needed to be pushed. Full frame.

The twins, Gordes, Vaucluse, 1955
NEGATIVE: 24×36 MM _ 15/1810
—— 181

September 9, 1955, in Gordes: commission to shoot at a friend's house. I photographed the parents by themselves, the parents with their children, the children playing. I particularly like the doubly reflected lighting here: the sun shines on the ground through the closed window and bounces back on the ceiling that redistributes it, softened, onto the Moses basket where the twins are lying.
I have a story to tell about it. It is not directly related to the circumstances of the shoot, but if you cannot wait, you can find it in the comments for the portrait in photo 340.
Probably taken with a 28-mm.
Make sure to keep the detail on the tiles during printing. Difficult.

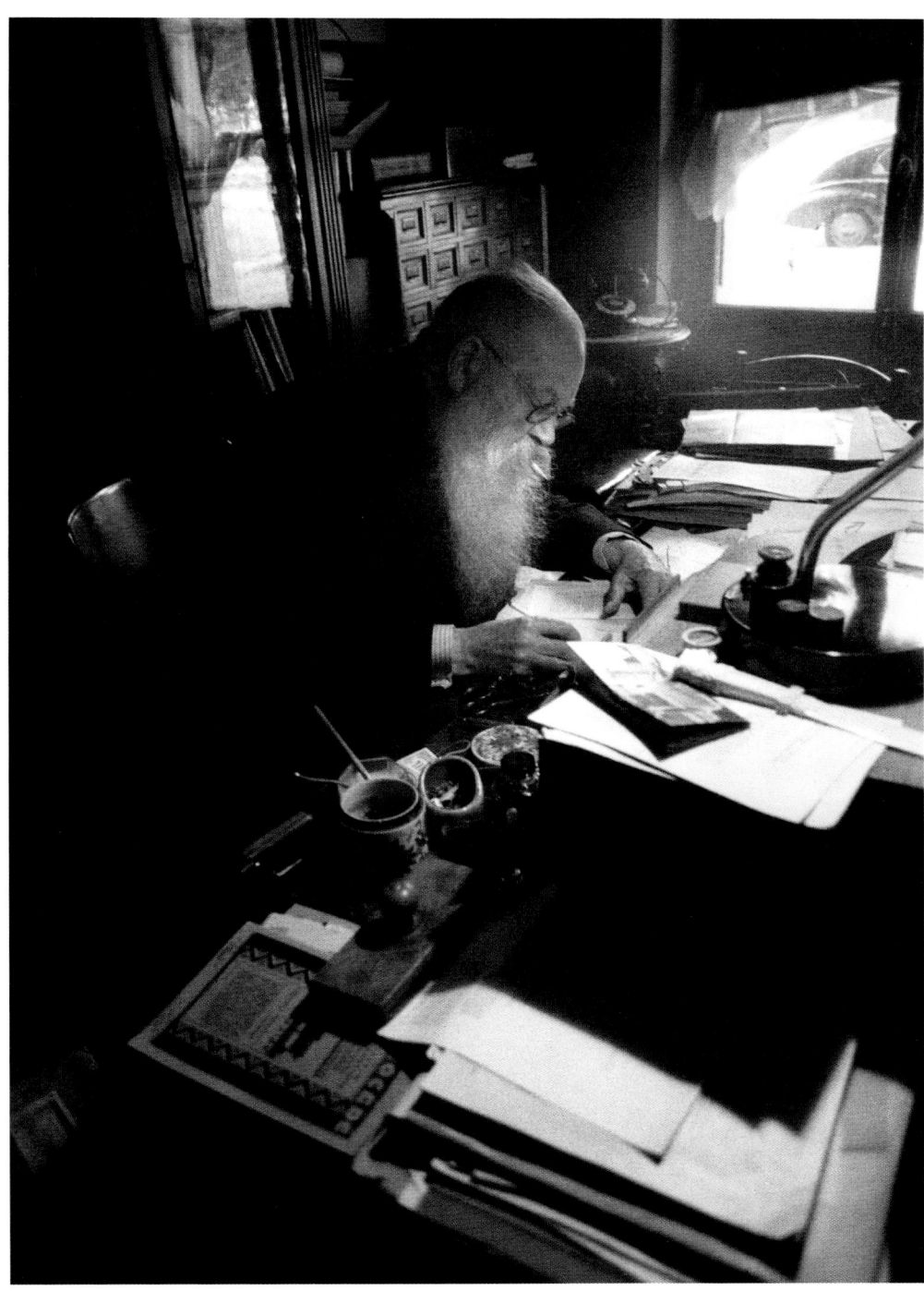

Louis-Philippe Clerc, Paris, 1955
NEGATIVE: 24×36 MM _ R16/0521
— 182

We had only just returned to Paris when my friend Herman Craeybeckx, founder and editor-in-chief of the Belgian magazine *Photorama*, commissioned me to do a story on Louis-Philippe Clerc, on the occasion of his eightieth year. Shamefully, I had not read the key works of this celebrated scholar, which are true bibles for photographic technique enthusiasts (covering optics, physics, chemistry, etc.) and I admitted as much to him. He remained courteous—he knew some of my pictures—and trusted me.

Throughout the shoot, my only fear was that he would set fire to his beard (he lit cigarettes constantly). My concern was misplaced, as it was not a fire that put an end, much later, to his scientific work. I chose this picture, which to me best captures the huge disarray of his office on the ground floor of boulevard de Port-Royal, near the Lion of Belfort. The distortion of the 28-mm lens accentuates this stretched composition. I had added a lamp to light the foreground.
Almost full frame.

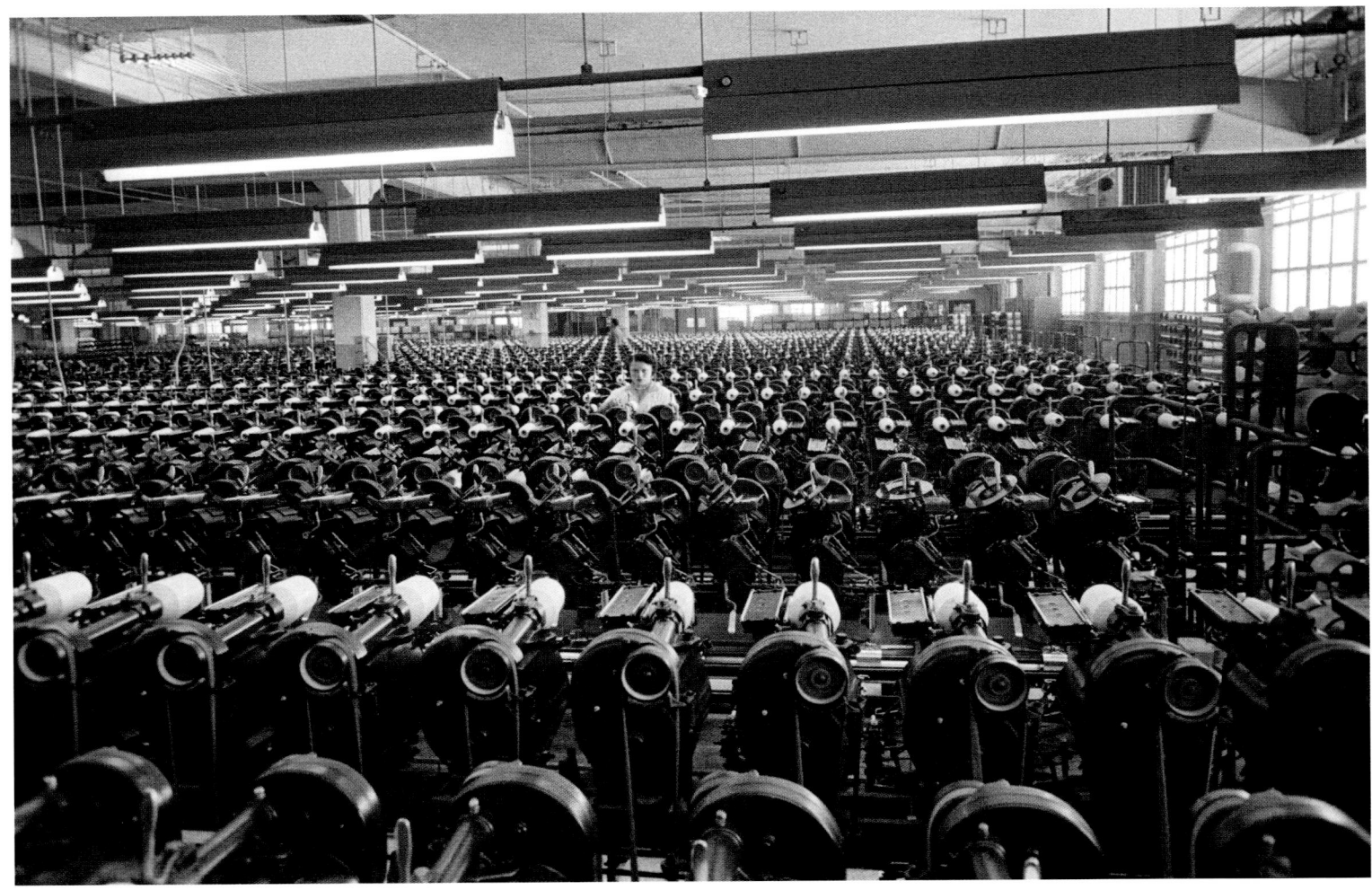

Weaving room, Rhodiaceta factory, Lyon, Rhône, 1955
NEGATIVE: 24×36 MM _ R17/0507
___ 183

Sciences et Vie magazine gave me a major assignment to cover Lyon from every angle: architecture, industry, culture, cuisine (great memories!), etc. On this October day in 1955, I was in the great spinning hall at Rhodiaceta. This was the ultimate in automation, a dehumanization personified by this single operator, whom I had positioned at a strong point in the composition. The 28-mm lens was open to f/8 for the maximum depth of field compatible with a 1/10 second shutter speed. During printing, ensure that the values are balanced out and avoid the halo effect caused by the windows on the right. Full frame.

**From an embankment
of the Rhône, Lyon, Rhône, 1955**
NEGATIVE: 24×36 MM _ F18/1438
___ 184

In Lyon again: my 2CV had stopped at a red light alongside the bank of the Rhône where some kids were playing. The composition was good: click. The light turned green and the flow of traffic carried me on to my next shot. 28-mm. Negative a little overexposed (no time to adjust my settings). Without over-correcting the houses on the opposite bank, the print should reveal the silhouette of Fourvière Cathedral, in the distance, above the Saône river.

Christmas week, rue de Sèvres, Paris, 1955
NEGATIVE: 24×36 MM _ P20/1004
___ 185

On a gray November afternoon, rue de Sèvres, on the Bon Marché sidewalk, a blind beggar was tirelessly grinding out tunes from his barrel organ. Two children stared, transfixed, at the accordion of perforated cardboard: that's where the music comes out! Rather harsh backlight, with the lower part of the negative quite underexposed. No doubt standard 50-mm. Partial crop.

French cooper in Soho, London, England, 1955
NEGATIVE: 24×36 MM _ R21/1333
___ 186

December 1955. Story on Soho in London, for *France Soir* (temporary job). Sylvère Habert, a French cooper who had just finished military service, had agreed to help out a friend who had fallen ill in London. Forty years later, the day this photograph was taken, he was still there, at 49 Frith Street, in the basement. The only light in this cellar was a 60-watt bulb covered in cobwebs, visible at the top of the image. 28-mm, f/4.5, 1/2 second, camera resting against a pillar. Full frame.

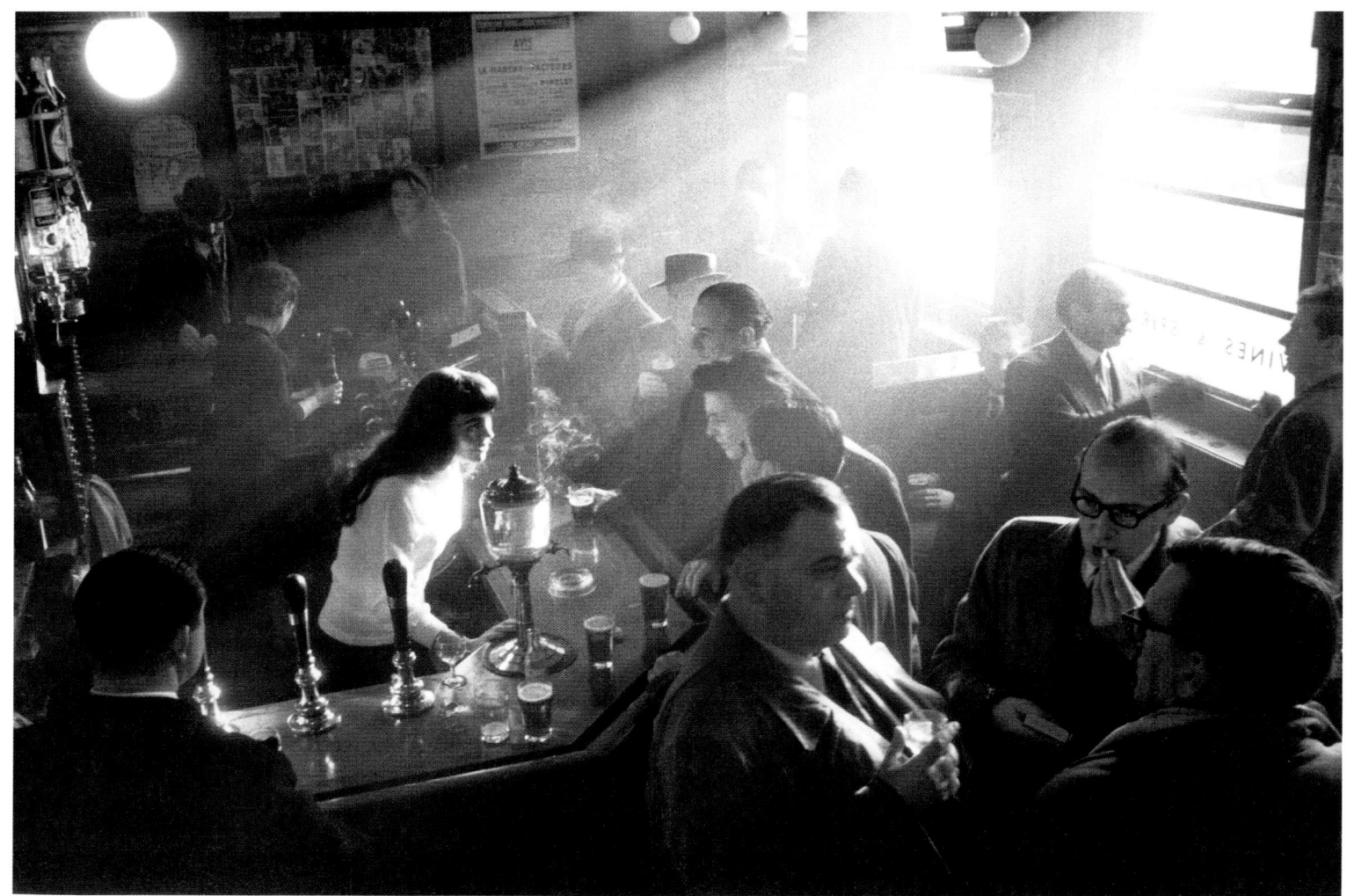

Pub in Soho, London, England, 1955
NEGATIVE: 24×36 MM _ R21/1805
—— 187

Same project, same part of town, in Gaston Berlemont's French pub—a late morning in December superbly lit by the low rays of the winter sun. I took a quick look around: great, a staircase! The ideal lookout: I wouldn't disturb anyone and I would be able to see everything. Two or three snapshots, taken very quickly, to make sure; you never know, some people are short-tempered drinkers. And then I waited for the young waitress to stand in a ray of sunshine. A marvel! Everything fell into place, even better than if I had set it up. Difficult print to balance, because of the very strong opposition between shadow and sunlight. A 28-mm, no doubt, probably at f/8 and 1/25 second. The film was Ilford HPS, later replaced by the HP5.

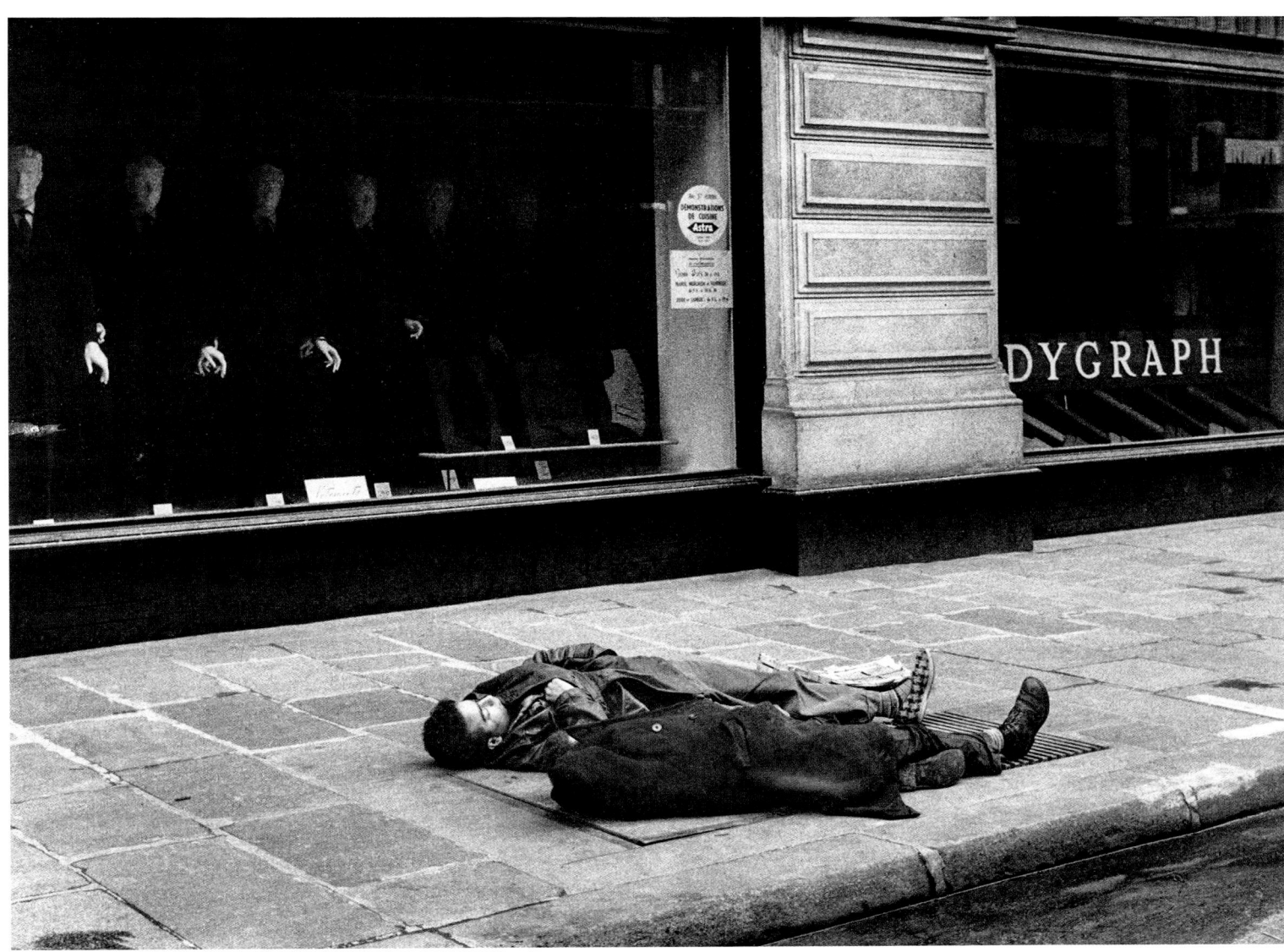

Rue du Pont-Neuf, Paris, 1956
NEGATIVE: 24×36 MM _ P22/0715
__ 188

January 2, 1956. I was reporting on the general election, striding across Paris to visit as many polling stations as possible, which led me that morning to rue du Pont-Neuf. I am not particularly fond of the easy effect created by the contrast between a situation and an inscription that seems to contradict it. In front of the windows of La Belle Jardinière, these two homeless men had found some warmth on the subway air vents.
35-mm. Very slightly cropped negative.

A café on rue Montmartre on a rainy night, Paris, 1956
NEGATIVE: 24×36 MM _ P22/2602
—— 189

Same day, in the evening. The cold had turned to rain. I walked quickly along rue Montmartre, toward the nearest metro. Glancing to one side, I saw this bistro full of customers waiting for the rain to stop. The effect was striking, and once again raised the classic dilemma: why take out the camera if it is going to get wet? My drawers were full of bistro shots. What difference would one more or less make? This wasn't an assignment, nor the subject I was focusing on. I would have been much better sheltering in the metro. And I was in a hurry. Nevertheless, I often remember this occasion, as if in a dream, with the camera at eye level, facing the bistro and pressing the button twice. It was certainly not a mistake, because this photograph was published many times, and it was chosen by a Milanese graphic designer for the cover of the Italian edition of my book *Sur le fil du hasard* (On Chance's Edge), under the title *Uno sguardo*. Difficult to print because of the strong contrast. Full frame.

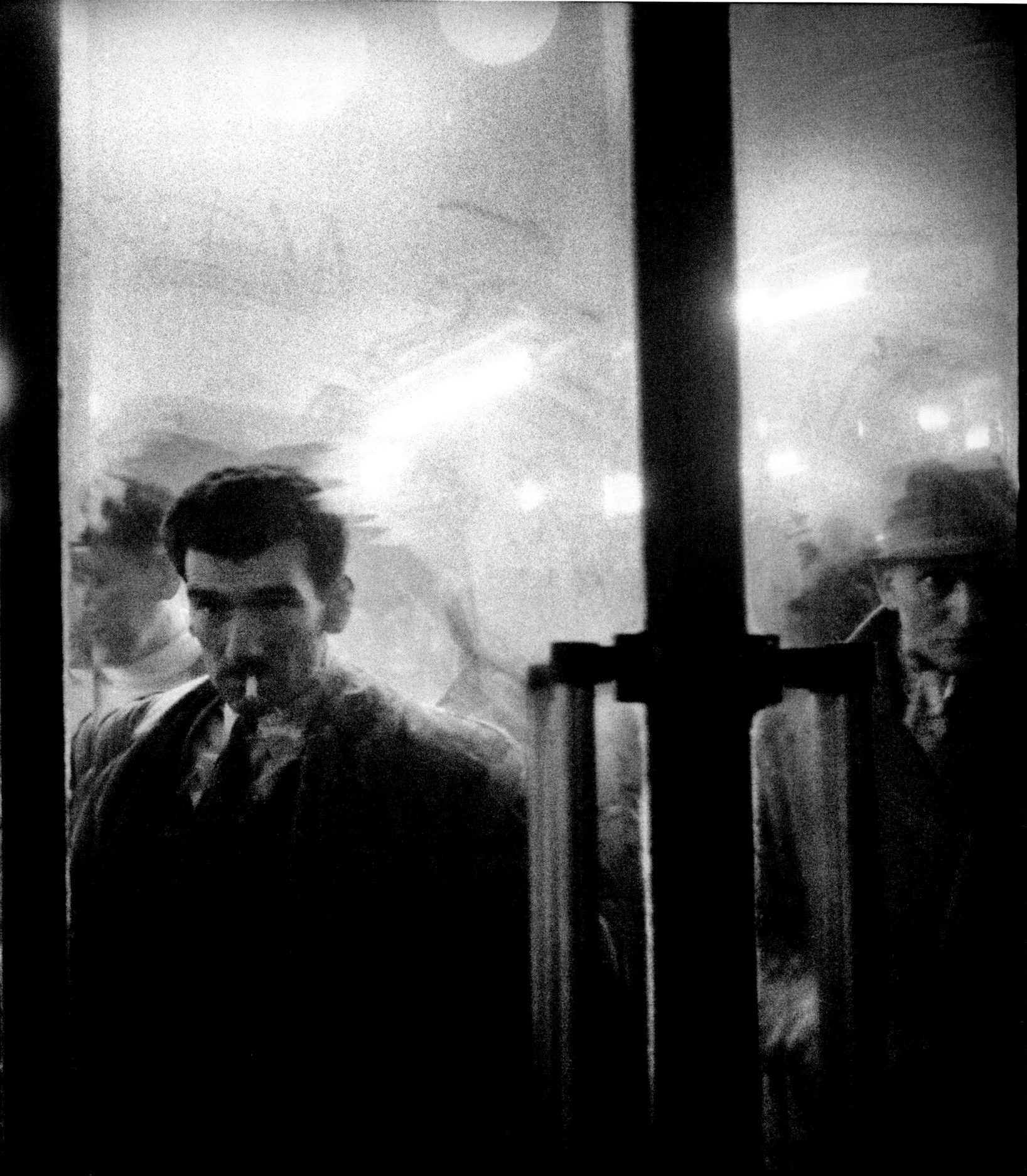

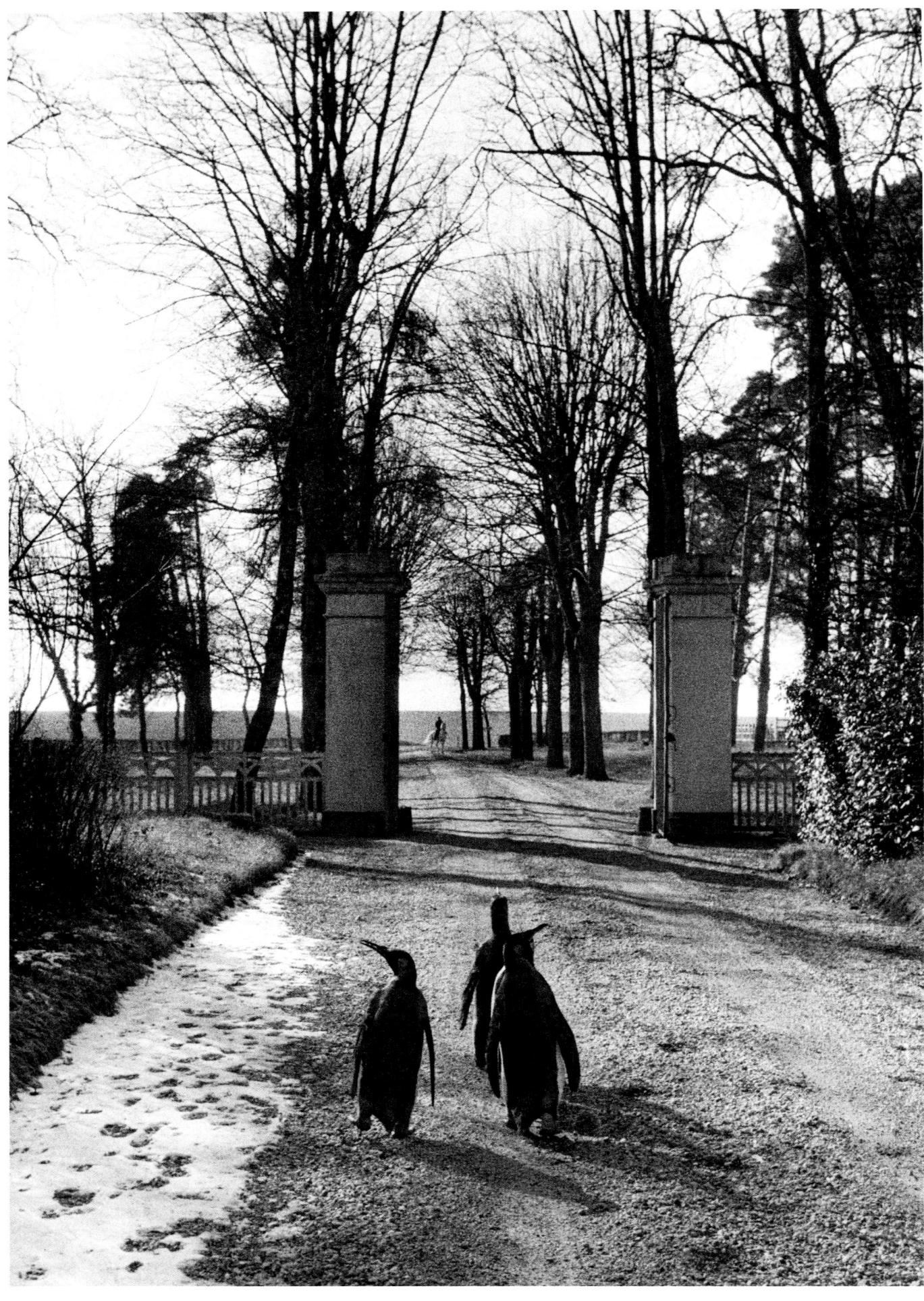

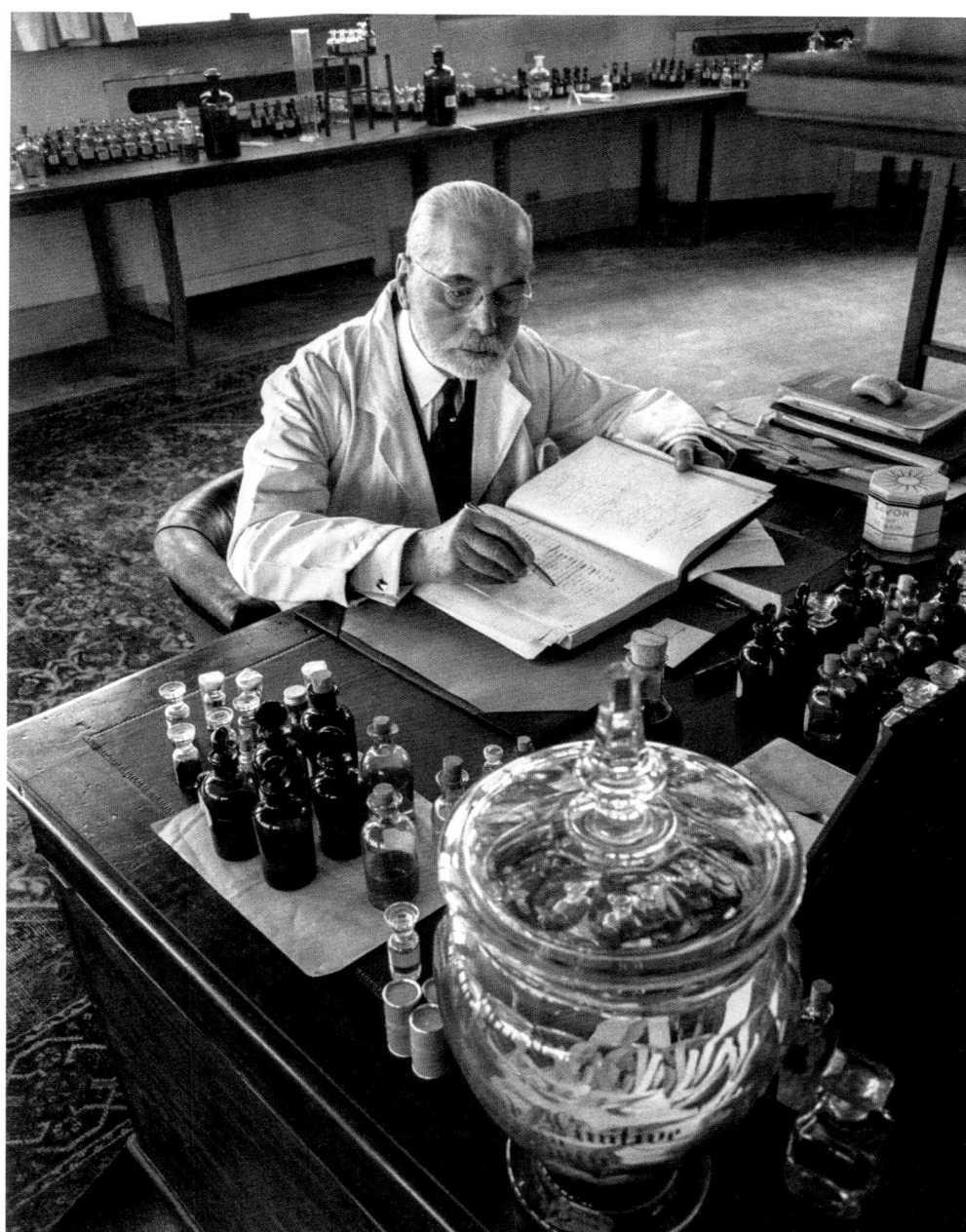

The Pinder circus off-season, in the park of a château in Touraine, Indre-et-Loire, 1956
NEGATIVE: 24×36 MM _ R25/1205
—— 190

February 27, 1956, in the afternoon. I was on the property of a château in Touraine where the Pinder circus spent the winter. I had just photographed a toddler playing with a lion cub, as well as a group of placid elephants. Still not satisfied, I was looking for an idea to beef up my project, when I ran into three penguins walking on a lawn. I grabbed a small branch, and then, quietly but anxiously, directed my trio of palmipeds toward the exit to photograph them framed by the pillars of the gate. Not easy considering that this little promenade, led by a stranger, was not part of their act. I was beginning to regret my idea when the merciful heavens granted me a miracle. At the end of the path a rider appeared, proudly atop a white horse. I quickly snapped a shot, although I didn't have time for a second because my penguins, out of deference to the horse, wisely pulled over on the side. I prayed to the gods for the photo to be good! 50-mm. Almost full frame.

Jacques Guerlain, Paris, 1956
NEGATIVE: 24×36 MM _ R26/1943
—— 191

Report on the Guerlain family in March 1956, for *Air France revue*. From among the images I took, I selected this spontaneous portrait of Mr. Jacques, the most illustrious of the family and the one who was respectfully called "the nose," in honor of his genius. It is not at all conventional to shoot a portrait with a 28-mm lens. But as long as you do not get too close to the model, the wide angle helps to situate the subject in its environment, as was already the case in photo 182 of Louis-Philippe Clerc. Daylight without any auxiliary input. Slight cropping top and bottom.

Spring cleaning, avenue Élisée-Reclus, Paris, 1956
NEGATIVE: 24×36 MM _ P29/1138
— 192

Walking along the street in May 1956, I came across this "spring cleaning" session. The wealth of the neighborhood, the maid's very traditional uniform, the accidental luxury—entirely in keeping with the general atmosphere—of the chestnut tree in full bloom, the simple but careful composition that I had time to construct in order to put each element in its place combine—in my eyes—to make this photograph the symbol of bourgeois life—sure of itself and carefully protected. No major printing issues. Almost full frame.

Boris Vian, Paris, 1956
NEGATIVE: 24×36 MM _ R29/2921
— 193

In April–May, an illustrated weekly from Warsaw commissioned me to do a story on Saint-Germain-des-Prés. The fruit of that work was this portrait of Boris Vian at his home in Montmartre, in his musical element, his face a little melancholy, as was often the case unless he was surrounded by friends. Daylight, 35-mm lens. Full frame.

The Eiffel Tower from Montmartre, Paris, 1956
NEGATIVE: 24×36 MM _ P29/2917
___ 194

I had just finished my job with Boris Vian and had climbed up to Sacré-Coeur in Montmartre. The weather was gray. Rue Azaïs overlooked a small garden from which the Eiffel Tower, viewed through a 135-mm lens, was framed by the branches of these trees, like in a Chinese scroll, as if they had been drawn for it. This was another of those unmissable opportunities because, when I passed by this location a few months later— and under a light that had none of the charm of this one—I noticed that the trees had been pruned. So, 135-mm lens. Cropping to the bottom, to remove a line of balconies that hit a wrong note.

Jean-Paul Sartre, Paris, 1956
NEGATIVE: 24×36 MM _ R30/1745
___ 195

I had been to Boris Vian's; I then asked to photograph Jean-Paul Sartre. His secretary gave me an appointment for the morning of May 24, 1956. I went to the writer's apartment at the time, on the corner of rue Bonaparte and place de Rennes. I suggested including the Saint-Germain-des-Prés bell tower in the background, which he accepted with a smile. As I had done ten days earlier at Boris Vian's, I made this picture vertical, framing the face at the bottom, a usual practice of mine when there is a strong focal point above the subject. 50-mm. Easy print: avoid bringing out Saint-Germain-des-Prés too much. Full frame.

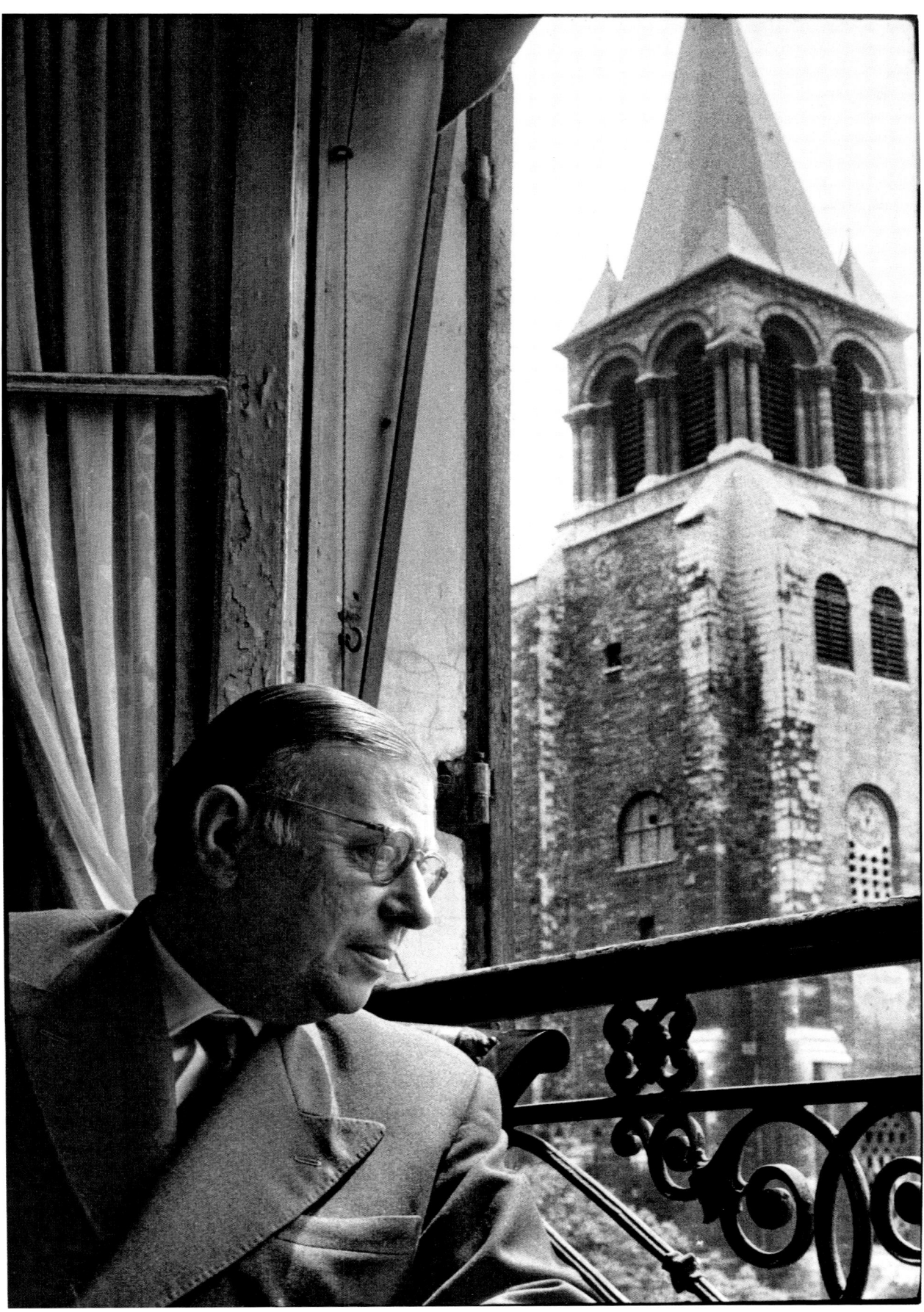

Île Saint-Denis, Seine, 1956
NEGATIVE: 24×36 MM _ F31/1741
— 196

There I was again, June 26, 1956, in Île Saint-Denis, pursuing my personal project about the islands of Paris, following up my own ideas and without any editorial constraints (see commentary on photo 155). I was interested in these two kids with model airplanes, in these slightly squalid surroundings, which I inevitably compared with the shot I had composed four years earlier with Vincent in Gordes. On this occasion, I asked nothing of them, and was happy just to choose my spot to balance the composition in relation to a few key elements. Probably 50-mm. Avoid darkening the ground too much when printing. Keep details in the sky. Almost full frame.

Île de la Jatte from the Pont de Neuilly, Paris, 1956
NEGATIVE: 24×36 MM _ F31/2122
___ 197

Same photographic project. Some industrial and advertising jobs were taking care of my finances, and I devoted almost all my free time to immersing myself in my islands, a world in which I lost myself as much as if I had set off to discover the Amazon or New Guinea. Here, there is a play of curves and lines, viewed from a well-researched location on the Île de la Jatte, with its small temple of Venus, framed by the west arch of the Neuilly bridge. It was the morning of June 22, 1956. 135-mm lens. Gray day, easy print. Full frame.

In square de l'Île-de-France, at the upstream tip of the Île de la Cité, Paris, 1956
NEGATIVE: 24×36 MM _ P32/2302
___ 198

That same day, I drove back toward Notre-Dame, around mid-afternoon. The sky had cleared and was emitting an almost lunar light (shown by the use of an orange filter). Upstream on the Île de la Cité, the horizon was blocked by the Pont de la Tournelle, which connects the left bank of the Seine to the Île Saint-Louis. The people suddenly thinned out in a strange way (a similar phenomenon can be seen in photo 202, on the Champ-de-Mars). I quickly grabbed the 28-mm lens to include the Gothic pattern at the bottom of the image and set the aperture to f/22 for maximum clarity in the depth of field. The clearness of the air, after the rain, allowed the sharpness of the details in the foreground to continue into the distance. This is not a soft photograph, but I love it for its air of strangeness. So, 28-mm and full frame. Do not hesitate to push the contrast when printing.

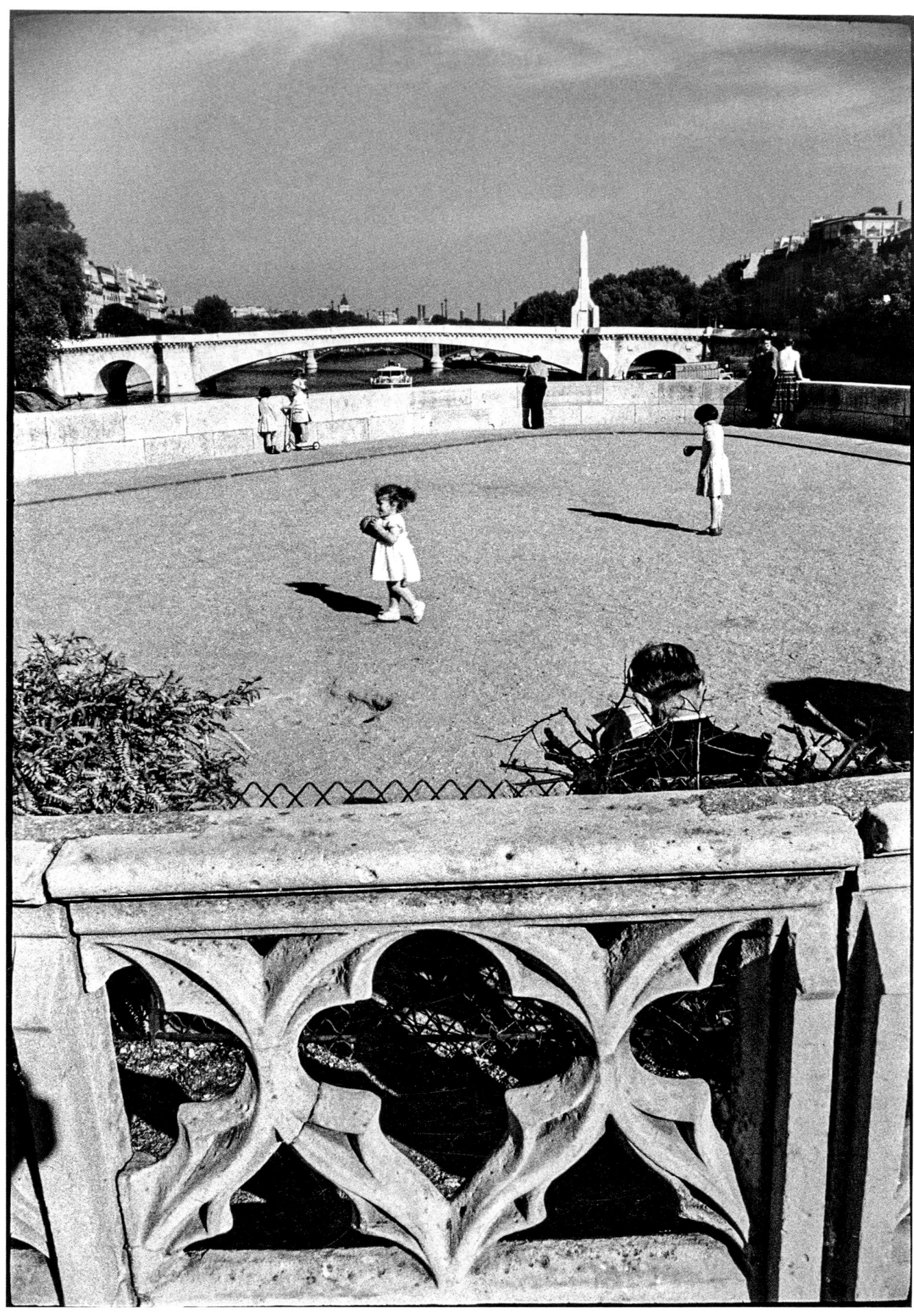

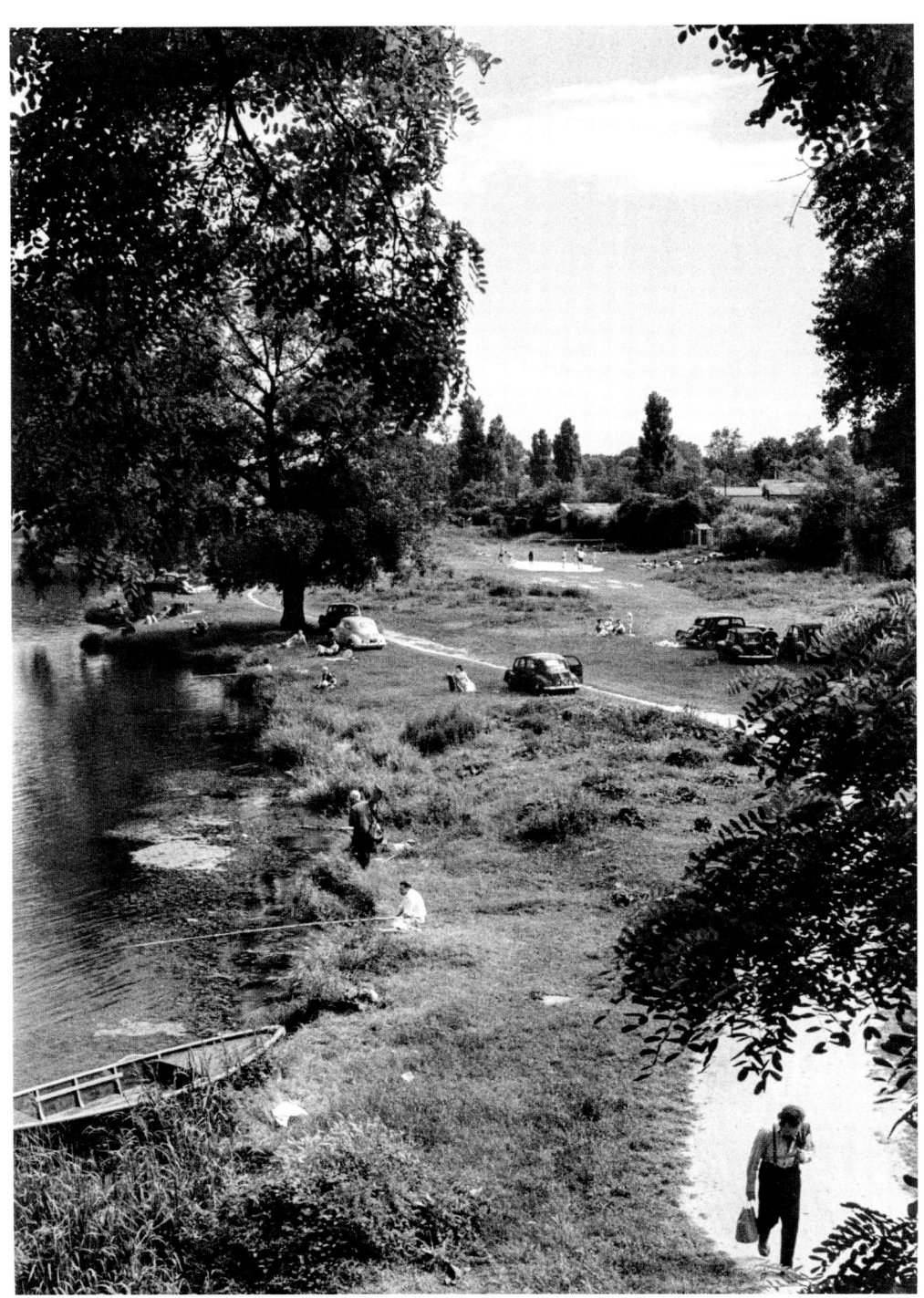

Île Brise-Pain, from the Pont de Créteil, Seine, 1956
NEGATIVE: 24×36 MM _ DUPLICATE _ F32/2834
— **199**

A few days later, on Saturday, June 30, 1956, I was looking down from the Pont de Créteil on people who had started to enjoy their weekend.
I like to compose my images vertically and in successive planes (I checked after I had done my first selection of 350 images: two-thirds were vertical compositions). The void created by a white hole on the right bothered me, but it balanced out the opening onto the sky between the trees. A little patience was required, but a few minutes was all it took: a pedestrian came along at the right time to fill this space, bringing a dynamism to this country scene with its vaguely scattered elements. That is how I added a new island to my series: Île Brise-Pain. 50- or 35-mm, I'm not sure; I would have to go back to check. Full frame.

**Between Île Brise-Pain
and Île Sainte-Catherine,
Créteil, Seine, 1956**
NEGATIVE: 24×36 MM _ F33/0541
— 200

Same day, around evening time. The perfect time of day to enjoy a short boat ride before thinking about dinner. These two couples were beginning to cross between two islands. The lush vegetation made the scene feel far from Paris, and easily recalled Maupassant's boaters and the world of the impressionist painters. Without too much effort, I chose to travel further back in time to evoke the eighteenth century and Watteau's *Embarkation for Cythera*. You have to dream.
Standard 50-mm. Full frame.

**Champigny islands seen from
La Varenne, Seine, 1956**
NEGATIVE: 24×36 MM _ F33/1242
— 201

The following day, July 1, 1956, in Champigny. The weather had turned gray. A fisherman was heading to his favorite spot, followed by his son proudly carrying the equipment. They walked across a chain of narrow islands, where there must have been some very fishy spots. I had my Foca mounted with a 135-mm lens. No printing issues, except to equalize the foliage to obtain a tapestry effect. Framing slightly shortened at the bottom.

First tourists of the day at the Champ-de-Mars, Paris, 1956

NEGATIVE: 24×36 MM _ P34/0122

—— **202**

July 13, 1956. My colleague Lucien Lorelle was writing a handbook for amateur photographers. He asked me to kindly provide him with a set of images of the same subject, photographed full frame, with five different focal lengths, from 28 mm to 135 mm, with appropriate comments. I chose the Eiffel Tower. The work was quickly done, and I was about to go back to my car when I came across this strange scene. It was still early in the morning, and the tourists had just started their assault course before piling back into their buses. The light was crudely filtered through a veil of white clouds, like real ground glass. The camera was equipped with a 35-mm lens. It was perfect. I quickly chose my position before this magical moment dissolved. If I had wanted to put this composition together for an advertisement for *Vogue* or *Harper's Bazaar*, it would have taken me much longer, and would not necessarily have been successful. It is often thanks to sheer chance that I captured the images that are dearest to me.
Full frame.

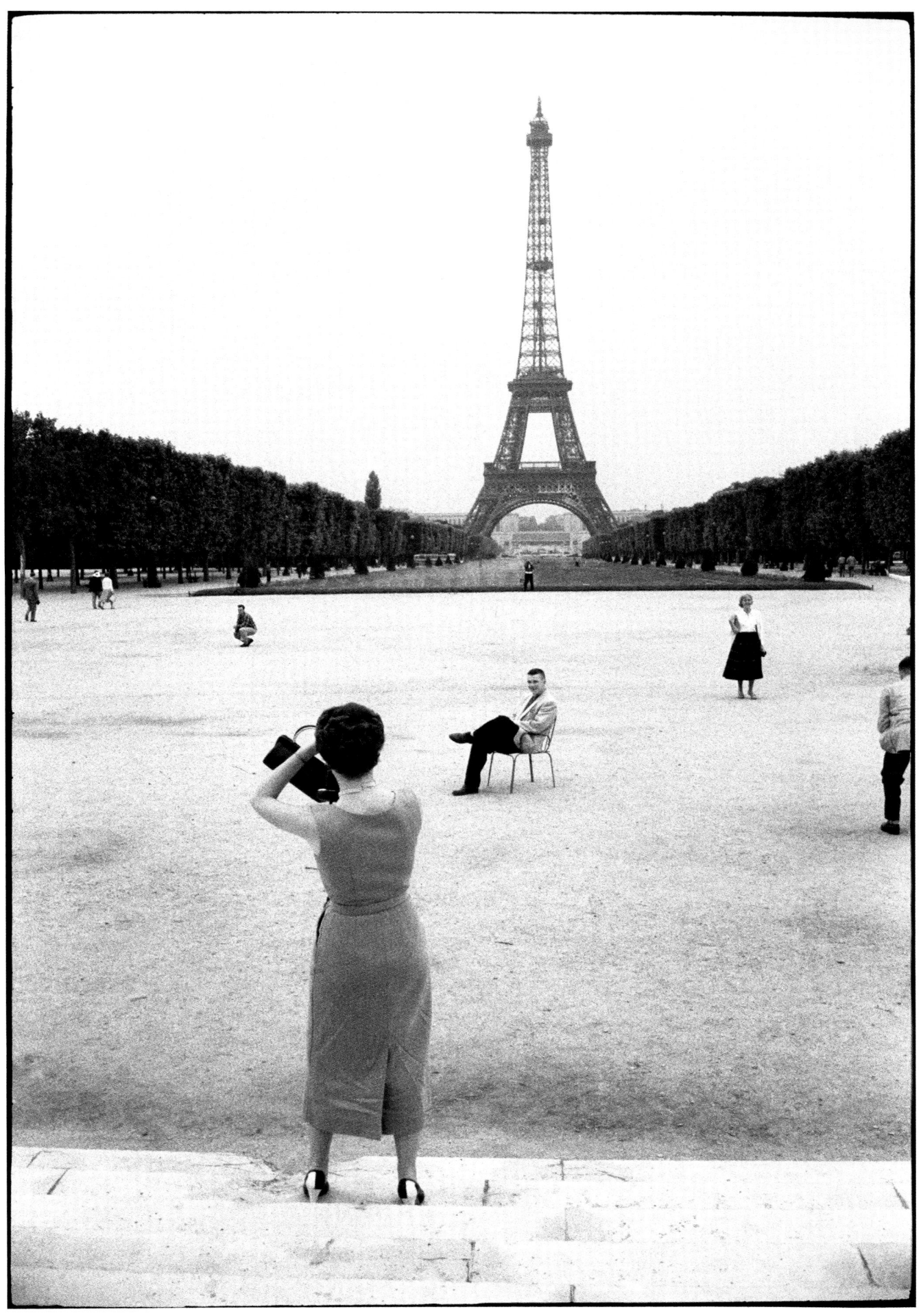

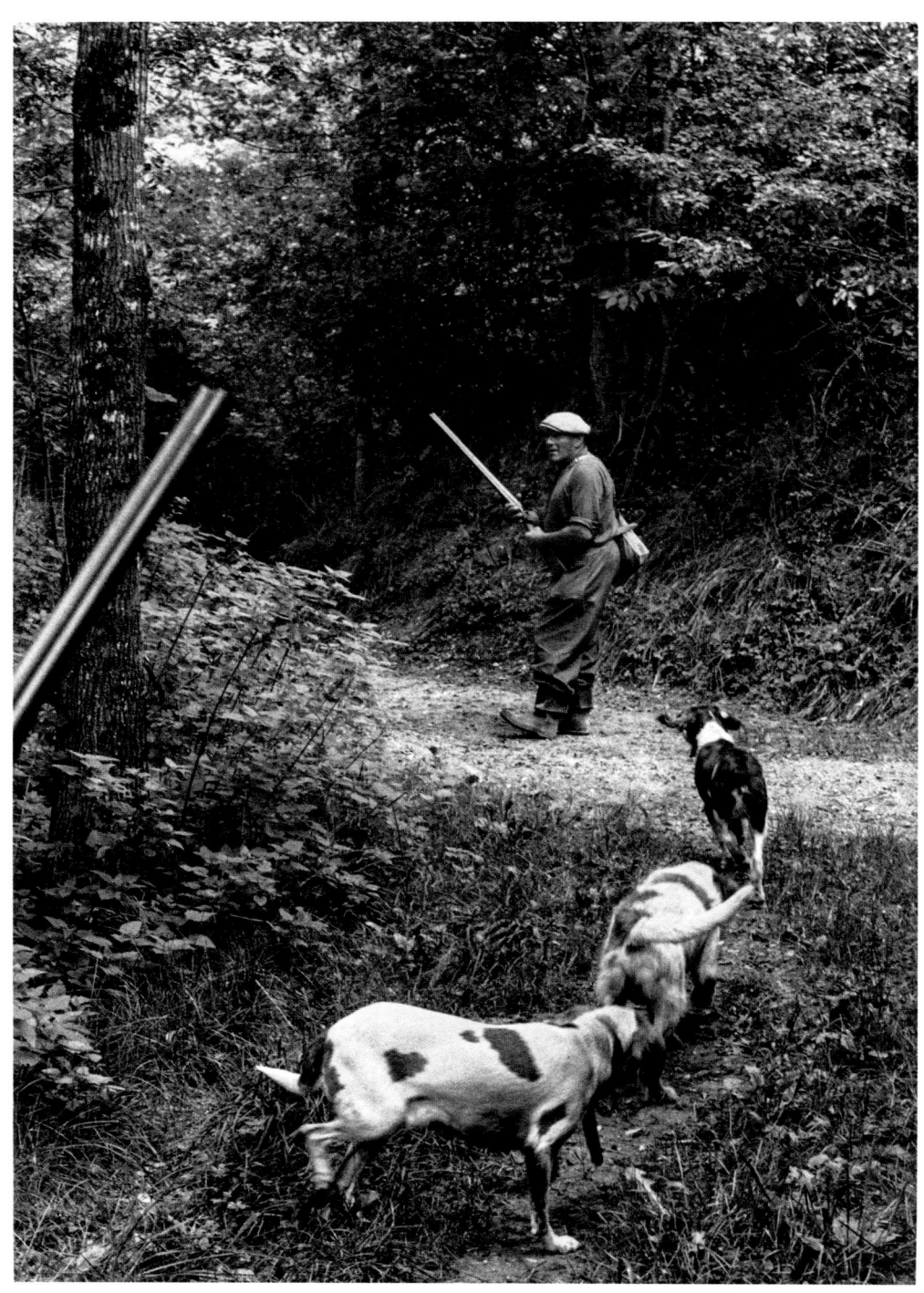

Hunting in Touraine, Artigny, Indre-et-Loire, 1956
NEGATIVE: 24×36 MM _ F37/2927
—— 203

Camera in hand, I was following a hunt organized by farmer friends in Touraine on September 22, 1956. After a few warm-up photographs, three dogs suddenly made a sharp turn at my feet, while two rifles formed a right angle. It is impossible to piece together what then occurred in the photographer's head: it was something like a preprogrammed response. All I remember in this mesh of conflicting sensations was the vague yet worrying impression that I had witnessed something special, but that I may have released the shutter at the wrong moment.
When using 35-mm, the decision to shoot full-frame works only with static or slowly changing subjects. In this case I was a little too far away, so the top and right-hand side of the image were cropped. 50-mm lens.

Quai de Conti seen from the dome of the Institut de France, Paris, 1956
NEGATIVE: 24×36 MM _ P39/0221
—— 204

I was looking for new viewpoints on the capital, and I thought that the panorama from the top of the dome of the Institut de France might be interesting. Having sweet-talked the relevant authorities, I was put in the care of the fireman on duty, because the route to the top was labyrinthine and required a degree of acrobatics. So, at 4 p.m. on October 20, 1956, I found myself gazing at Paris from a narrow, circular walkway surrounded by a thin parapet. First photograph: the shadow of the dome projected onto the golden fall foliage of the poplars on quai de Conti, taken with both cameras. At that time, my satchel contained two camera bodies: one for black-and-white, the other for color, plus five lenses, various filters, and a photocell for color. Then, as diligently as possible, I scanned the surrounding view and identified its best features, because this climb is not as simple as the one up to the belvedere of the Buttes-Chaumont. But getting back to this image, it was taken with a 50-mm just as the pedestrians and vehicles came together nicely. Needless to say, from below this shadow effect could not be seen at all. The negative has some diagonal scratches, so the print therefore requires careful retouching. Full frame.

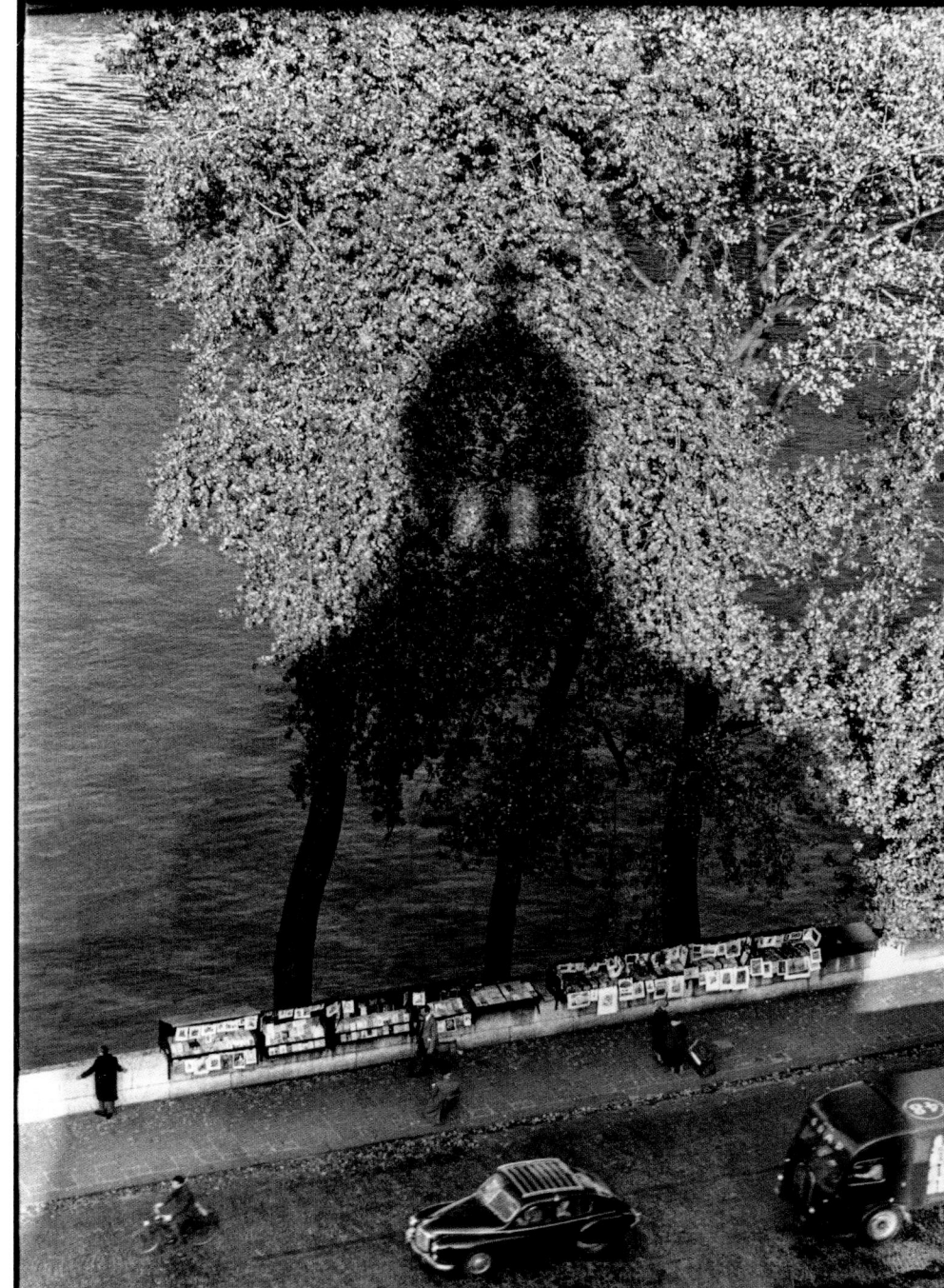

Christmas week, boulevard Haussmann, Paris, 1956
NEGATIVE: 24×36 MM _ P40/0212
___ 205

December 15, 1956. For the third year running, I was on the hunt with a 35-mm camera for an image that defined Christmas, its ritual and pleasures. What would become of that image is another story. I was near the Chaussée-d'Antin metro station, poking around. Suddenly, a little girl reached out and probably said to the newspaper vendor: "You've put your hood on." 28-mm lens. Highly underexposed image, which is difficult to print in such a way as to keep the detail in the blacks. Full frame.

New Year's Eve, Paris, 1956
NEGATIVE: 24×36 MM _ R40/1911
___ 206

We let Vincent (who would soon be seventeen) organize a party at our place on passage des Charbonniers on New Year's Eve. Marie-Anne and I appeared only now and then, to bring food and drinks. But I wanted to keep some reminders of the event and set up some pretty high floodlights here and there, in order to be able to work at 1/25 and 1/50 second with an average aperture setting. Of course, I positioned myself on a stool. Probably a 35-mm. Full frame.

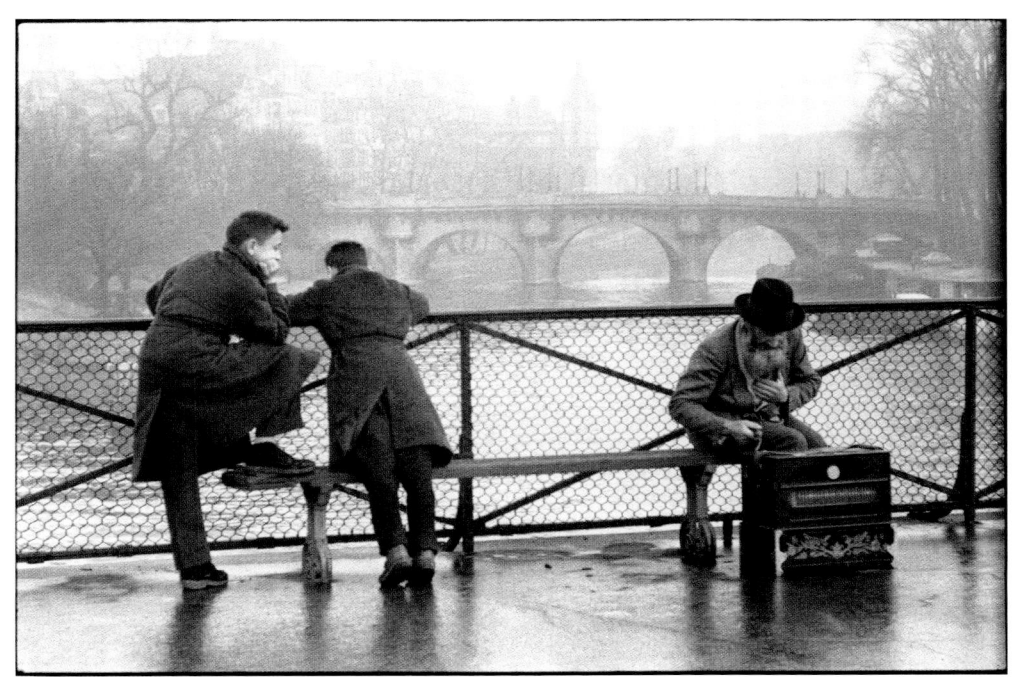

The organ-grinder on the Pont des Arts, Paris, 1957
NEGATIVE: 24×36 MM _ P40/2643
___ 207

Whatever the weather, this figure, a fixture on the Pont des Arts, never stopped grinding out old melodies from his mechanical repertoire. Here I was once more, on a walking route that, to the north, led me to the Louvre (full of my cherished favorites: Flemish masters and painters from the school of Padua), and to the south, after passing through a wing of the Institut de France, took me to the welcoming home of Romeo Martinez. On this January day in 1957, it was drizzling. Behind the indifferent young man, a sensitive soul was listening to the refrains of the barrel organ, conjuring up dreams. Or am I making things up? Nonetheless, that is how I experienced the moment, and that is how I relive it every time I reexamine this record. 50-mm lens. Preserve the light gray of the background in printing. Full frame.

Place de la Bastille seen from the July Column, Paris, 1957
NEGATIVE: 24×36 MM _ P43/0313
___ 208

On this beautiful morning of February 2, 1957, I emerged at the top of the July (aka Bastille) Column, taking the opportunity to catch my breath as I looked at the view. I was surprised by the strangely attractive effect created by the plunging vertical view down the column, whose base can be seen resting on its square plinth. On the right, the sentry box. Highly decorative ornamentation on the circular pavement, streaked by the shadows of the balustrade. I waited for a pedestrian to provide a sense of scale. If you hide this character, the photograph is a mystery. I forgot to take note of the lens I used, probably the 90-mm. Impossible to check: the column, which is severely damaged, can no longer be visited. Full frame.

The lovers of the Bastille, Paris, 1957

NEGATIVE: 24×36 MM _ P43/0417

—— 209

Same location, same afternoon. Joined by a couple of lovers. Reciprocal discretion. However, I could not resist the temptation to photograph them in their charming embrace, against the panorama of the west of Paris. They pretended not to notice; perhaps they were even happy to let me have this record of their joyous love. The light of Paris is always at its most beautiful after the rain clears. A few clouds still lingered here and there, filling the sky attractively: another gift to the photographer. On this afternoon, I made other photographs that I also like, but I had to make a choice. Framing corrected slightly to respect the parallel of the horizon.

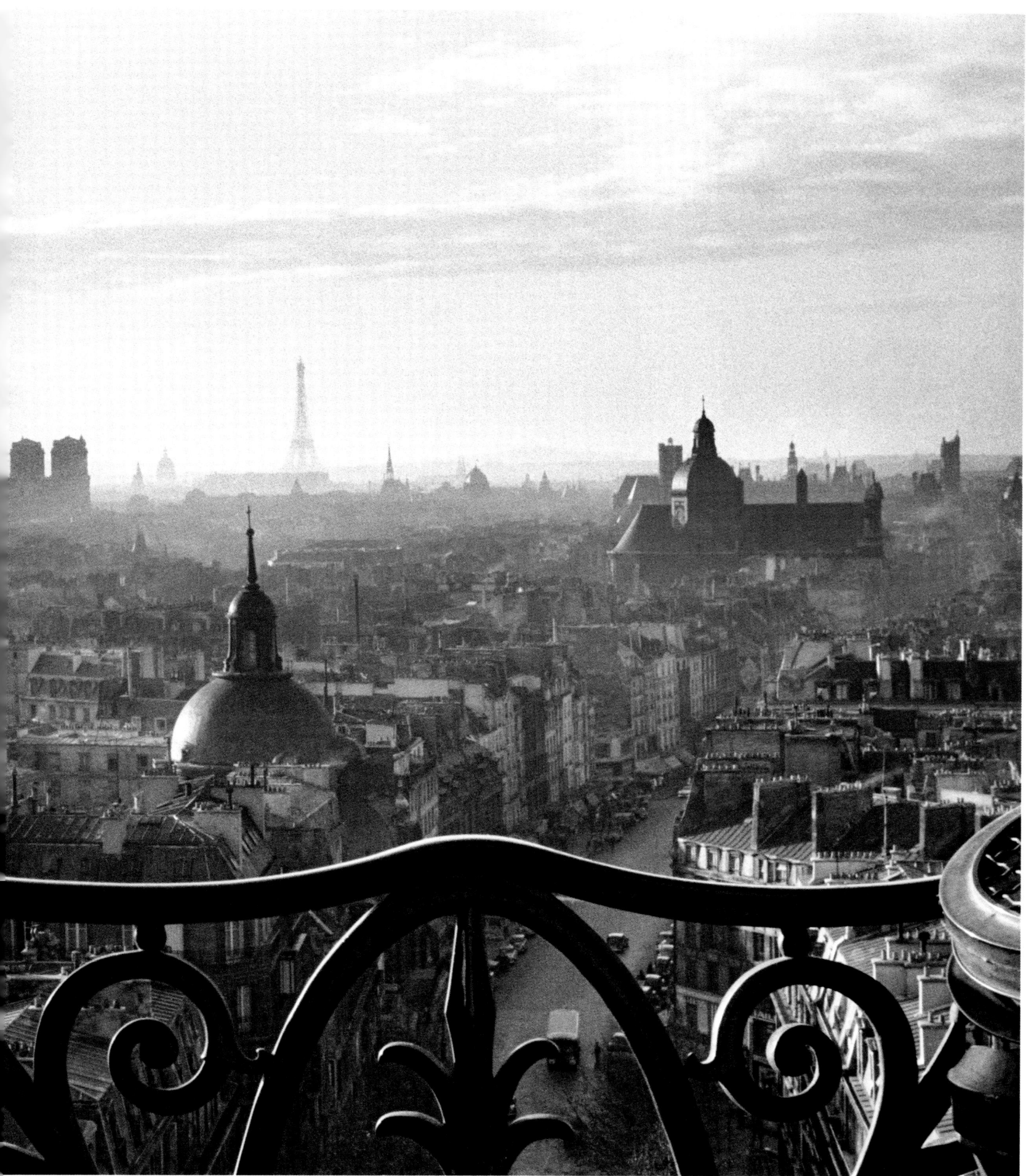

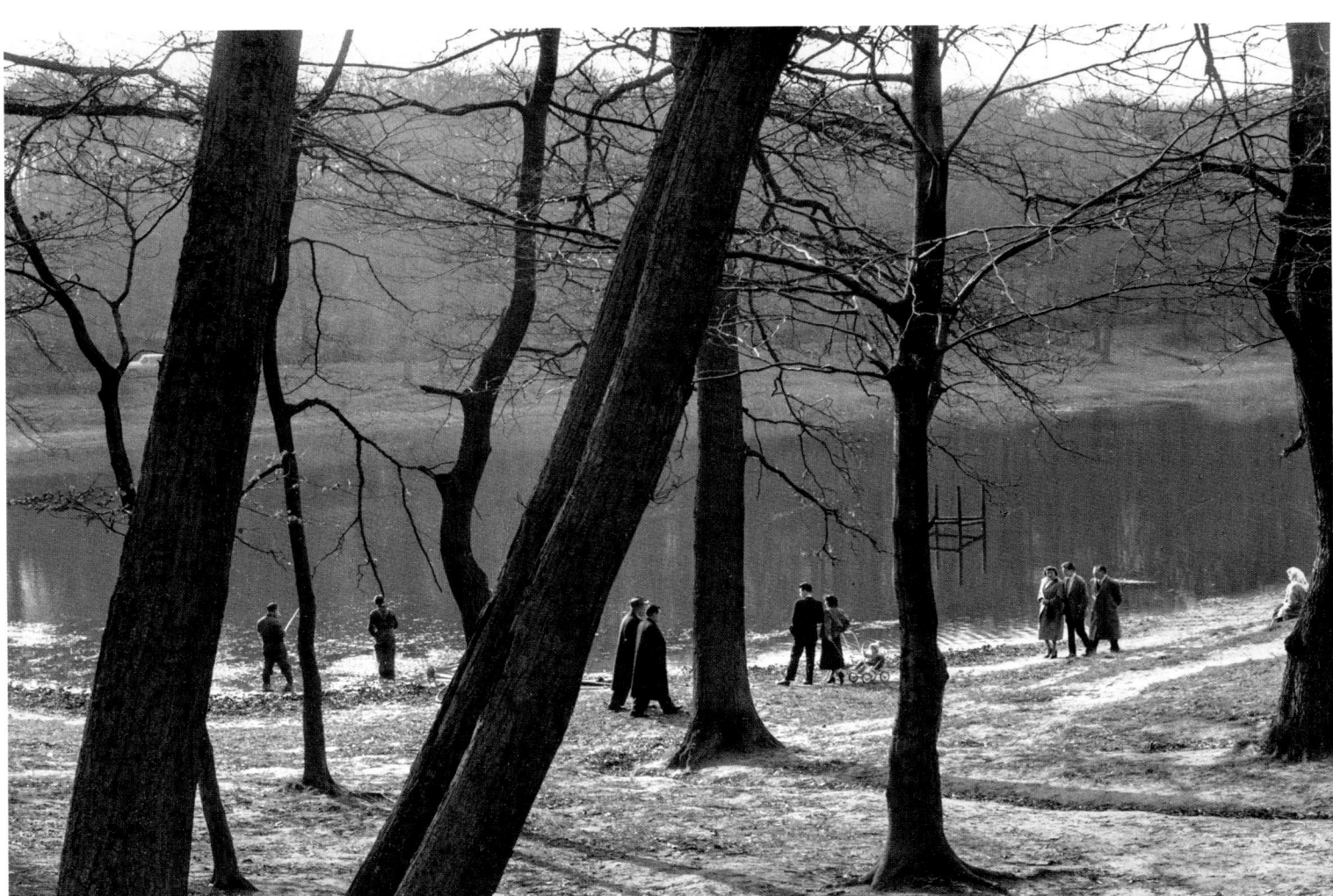

**Villebon pond in Meudon,
Seine-et-Oise, 1957**

NEGATIVE: 24×36 MM _ F43/0439

—— 210

In the woods of Meudon, February 3, 1957. Sometimes on Sundays Marie-Anne and I would visit Georges and Éliane, my brother and sister-in-law, who lived in a house in Clamart. The weather was good and our walk took us to the edge of Villebon pond. I was struck by a perfect idea for a picture. From where I stood (it cannot have been a coincidence), I saw a few figures standing motionless between the trees: the two fishermen on the left and the couple with the baby carriage. I wanted to fill in the empty space at the center and, particularly, the more awkward one on the right. I was in the realm of the unexpected, when anything can happen. You need to be patient, in order to earn your miracle, but expect to be frustrated when nothing happens. Suddenly, I saw two men coming from the left who were about to cross that key area. At the same time, as if staged by an attentive and friendly director, a trio entered from the right. I pressed the shutter when the walkers in the center moved their right feet forward in perfect alignment and as the trio arrived just where I wanted them. In an incredible turn of events, a woman in a light-toned scarf came to complete the picture, sitting in the only spot still available. I wanted to shout! An opportunity like this makes you feel immortal. Instead, I mentally bowed in grateful humility; it made up for the (too) many instances where things either went haywire or simply did not happen. Full frame.

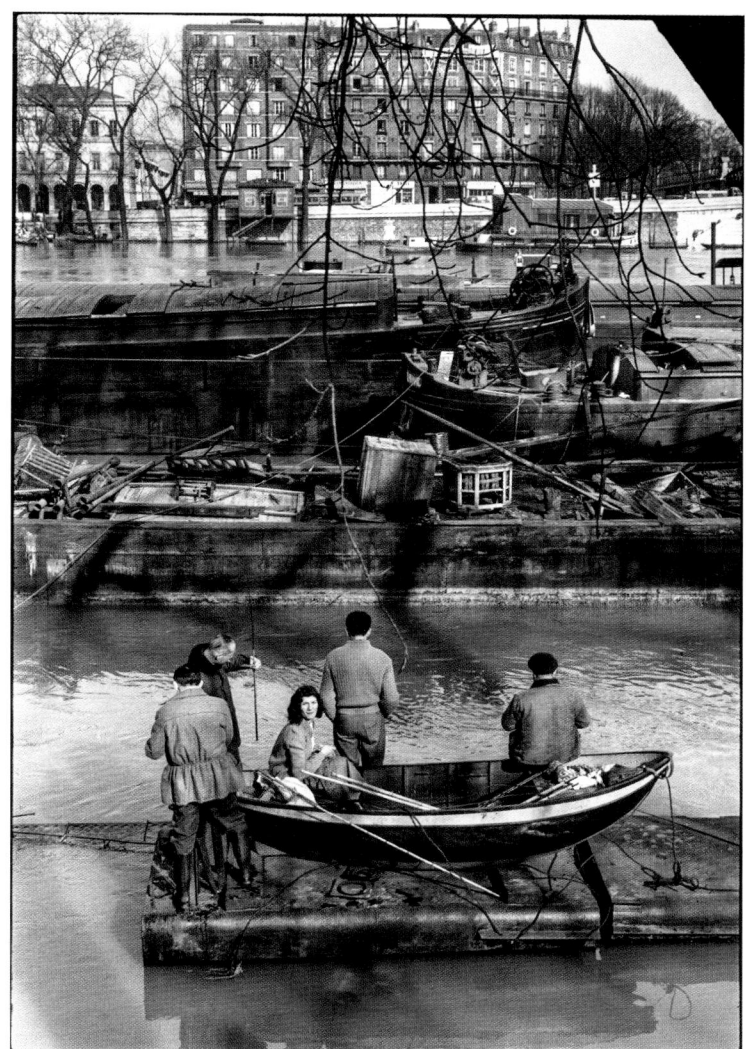
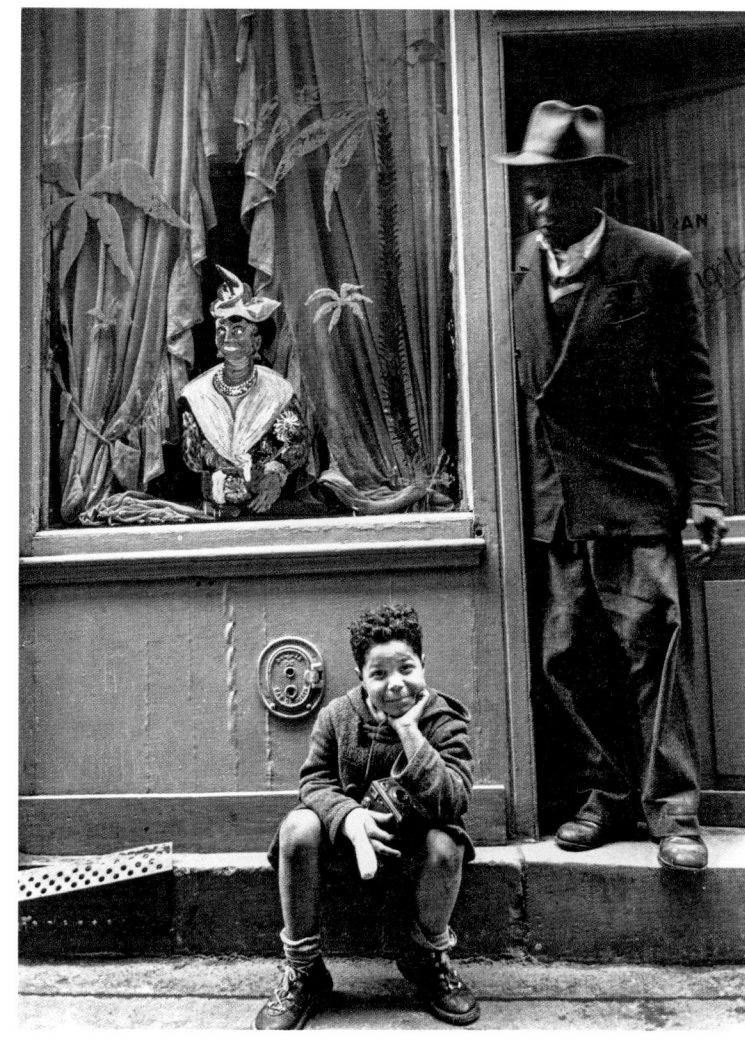

Quai d'Austerlitz, Paris, 1957
NEGATIVE: 24×36 MM _ P43/2427
___ 211
On the Left Bank quay, upstream from the Pont d'Austerlitz. Strange spectacle of a boat in dry dock surrounded by four fishermen who were busying themselves, while an attentive fairy godmother distributed equipment and sandwiches. March 2, 1957; fishing season had just begun, and the weather was fine.
Full frame.

Rue Xavier-Privas, Paris, 1957
NEGATIVE: 24×36 MM _ P44/1741
___ 212
In March 1957, I had the unreasonable idea of doing a major project on rue de la Huchette and its surroundings, without any assignment or commission of any kind. To get started, I began to photograph random encounters, at first without a central theme. This photograph was taken on rue Xavier-Privas. I was in the neighborhood several days a week, at all hours, and ended up, an adult of forty-seven, being part of the furniture, chatting with everyone, and otherwise behaving with the utmost discretion. With a few assignments to cover my costs, I was able to pursue two totally impractical projects at the same time. The first, my odyssey around the islands of Paris (see photo 155), I pursued like an expedition to a distant country, solely to see what I could find. The second was also a pipe dream, since it focused on a group of minors estranged from their families. It was a valid exercise for a sociologist, but not for a photographer. No publication took this project on.
Full frame.

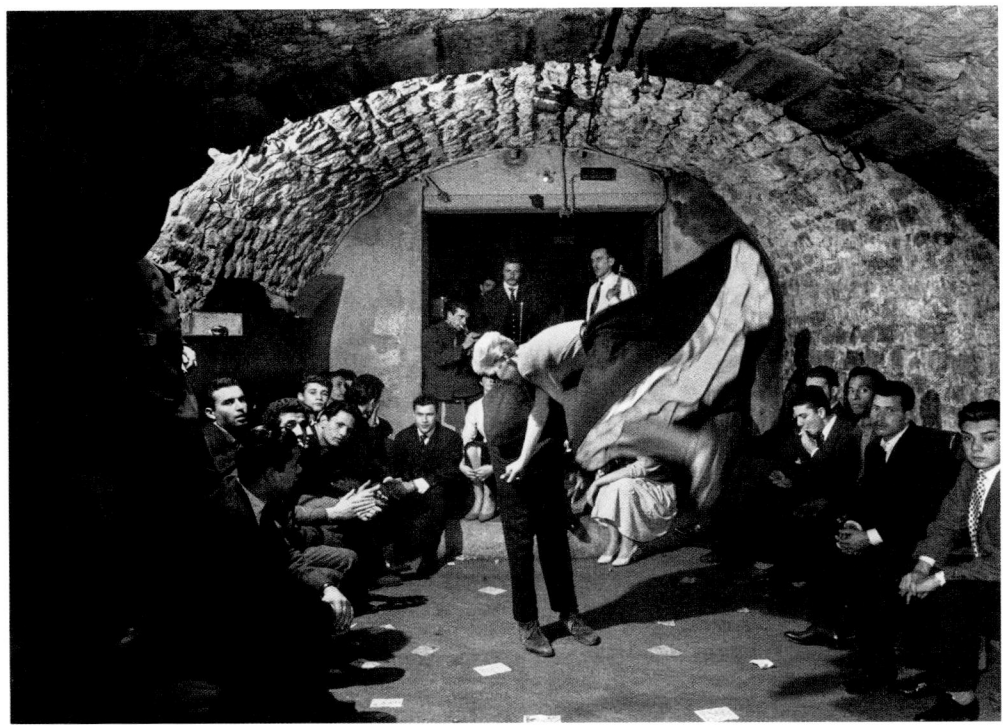

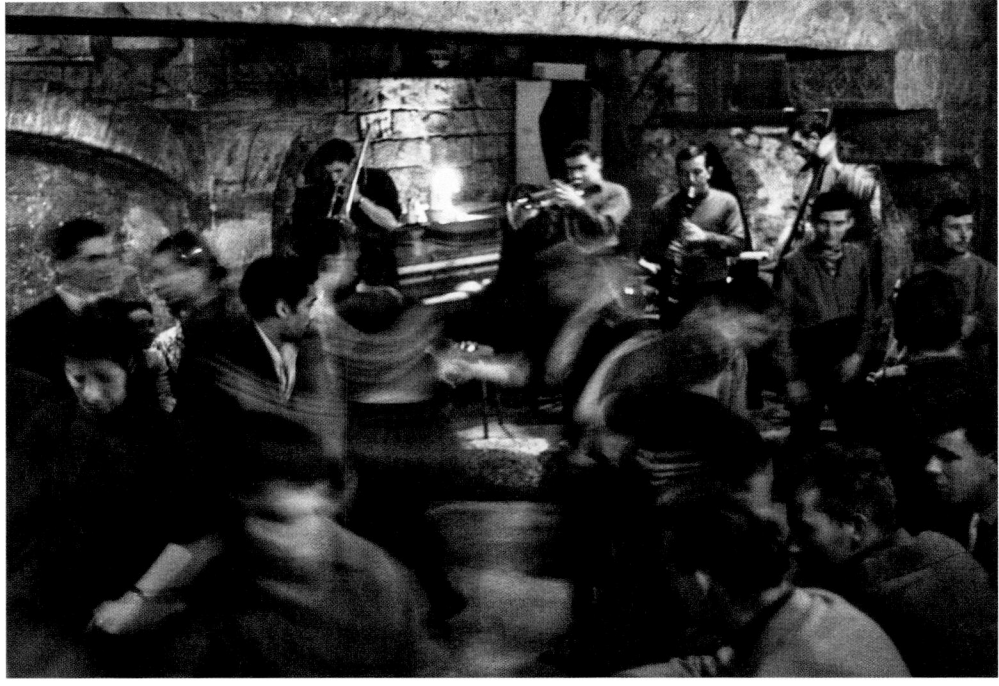

In a cellar, rue de la Huchette, Paris, 1957
NEGATIVE: 24×36 MM _ P45/0328
— 213

Night of March 30, 1957. Dancing the jitterbug in a cellar on rue de la Huchette. Double magnesium flash: weak direct bulb on the right, with a stronger bulb at the end of a long wire ending, on the left, behind the fall of the first arch of the vault. Tray type flash—i.e., slow-combustion—allowing for a 1/200 second photograph to be taken during its illumination. 28-mm, f/11. Print to be balanced according to the strong lighting disparities. Almost full frame.

Caveau de la Huchette club, Paris, 1957
NEGATIVE: 24×36 MM _ P45/2424
— 214

The next morning I developed my jitterbug photograph and noticed how accurately I had timed the mechanical trigger during the combustion of the flash tray. So I went back on the night of March 31 to photograph the Caveau de la Huchette club using two techniques. The first was identical to the one used the day before for the jitterbug photograph, "freezing" motion at 1/200 second. The result was uninteresting, as expected. The second was more complex, without flash, and required measuring the poor ambient light. My photocell showed 1/2 second at f/2.8. "All" I needed to do was to find a stable prop on which to wedge the device in a position that would ensure good framing, and trigger at a time when the musicians were not moving too much but the dancers were grouped harmoniously. During the half-second exposure, their movement would be captured on the film with a blur that I thought might be interesting. "Elementary, my dear Watson!" I made three pictures. This is the one I like best. 50-mm. Slight cropping on the left.

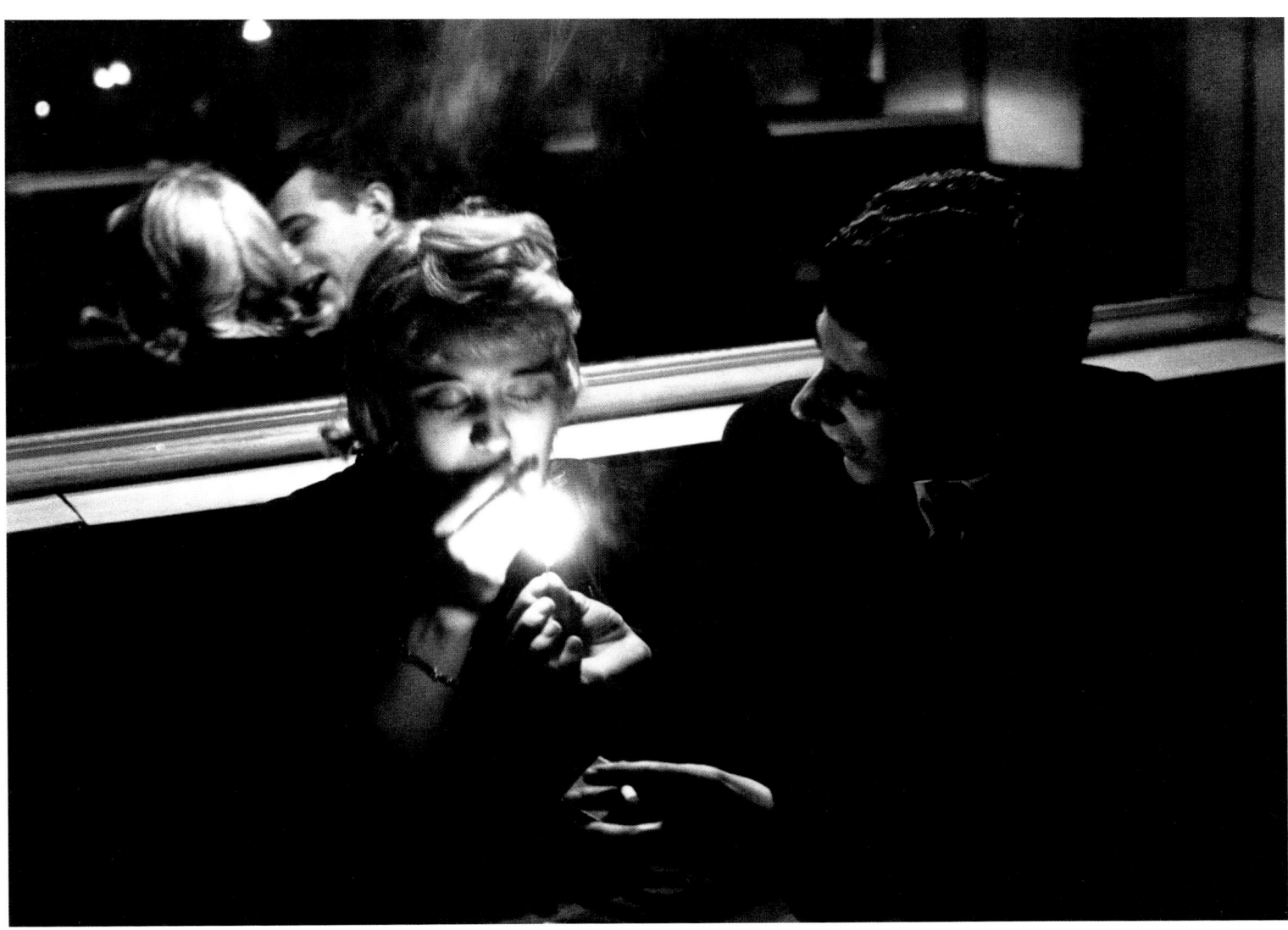

**At Le Bidule café,
rue de la Huchette, Paris, 1957**
NEGATIVE: 24×36 MM _ DUPLICATE _ P45/2702
—— 215

During the day, young people spent their time either in the street or in one of their regular local cafés, such as Popoff or Le Bidule. This image was made in the latter establishment, lit mainly by a match: 1/10 second, f/1.9. There is no miracle: a match held 4 in. (10 cm) away from the face gives more light than a 75-watt bulb hanging 5 ft. (1.5 m) away. Cropping left and right.

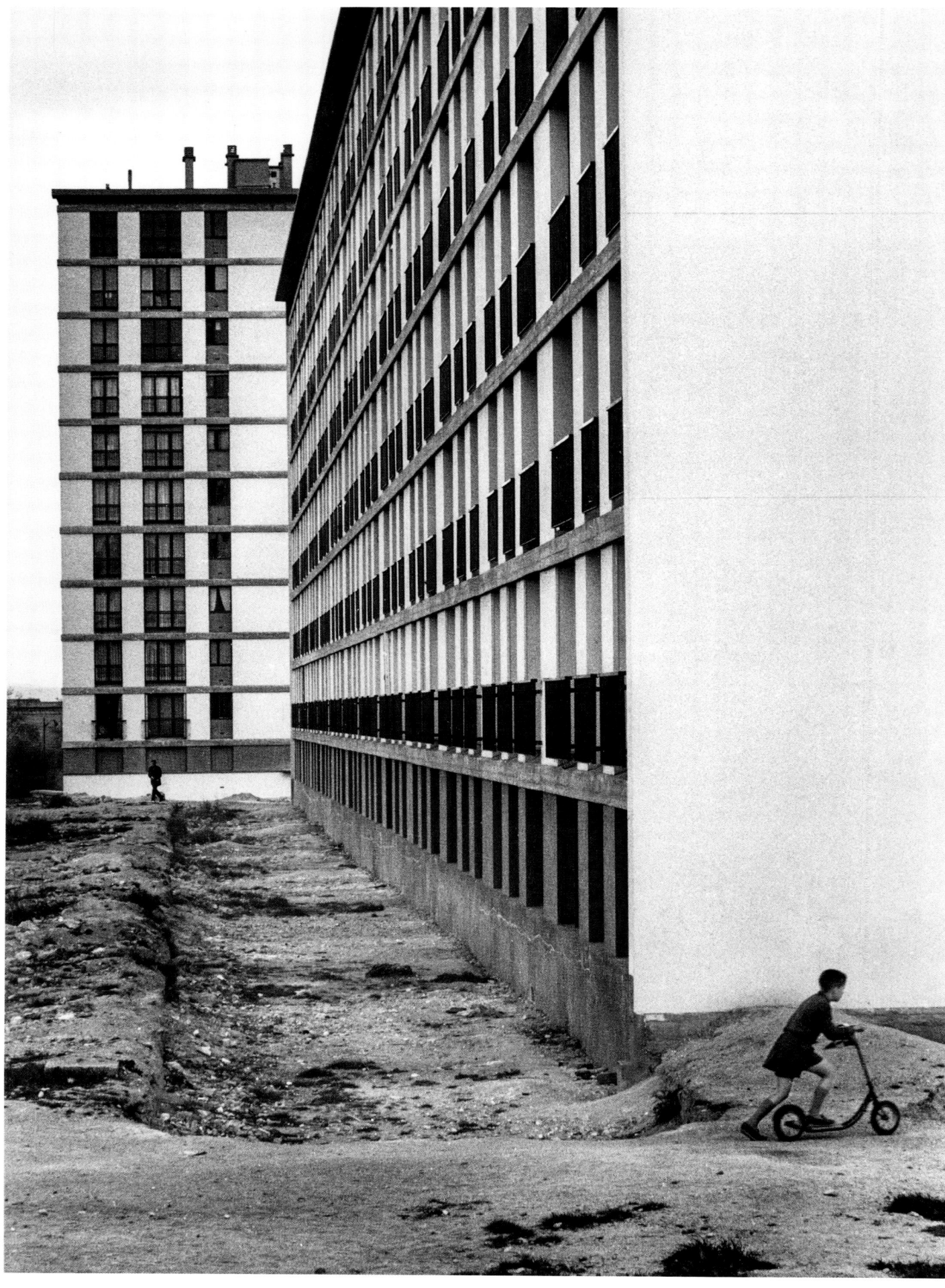

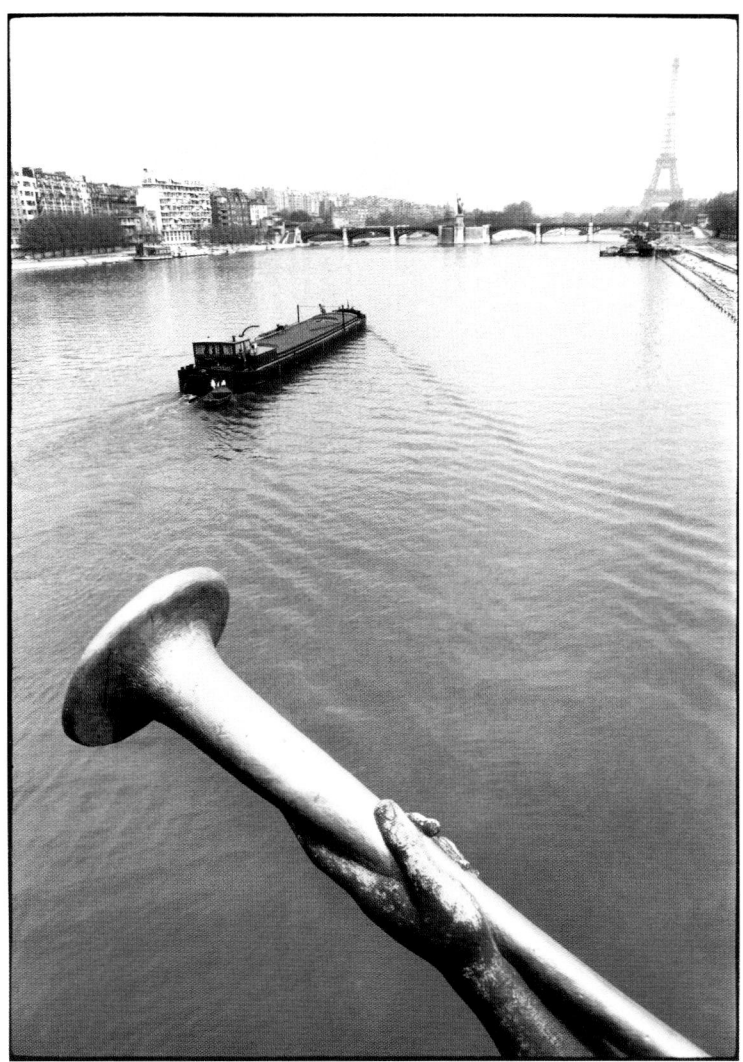

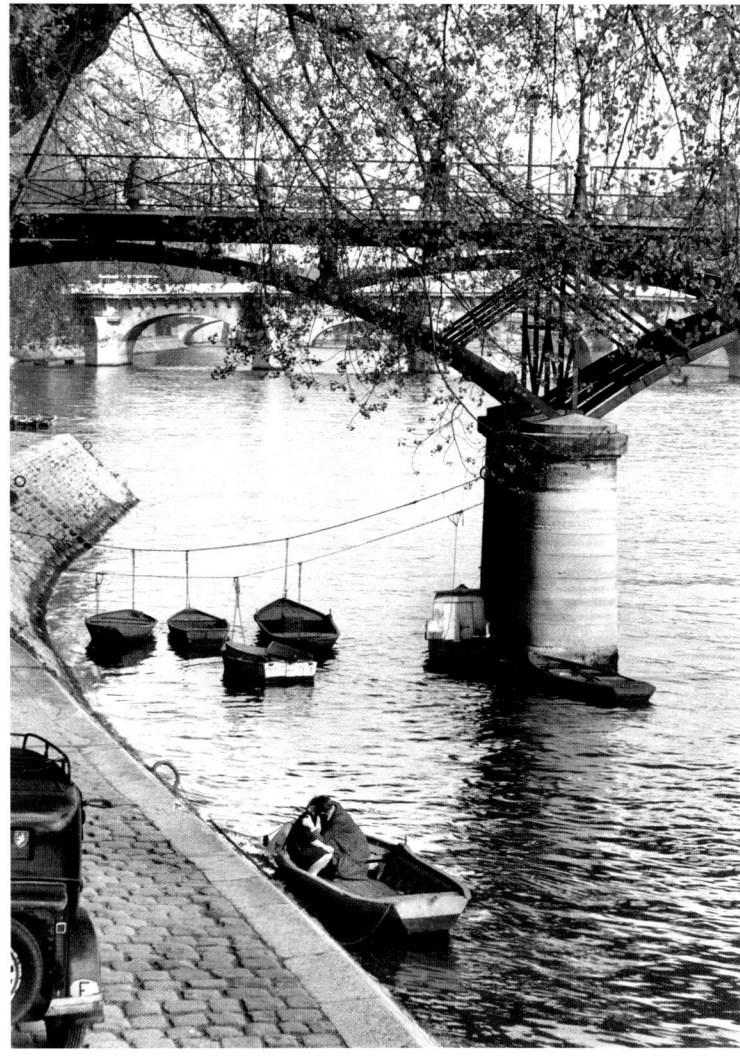

New public housing project at Porte de Vanves, Paris, 1957
NEGATIVE: 24×36 MM _ P46/0837
— 216

During the 1950s, low-rent housing projects were popping up all over the place, disrupting the urban fabric and the old walls that surrounded the capital. I grabbed this image at Porte de Vanves while on one of the little trips to the flea market that Marie-Anne and I made from time to time, urgently looking for objects as indispensable as they were useless. These sadly banal buildings had nothing to inspire the photographer. However, to my delight, I was moved by this boy involved in a high-energy cross-country scooter event, which led to the creation of another image to be filed under "reconstruction," "urban planning," "game," "childhood," "suburbs," etc.

The Seine seen from the Pont Mirabeau, Paris, 1957
NEGATIVE: 24×36 MM _ P46/1219
— 217

I was crossing the Seine on the Pont Mirabeau, smiling, as I always do, at this trumpet brandished by a bronze hand. As I looked up, my gaze followed a self-propelled barge moving downriver in the direction of the Île aux Cygnes, its path leading, in my viewfinder, to that ideal point where the shutter release itches to be pressed. The timing was right; a second later and it would have been too late. 28-mm. Full frame.

The lovers of the Pont des Arts, Paris, 1957
— 218

NEGATIVE: 24×36 MM _ P47/1206

In the old days, below the quai du Louvre, under the first arch of the Pont des Arts, a string of flat-bottomed boats awaited fishermen and lovers. I must have been a little distance away, moving down the ramp leading to the quay on that overcast spring day. I framed the shot with a 90-mm, and this is what I caught. Almost full frame.

**Near the Poitevin Marshes,
Sansais, Deux-Sèvres, 1957**
NEGATIVE: 24×36 - P49/1808
__ 219

Easter vacation 1957, not far from the Poitevin Marshes. This is the mere record of a little aesthetic moment, one morning after the rain, in the haze of a new dawn, singing softly. 90-mm. Bring the gray out in the sky during printing. Almost full frame.

**The lovers of the Pont Royal,
Paris, 1957**
NEGATIVE: 24×36 MM _ P49/2737
__ 220

Alongside my projects on the fauna of la Huchette and the islands, I continued to catalogue the bridges of the Seine. There are more than thirty of them, and I have taken them all, from Issy-les-Moulineaux to Charenton-le-Pont. This is very documentary work, whose austerity I tempered by including, whenever possible, a human element. That is, I tried to establish a balance between architecture and those who use it. It was difficult because I worked on this theme *without any commission*, and my natural inclinations led me to forget the bridges or, rather, to use them as a pretext for drifting toward the unexpected. That is how I found myself at the quai des Tuileries, just downstream from the Pont Royal, on a spring morning with a misty sun. Of course, I took other photographs where the bridge formed the main subject. 90-mm. Full frame.

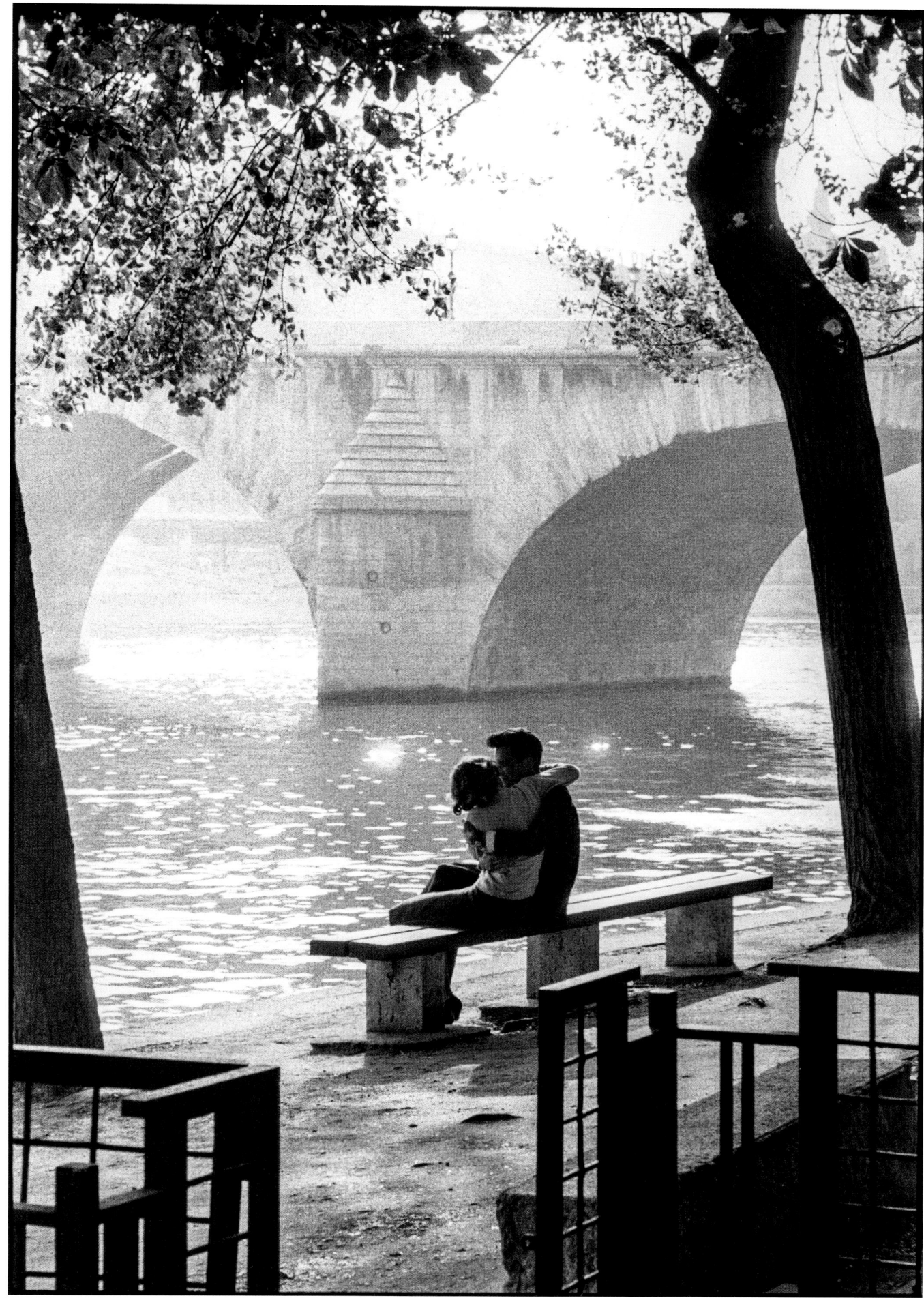

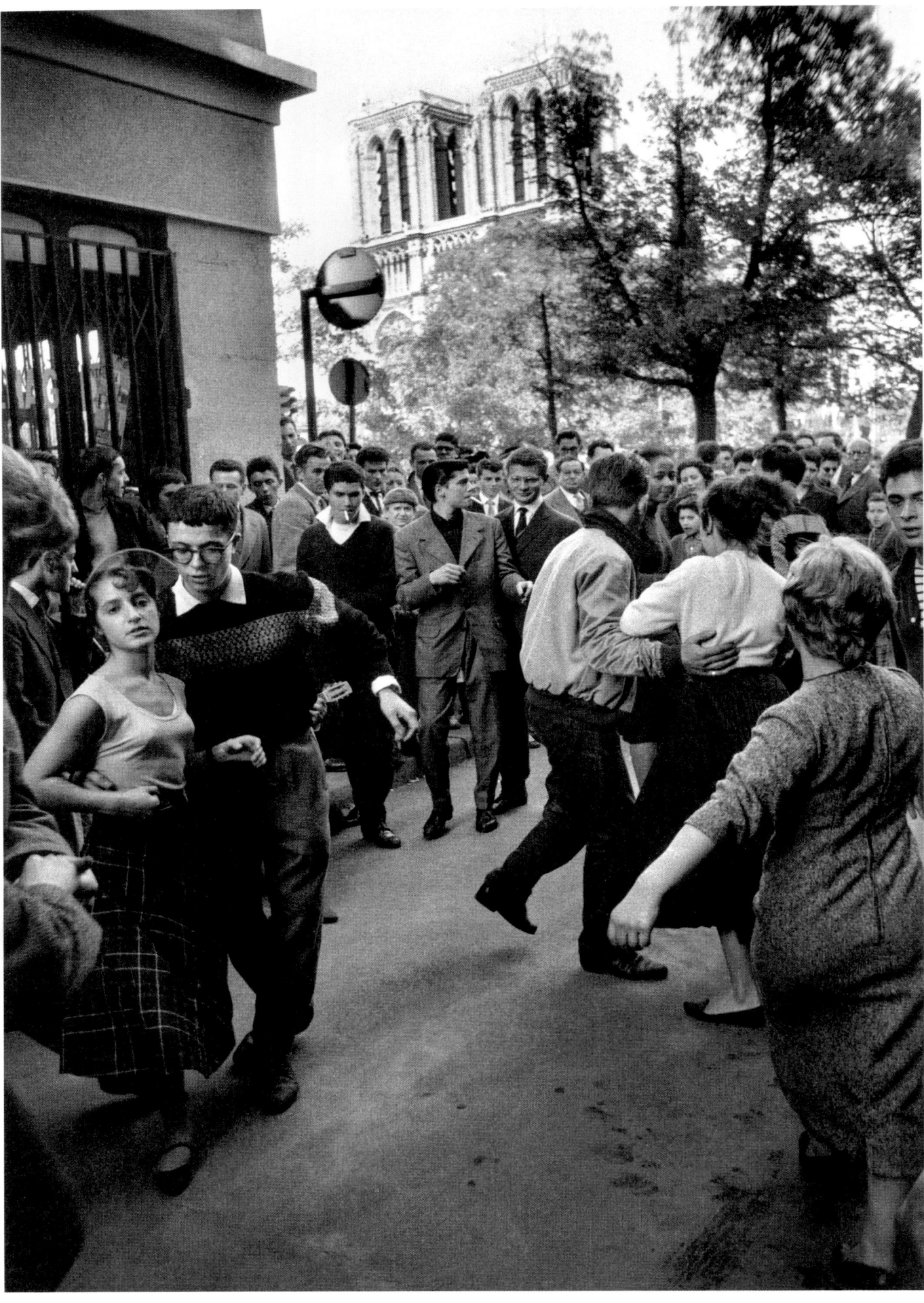

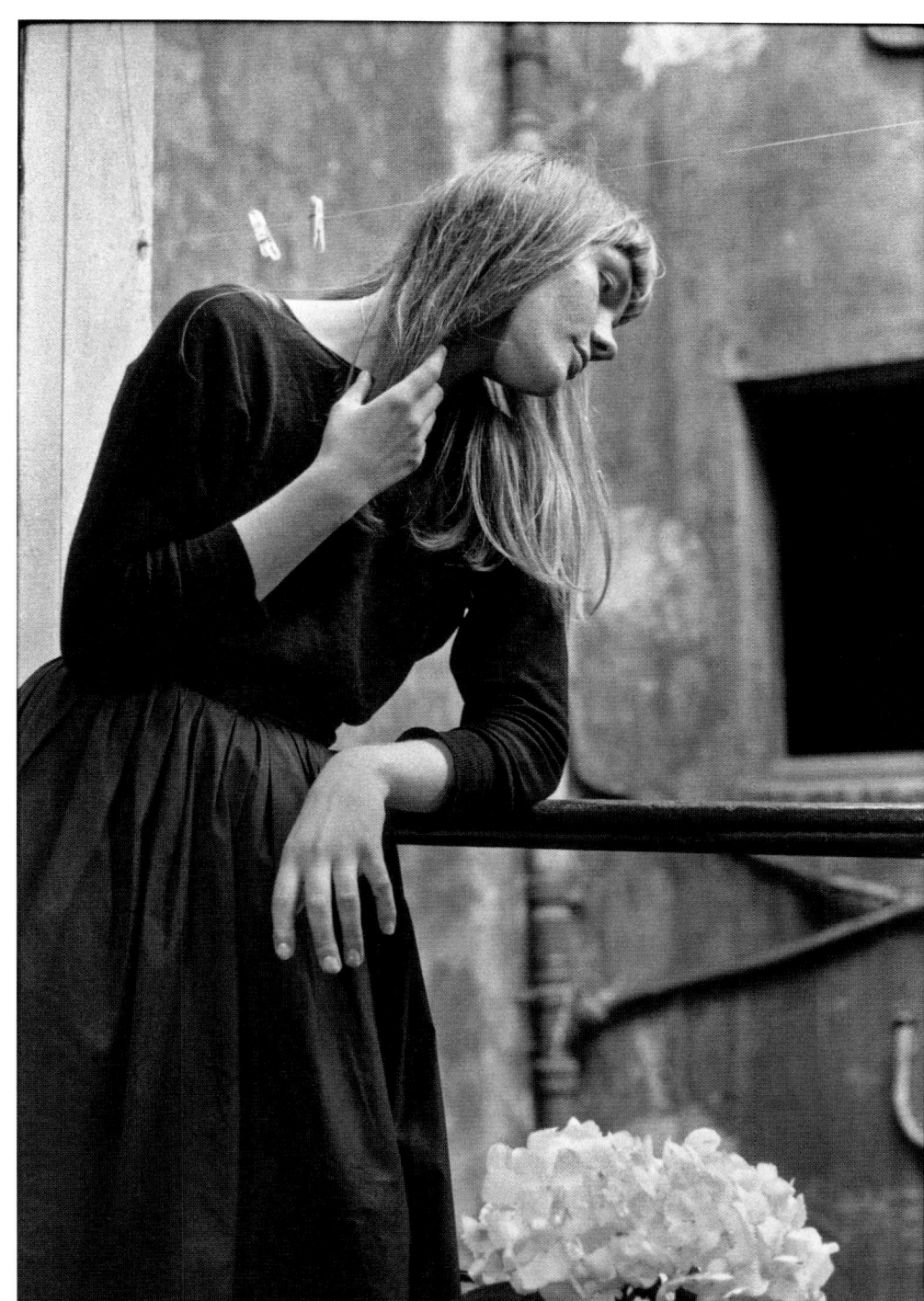

Rue de la Huchette, Paris, 1957
NEGATIVE: 24×36 MM _ P50/2137
— 221

May 19, 1957. Over a period of two months, the young people of la Huchette had become used to my Foca, my discreet curiosity, and my balding head. I asked them to organize an impromptu dance near rue du Petit-Pont, so that Notre-Dame was in the background. Off they went, leaving me unable to direct their seemingly incoherent movements. Still, a small space opened up, and I immediately took advantage, using 1/100 second. I made a few more clicks, so that they did not think I had changed my mind, and I then mingled with them in search of other ideas for photos. 35-mm. Difficult print: negative underexposed at the bottom, overexposed on Notre-Dame. Almost full frame.

Courtyard on rue de la Huchette, Paris, 1957
NEGATIVE: 24×36 MM _ P51/2119
— 222

I made friends with a small group of young people. They invited me to a dinner in a small house where they all met, an oasis of calm. One of the girls was waiting for a latecomer, and her pose was so natural that I spontaneously blurted out the same phrase that, eight years earlier, had made Marie-Anne freeze in *The Provençal Nude*: "Stay as you are!" I didn't invent those magic words, but they have often come in useful and sometimes still hint that an image might be worth keeping. Almost full frame.

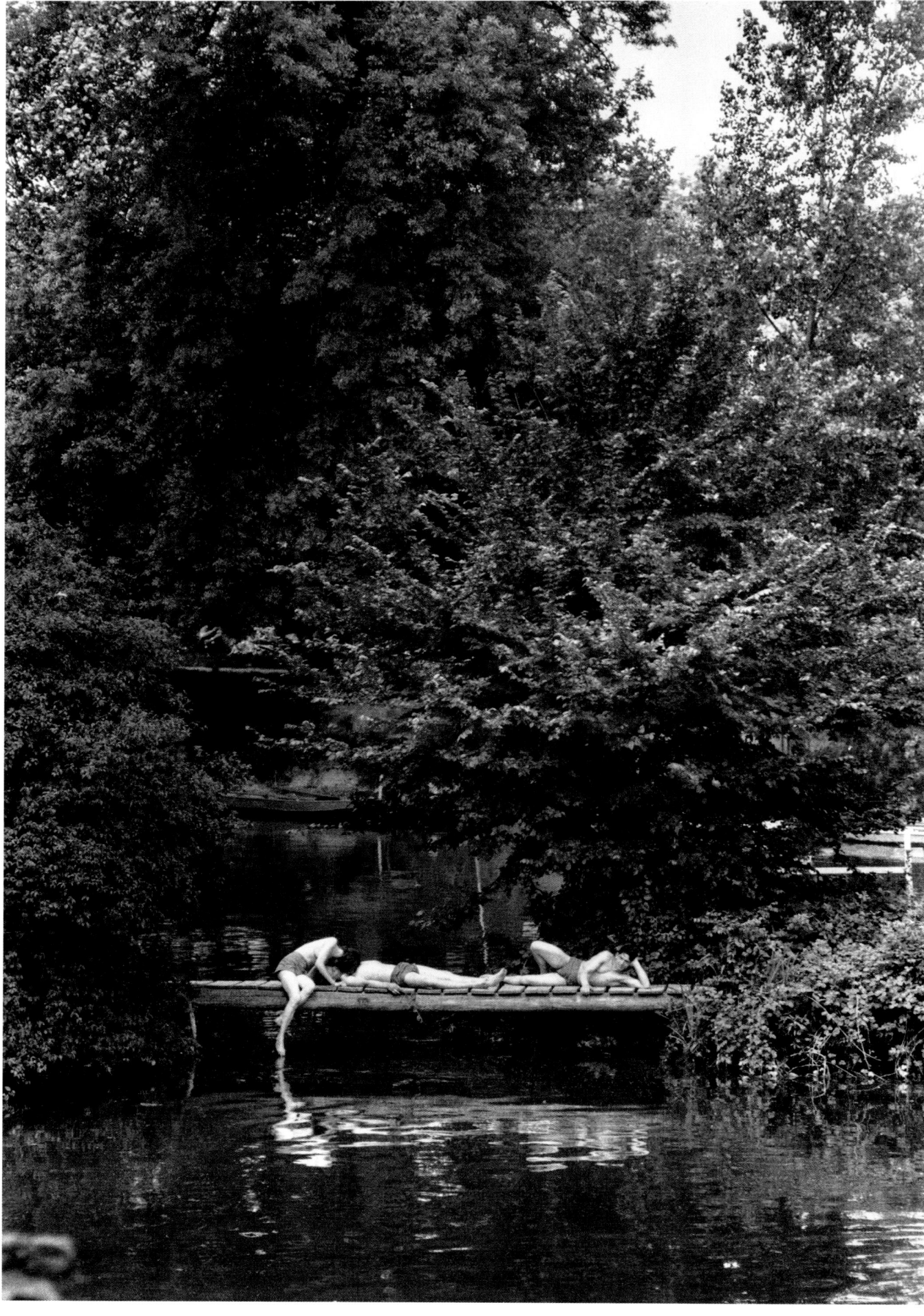

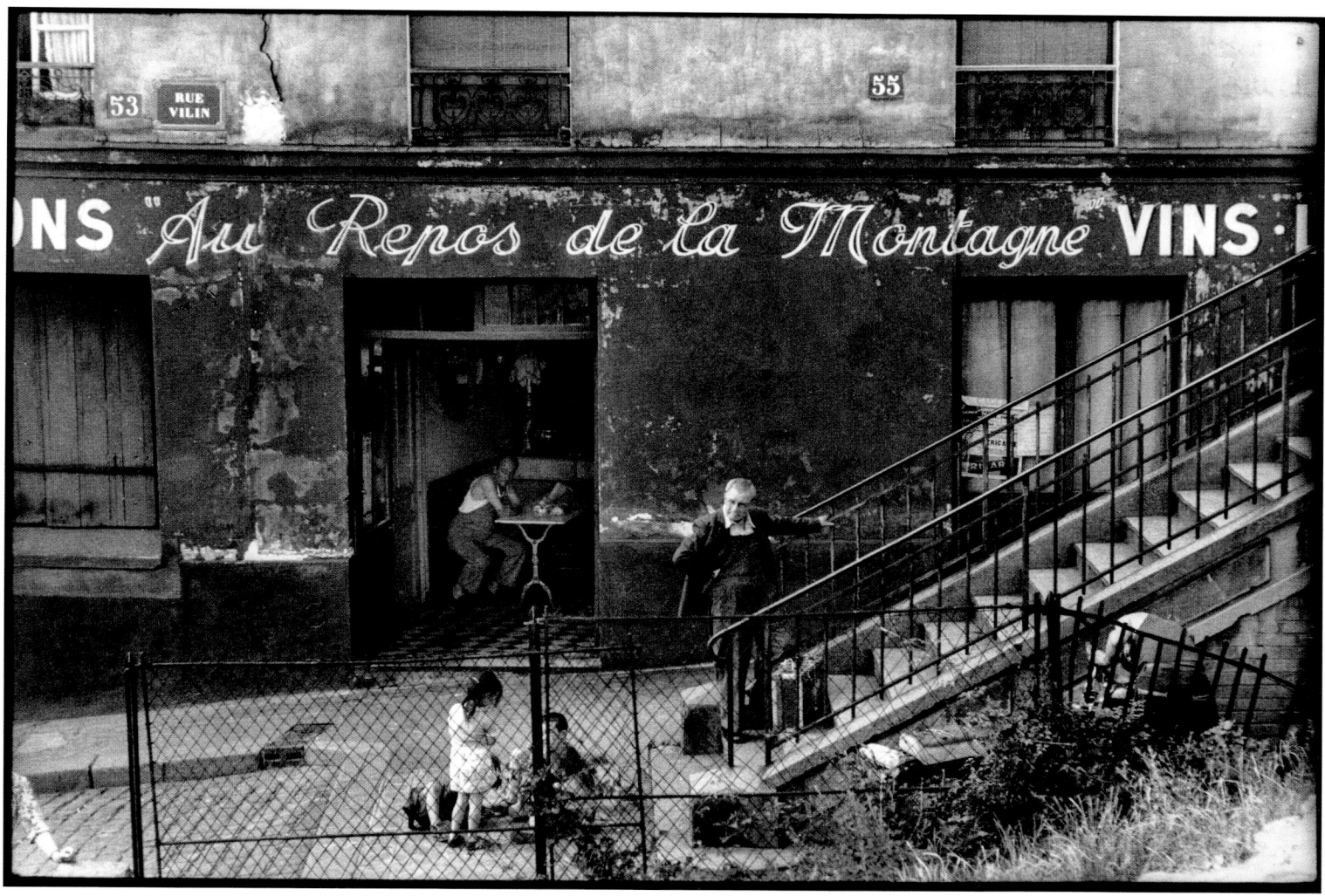

The footbridge, Champigny-sur-Marne, Seine, 1957
NEGATIVE: 24×36 MM _ F52/2617
— 223

Vogue asked me to scout some country locations, near water and near Paris, for a series of ready-to-wear photographs. Since I had been visiting the islands of Paris, I had already dealt with this theme. So I returned to the banks of the Marne and, on a gloomy June 15, 1957, I took, among other shots, this one that I like very much. It became the cornerstone for a series of raincoat photos and later appeared several times in magazines and books, just as it appears here. It is a kind of cousin to photograph 201, the fisherman and his son. 135-mm lens. Printing requires great attention to the balance between the rendering of the foliage and the characters' forms. Full frame.

The descent of rue Vilin, Paris, 1957
NEGATIVE: 24×36 MM _ P53/4141
— 224

In early July 1957, the magazine *Focagraphie* commissioned me to do a small series on Belleville and Ménilmontant. This is the photograph that I like best. 35-mm lens. When printing, the interior of the café needs to be pulled back a little to bring out the customer. Full frame.

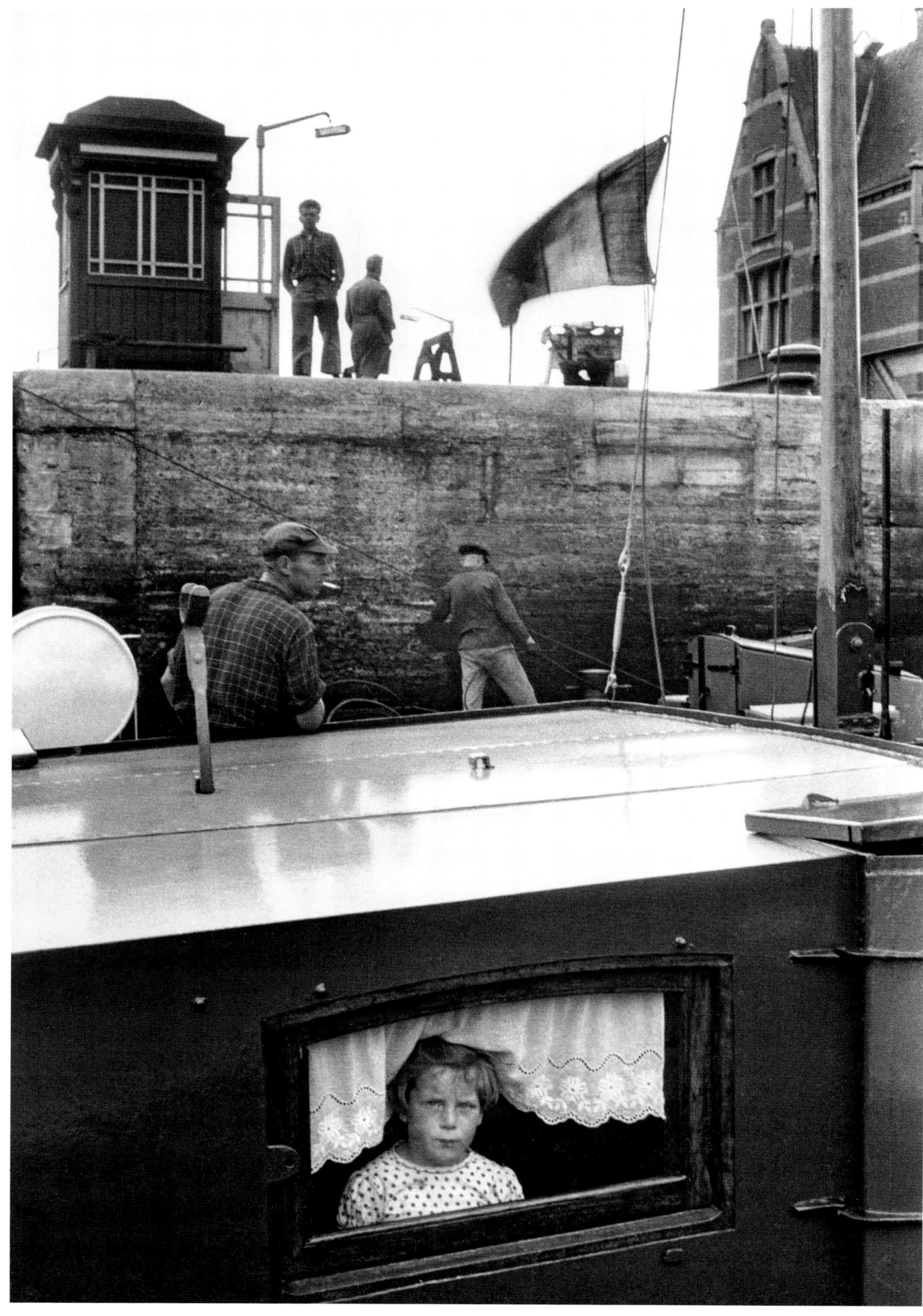

Opening a lock on the Scheldt, Antwerp, 1957
NEGATIVE: 24×36 MM _ 54/0220
___ 225

On July 15, 1957, determined to take the scenic route from Paris to the Vaucluse, we headed our 2CV toward Belgium. We were expected in Antwerp by our friends the Craeybeckx. Our friend Herman—who was held up elsewhere—had strongly recommended taking a boat trip on the Scheldt, but I found myself bored to death while waiting for one of the locks to be opened. Nonetheless, I managed to get this photograph out of it, which passes (I admit, modestly) for one of my best. I note that, in this almost-frontal composition, something is happening on all three levels. I recognize myself totally here, with my joys and worries, and my soul-searching. Enough! Backlight difficult to print with consistent results. Full frame.

At Tongerlo Convent, near Antwerp, Belgium, 1957
NEGATIVE: 24×36 MM _ 54/0623
___ 226

Five days later, I drove all four of us, Paula, Marie-Anne, Herman, and me, to various corners of the Flemish countryside. This was taken on the lawns of Tongerlo Convent. Nothing very exciting was happening, aside from my guide's friendly and erudite conversation. Suddenly, I whispered to him: "Stand still, don't say another word." Three doves had just landed not far from us. They moved ahead in no particular order, except for one fleeting moment, which I immediately captured. I turned to Herman, who, speechless, was frozen to the spot and was watching me proceed. I sent him this image shortly afterward, which he used as an excuse to write an article, reprinted many times, entitled: "What makes a good photograph?" A few months later, he sent me his work when it first appeared, accompanied by my photograph, in a French-language Belgian magazine. His cover letter read, "On that day, you helped me clarify my ideas." 50-mm. Almost full frame.

**Herman Craeybeckx,
Antwerp, Belgium, 1957**
NEGATIVE: 24×36 MM _ 54/0730
— 227

Herman Craeybeckx in his attic office. He had just retired and had lovingly fitted out a "thinking-perch" for himself, where he intended to study and write often, which he did, though less than he—and his relatives— had hoped. A humanist, musician, polyglot, and historian, he had known true heartbreak (the death of an only son in the Resistance). Our friendship arose around the time that I made friends with Romeo Martinez. The two men knew and admired each other. I decided to immortalize this set-up and the carefully organized desk, a symbol of its user's rigor. Through the window you can see the garden where, between conversations on every subject imaginable, we had furious ping-pong tournaments. 28-mm. Quite simple to print. Almost full frame.

**Saint-Saturnin-lès-Apt,
Vaucluse, 1957**
NEGATIVE: 24×36 MM _ F55/3008
— 228

About three weeks later, in August 1957, at Saint-Saturnin-lès-Apt in the Vaucluse, we took a little tour of the nearby villages. On this café terrace, Marie-Anne had found a subject for a quick gouache. Later, as I returned from a walk, I saw this scene that, at the right distance, appeared in my 90-mm viewfinder as if the curtain had suddenly lifted on a Marcel Pagnol play. But there was a space in the center of the scene. Just at the right moment, opening the café's beaded curtain, this determined little boy came out to go about his business. It completed the image. 90-mm. Backlight a little difficult to modulate. Almost full frame.

Pont Alexandre III, Paris, 1957
NEGATIVE: 24×36 MM _ P58/3130
—— 229

On a hazy evening in November 1957 on the Pont Alexandre III, the pedestrians passing at regular intervals heightened the dramatic atmosphere. This is a period when, in a rather random fashion (driven by what demon?), I was taking on projects that were somewhat idealist. There were the islands of Paris, a subject I was far from having exhausted, then the rue de la Huchette project, and now the bridges of Paris. In any case, these projects enriched my archives, and, once in a while, one random publication or another paid royalties. Here, I had been walking up the bridge toward the Grand Palais and, just in case, had equipped my Foca with the 135-mm telephoto lens. Holding my breath, I pressed the shutter five times. The last shot was the best. Average difficulty printing.
Almost full frame.

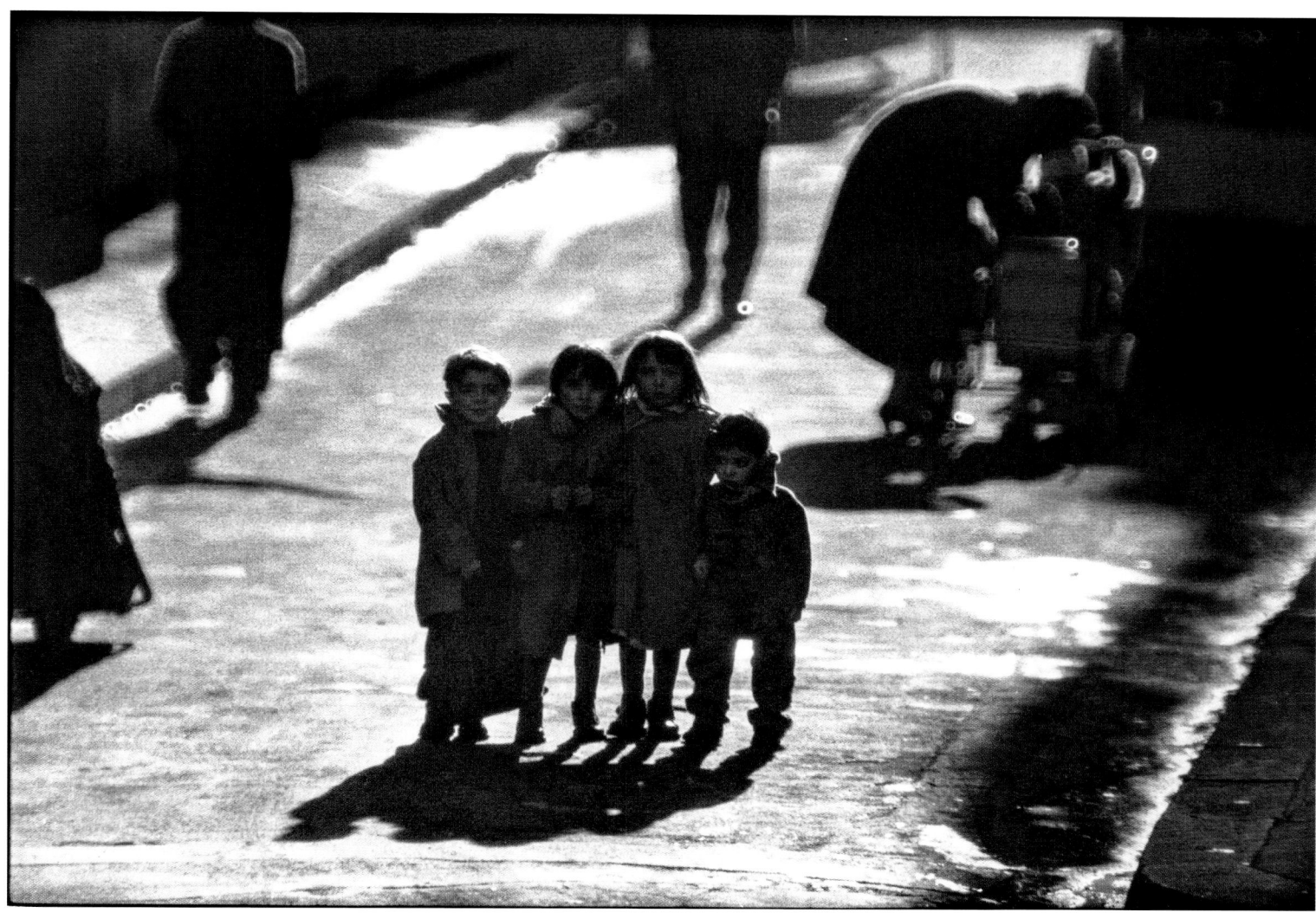

**Rue de Bièvre from the
quai de Montebello, Paris, 1958**
NEGATIVE: 24×36 MM _ P59/3939
___ 230

OPL (Optique et précision de Levallois) was the inventor of the Foca—the French Leica—among other cameras: my faithful companion from 1955 to 1981. OPL gave me the opportunity to try out its 500-mm focal mirror lens, which was a kind of scoop at the time. I already owned a micro-Foca SLR body (see photos 233 to 236), which had been provided by the same company. Onto this body I screwed the new and curious barrel-shaped lens. Thus assembled, the equipment offered a good grip and, for an experienced photographer, shutter speeds of 1/50 or even 1/25 second were perfectly achievable without a tripod. The aperture could not be adjusted: its was fixed around f/6.3, and the bright spots outside the plane of focus were reflected in the form of luminous circles (other photographers have since played on this specific effect). The parameters of this selection prevented me from making multiple examples, but here is one showing a backlit scene on rue de Bièvre, I believe, from the sidewalk of the secondhand booksellers on the quai de Montebello. The print must be balanced so that the children's features are not too dark. Full frame.

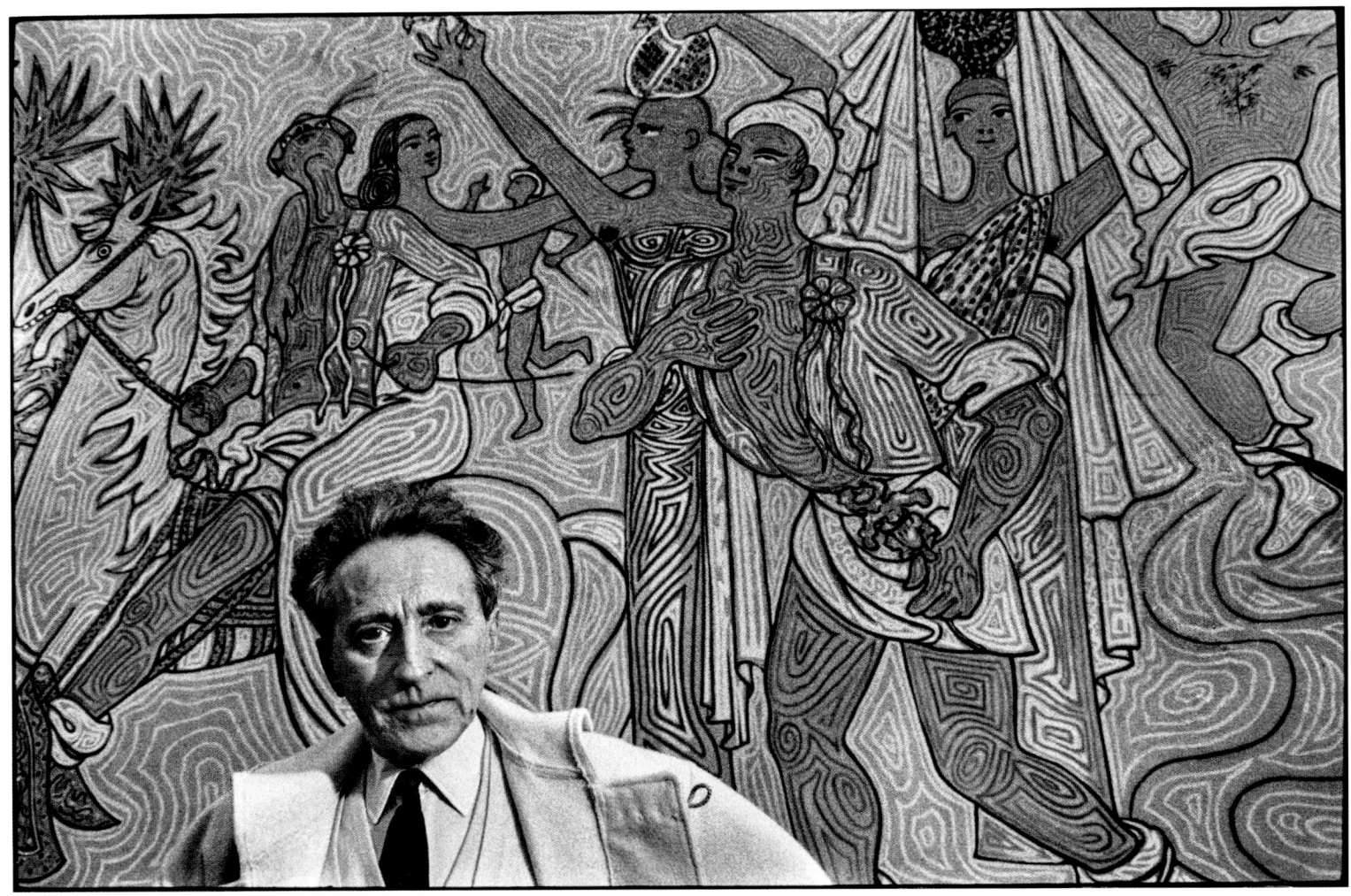

**Jean Cocteau, Menton,
Alpes-Maritimes, 1958**
NEGATIVE: 24×36 MM _ 60/3725
—— 231

In March 1958, I was finishing a fashion story for *Vogue*, shot between Villefranche-sur-Mer and Cannes. The schedule for meeting the print deadline meant the model had had to pose in bathing suits during the Mistral, interspersed with sips from a stiff hot toddy. Edmonde Charles-Roux, then director of the magazine, told me to go to Menton to see Jean Cocteau, who had just finished the decoration of the marriage room at the town hall. Warm welcome, poor light. I unrolled a few feet of wire and, about thirteen feet (four meters) to the right, fixed the auxiliary flash on a pole (the main flash was kept off circuit). Tried the flash from various angles and different compositions. A new example of what I call not a portrait, but a character *in situ*, the focus being equally on the man and his surroundings. Equalize the values of the interior during printing. Almost full frame.

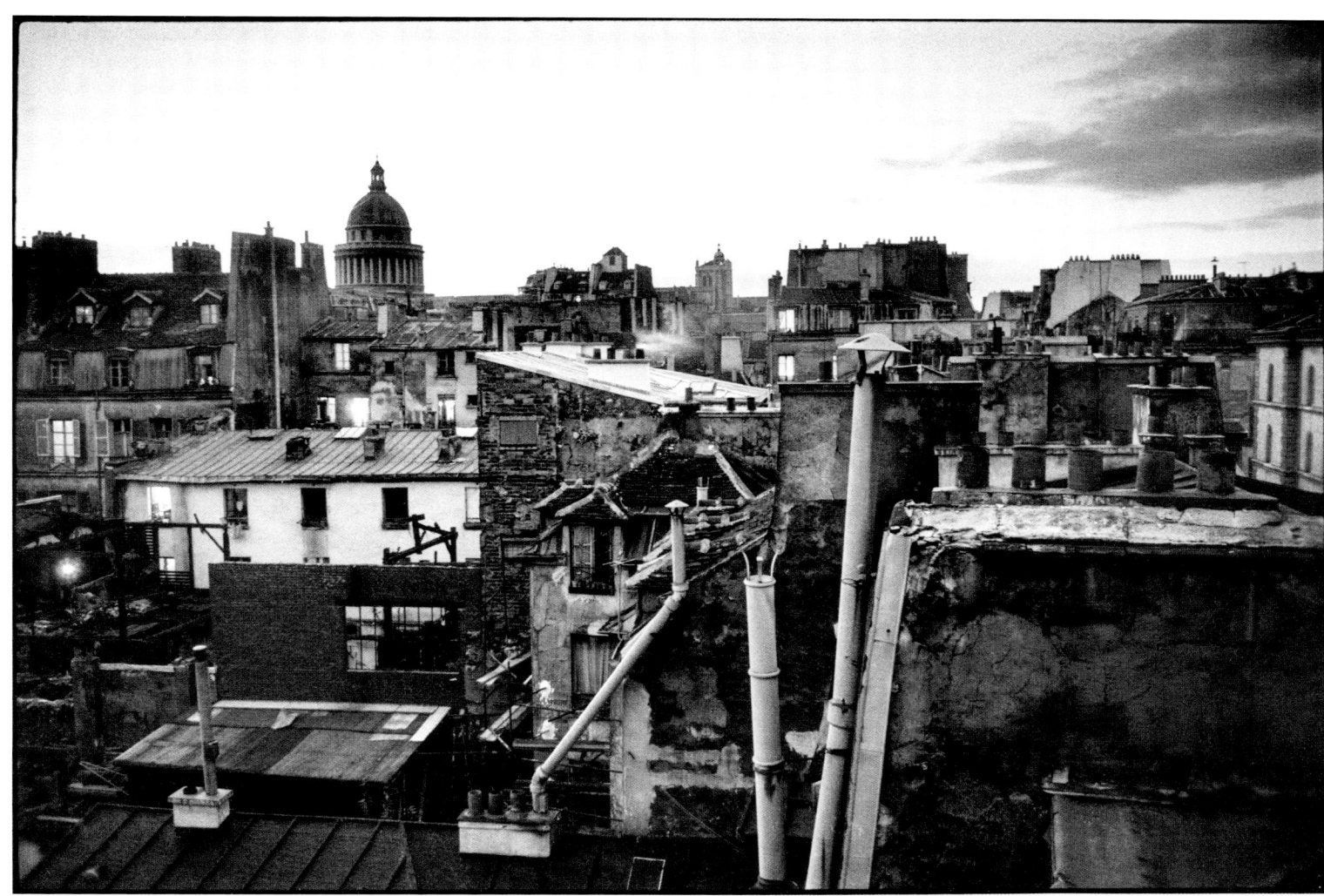

View from the top of a house on rue Mouffetard, Paris, 1958
NEGATIVE: 24×36 MM _ P61/5015
__ 232

I was working on a project on the Mouffetard district and, from time to time, at random, I would climb staircases to the top, just to see what I could see. Excellent for the lungs and for hunting good images. On this evening of May 5, 1958, I had arrived at a good moment. It was dark enough for some windows to be lit up, and still bright enough for the incredible jumble of courtyards to be made out (see the commentary on photo 168). The print should emphasize the twilight effect, and also highlight the few clouds that were in the process of dissolving. Maybe a 35-mm lens. Full frame.

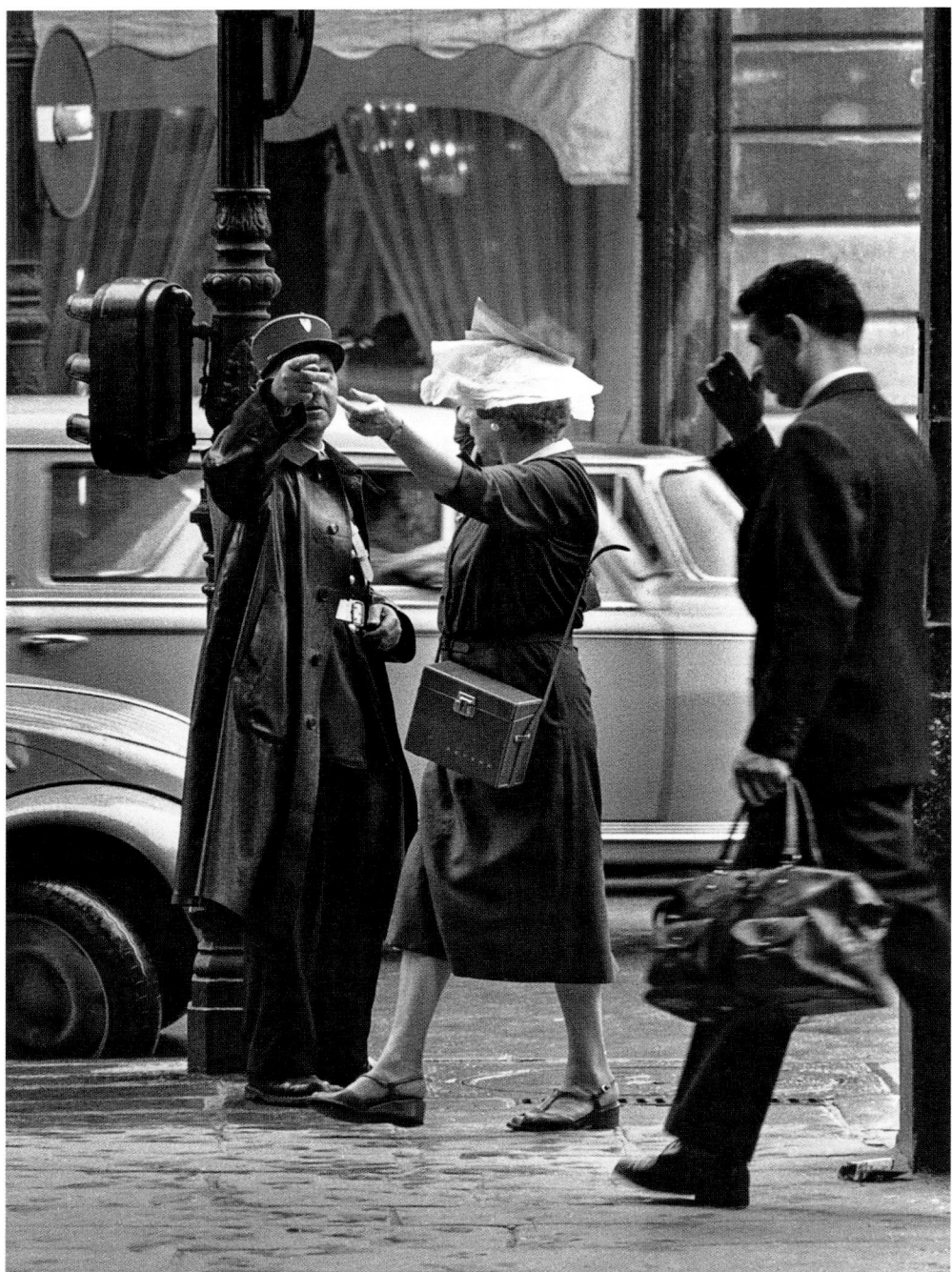

Rue de Castiglione, Paris, 1958
NEGATIVE: 24×36 MM _ P63/0116
___ 233

I was testing out my 200-mm lens screwed onto my micro-Foca body around Paris, to warm up for a series of fashion photographs in Paris that *Vogue* had let me schedule for early August (photos 235 and 236). It's not easy to use a long telephoto in the urban traffic: just as everything looks set, someone will suddenly appear in the frame and walk all the way along the sidewalk in the very axis of your shot. Used from time to time, however, without worrying about the bigger picture, the long telephoto lens creates a specific atmosphere that has its place. July 1, 1958, rue de Castiglione.
No printing issues. Almost full frame.

Rue du Vingt-Neuf-Juillet, Paris, 1958
NEGATIVE: 24×36 MM _ P63/0431
___ 234

Having climbed onto the low railing wall of the Jardin des Tuileries, I used my 200-mm to look down on the traffic on rue de Rivoli toward rue du Vingt-Neuf-Juillet, close to the Rapho agency (which I probably dropped into). The light was low on this summer day, and for the depth of field I had to close the aperture to around f/16, which meant working with 1/50 second shutter speed, slightly blurring the passersby. No matter. As the violinist Georges Enesco used to say to his students, "Playing a little off-key is more expressive." Quite simple to print. Almost full frame.

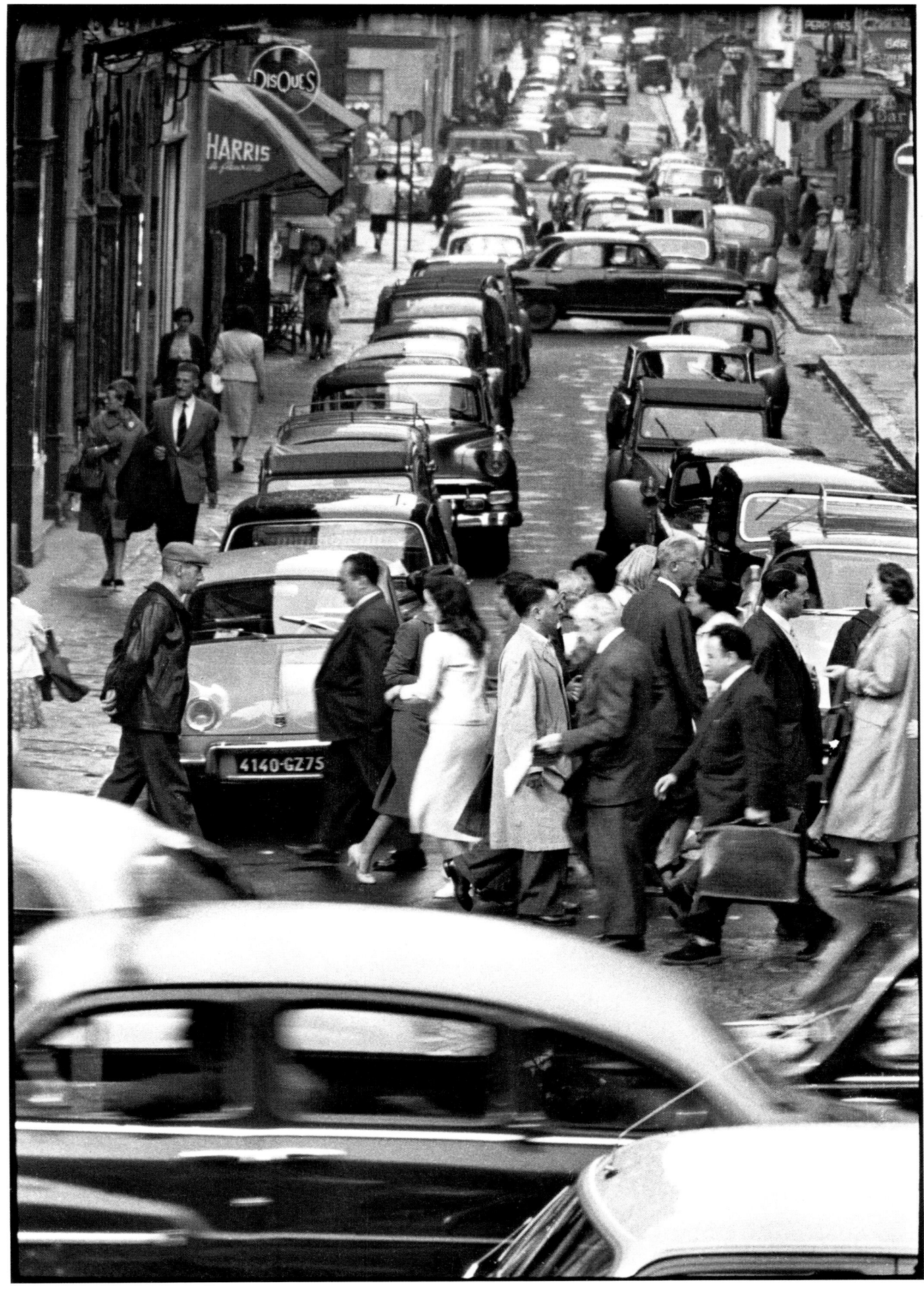

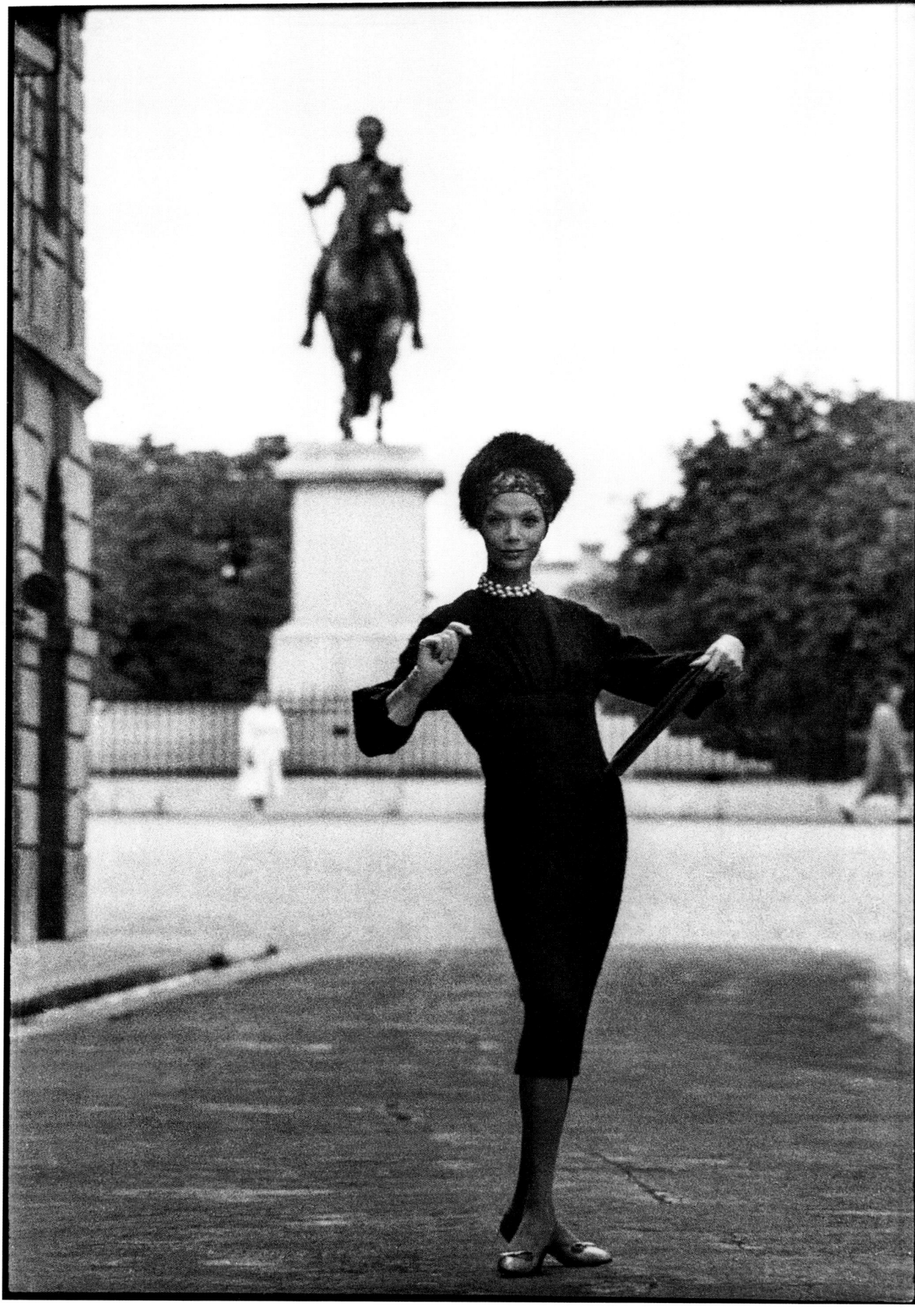

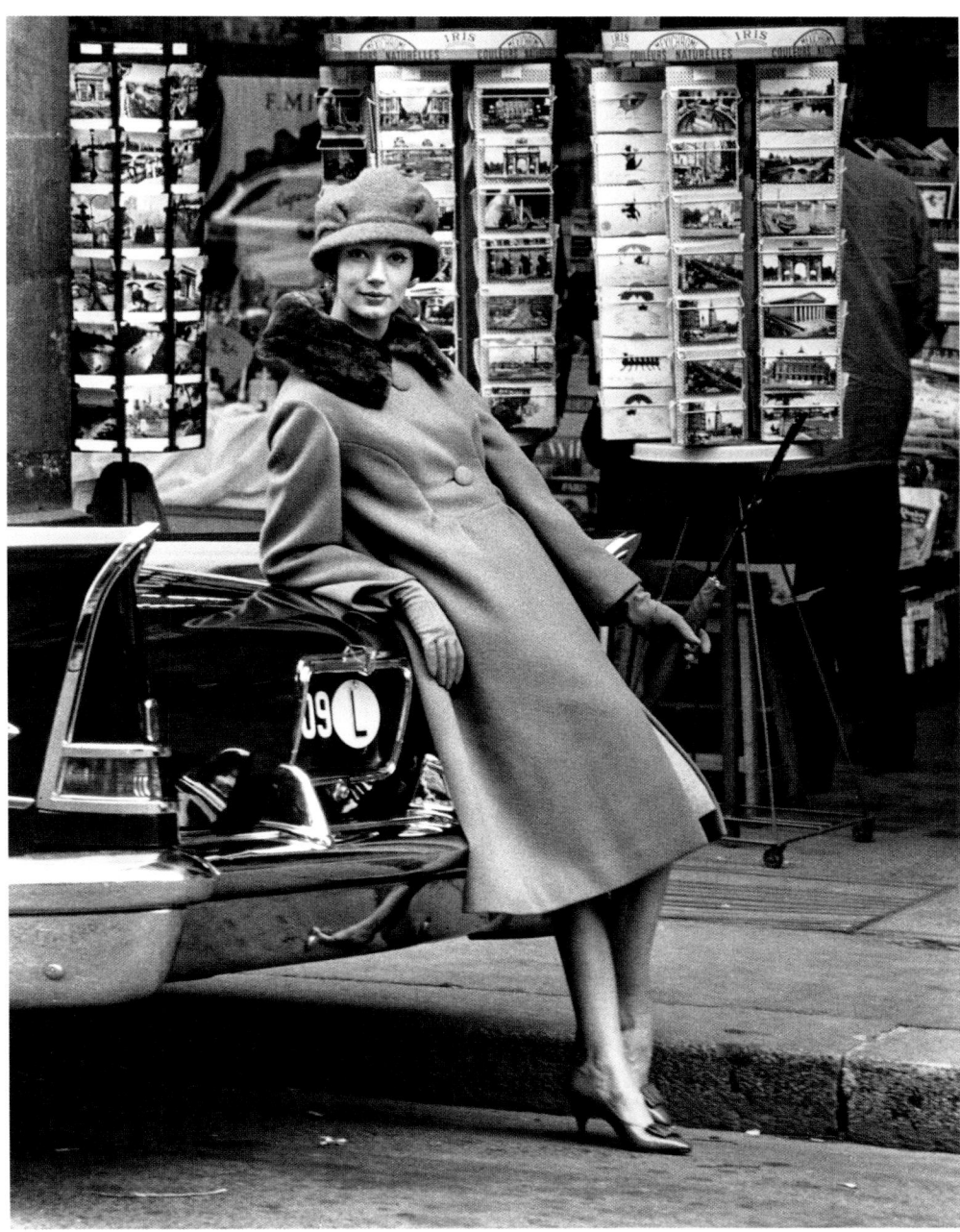

Quai de l'Horloge, Paris, 1958
NEGATIVE: 24×36 MM _ P63/3004
—— 235

I left Marie-Anne and Vincent in Gordes for a few days, and was in Paris on August 7, 1958, for *Vogue*. I was on quai de l'Horloge, and the model was quite far away because of the lens I had chosen (200-mm on a micro-Foca camera). I made her imitate, in a mirror image, the gesture of good King Henry IV on his horse. Few people in the streets, aperture open enough to separate the planes. The light was quite soft; all okay. Tricky print. The beauty lies in the shadows, and so does her complexion. To make things worse, it's a backlit shot. You'll just have to manage. That's part of the job. Full frame.

Rue de Castiglione, Paris, 1958
NEGATIVE: 24×36 MM _ P63/3446
—— 236

Afternoon of the same day with another model, rue de Castiglione. Same technical equipment: 200-mm on a micro-Foca body.*
I found a luxury car that fit the brief very well, and my model was in a good mood. Fashion photography can be exhausting work. For me, it was only part of my professional activity, and I often had fun. Cropping to the top.

* The 200-mm was also used for photo 272.

**On the upstream tip of the
Île Saint-Louis, Paris, 1958**
NEGATIVE: 24×36 MM _ 64/4638
___ 237

If I had been offered a little basic wage and annual supplies to photograph Paris and the banks of the Seine, I would have needed nothing more to be happy. On the upstream tip of the Île Saint-Louis on October 25, 1958; my three fishermen (three again!) pulled up their three lines at the same moment. Click. Print to be adjusted to equalize the gray on the Seine. Caught a little unawares, I unframed my shot a little, and it requires straightening to avoid exaggerating the slope of the horizon (see photo 350, the last photograph of this selection).

**On the Pont de Bir-Hakeim,
Paris, 1958**
NEGATIVE: 24×36 MM _ P64/4809
___ 238

In the cycle of my Parisian work on the islands and bridges, I found myself that day on the Pont de Bir-Hakeim, which crosses the Île aux Cygnes. I chose to release the shutter when the following converged: a metro train traveling toward Dupleix (my right-hand side), and pedestrians walking past. The use of the 28-mm from a low angle introduces lots of distortion.

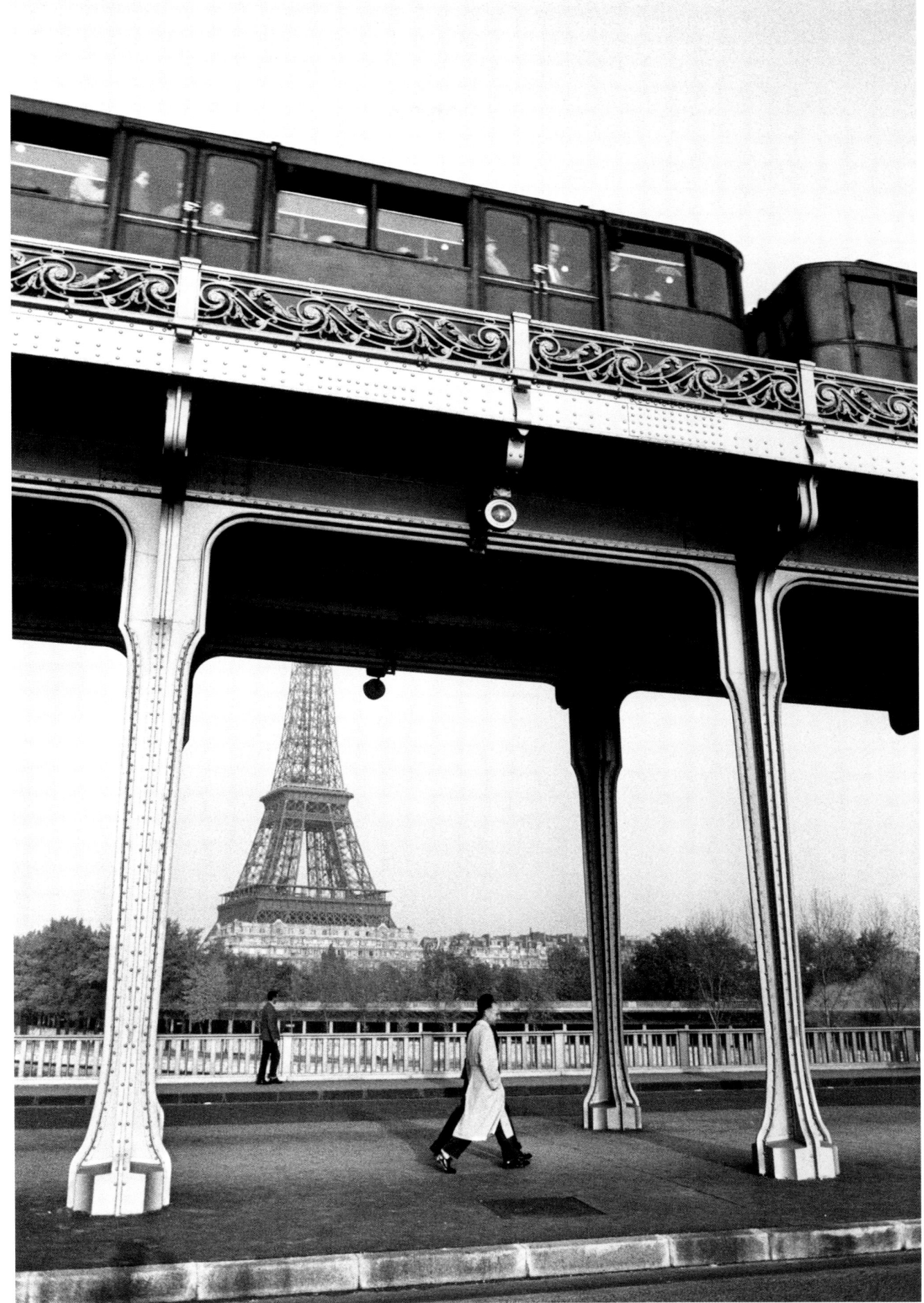

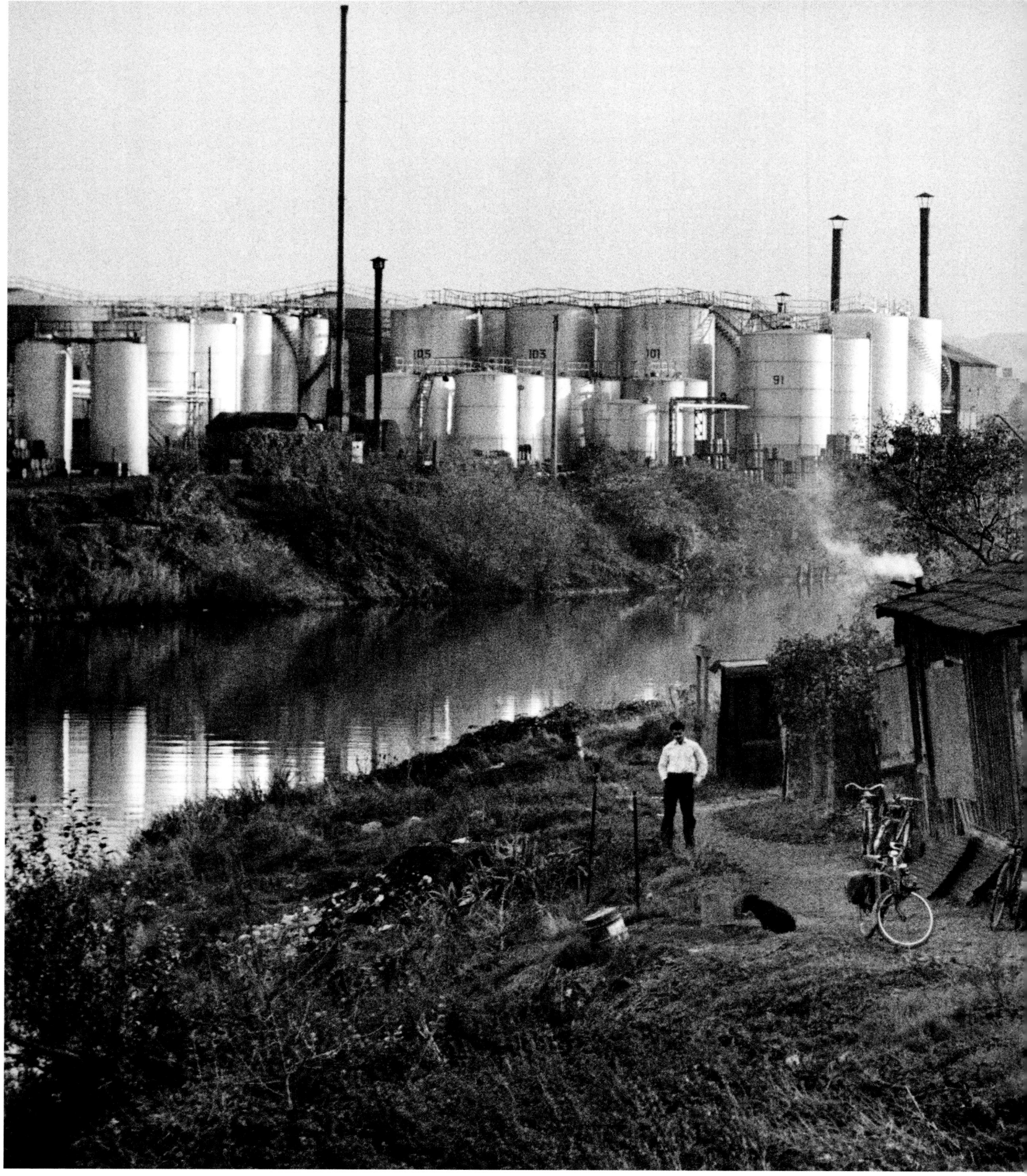

Nanterre, Seine, 1958
NEGATIVE: 24×36 MM _ F:65/0409
___ 239

I spent too many weekends exploring my islands, all alone, since it really is alone that I prefer to work on the unknown, even if this solitude often weighs me down. As the weather was good, Marie-Anne and I went together on this November 1, 1958, to explore the islands downstream of Paris. We stopped here, perched on a pier, gazing at this rather squalid suburban landscape that was nonetheless touching in the pearly light. Marie-Anne was especially interested in the view on the right: she had a weakness for painting allotment gardens. I was looking at the multicolored Shell reservoirs, which I photographed in color from a variety of angles, because I expected—and this turned out to be the case—that they would work as a backdrop for some fashion photographs for *Vogue*. It was Sunday in Nanterre; the Seine was flowing calmly, and I had once again brought something back from my hunt. Printing: take care to bring out all the tones, from the foreground to the misty elements in the distance. Full frame. 50-mm.

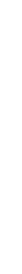

Izis, Gordes, Vaucluse, 1958
NEGATIVE: 24×36 MM _ 65/2344
___ 240

In *Photorama*, the beautiful quarterly magazine founded and directed by Herman Craeybeckx (see photos 225 to 227), I had published a report on Gordes, which included text and photographs. Izis, who received the magazine, rushed to the phone and begged Marie-Anne and me to find him a house in the village, whose charms my lyrical description had talked up. I tried to get a few words in and managed to explain that we were going to Gordes in six weeks, and that he should join us with his wife: we would arrange everything. Loulette, Izis's wife, was held up, so Izis came alone. He was blown away by it all, ignored the challenges (1958 was not 1948), and we began the search. This photograph was taken at the end of a meal at our home (between Christmas and New Year), by the light of an oil lamp and two candles. Six months later, the pair knew the torment of the building site. 28-mm. Relatively easy to print. Framing slightly straightened.

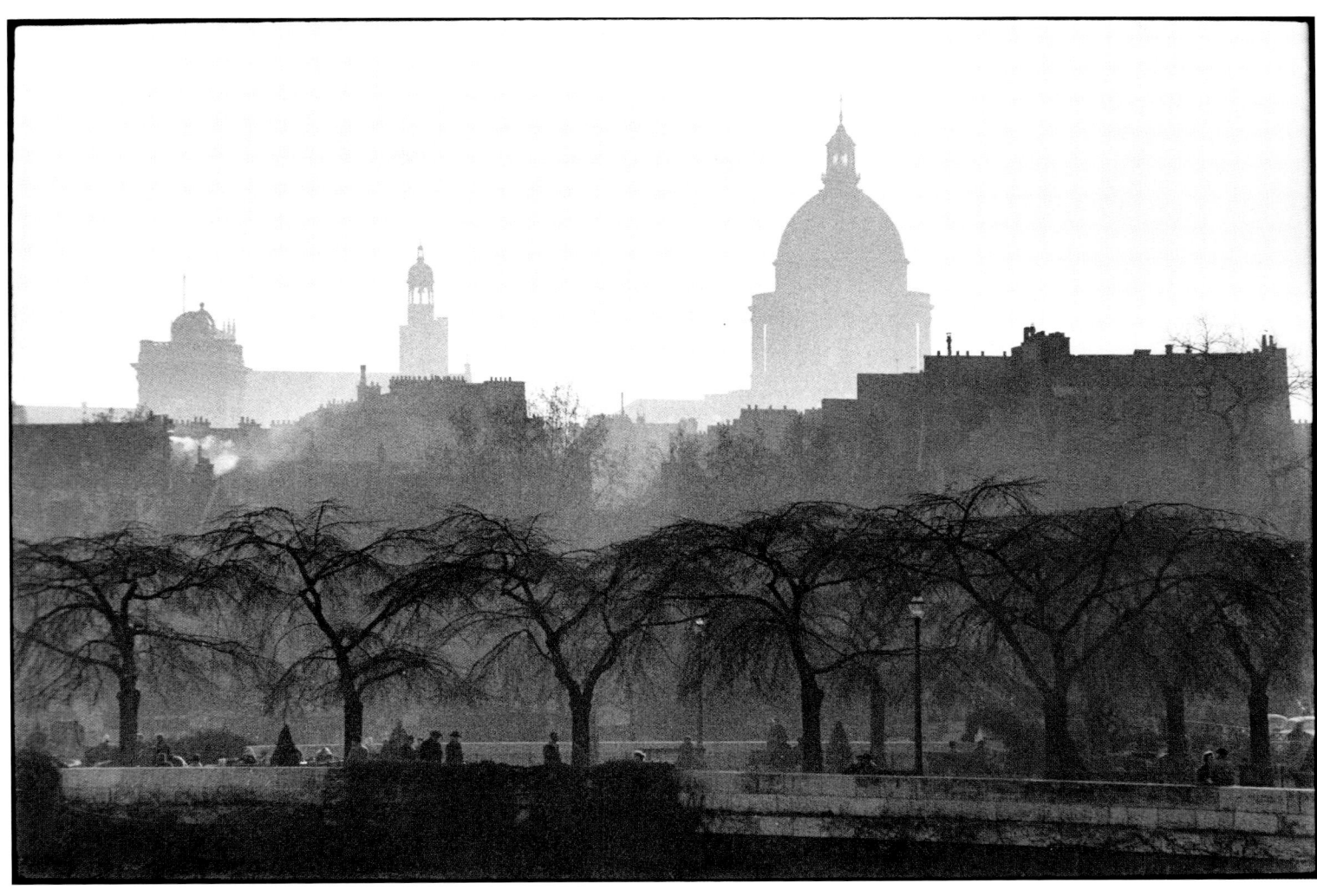

The Left Bank of the Seine, from the Pont Saint-Louis, Paris, 1959

NEGATIVE: 24×36 MM _ P65/3625

—— 241

On January 28, 1959, the very gloomy weather suddenly cleared up, and a cheerful sun urged me to go out. I headed to the quays. Of all the photographs that I took that day, two appear in this collection: this and the next one. They were taken from the same roll. I was on the Pont Saint-Louis when I saw this misty Left Bank landscape above the bare trees on the upstream tip of the Île de la Cité. The Pantheon emerged and, on its left, the church of Saint-Étienne-du-Mont. 90-mm. Light print. Full frame.

The children's barge, Paris, 1959
NEGATIVE: 24×36 MM _ DUPLICATE _ P65/3908

Of all the photographs that are very close to my heart, this one, *The children's barge*, stands alone. It would take too long to relate, in the context of these notes, the history of the contact sheet of which it forms the penultimate image. I started writing the story, although I'm not sure I can analyze what this adventure represented for me on that day and how deeply it affected me.* I will only say that I captured this totally unexpected scene just as it was about to slip past me; that I find not only its content, but also its form, satisfying (it is full frame); and, finally, that I have never shaken so much as when, after the development and fixing of the film was done, I examined the negative near the ground glass of the inspection lamp. This photograph was a revelation, and suddenly caused me to totally reevaluate myself. At the same time, it made me understand—beyond my ordinary work—the profound meaning of that which I still pursue. It was the photograph that repeatedly held me back when I was about to give it all up. 50-mm. Underexposed negative, hard to print. Full frame. Two indelible stains that occurred around 1965 require very good retouching. Prints should be made from a very good duplicate in the future.

*The article appeared in the July–August 1985 issue of *Photo-Magazine*.

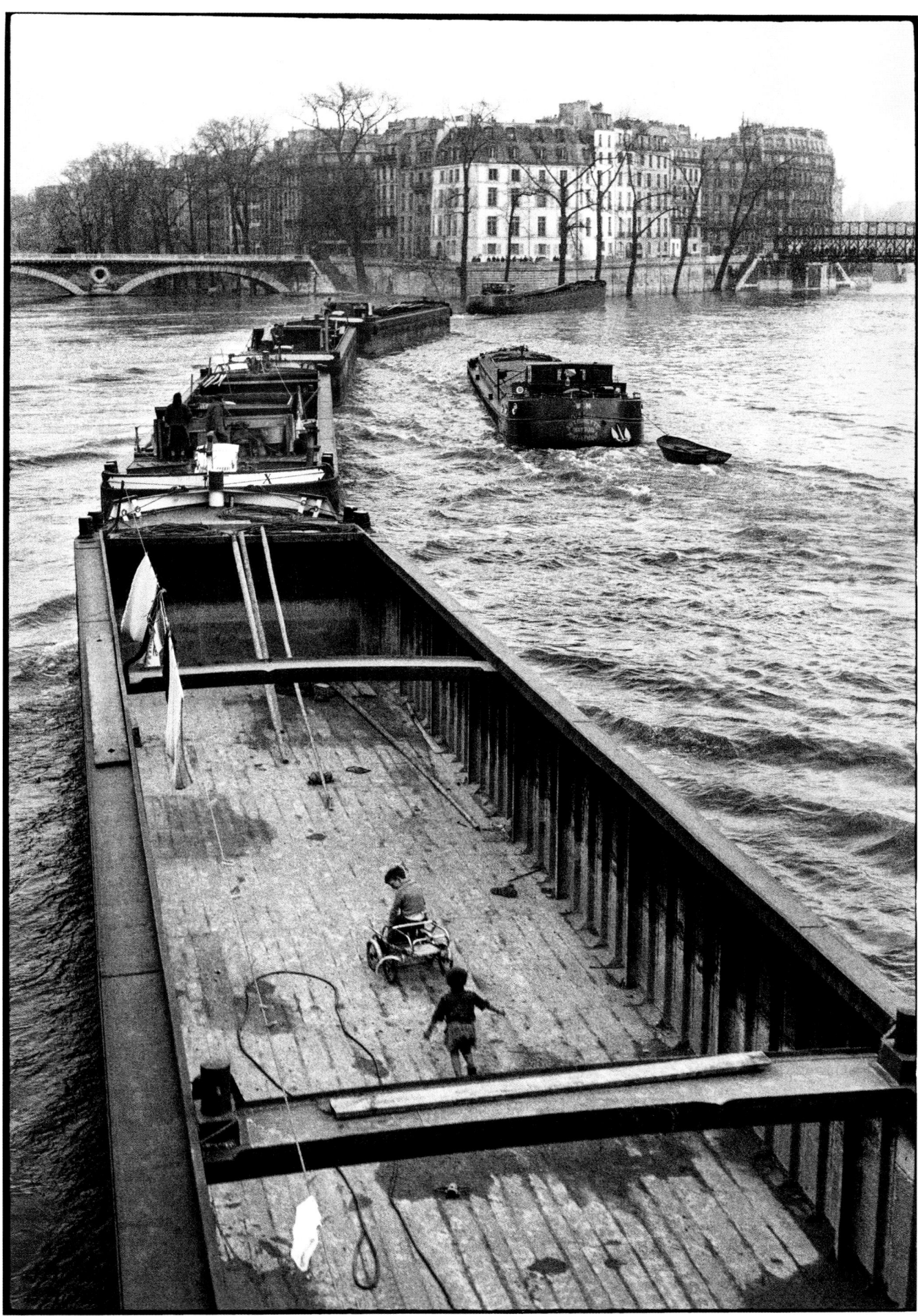

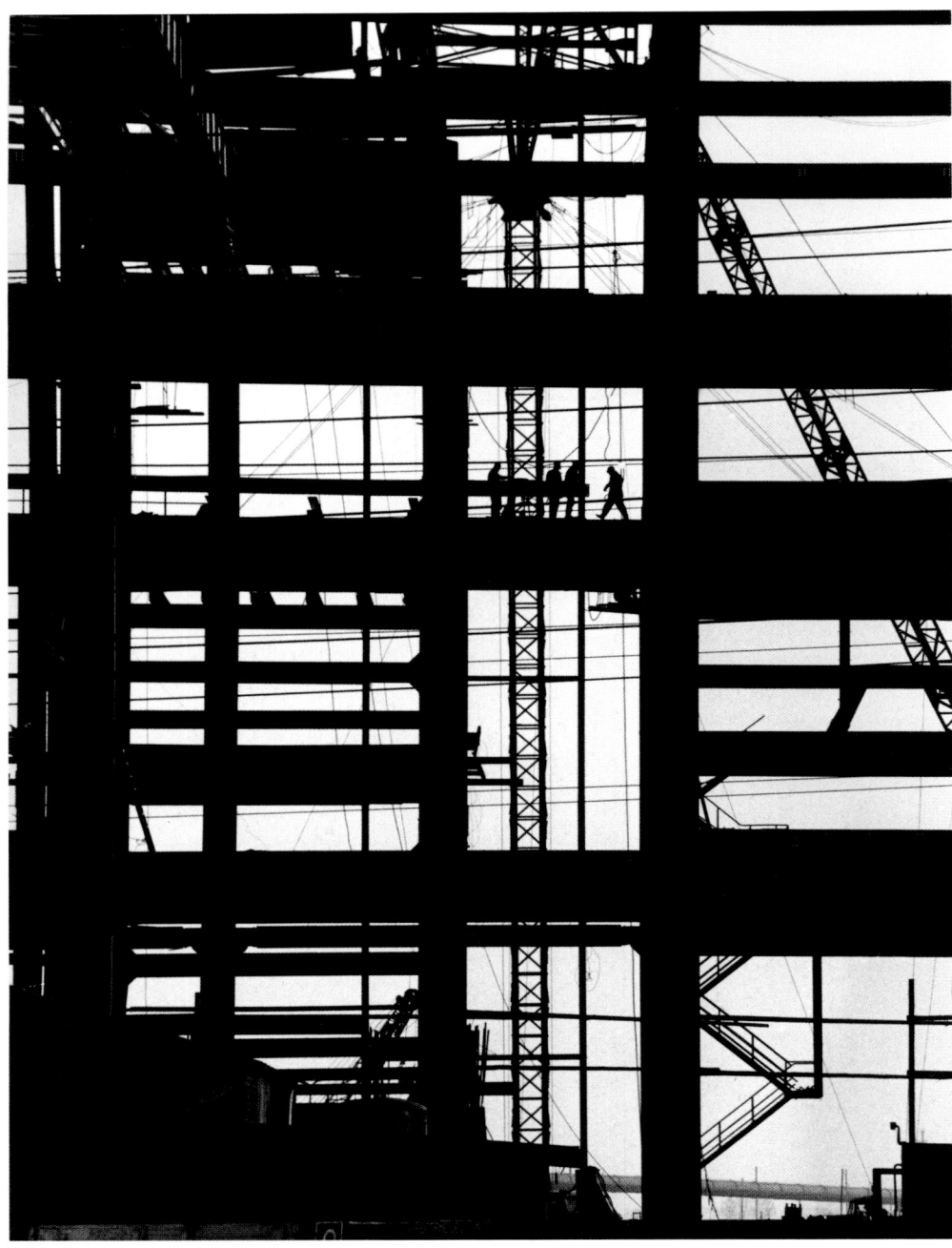

Richemont steel plant, Moselle, 1959
NEGATIVE: 24×36 MM _ F66/5018
___ 243

In relation to photo 102, *The broken thread*, I mentioned my dual behavior when I am entrusted with producing a carefully planned report on industry. I diligently fulfill my contract, but if the unexpected happens during the course of the journey I seize it at once (even if I have to come back to it if it can be improved); then I get back to business. My February 1959 session at the Richemont steel plant was over: the suitcases had been put away in the cupboards, the lamp-holders were folded up, and I was heading for the exit. But my Foca case, with its black-and-white and color bodies and five lenses, never left my side. Looking up at that subtle geometry silhouetted by the setting sun, I noticed those few workers standing on a platform. I then took a step back to frame, in one-point perspective, the most graphic part of the scene, and took two shots: one in which the man in motion was walking to the right, and the second, much more aesthetically pleasing, in which he was returning to the center. And, once again, this unscheduled picture was given a full page in the publication. 135-mm, f/11, 1/100 second. Full frame.

The snack break, Richemont steel plant, Moselle, 1959
NEGATIVE: 24×36 MM _ F67/0903
___ 244

Same location, same trip. In the course of my work on factories, I followed the principle of skipping lunch. Firstly, especially in the months when the days are short, it is during lunch break that there is the best external light. Then, while the factory was running at half speed, I could take close-ups of details of the machines at rest, that is to say, free from vibrations. Finally, it was the perfect time to explore freely, hard hat on head and a pâté sandwich in hand, Foca on chest, and bag slung over the shoulder like a soldier's satchel. This ironworker—perhaps one of the four men pictured in the previous photo—was waiting for something, but I wasn't interested in that. I captured this moment in a really fine light, we waved at each other, and I continued playing truant. 28-mm, f/11. Almost full frame.

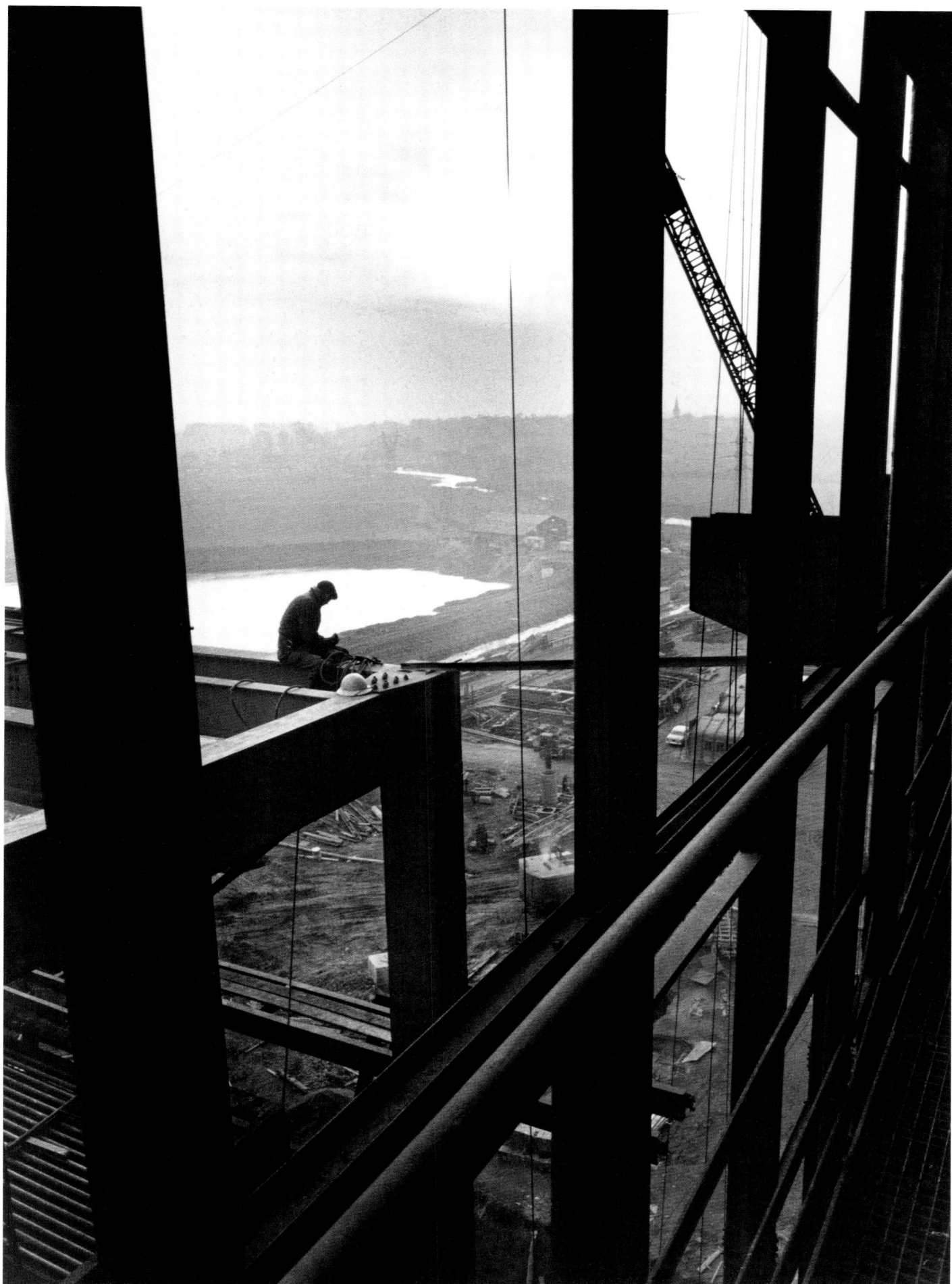

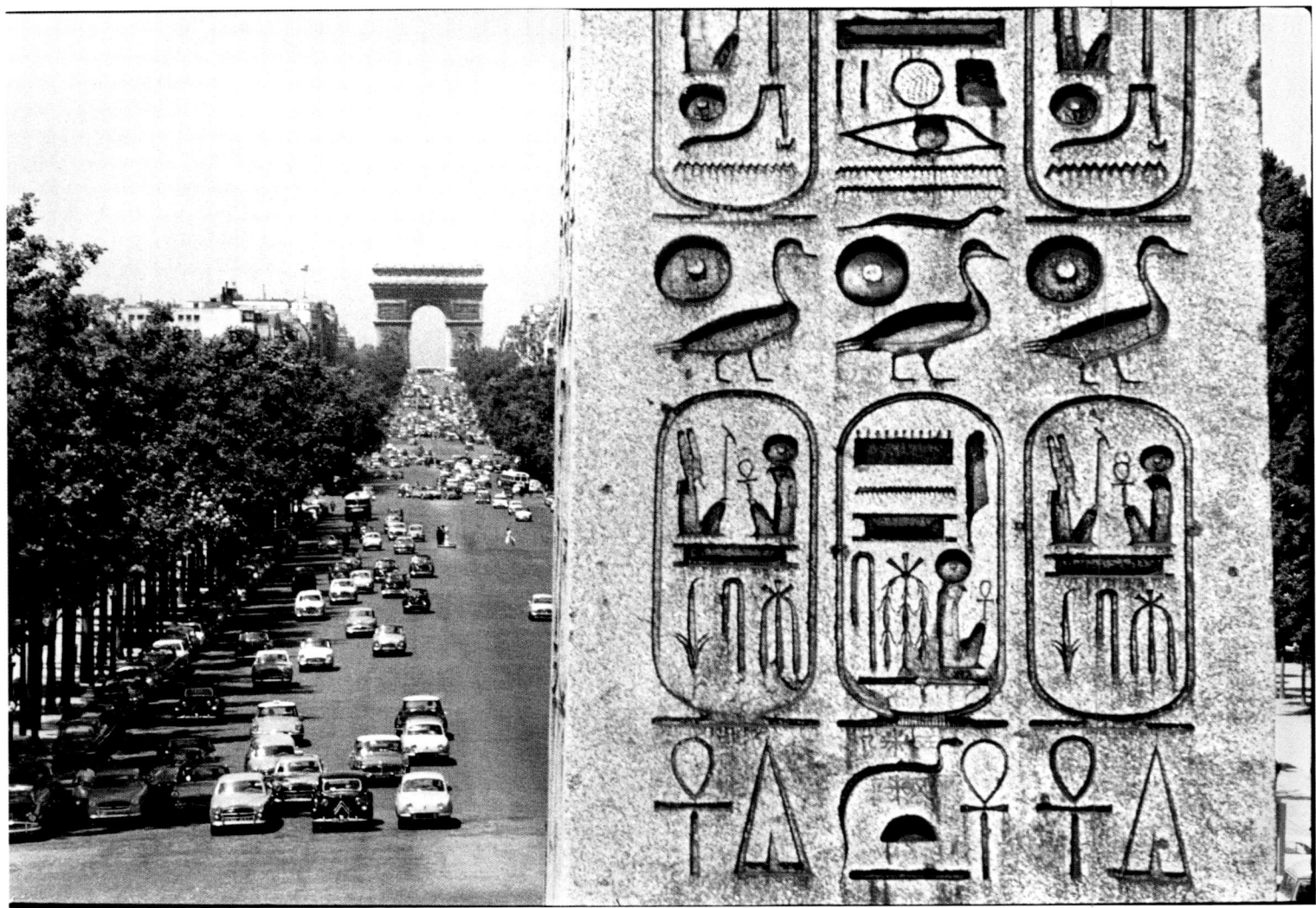

The Luxor Obelisk and the Champs-Élysées, Paris, 1959
NEGATIVE: 24×36 MM _ P69/4032
—— 245

Paris, July 15, 1959. As my work took me across place de la Concorde, my eye was caught by the scaffolding around the Luxor Obelisk. I assumed that the official stands built for the festivities of the previous day had not yet been dismantled and, rejoicing in the fact that Paris was deserted and I could easily park my car, I inspected the surrounding area to ensure that no patrolling policeman would come to obstruct my plans. I swifly climbed up to the right spot and, very quickly, took a few shots, in black-and-white and color. 90-mm, f/16. Full frame.

**Calle della Bissa,
Venice, Italy, 1959**
NEGATIVE: 24 × 36 MM _ 70/2833
___ 246

Venice. A few days later, Marie-Anne and I embarked on a journey to northern Italy. Thanks to Romeo Martinez's local contacts, we found accommodation close to Piazza San Marco, at the home of a dear *signora* who spent her days on the phone. It was our first time together in this inexhaustible city (I had passed through, a little quickly, during a round trip in 1938), and my Foca worked continuously. Generally, each of us went our own way and we would meet at mealtimes: Marie-Anne painted gouaches and I searched for subject matter at my own pace.
A little domestic scene on Calle della Bissa, not far from the Rialto Bridge. Everything was wonderfully organized, but I was missing a dynamic element on the left. I waited, running the risk that the worthy gentleman would finish reading, or that the gossips would come to the end of their conversation (I was less worried about that). Suddenly, on my left, the little baker arrived. A winner. In short, the phenomenon that I described in photo 210, of the Villebon pond, appeared again in a simpler way.
28-mm, f/16. Print difficult because of a slight overdevelopment that increased the contrast of the negative.

The conversation, Venice, Italy, 1959
NEGATIVE: 24×36 MM _ 70/2941
__ 247

Narrow street, late-afternoon light; a mix of natives and tourists. I do not know what I was standing on: perhaps the first steps of one of Venice's innumerable bridges. 35-mm, f/16, 1/25 second.

A working-class area of Venice, Italy, 1959
NEGATIVE: 24×36 MM _ 70/3221
__ 248

At dusk, somewhere near the Ghetto Nuovo. I stepped over the threshold of this bistro, a meeting place for stonemasons after work. I was discreetly looking for a suitable angle. Suddenly, from far away, I heard the clear voices of young girls. I went back into the street, followed by the little boy, who was very eager to appear in the picture. The girls in question then appeared, walking briskly. I quickly slid to the left and, thanks to the 28-mm miraculously in place—too bad for the strong clash of light sources—I framed what you see in front of you. The focus was approximate; the aperture, probably f/4.5, did not ensure the desired depth of field, nor the 1/25-second shutter speed stop the movement of the damsels. But if the technique was found wanting, the spirit of the scene was preserved. I took the risk of a complicated experiment. In the end, I do not regret a thing. That is how it was! Print requiring some difficult dodging. Almost full frame.

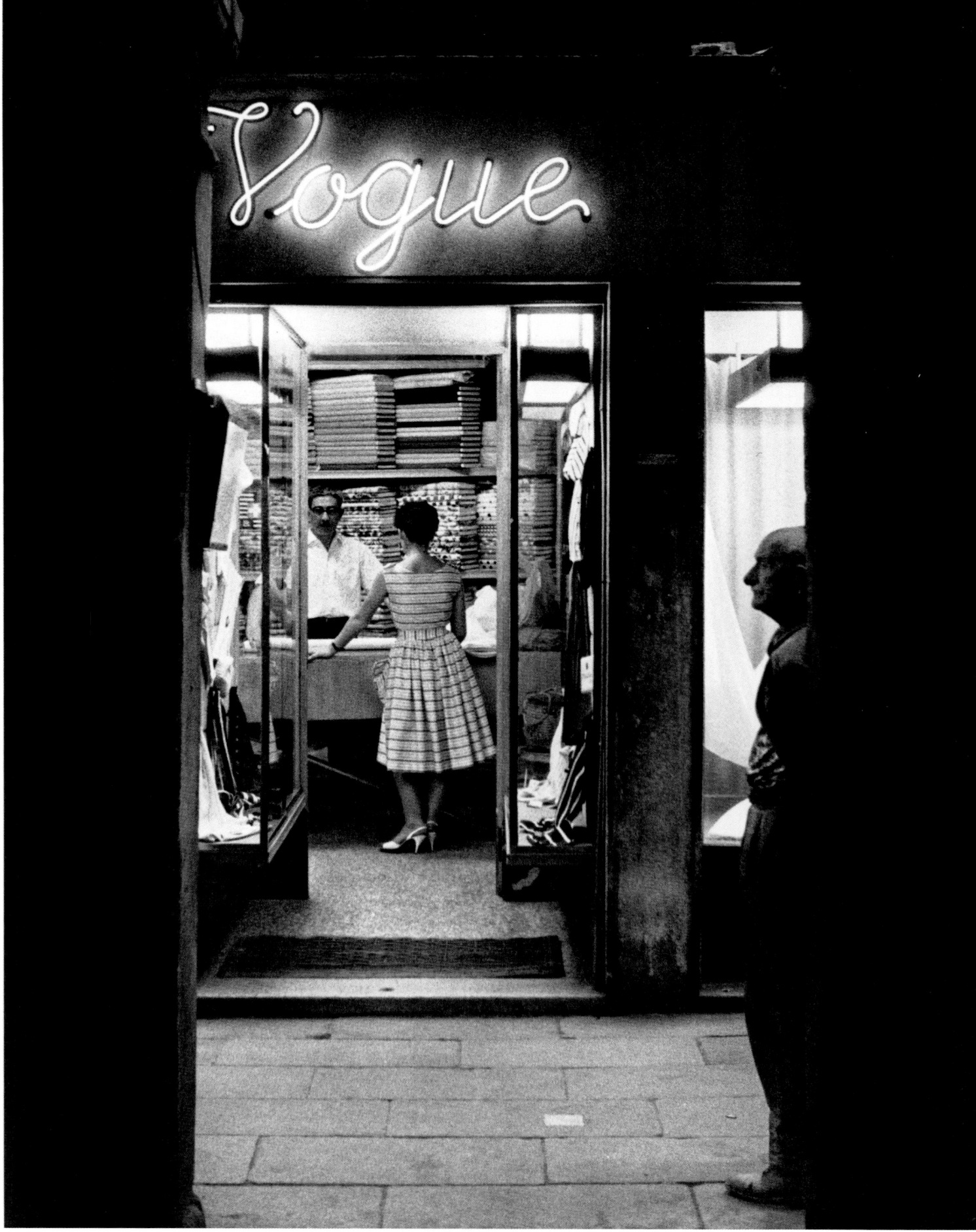

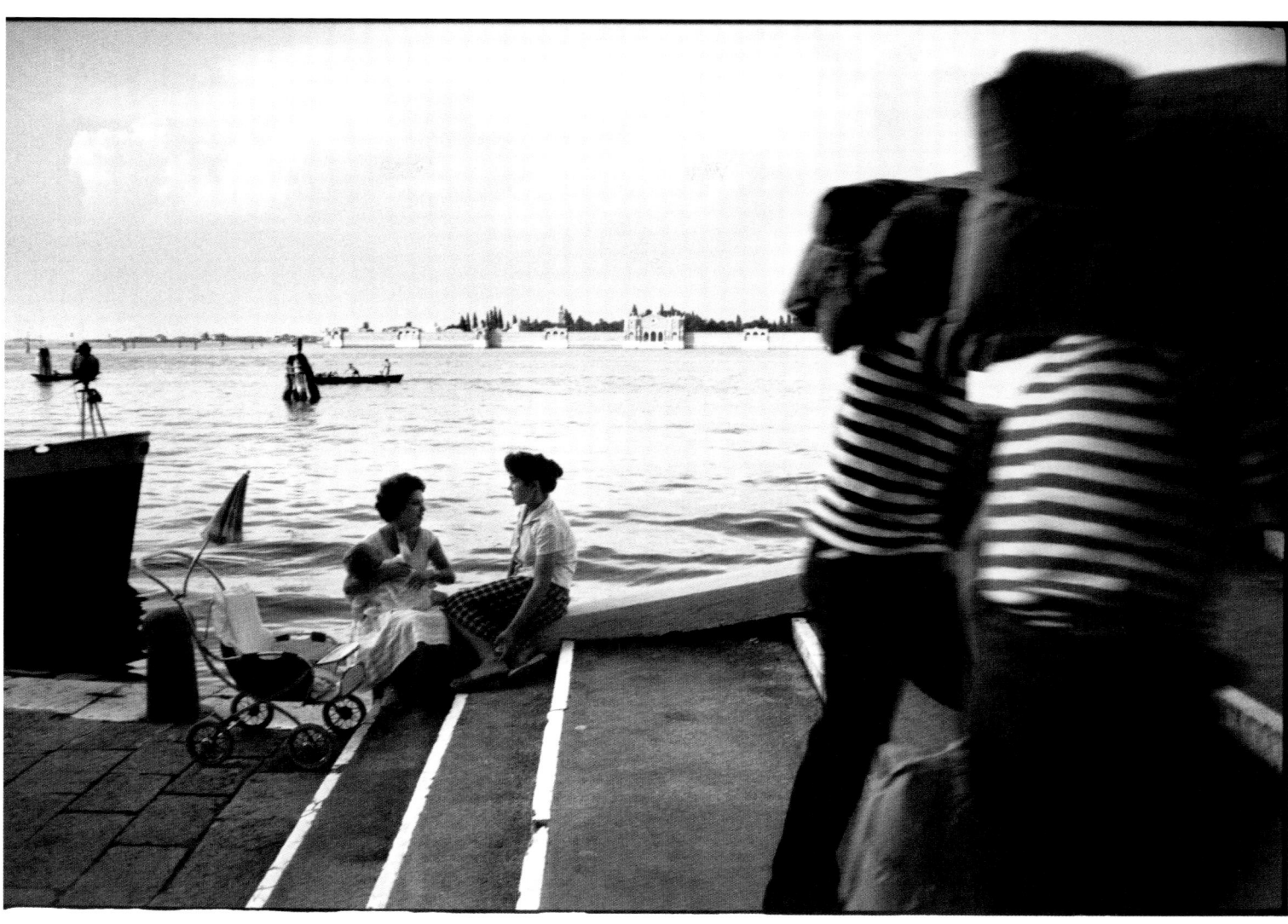

Night walk in Venice, Italy, 1959
NEGATIVE: 24×36 MM _ 70/3434
___ 249

A highly graphic conjunction of planes and values taken completely front on (nothing but right angles). These three characters are a little unsettling, as if caught in a freeze-frame from a movie. I was amused by the shop sign, a naive tribute to the magazine I worked for quite a lot. Nothing else to add; I'm not very good at multilayered interpretations. 50-mm. Probably 1/25 second at f/6.3. Print a little difficult because of the strong contrasts. Almost full frame.

Fondamente Nuove quays, Venice, Italy, 1959
NEGATIVE: 24×36 MM _ 70/4116
___ 250

Fondamente Nuove, the northern quays of the city of the Doges; the Murano cemetery in the background. At the foot of one of those many different staircase-bridges— recurring curse of the tired walker—two young mothers were chatting. I had no particular desire to capture this moment. However, male voices coming from the left caught my attention. I was (almost) in a good spot and, once again, the 28-mm was on the Foca just at the right time. I quickly climbed a step to get in position and released the shutter at the perfect moment. Another risky photograph, because the dockers were walking fast and there would be no second chances. Maybe this type of stress suits my temperament. In any case, the failures—and of course there were some—never deterred me. 28-mm, probably f/16. 1/50 second. Full frame.

**Fondamente Nuove,
Venice, Italy, 1959**
NEGATIVE: 24×36 MM _ 70/4224
___ **251**
Venice. Same location, slightly later.
The sun, which was already a little low,
created sharp silhouettes against the
backlight. I switched out the 28-mm for
its exact opposite, the 135-mm, which
would best frame the image that I was
hoping for, and which I could already see
in my head. Just as I hoped, a little girl
stepped onto the bridge. A single click.
One regret: I would have preferred it if
the rower's boat were a little detached
from the wooden posts, with which it
merges. And then, in my haste, my framing
was a bit off. It needs to be corrected
in printing to restore the horizontality
of the upper plane. Also make sure to
balance the contrasts and not to bring
out the gray on the surface of the water.

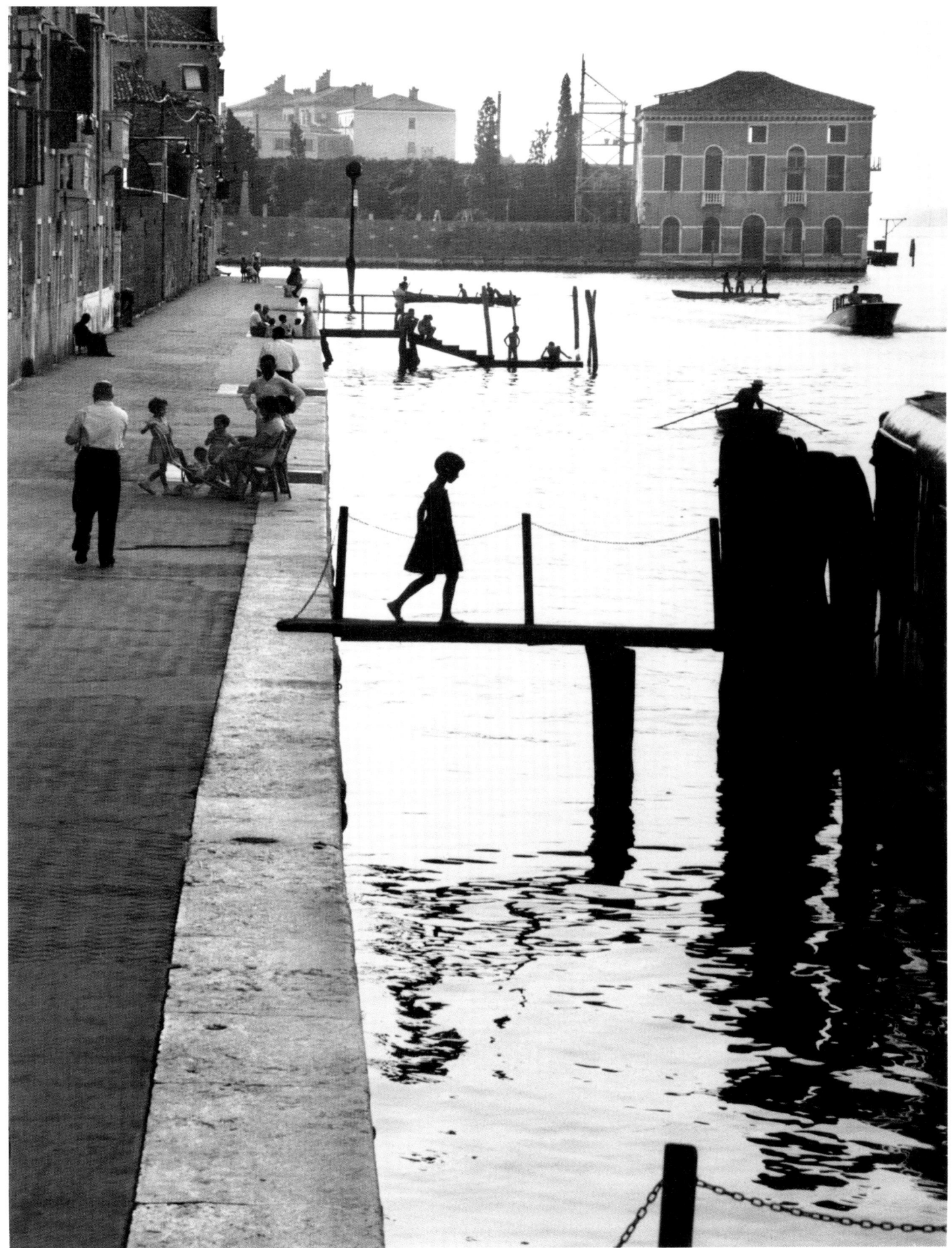

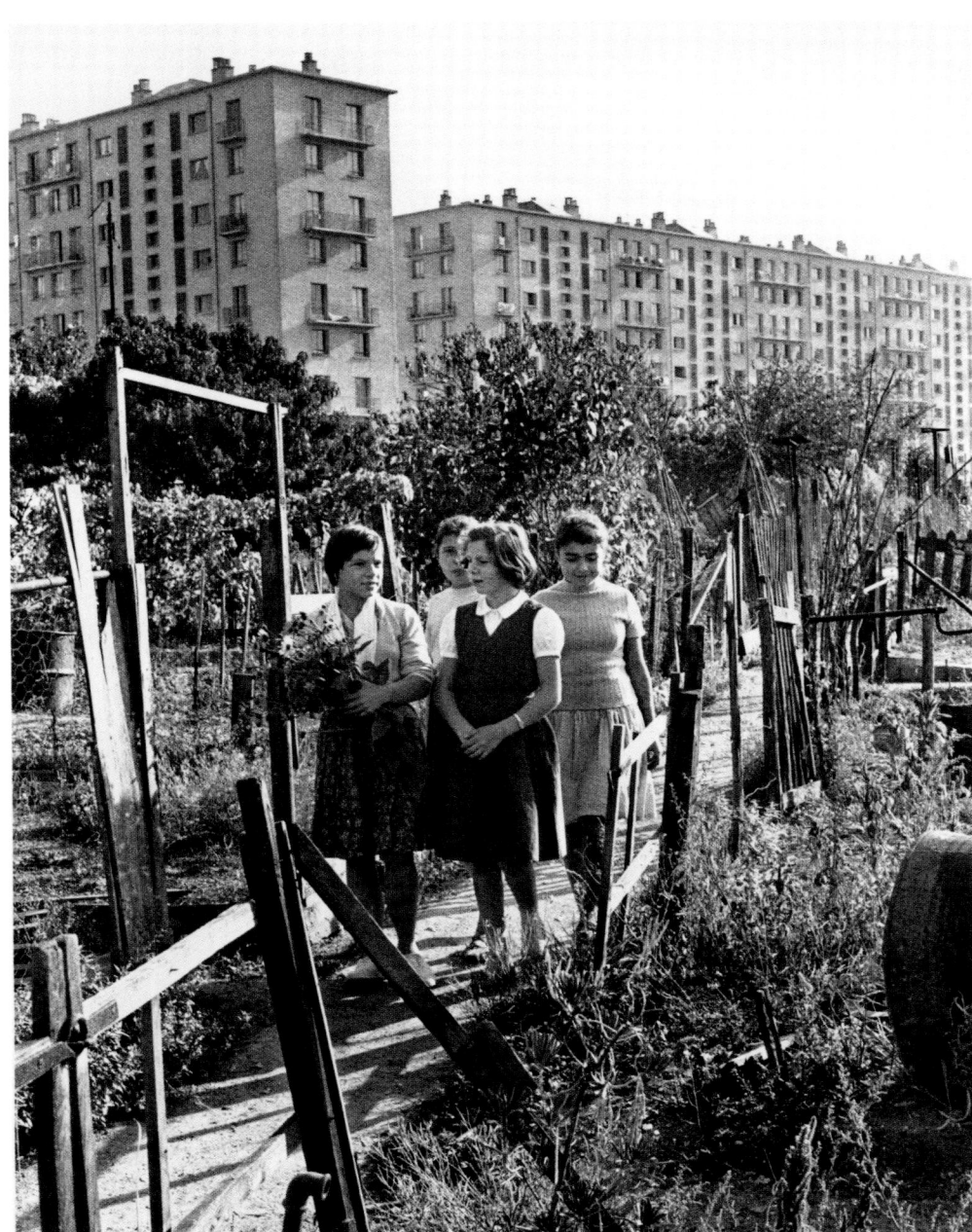

New buildings and allotment gardens, Bagneux, Seine, 1959
NEGATIVE: 24×36 MM _ F72 / 0923
__ 252

September 1959. *Marie-Claire* commissioned me to work on the *cités nouvelles* (housing projects). This photograph is from the series. I took it in Bagneux. In a way, it symbolizes the inexorable erosion of suburban gardens by the housing projects. 50-mm. Full frame.

Belleville youths, under the stairs of rue Vilin, Paris, 1959
NEGATIVE: 24×36 MM _ P72/4039
__ 253

My work on the housing projects (see previous photo) made me seriously tired of concrete, so I interrupted that job with some more classic work. On September 26, 1959, I found myself in the neighborhoods of Belleville and Ménilmontant, where rampant reconstruction was taking place. Unfortunately, more often than not, this was for the worse rather than for the better. 28-mm lens, full frame.

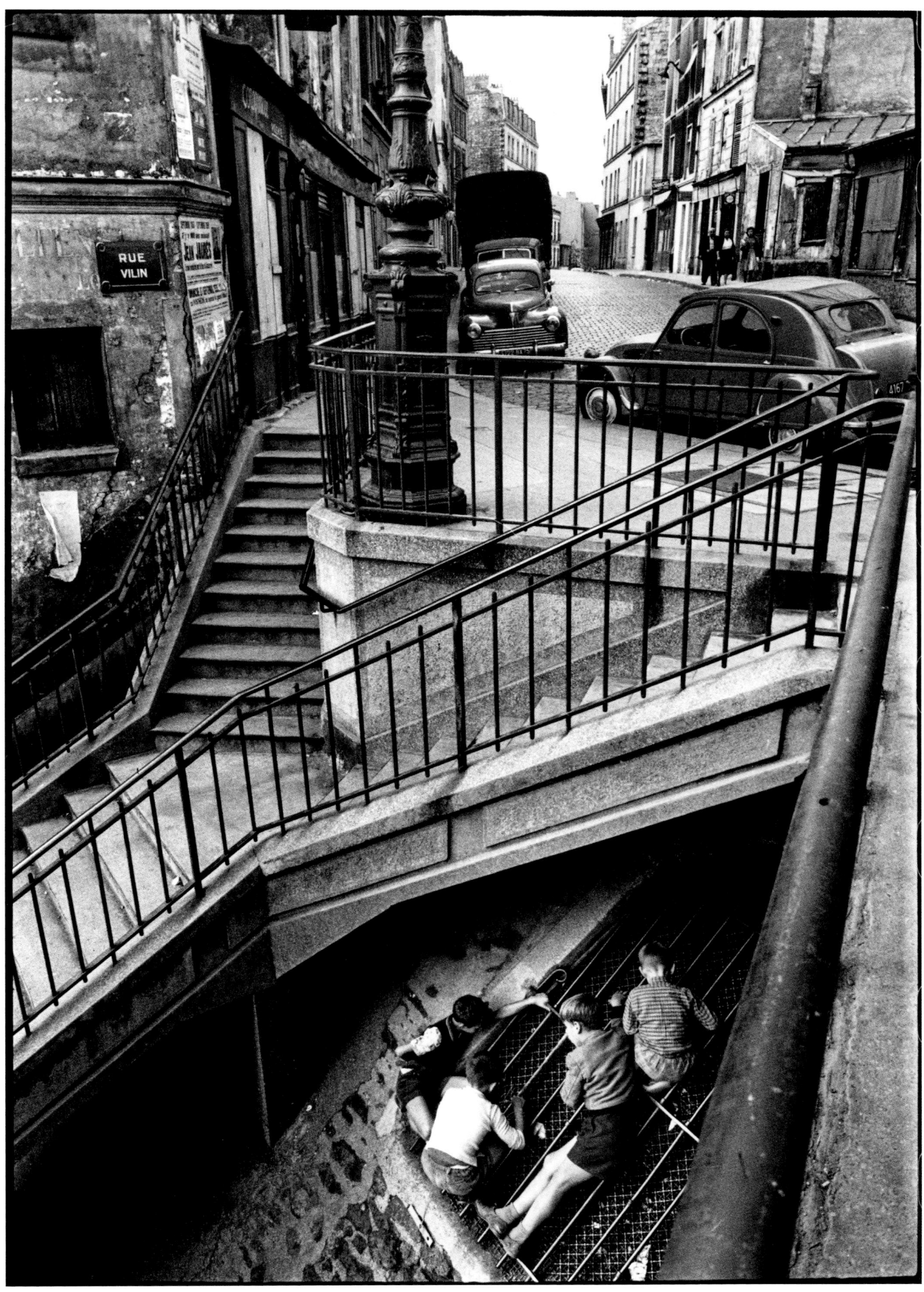

New construction, Pré-Saint-Gervais, Seine, 1959
NEGATIVE: 24×36 MM _ P73/0143
___ 254

Still working on the project on new constructions, I found myself on October 2, 1959, in Pré-Saint-Gervais, on the grounds formerly occupied by fortifications, which by then had become wonderful places for games and adventures for generations of children and teenagers. 90-mm. Almost full frame.

New construction, Porte de Pantin, Paris, 1959
NEGATIVE: 24×36 MM _ P 73/0402
___ 255

The next day, toward Porte de Pantin, it was past noon, and I was looking for a last photograph on a subject that was seriously beginning to tire me. The plan of these new neighborhoods was incomprehensible, with their block-like buildings emerging out of the ground, apparently at random, separated by vacant lots that would hopefully look like streets in the not-too-distant future. I was in one of these houses, looking for a distinctive framing, and was giving up on the hope of encountering a human form, when a little girl suddenly rushed into the entrance. I just had time to release the shutter. 28-mm. The print requires reframing because the shot is a bit crooked.

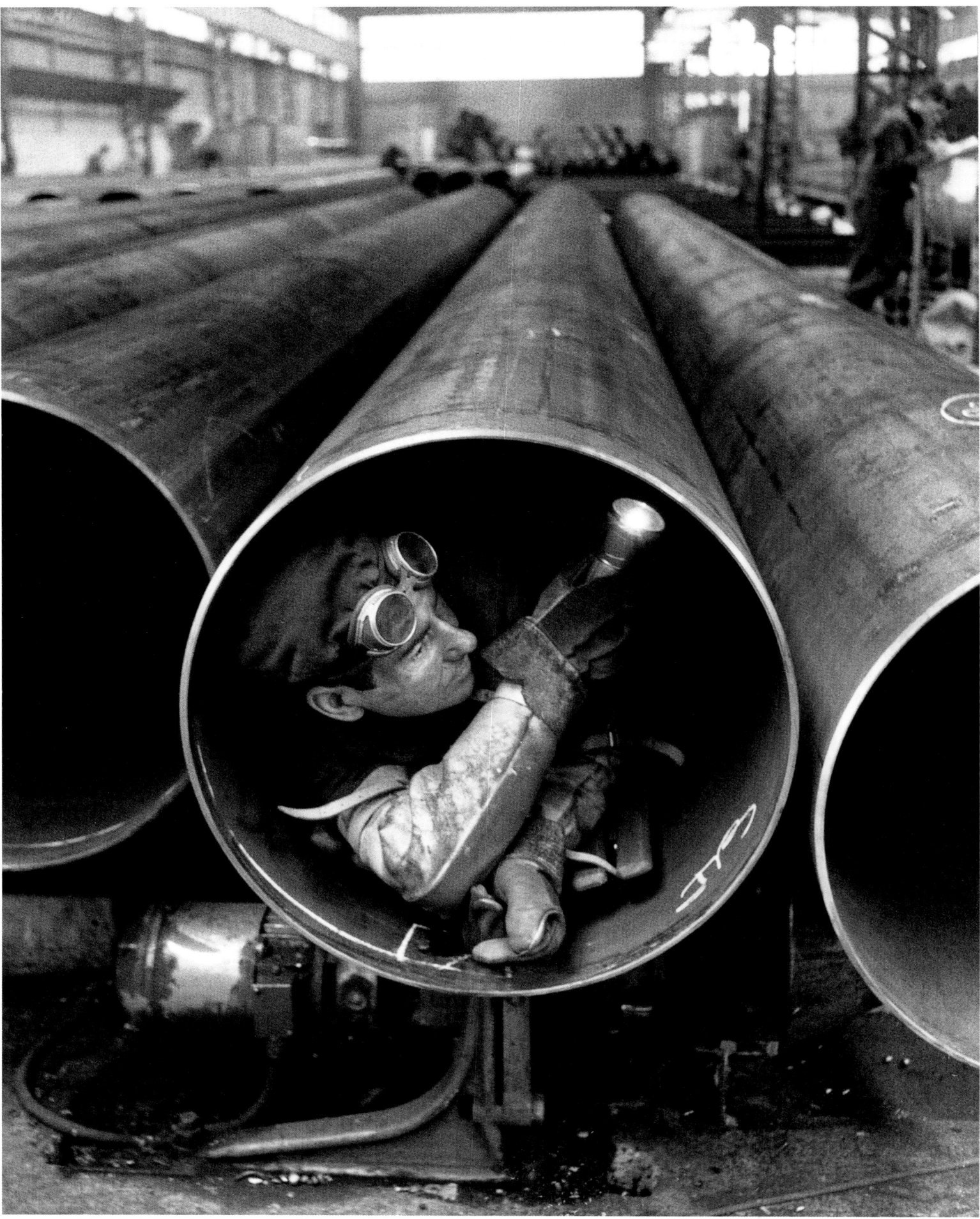

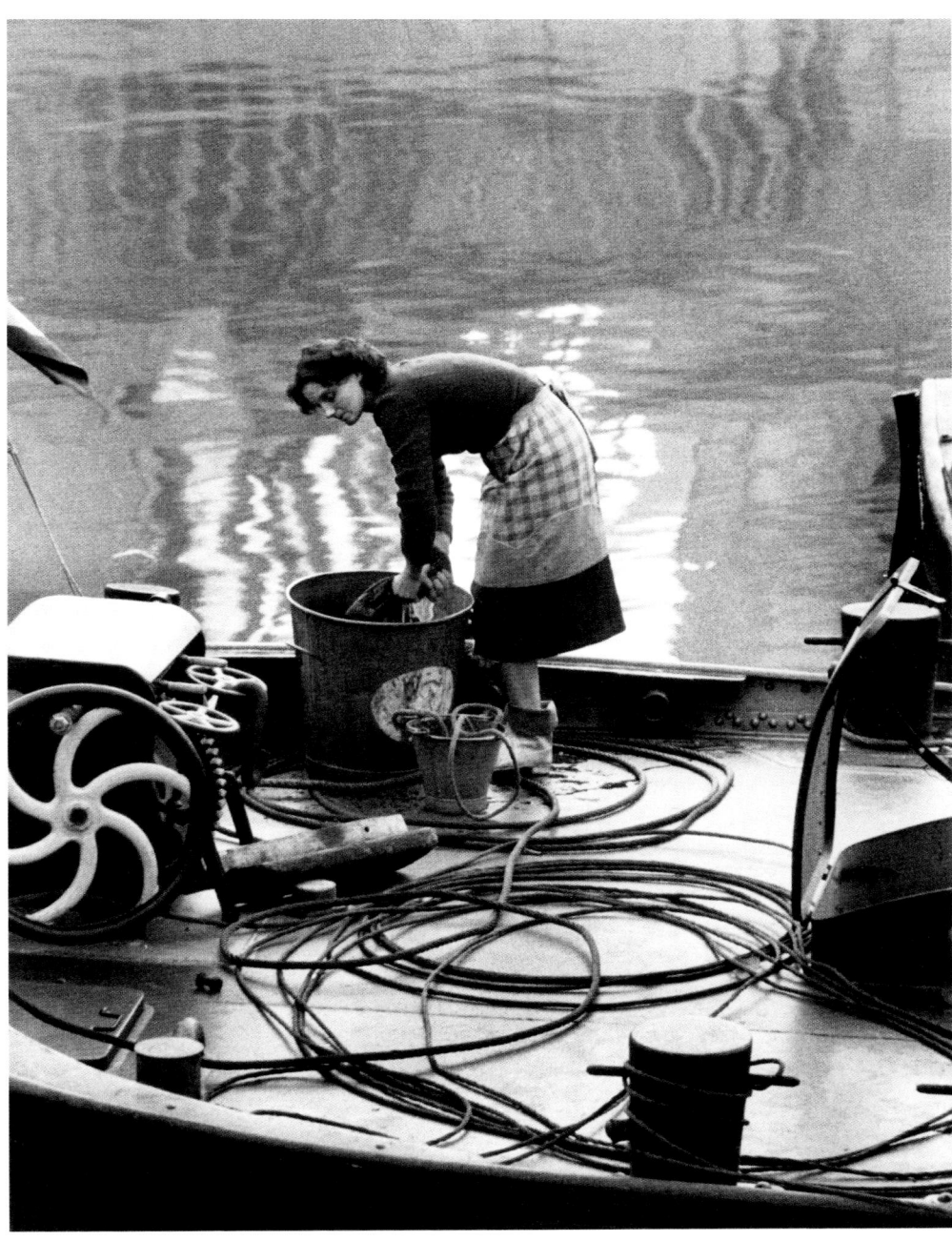

Lorraine-Escaut factory, Sedan, Ardennes, 1959
NEGATIVE: 2¼ × 2¼ IN. (6 × 6 CM) _ I29/10/25
___ 256

Industrial report in Sedan, end of October 1959, at the Lorraine-Escaut tube factories. As always in this kind of work, I used different camera formats, depending on the technical requirements. The photograph shown here comes from a 2¼ × 2¼-in. (6 × 6-cm) negative. The man is lying on his contraption on wheels, which he uses to travel inside the tubes to check the quality of the weld.
No printing difficulties. Lateral cropping.

The mariner's wife, Paris, 1959
NEGATIVE: 24 × 36 MM _ P75/1505
___ 257

Kischka, the general secretary of the annual exhibition *Les Peintres témoins de leur temps* (Painters as Witnesses of their Time) and a painter himself, had asked me to photograph about twenty writers to illustrate the catalog of the 1960 exhibition (see next photo). As usual, I took these portraits at the subjects' homes, or in places that I thought suited their personalities. On that morning, December 5, 1959, I had an appointment with one of them, at a mutually agreed location, at the foot of a crane on quai de la Râpée. I was a little early and was busy watching the boatmen on their houseboats, which led to this photograph.
I think it was taken with a 135-mm lens. Full-frame print, slightly cropped at the top of the image.

Henri Jeanson, Paris, 1959
NEGATIVE: 24×36 MM _ 75/4031
___ 258

I mentioned in the comment for the previous photograph my commission to illustrate the catalog for the 1960 show *Les Peintres témoins de leur temps*. The theme for this year was youth, and about twenty writers had written texts on the subject. This photograph shows Henri Jeanson at home. He was famous for his caustic wit, and it was in the middle of a sentence in which this was being freely expressed that I captured this expression.
50-mm. Full frame.

Richemont steel plant, Moselle, 1960
NEGATIVE: 24×36 MM _ CNA1/4901
___ 259

Here we have the manipulated print of a negative normally referenced as 77/3631, taken in March 1960 in the control room of the Richemont steel plant in the Moselle. For a graphic composition the following year, I made a duplicate from the original negative with greatly enhanced contrast, hence this result. A reproduction of this version appeared in the book *Images de Camera* (Camera Images), published in 1964 by Hachette, based on the Swiss edition by C. J. Bucher in Lucerne.

John Heartfield, East Berlin, East Germany, 1960
NEGATIVE: 24×36 MM _ 79/2840
___ 260

The Association of East German journalists organized an international conference in East Berlin in April 1960. I had been invited and gave a presentation on the state of photojournalism in France. I had not been given enough notice to take part in the international exhibition of reportage photography, which was shown in the association's official headquarters, but I was invited to attend the jury's deliberations for the awards. This jury, also international, was chaired by John Heartfield, the universally famous creator of anti-Hitler photomontages in the 1930s. He is seen here, pronouncing the final decision of the jury, with characteristic ardor. We were to spend a part of the afternoon alone together, and I told him that I had known his work since 1935, when he had been introduced by Aragon at the Maison de la Culture in Paris, rue Navarin, in a lecture entitled: "John Heartfield and Revolutionary Beauty."

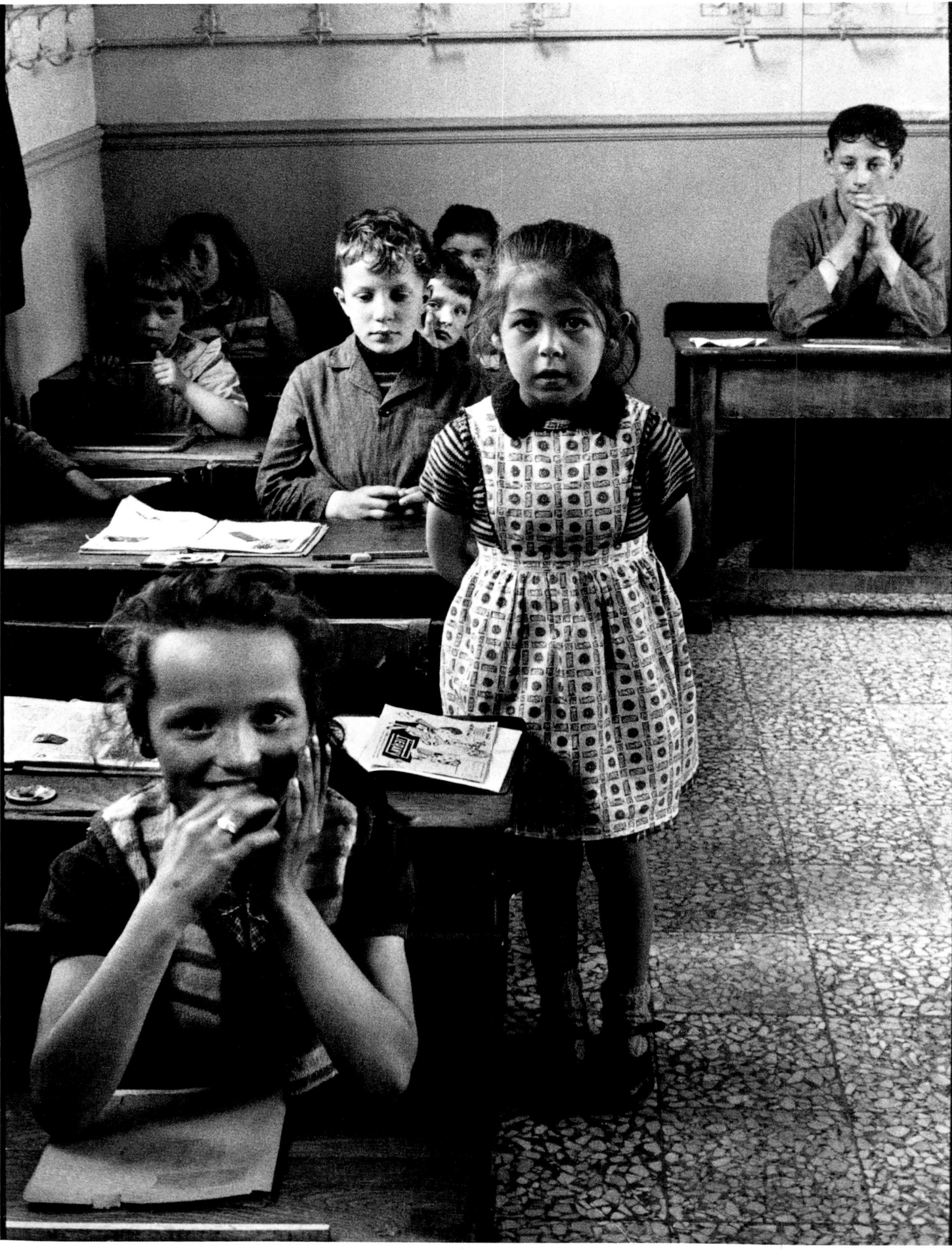

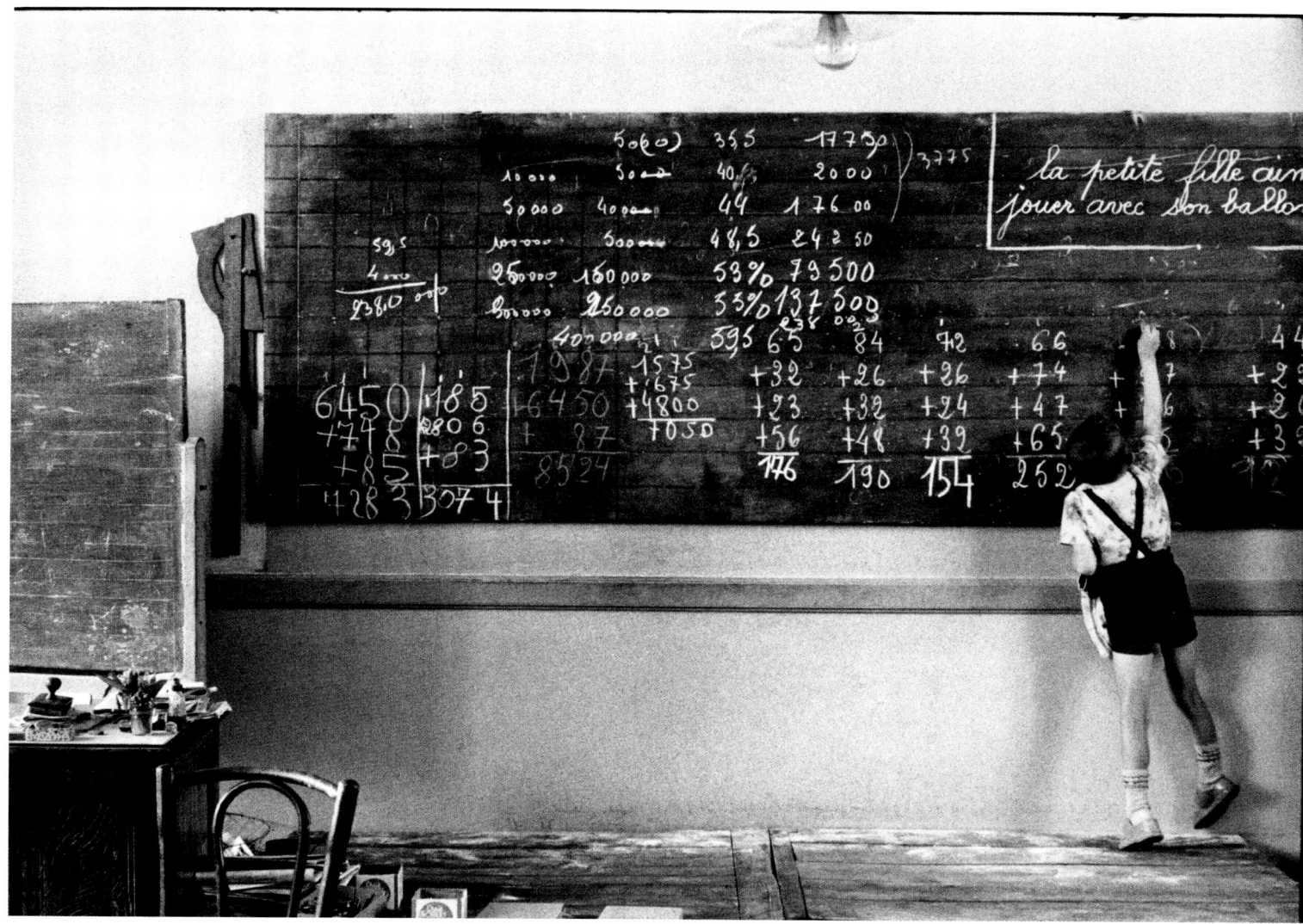

Rural school, Montigny, Marne, 1960
NEGATIVE: 24×36 MM _ R80/3133
___ 261
A single-class public school (pupils from six to fourteen years old) in a small village in Champagne. Photo story in *Regards*, June 1960.
90-mm lens. Daylight. Easy print.

Rural school, Binson-et-Orquigny, Marne, 1960
NEGATIVE: 24×36 MM _ R80/1612
___ 262
Same project as the previous photograph. This blackboard sums up the activity of a single class, with its exercises of various levels of difficulty.
50-mm lens. Daylight.

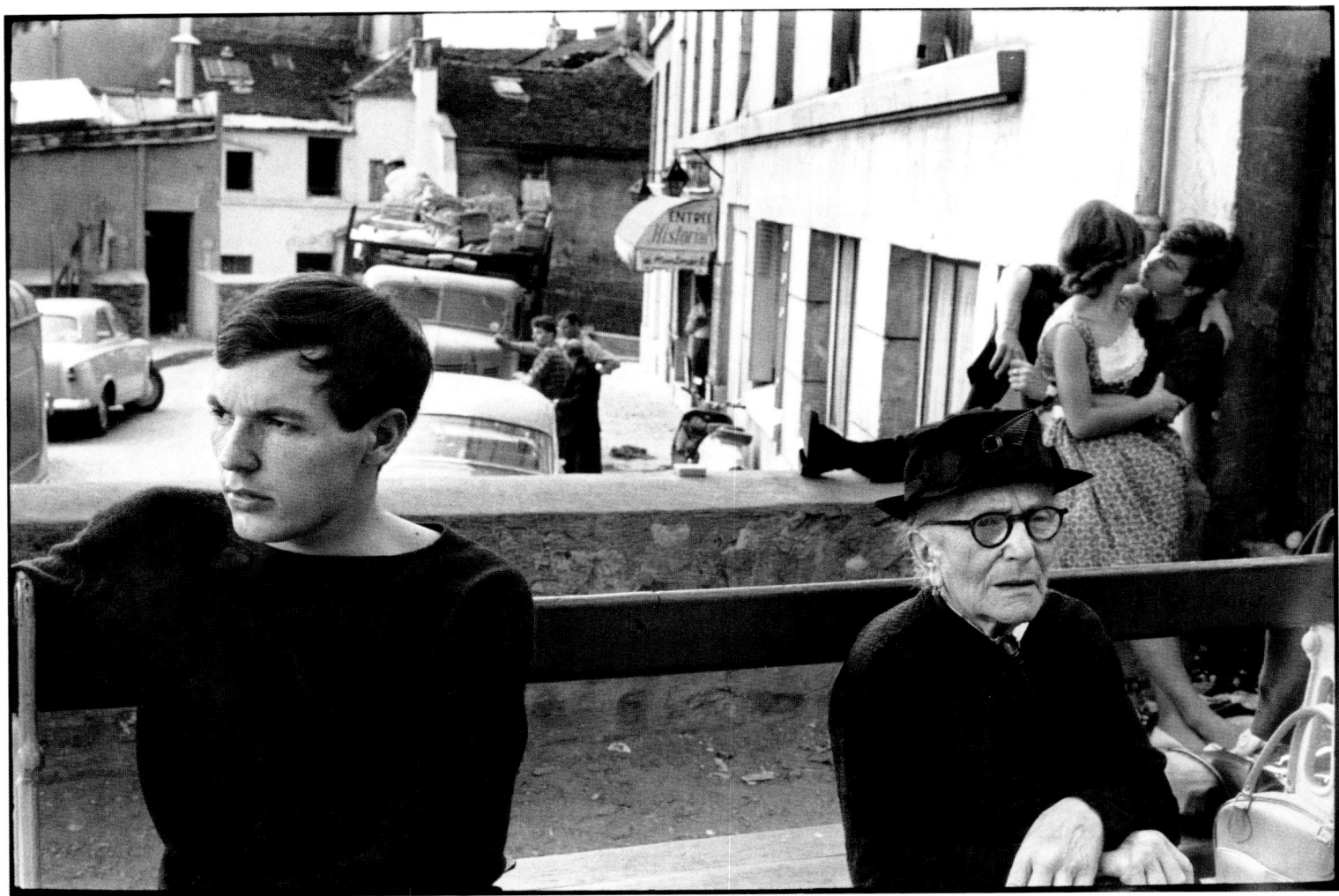

Montmartre, Paris, 1960
NEGATIVE: 24×36 MM _ P81/3324
__ 263

A morning of June 1960, with Vincent in Montmartre. At the time he was taking drama lessons and wanted to build up a photographic portfolio. I had my young actor sit at the end of a bench where an old lady was already settled. On the right in the background was a couple of lovers whom Vincent, immersed in his own thoughts, had not noticed. The idea came to me to associate, in my image, the lead actor with the other three characters. As part of my teaching, I usually hid the couple when I showed this photograph, asking my students: "What do you think this boy is thinking about?" The answer was almost always: "He has a problem with his grandmother." I would then uncover what I had hidden and the boy's sadness was immediately attributed to what was happening behind him.
50-mm lens.

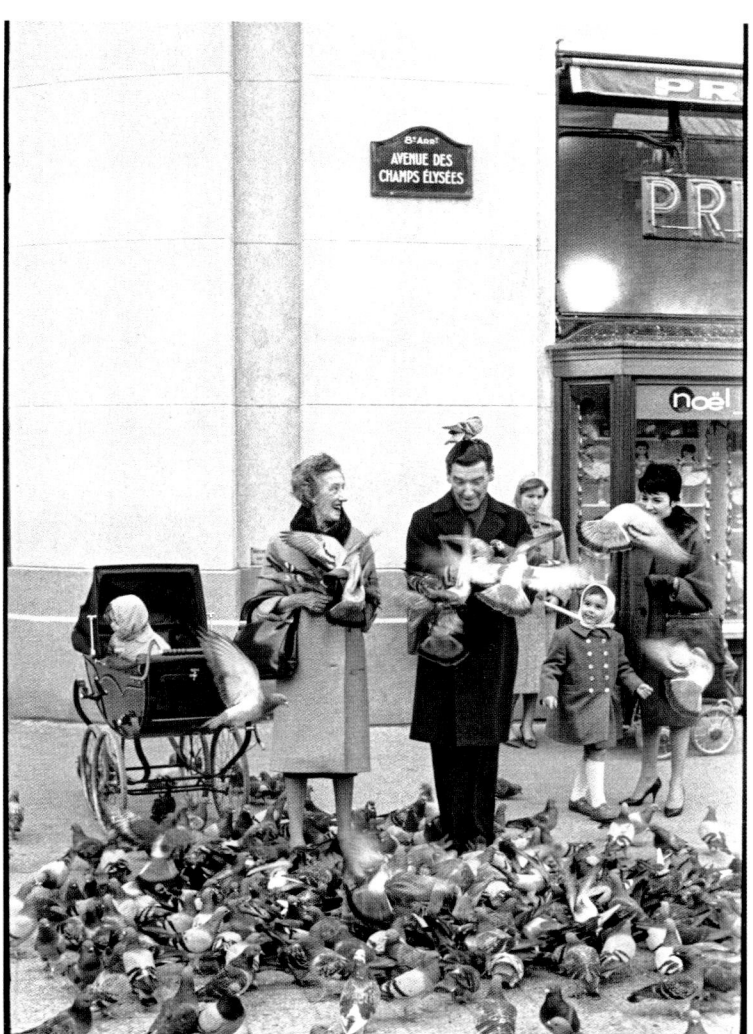

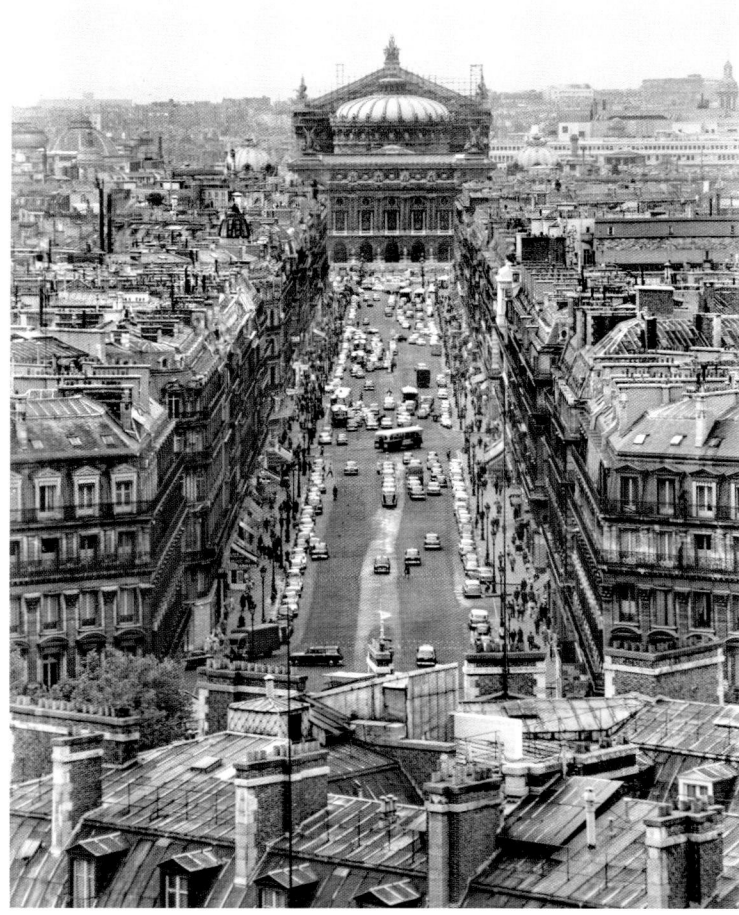

Avenue des Champs-Élysées, Paris, 1960

NEGATIVE: 24×36 MM _ P84/2631

___ 264

December 1960. I was leaving a two-week secondment at UNESCO to illustrate a special issue of its magazine, *Courier*, on the biennial General Conference, which had just been held during the month of November. Quick, a bit of fresh air! It was, I believe, shortly before the first "depigeonization" of the capital. Once again, I was walking around Paris to refresh my archives on the theme of Christmas. 35-mm. Full frame.

The Opéra seen from the roof of a wing of the Louvre, Paris, 1961

NEGATIVE: 24×36 MM _ P87/1916

___ 265

In my photo story for the UNESCO *Courier*, I had the opportunity to go up onto one of the terraces of the Louvre, so of course I took some shots, notably of the Eiffel Tower and the Invalides. The idea then came to me to create a set of photographs of monuments and perspectives of the capital, taken from the roofs of easily accessible public monuments as well as from unexpected bell towers. While wandering along avenue de l'Opéra from north to south one day, I noticed that one of the apexes of the Louvre lined up exactly with this road. With some difficulty, I finally got permission to climb with my equipment onto the roof of the Richelieu Wing, and it was from up there, at the end of April 1961, with a 135-mm telephoto lens, that I took this unusual view of the Opéra and avenue of the same name. The monotony of the traffic is broken by the oblique silhouette of a bus coming from rue des Pyramides. The gray day did not offer a very photogenic light, but it has the advantage of delving into all the details. Cropping only to the sky.

**Le Gobelet d'Argent café
on rue du Cygne, Paris, 1961**
NEGATIVE: 24×36 MM _ P87/4704
__ 266

In May 1961, the monthly magazine *Europe-Auto*, which I had recently begun to work for on a regular basis, assigned me a story on the truck drivers who transported goods for the market of Les Halles. That is how I found myself at 3 a.m. on May 17, 1961, after my work in the Baltard pavilions, in front of the Gobelet d'Argent, one of the many cafés where the different workers from the "belly of Paris" came to seek comfort, day and night. Ambient artificial lighting. 50-mm lens. In printing, hold back from darkening the woodwork frontage in order to retain the detail of the decoration. Full frame.

**July 14 ball on the Île
Saint-Louis, Paris, 1961**
NEGATIVE: 24×36 MM _ P88/4410
__ 267

We usually left Paris for our house in Gordes in the second half of July or early August. So we typically spent July 14 in Paris, enjoying the little public dances—a feast for the eyes and the heart—in which the French Republic and *joie de vivre* were celebrated day and night. The work of the freelance photo-illustrator consists, in part, of assignments—essential for one's livelihood—but also photographs taken for pleasure. The pleasure is no less useful, because it keeps you fresh and it allows you to enrich your archives along the same lines as the photographic agencies, that is to say, constantly filling your files with new images on classic themes. July 14 is one of those themes (like Christmas, the quays, winter, neighborhoods, young people, old people, work, hobbies, etc.). My contact sheets—an irrefutable record—tell me that, after photographing the vacation exodus in the train stations of Paris and having taken various photographs of Marie-Anne during a camping weekend, I photographed alone on the night of July 13–14. On July 14, we went with a friend to the firemen's ball on rue du Vieux-Colombier, and to various open-air dances on the quays. This photograph was taken on the prow of the Île Saint-Louis. Exceptionally, because I do not know of any other examples since I began working with the Foca, it is a vertical framing taken from a horizontal negative. 28-mm lens.

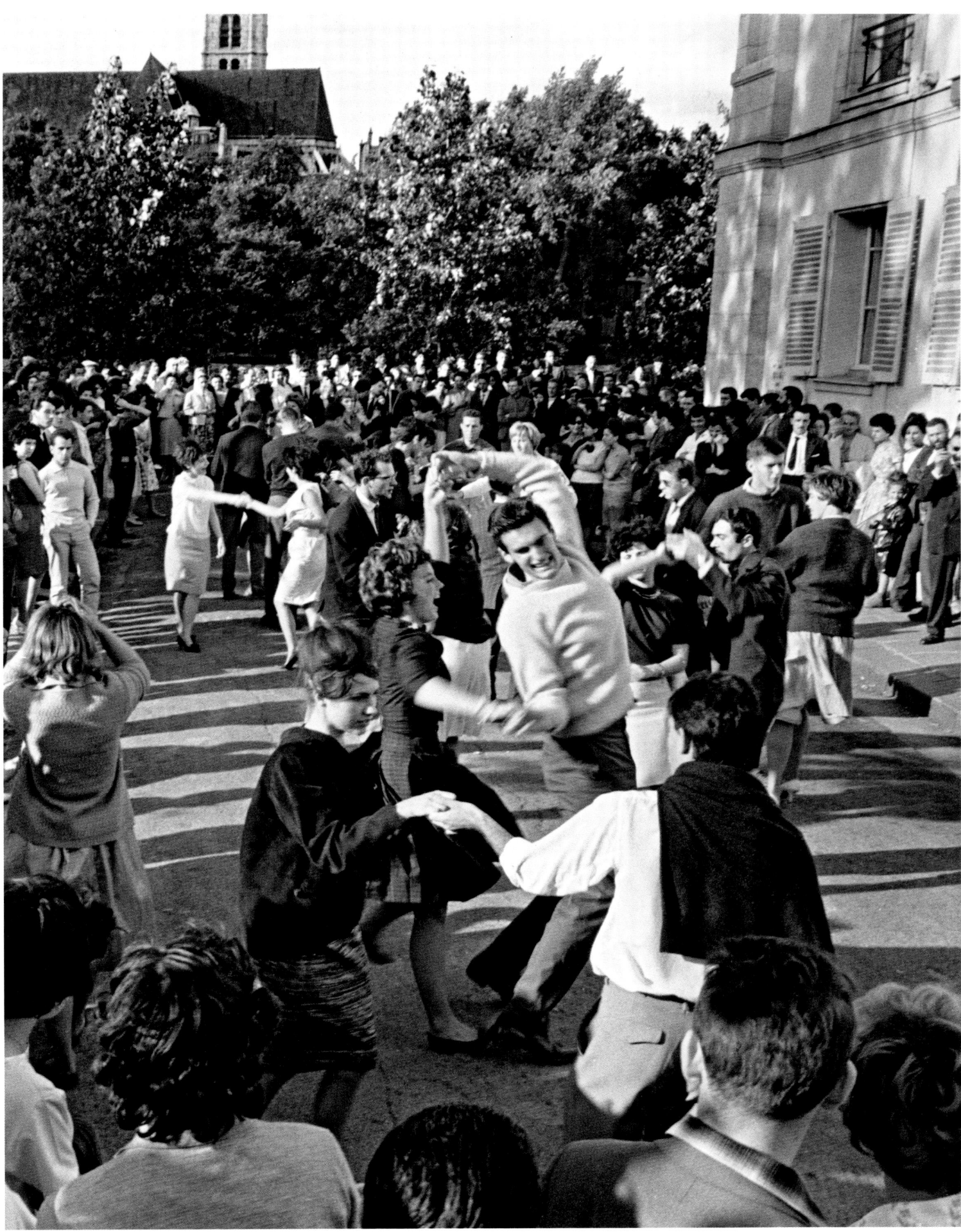

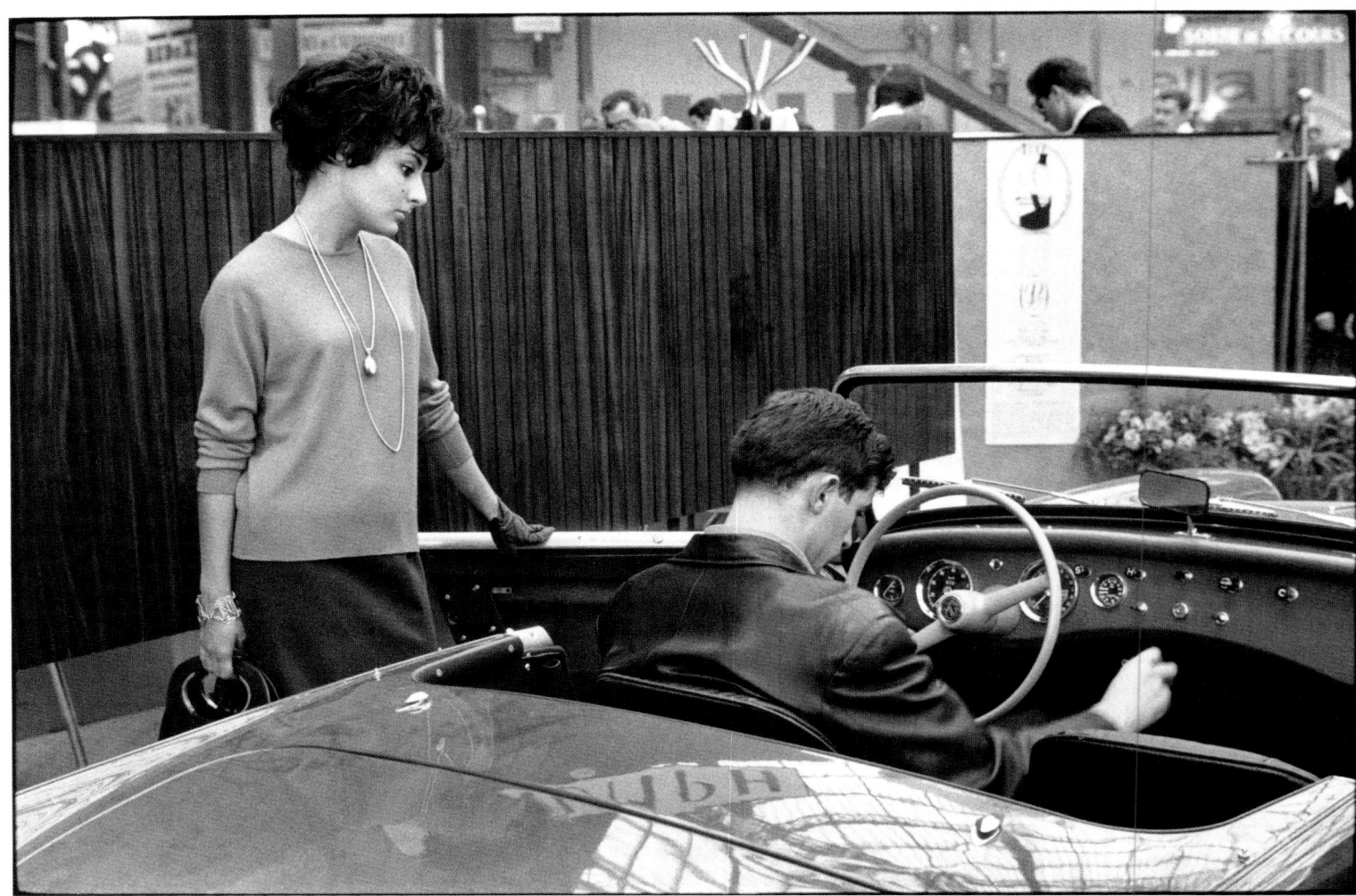

**The Salon de l'Automobile,
Grand Palais, Paris, 1961**
NEGATIVE: 24×36 MM _ P91/0728
— 268

It was October, the month of the "Salon," where I was on duty for *Europe-Auto* (see photo 266). These contact sheets tell me that I shot three rolls there. I think this photo does not require any particular comment. A writer might find in it an incident or the start of a short story or novel. It was not used by the client, which I understand perfectly: it is too literary—and I say this without irony. I knew I was there for a specific purpose: to document. I documented, which gave me the right to take additional images for myself, even if they never came out of my drawer. That is my luxury.
50-mm lens, daylight without any backup lighting. Full frame. Easy print.

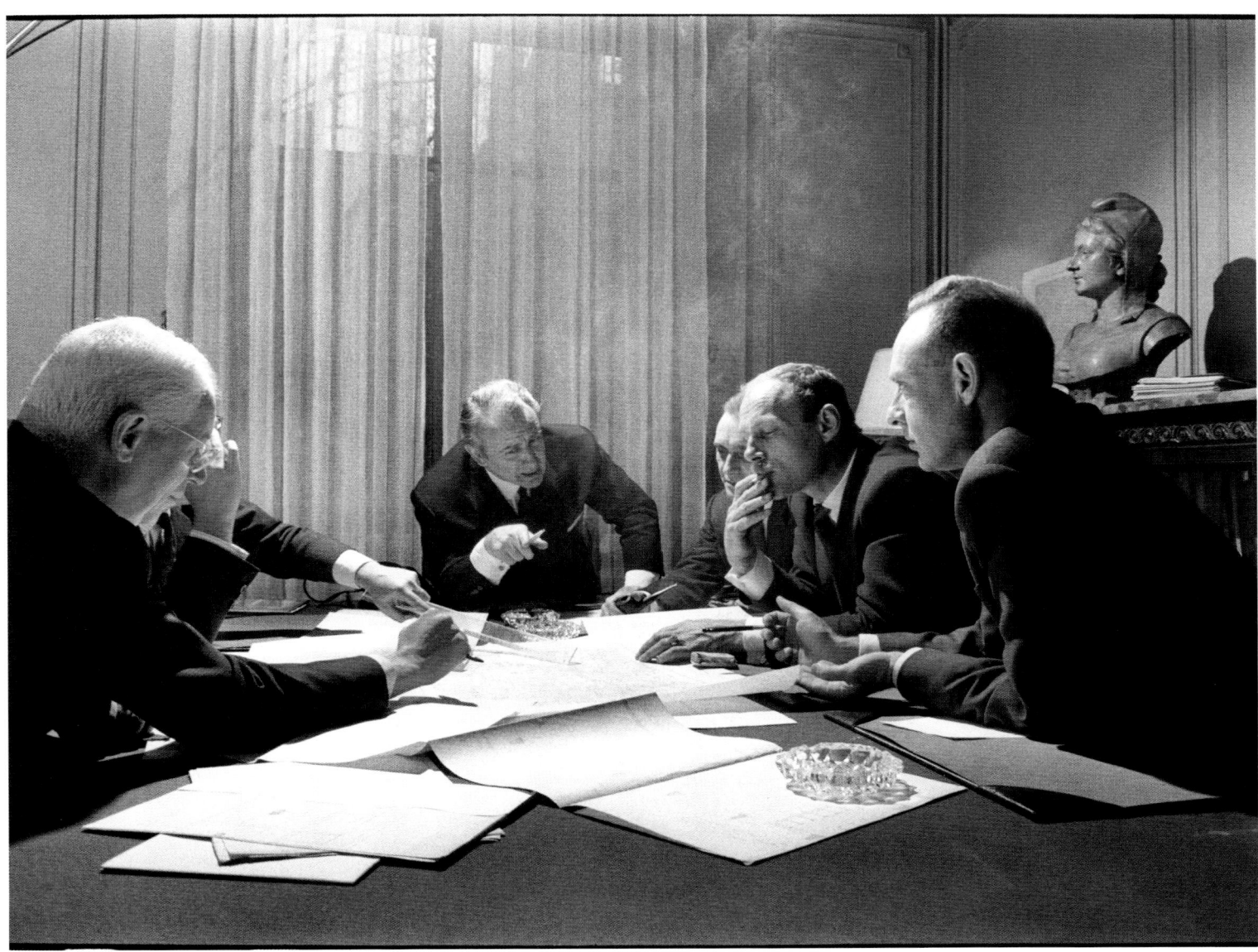

Advertising campaign, Paris, 1962
NEGATIVE: 24×36 MM _ R98/0803

So far, I have hardly mentioned my work as an advertising photographer. To tell the truth, even though it provided me with some interesting moments owing to specific difficulties that I had to overcome, it did not leave me with lasting memories. A major advertising agency had asked me to create an image illustrating the following theme: the municipality of a wealthy town was holding a council meeting on urban development issues. It was primarily a stage-management issue: finding a room (one of the agency's conference rooms would do); suggesting the official setting (I rented a bust of the French Republic from a mold maker) and urban planning (I borrowed plans from an architect friend); finding characters of various ages (based on their photographs, I hired seven actors available for this kind of performance). After that, it involved directing actors. We needed to suggest a certain tension during the meeting, which had to appear in all the photographs, since the advertising agency wished to be able to choose from a large number of images. I had designed my lighting from a two-lamp (portable) electronic flash: one directed vertically from a high angle to the center of the group, the other pointed to the ceiling so that the surface of the latter would redistribute a broad beam of light to soften the shadows. Each of the lamps was attached to a ball-head lamp holder, and my Foca was connected to the flash generator by a wire of about thirteen feet (four meters), which did not allow me much freedom of movement. The lens was a 35-mm open to f/11.

Marie-Anne, a Christmas weekend, Cuisy, Seine-et-Marne, 1962
NEGATIVE: 24×36 MM _ 98/4103
__ 270

During a Christmas weekend in 1962, in a bungalow near Paris. Marie-Anne smoked a post-coffee cigarette, and the low, slanted sunlight played in her hair and in the plumes of smoke. The camera was—surprise, surprise—close at hand. Two shots: this is the best. 50-mm. Framing slightly cropped at the bottom.

The sailor's farewell, Paris, 1963
NEGATIVE: 24×36 MM _ P99/3509
__ 271

The dilapidated house where we lived between 1946 and 1964 overlooked a passage linking rue Lecourbe and boulevard Garibaldi, and as a result, we saw a lot of people passing by. It was in February 1963, around noon: chance had brought me down from the second floor where Marie-Anne had her painter's studio and I had my office and lab. In front of one of the ground-floor windows this young couple had stopped, motionless, with the grave expression of those who are about to part. Maybe it was the end of a military leave? Just in case, I jumped for my camera, hoping dearly that there would still be enough time for the picture. Yes, they were still there and, from the dark interior where they could not see me, I took seven shots. Very indiscreet! Am I a voyeur? Yes, in a sense. I am still trying to persuade myself that the fine curtains scramble their faces, and that my behavior was not reprehensible. After all, I was not going to distribute this photograph like a leaflet. I own the negative and no one else can print it, or not without my permission. 50-mm. Difficult print because of the grayness of the negative. Full frame.

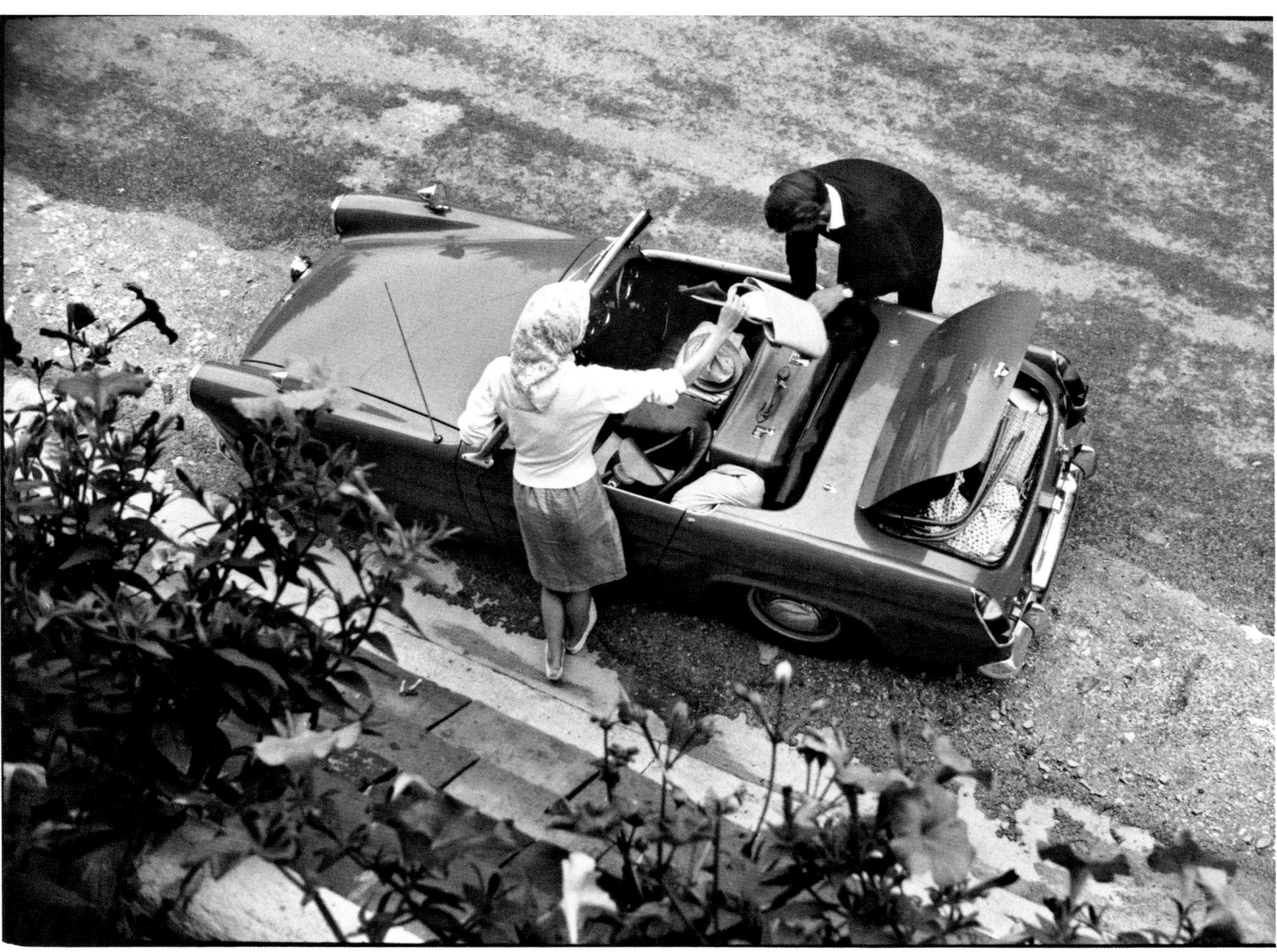

Avenue d'Iéna, Paris, 1963
NEGATIVE: 24×36 MM _ P101/1813
___ 272

This photograph was taken at a time when most of my professional income came from commercial photography (industrial and advertising). I was nevertheless often in contact with clients who knew how to use my particular skills: an ability to seize the moment, based on specific criteria and in accordance with the nature of the assignment. The Publicis agency had thus commissioned me, on behalf of a major oil company, to take a series of photographs in Paris and a dozen big French cities, in which two men and a Citroën or Simca car had to appear each time. The photograph had to look like a documentary image, the place had to be immediately identifiable, and the composition vertical. And each location had to provide enough material for several different photos (for Paris it was place de l'Étoile, the Pont-Neuf, and the Champs-Élysées). This image was taken on avenue d'Iéna, in February 1963, me standing on a bench, with a 200-mm telephoto. As far as I know this photograph has not been published. Nevertheless, for the theme of Paris it is the one I prefer. Average difficulty print. Full frame.

Vincelotte, Yonne, 1963
NEGATIVE: 24×36 MM _ F108/1834
___ 273

At the beginning of August 1963, Marie-Anne and I headed to the South. As we had left late in the afternoon, we stopped overnight at Vincelotte, in the Yonne. My contact sheet reminds me that I had risen first the next morning and was going back to the hotel to have our breakfast, when I took four pictures of this young couple preparing to leave from the opposite sidewalk. And then, because the window of our room was just above the car, I thought I would maybe have the time to take a more interesting high-angle shot. This photograph is the most compelling of the four that I took from there. I even had time to take it in color as well. 50-mm. No printing difficulties. Full frame.

L'Oréal chemistry laboratory, Aulnay-sous-Bois, Seine-et-Oise, 1963
NEGATIVE: 24×36 MM _ 108/3440
—— 274

The Oscar Publicité agency sent me on a short industrial/advertising shoot to the L'Oréal factory in Aulnay-sous-Bois. From two rolls of thirty-six frames taken that afternoon on September 12, 1963, this is the image that stayed with me. The collaboration of the chemist who was there was invaluable, as was the fortuitous sunbeam responsible for the projected shadow on one side of my model's nose, because at no point did I use any extra lighting. 28-mm, daylight. Easily balanced print. Full frame.

Provençal festival, La Crémade, near Saumane-de-Vaucluse, Vaucluse, 1964

NEGATIVE: 24×36 MM _ F113/1034

—— 275

Because of gray weather (interspersed with too few sunny spells), I had almost missed out on a series of large-format 4 × 5-in. (10 × 12.5-cm) color shots of the little port of Portofino, commissioned by Air France for its calendar. So I was returning in stages in a car rented in Nice, allowing me to take a maximum number of color photos for other uses, both editorial and advertising. That's how I arrived, on April 17, 1964, in Gordes, where a local newspaper announced that a big traditional festival would be held on the following Sunday morning, in the hamlet of La Crémade, not far from L'Isle-sur-la-Sorgue. The potential for some nice extra work was on the horizon: I decided to attend if the weather turned nice. I was equipped mostly for color: 4 × 5 in. (10 × 12.5 cm) and 2¼ × 3¼ in. (6 × 9 cm). But I also had my two Foca bodies. This photograph was taken at dusk, when the bulk of the crowd had gone, leaving plenty of room for the insatiable dancers to expend their excess energy in increasingly breathless folk dances. 50-mm. The print is quite difficult to balance to bring out the succession of planes that were very unevenly lit by the low sun. Full frame.

Place de l'Opéra, Paris, 1964
NEGATIVE: 24×36 MM _ P114/2009
__ 276

A period of hard work, leaving little spare time for random chances. I went back to the Richemont steel plant in Moselle (the fourth time in six years). But I needed to redo photographs in Paris, for myself and for the needs of Air France's advertising department. A certain number of them were shown at the end of the year in the exhibition *Six photographes et Paris* (Six Photographers and Paris), at the Pavillon de Marsan (participants: Robert Doisneau, Daniel Frasnay, Roger Pic, Jean Lattès, Nicéphore Niépce, and Ronis). Not to state the obvious, but place de l'Opéra is one of the most difficult places to photograph in Paris. The flow of pedestrians is constantly interrupted, thanks to both the metro exit and the rhythm of the traffic lights. Everything comes together miraculously when a truck—many pass through this square—arrives and ruins everything. On May 27, 1964, I was once again looking to add some new images of this important location to my archives. The Opéra's façade had just been restored and, despite the sky being a little overcast, it lit up the theater of the street, an entertaining mix of pigeons and pedestrians.

The tourist in Paris, 1964
NEGATIVE: 24×36 MM _ P115/1517
__ 277

July 1964. I continued my photographic wanderings in Paris, for the two reasons mentioned in the previous photo. I worked with two camera bodies, one for black-and-white, the other for color. Because the day of July 8, 1964, was scattered with showers, I had the idea of photographing Vincent— we had an errand to run together near the Trocadéro—as a foreign tourist, happy to be in Paris despite the rain. Needless to say, it was not selected by the client: we were not going to display photographs abroad that show it can rain in Paris. But it was chosen as the cover for my book *Mon Paris*. 50-mm. Full frame.

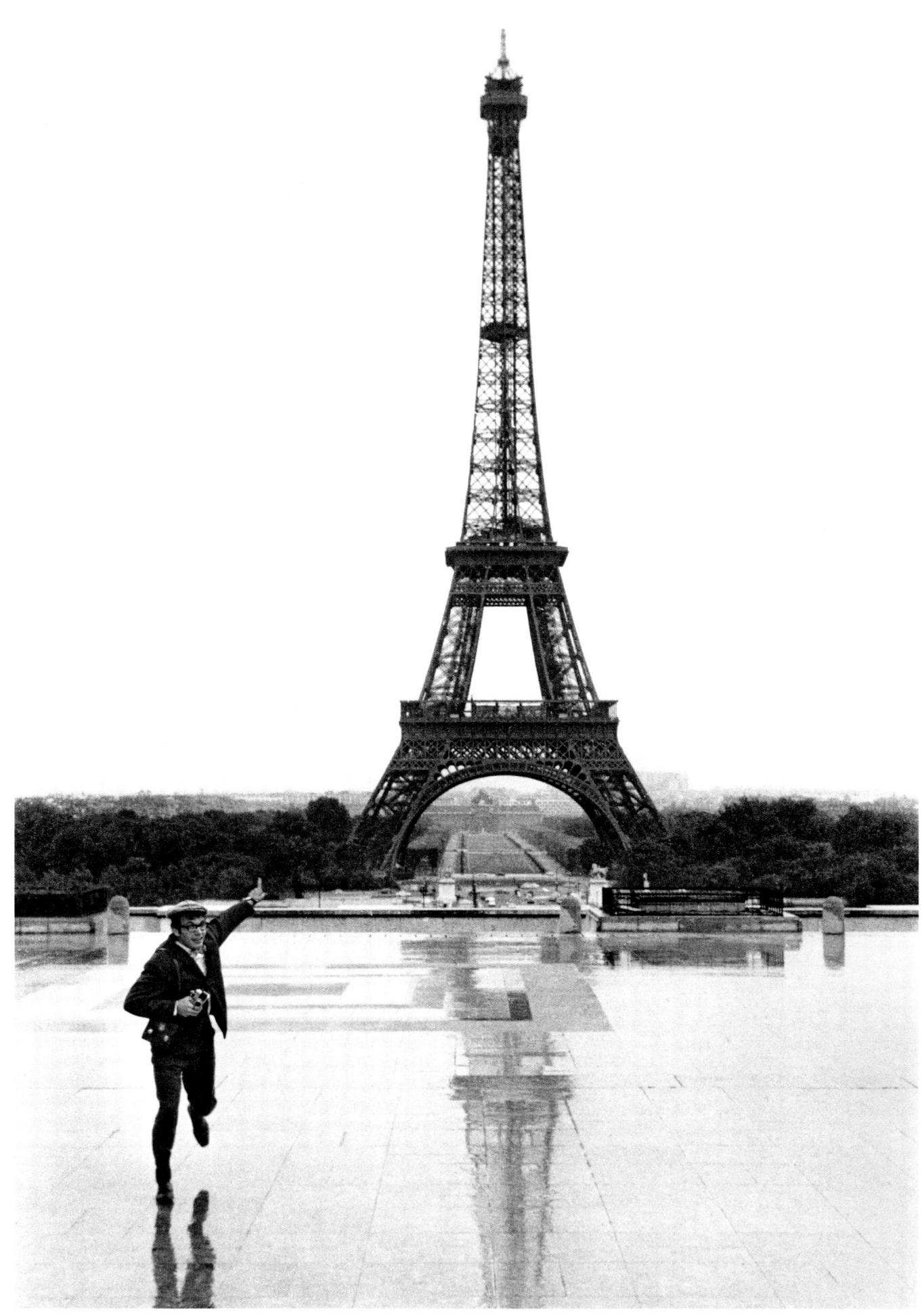

Paris photomontage, 1964
NEGATIVE: 4×5 IN. (10×12.5 CM) _ I34/10/3
—— 278

During the 1960s, I had a close relationship with Air France's advertising department. I was asked to produce a black-and-white mural that could possibly be used in other ways (endpapers, etc.). From my Paris archives (Paris was the theme specified), I created a photomontage, from which I then made a large-format duplicate negative, treated using processes from the arsenal of "photographic design." This is the version I like best. I also chose it as the endpapers in *Mon Paris*.

The wise man of the quai des Orfèvres, Paris, 1965
NEGATIVE: 24×36 MM _ P122/3018
—— 279

At the end of October 1965, as a pedestrian and photographer of Paris, I was once again crossing the Pont-Neuf from north to south with the idea of doing some work on the square du Vert-Galant, a spot where the cosmopolitan young met. Automatically glancing to the left, this is what I saw, on the lower level of the quai des Orfèvres. 50-mm. During printing, take care to soften the dim light on the figure a little. Full frame.

Île-de-France landscape, Cuisy, Seine-et-Marne, 1966
NEGATIVE: 24×36 MM _ P123/3924
___ 280

In the 1960s, we fairly regularly spent our weekends in a small house in the forest between Meaux and Dammartin-en-Goële. At the beginning of the second week of January 1966, there had been heavy snowfall in the Paris area, and I had photographed the city in an unusual light. I took the camera to the country and went on a landscape photographer's excursion. I like this photograph for the very reason that it is not structured according to the classic rules of pictorial aesthetics. It is a jumble of thickets and brambles, with the kinds of trees found in unmanaged woods. The snow reflects the weak light of an overcast winter's afternoon. It's sad, but spectacular at the same time. Probably 28-mm. The print must be very light, with low contrast. Full frame.

The breakdown, on the Autoroute du Sud between Gentilly and Arcueil, Seine, 1966
NEGATIVE: 24×36 MM _ F129/4234
___ 281

Taken from a lane along the Autoroute du Sud, outside Paris between Gentilly and Arcueil, on a Saturday in October 1966. This gentleman had broken down a few hundred feet from the capital, and must have found the happy roar of the other cars difficult to listen to. At least, that is the idea that I tried to suggest by waiting for the convergence, in my line of sight, of several vehicles traveling *in both directions*. There was a chance that it would happen, but it was not at all sure, and it had to occur before the end of the repairs. To get the motion blur of the vehicles— the translation of the idea of speed into photographic language—I set my shutter speed to 1/25 second. 90-mm. Easy print. Cropped to the left and bottom.

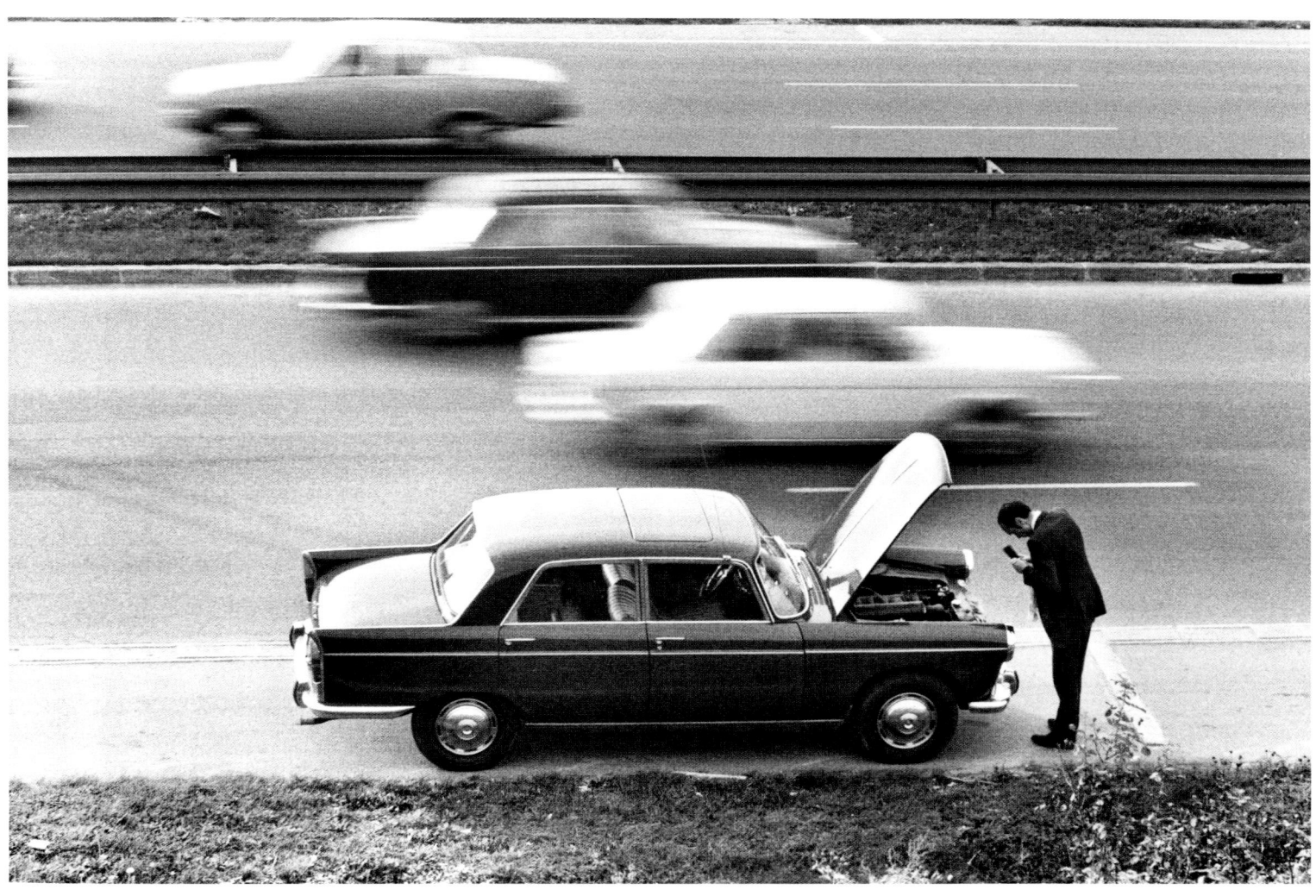

**Le Monde's new printing press,
Paris, 1967**
NEGATIVE: 24×36 MM _ R130/3801
___ 282

Le Monde newspaper asked me to do a short project on its new printing press, not to publish in its pages—at that time there were photographs only in the advertisements section—but for external uses that I have since forgotten. This is the photograph that I remember as being the liveliest of my series. Ambient electric lighting.
35-mm. Partial crop.

**At the East Berlin Zoo,
East Germany, 1967**
NEGATIVE: 24×36 MM _ 133/1427
___ 283

In 1967, the German Democratic Republic was not yet officially recognized by France, and an organization called Échanges Franco-Allemands, which was working toward a better mutual understanding, asked me to undertake a major documentary project on East Germany, leading to an exhibition that would be shown in Paris and then travel around the country. My work was done in two stages: a first stay of three weeks in July, for the outdoor images; and a second one of the same duration in October, specifically for cultural themes. This picture was taken at the East Berlin Zoo.
50-mm. Full frame.

Sailors' café in Rostock, East Germany, 1967

NEGATIVE: 24×36 MM _ 133/4230

___ 284

The next part of the story on the GDR. On July 5, I was in Rostock, a former Hanseatic city and a port on the Baltic Sea. At nightfall, for some local color, my contact took me to a sailors' café, urging me to be careful, because at this late hour many were drunk and did not appreciate the sound of the camera shutter. Watchful but stubborn, I noticed an easily accessible indoor balcony and, taking advantage of the booming jukebox, I pressed the shutter several times as casually as can be. The light was meager, dispensed by suspended fixtures that were far apart, making the printing of my negatives quite difficult. Working with a flash was obviously out of the question. 50-mm. Full frame.

On their own, a Saturday night, Wernigerode, East Germany, 1967

NEGATIVE: 24×36 MM _ 137/3220

___ 285

Two weeks later, July 22, 1967. This is Wernigerode, a small town in Thuringia, during a small dance on a Saturday night. I worked away without anyone paying attention. At one point, I saw a balcony—an obsession of mine that almost always proves beneficial—that was occupied only by this couple. I took a few shots of the dancers, so that the couple would forget about me, and I finished up by taking a few pictures from behind them. The couple is sharp, my dancers are blurry. Perfect for what I wanted to express: two young people cut off from the rest of the world. 50-mm. Full frame.

In the park of Sanssoucl Palace, in Potsdam, East Germany, 1967

NEGATIVE: 24×36 MM _ 138/0236

—— 286

The next day I was back in Berlin, since it was the last day of this first part of my report on the GDR. I went to Potsdam, the Prussian Versailles where, in the park of SanssoucI Palace, I saw a group of little Berlin kids happily messing around. Since they probably found me funny, too, they asked me to photograph them. I accepted on the condition that I could choose the location, which was quickly agreed. I asked them to stand in front of the sphinx, and this is the result. 50-mm. Print without problems. Full frame.

Children's choir, Leipzig, East Germany, 1967
NEGATIVE: 24×36 MM _ 140/4723
__ 287

Two and a half months later, during the second part of my report in the GDR. On a rather dark October afternoon—beggars can't be choosers—in Leipzig, I was allowed to attend a rehearsal of the children of the famous choir of St. Thomas's, the church where Johann Sebastian Bach was the music director and where many of his compositions were performed. These children were singing Bach—and how they sang! I climbed up on the last bench and took several shots, because my passion for the Great Cantor made my pulse race, a highly unfavorable condition for taking photographs at 1/10 second on an unstable support. 28-mm, underexposed negative. Full frame.

Exhibition of German art, Zwinger Museum, Dresden, East Germany, 1967
NEGATIVE: 24×36 MM _ 141/0433
__ 288

Dresden, the Zwinger Palace, now a museum, in a wing where an annual exhibition of German contemporary art was held. I had been, from afar, unnerved by the fascination this statue exerted over the little girl. I had seen her, taking advantage of a moment when she was alone, slowly circling it and, after a quick look around, placing a kiss on the bronze cheek (I have a photo of the kiss, but it is not very good). She then ran after the two men to share her feelings, bombarding them with questions. A few days later I was in the studio of Christa Sammler, a young woman sculptor, who, in the middle of our conversation, took a smaller version of the reclining woman out of a padded case, explaining that it was the maquette of a large statue she had sent to the Zwinger. I told her the story of the little girl. After my return to Paris, I sent her the photograph taken in her studio with the little sculpture in the box, as well as the one you have in front of you. I received a quite lovely reply. That is also part of the life of a photographer. 28-mm, daylight. In printing, overexpose the windows to reveal the venetian blinds and the tower in the left opening. Full frame.

Dresden Technical University, East Germany, 1967

NEGATIVE: 24×36 MM _ 141/2323

—— 289

End of October, at Dresden Technical University, a few minutes before the start of the physics class. This photograph was taken from a gallery located halfway up the amphitheater. This shot was executed with the 50-mm lens. I made another diagonal image using the wide-angle 28-mm, to show all the students and their professor. This one, where only part of the audience can be seen, but whose frame is (almost) filled, gives a much better idea of numbers than the other one, because it calls on the imagination. Artificial light. 50-mm lens. Print requiring some additional exposure time in some lighter areas. Full frame.

Leipzig, East Germany, 1967
NEGATIVE: 24×36 MM _ 142/1607
___ 290

End of October in Leipzig. The conversation was dragging on and the children were getting impatient. What am I going to add? That from the moment I noticed the girl's annoyance, I needed to wait for the gesture that would best express her feelings. I was able to get what I was looking for (even the child in his stroller, turning toward his mother). But it happened so suddenly that, in my haste, I slightly tilted the vertical. 28-mm. Full frame.

Since East Germany was not yet officially recognized by France in 1967, no official venue accepted to host the exhibition drawn on my reporting. The work was first presented at Montreuil town hall, then at the municipal museum of Amiens (twinned with Görlitz); where next I cannot remember.

Descending from the castle to the city, Prague, Czechoslovakia, 1967
NEGATIVE: 24×36 MM _ 142/4316
___ 291

My work in the GDR ended with a return to Dresden for some additional photographs. I had obtained a visa for Czechoslovakia in Paris, and I intended to end my journey with a short stay in Prague, which is just over 70 miles (120 km) from Dresden. Once again, I visited Prague (my third time). It was a gray day, and from time to time a little cold rain fell. From the middle of this stepped alley leading down to the city center, the cityscape was well composed, but there were few pedestrians and so I waited. I heard people coming down behind me, but I did not turn around, in order not to attract attention. Another photograph. Curiously—but is it really that strange?—I composed a perspective that recalls a photograph taken between the Buttes-Chaumont and Belleville some eighteen years earlier (photo 79). 50-mm. Highly underexposed negative.

Rainy evening on the Charles Bridge, Prague, Czechoslovakia, 1967
NEGATIVE: 24×36 MM _ 142/4418
—— 292

The following evening, from scaffolding erected at one end of the famous Charles Bridge, which was being restored. In the background the district of Malá Strana can be seen, and the hill where the cathedral and castle stand. The blurred effect of this image was not intentional. A clumsy maneuver had shifted the lens from its normal position, causing an unintentional blur, but one that was very well suited to this rainy early November. There is such a thing as a happy mistake, like this one. 50-mm. Full frame. Easy print.

**A weekend at Cuisy,
Seine-et-Marne, 1967**

NEGATIVE: 24×36 MM _ F143/0219

A November morning in Seine-et-Marne, during a walk. I found something poignant in these tormented-looking trees, standing out against the mist. I accented the graphic effect using a 90-mm lens. Cropping on the edges.

A Sunday at the Louvre Museum, Paris, 1968
NEGATIVE: 24×36 MM _ P144/1015
—— 294

At the Louvre, where I returned several times a year, usually with the camera. I had noticed, on busy days, that the frame of Jacques-Louis David's famous painting of the coronation of Napoleon was entirely obscured by visitors, and that they were illuminated by the overhead skylights, a little like the central characters of the painting. To succeed in blending the two worlds, several conditions had to be met, the first of which was a good depth of field, which requires a small aperture, thus good light, thus a time when the sun is high. As the sunny season is fortunately the one where there are the most people in the Louvre, and it was April, all I had to do was choose a point of view that captured a good spatial arrangement of the group's various elements.
28-mm. Underexposed negative. Full frame.

"The Eye Listens," Louvre Museum, Paris, 1968
NEGATIVE: 24×36 MM _ P145/0406
—— 295

"The Eye Listens" (says poet Paul Claudel). Same location, one month later. This is not a comical illusion, but a representation of the modern phenomenon of audiovisual communication. Many visitors to the Louvre—a majority of them foreigners—hire these didactic audioguides. I was spoiled for choice. I chose this couple, a mother and son apparently, because the young age of the child and his seriousness amused me, especially at the moment when a small display of impatience caused this movement of his foot.
35-mm. Easy print. Full frame.

Jardins du Trocadéro, Paris, 1968
NEGATIVE: 24×36 MM _ P146/0731
— 296

I was preparing an exhibition on Paris commissioned by the Ministry of Foreign Affairs and designed to travel outside France, to various capital cities, and I wanted to include in my selection some photographs from that year. These are the Trocadéro water displays on a June afternoon. The silhouette of these young people stood out against the backlight, and I used a 135-mm telephoto to take advantage of the flattening effect caused by this type of lens. I obtained a visible shortening of the space between the couple and the pair of vertical jets, and, since I found myself in an alley overlooking the scene, the sky was cut out. Normal print. Almost full frame.

The place du Pont-Neuf seen from the dome of the Institut de France, Paris, 1968
NEGATIVE: 24×36 MM _ P146/1114
— 297

Same month of June. I remember that twelve years earlier, but in the fall, I had been given permission to photograph Paris from the dome of the Institut de France (see photo 204). Given authorization once again (I had show my photographs from 1956), I was up there for the second time just when a riverboat passed on the Seine. The photograph reproduced here was made with a 135-mm lens. It shows the southern section of the Pont-Neuf, the typical houses of the place Dauphine, and, against the sky, from left to right, the Hôtel de Ville, the church of Saint-Gervais, and the dome of Saint-Paul. Under the left arm of the crane, the Bastille Column can be seen. Full frame.

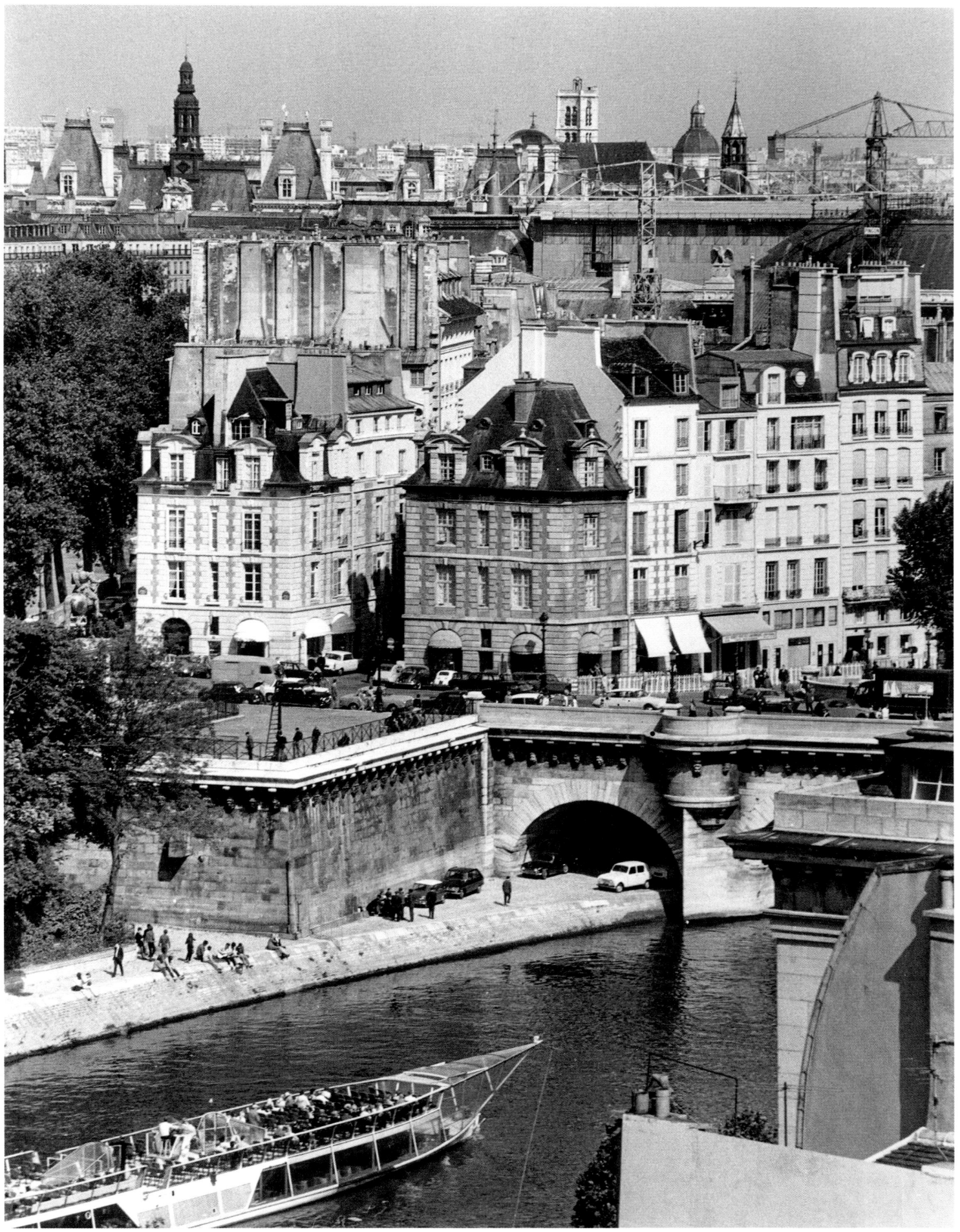

On the sidelines of a story on the first Pan-African Festival, Algiers, Algeria, 1969
NEGATIVE: 24×36 MM _ DUPLICATE _ 153/2914
___ 298

In July 1969, the first Pan-African Festival was held in Algiers. The Algerian government commissioned William Klein to make a film about the event; five photographers were in charge of color photography (Dominique Darbois, Édouard Boubat, Pierre Jahan, Laurent Pinsard, and Willy Ronis). I had also brought my black-and-white camera body, and this photograph is taken from the small number of images that I made with this second camera. It is simply a memory of the crowds in the streets near the seaside. I had climbed on a bench to get an elevated view. An incident during development, as happens to any photographer, had made my original negatives too light for a good print. From those that I wanted to keep, I made duplicates with normal contrast by contact on special film (Kodatone, which has unfortunately been discontinued). Framing cropped at the top.

Open-air concert during the first Pan-African Festival, Algiers, Algeria, 1969
NEGATIVE: 24×36 MM _ DUPLICATE - 153/3217
___ 299

Same project, during an open-air evening concert, Algiers, July 1969. Duplicate negative cropped at the bottom.

Baie des Anges marina, Nice, Alpes-Maritimes, 1970
NEGATIVE: 24×36 MM _ F162/1323
___ 300

Having done several projects for the Ministry of Foreign Affairs for its overseas exhibitions (see photo 296), I proposed a new theme: French architecture since the liberation. I was asked to provide a number of examples before a decision was made, so that the organizers could judge a cohesive body of images. The subject, which I had thought about a lot, greatly interested me and I decided to take risks. I worked on it, on and off, for nearly two months. In the meantime, budget cuts derailed the project. This photograph was taken at the end of August alongside a series on marinas and new vineyards on the Côte d'Azur. 28-mm. Full frame.

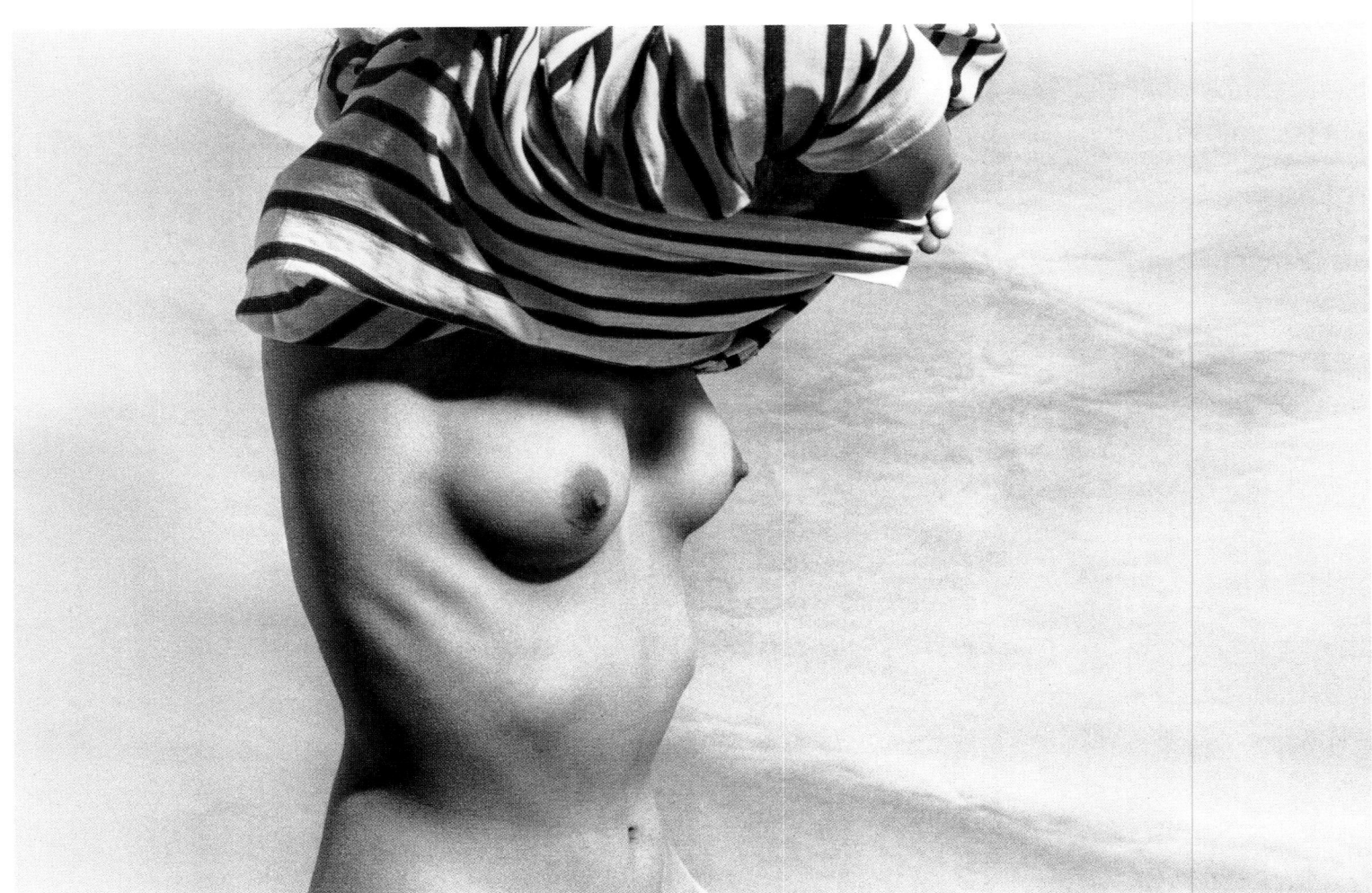

**Nude with striped shirt,
Paris, 1970**
NEGATIVE: 24×36 MM _ 163/0616
___ **301**
An excerpt from a series of nudes taken in September 1970. The subject was a model who had posed for me several times for advertising work. The background gives the impression that the photograph was taken at the beach. In fact, it was artificially lit in my studio, and the impression of swell comes from the imperfections on the lower part of my white background, which had not been unrolled to the ground. 50-mm. During printing, hold back the left side of the background to get an equal tone. Full frame.

Nude, Paris, 1970
NEGATIVE: 24×36 MM _ 163/0721
___ **302**
Same session, same model, same type of lighting. The print must be held back in order to obtain a very light and even tone. Same lens; cropping on three sides to ensure rigorous centering.

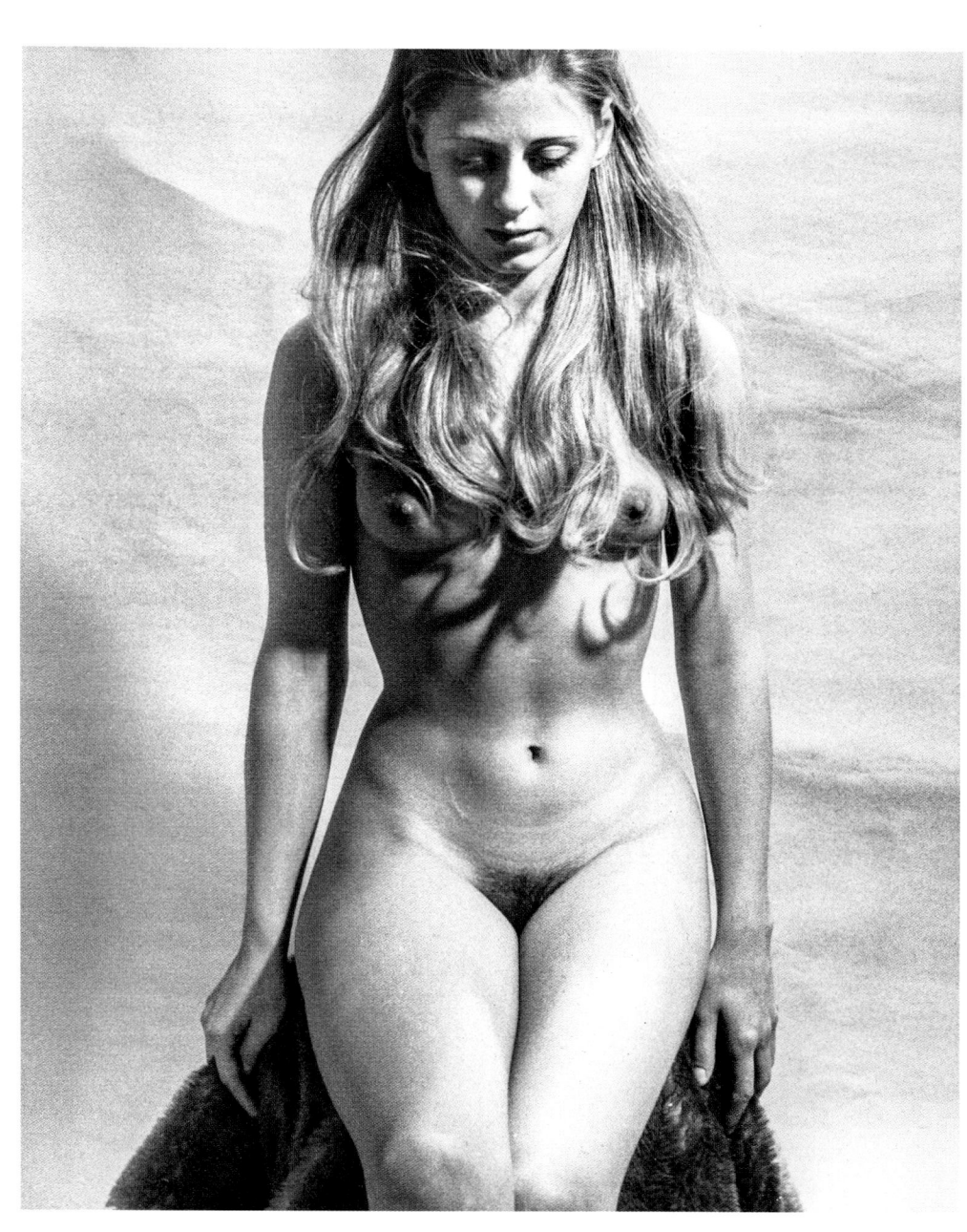

Maine-Montparnasse district, Paris, 1970
NEGATIVE: 24×36 MM _ P163/2638
__ 303

My project on recent architecture in France included a major series on Paris. The building shown here is part of the Maine-Montparnasse complex. The reflection, distorted by the curved surfaces of the hood of a Citroën DS, was interesting but insufficient. Very few pedestrians passed by here. Finally, this woman appeared, pushing her child's stroller. One take, of course. 28-mm. Difficult print to balance. The sun of a September afternoon harshly illuminates the façade while the pavement is in shadow, so underexposed. Full frame.

Porte de la Chapelle, Paris, 1970
NEGATIVE: 24×36 MM _ P163/3915
__ 304

Another image taken on the sidelines of my project on architecture. I had thought of incorporating a sequence on highway interchanges. Returning from a trip on the outskirts of the capital, I had planned to pick up my car under the awning formed at this point by the raised Autoroute du Nord as it reaches Paris. I had been fascinated by the parabola outlined by the slab, with the series of hoods reflecting the sky. I waited for a few cars to pass in the left lane and set the shutter on a semi-slow speed (1/25 second) to get the motion blur of the shot. 28-mm. Easy print. Full frame.

Pablo Picasso, Vallauris, Alpes-Maritimes, 1950/1971
NEGATIVE: 4×5 IN. (10×12.5 CM) _
FROM 2¼×2¼-IN. (6×6-CM) NEGATIVE _ D41/1
___ 305

I had photographed Picasso several times, particularly in August 1950 in Nice and Vallauris (see photo 107). This image is known as a posterization. It is an interpretation of the normal negative by means of successive duplicates and prints, resulting in a clear separation of tones. I'm not fond of laboratory contrivances but, from time to time, it's fun to go out of one's comfort zone. My original negative is a 2 ¼ × 2 ¼-in. (6 × 6-cm), in which Picasso was lit from above and half-backlit with a magnesium flash attached to the end of a long wire and clipped to the top of a door. My posterization is made up of two contiguous 4 × 5-in. (10 × 12.5-cm) negatives, one for the gray, the other for the black, slightly offset from each other, and taped together on their four edges. To be framed according to this model.

**At the Louvre Museum,
Paris, 1972**
NEGATIVE: 1×2¼ IN. (24×58 MM)
ON 24×36-MM FILM _ P170/3216
—— 306

In July 1972, I borrowed a particular type of camera, with a lens that pivots during the opening of its focal-plane shutter (which also pivots), producing 1 × 2 ¼-in. (24 × 58-mm) negatives on 24 × 36-mm film. The camera is tricky to use because the images are affected by inevitable distortions—especially when the viewfinder axis deviates from the horizontal. What's more, if the balanced distribution of moving characters is difficult to achieve with a conventional camera, with a sweeping panoramic set-up it becomes a real, if not insurmountable, struggle, as can be seen here. This type of camera, which was—very surprisingly—invented during the era of the early daguerreotype (Van Martens, 1854), was taken over by Kodak in the late nineteenth century, then more recently and in a smaller format by the Japanese (Widelux) and the Soviets (Horizont). I made regular use of a Horizont, acquired after my first tests (the Russian camera being three times cheaper than the Japanese one), to create color landscapes in Provence, in 1973–74. The enlargement of the negatives must obviously be carried out with an enlarger for 2 ¼ × 2 ¼-in. (6 × 6-cm) format or bigger. The same applies for the projections of color slides. Photo 310 is another photograph taken with the same device.

Rue Blaise-Pascal, Arles, Bouches-du-Rhône, 1975
NEGATIVE: 24×36 MM _ F184/4903
— 307

Between 1972 and 1983, we lived in the Vaucluse, first in Gordes, then in L'Isle-sur-la-Sorgue. Arles was around forty miles (sixty-five km) away, and every year in early July we went there during the opening week of the Rencontres d'Arles photography festival. Aside from the program of screenings and exhibitions, Arles provided the opportunity to see a number of photographer friends and to get acquainted with foreign photographers. From time to time I would leave the hubbub of the photographic world to make some incursions into the city. This was how I captured these children in a neighborhood that I particularly like, the district of La Redoute, on the heights behind the amphitheater.
50-mm. High contrast negative. Make sure to bring out some details in the sunny part, and to hold back the areas in the shadows. Framing slightly straightened.

Vacation in Najac, Aveyron, 1976
NEGATIVE: 24×36 MM _ F188/3218
— 308

September 1976. We were on a trip in the southwest and stopped at Najac, in the Rouergue. This view was taken one morning from our hotel, while I was planning the rest of our journey. Its creation was not exactly as it appears on the image. I moved the three seats and corrected the position of the glasses for a more rigorous composition. The chosen lens was a 28-mm, and it is the slightly raised angle that causes a distortion in the edges of the bay window. Make the print by holding back the foreground and exposing the sky, so that the clouds appear clearly.

Christmas week, Concorde metro, Paris, 1977
NEGATIVE: 24×36 MM _ P190/4121
___ 309

The Vaucluse period (1972–83) was interspersed with trips to Paris. This photograph was taken on November 20, 1977, on place de la Concorde at the end of the morning, when I had just left the Rapho agency to go to another meeting. I did not ask these Santa Clauses who they were writing to. This little event amused me, and I quietly released the shutter twice: the first time was too fast; for the second, I took a little more time. 35-mm. Full frame.

Self-portrait, L'Isle-sur-la-Sorgue, Vaucluse, 1978

NEGATIVE: 1×2¼ IN. (24×58 MM) ON 24×36-MM FILM _
191/3413
___ 310

Self-portrait in my office in L'Isle-sur-la-Sorgue, April 13, 1978, on a gray day, with additional electric lighting on the back wall. Focal-plane camera (see commentary for photo 306)—a type of camera originally made to be used horizontally. In addition, it has a fixed focus to infinity, which precludes sharpness in the foreground, except with a wide aperture and therefore strong light, which was not the case here. I had foreseen this inconvenience in 1972 when I acquired the camera, and I had an optician friend of mine cut, in dimensions allowing their easy placement, two auxiliary lenses for close distances. Note in passing that the shutter speed cannot be adjusted. The composition of this photograph being based on vertical framing, the usual mess of my desk was slightly adjusted to balance the composition. Quite a contrasted negative, requiring overexposure of the areas with a light background during printing.
Full frame. 1/30 second, f/5.6.

Châtelet–Les Halles RER station, Paris, 1979

NEGATIVE: 24×36 MM _ P195/4908

— 311

During a stay in Paris in February 1979. It was the first time that I took the RER train. At Châtelet–Les Halles station I had picked up on this array of telephones. To take a photograph according to my criteria, two conditions had to be met: I had to be able to position myself so that the composition was balanced; and the figures had to be well spaced out. A fortunate coincidence meant that two of the phones in the foreground were unoccupied, which enhanced the overall look. I would never find such favorable conditions again (and I returned often). 28-mm. Balance the print so that the figure seen from behind, in the background, is quite visible. Framing a little shortened to the right.

Dance rehearsal at the charterhouse of Villeneuve-lès-Avignon, Gard, 1979
NEGATIVE: 24×36 MM _ F197/1200
___ 312

During a visit to the charterhouse of Villeneuve-lès-Avignon in July 1979. I was heading toward the exit when I saw, in line with two open doors, a solitary dancer practicing in the chapel, which was the space devoted to dance performances. The backlight was tempered by a large awning, which softened the harshness of the midday sun.
90-mm. Quite easy to print.
Straighten the framing.

Villevieille area in L'Isle-sur-la-Sorgue, Vaucluse, 1979
NEGATIVE: 24×36 MM _ F197/1237
___ 313

The year 1980 was announced as the French Year of Heritage. The head of the heritage photographic department at the Ministry of Culture commissioned ten photographers to undertake a photo story on a subject of their choice. I chose to represent the many aspects of the small town where I lived back then, L'Isle-sur-la-Sorgue in the Vaucluse, as well as other sites that were typical of the district. This is the Villevieille area in L'Isle-sur-la-Sorgue in July 1979. I had climbed up onto a parapet on the river, inspired by the coexistence in my frame of one of the waterwheels (there used to be over forty) and the pétanque players. 28-mm, late-afternoon backlight speckled through the plane trees. Balance the print between the very sunny areas and the areas in the shade. Full frame.

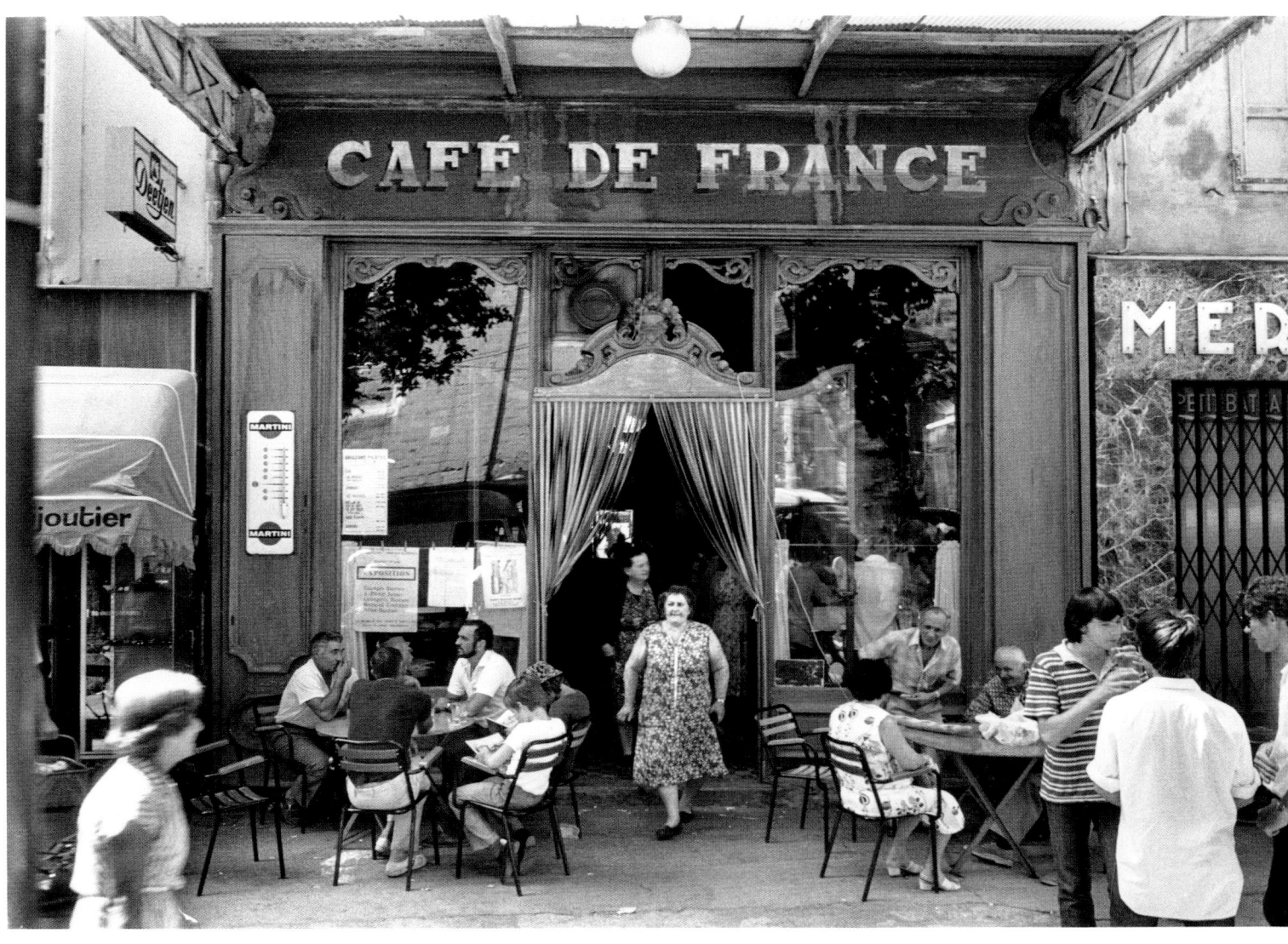

Market day in L'Isle-sur-la-Sorgue, Vaucluse, 1979
NEGATIVE: 24×36 MM _ F197/3035
___ 314

This photograph is also part of my Heritage project. It shows the hustle and bustle of a street of L'Isle-sur-la-Sorgue on a Sunday morning, which is market day. This bakery had caught my attention because it had retained its early twentieth-century style. The rue de la République is very narrow, so I used my wide-angle 28-mm. Full frame.

The Café de France, L'Isle-sur-la-Sorgue, Vaucluse, 1979
NEGATIVE: 24×36 MM _ F197/4406
___ 315

A Sunday in August 1979 in L'Isle-sur-la-Sorgue. Little by little, this small town was losing its old storefronts. I believe this one is protected, and I devoted a number of black-and-white and color photographs to it. That morning, I took advantage of a van parked just in front of the Café de France, on place de la Liberté, in front of the church. Having climbed up on the vehicle's running board, I took this image, waiting for a typical character to exit the café at the same time as a satisfactory composition arranged itself in the foreground on either side. During printing, overexpose the areas that are too bright. Framing slightly cropped to the left.

"Nego-chin" boat, L'Isle-sur-la-Sorgue, Vaucluse, 1979
NEGATIVE: 24×36 MM _ F198/4223
___ 316

In fall, on the Sorgue, upstream of the city center, these children maneuver a traditional flat-bottomed fishermen's boat of L'Isle-sur-la-Sorgue, known in Provençal as "nego-chin" ("drown-dog") because of its characteristic instability. Photograph taken against the light, around 4 p.m., with a 90-mm lens. The print is quite difficult to balance. Full frame.

Town drummer on a market day, L'Isle-sur-la-Sorgue, Vaucluse, 1979
NEGATIVE: 24×36 MM _ F198/4830
___ 317

The town drummer, a popular figure of L'Isle-sur-la-Sorgue, preparing to make an announcement on a Sunday morning in late September. This is not a candid photograph. I chose to position my model for a slightly high-angle shot, from the church steps and against the light. In the background, behind a plane tree, the Café de France pictured in photo 315 can be seen. Why a high angle? Because the character stood out better against the broad surface of the unevenly lit ground. 35-mm. The printing—a little difficult, as is always the case with backlight— must preserve the detail in the face.

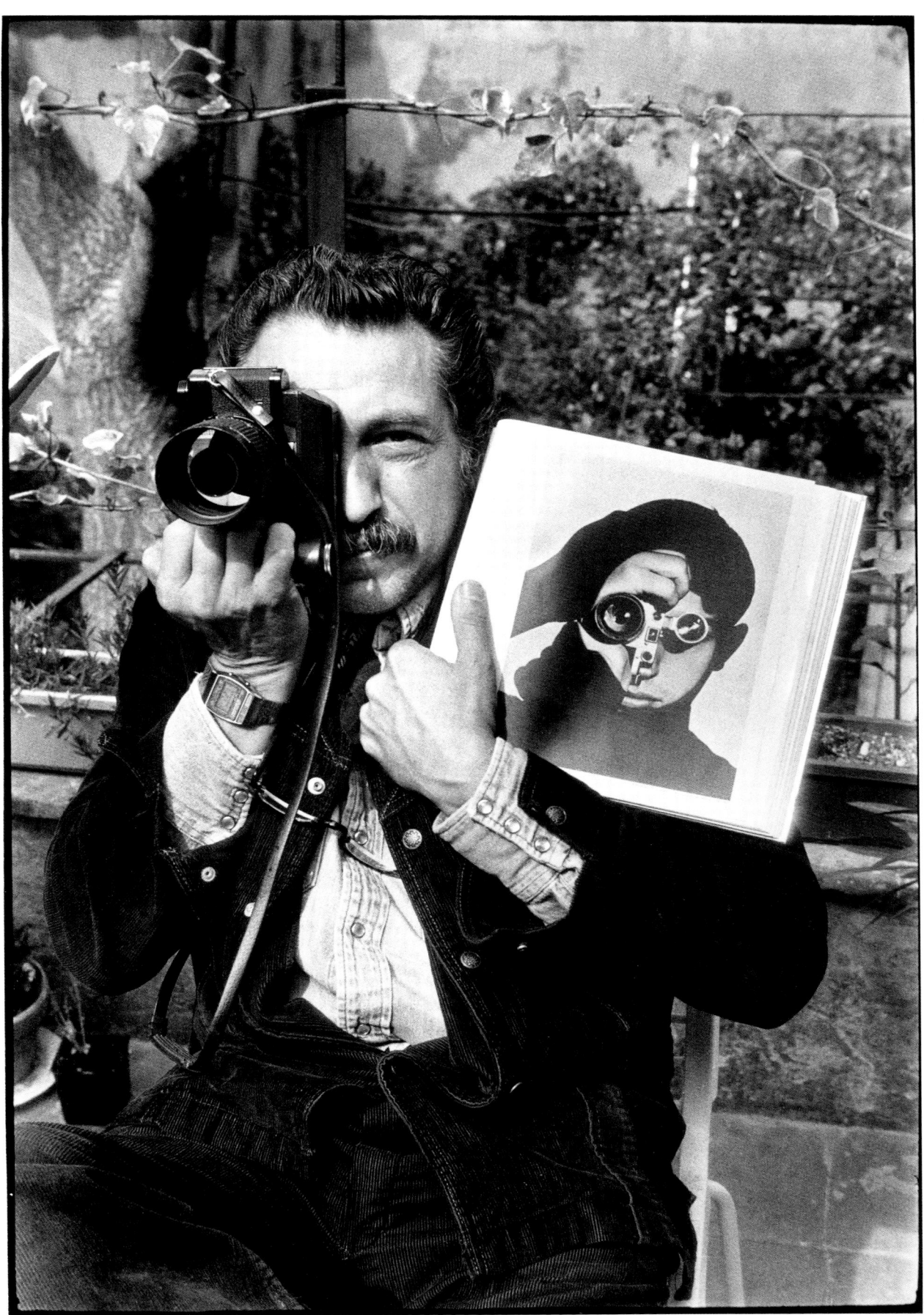

Avenue Simon-Bolivar from the staircase of rue Barrelet-de-Ricou, Paris, 1980
NEGATIVE: 24×36 MM _ P202/2933
___ 320

My trips to Paris had become more frequent, and I made plans with each visit to devote a little more time to hunting for images. I had gone up to the capital during the first week of September 1980 for an interview by Pierre Descargues on France Culture radio, and for a portrait of Danielle Darrieux commissioned by *Paris-Match*. This photograph is a replica of one taken with a Rolleiflex in the late 1940s (see photo 79). It was the first time I had returned to this staircase on avenue Simon-Bolivar. Certainly, I could not hope to find such a successful conjunction of multiple photogenic elements as before, and it should be said that the old image had acquired, with time, the charm of the past. Apart from the new houses in the background, little had changed. It was not taken in the same season or at the same time, but I like this photograph too. 35-mm. No particular printing difficulties. Full frame.

The Orgues de Flandre housing complex from rue de Bellevue, Paris, 1980
NEGATIVE: 24×36 MM _ P202/3836
___ 321

In some of my comments I have mentioned the personal inclinations that made me return so often to the locations where I experienced strong emotional and photographic pull. Belleville and Ménilmontant, along with the quays, were areas I spontaneously went to on my Parisian journeys. Photo 166 took us into Chez Victor, the bistro-*guinguette* at the top of the impasse Compans. Today, there are skyscrapers in its place, although not those shown in this photograph, among which I walked on September 7, 1980, fighting unnecessary nostalgia. The day was beautiful and, glancing around to make sure no suspicious caretaker was in sight, I climbed up onto a terrace overlooking rue de Bellevue and, moving along it to choose my foreground carefully, I took this photograph of the skyscrapers of the Orgues de Flandre housing complex. Borrowed SLR camera, with a 70–150-mm zoom lens. Easy print. Full frame.

Canal Saint-Martin, Paris, 1980
NEGATIVE: 24×36 MM _ P203/0425
—— 322
Canal Saint-Martin on a beautiful fall afternoon. I was on quai de Jemmapes, the half-backlight was good; I waited for someone to climb the bridge. Borrowed SLR camera. 70–150-mm zoom lens. Easy print. Full frame.

Nafplio, Greece, 1980
NEGATIVE: 24×36 MM _ 204/2614
___ 323

My Foca cameras were tired. They had been in use since 1955 and were entitled to a peaceful retirement. I had long wanted to trade in the coupled rangefinder for the SLR system, so I acquired an SLR with a 50-mm zoom, a 28–50-mm zoom, and a 75–150-mm zoom. I now see that 90 percent of the photographs taken since October 1980 (the month of acquisition) were made using the 28–50-mm zoom. My friend the Greek photographer John Demos invited Marie-Anne and me to stay with his family, for an exhibition of about fifty of my photographs that he had planned for October–November 1980 in the gallery he ran with some colleagues in Athens. This photograph was made in the small port of Nafplio, in the Peloponnese, where we had gone to rest for a few days before leaving our friends. 75–150-mm zoom. Easy print. Framing slightly reduced and straightened.

Rue des Amandiers, Paris, 1980
NEGATIVE: 24×36 MM _ P205/0815
___ 324

November 1980, in the renovated portion of rue des Amandiers, twentieth arrondissement, Paris. 75–150-mm zoom.
Full frame.

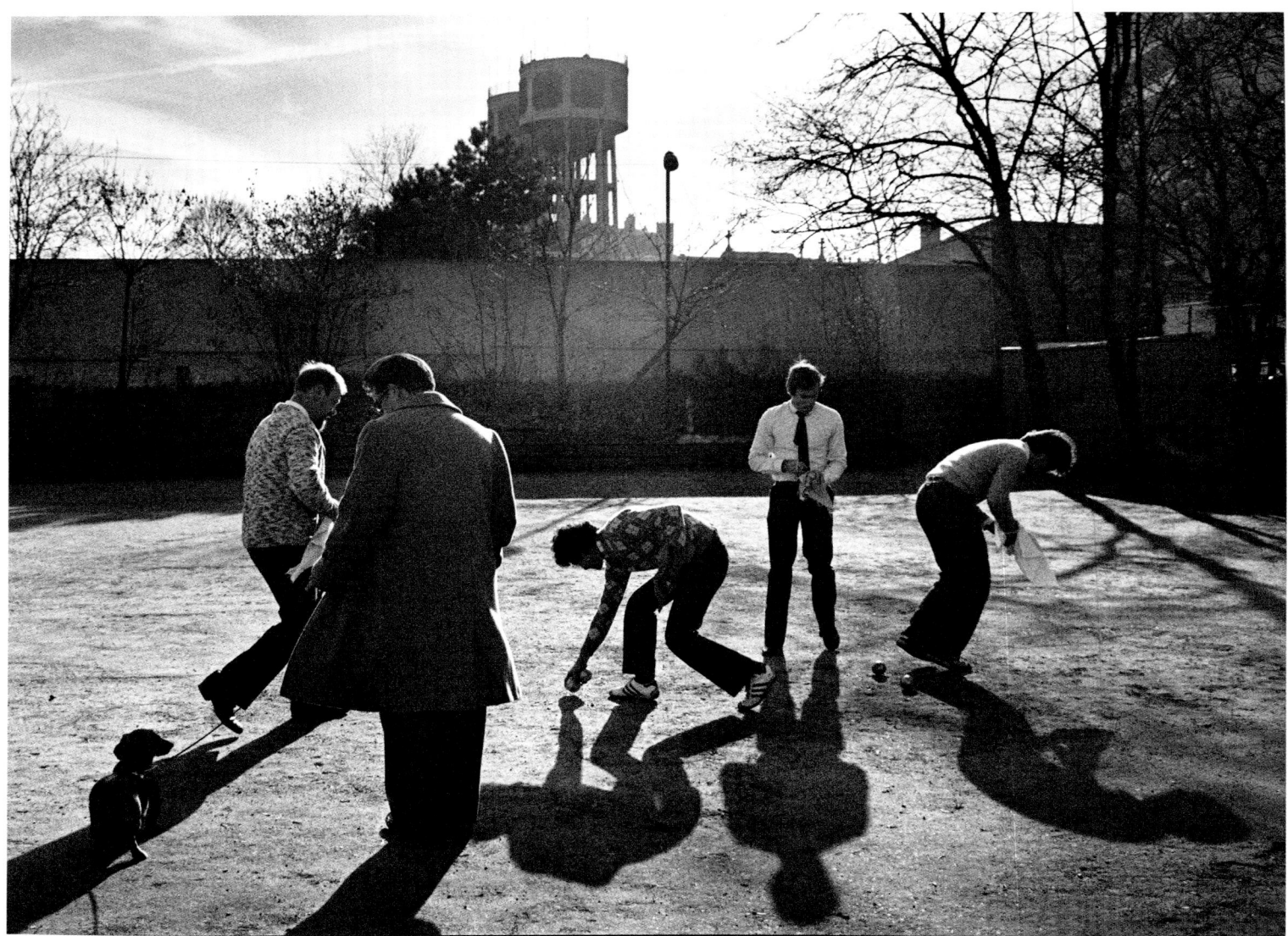

At the corner of rue de Belleville and rue du Télégraphe, Paris, 1980

NEGATIVE: 24×36 MM _ P205/3311

—— 325

November 1980. Another trip to Paris to see friends, visit exhibitions, and attend the talks scheduled for Photography Month. Also I had to attend the opening of my own exhibition at the Fnac Montparnasse: sixty photographs from the 130 in my book *Sur le fil du hasard* (On Chance's Edge), just published by Contrejour. Once again, I went back to Belleville and Ménilmontant for a new series of photographs. This one was made around noon on November 20, at the corner of rue de Belleville and rue du Télégraphe. It was taken straight into the light. An image of this type is hard for its author to comment on. It belongs to the family of unpredictable and fleeting situations: here, the perfect symmetry of the two stooping men frames the standing player. I have often noted in similar situations that, immediately after the click, it is as if there's a gap in the memory—at least in mine—and I feel that I may have captured something important, but without being able to remember the details. Scrutinizing the negative in front of the ground glass of the inspection lamp, just after the fixing process, everything comes flooding back, either to fill you with joy or to crush you. 28–50-mm zoom, probably set to 28 mm. Very delicate print if you want detail everywhere and to bring out the clouds. Framing cropped a little to the left.

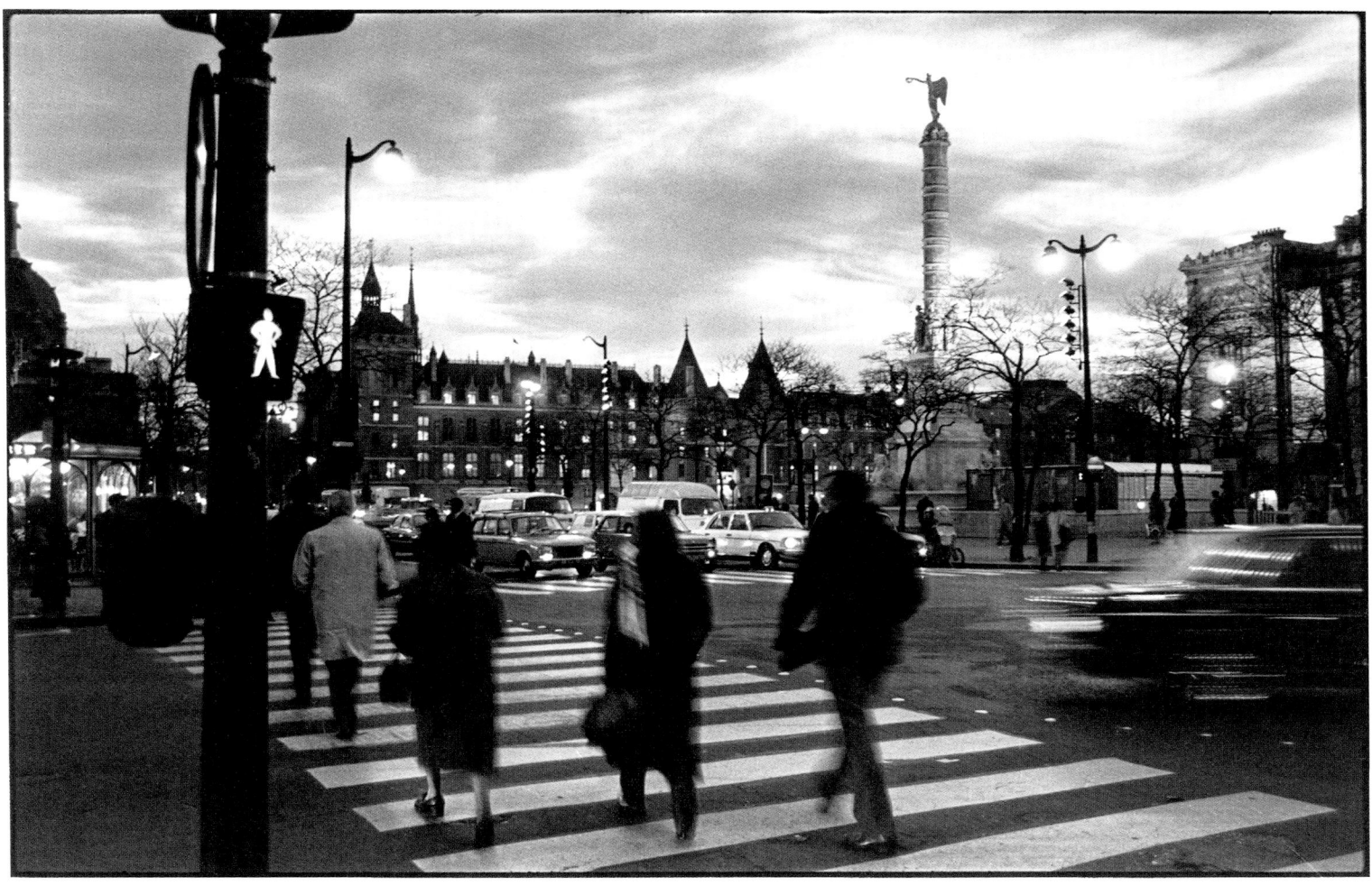

Place du Châtelet, Paris, 1980

NEGATIVE: 24×36 MM _ P206/0101

— 326

Late afternoon, November 20, 1980. I had returned from a session in the old districts to join Marie-Anne at our hotel, near the Forum des Halles. I came out of Châtelet metro station and felt something like a shock: the spectacle of a sumptuous twilight sky. Very quickly, I looked for an angle that would situate the location unequivocally, with the Conciergerie on the other side of the Pont au Change. I waited for the little green man to light up, inviting the pedestrians to cross, and captured a passing taxi with motion blur. In truth, I released the shutter four times and hoped, as I left, that the third would be the one (I was not mistaken). 28–50-mm zoom. Normal print; prioritize the sky. Full frame.

Rue de la Monnaie, Paris, 1981
NEGATIVE: 24×36 MM _ P206/3527
___ 327

March 3, 1981, in Paris. On the afternoon of our arrival, leaving the hotel on foot to cross to the Left Bank over the Pont-Neuf, we passed by excavation works (the future road tunnels between the Forum des Halles and the Bourse du Commerce). A machine operator was standing on the backhoe. I changed positions to improve my point of view, framing him between two windows of the Samaritaine department store. My distance required me to use the 75–150-mm zoom, and I took some shots of this unusual sight. My position was uncomfortable: the narrowness of the pedestrian crossing meant that we were jostled. Marie-Anne was with me, and my photographic vigilance was affected by my concern for her. After development, I noticed that the six negatives I had gotten were all tilted to the right! The print must therefore be straightened, and the triangle on the lower right under the tire be hidden by a second exposure in which part of the main image is masked. The whole lower part of the negative also needs to be strongly overexposed beforehand, which is much more illuminated than the area of the windows. What a lot of work!

Front de Seine district, Paris, 1981
NEGATIVE: 24×36 MM _ P207/1406
___ 328

Same stay, four days later. A curious coincidence: on my way to Brassaï's, I was flagged down by Doisneau who was passing in his car. My afternoon program was to photograph the Front de Seine district. I met Marie-Anne in the late afternoon and invited her to visit this neighborhood, which I had come to know quite well, with me the next morning, on Sunday. It was during this second session that I took this photograph. I had spotted the vantage point: the Eiffel Tower reveals that this is Paris in the Front de Seine district and not La Défense. I needed people, since I do not understand city photography without figures. A few minutes of waiting and I had what I wanted. 75–150-mm zoom. Normal print. Full frame.

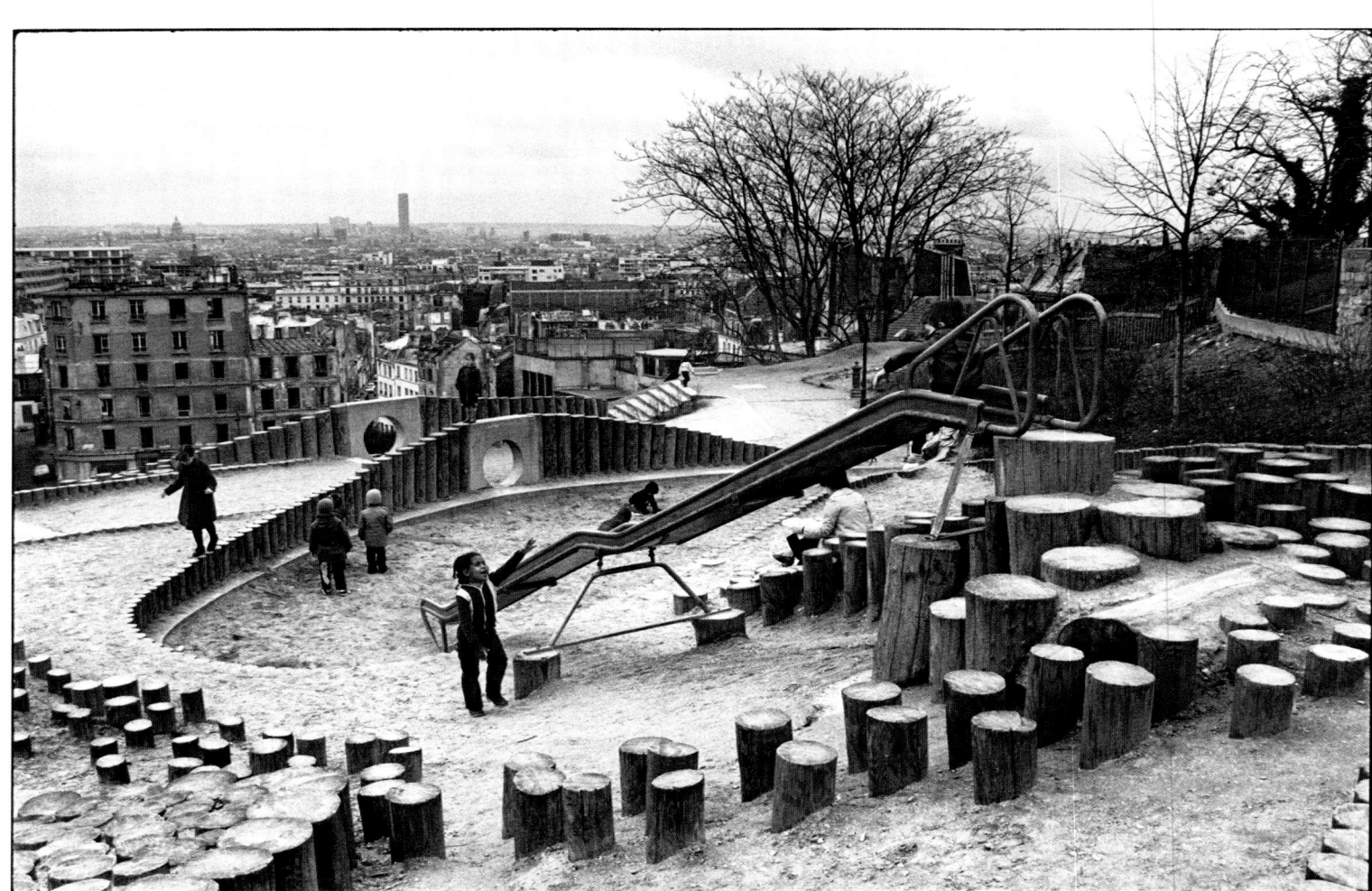

Playground, rue Piat, Paris, 1981
NEGATIVE: 24×36 MM _ P207/3103
___ 329
March 11, 1981. Our stay in Paris continued, as I needed to work out the details of my trip to New York for my exhibition at the French Cultural Center, organized by the Ministry of Foreign Affairs for the following spring. I went back to Belleville where, instead of the dilapidated houses at the top of rue Vilin, I discovered this playground where some children were playing. 28–50-mm zoom, set to 28 mm. Difficult enough print to balance if you want all the planes to be legible, sky included. Full frame.

The Orgues de Flandre housing complex, from rue de Flandre and rue de l'Ourcq, Paris, 1981
NEGATIVE: 24×36 MM _ P207/4232
___ 330
In September 1980, I had photographed the skyscrapers of rue de Flandre from afar, from the heights of Belleville (see photo 321). On this morning of March 13, 1981, I decided to go and see them up close. At the crossroads of rue de Flandre and rue de l'Ourcq, I stopped in my tracks in front of this mix of old buildings and modernism. I adjusted my 75–150-mm zoom lens to the focal length that gave the best framing from the vantage point I had chosen and waited for some pedestrians to step into the frame. Not just any old ones: human types in harmony with my impression of this neighborhood. Normal print. Full frame.

Rue Pierre-Lescot, Forum des Halles, Paris, 1981
NEGATIVE: 24×36 MM _ P207/4832
__ 331

Rue Pierre-Lescot, on the edge of the Forum des Halles, on a rainy day. I was waiting, sheltering under a café awning, for characters with umbrellas judiciously arranged in the frame. Important to capture them in the most characteristic phase of walking, that is to say when the heel of the front foot has hit the ground and the back foot has not yet left it. It is interesting to note that this is the case of all three central characters. A lucky coincidence? Perhaps there is also, without them realizing it, a sort of unconscious synchronization of pedestrians moving together, at the same speed, in the same direction. At least, this is a phenomenon that I have observed several times, in my search for the best walking shots. 28–50-mm zoom. Framing cropped on the right and on top. No printing difficulties.

Rainy day at the Centre Georges Pompidou, Paris, 1981
NEGATIVE: 24×36 MM _ P207/5008
__ 332

That same evening, while leaving the Centre Pompidou, I became fascinated by the sun highlighting the runoff of a recent shower on the plastic cylinder of an exterior walkway. Two photographs without people, as if to warm up; a third with a couple I was not sure of; a fourth, this one, that I felt could be the one. 28–50-mm zoom. Difficult to print, because detail is needed in the sunny parts, while still allowing the pedestrians to be seen on the Beaubourg forecourt. Full frame.

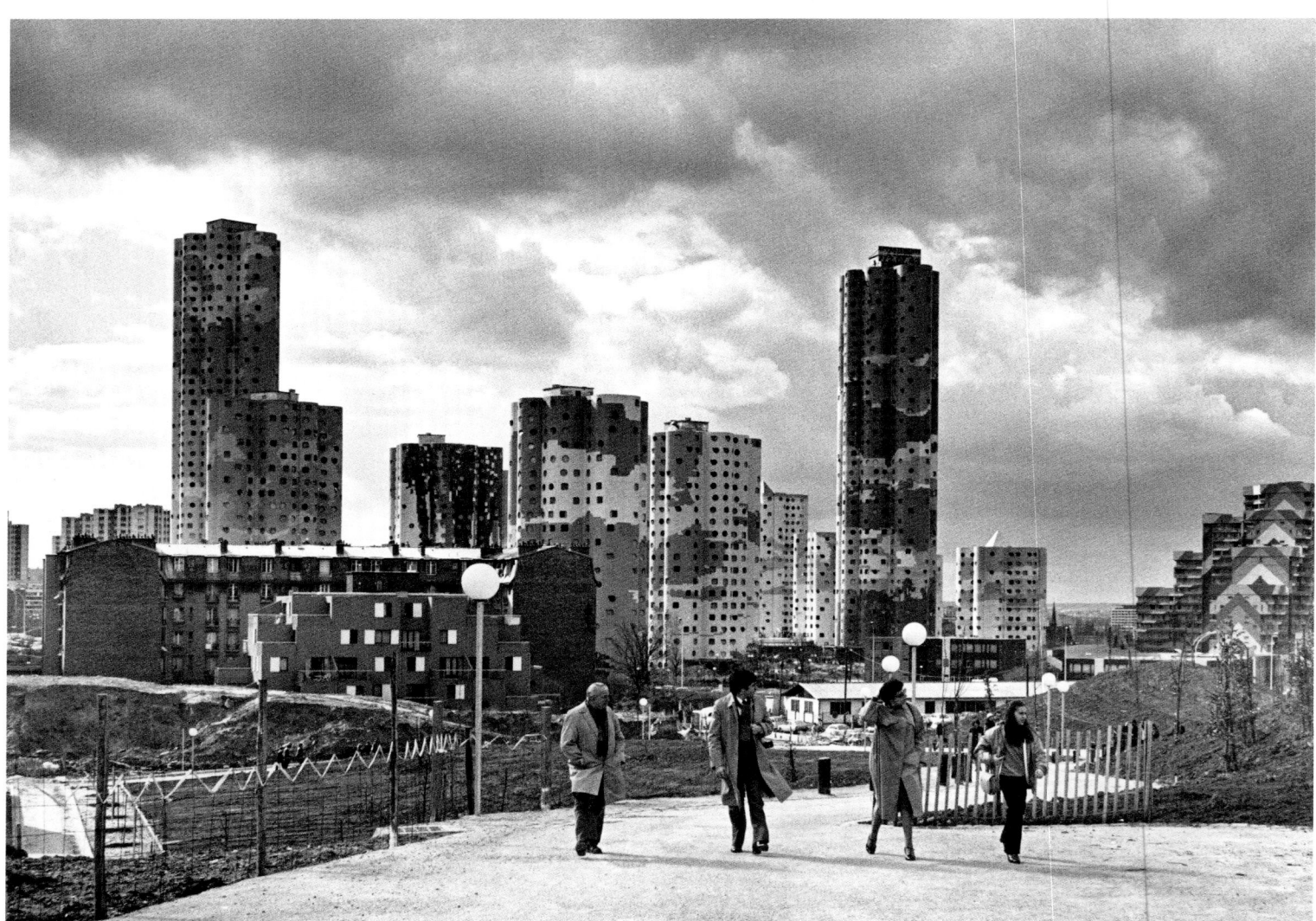

The Aillaud towers of Nanterre seen from La Défense, Hauts-de-Seine, 1981

NEGATIVE: 24×36 MM _ P208/1141

—— 333

I had explored the Front de Seine, so it was no surprise that I went to the district of La Défense. I spent part of the afternoon of March 14, 1981, there. I naturally chose a Saturday, the day when the area was the most lively. After leaving La Défense, pushing further west, I was struck by the unusual appearance of the towers in Nanterre designed by the architect Aillaud. The sight was all the more arresting because their two-tone decoration was like a replica of the dramatic sky that hung over the landscape. I waited for a few pedestrians to pass by, but I was concerned because the sun was playing hide-and-seek with the clouds, and I needed light, both on the towers and on the pedestrians, otherwise everything in my frame would be nothing more than a gray and confused mass. Of all the frames I took, this one met those conditions. 75–150-mm zoom. Full frame.

Futuristic landscape, La Défense, Hauts-de-Seine, 1981
NEGATIVE: 24×36 MM _ P208/1213
___ 334

A few minutes later, on the way back to the center of La Défense, a futuristic landscape appeared. A lone teenager was practicing on the empty esplanade. I chose to press the shutter when his silhouette balanced out the vertical mass of the tower emerging behind the glass pyramids. 28–50-mm zoom. Difficult print, as is always the case with backlight. Make sure to hold back the face (not excessively) so that the features are a little visible. Full frame.

Pedestrians in the Forum des Halles, Paris, 1981
NEGATIVE: 24×36 MM _ P208/2133
___ 335

During our increasingly frequent stays in Paris, we stayed in the Châtelet district, the most practical for my various appointments. The Forum des Halles was around three hundred feet (one hundred meters) from the hotel, and I followed the site's evolution closely. The great wall of the boiler plant would soon be hidden by a large building that had begun to emerge from the ground. It was high time that I preserved a souvenir of the three pedestrians painted on the wall in a fun trompe-l'oeil (by Fabio Rieti). I had long been waiting for an opportunity to make use of them. It came on the evening of March 14, 1981, with the late-afternoon march of Parisians, fences marking out their compulsory route. The conflation of perspectives could be achieved only by reducing the size of the live figures, to bring them closer to that of the painted characters. I achieved that by moving away, so that I could take my shot using the longest focal length (150 mm) of my 75–150-mm zoom. Full frame.

Fire truck passing on Madison Avenue, New York, NY, 1981

NEGATIVE: 24×36 MM _ 208/4302

—— 336

The exhibition held at the Fnac the previous year, for the publication of my book *Sur le fil du hasard* (On Chance's Edge)–and during Photography Month in 1980–was repeated in April 1981 at the request of the cultural department of the Ministry of Foreign Affairs, at the French Cultural Center in New York. I had been invited for the hanging and the opening, plus a few more days for the inevitable and interesting meetings that would follow. Returning at twilight from a tour downtown with the cultural attaché of the embassy, I suddenly heard the characteristic siren of a fire truck demanding right of way. I aimed, as if obeying orders, through the windshield of our car, just as the firefighters passed us. 28–50-mm zoom. During printing, darken the sky (in photographs taken at dawn or dusk, the skies are always overexposed) and bring out the details in the back of the taxi in front of us. Full frame.

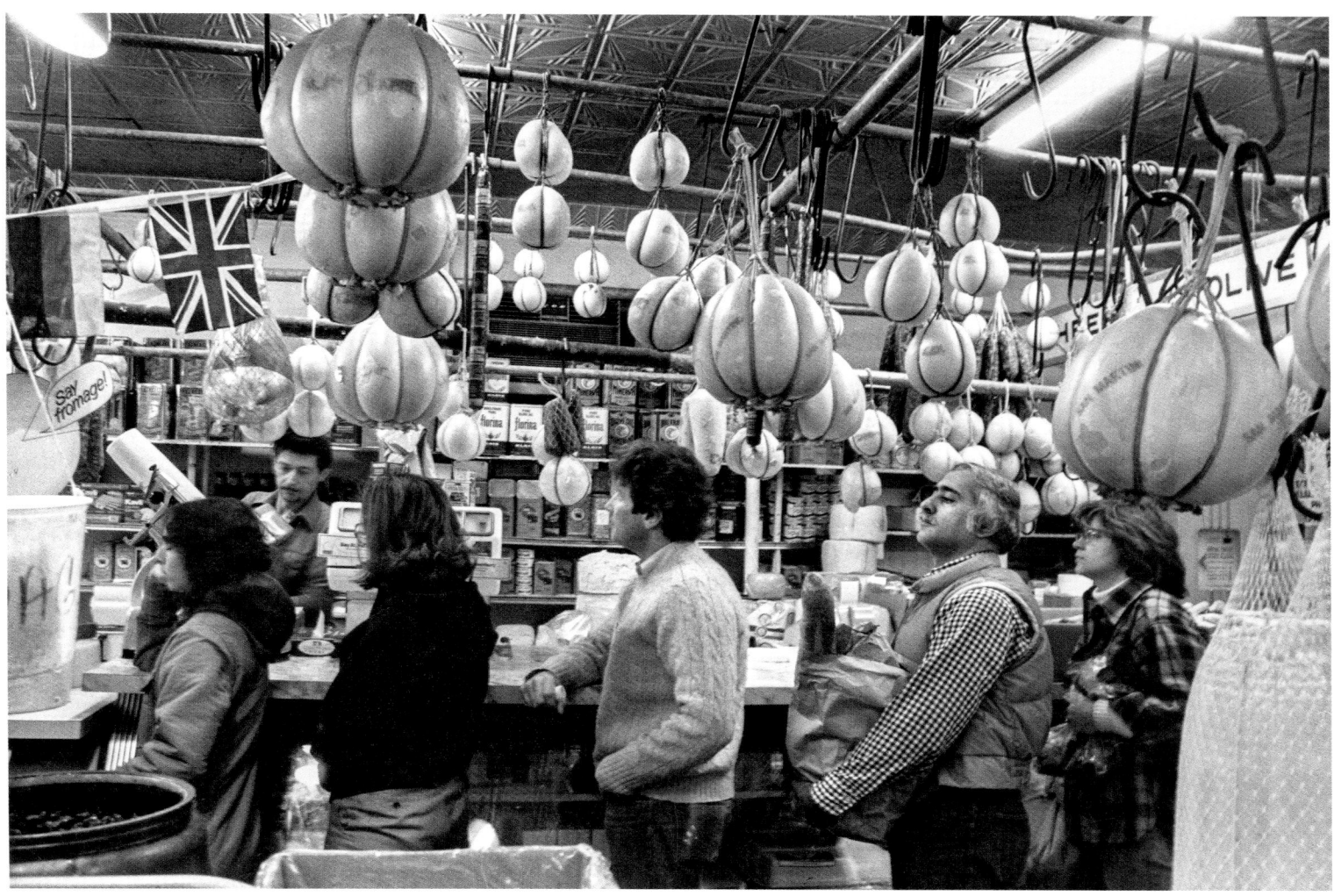

**Italian market,
Philadelphia, PA, 1981**
NEGATIVE: 24×36 MM _ 209/1535
___ 337

For the opening of my exhibition in New York, my cousin Bernard J. Ronis and his family came from Philadelphia. We set a date to meet the following weekend in that city. On this Saturday, April 25, I had only just arrived when Bernard took me to the Italian market to go shopping. I brought back, among other things, this image of a grocery store. Those are cheeses hanging from the ceiling.
28–50-mm zoom. Light cropping on the left.

**Young woman hailing a taxi,
New York, NY, 1981**
NEGATIVE: 24×36 MM _ 209/4133
___ 338

April 27, 1981. I enjoyed a few hours of freedom by walking around Greenwich Village, in Lower Manhattan. This young woman had signaled to a taxi and was waiting for it. She stood out well on the road and, as the vehicles stopped at the red light, I added her to my collection. She was very laid back. I made several shots; she thanked me with a smile. 28–50-mm zoom. Full frame.

**Bruce Davidson,
New York, NY, 1981**
NEGATIVE: 24×36 MM _ 210/0436
___ 339

I only took the subway once in New York. I sat on a jump seat. Three stops later, the door opened and in came the photographer Bruce Davidson, covered in cameras. I took the initiative of photographing him: he responded in my direction. Chance was truly on my side. 28–50-mm. Full frame.

**Bella, twenty-six years later,
New York, NY, 1981**
NEGATIVE: 24×36 MM _ 210/2105
___ 340

Two days later, at the French Cultural Center on Fifth Avenue, one of the employees turned out to be Bella, one of the little twins that I had photographed in a Moses basket in Gordes, in September 1955 (photo 181)! To celebrate this reunion, I took her portrait on a balcony, with Central Park and the skyscrapers of the Upper West Side in the background. I waited for the light wind that was blowing to lift a few strands of her hair. 28–50-mm zoom. Framing slightly cropped to the left.

Nude, New York, NY, 1981
NEGATIVE: 24×36 MM _ 210/2329
___ 341

During the opening of my exhibition in New York, three young women, having seen *The Provençal nude* (photo 94), asked to pose for me. Here is one of these nudes, taken under an abstract Paul Jenkins canvas. Quite apart from the fact that this type of proposal is hard to imagine in France, I note that I structured this photograph according to a vertical composition I know well: a frontal view with superimposed parallel elements. 28–50-mm zoom. Daylight. Full frame.

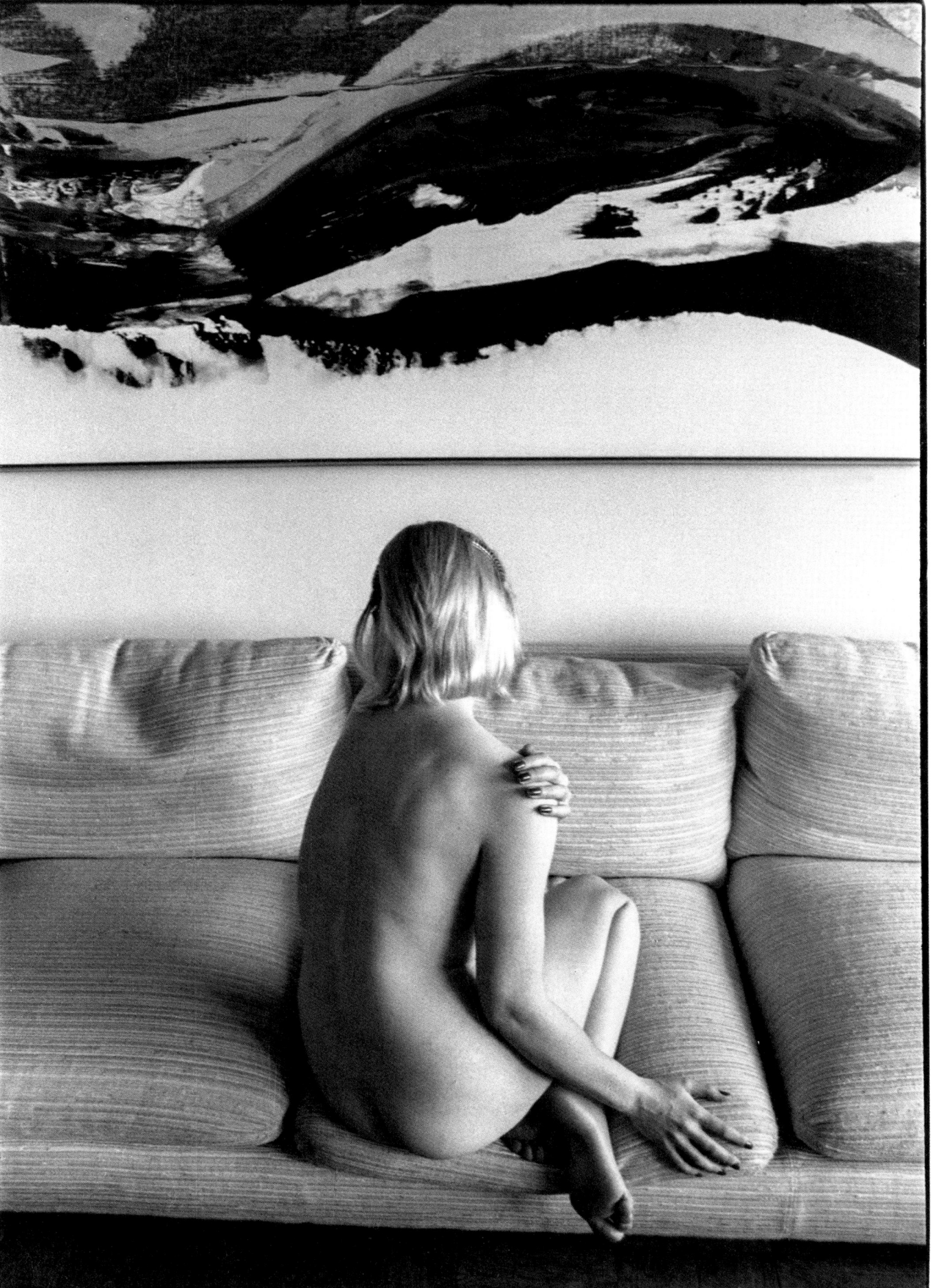

Picnic at the Villa Medici, Rome, Italy, 1981
NEGATIVE: 24×36 MM _ 211/4609
___ 342

During the Rencontres d'Arles photography festival in July 1980, my colleague Jean-Claude Dewolf introduced me to Bernard Richebé, his former assistant and the first photographer to win the Prix de Rome scholarship. Bernard invited Marie-Anne and me to spend a week at the Villa Medici in June 1981. This photograph was taken in the gardens of the villa, completely improvised, after a large picnic. I was attracted by the child's shrieks of delight and had the time to press the shutter twice. This is the second shot. 28–50-mm zoom. The exposure time must be adjusted during printing to get detail in the sun-splashed lawn areas. Full frame.

Nude, Villa Medici, Rome, Italy, 1981
NEGATIVE: 24×36 MM _ 212/3713
___ 343

This nude was taken at the Villa Medici, during the same stay in June 1981. The light came from a small square window, quite far from the model, hence the harshness of this lighting. The foot in the lower left corner is my left foot. Given the high angle I had chosen, I could hardly avoid it. In any case, it was occupying an empty corner, so I accepted it. 28–50-mm zoom, around 28 mm. Full frame.

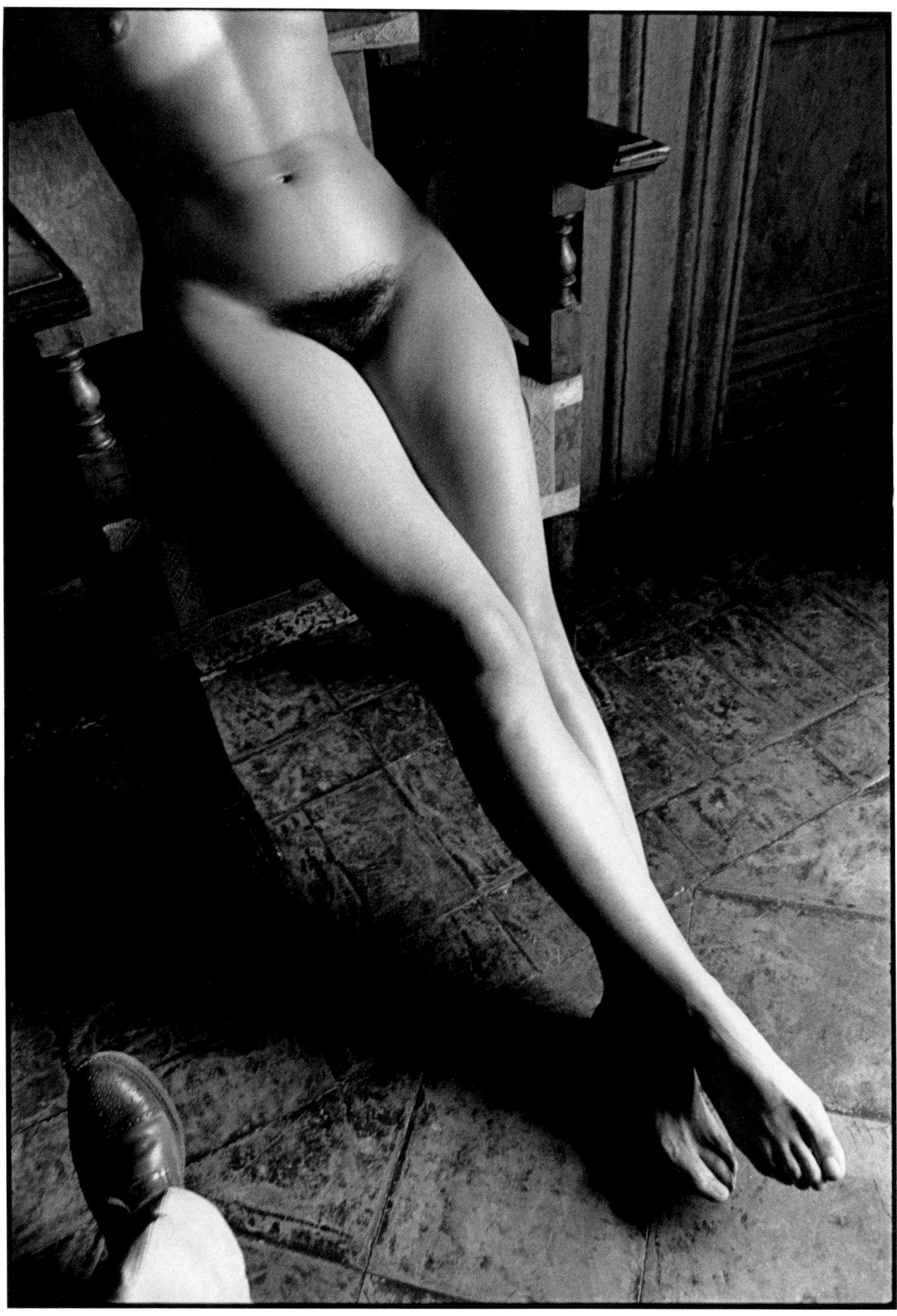

Paris seen from above, Centre Georges Pompidou, Paris, 1981
NEGATIVE: 24×36 MM _ P216/1924
__ 344

September 1981, a new trip to Paris. Coming out of a long visit to the *Paris-Paris* exhibition, in which I had taken part by sending many photographs dating from 1938 to 1957, I saw this couple contemplating the panorama of Paris in the beautiful afternoon light. I was struck by the opposing arches made up by, on the one hand, the silhouettes prolonged by their projected shadows and, on the other, the two arcades of the walkway. I also realized that I could include the Eiffel Tower and the Invalides in my image. This apparently very simple subject caused me a lot of trouble: the pose of one of the youngsters was always out of tune with the other. I took seven frames; this is the fifth. I had almost given up. I will never accept that in candid photography you just need to seize the right moment.
28–50-mm zoom. Framing slightly straightened.

Panorama toward the south, from the top of Montmartre, Paris, 1981
NEGATIVE: 24×36 MM _ P216/3401
__ 345

A few days later, I decided, after a fruitless walk along the Canal Saint-Martin (nothing of interest: things do not always work out as one wishes), to try my luck in Montmartre. The landscape stood out with a rare sharpness. A pigeon passed that I captured at the very last moment, and from this imbalance a kind of strange charm emerged, as if to suggest a goodbye. At least that is my feeling, and I decided to claim this image that was imposed on me rather than planned as my own.
28–50-mm zoom. Orange filter. Full frame.

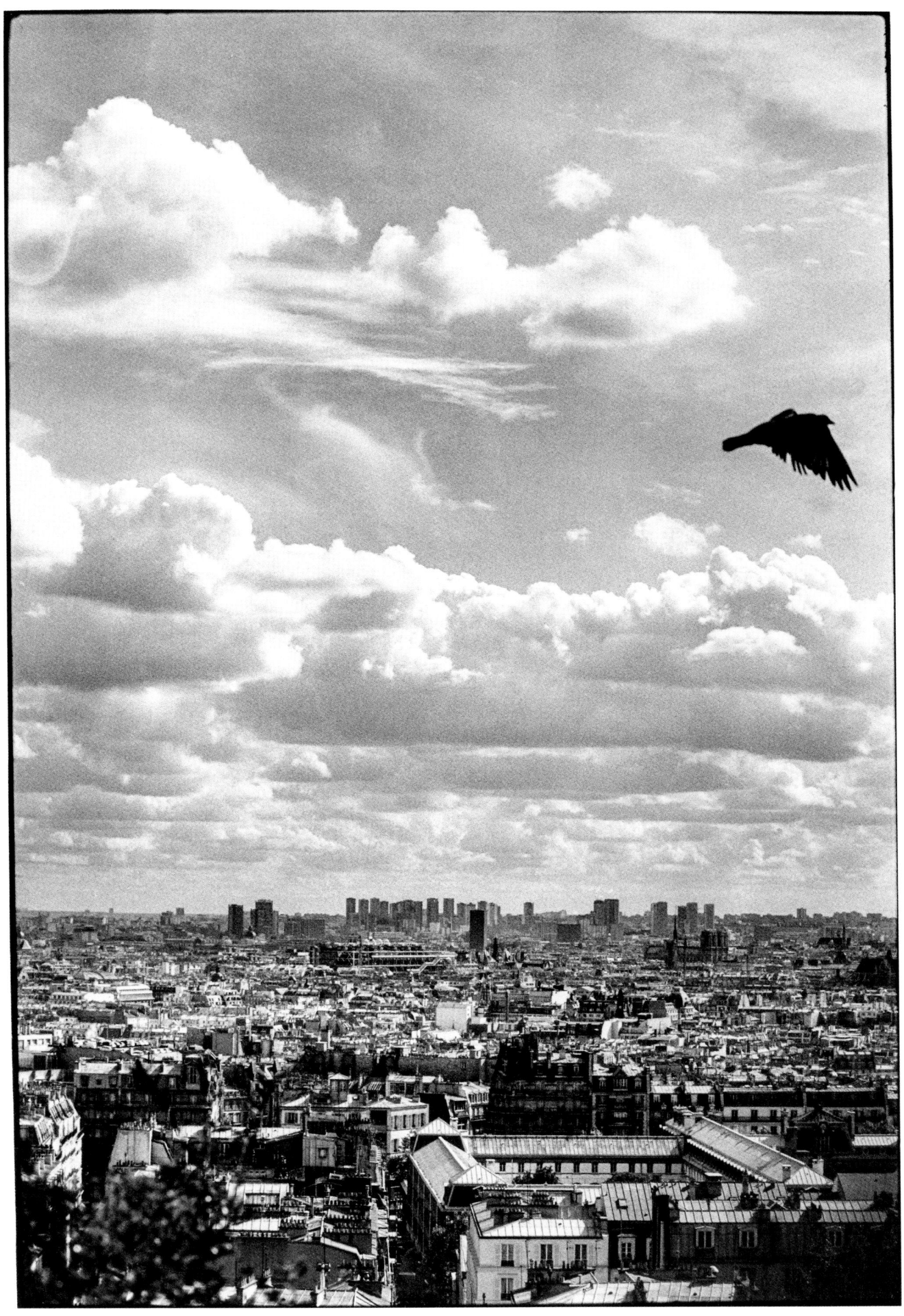

Near the Forum des Halles, Paris, 1981

NEGATIVE: 24×36 MM _ P216/4321

___ 346

The following day, on the last day of this September Parisian trip. I was returning from a meeting with the filmmaker Patrick Barbéris, who wanted to shoot a real-time film about my reunion with Rose Zehner, the militant union delegate whom I photographed in March 1938 during the Citroën strike (see photo 17). The weather was gray and, alone near the Forum des Halles, this musician was practicing his drumming.
28–50-mm zoom. Straightened framing.

Daphne, Greece, 1982

NEGATIVE: 24×36 MM _ 219/0831

___ 347

At the end of July 1982, we were in a Greek village in the mountains, near the Albanian border, at the home of our friends the Demos. We had had a picnic in a small wood; it was late afternoon and the littlest of my friend's daughters was getting bored and went to sulk against her father's car. I watched this little game when, all of a sudden, something encouraged me to fix this moment on film. I headed slowly toward the child, whom I did not want to frighten and, just as I released the shutter, in my head a photograph appeared that I had taken twenty-eight years earlier, in southern Alsace: a child of the same age near the wheel of a cart (see photo 145).
28–50-mm zoom. Full frame.

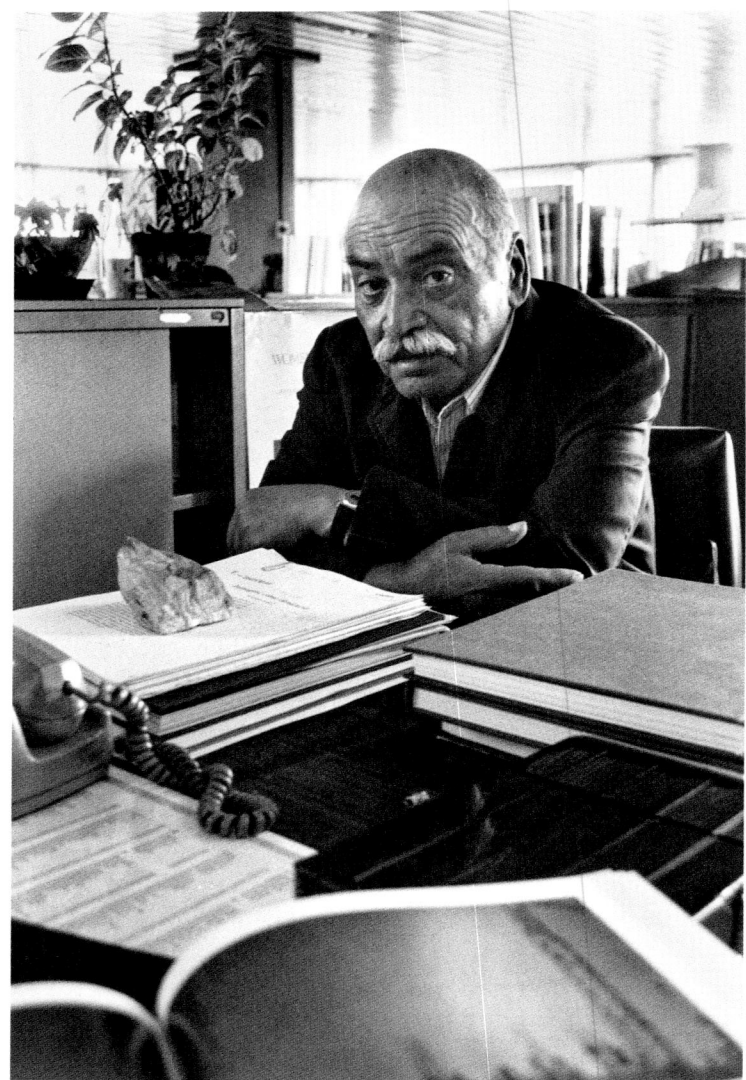

**Christmas week,
Charleroi, Belgium, 1982**
NEGATIVE: 24×36 MM _ 219/4616
___ 348

Christmas week in Charleroi, Belgium, where I was invited for the opening of my exhibition at the Photographie Ouverte gallery. The following afternoon, I had two hours of free time that I decided to devote to visiting the city. It was a Saturday, and people were shopping for the holidays. I slowly went up rue de la Montagne and found a square where I felt that there was a photograph to be taken. It was raining a little, but that was so common that umbrellas were slow to open. I took seven photographs: the fifth was the one. I mean to say that I got what I was hoping for: an umbrella on either side of the staircase, and the characters distributed throughout the composition with no gaps. 28–50-mm zoom. Very difficult print: the foreground is underexposed, and the sky is overexposed, as is always the case when there is little light on the ground. Nevertheless, the print requires masking to allow the fairy lights to appear. However, it is necessary to hold back the woman with the umbrella, just enough that her features are recognizable without tipping into gray! Full frame.

**Romeo Martinez,
Milan, Italy, 1983**
NEGATIVE: 24×36 MM _ 220/3008
___ 349

The publisher Fabbri in Milan was preparing the printing of my monograph, and I went there, on June 7, 1983, to supervise the color separation of the sixty photographs that appeared in the book. I was told that Romeo Martinez, the artistic director of the collection, was in house and, shortly after, I joined him in an editorial office. We spoke for a while, and I decided to preserve a memory of this meeting, because the complex lighting brought out remarkably the features of this man who, for the last thirty years, has honored me with his friendship. 28–50-mm zoom. During printing a few details need to be brought out from the harshly lit areas in the background. Full frame.

At the upstream tip of the Île Saint-Louis, Paris, 1983
NEGATIVE: 24×36 MM _ P222/1416
—— 350

November 19, 1983. For the last three months we had become Parisians again. Toward the end of a walk along the Seine, we found ourselves at the edge of the small square overlooking the upstream tip of the Île Saint-Louis, in a place where I have, in the past, often tried my luck (see photo 237). But here was something new: before my eyes, resting against the quay and rummaging their beaks through their feathers, were three swans. Alas, they were badly positioned and, while adjusting my zoom to 50 mm, I wondered aloud: "What could I possibly do?" "Shout, clap your hands," whispered Marie-Anne. I followed her advice, and the birds, disturbed, swam majestically upstream while three teenagers, who had since appeared, shared their thoughts. I have said many times that I do not like to take photographs when I'm not alone. What ingratitude! There are some interesting exceptions.

In no way do I believe that I have my own fairy godmother who has sown little miracles in my path throughout my life. Rather, I believe miracles pop up all the time and everywhere, but we forget to look for them. What a joy to have been looking in the right direction so often!

DONATION 2
1991

ALBUM_05 : PHOTOGRAPHS 351 > 470

This album completes the first four, which comprise photographs chosen between 1926 and 1983, the year of my first donation to the State. It must be said that having to select 350 pictures from an output spanning over sixty years left me with a feeling of no little regret. This is therefore not a collection of second choices, but rather, if I may say so, a surfeit that has been rescued. It runs in parallel with and covers the same period as the previous group, and goes beyond it time-wise by including some twenty-five photographs taken between 1983 and 1989, the year of my second donation. The commentary alongside each photograph provides information on the circumstances of the shot and some technical details, where necessary, but does not always explain the result. We each possess an inner vision. A successful photo is, in part, a portrait of its author, who often remains silent about what is most important, either because they are not capable, or because they are too modest. We would struggle to examine ourselves successfully or reveal the inner workings of our behavior. A Hebrew proverb provides a good answer to the problem: "We don't see things as they are: we see them as we are."

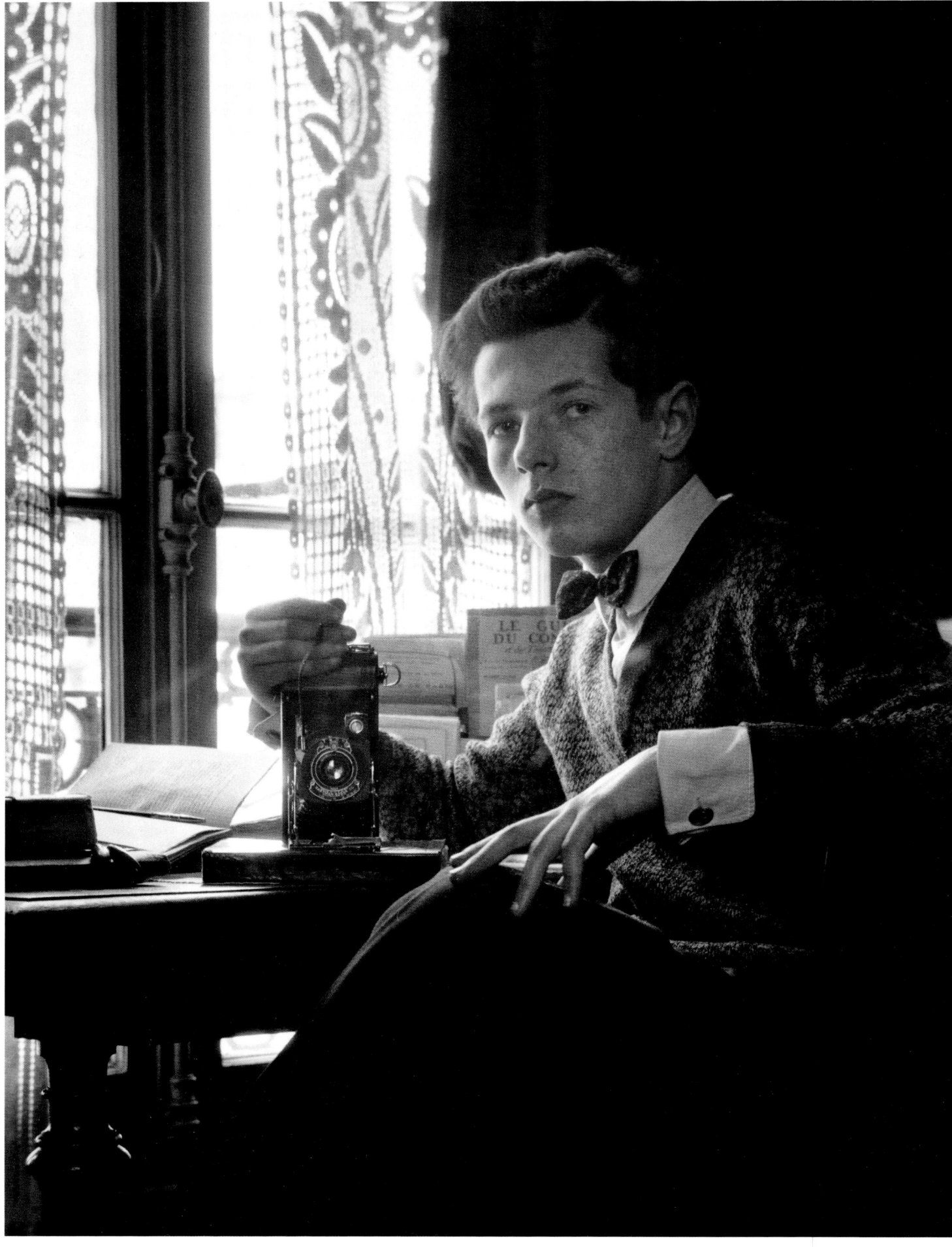

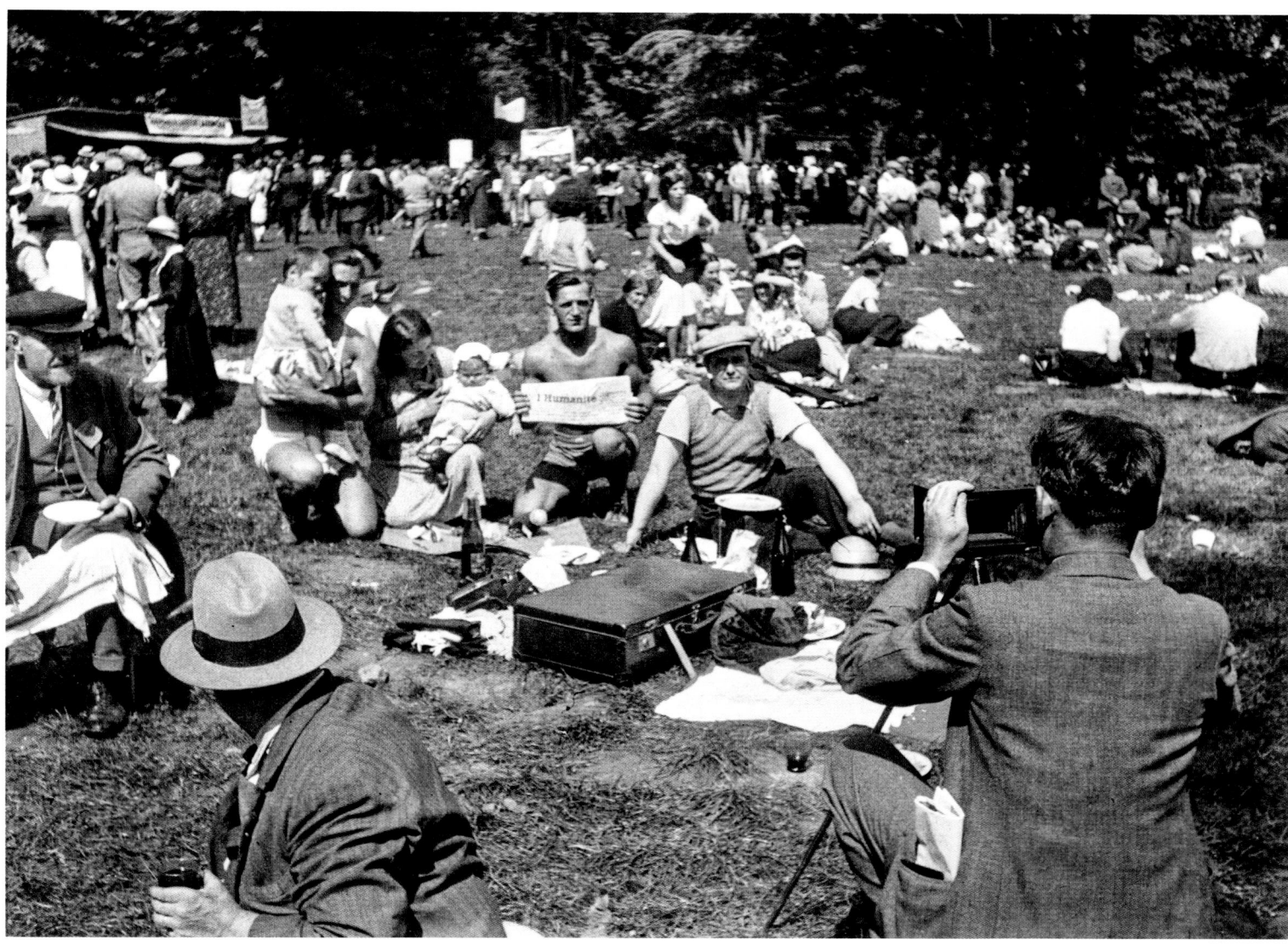

Self-portrait in the family apartment, Paris, 1929
NEGATIVE: 2½ × 4¼ IN. (6.5 × 11 CM) _ D09/2
___ 351

This photo was taken in the mirror of my wardrobe, in the same month of June as the self-portrait with a violin (photo 4). It shows my first camera, a 2½ × 4¼-in. (6.5 × 11-cm) folding Kodak. In the background, half hidden by my shoulder, is an issue of *Guide du concert,* a weekly to which I subscribed. The cable release is in my hand, placed on the device, whereas for my picture with the violin it was probably my brother who had pressed the shutter. The aperture was closed to f/11 (that can be read with a linen tester on the picture). Unknown shutter speed. The negative was flipped during printing, since it was not a direct shot but a reflection in a mirror.

L'Humanité festival in Garches, Seine-et-Oise, 1934
NEGATIVE: 1⅛ × 1⅝ IN. (3 × 4 CM) _ R4/5/1
___ 352

The Quatre-Cèdres park in Garches where, in early September, the annual *L'Humanité* festival then took place. It was picnic time. A group was being photographed as a record of this memorable day. The operator was probably using a 3½ × 4¾-in. (9 × 12-cm) format camera. He had just removed the ground-glass focusing screen, through which he framed and focused the shot. He would then introduce his plate-holder. One very popular camera in the past (it was a favorite with French soldiers during World War I) was the Vest Pocket Kodak, which gave eight 1⅝ × 2½-in. (4 × 6.5-cm) format photos. A smaller camera appeared around the 1930s, using the same film but yielding sixteen 1⅛ × 1⅝-in. (3 × 4-cm) frames. This picture was taken with that camera.

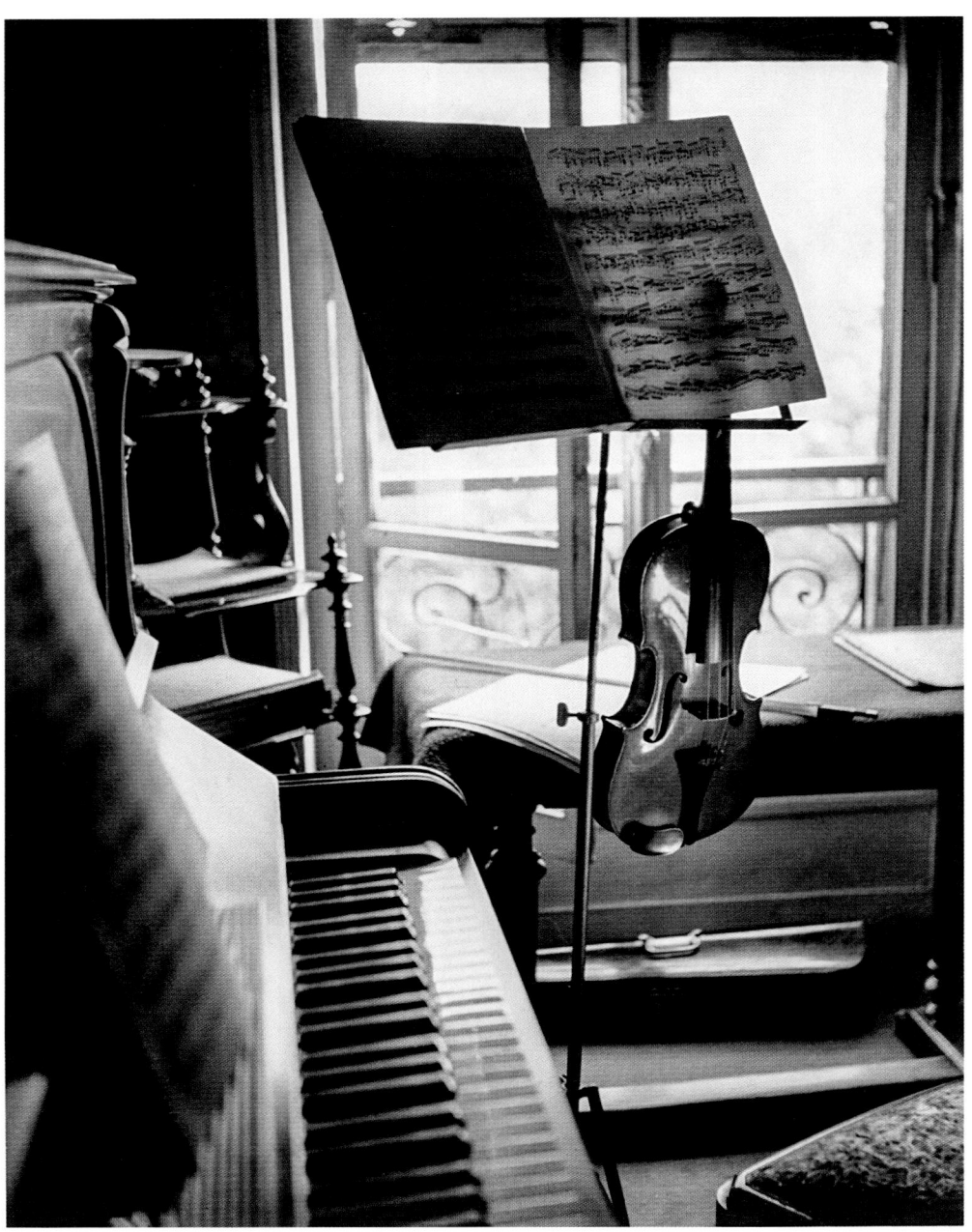

My violin, Paris, 1936
NEGATIVE: 2¼×2¼ IN. (6×6 CM) _ D6/21
___ 353

In my apartment at 117 boulevard Richard-Lenoir, where my parents and I had just moved in. It was through the wrought-iron detailing of the balcony handrail that, ten years later, I took the picture of the busker (photo 42). Relatively open aperture so as to favor the violin, which I focused on, hence the slight blur on the piano and background. Meticulously framed composition—the camera was surely screwed onto the tripod—cropped during printing into a vertical rectangle from the square 2¼ × 2¼-in. (6 × 6-cm) negative. The score of Johann Sebastian Bach's Chaconne was on the music stand. I never dissociated those two activities: on the one hand, the highly structured photograph, to which I devoted the necessary time; on the other, the candid photograph, which benefited—like the first type, but without my always being aware of it—from a graphic rigor acquired through the practice of drawing and attending museums, particularly the rooms devoted to seventeenth-century Flemish painting.

Bicycle tour around Paris, 1937
NEGATIVE: 2¼×2¼ IN. (6×6 CM) _ Z7/40
___ 354

I had acquired my first Rolleiflex during a cycling weekend with friends. The camera was held close to the ground here. This is a common type of framing with 2¼ × 2¼-in. (6 × 6-cm) cameras (those with a vertical ground-glass viewfinder). The same framing with a 24 × 36-mm camera would be possible only by lying flat on the ground. The focus is on the young woman. The aperture—probably f/5.6—ensures a certain (intentional) blur on the bike. This is not a candid shot but a studied composition; one could call it an outdoor double portrait.

Boulevard Voltaire, Paris, 1937
NEGATIVE: 2¼×3¼ IN. (6×9 CM) _ P7/137
___ 355
Nighttime photo on boulevard Voltaire, taken with a 2 ¼ × 3 ¼-in. (6 × 9-cm) Ikonta folding camera, in winter. Two light sources: the moon, behind the chimneys (which inspired the photo), and a lamppost— off-camera to my right—that lit the tree in the foreground. Camera screwed onto the tripod. Aperture presumably closed to f/22, to ensure a great depth of field. Partial cropping. Exposure time not recorded.

Boulevard Richard-Lenoir, Paris, 1938
NEGATIVE: 2¼×3¼ IN. (6×9 CM) _ P8/144
___ 356
Same camera as for the previous photo; same window as the one in photo 353. End of fall. Very high-angle image taken through the window pane (distortion of the bench). The camera was likely handheld, focus set to infinity, aperture fully open (f/4.5 in this case), resulting in a very pronounced blur of the foreground and, consequently, a clearer feeling of depth than if everything had been uniformly in focus. Full frame. The bench and the two trees also appear in the photo of the busker of 1946 (photo 42).

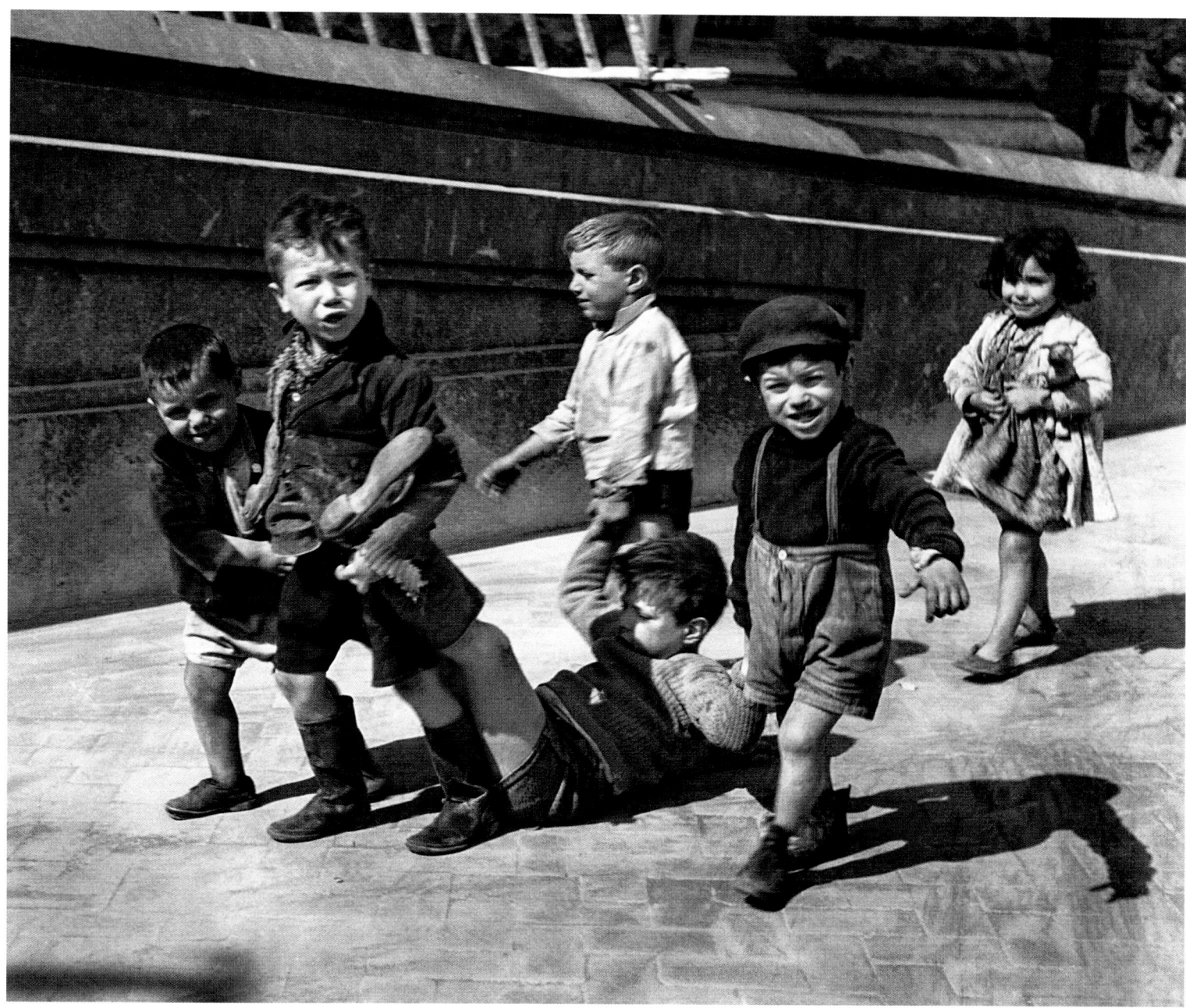

Little Neapolitans, Italy, 1938
NEGATIVE: 2¼ × 2¼ IN. (6 × 6 CM) _ C8/53
__ 357

Taken during a Mediterranean cruise, not as a tourist but to provide the organizer of the trip with a set of photographs for advertising. In a photograph such as this, it helps to position oneself so that the figures are clearly separated from one another, to ensure the legibility of the subject. Framing cropped top and bottom.

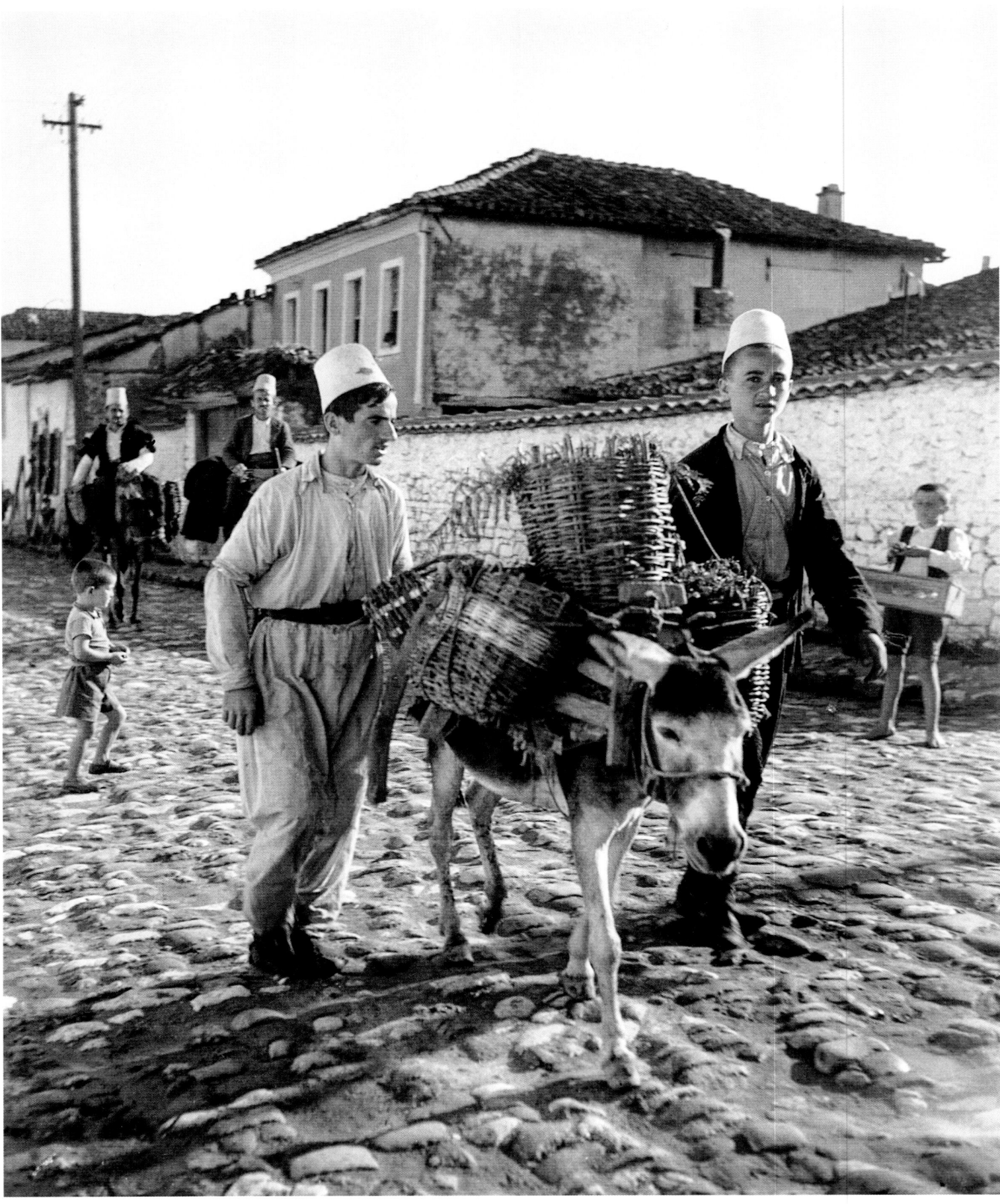

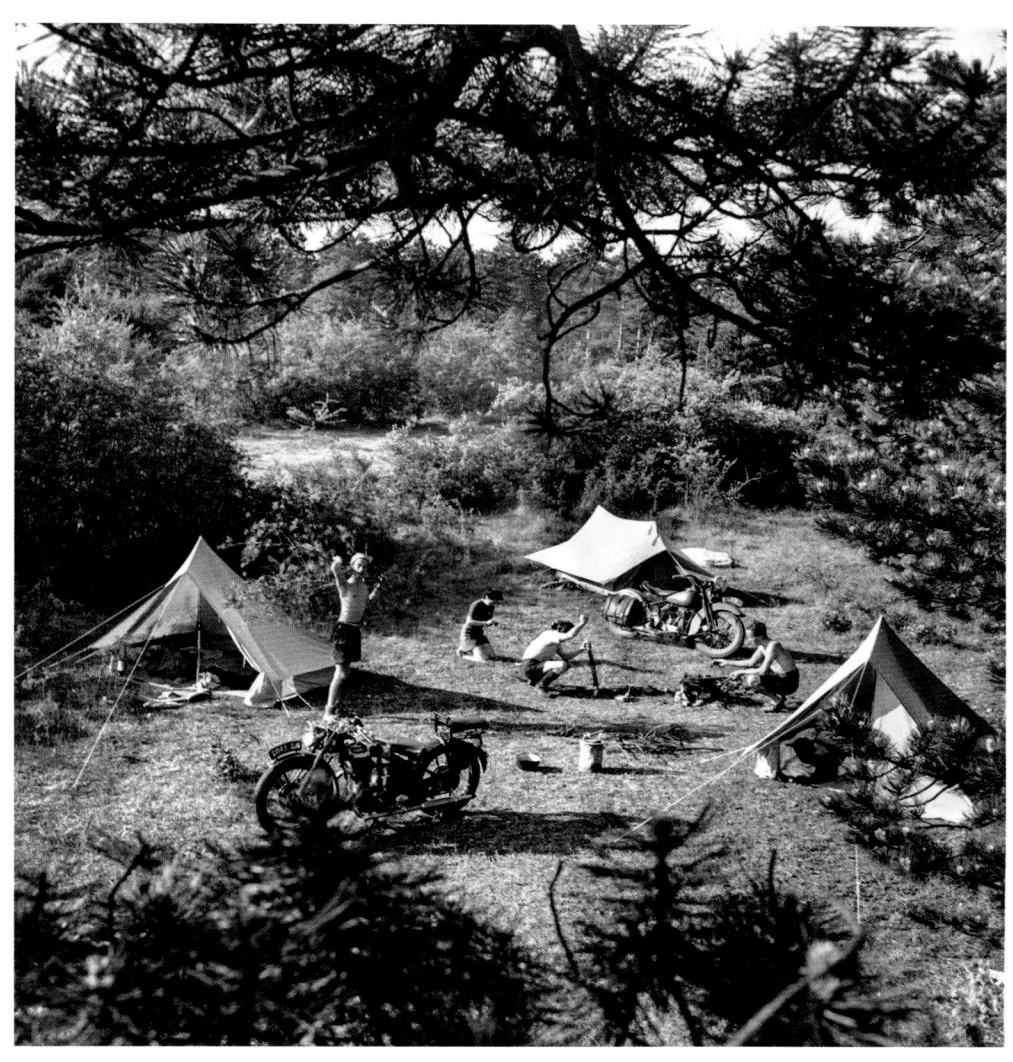

Campsite on the outskirts of Limay, Seine-et-Oise, 1939
NEGATIVE: 2¼×2¼ IN. (6×6 CM) _ Z9/91
___ 359

We were a group of camper-motorcyclist friends keen on wild camping (forbidden nowadays). Our favorite spot was around Limay, in a wooded area at the top of a hill. I had climbed a tree to separate all the planes. This is a "reconstructed candid photograph." It would have been better if the character on the left were not looking in my direction. Good lighting with slanting sun, late afternoon.
Full frame.

An alley in Durrës, Albania, 1938
NEGATIVE: 2¼×2¼ IN. (6×6 CM) _ B8/261
___ 358

Summer cruise. Same assignment as for the Easter cruise (previous photo). Legibility is achieved by balancing the main subject with a second symmetrical plane (the two kids, left and right). Almost full frame.

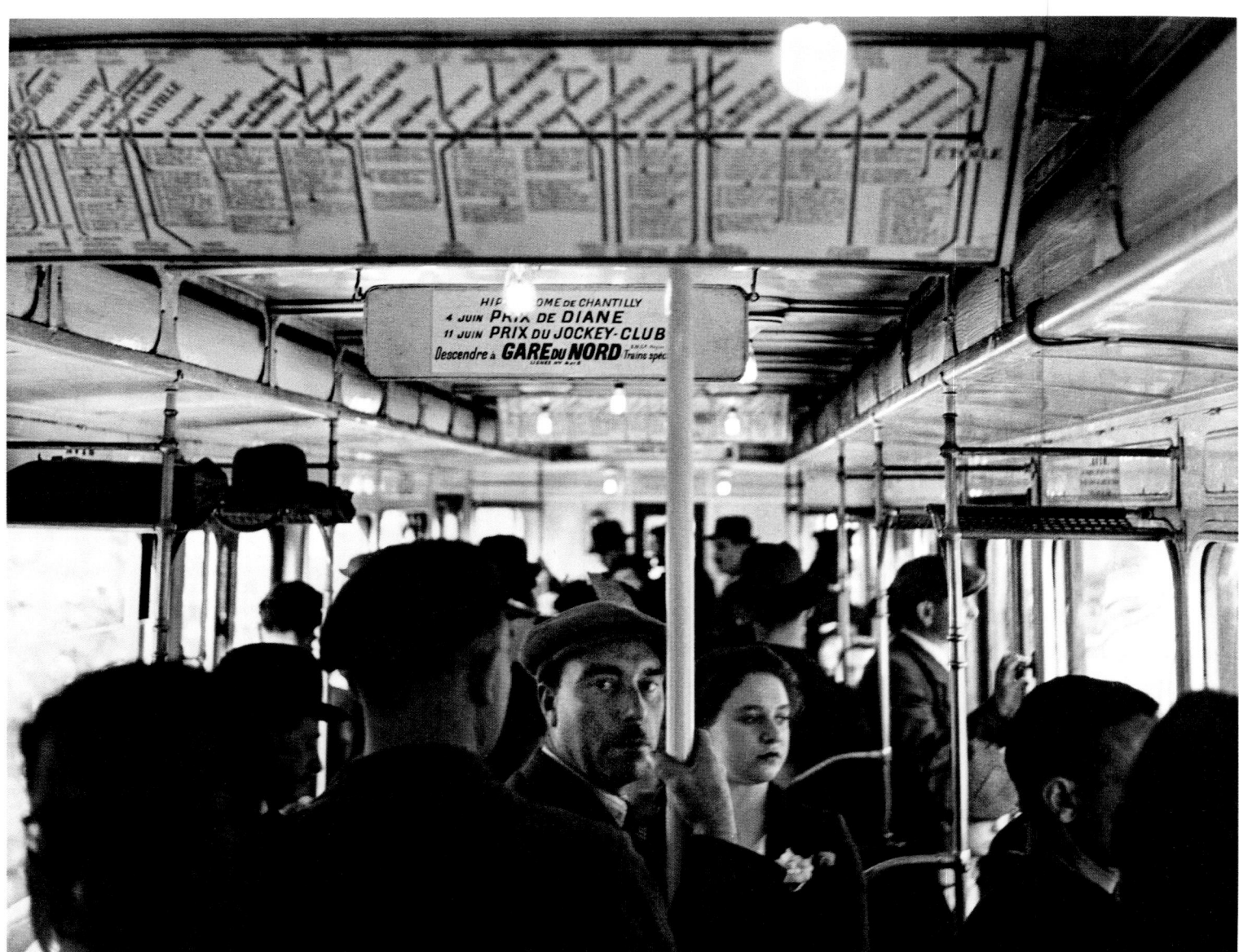

On the elevated metro, Paris, 1939
NEGATIVE: 2¼×2¼ IN. (6×6 CM) _ P9/36
___ 360

The daylight must have been weak, and I had worked with a fully open aperture, hence the shallow depth of field. Focus on the young woman. Framing by guesswork, camera held over my head. Partial crop.

The kiss, Antibes, Alpes-Maritimes, 1942
NEGATIVE: 2¼×2¼ IN. (6×6 CM) _ R12/28
___ 361

A little scene captured during a walk with friends on a Sunday in Antibes. No particular technical commentary, except for a very open aperture to ensure total background blur. It is the young woman's funny expression that motivated this shot. Very partial framing.

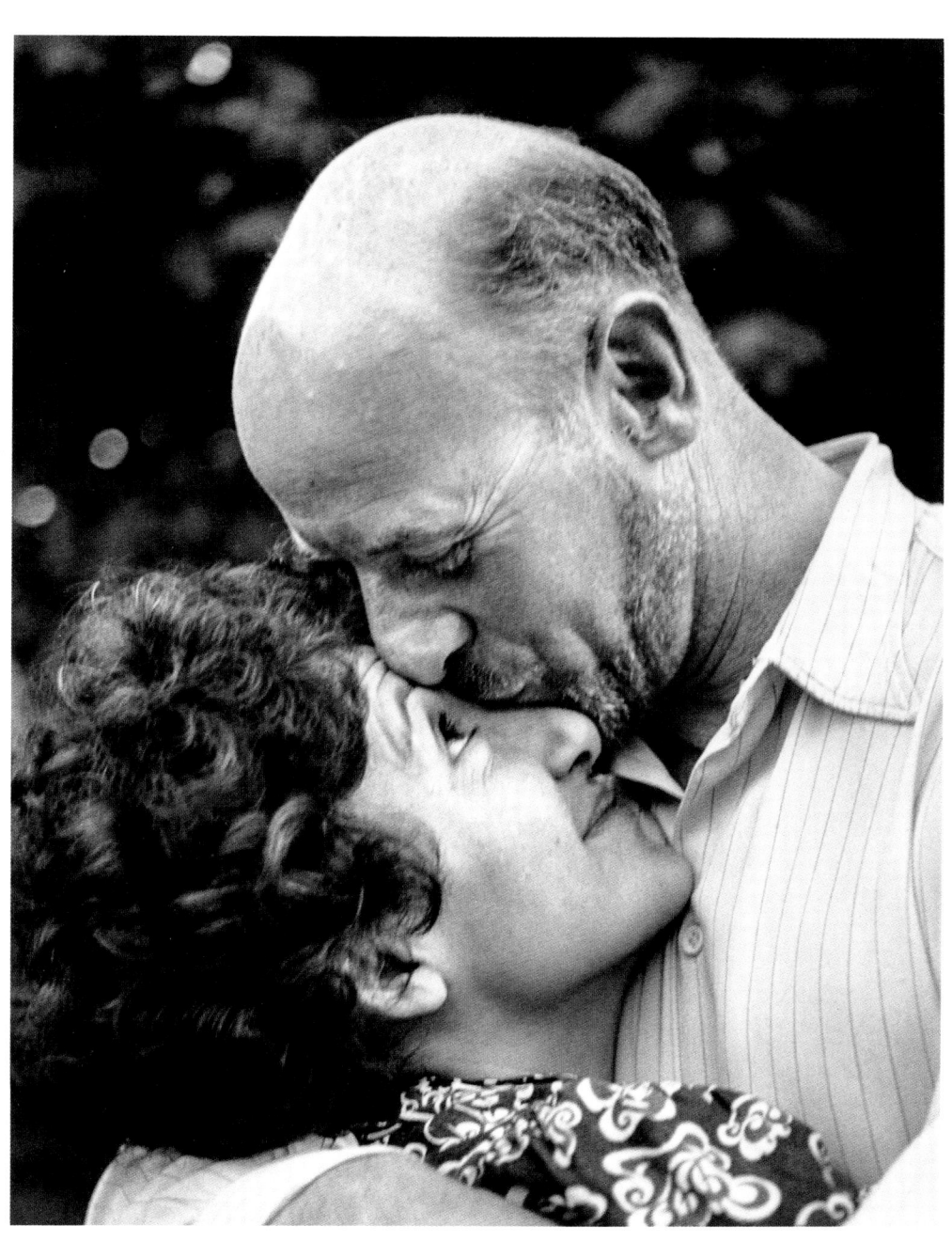

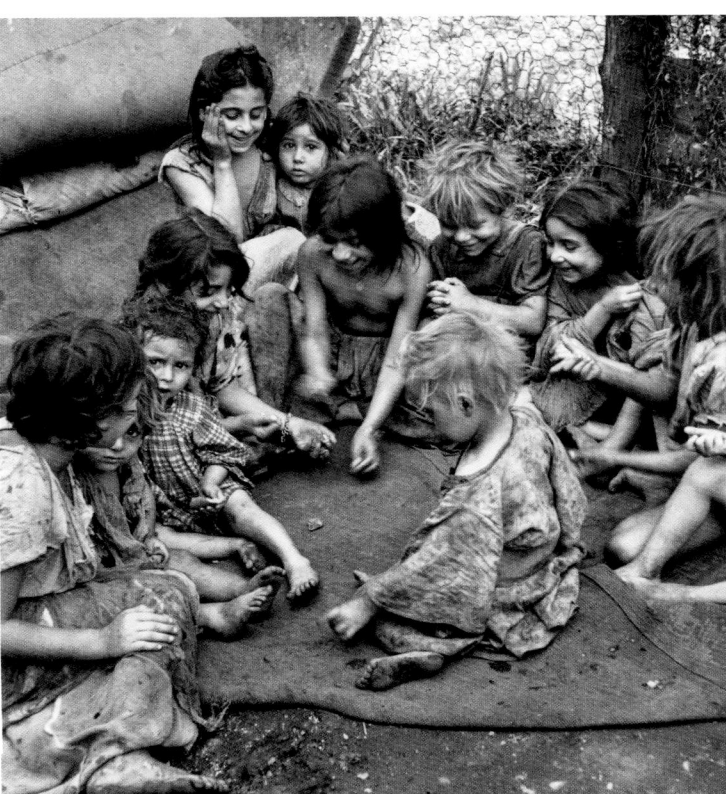

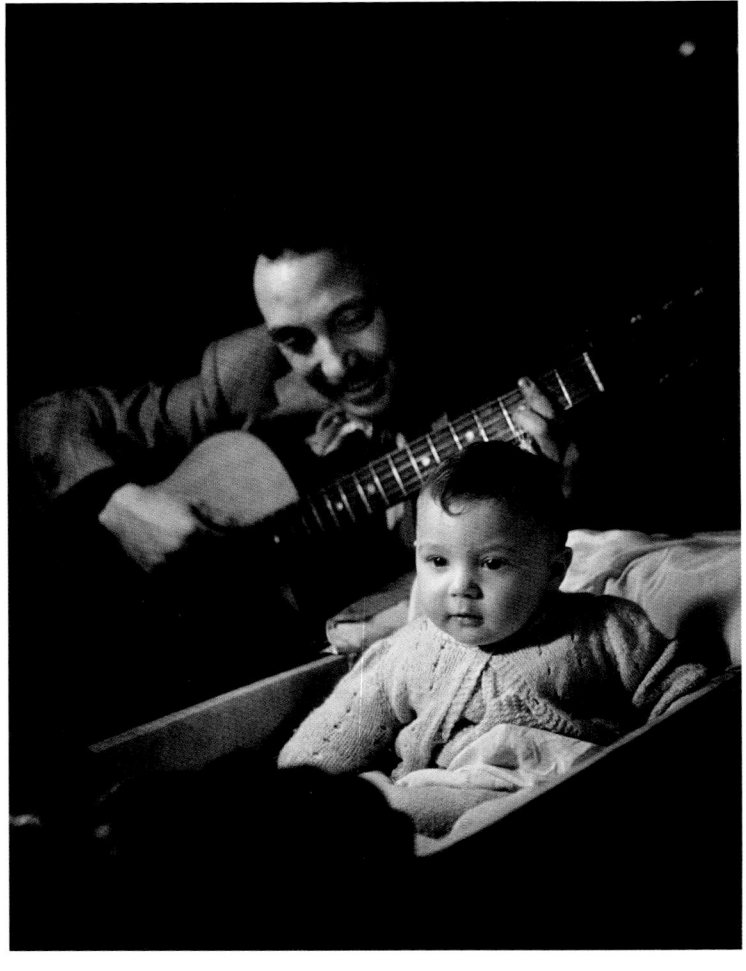

With the Roma of Montreuil, Seine, 1945
NEGATIVE: 2¼×2¼ IN. (6×6 CM) _ R15/29/29
___ 362
Photograph from a commissioned project on settled Roma in Montreuil (see also photos 33 and 34). Animated game of jacks. High-angle shot from a chosen position. Full frame.

Django Reinhardt and his son, Paris, 1945
NEGATIVE: 2¼×2¼ IN. (6×6 CM) _ R 15/2/9
___ 363
Charles Delaunay, the director of *Jazz-Hot* magazine (and an army friend), had commissioned a small project from me on Django Reinhardt (see photo 26). His son was sitting in his stroller. The room was so small that I photographed my two characters by turning my back to them and facing a large mirror hanging on the wall. Electric lighting with a light bulb screwed into a clamp light directed toward the child, who was my main subject. Open aperture, intentional blur of the father. Partial crop. The negative must be flipped left to right in printing, as was the case for my self-portrait (photo 351).

Vincent writing, Cavignac, Gironde, 1945
NEGATIVE: 2¼×2¼ IN. (6×6 CM) _ E15/40
___ 364
In Cavignac in the Gironde. Very high-angle backlight from a sunbeam descending through a high window. The child's cheek is indirectly lit by the beam ricocheting from his right shoulder. This was the same morning as the photo *Vincent with a bowl* (see photo 37).

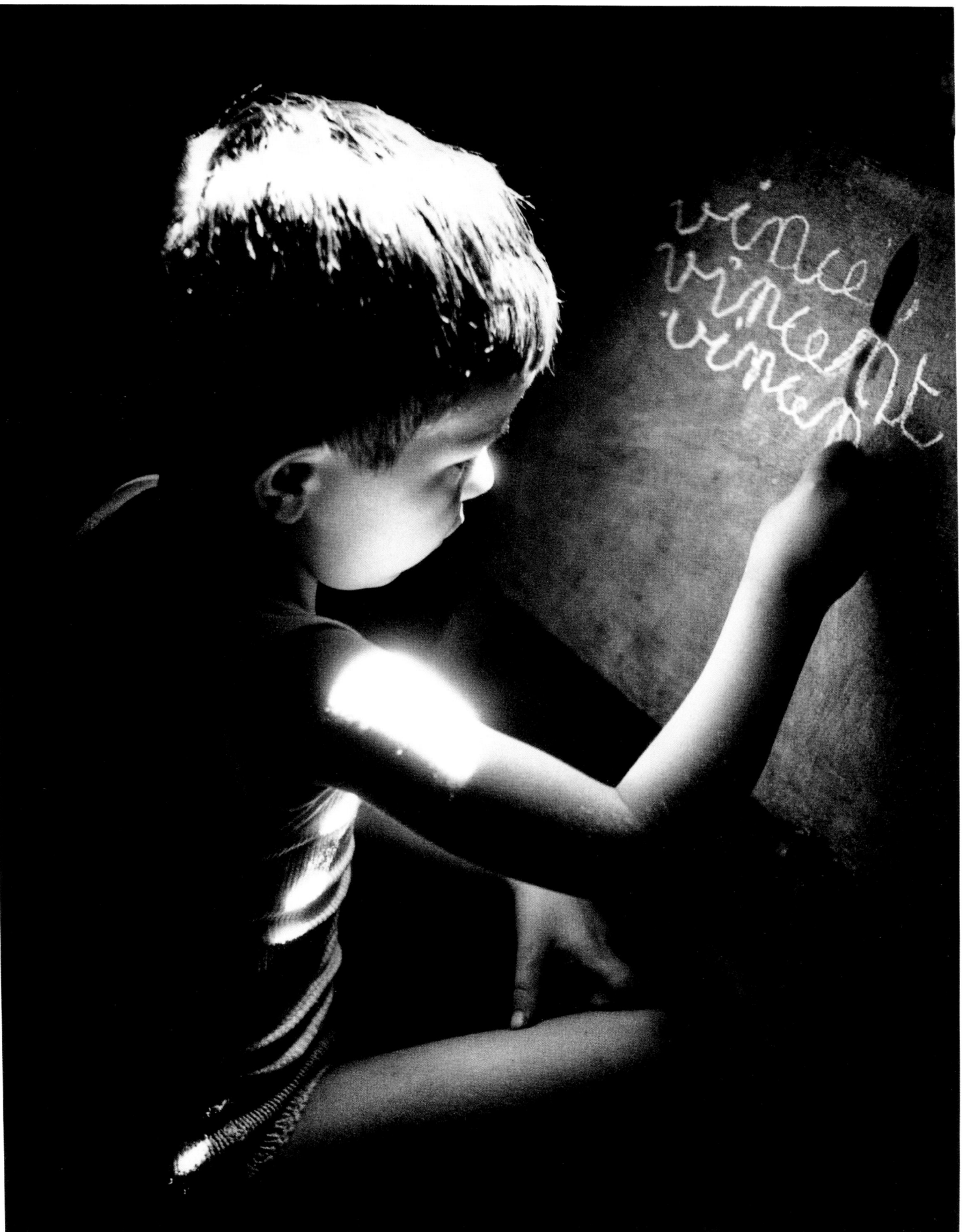

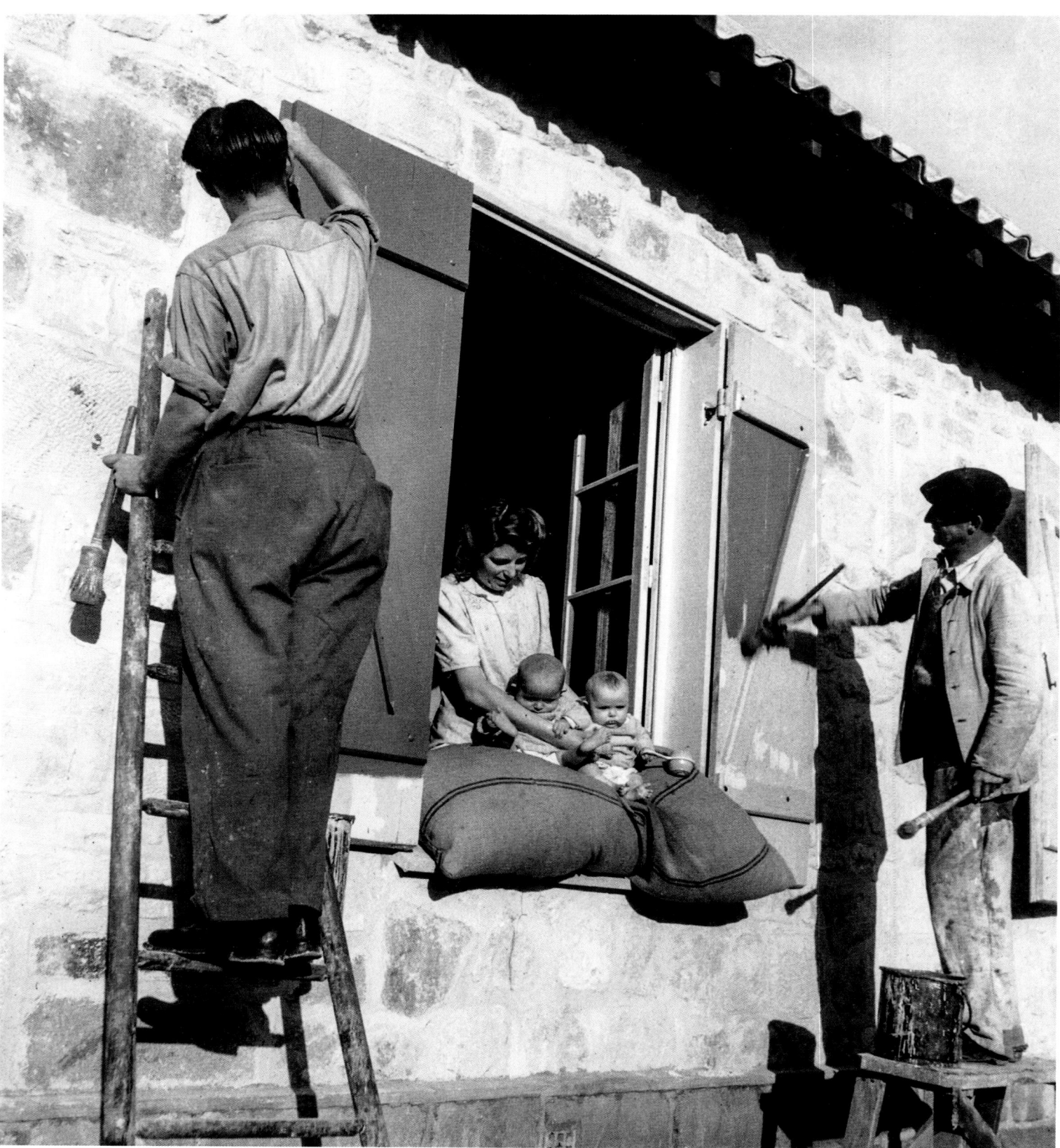

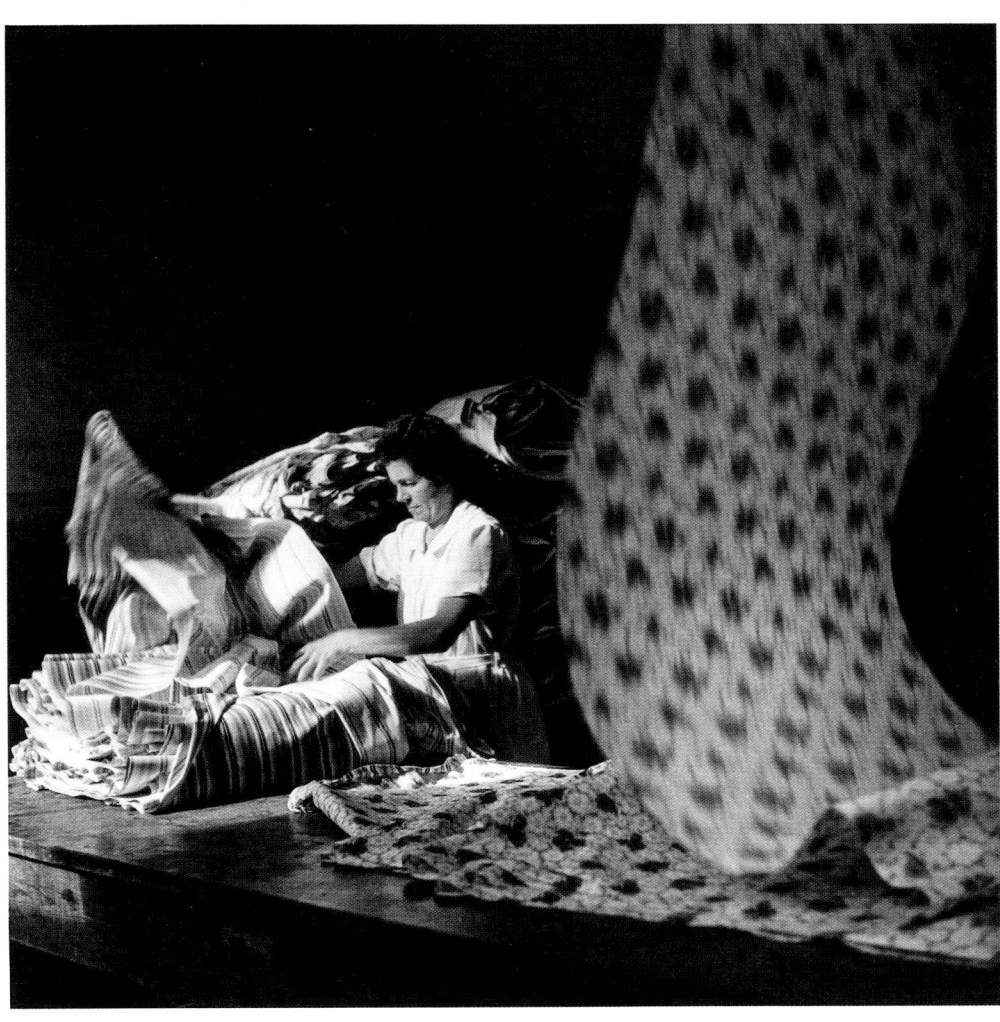

**The reconstruction of
Argentan, Oise, 1946**
NEGATIVE: 2¼×2¼ IN. (6×6 CM) _ R16/20/30
__ 365

The MRU (Ministry for Reconstruction
and Urban Planning) sent me to Normandy
to photograph the government's efforts
to provide those devastated by war
with livable housing. My mission was
limited to three cities: Alençon, Évreux,
and Argentan. This photo was made in
the last of these, on a sunny day after
a period of rain. This mother, who had
already moved into her still-unfinished
house, was taking advantage of the good
weather to give her twins some air.
Full frame.

**Fabric-printing factory,
Mulhouse, Haut-Rhin, 1946**
NEGATIVE: 2¼×2¼ IN. (6×6 CM) _ R16/26/68
__ 366

The Rapho agency sent me to the Haut-
Rhin for an industrial report on some
textile factories. The main objective was
to illustrate a special issue of the journal
published by the Société Industrielle de
Mulhouse, dedicated to the bicentenary
of printing on fabric. In this type of work,
the scenario is almost always the same.
I start by visiting the business, camera
around my neck and pencil in hand,
guided by the engineer who points out
the desired subjects. During the tour, I am
almost always drawn to a subject outside
the program, interested by a gesture or
a sudden burst of light that, as the sun
moves, lasts only for a limited time. It
is compelling. I keep my guide waiting
and take a picture "for myself." It almost
always ends up in the final selection.
Almost full frame. No additional lighting.

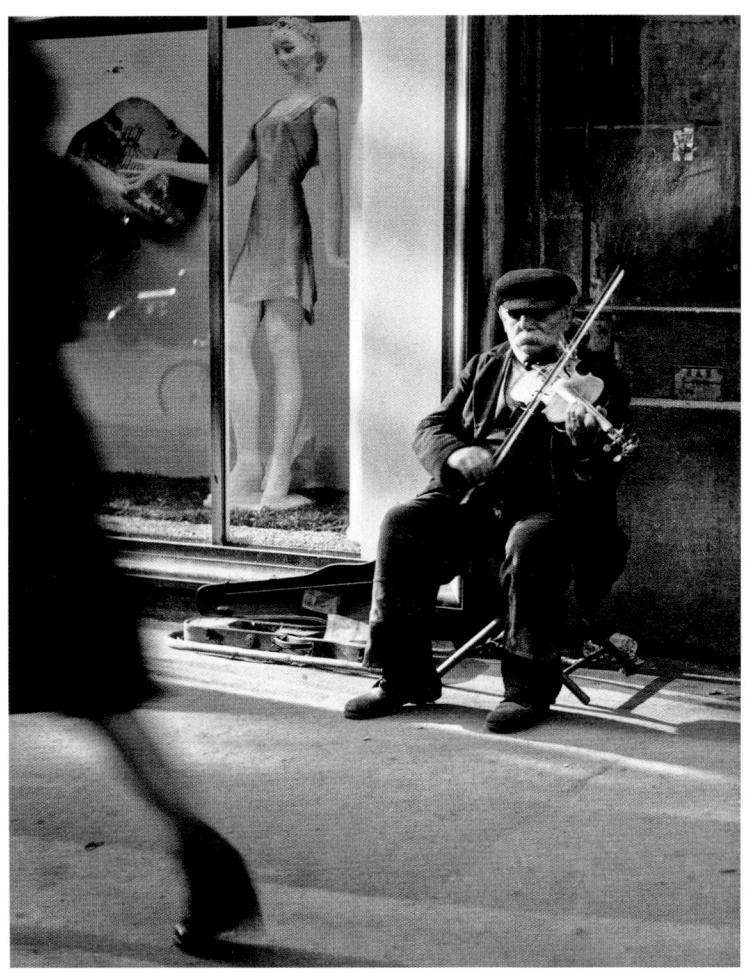

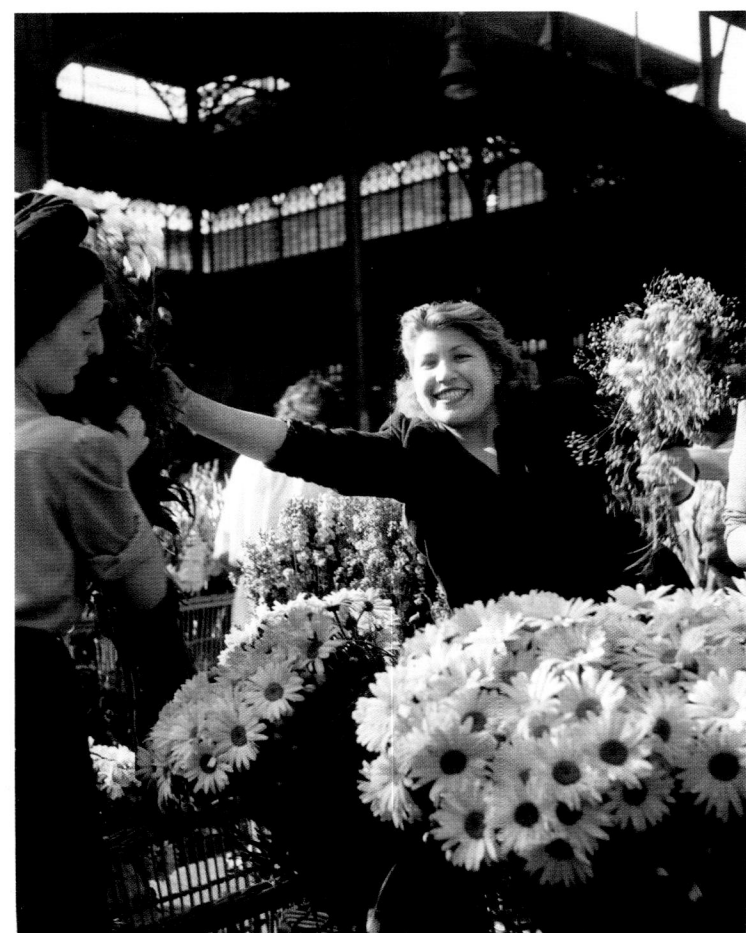

Blind musician, boulevard Haussmann, Paris, 1946
NEGATIVE: 2¼×2¼ IN. (6×6 CM) _ P16/189
___ 367

On this particular morning my appointments had led me to boulevard Haussmann. Near the window of the Printemps department store, in a ray of sunshine, a blind violinist was playing for some change. The truncated presence, on the left, of a hurried female figure is not the result of error. It is deliberate and intended to suggest pedestrian traffic. The viewpoint is at chest height, as is often the case with this type of camera: the image is framed on a horizontal focusing screen, meaning that it is viewed from above. Almost full frame.

The flower pavilion at the Halles de Baltard, Paris, 1946
NEGATIVE: 2¼×2¼ IN. (6×6 CM) _ P16/2/6
___ 368

I was exploring the central covered markets of Paris, the Halles de Baltard, which were to be destroyed in 1971 to make way for the Forum des Halles. A lucky ray of sunshine illuminating the florist provided me with an interesting framing device. The slightly low-angle shot reveals the metallic architecture of the pavilion. I waited for the young woman's gesture before releasing the shutter. I was not bothered by her gazing directly at me. I did not work on the principle of always being an invisible witness. In my opinion, the complicit smile even adds a certain charm to this very ordinary scene. Almost full frame.

Ludmilla Pitoëff, Paris, 1947
NEGATIVE: 2¼×2¼ IN. (6×6 CM) _ R17/7/1
___ 369

A photo story on Ludmilla Pitoëff, the wonderful actress who, alongside her husband Georges, devoted herself body and soul to contemporary theater between the wars and beyond. When I started to work there was a power outage. My portable lights had stayed in the bag. Everything was done with the meager light dispensed by the windows. Framing slightly cropped on the sides.

Signes, Var, 1947
NEGATIVE: 2¼×2¼ IN. (6×6 CM) _ F17/380
— 370

I had started out, without a contract, on a book project dedicated to the Sainte-Baume mountain range straddling the Bouches-du-Rhône and the Var. It was quite an undertaking, and so exciting that I abandoned any commercial prudence and devoted almost all of my summer vacation to it. This is Signes, a town lost at the foot of the mountains. A common little scene around the village fountain. The plane trees let in a softened light. The woman and girls busied themselves. The boys were having fun. Lateral cropping. Quite a difficult print because of the clash between shadow in the foreground and bright sunlight on the houses.

Joinville-le-Pont, Seine, 1947
NEGATIVE: 2¼×2¼ IN. (6×6 CM) _ R17/25/50
— 371

I was with a group of friends and was finishing my project for the *Album du Figaro* on the *guinguettes* (open-air cafés) on the outskirts of Paris. In the prevailing cheer of this late summer afternoon, the joker of the bunch sang his song. The scene is partially lit by a magnesium flash, which produced this somewhat unreal and not very well-balanced light. Photo 55 was taken during the same assignment, spread over several weekends, and incorrectly described as in Nogent instead of Joinville. Almost full frame. An accidental cast to the right of the negative makes printing very difficult.

Sunday rest, Champigny-sur-Marne, Seine, 1947
NEGATIVE: 2¼×2¼ IN. (6×6 CM) _ R17/25/22
— 372

Same project as the previous photo but in Champigny-sur-Marne. At that time, riverbanks were inviting places. They have since almost all been "redesigned" into planned pathways, which are pleasant but less charming. It was hot. We may have gone a little heavy on the white wine accompanying the mussels and fries. The sky does not appear in the photo; the half-backlight darkens the opposite bank. The boat, with its triangular sail, drifts in the direction of the photo's convergence lines. This creates a dreamy image, a little melancholy. Almost full frame.

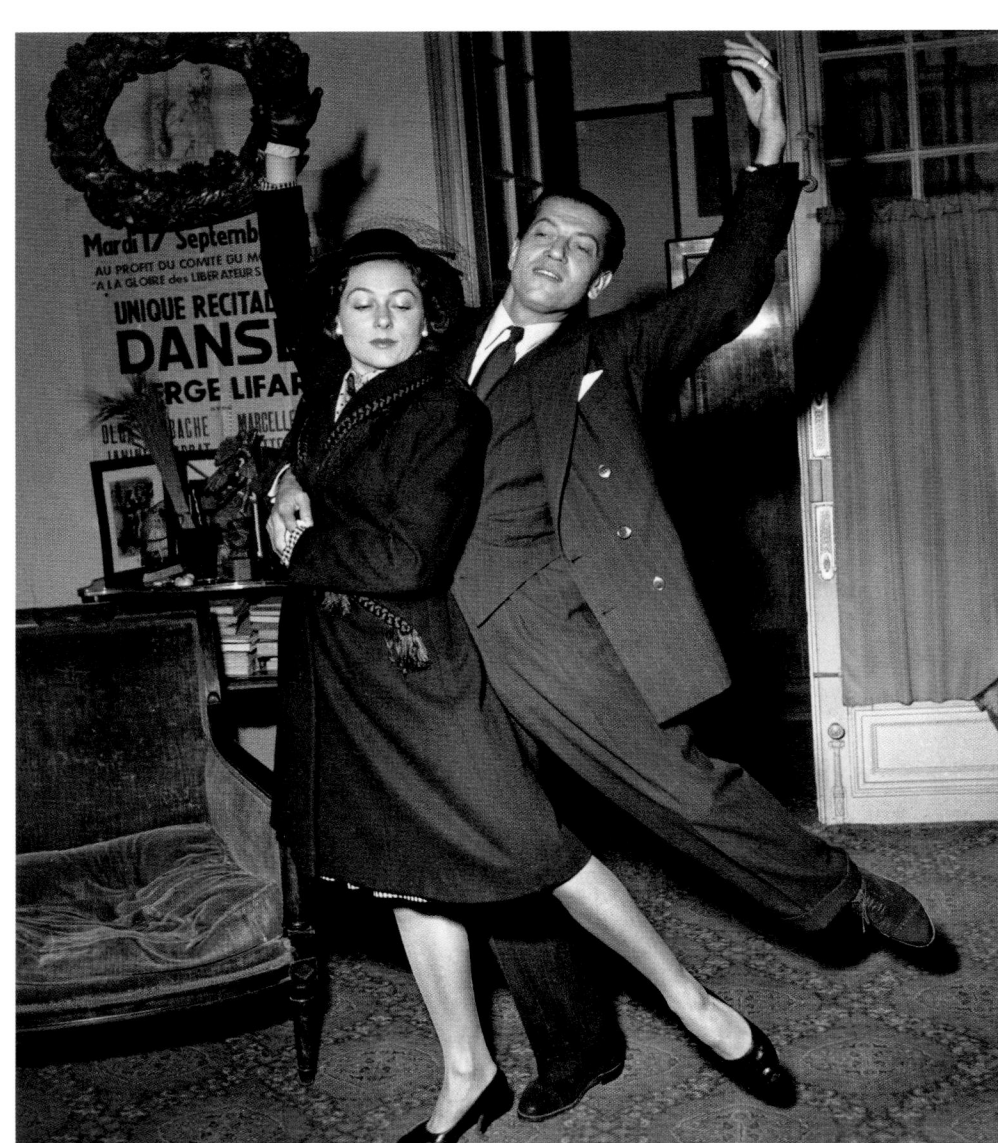

**Yvette Chauviré and
Serge Lifar, Paris, 1947**

NEGATIVE: 2¼×2¼ IN. (6×6 CM) _ R17/27/20

—— 373

I did a short project on the ballet dancer Serge Lifar, in his apartment, for the weekly *Cavalcade*. The prima ballerina Yvette Chauviré, who had been visiting, was about to leave. As the atmosphere was relaxed, I suggested the famous artists dance a pas de deux for a half-serious, half-ironic image. They accepted. Frontal flash lighting, ordinary "news" style. I made room for the poster announcing the recital, likely the reason for the assignment. The framing is slightly tilted to energize the pose frozen by the flash.

**In front of Chez Mestre,
Paris, 1947**

NEGATIVE: 2¼×2¼ IN. (6×6 CM) _ BM17/133

—— 374

The painter Daniel Pipard, a child of Ménilmontant, had introduced me to a young couple from there whom I photographed in November 1947. This was one of those photos, taken in a street whose name I have forgotten; maybe rue des Cascades. The second, also taken at night, does not appear in these albums. It can be found at the end of my book *Belleville Ménilmontant*.

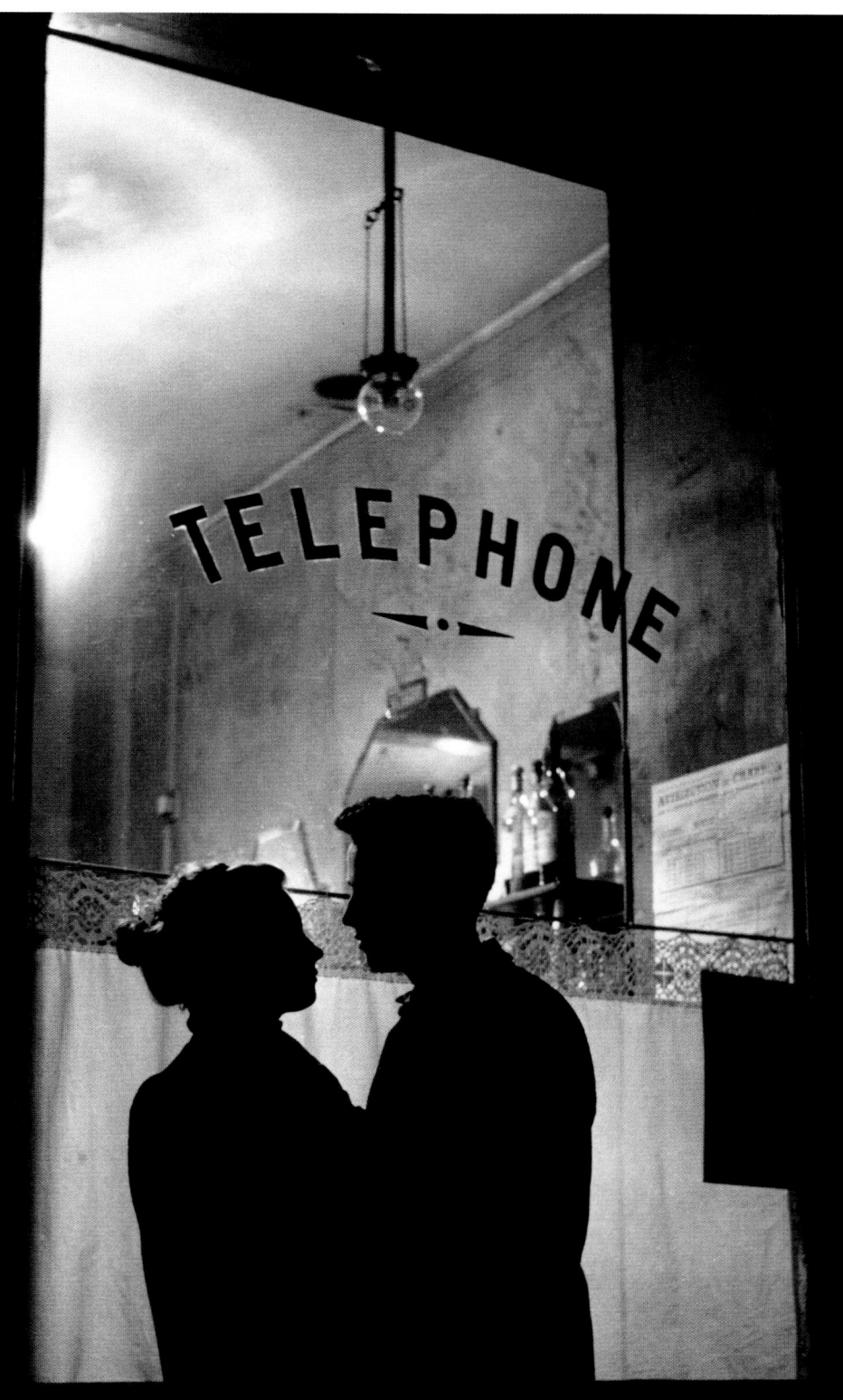

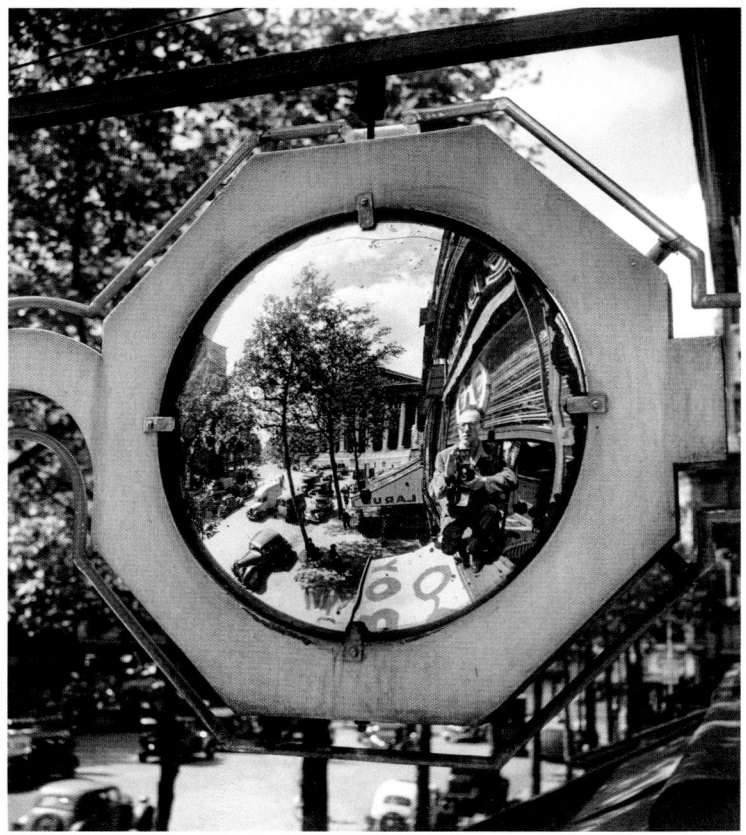

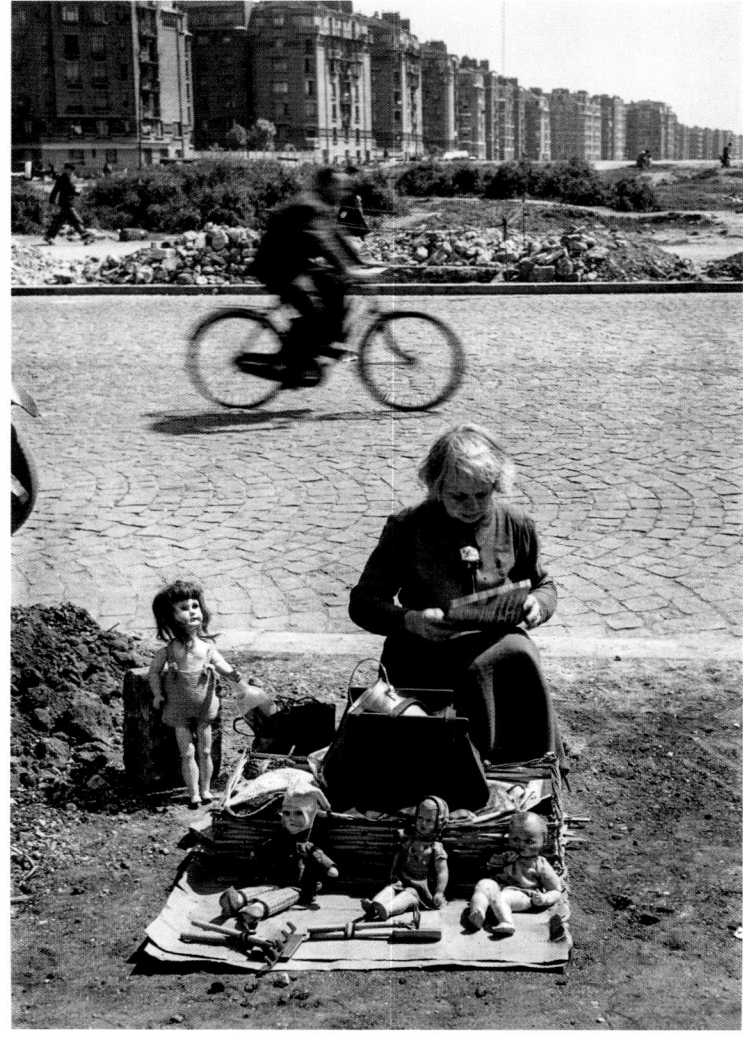

Self-portrait in a sign on rue Royale, Paris, 1948
NEGATIVE: 2¼×2¼ IN. (6×6 CM) _ P18/40
___ 375

What was I doing on rue Royale, on a fine early summer's morning? Perhaps I had left the *Life* offices on place de la Concorde and decided to take the metro at Madeleine. The fact remains that the sight of the giant glasses over the optician Leroy, forming a quadruple convex mirror, had given me the idea for a baroque self-portrait. I obtained permission to step over the railing of the second-floor window (the manager must have been an athlete who trusted me), and this is the result. I didn't flip the negative, as is usually the case for a portrait taken in a mirror (see photos 351 and 363), because the true nature of the surroundings had to be respected.

Flea market, Porte de Vanves, Paris, 1948
NEGATIVE: 2¼×2¼ IN. (6×6 CM) _ P18/139
___ 376

We had been living in the fifteenth arrondissement since the end of 1946. On the weekends Marie-Anne and I often went for a walk at the Porte de Vanves flea market (where the Périphérique highway circling Paris would later be dug), both to hunt for knickknacks (we hadn't completely finished moving in) and for fun, with the camera hanging around my neck while I was at it.
I like this slightly melancholic backlighting. My framing is a little off: not enough going on to the left. But the sudden appearance of the cyclist had not left me enough time to refine my set-up. I should have waited for a new opportunity, but that is impossible when someone else is with me. Cropping to the right.

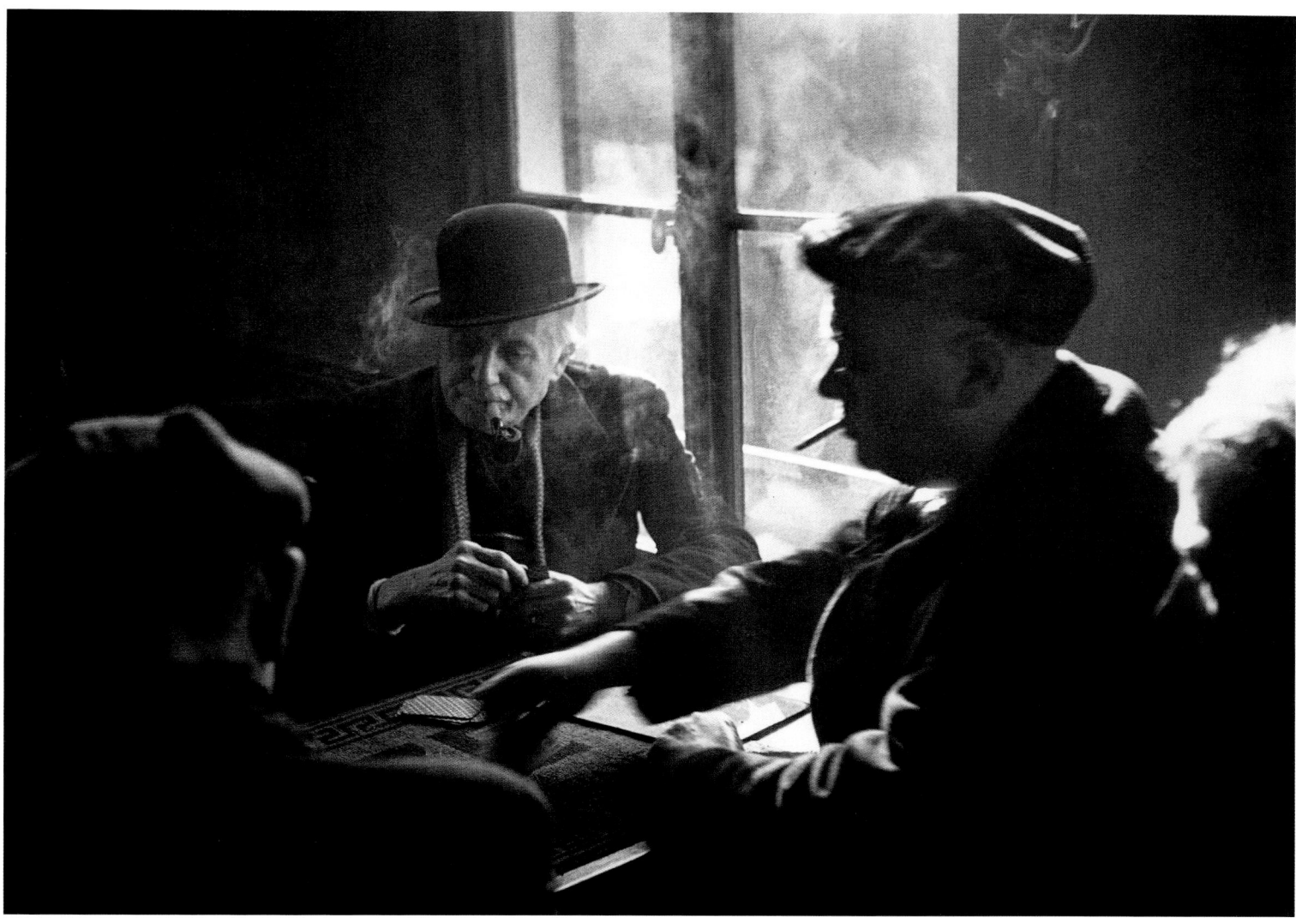

The rue des Cascades bistro, Paris, 1948
NEGATIVE: 2¼×2¼ IN. (6×6 CM) _ P18/156
___ 377

One of the photos I like best from my book *Belleville Ménilmontant* is of the *belote* players on rue des Cascades (photo 68). This was a bistro-*guinguette* on three levels, on the steep slope that separated rue des Cascades from rue de la Mare. On the ground level there was a bar with a counter and a few tables. A winding staircase descended to a new room with windows opening to the west. And from there one could descend further into an elongated courtyard, an area reserved for pétanque players, with some shrubs and an arbor. All this was demolished in the great upheaval of the 1960s–1970s. Pleasant houses have been recently built in this spot, but a kind of friendly charm has completely disappeared. The close-up above was taken just before the photo published in the book. I used it again in *My Paris* (p. 150). Cropping top and bottom.

The speleologist's goodbye, Montsalier, Basses-Alpes, 1948
NEGATIVE: 2¼×2¼ IN. (6×6 CM) _ R18/21/61
___ 378

Around Easter, Rapho sent me to do a report for *L'Illustration* on caving in the Caladaïre chasm in the Alpes-de-Haute-Provence. Before descending myself (winched two hundred feet [sixty meters] on the end of a steel wire in the dark), I recorded the sidelines of the expedition. This photo shows the head of the caving team kissing his wife goodbye. The material for the report, for which I also drew up the text, was fairly well used, except for one major disappointment. At the last moment, the photo chosen for the cover was replaced by a portrait of the head of the Marshall Plan for France: news *oblige*. Partial crop.

Claridge hotel, avenue des Champs-Élysées, Paris, 1948
NEGATIVE: 2¼×2¼ IN. (6×6 CM) _ R18/47/4
___ 379

Report on the Claridge hotel on the Champs-Élysées. Staged photo. No particular comment, except that, having marked out the right viewpoint in the morning, I decided to come back in the afternoon for more favorable light. Slight cropping left and right.

Vallon des Auffes, Marseille, Bouches-du-Rhône, 1949
NEGATIVE: 2¼×2¼ IN. (6×6 CM) _ F19/163
___ 380

On the corniche in Marseille, level with the Monument aux Morts des Armées d'Orient, is a small picturesque port: the Vallon des Auffes. Taken on their own, most of the houses bordering this cove—more or less knocked together by their owners—are rather ugly. However, seen as a whole from the bridge formed by the corniche at that spot, the spectacle is superb, with Notre-Dame de la Garde rounding out the perspective on the same axis as the valley. It was nap time. One man was cleaning his boat; two others, who had probably spent all night fishing, slept, huddled against each other at the bottom of their boat. Lateral framing.

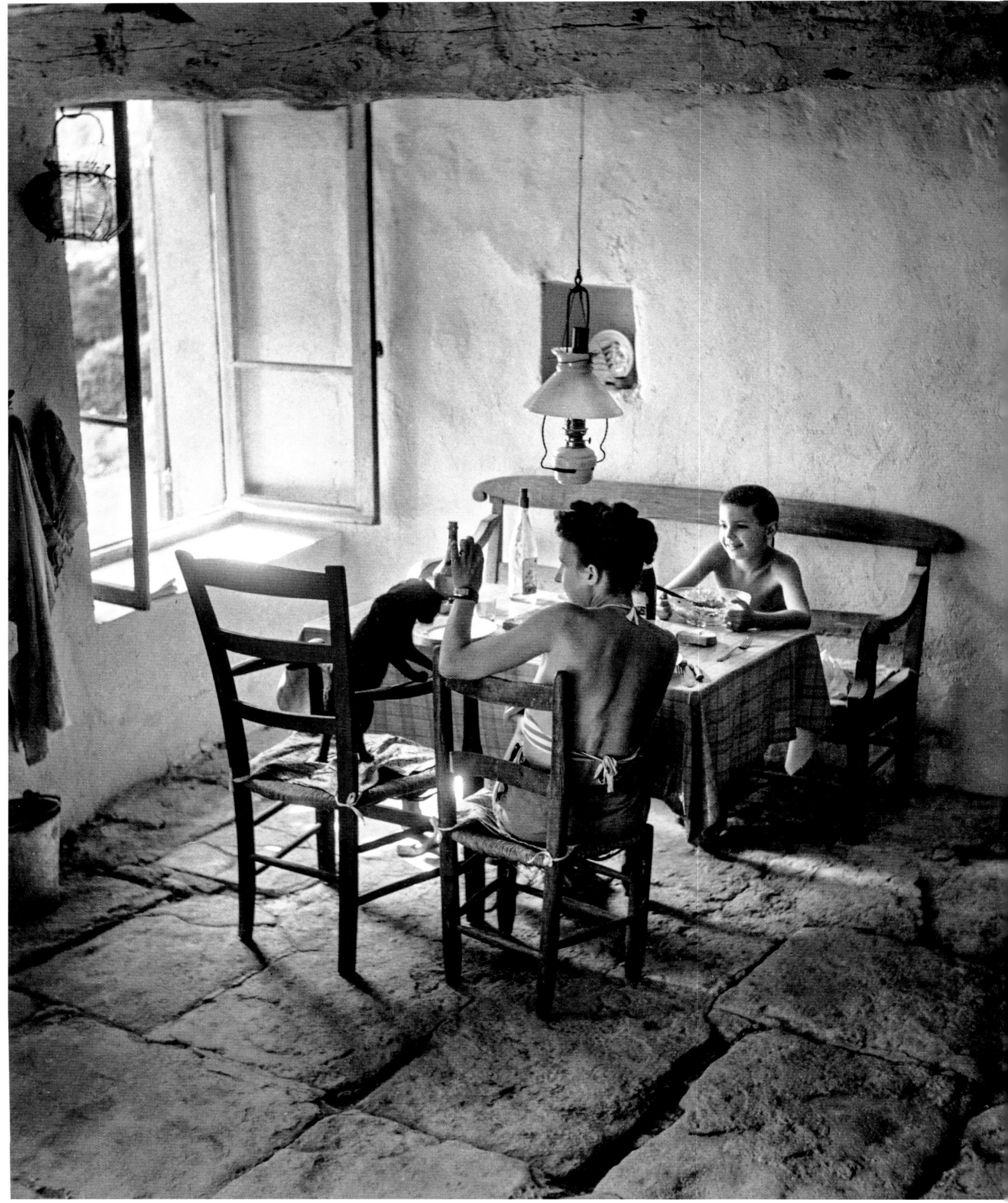

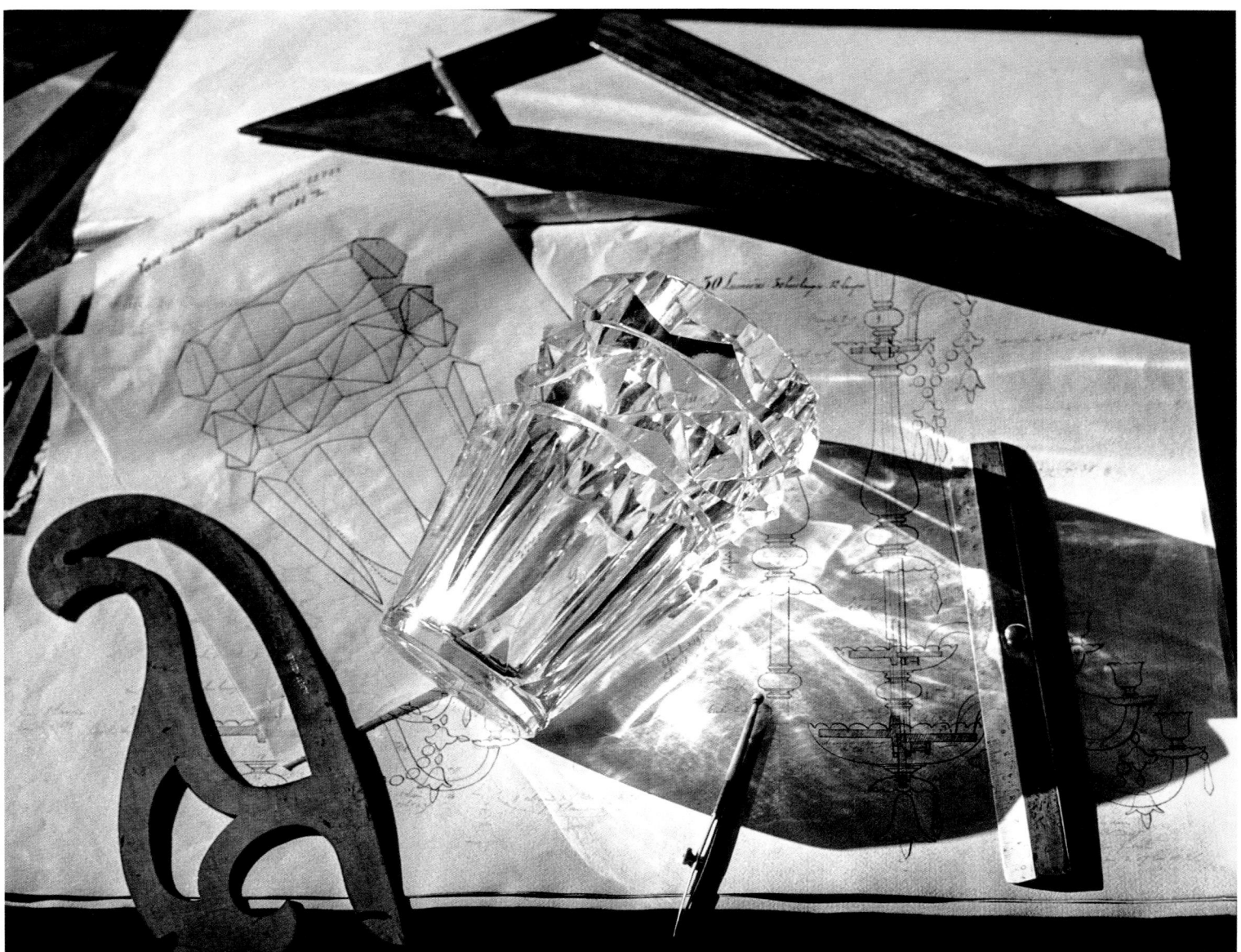

**The kitchen-living room,
Gordes, Vaucluse, 1949**
NEGATIVE: 2¼×2¼ IN. (6×6 CM) _ F19/231
___ 381

The end of a summer vacation meal in our house in Gordes, in the kitchen-living room where we had just installed a large window (these were formerly the sheep's quarters). Through this window, three years later, I would take *Vincent and the model aircraft* (photo 129). It was also from the top of the stairs leading from the kitchen to the second-floor bedroom that *The nap* (photo 95) was taken. And, finally, it was in the room on the second floor that, during the same summer as the facing photo, *The Provençal nude* was taken (photo 94).

**In the drawing workshop
at the Baccarat factory,
Meurthe-et-Moselle, 1949**
NEGATIVE: 2¼×2¼ IN. (6×6 CM) _ I19 BACC 14 I19/14
___ 382

My wanderings around the Baccarat crystal factory had taken me through the drawing workshop. The design for a vase was on a table, lit by a ray of slanting sunlight. I asked one of the designers if this vase could be found in the factory. When he answered in the affirmative, I had it brought and arranged it in a favorable light. I moved the items that were already on the table only slightly. My "still-life symbol" was composed. Cropping to the top.

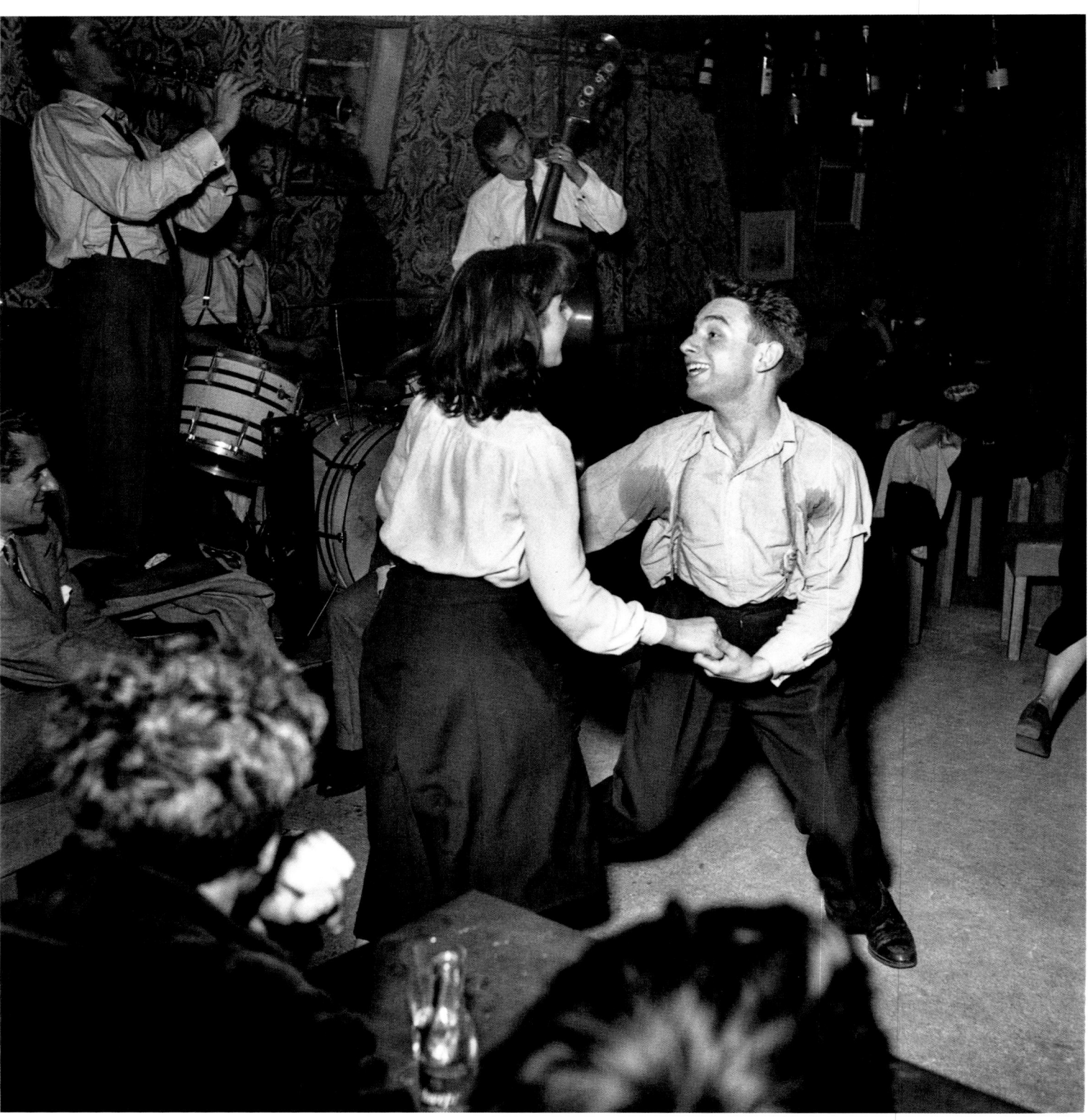

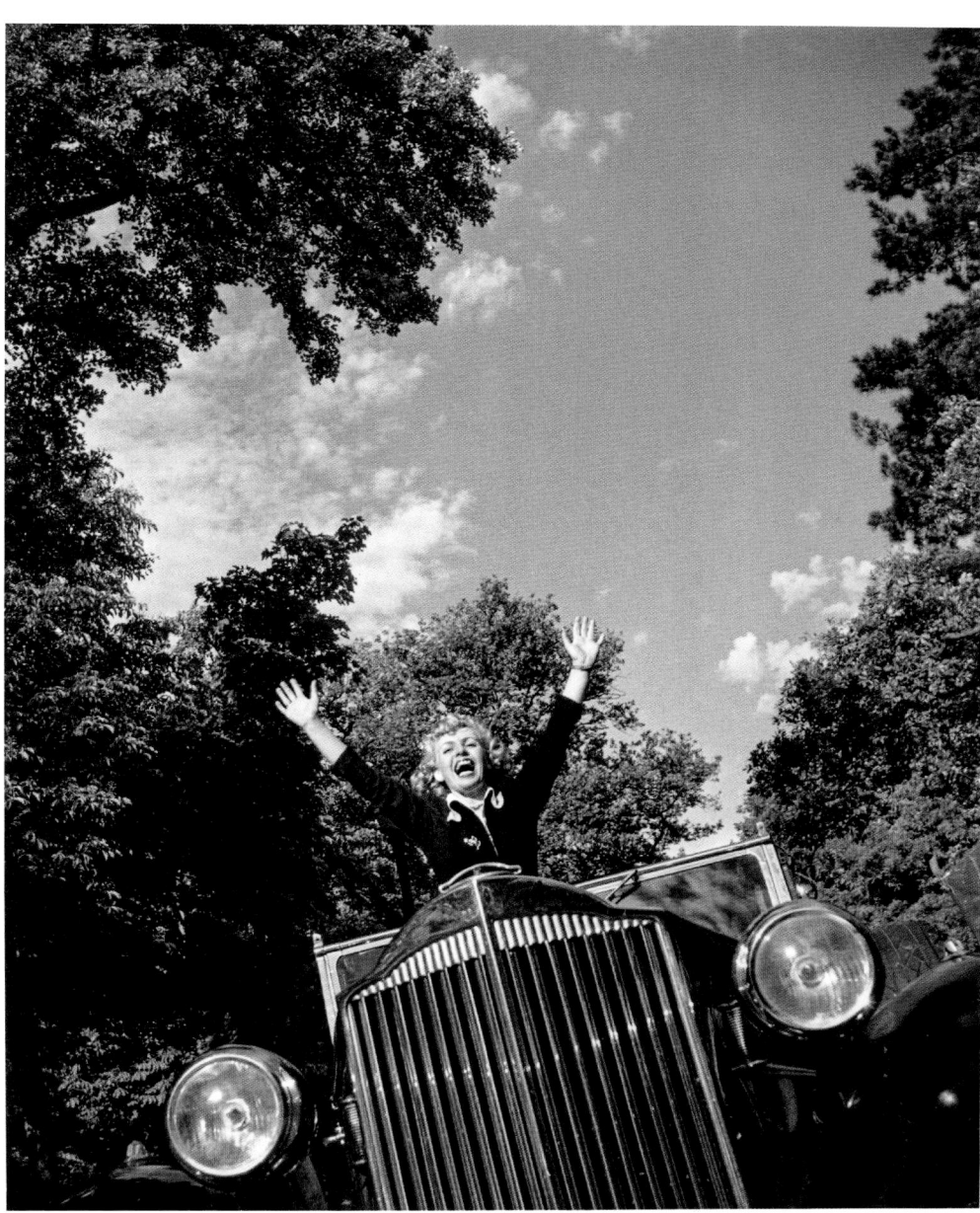

**The Vieux-Colombier
club, Paris, 1949**
NEGATIVE: 2¼×2¼ IN. (6×6 CM) _ R19/14/19
__ 383

Taken from a photo story on Americans in Paris commissioned by *Time* magazine. Throughout this job, I had benefited from a young colleague who volunteered to hold the flash at the end of a long wire unwound to the required distance. For this photo he wasn't with me, and I did not ask for any help for fear that the dance would end, and that it would be impossible for me to find this couple again, particularly the young man, who had fascinated me. I therefore used a frontal flash, which I normally avoid. This was at the Vieux-Colombier club, and Claude Luter was playing clarinet. See photo 91, taken on the same night, with the flash held about ten feet (three meters) to my left. (Photo 91 was mistakenly described as taking place at the Saint-Germain club.)

Queen for a Day, Paris, 1949
NEGATIVE: 2¼×2¼ IN. (6×6 CM) _ R19/19/31
__ 384

Point de Vue had entrusted me with a report on a radio station that periodically organized a popular show called *Reine d'un jour* (Queen for a Day). The winner was treated to a dream day full of beautiful surprises and gifts. In the photo selected here, taken during the break from a drive in the Bois de Boulogne in a Rolls Royce, she was overjoyed. The gesture was requested for the picture, but my work was greatly facilitated by the winner herself, who was clearly a gifted actress. Lateral framing.

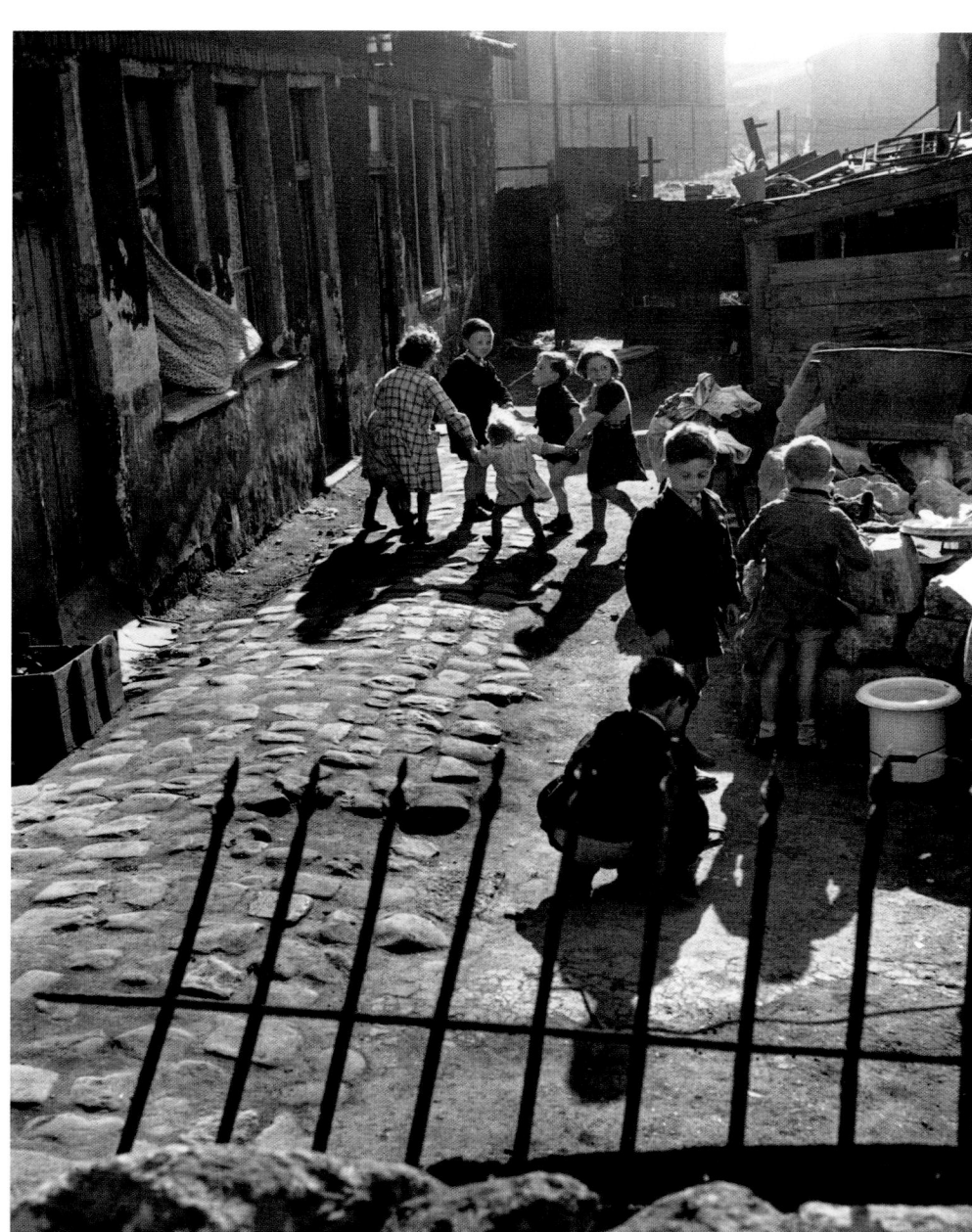

The children of Aubervilliers, Seine, 1950
NEGATIVE: 2¼×2¼ IN. (6×6 CM) _ R20/8/37
__ 385

Report for *Regards* on the children of Aubervilliers (see also photo 104). It was made in a particularly disadvantaged area of this working-class suburb. Completely backlit. The shot was taken from an elevated viewpoint, to separate the planes and reduce the presence of the sky. The shutter was released when the smallest character in the circle was in line with my camera. Cropping left and right.

Gare du Nord, Paris, 1950
NEGATIVE: 2¼×2¼ IN. (6×6 CM) _ D20/8
__ 386

I do not think that this picture is from a commissioned story because the negative is filed in an envelope labeled "Locomotives, trains, train stations," and the plastic pocket that contains the negative is marked "Gare du Nord." Completely backlit (as in the previous picture), which helps to accentuate the contrast between the plumes of smoke and the light background of the sky. Full frame.

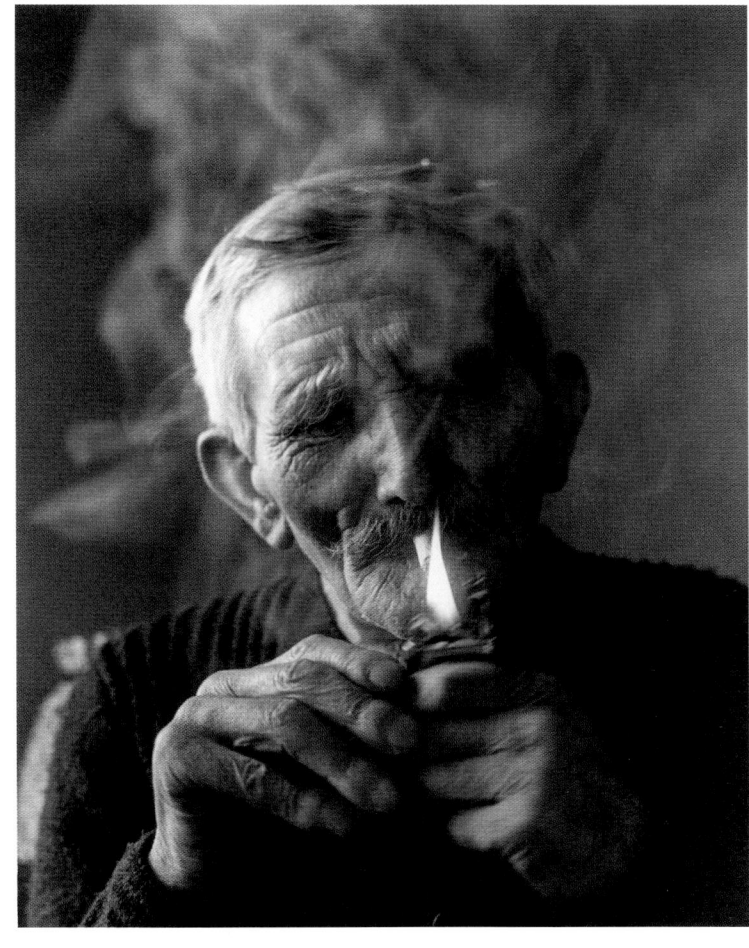

Miner with silicosis, near Lens, Pas-de-Calais, 1951
NEGATIVE: 2¼×2¼ IN. (6×6 CM) _ R21/1/4
___ 387

This miner with silicosis has already appeared in photo 109. He is pictured here behind his window, in a miner's cottage in Lens, his face ravaged by the final stages of the disease.
This negative was almost unusable because of a mistake I made while loading the film. As a result, the print requires partial retouching in its upper section. Almost full frame.

Marie-Anne and Vincent, Christmas, Paris, 1951
NEGATIVE: 2¼×2¼ IN. (6×6 CM) _ R21/28/21
___ 388

A small project on "Christmas at home." From an "illuminated Christmas tree" series, I selected this double portrait of Marie-Anne and Vincent. Their faces are lit exclusively by small candles. The multiplicity of light sources ensures that there are no projected shadows. Framing slightly cropped.

Nonagenarian, Noyon, Oise, 1952
NEGATIVE: 2¼×2¼ IN. (6×6 CM) _ R22/10/40
___ 389

Réalités commissioned a project from me about the elderly, which included this close-up of an unrepentant nonagenarian smoker. The lighting, which is rather harsh, comes from a window to the left of the frame. The framing is very partial. Indeed, the standard focal-length lens on the 2¼ × 2¼-in. (6 × 6-cm) camera leads to major distortions when the subject is too close. In this case the hands are oversized compared to the face. A close-up portrait requires a focal length of at least twice the standard lens. For 24 × 36-mm cameras with interchangeable lenses, a focal length of 90 mm is generally used.

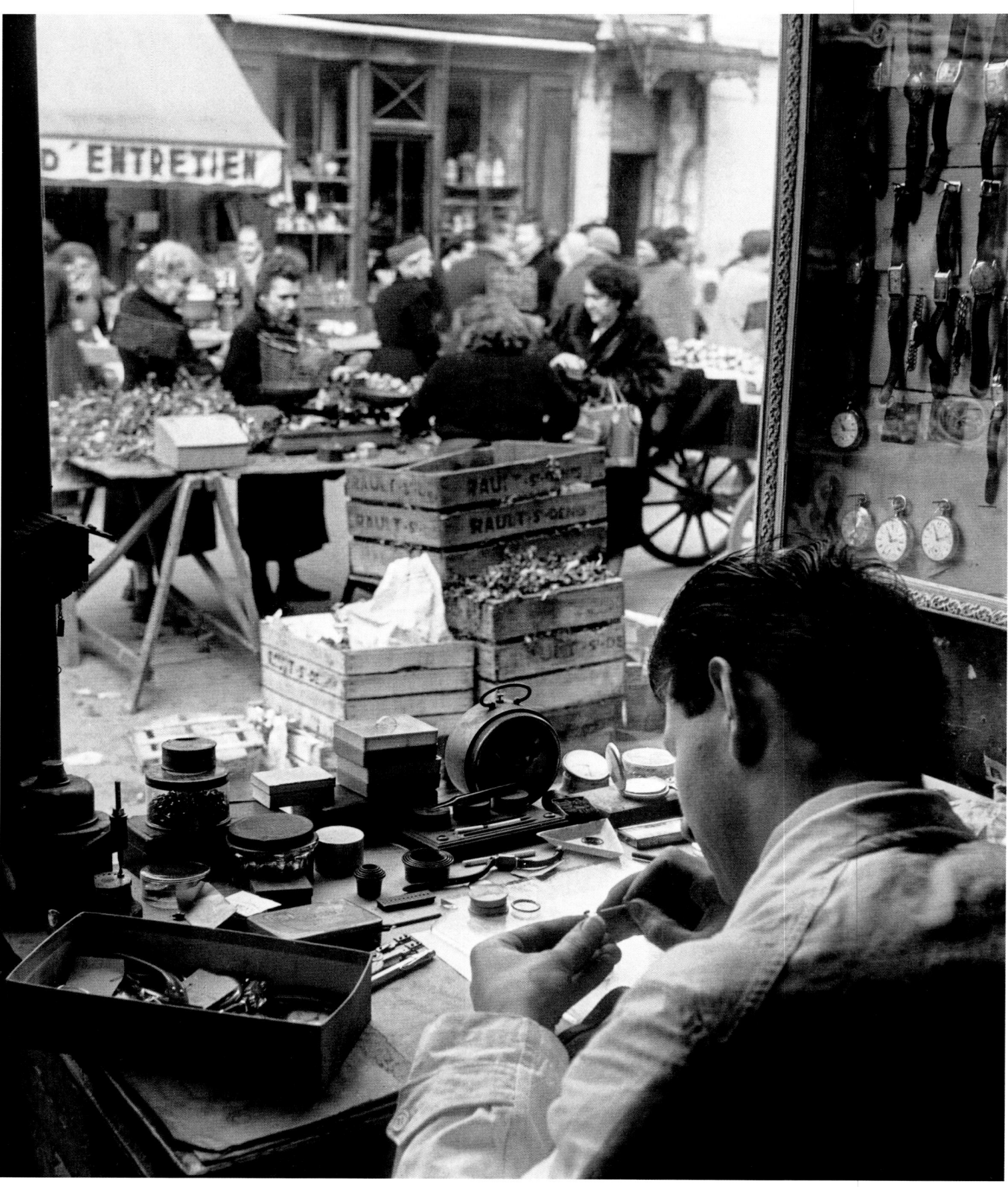

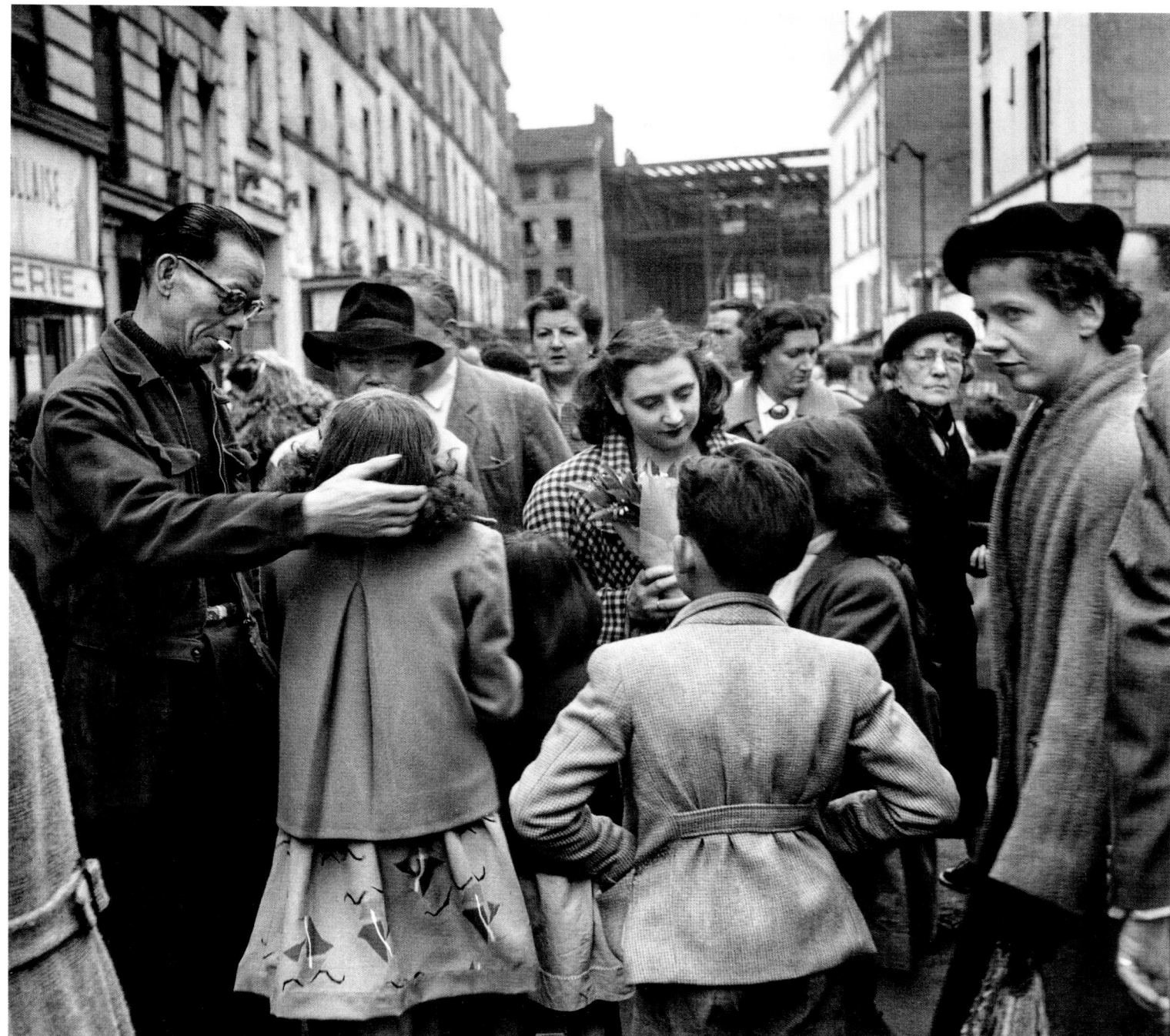

**In a watchmaker's store,
rue d'Aligre, Paris, 1952**
NEGATIVE: 2¼×2¼ IN. (6×6 CM) _ R22/14/42
— 390

During my report on the Aligre market in the twelfth arrondissement (see photo 125), I had noticed this little watchmaker's store. It was located on rue Aligre between place d'Aligre and rue de Charenton (most of the boutiques on this stretch have now disappeared). This young craftsman had kindly allowed me to work from his store, which gave me an interesting backdrop for the eye-catching market stalls and housewives in the neighborhood.
Slight lateral cropping.

Aligre market, Paris, 1952
NEGATIVE: 2¼×2¼ IN. (6×6 CM) _ R22/14/136
— 391

The story on the Aligre market had been delivered three weeks prior. As was often the case, I had become attached to the location and the subject, and had decided to take some pictures there on May 1. This is one of them: two friendly families meeting up.
Cropping top and bottom.

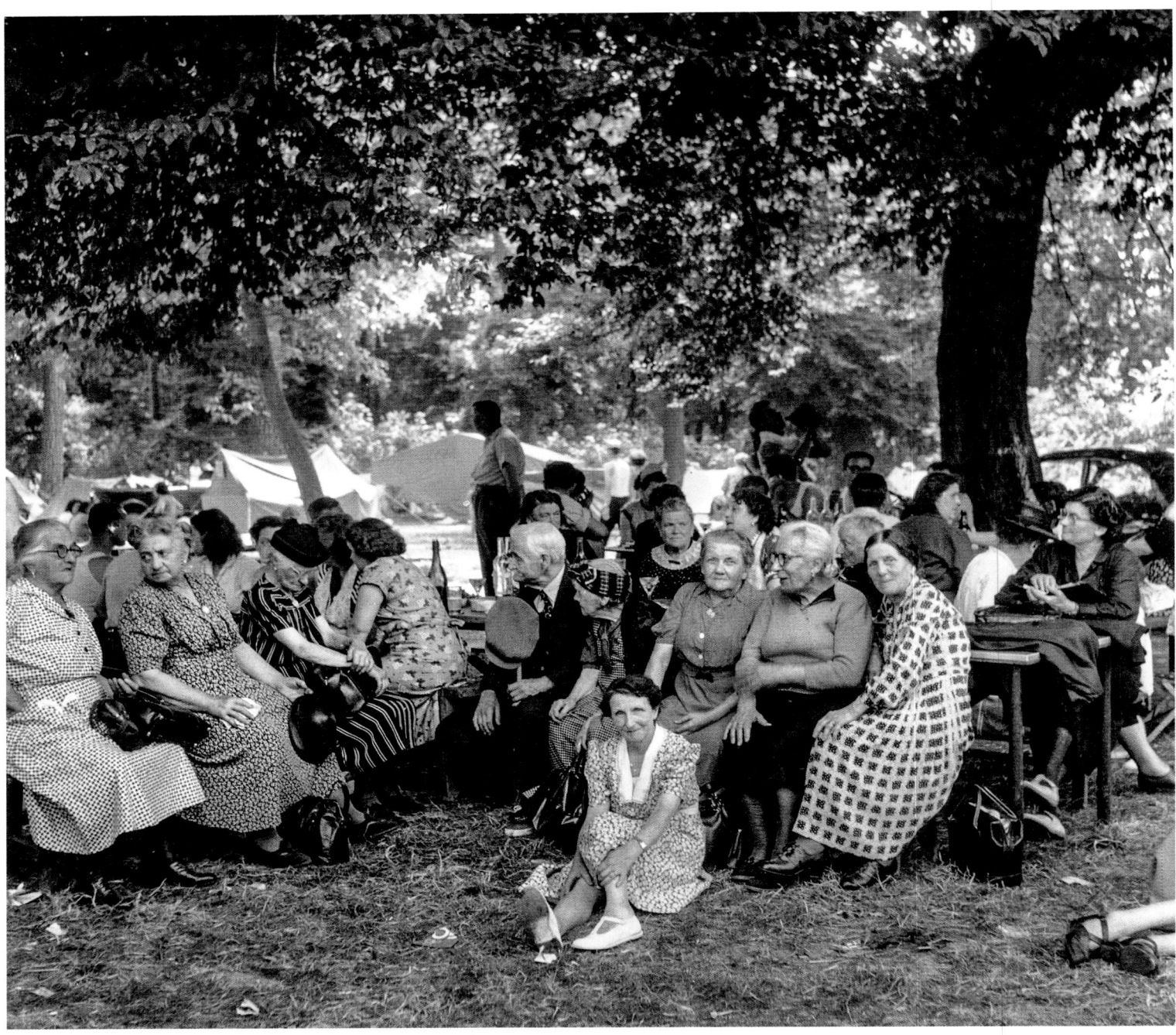

**Baillet-en-France,
Seine-et-Oise, 1952**
NEGATIVE: 2¼×2¼ IN. (6×6 CM) _ R22/23/4
___ 392

The SNECMA works council had invited me to a staff party in the Baillet-en-France park, between the forests of L'Isle-Adam and Montmorency. This picture shows a group of retirees, happy to get together on this beautiful Sunday in June.

Mont Saint-Michel, Manche, 1952
NEGATIVE: 2¼×2¼ IN. (6×6 CM) _ F22/310
___ 393

From the top of the ramparts of Mont Saint-Michel, I had noticed two fishermen crossing a rocky area at the foot of the wall in order to get closer to the water. I quickly went down to get nearer, on the off-chance of a photograph, and was able to take this frame when they were already far away. Very small aperture, to obtain a maximum depth of field. Cropped framing on the sides. The day before, I had taken photo 123 from the window of our hotel room.

Fisherman's yard at Mont Saint-Michel, Manche, 1952

NEGATIVE: 2¼×2¼ IN. (6×6 CM) _ F22/357

___ 394

Working-class yards often present an image of picturesque chaos, particularly for those indiscreet enough to peer in as their train takes them through the suburbs of the big cities. The reason for the chaos is simple: there isn't enough room. This somewhat surreal yard is not enclosed by four walls. Tourists to Mont Saint-Michel walk along one side while the other is open and enjoys stunning views of the sea. Otherwise, this picture is a typical example of the full-frame use of the 2¼ × 2¼-in. (6 × 6-cm) format.

Tour de France passing through Carpentras, Vaucluse, 1952

NEGATIVE: 2¼×2¼ IN. (6×6 CM) _ R22/25/1

___ 395

It was July, and we were heading down by car to our house in Gordes—acquired as a ruin in 1948—to spend our vacation and pursue a new round of work. In Carpentras we had to stop to let the Tour de France go past (there was no highway as yet). I climbed on the side of my old Citroën (a 1934 Rosalie) and immortalized the racers by following them in the framing viewfinder of my Rollei, like the hunter who follows a duck in his crosshairs. I chose a small aperture, which forced me to use a relatively slow shutter speed, 1/25 second. In this way, the spectators and the environment are the ones that "move" and are blurred (see the opposite effect in photos 153, *Bollène*, and 281, *The breakdown*).

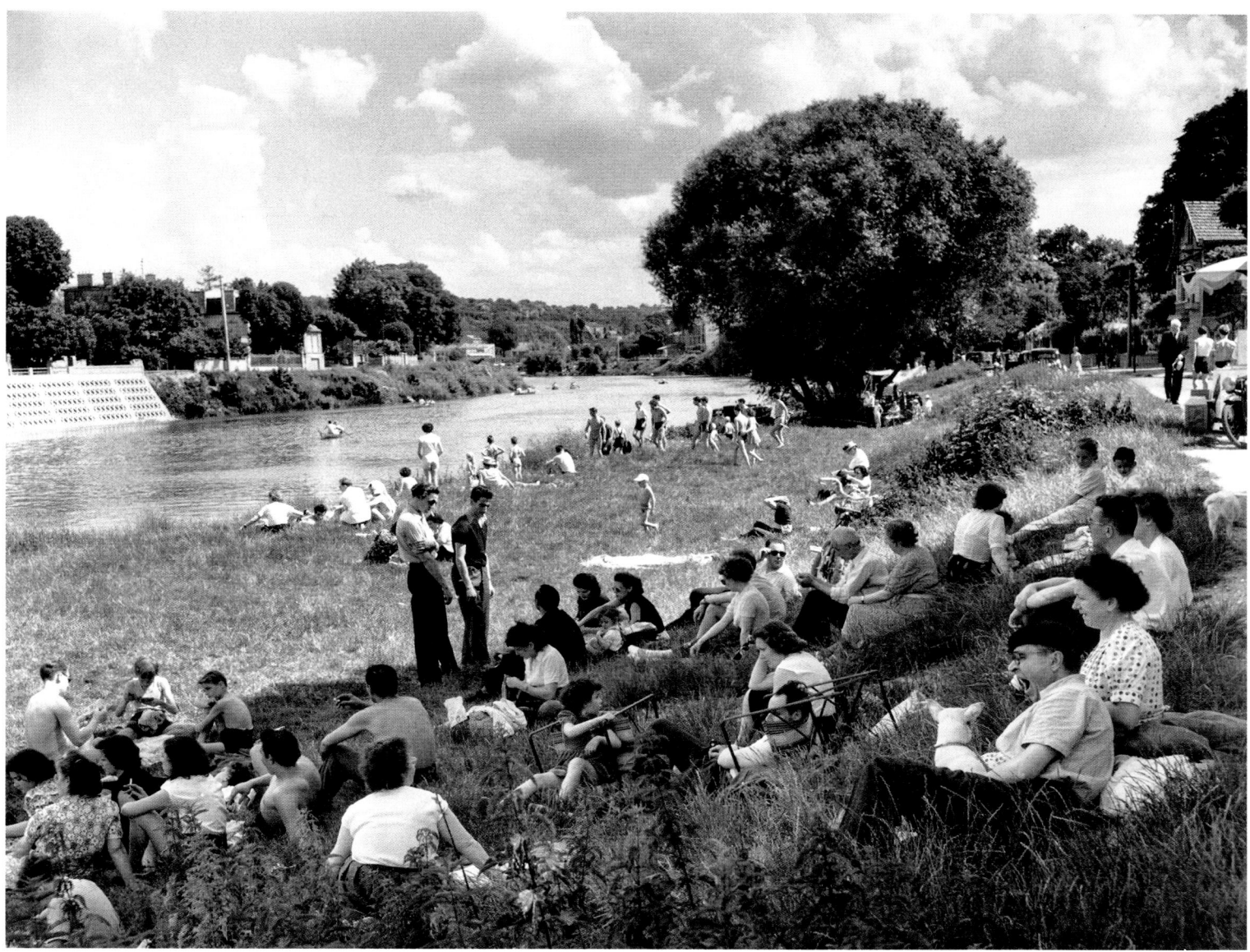

**Square du Vert-Galant,
at the downstream tip of the
Île de la Cité, Paris, 1953**
NEGATIVE: 2¼×2¼ IN. (6×6 CM) _ P23/96
— 396

The quays: one of my favorite routes between two assignments. I was standing on the wall separating the square du Vert-Galant from the sidewalk that goes around it. This retiree had turned his back to the sun (hidden at the time of this shot) for better reading conditions. Beyond the trees is the Louvre.
Framing cropped on the right.

**Le Perreux-sur-Marne,
Seine, 1953**
NEGATIVE: 2¼×2¼ IN. (6×6 CM) _ F23/865
— 397

I believe that on this day I was looking for pictures of young girls sailing on the Bonneuil basin, to illustrate a brochure on water sports that the publisher Montel had commissioned from me. In any case, I know that having completed my work on the Bonneuil basin, I strolled along the banks of the Perreux, in search of images of "Sunday on the water's edge" for my archives. The Marne was calm on this late afternoon in June. On the right, a bored man is yawning.
Cropping top and bottom.

A Sunday on the frozen lake of the Bois de Boulogne, Paris, 1954

NEGATIVE: 2¼×2¼ IN. (6×6 CM) _ R24/5/11

___ 398

February was very cold that year. I heard on the radio that the Bois de Boulogne lake had frozen enough to allow ice skating. Naturally, I went for the occasion. The sweeper in the center ventured onto the ice with the grace and prudence of a tightrope walker, presumably to sweep any possible trip hazards—twigs, stones, etc.—from the area. The policeman, frozen cold, is on duty to provide order and security. Cropping top and bottom.

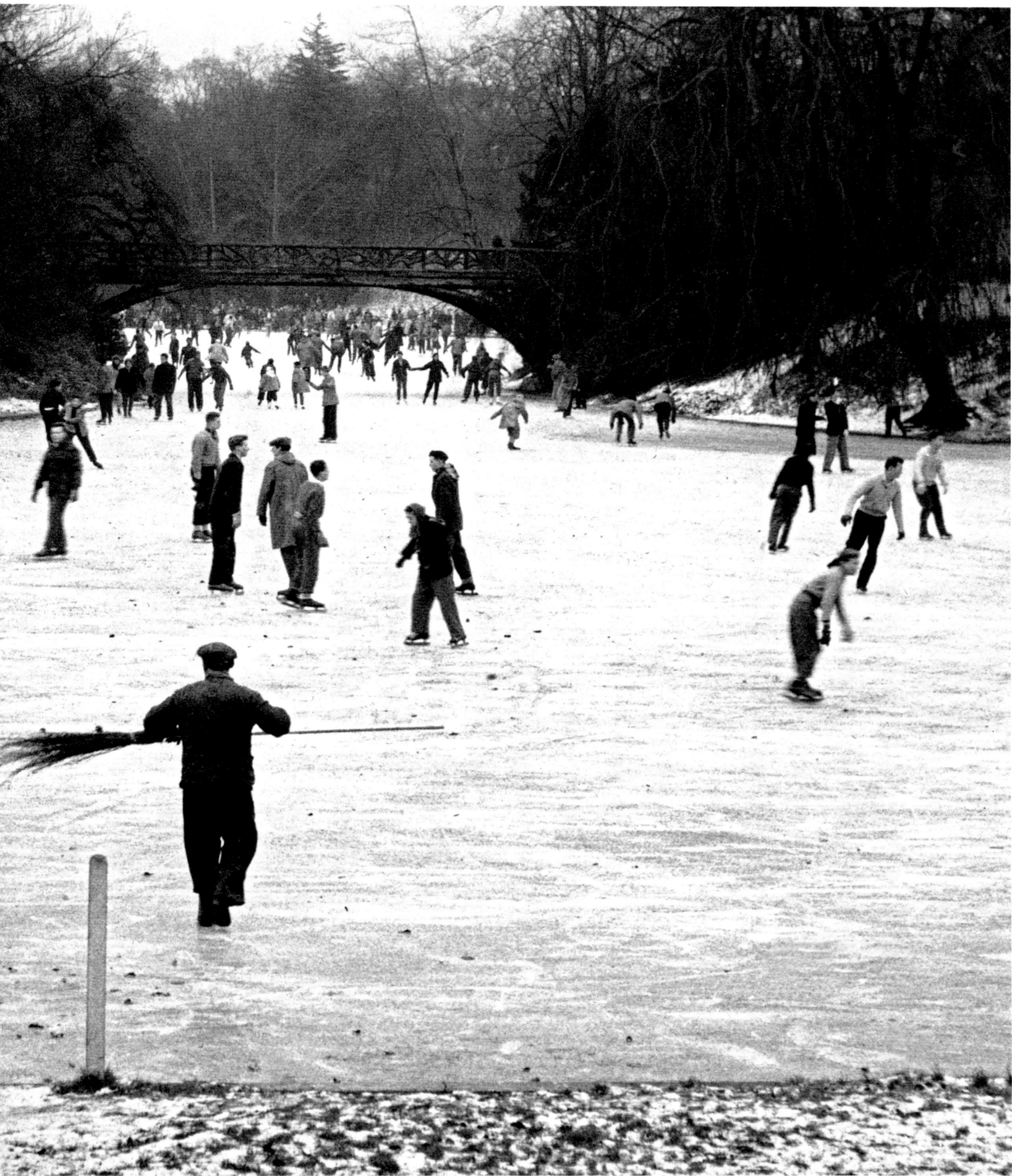

Women's car race, Paris, 1954
NEGATIVE: 2¼ × 2¼ IN. (6 × 6 CM) _ R24/6/79
___ 399

Rainy month of March. One of the organizers of the women's Paris–Saint-Raphaël race commissioned a small series from me on the start of the race, at a gas station in the fifteenth arrondissement. As the subject didn't interest me very much, or because I didn't find enough material, I fell back on the periphery of the story. This apprentice bricklayer, fascinated by cars, had stopped to take a look. He had no idea that his image, from that moment, would be filed away in the archives of a photographer and might reappear in this way after slumbering in a drawer for thirty-six years.
Cropping left and right.

Violin-making, Mirecourt, Vosges, 1954
NEGATIVE: 2¼ × 2¼ IN. (6 × 6 CM) _ R24/7/18
___ 400

I had just taken photos in two textile factories in Guebwiller (Haut-Rhin). I was traveling by car, which meant that I could add to my archives, covering both tourism and subjects spotted along the way. Beforehand, I had done some work in a mill and a mechanical engineering plant, both in Mulhouse. I was by then very close to a somewhat secret area that a local friend of mine had told me about: the Sundgau, a province at the very south of Alsace on the Swiss border (see photos 143, 144, and 145). My program for the return trip included some work in a weaver's workshop in Luxeuil-les-Bains, from where I went to Mirecourt, the heartland of violin-making. This image is taken from a series shot in a violin-maker's workshop in that town. It shows the insertion of a small piece of wood wedged between the bottom of the instrument and the soundboard, known as the violin's "sound post."

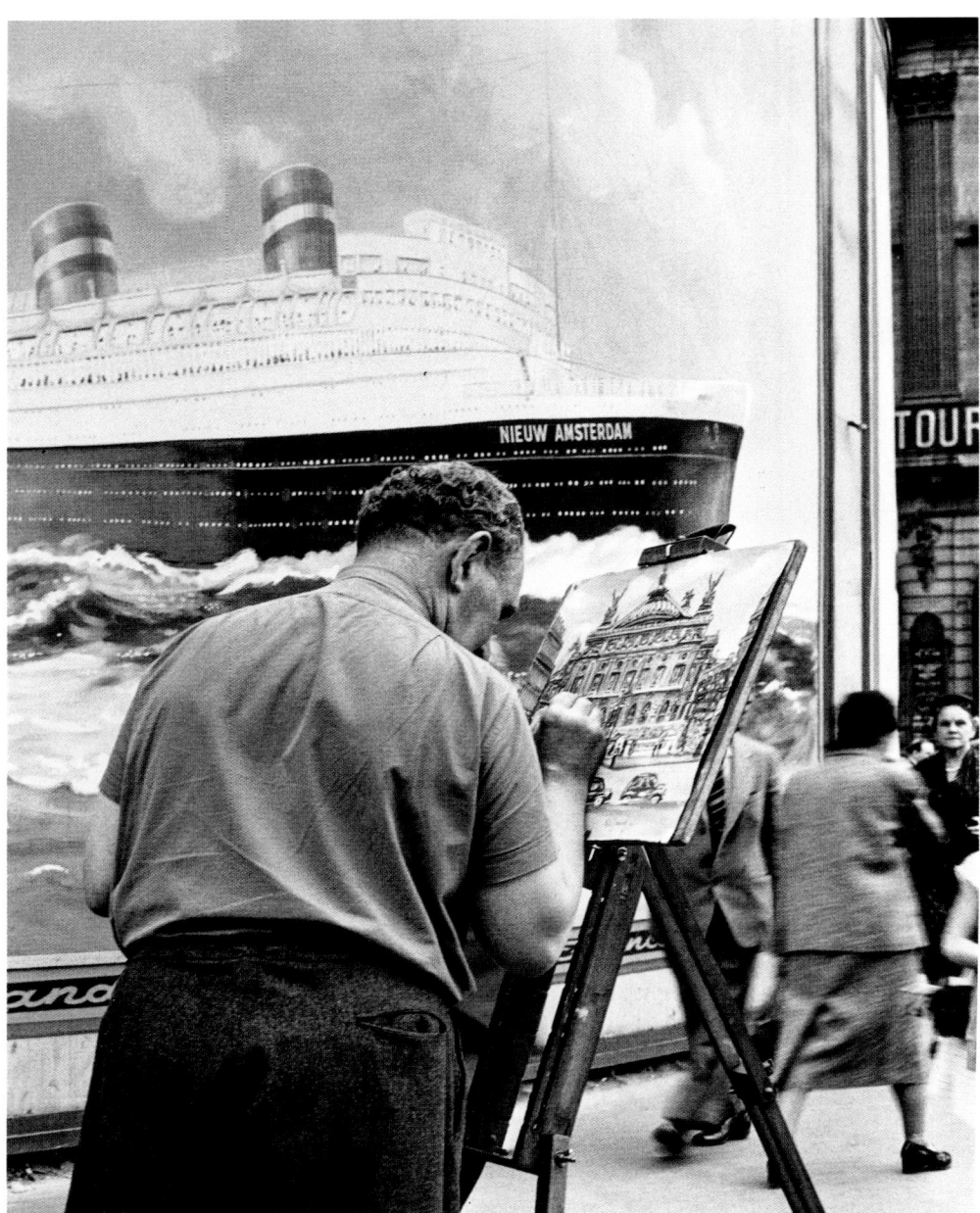

Corner of avenue de l'Opéra and rue de la Paix, Paris, 1954
NEGATIVE: 2¼×2¼ IN. (6×6 CM) _ P24/44
— 401

I was coming out of a travel agency on avenue de l'Opéra when I met this man painting the Palais Garnier in great detail. The ordinariness of the scene is shattered by the presence of the huge advertising billboard in the background, which could easily have been the work of the same meticulous artist. The very tight framing helps to make the situation more surreal.

Quai d'Ivry, Paris, 1954
NEGATIVE: 2¼×2¼ IN. (6×6 CM) _ P24/116
— 402

Small outing on the banks of the Seine upstream from the Ponts de Bercy, Tolbiac, and National in early October. This photo was taken from the Left Bank, from under the Pont National, looking toward the factories in Ivry. Cropping top and bottom.

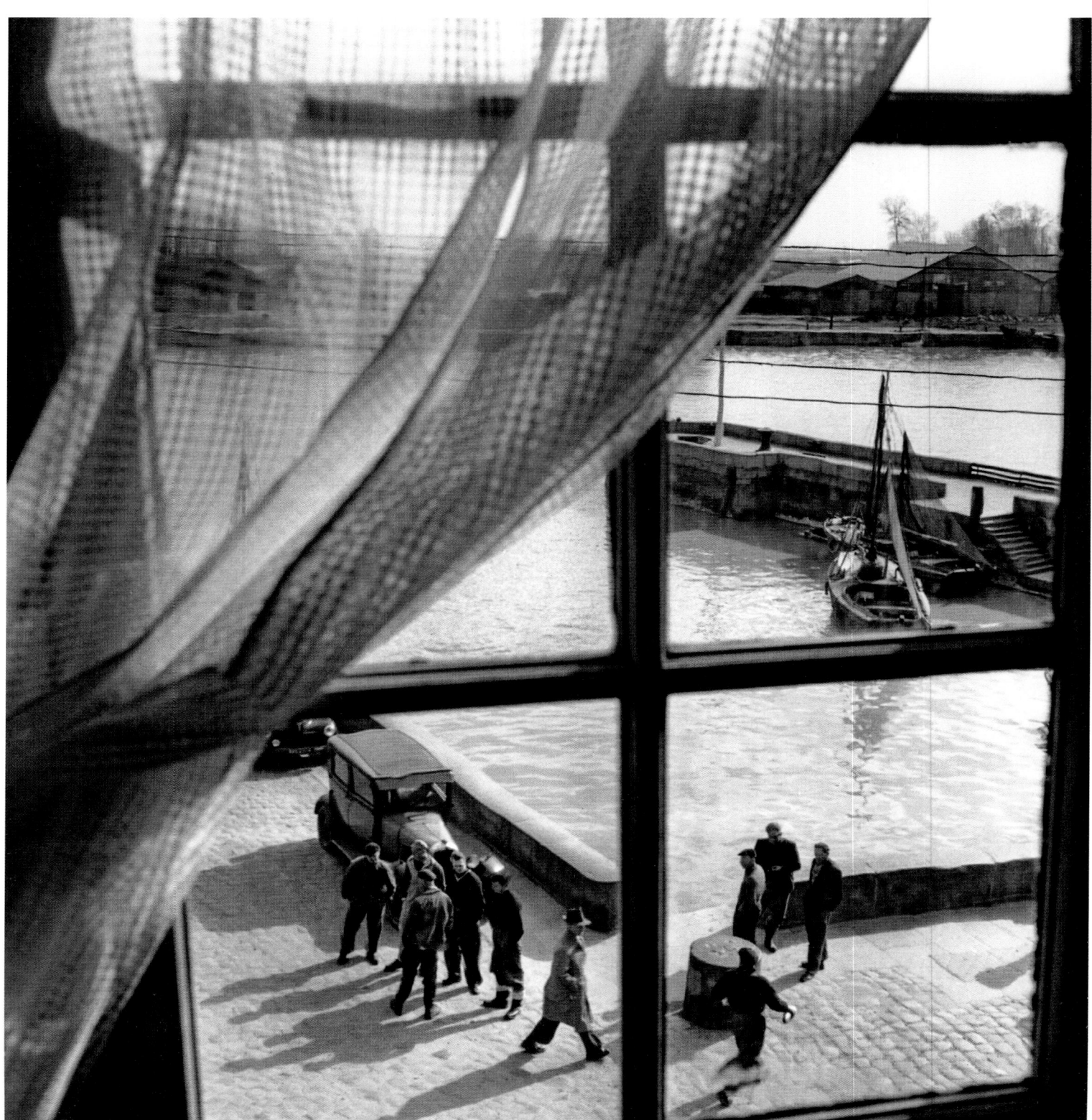

Honfleur, Calvados, 1954
NEGATIVE: 2¼×2¼ IN. (6×6 CM) _ F24/116
___ 403
No trace of this weekend in Normandy in my diary for that year. I just remember that I had spotted a hotel with windows that would likely provide an interesting view of the port of Honfleur.
Full frame.

Honfleur, Calvados, 1954
NEGATIVE: 2¼×2¼ IN. (6×6 CM) _ F24/126
___ 404
Same trip. We were strolling along the harbor. Another example of a previsualized photograph. After seeing this woman and then the glazed door under the vaulted entrance, I realized that the composition would make an interesting picture.
Framing slightly cropped laterally.

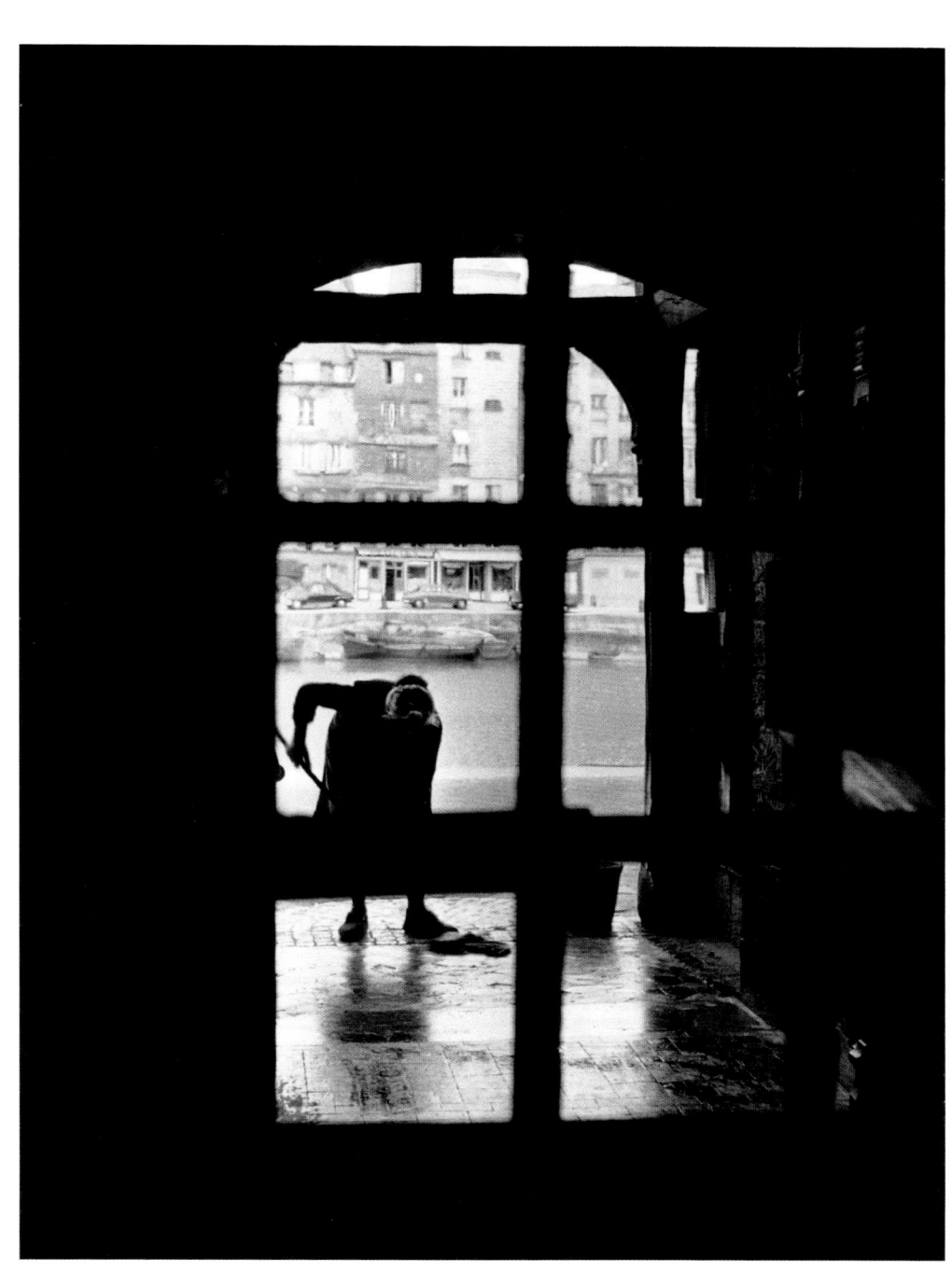

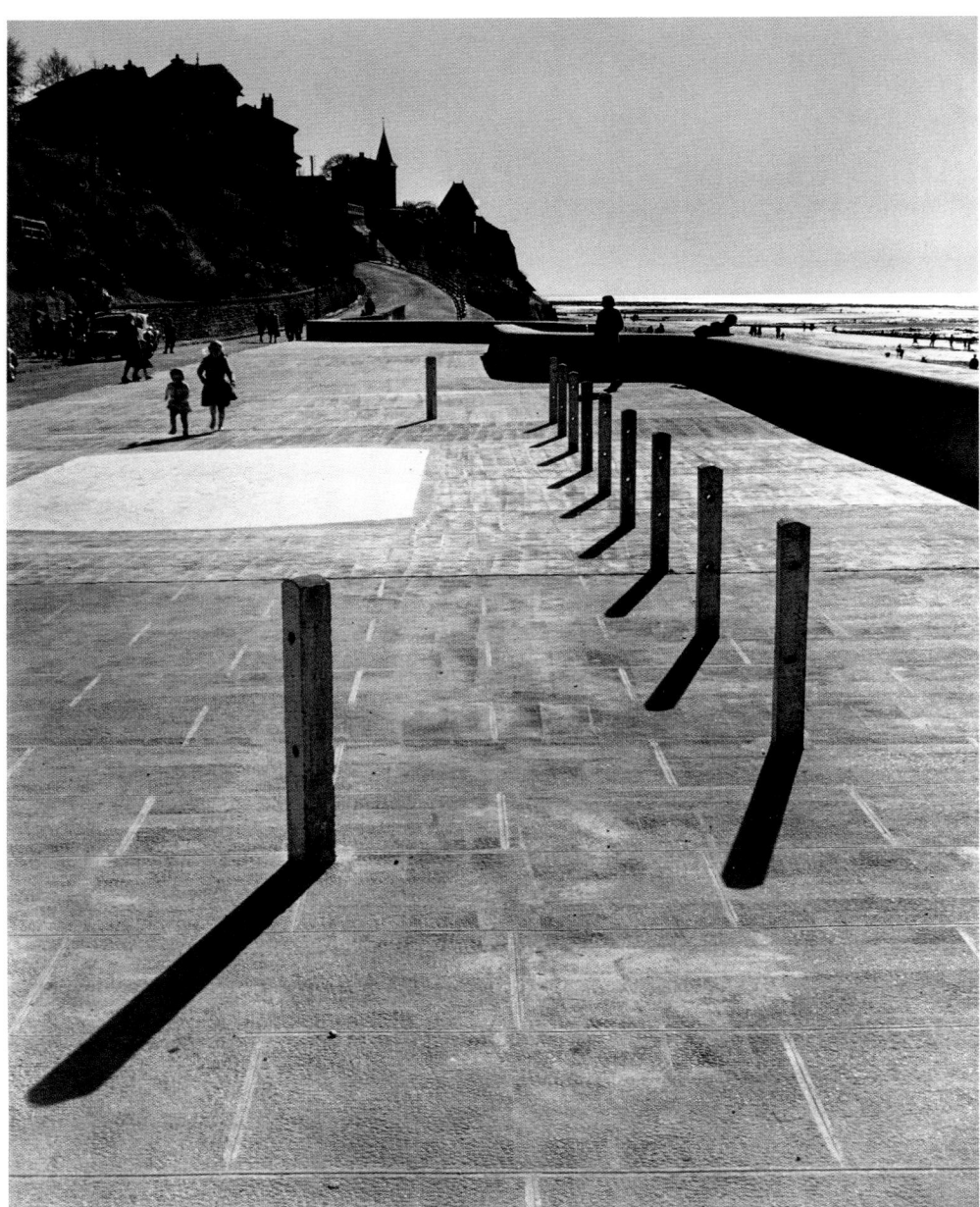

Villerville, Calvados, 1954
NEGATIVE: 2¼×2¼ IN. (6×6 CM) _ F24/157
___ 405
End of our short stay in Normandy. On the seawall of Villerville, a small seaside resort that was quiet on that day, a harsh backlight created sharp, graphic lines in a semiabstract composition. The little space given to the sky contributed to a certain dramatization of the subject. The two children in the background on the left filled an otherwise overly inhuman vacuum. Lateral cropping.

Louis Aragon, Paris, 1954
NEGATIVE: 2¼×2¼ IN. (6×6 CM) _ R24/31/9
___ 406
Visiting the famous couple of Elsa Triolet and Louis Aragon on rue de la Sourdière. I was there to do a double portrait of the two writers in the same image, and a portrait of the poet alone as director of the weekly *Les Lettres françaises*. The session was interrupted by the telephone. This picture wasn't part of the plan. In the background, Elsa Triolet is leaving the room for the kitchen. Lateral cropping.

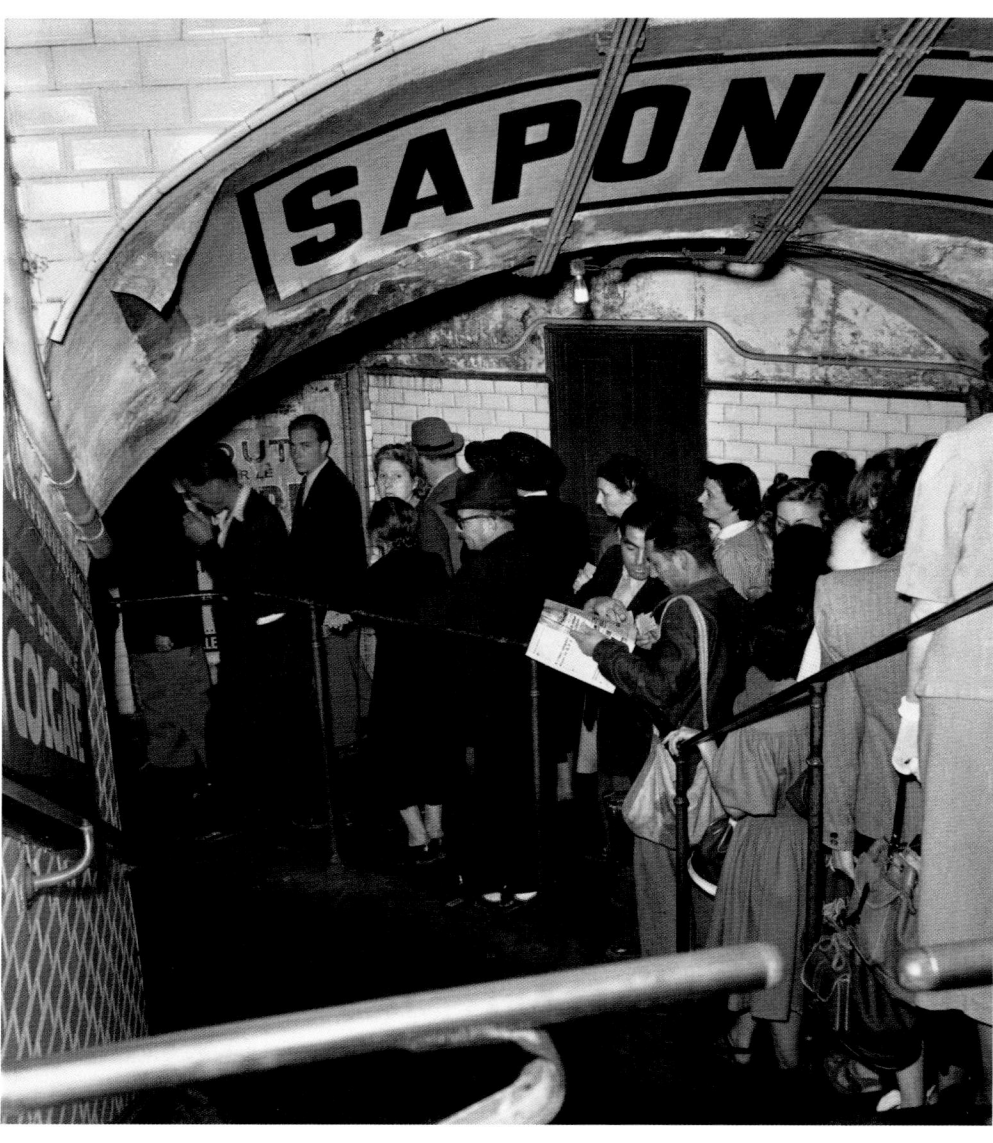

Metro staircase, Paris, 1954
NEGATIVE: 2¼×2¼ IN. (6×6 CM) _ P24/224
___ 407

At that time, the turnstiles allowing access to the metro platforms closed automatically when the trains were arriving, blocking passengers for a while in the corridors and stairs. It was the evening rush hour. I used a flash to preserve the memory of this familiar scene. Full frame.

Au Rendez-vous des Camionneurs bistro, quai des Orfèvres, Paris, 1955
NEGATIVE: 24×36 MM _ P8/1444
___ 408

At the end of 1954, I gave up my two stalwart Rolleiflexes (one for black-and-white, the other for color) and definitively adopted the 24 × 36-mm format (see commentary on photo 157), first with borrowed cameras and then, in the spring of 1955, with my own equipment. This shot was taken at the Rendez-vous des Camionneurs bistro on the quai des Orfèvres, during one of my walks on the quays. I had climbed the staircase leading to the mezzanine, from where I had a bird's-eye view with this interesting framing. To liven up my picture, I waited for a car and a pedestrian to go past. Beyond the semicircular glazed frame above the door the arches of the Pont-Neuf are visible. I would use this viewpoint again nine years later, when I returned to this bistro as part of a color story commissioned by Air France on the *terroir* restaurants of Paris. Full frame.

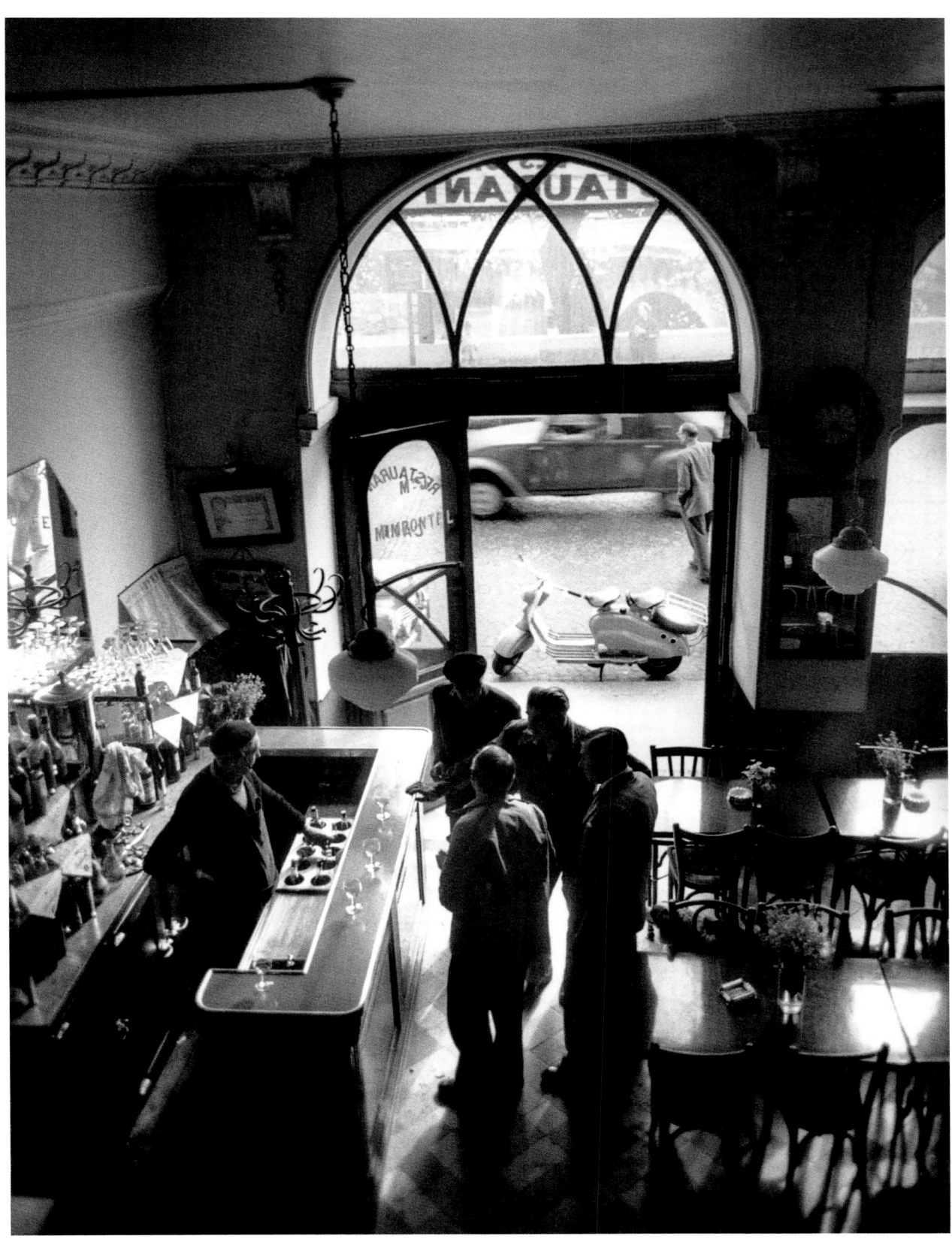

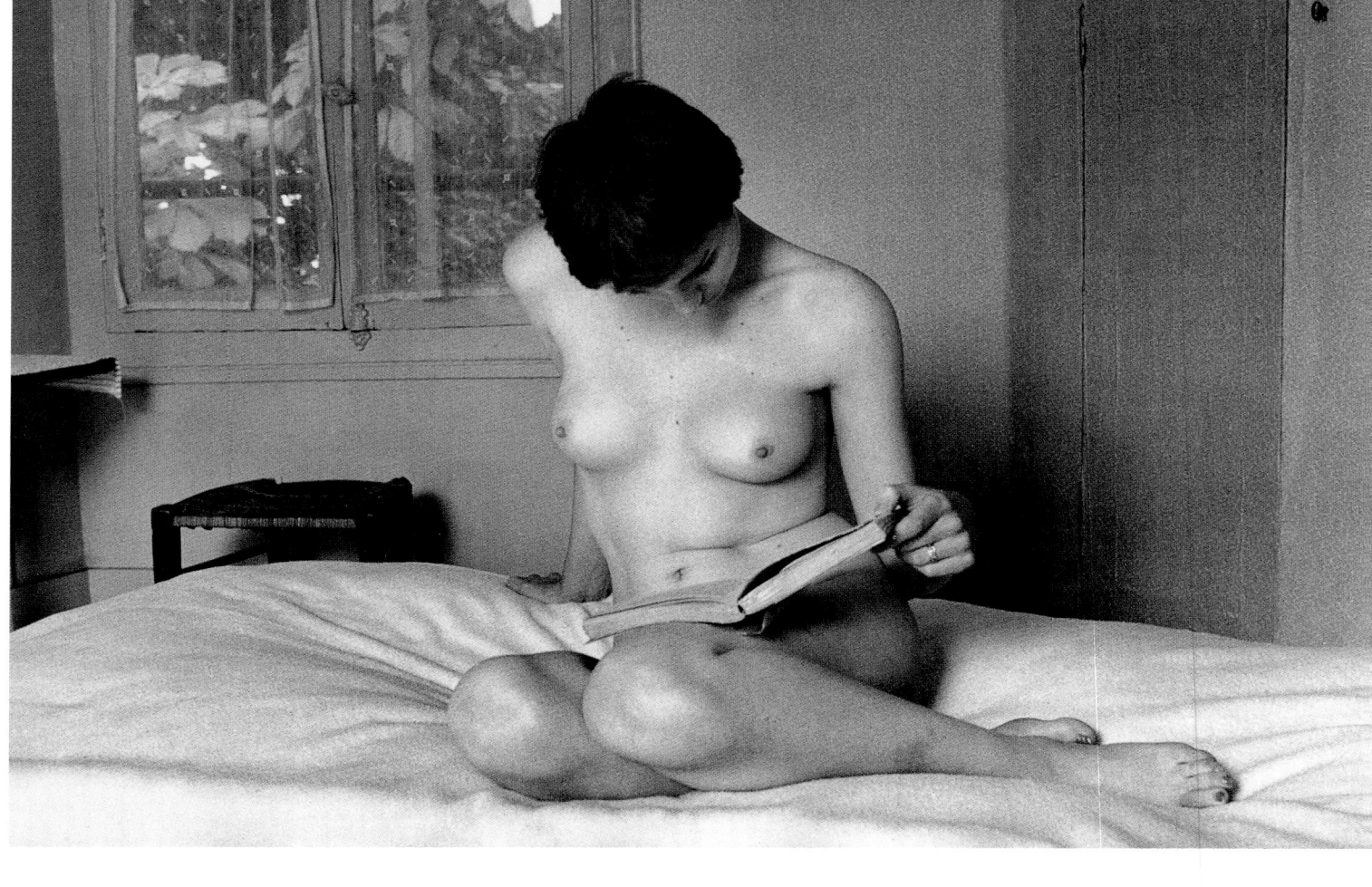

**Nude reading, Sceaux,
Seine 1955**
NEGATIVE: 24×36 MM _ D9/0940
— 409

A colleague recommended this model, a journalist who took this second job to top up her income. These shots took place at her home in the suburbs at the end of May. See also my photos 175 and 176. All the pictures were taken in natural light. Full frame. Since I started working in small format, my negatives are almost always enlarged full frame. The 35-mm format is a rigorous taskmaster.

**Saint-Germain-des-Prés,
Paris, 1956**
NEGATIVE: 24×36 MM _ P29/1644
— 410

During the spring of 1956, I undertook a project on Saint-Germain-des-Prés for a Polish weekly. As well as the leading figures I met—Boris Vian (photo 193), Jean-Paul Sartre (photo 195), etc.—I also roamed around the neighborhood. This photo was taken on one of my hunts in the area, following my own fancy. Almost full frame. 50-mm lens.

Place de Fürstenberg, Paris, 1956
NEGATIVE: 24×36 MM _ P30/1810
— 411

During this same project I suggested showing place de Fürstenberg. None of the photos that I had previously taken there really satisfied me, except for my nighttime fashion shot commissioned in 1952 by Lucien Vogel for a full page in *Le Jardin des modes* (see photo 120). While looking for a favorable viewpoint I noticed a small upstairs window that could provide an interesting perspective, given the lighting at the time. The building was a private school for girls and, when I described the window to the director, she exclaimed: "But those are the toilets!" "Never mind, Madame, I assure you that it will provide the best angle." Permission was granted. The window was very tall and narrow, and I climbed on the seat. No safety net. I raised the camera in both hands and framed by guesswork, at an angle I estimated would work. My hunch was correct. The image just needed to be cropped a little by cutting the right of the negative. 28-mm lens.

Concarneau, Finistère, 1956
NEGATIVE: 24×36 MM _ F36/0316
— 412

At the beginning of August, we left on a photographic vacation (!). Destination: Brittany (before heading to Gordes mid-month). Many photos taken for my archives. On that morning, in Bénodet, a little scene captured on the fly. Framing slightly cropped.

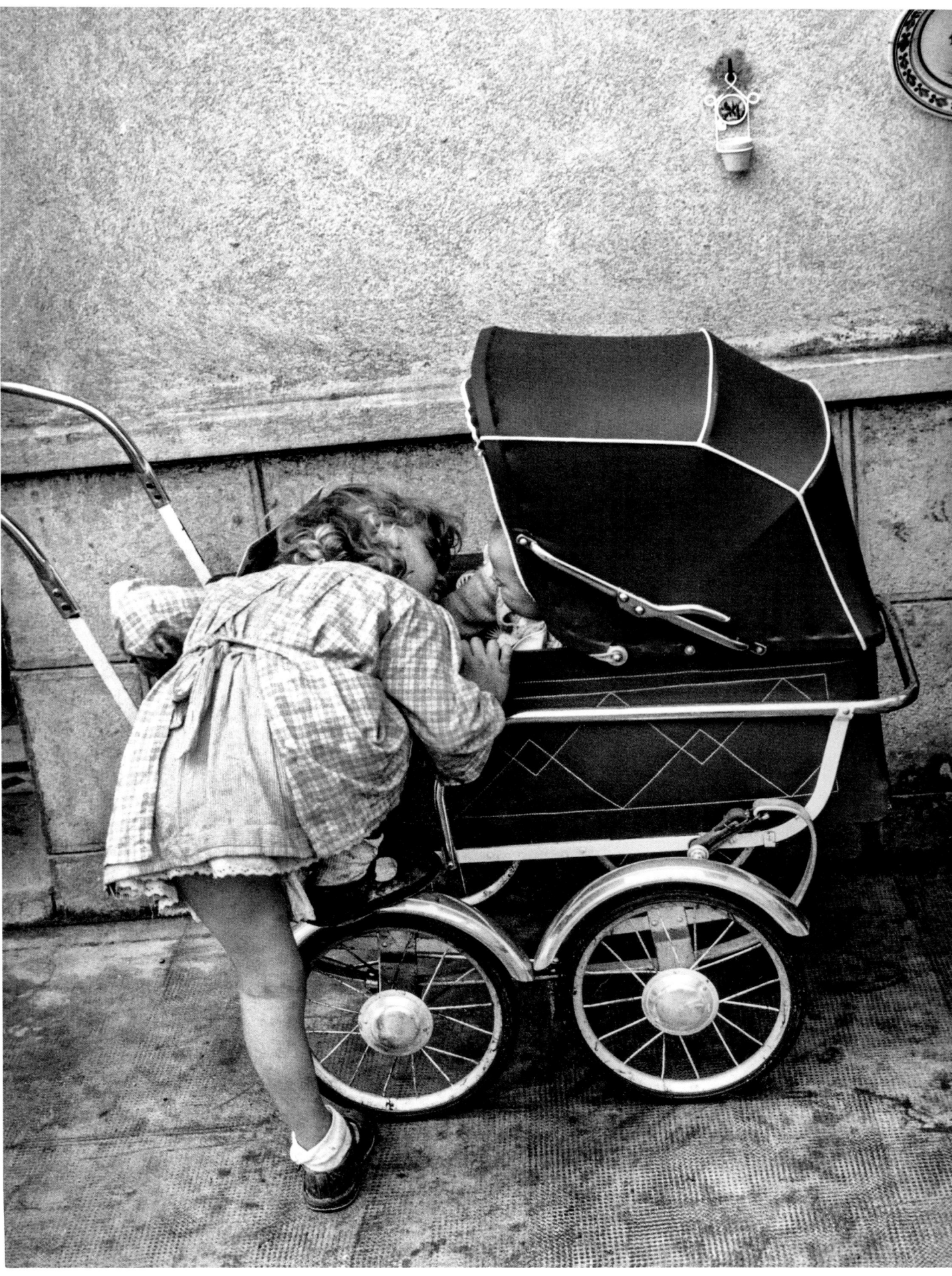

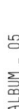

The Pont des Arts seen from the dome of the Institut de France, Paris, 1956
NEGATIVE: 24×36 MM _ P39/0220
___ 413

It was October 23. (Since starting to work in small format, I had adopted a very precise filing system for my negatives.) I obtained, with great difficulty, permission to climb up into the dome of the Institut to take photos of the Seine, bridges, roofs— in short, everything one could expect to discover from up there, and more. I had my full kit: my two Foca bodies (black-and-white and color), five lenses, filters, lens hood, etc. The weather was beautiful. I took this frame with a 28-mm, just as a riverboat was passing under the Pont des Arts. I then discovered the shadow of the dome on the tree to the right, which provided me with two pictures, in black-and-white and color, of it rising above the pavement of the quai de Conti (see photo 204). It was also from this extraordinary lookout that twelve years later, using a 135-mm lens, I took photo 297 showing the place du Pont-Neuf, the Hôtel de Ville, etc.

The lovers of the square Vert-Galant, Île de la Cité, Paris, 1957
NEGATIVE: 24×36 MM _ P41/0634
___ 414

Early January, another walk along the quays. The indiscreet 135-mm lens brought me closer to these lovers, who could not have cared less about the temperature or their surroundings. To fill in the foreground, I waited for the first boat willing to go upstream before the couple left. I got lucky. Note the black frame around the image. This is the edge of the full image and, for many (young) photographers, proof that they haven't cheated with the framing. I am less categorical. When I am surprised by a sudden event and press the shutter before I have had time to fully control the framing, I am not ashamed to recrop the image a little during enlargement (even if I lament it). The full negative is an ideal. But, with the unexpected, the ideal is not always guaranteed.

**The shadow of the July Column,
place de la Bastille, Paris, 1957**
NEGATIVE: 24×36 MM _ P43/0210
___ 415

On this Saturday, February 2, I was at the top of the July Column on place de la Bastille. It was early afternoon. The shadow of the column on the corner of boulevard Richard-Lenoir gave me an unexpected picture. I waited, of course, for the traffic to take on a harmonious form within the frame. As I was about to descend, I noticed the presence of a pair of lovers (see photo 209). Instinctively, I took their image (only one negative). I had no idea how successful this photograph would later become, nor that another chance encounter, some thirty-one years later, would turn this couple into friends of mine (see photo 460).

**In the kitchen-living room,
Gordes, Vaucluse, 1957**
NEGATIVE: 24×36 MM _ F59/1841
___ 416

Christmas vacation in Gordes. It had snowed. The cat looks melancholically at the transformed landscape. No particular comment. I may have slightly changed the position of the three objects on the windowsill. Maybe I didn't touch anything. The only thing I'm almost certain of is making sure that the two cypresses could be seen. Through this same window, in summer 1952, I had photographed *Vincent and the model aircraft* (photo 129).

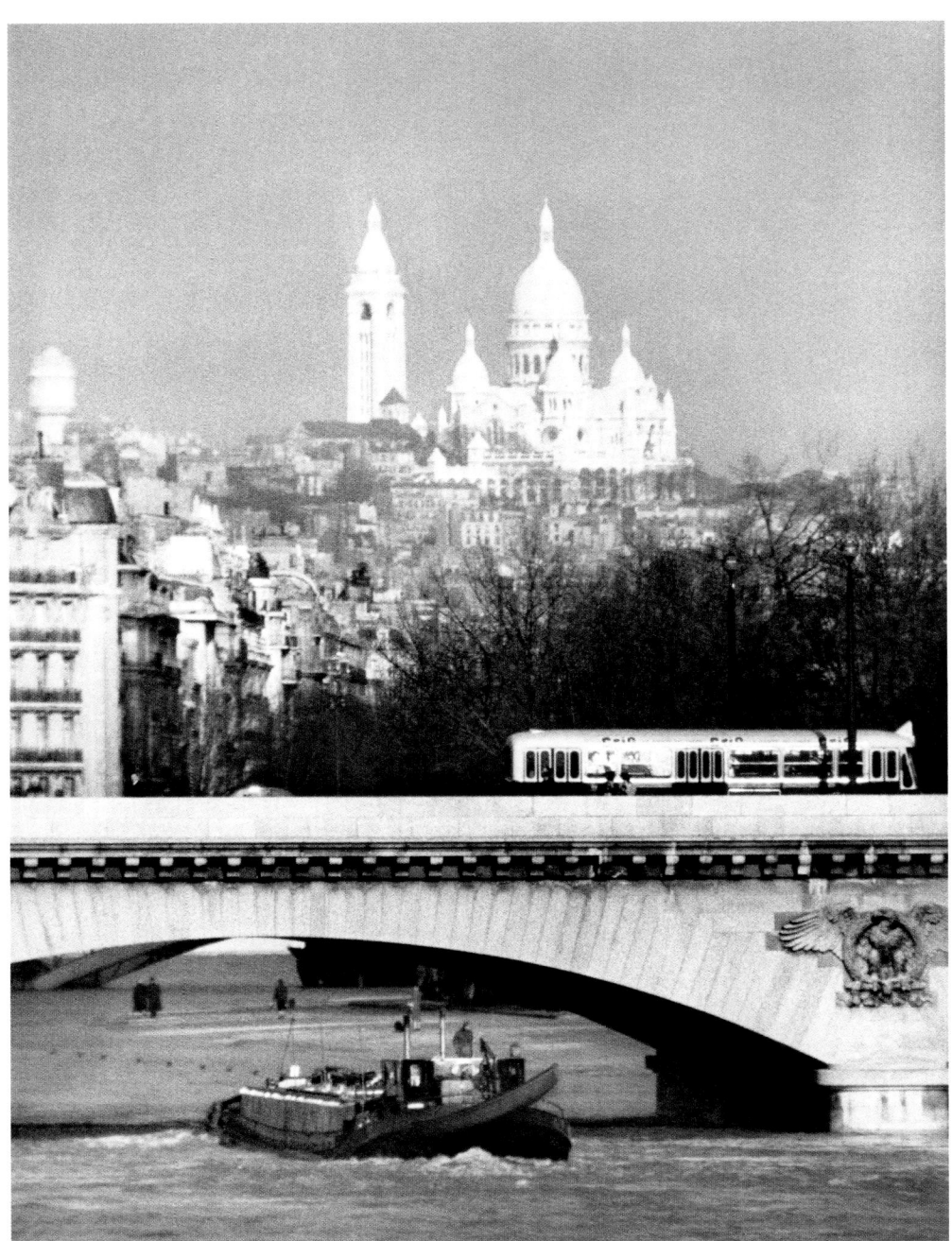

Pont d'Iéna and Sacré-Coeur Basilica, Paris, 1957
NEGATIVE: 24×36 MM _ P60/1322
— 417

I was working on an article for *Focagraphie*, text and photos, on the qualities of the 500-mm catadioptric lens that OPL (the makers of Foca cameras) had entrusted me with. I was on the Right Bank, very close to the Pont de Bir-Hakeim. The lens (a real barrel; they have become much more compact since) was screwed onto the micro-Foca SLR casing, with the Foca body mounted behind. The angle of view is ten times narrower than that of the 50-mm. This means that the foreground must already be quite far away when focusing to infinity. That is the case here, where the lower part of the image shows the Pont d'Iéna. I waited for the boat, and then the bus, to be in the right place. Technical prowess is not incompatible with attention to the composition.

Lake Maggiore, Italy, 1959
NEGATIVE: 24×36 MM _ 69/4418
— 418

On our way to Venice, we did not have much time to devote to Lake Maggiore. Why not have a souvenir of this short stop? This holidaymaker on her own rock amused me. A small sailboat passed by: the timing was perfect. 50-mm lens.

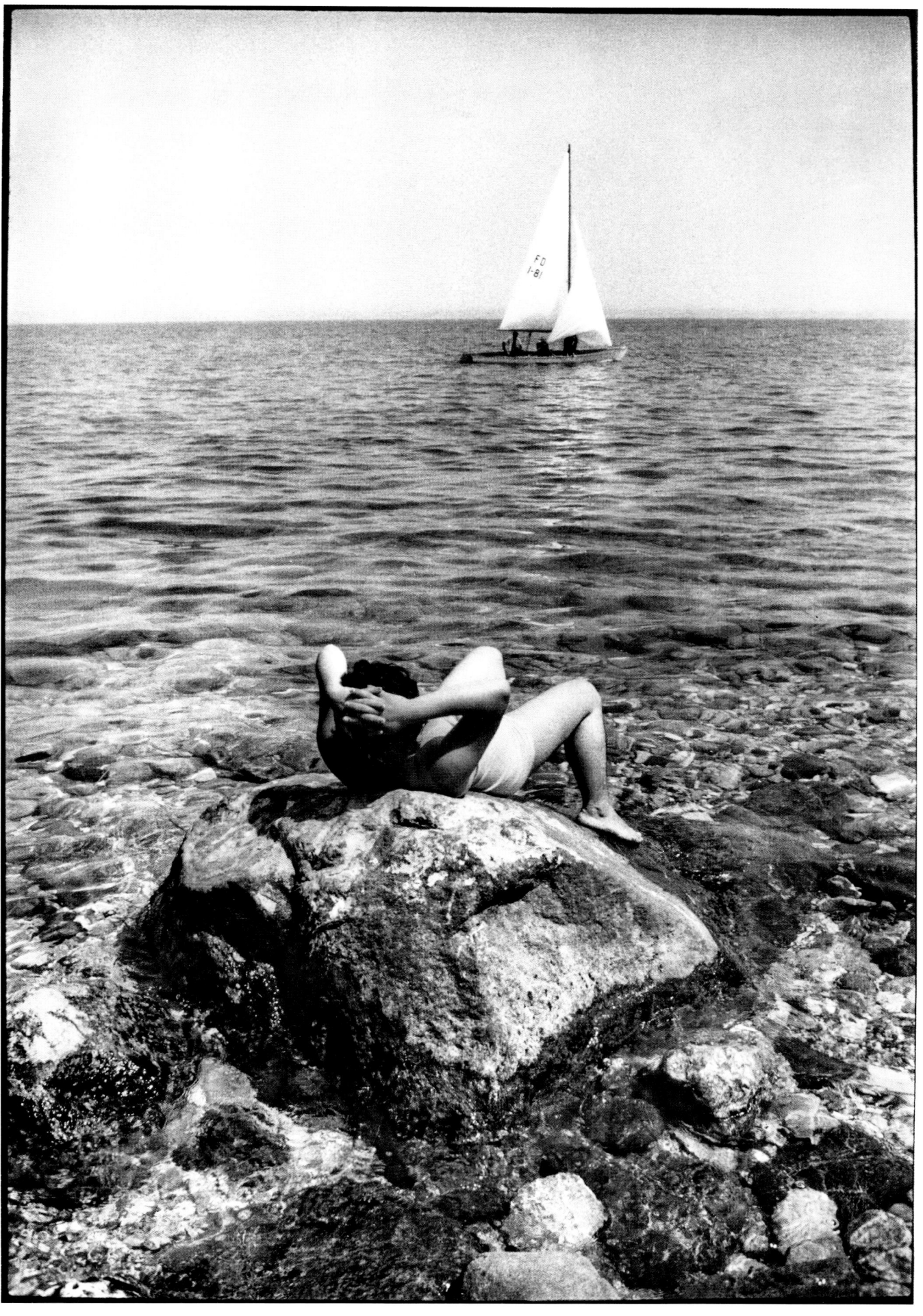

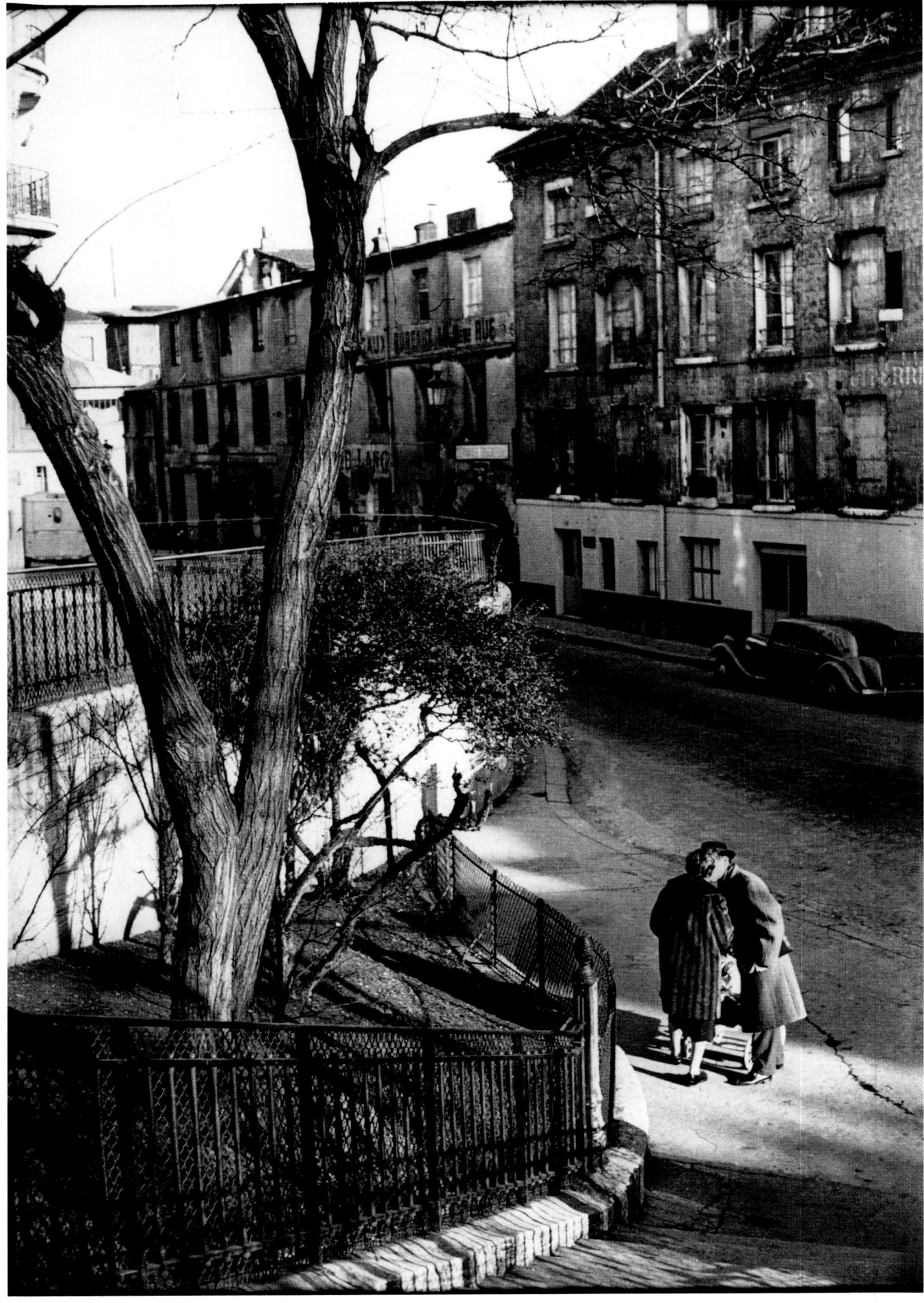

The lovers of rue de la Clef, Paris, around 1957
NEGATIVE: 24×36 MM _ INTERNEGATIVE FROM A SLIDE _ DAC1/4620
—— 419

I will admit, a little ashamedly, that I cannot date this photograph more precisely than to a three-year period. I printed it from a black-and-white internegative I had made from a Kodachrome slide. At the time, extreme negligence meant I did not date my slides with the same care as I did my black-and-white negatives. I just know that it was on rue de la Clef, around 1956–57, and, having recently wanted to find this location again, I discovered that the area had been transformed by redevelopment. 50-mm lens. Full frame.

New buildings, Maison de l'ORTF, from a building on rue Jean-de-La-Fontaine, Paris, 1959
NEGATIVE: 24×36 MM _ P72/0427
—— 420

My assignment was "The new buildings in the Paris region," and I was near the future Maison de la Radio. Noticing a building that was quite far away but had the advantage of being in line with both the Maison de la Radio and the Eiffel Tower, I obtained permission—this building itself being under construction—to use an open freight elevator. I stopped at the level that afforded me—horizontally, with the 135-mm lens—an interesting view of the two towers that were just slightly out of alignment. I waited a moment for the figure spraying a protective product on the building framework to assume an interesting pose, and my wish was granted. I then took some additional shots with other lenses and with my color body. Full frame.

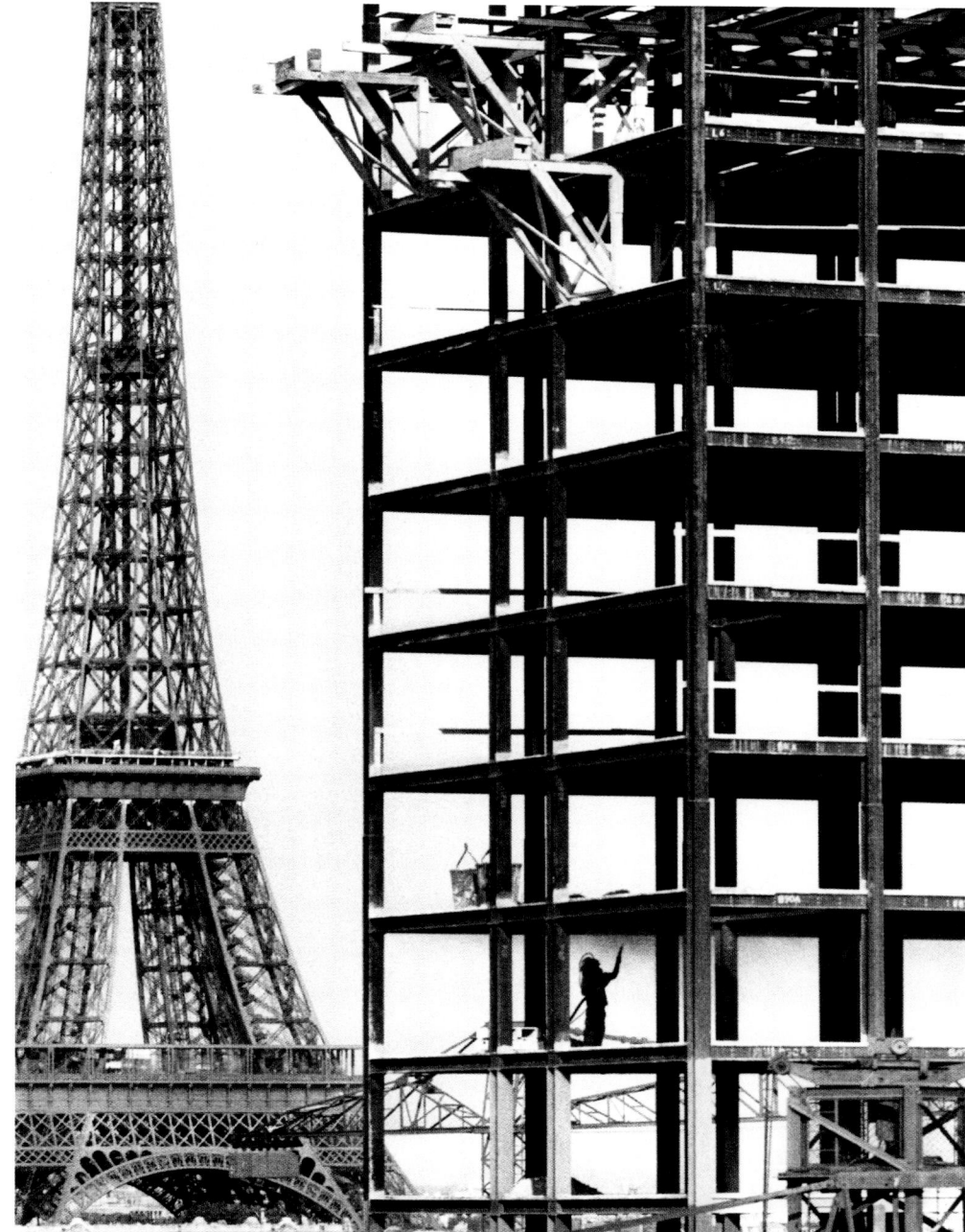

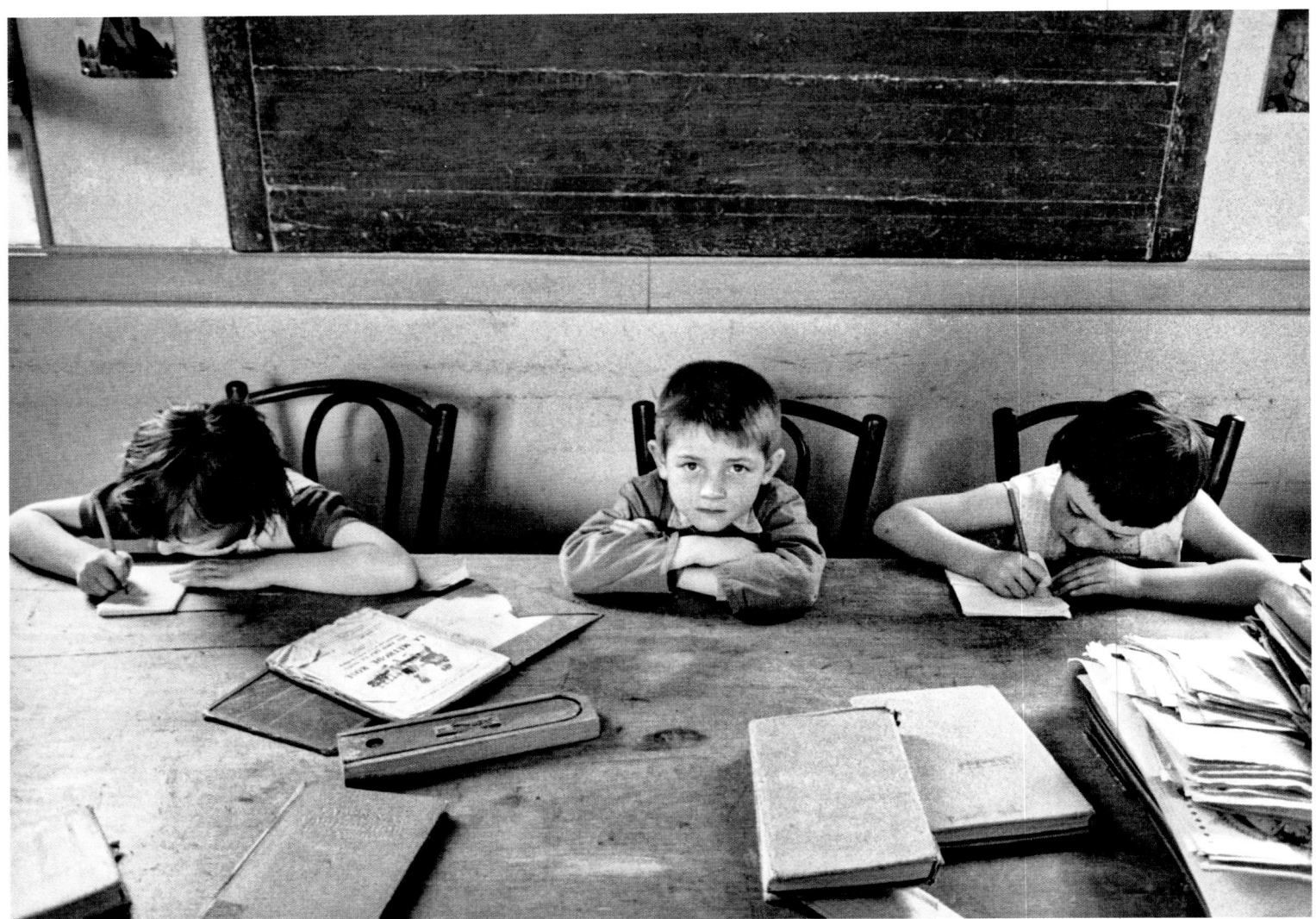

Rural school, Binson-et-Orquigny, Marne, 1960
NEGATIVE: 24×36 MM _ F80/1736
___ 421

The subject of this project: a secular rural school with a single class. Location: Binson-et-Orquigny, in the Marne, in May. 28-mm lens, because of the lack of space (I was working between the tables). From the same project, see photos 261 and 262. Natural light. Almost full frame.

The organ-grinder on the Pont des Arts, Paris, 1960
NEGATIVE: 24×36 MM _ P82/2717
___ 422

We already know this organ-grinder, whom I had photographed in January 1957 (photo 207). Here, it was summer and he had chosen a spot in the shade. The camera angle provides a lot of information: the location, the character, the Pont des Arts (once more), a passing riverboat (I had waited for it), a pediment of the Louvre beyond the leafy trees on the Right Bank. The 50-mm lens was stopped down to at least f/16 to ensure the maximum depth of field.

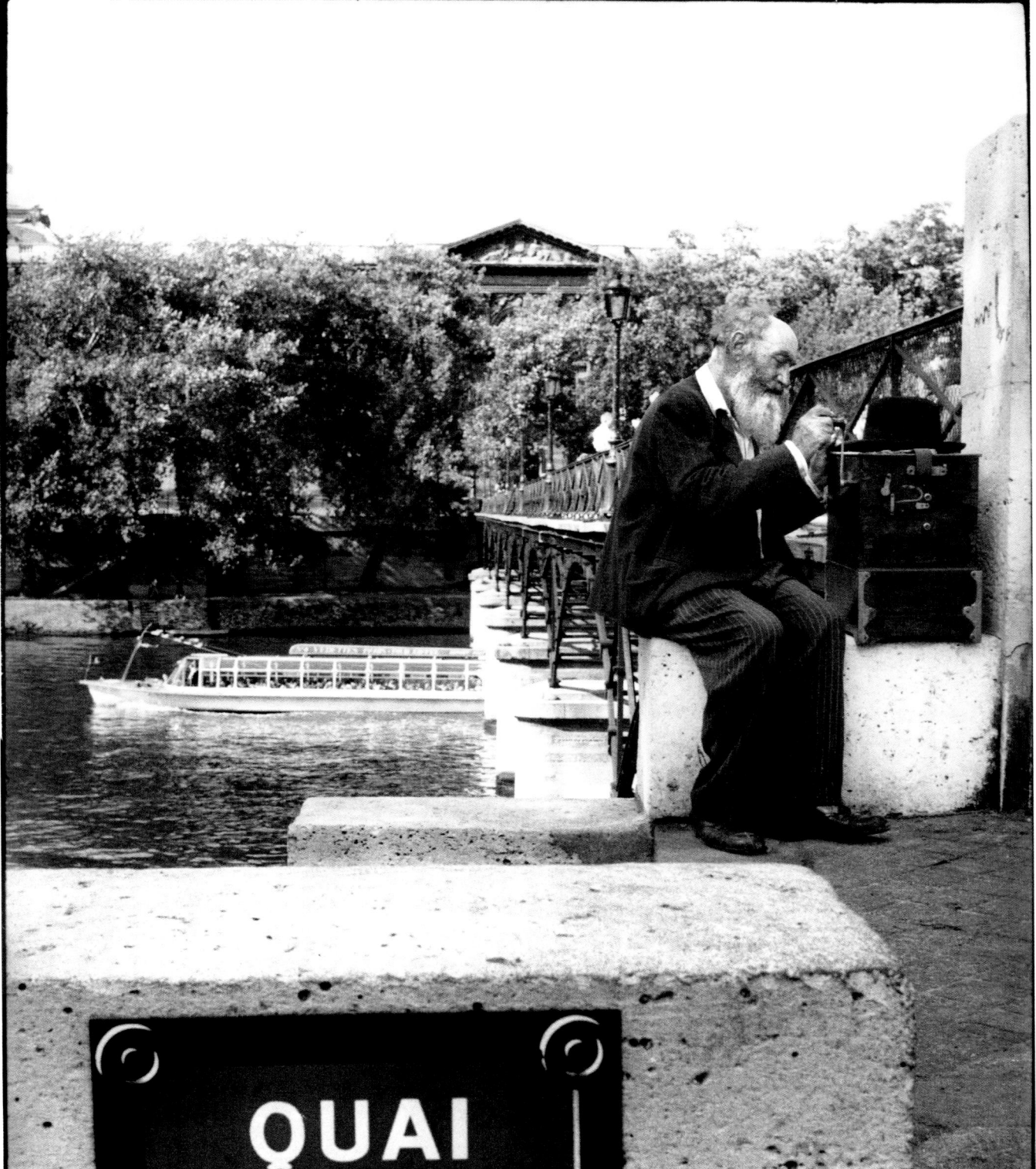

Quai de Valmy, Canal Saint-Martin, Paris, 1961
NEGATIVE: 24×36 MM _ P90/2242
___ 423

The monthly magazine *Réalités* had commissioned me to do a report with a "Simenon-style" atmosphere to accompany a critical study on the author of the fictional detective Jules Maigret. I shot almost everything between 4 a.m. and 6 a.m., in September, along the Canal Saint-Martin. This is quai de Valmy, near the bistro where truck drivers come to down a liqueur coffee before getting back behind the wheel. 50-mm lens with a wide aperture, 1/10 second, handheld.

The Pont des Arts, Paris, 1964
NEGATIVE: 24×36 MM _ P115/2935
___ 424

Between a technical story for *Europe-Auto,* my reportage on *terroir* cuisine for Air France, and our vacation in Gordes, I found myself at the tip of the square du Vert-Galant on a late afternoon in July. The clouds suddenly parted and gave me a nice ray of sun shining on the river. Quick: the 90-mm and click.

Rue du Temple, Paris, 1964
NEGATIVE: 24×36 MM _ P117/3102
___ 425

Once again, a break between two jobs for *Europe-Auto*. A little trip into the Marais, from which I brought back a few pictures, black-and-white and color. I neglected to note down the address of this mini store. Maybe it is still there? 50-mm lens. Almost full frame.

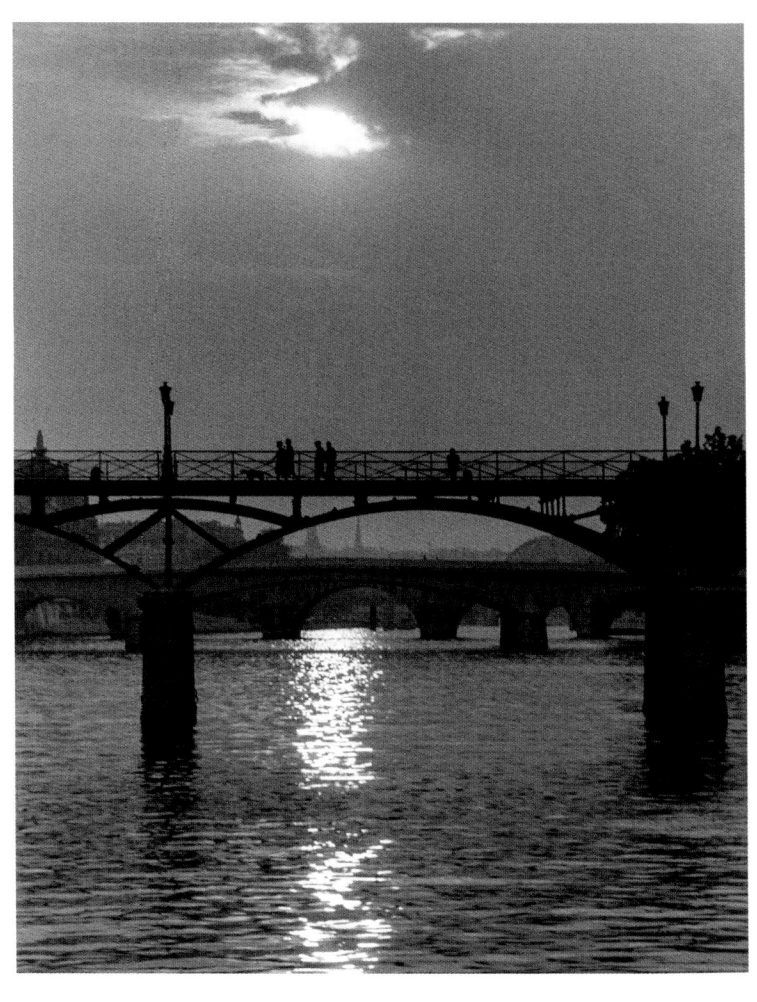

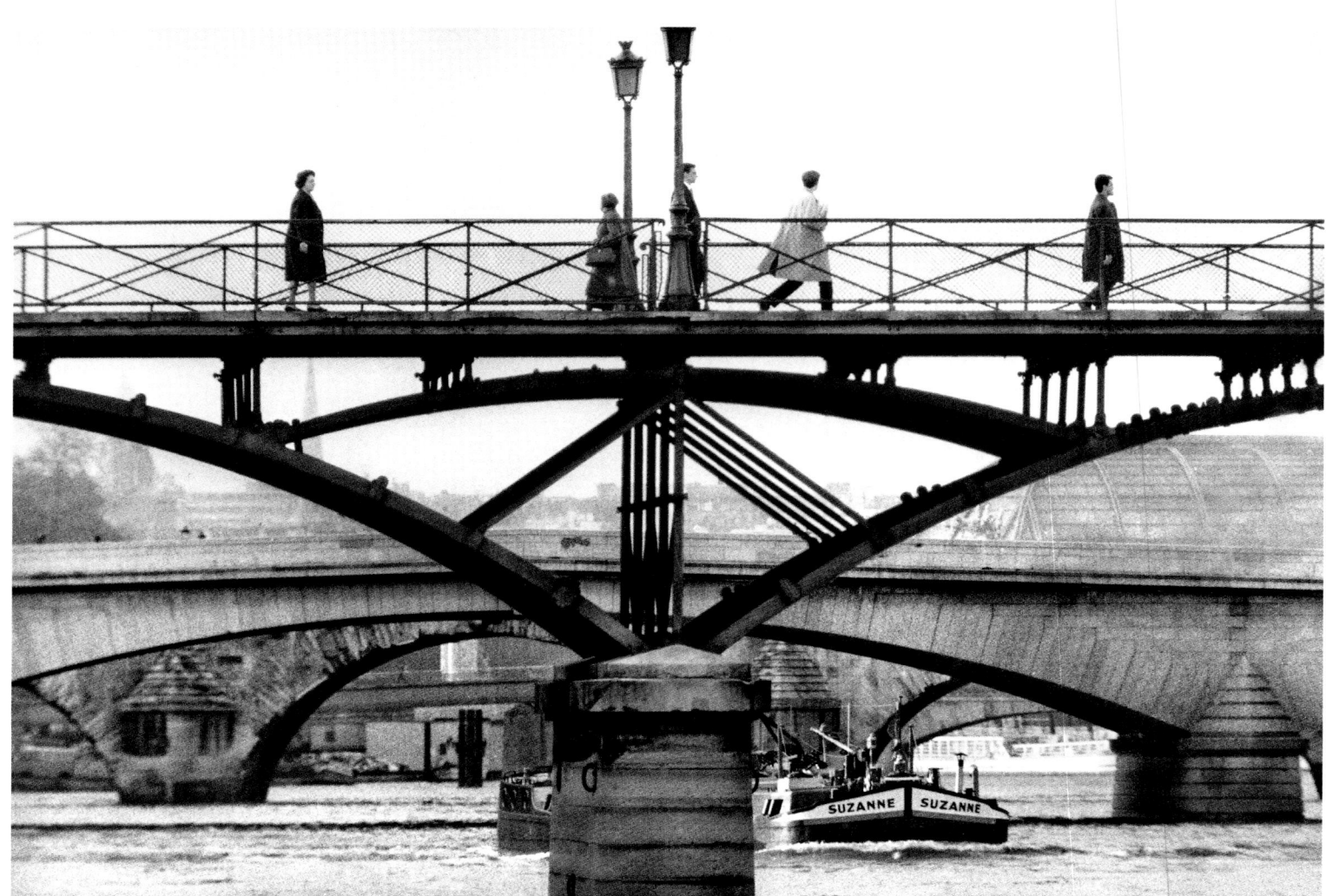

**Detail of the Pont des Arts,
at the downstream tip of the square
du Vert-Galant, Paris, 1966**
NEGATIVE: 24×36 MM _ P124/1411
___ 426

A few days earlier, one of the directors of *Stern* had given me an Edixa camera mounted on the Novoflex system, made up of a rifle butt with its trigger (to release the shutter) and a device for fast focusing. It is a little embarrassing to go out in the street equipped like this, and some people I passed looked slightly worried, mainly when I shouldered my machine. The 400-mm lens was mounted on the body for the photo above, taken from the square du Vert-Galant, as was photo 424.
Full frame.

Pont au Double, Paris, 1966
NEGATIVE: 24×36 MM _ P125/3427
___ 427

On the corner of the Pont au Double, on the Notre-Dame side. The artist was finishing from memory the painting he had done of the Petit-Pont, a few hundred feet downstream. His muse, patient, watched and waited.
Full frame.

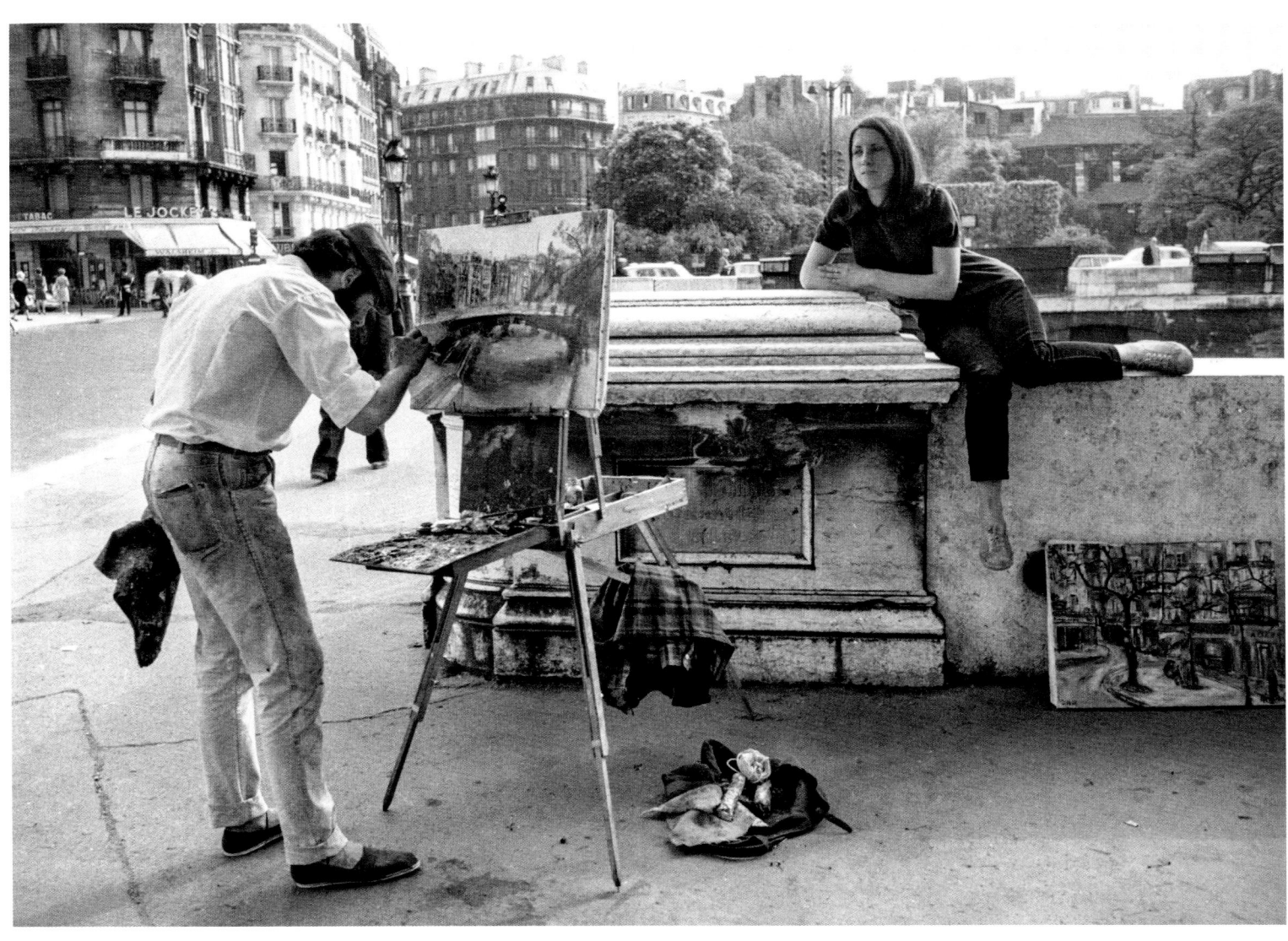

Self-portrait in East Berlin, East Germany, 1967

NEGATIVE: 24×36 MM _ 133/3137

— 428

I walked into the Hotel Berolina in East Berlin, where I had a room for two nights. I would be crisscrossing East Germany for three weeks, with a stop in Prague, and then my work would take me to Dresden. On this evening, I was in the hallway on my floor just as the sun came in line with it. A good opportunity for a self-portrait with the 28-mm lens. Full frame.

Musical instrument workshop, Kligenthal, East Germany, 1967

NEGATIVE: 24×36 MM _ 136/0518

— 429

July 18. I was in the musical instrument workshop in Kligenthal, East Germany (see photos 283 to 290). Two workers had just finished their meals in the canteen. Before getting back to work, one of them played "Michelle" by the Beatles. His companion, spellbound, listened to this tune for the first time. I had climbed up on a stool to better separate the planes. Full frame.

Nude, Gordes, Vaucluse, 1971
NEGATIVE: 24×36 MM _ D167/2324
___ 430

We had invited over a former student from Marie-Anne's drawing and painting class. From a series of nude studies of this model, I chose this photograph, taken with a 28-mm in our house in Gordes. The wide-angle sometimes has surprises in store: I had left my photoelectric cell on the bed. A little bit of retouching will turn this accessory into an unidentifiable object. Slightly cropped frame.

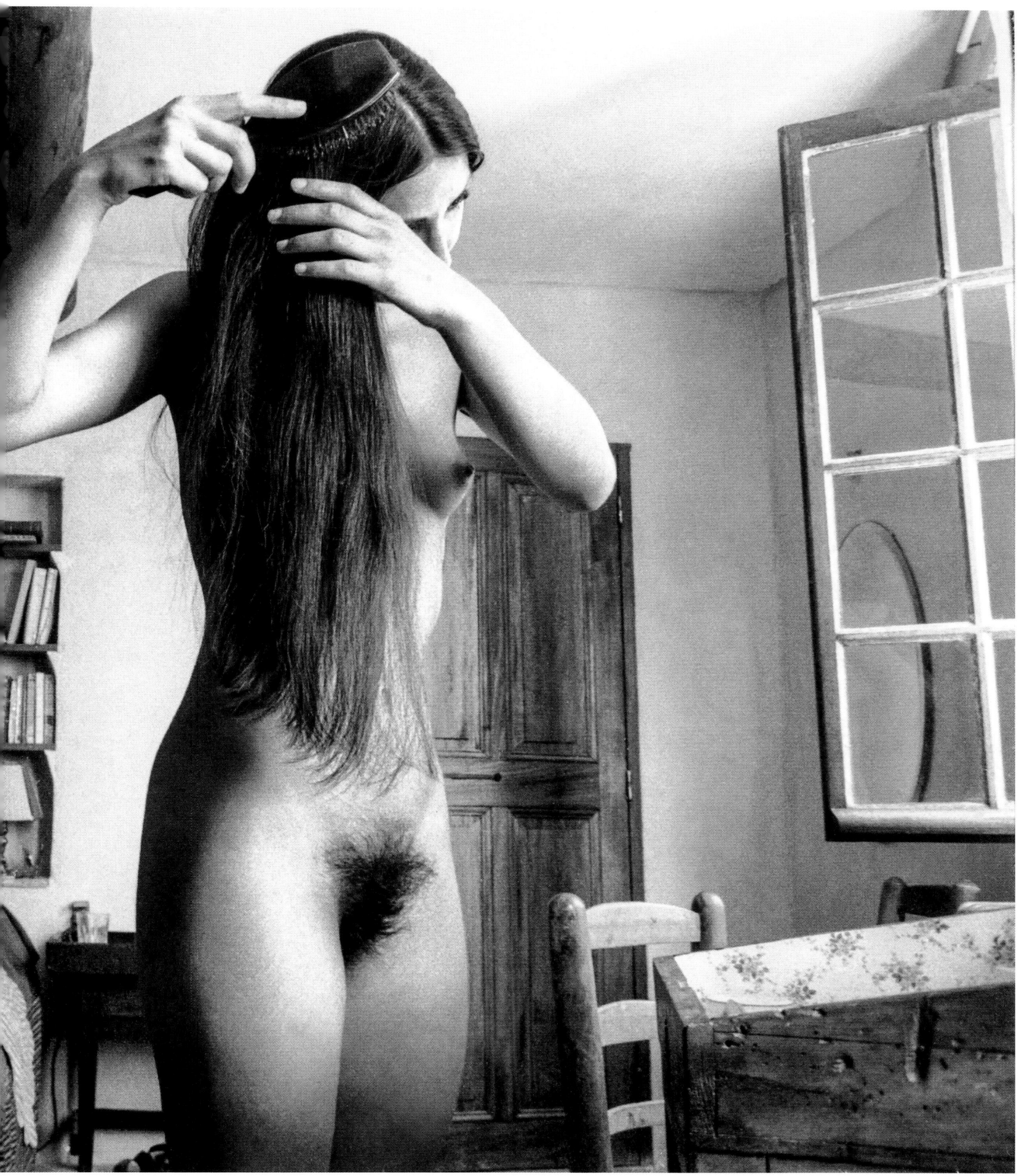

The night of July 14, L'Isle-sur-la-Sorgue, Vaucluse, 1974
NEGATIVE: 24×36 MM _ F132/3320
— 431
We had just begun to set up our new home in L'Isle-sur-la-Sorgue. We wouldn't leave Gordes for another year, but we went to L'Isle more and more often. On this night of July 14, there was a dance in the church square. In spite of the very dim light, I managed to capture the movements of these two girls. Very difficult print owing to underexposure. Full frame. 50-mm lens.

Locquirec, Finistère, 1979
NEGATIVE: 24×36 MM _ F198/3236
— 432
September in Locquirec. I had spotted this small port in Brittany during two days of scouting before starting my workshop at the first Lannion photography festival. Marie-Anne and I had liked the area, and we had booked a room to rest for a week after work (the two other workshop leaders were Guy Le Querrec and Dennis Stock). The hotel grounds bordered the sea. My friend the historian Romeo Martinez had just sent me the big catalog of the Venice festival and his book on Atget (Electra, Milan). I wanted to mark the date by associating it with this almost magical stay. This is a landscape-cum-still-life of a kind I like to take when the opportunity arises. See also photos 433 (Velleron) and 450 (Le Crotoy), as well as photo 308 (Najac). Full frame.

The Vieux Moulin inn, Velleron, Vaucluse, 1979
NEGATIVE: 24×36 MM _ F199/1324
— 433
We often went to dinner at the Vieux Moulin, the inn where the talented Mme Bastian extended a warm welcome to customers and friends. Velleron is in the district of L'Isle-sur-la-Sorgue, and I took advantage of the preparations for a banquet to come in the late morning and celebrate the cuisine of Provence as part of my photographic project for the Year of Heritage. Another example of a composition broken up into three stacked planes, in a vertical format. 28-mm lens. Full frame.

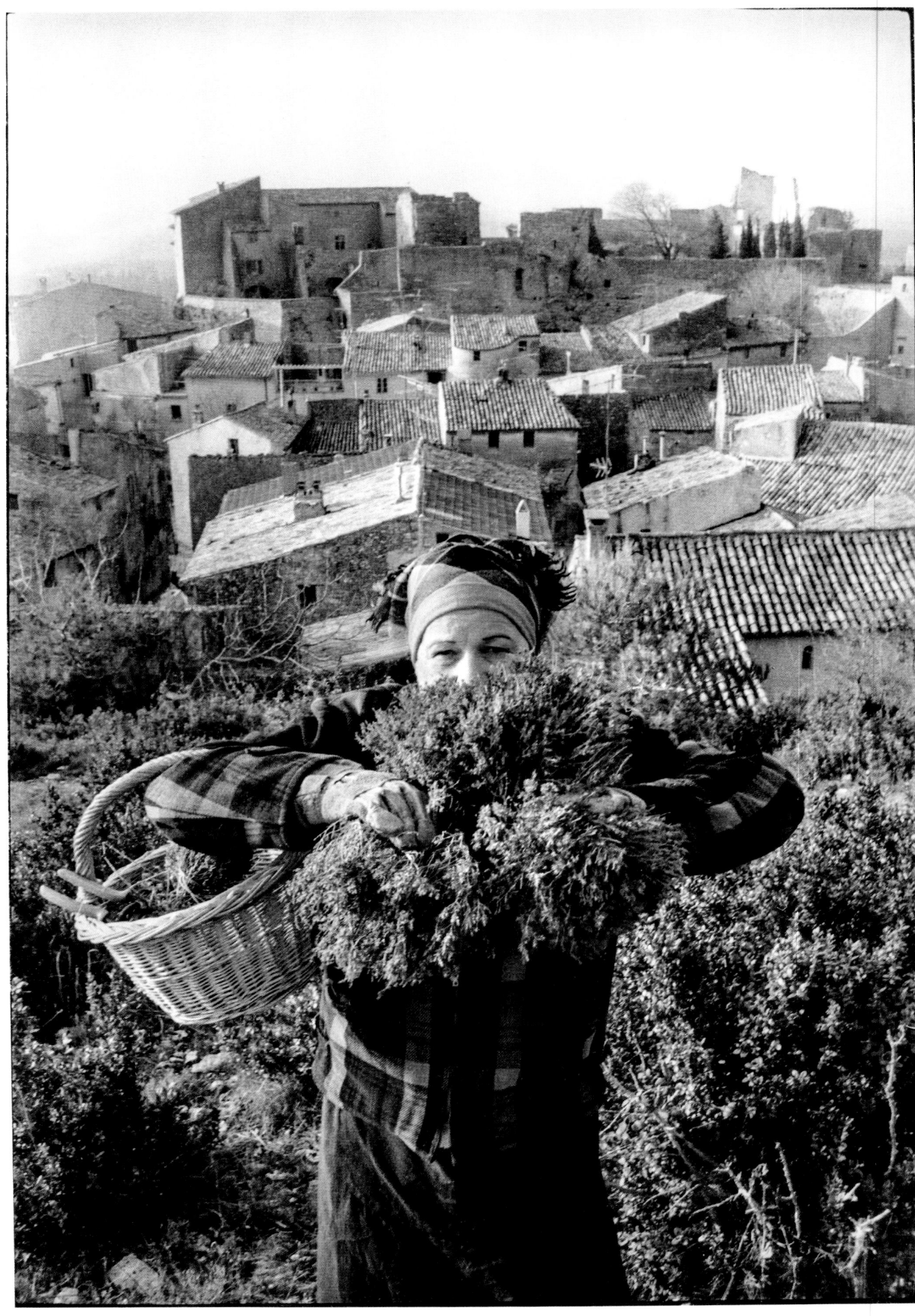

The thyme-picker, Lagnes, Vaucluse, 1980
NEGATIVE: 24×36 MM _ F200/2519
___ 434

The deadline for my assignment for the Heritage project was approaching. Among other subjects, I still needed to photograph a thyme-picker in Lagnes. Unluckily, she had fallen sick. I re-created her outfit on Marie-Anne and, following a bountiful harvest that we gathered together on January 13, I captured the subject in the facing picture with a 50-mm lens. I had climbed onto a rock for a better view of the village. Full frame.

Rue Eugénie-Cotton, between new buildings in Belleville, Paris, 1980
NEGATIVE: 24×36 MM _ P202/4013
___ 435

I had been making quite frequent trips to Paris for about a year, mainly for professional reasons. In this sunny month of September, I took advantage of a break between two meetings to go up to Belleville. Where the Chez Victor *guinguette* once stood, on impasse Compans (see photo 166), everything had been knocked down and leveled, and five skyscrapers had been erected. At the top of rue Eugénie-Cotton (the street's new name), in this playground, boys and girls were playing in the new setting. 28-mm lens. Full frame.

Danielle Darrieux, Paris, 1980
NEGATIVE: 24×36 MM _ 203/1504
___ 436

Two days later, *Paris-Match,* who learned I was in Paris through Rapho, commissioned me to do a photo story on Danielle Darrieux. I did the job with a borrowed Canon (my Foca's shutter had just stopped working) at the Marigny theater, where the great actress was rehearsing a new play. This and most of the other photos were taken in natural light. 35-mm lens. Full frame.

Brassaï, Paris, 1981
NEGATIVE: 24×36 MM _ 207/0706
___ 437

Another trip to Paris. I took the opportunity to visit Brassaï, whom I had not much seen since 1972, when we moved to the Vaucluse. This is a souvenir photo, taken quickly a few minutes before leaving, in the daylight of his office. 28–50-mm zoom lens set to 50 mm.

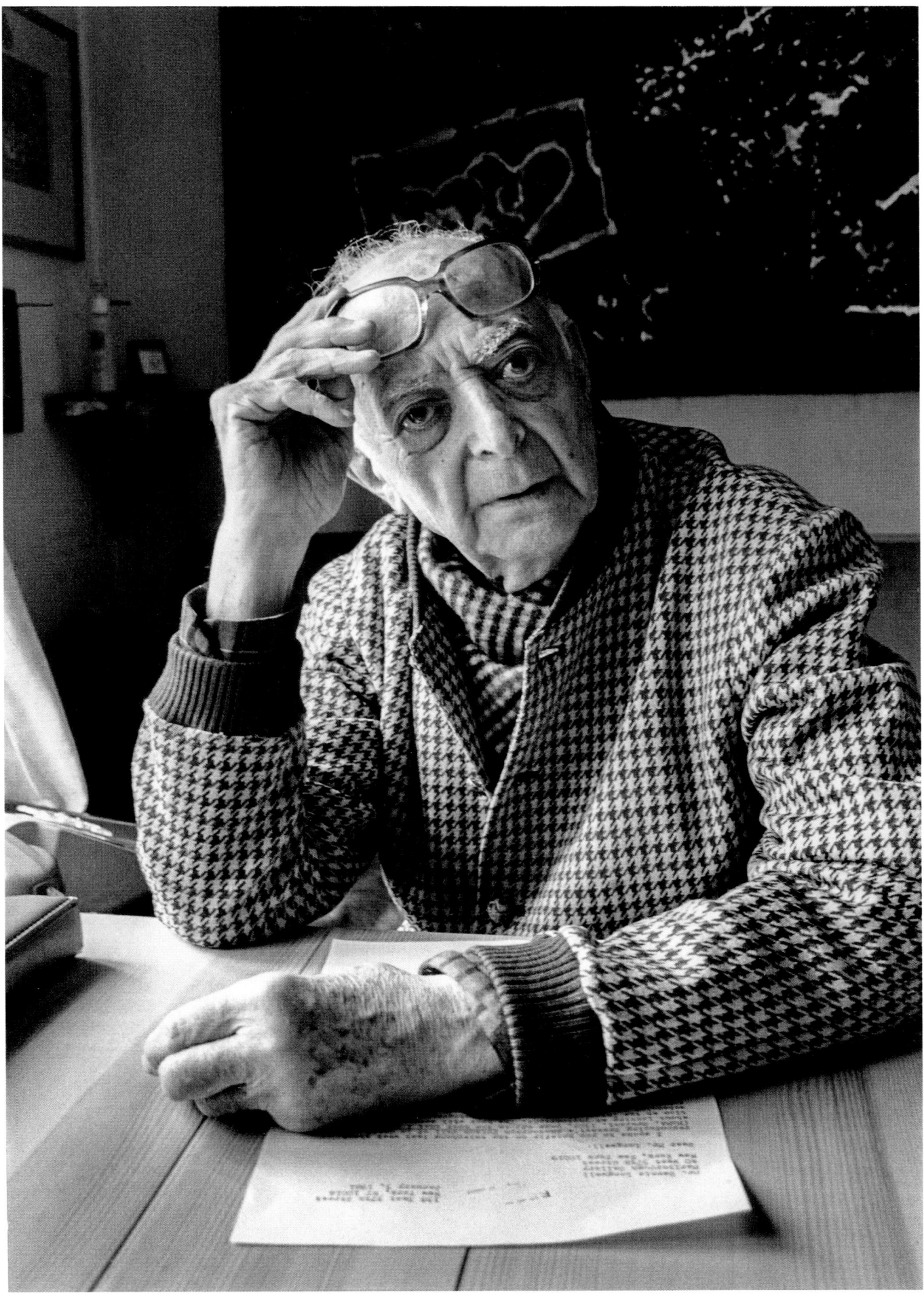

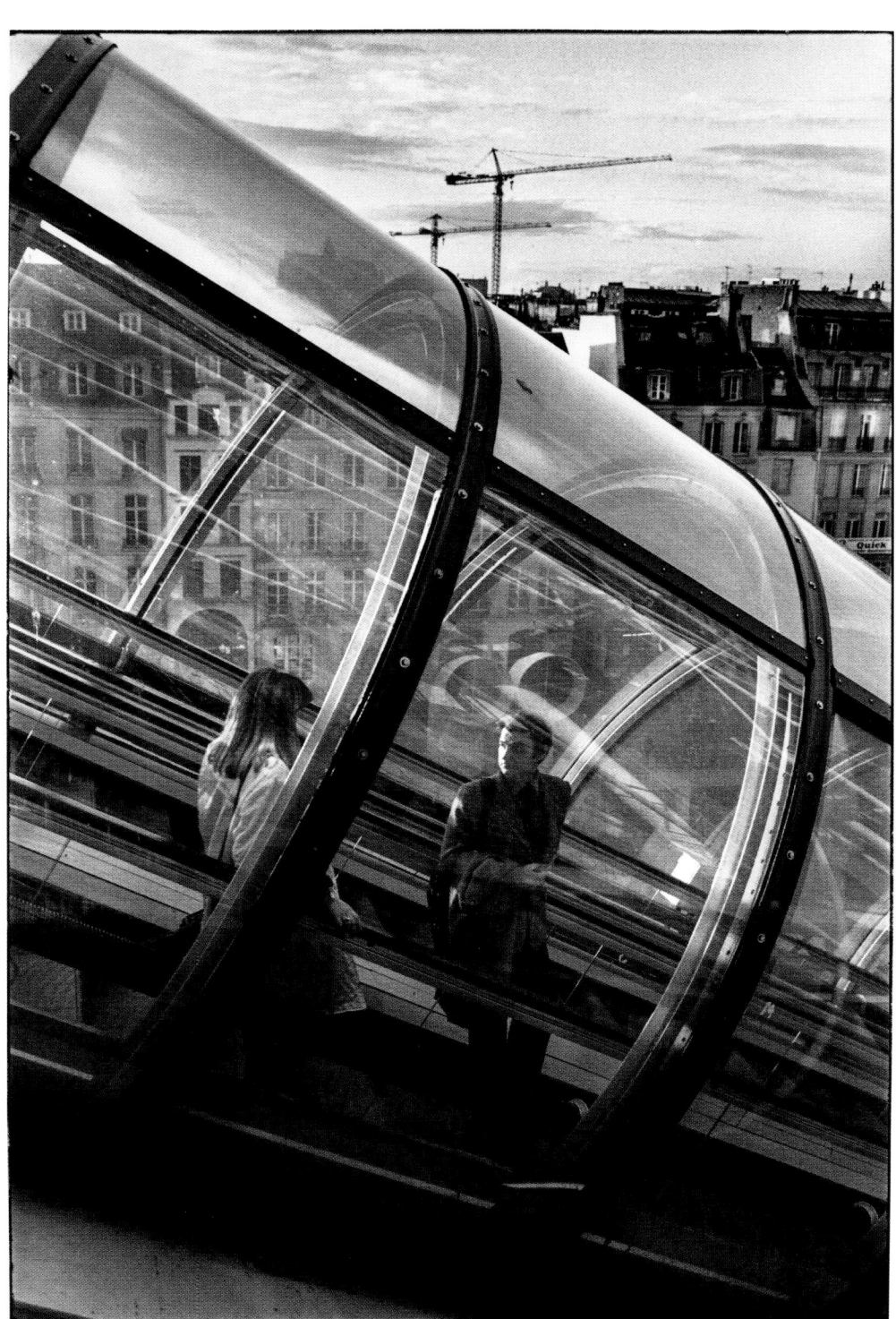

On the escalator of the Centre Georges Pompidou, Paris, 1981
NEGATIVE: 24×36 MM _ P208/0323
__ 438

A few days after my visit to Brassaï, I took some photographs at the Centre Georges Pompidou, on my own time, for pleasure (it was one of my first visits to Beaubourg), and as I was leaving I captured this snapshot in the late afternoon sun. I had decided to update my equipment almost a year previously. My Foca coupled rangefinders had earned their retirement (twenty-six years of service), and the Canon that I had borrowed the previous fall had confirmed my decision to choose an SLR camera. I opted for a Pentax ME Super, compact and mid-priced, with a 50-mm f/1.7 lens (for situations with very low light), and a 28–50-mm and 75–150-mm zoom, all three of the same brand as the camera. Since making this acquisition, I note that I have used the 28–50-mm zoom 98 percent of the time. I used that lens to take the facing picture. Full frame.

Times Square, New York, NY, 1981
NEGATIVE: 24×36 MM _ 210/1504
__ 439

An exhibition at the French Cultural Center in New York took me to the city for the first time. I was kept very busy with events relating to my exhibition but managed to escape for a few hours by combining, dexterously, appointments and free time. On the right, a familiar scene on Broadway (see photos 336 to 341). Almost full frame.

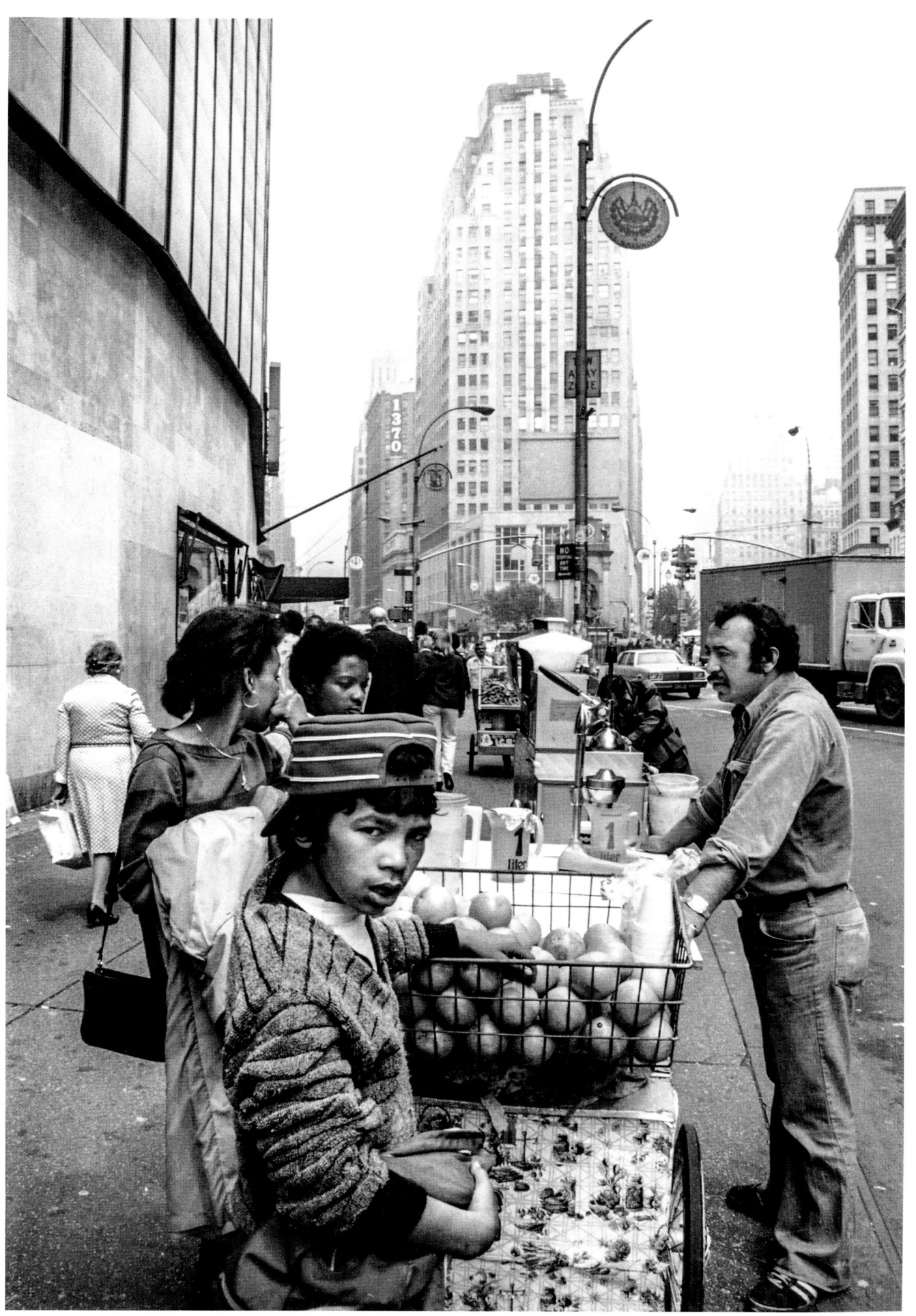

**A courtyard on rue
des Envierges, Paris, 1981**
NEGATIVE: 24×36 MM _ P216/2625
— 440

September. My professional duties often took me to Paris, where I also felt an urgent need to take more photographs in my favorite neighborhoods. This particular morning I was in Belleville, where, by chance, I discovered this backyard that I didn't know. I would have preferred to have been there when the housewives were hanging out their laundry, but I like this image as it is. 28–50-mm zoom used at 28 mm. Full frame.

**Rue du Grenier-Saint-Lazare,
Paris, 1981**
NEGATIVE: 24×36 MM _ P216/3013
— 441

Same trip. I left Beaubourg and crossed the quartier de l'Horloge. The raking sunlight was illuminating this badly restored façade on rue du Grenier-Saint-Lazare—the perfect opportunity to capture this little scene in exceptional light. 75–150-mm zoom. Framing slightly cropped.

Should I explain once more the whys and wherefores of this or that shot? As far as I'm concerned, it involves an ability to react on the spot to anything that resonates with my true nature. Or the fact that, during my wanderings, my immediate surroundings stop me in my tracks and— before I even raise the camera—I frame a possible scene in my mind. This event will either happen (the couple exchanging looks in photo 438) or not (as is very common), and I will be on my way. In the case of the facing photo, the raking light on the wall had fascinated me, and the presence of the two people in the frame confirmed the urgent need to take the shot; without them I would have admired the wall without reacting. As for defining my true nature, I will not do it. It is not up to me to conduct a self-analysis: I can try only to shed light on some of my actions.

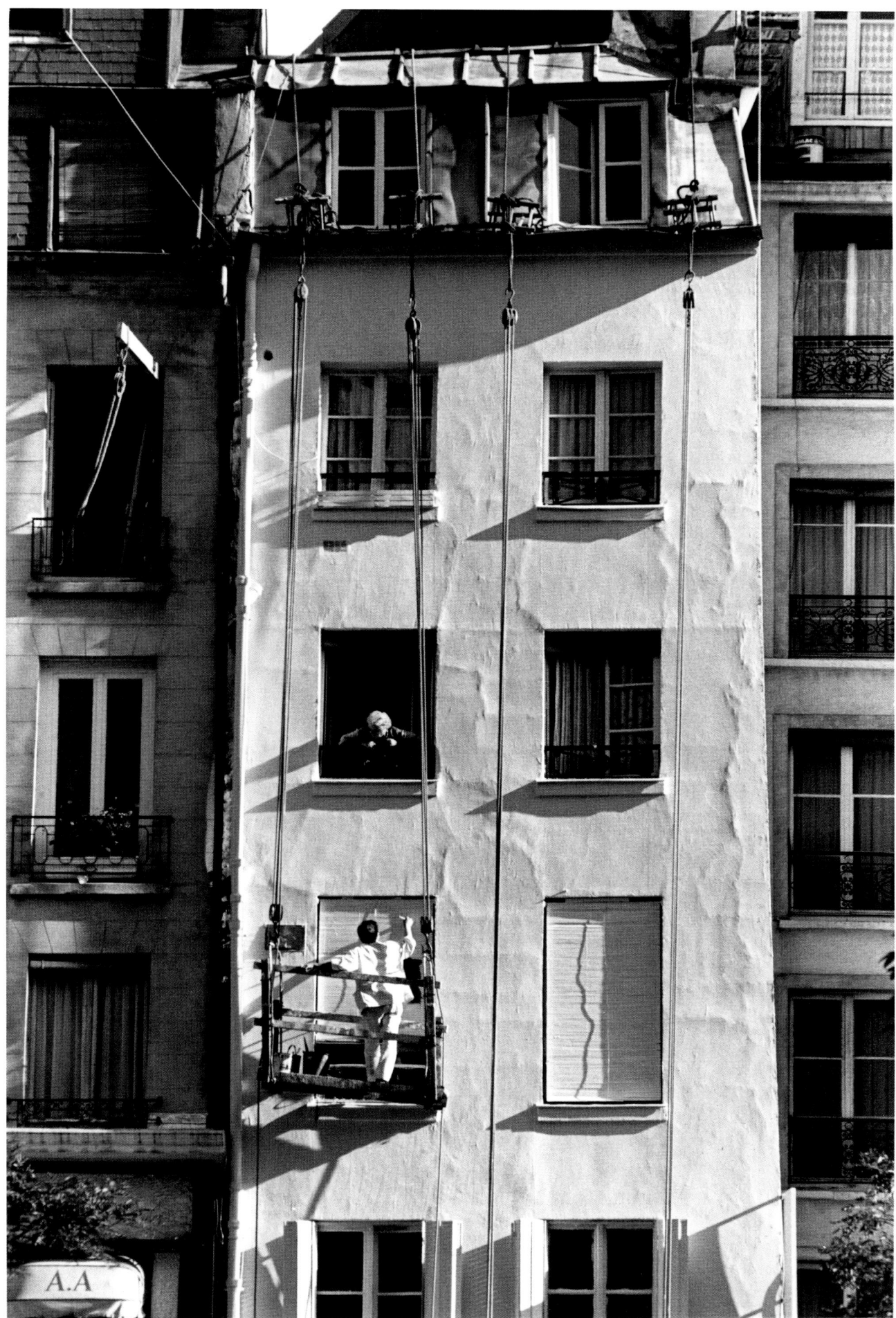

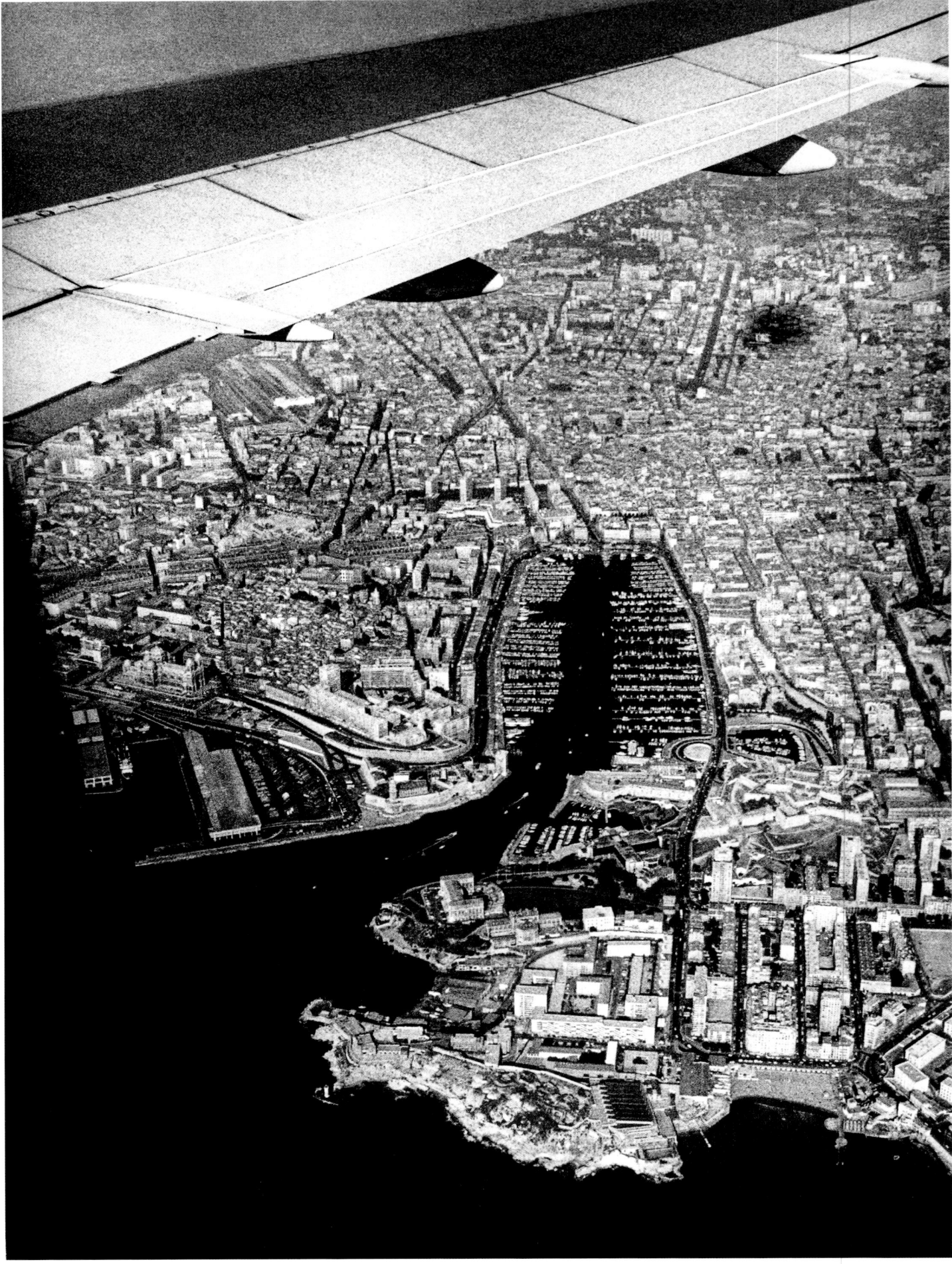

Entrance to the Old Port, Marseille, Bouches-du-Rhône, 1982
NEGATIVE: 24×36 MM _ F219/1534
—— 442

Returning from a trip to Greece. We were going to land at Marseille-Marignane airport. I suddenly recognized the Old Port, as chance had placed me on the right side of the plane. I quickly took out my Pentax and, on the fly, captured this beautifully lit landscape from the Pharo peninsula all the way past the Canebière and boulevard Jeanne-d'Arc. Framing slightly cropped at the bottom. A note for those travelers who take photographs from planes: use a wide aperture, since the shallow depth of field helps to erase the spots and scratches on the windows.

A courtyard on rue de Charenton, opposite rue Beccaria, Paris, 1983
NEGATIVE: 24×36 MM _ P221/1604
—— 443

We had resettled in Paris. Our apartment was located in the Aligre neighborhood, and I soon began to undertake reconnaissance missions, camera in hand, in the twelfth arrondissement, which I, an old Parisian, knew nothing about. This photo was taken in a courtyard on rue de Charenton, one morning when, returning for the fourth or fifth time, I finally met someone engaged in domestic activity. 28–50-mm zoom. Full frame.

**The lift bridge on rue de Crimée,
La Villette basin, Paris, 1983**
NEGATIVE: 24×36 MM _ P221/3334
— 444

On this late-September morning, I had climbed a few steps on the edge of the lift bridge on rue de Crimée on the basin of La Villette. I waited: these two young cyclists appeared, and at the same time two women arrived from the other direction on the opposite sidewalk. That was it. I guess my 28–50-mm zoom was set to 35 mm. One of the preconditions for a good photo—I have often mentioned it—is to be *well positioned*, to take up the right viewpoint. Only then can you decide the breadth of the visual field to cover, what to include or exclude. Then you select the focal length of the lens or the angle of the zoom. Warning: the zoom lens means one tends to go too wide.

**A courtyard on rue du Faubourg
Saint-Antoine, Paris, 1983**
NEGATIVE: 24×36 MM _ P221/3833
— 445

A picturesque courtyard on rue du Faubourg Saint-Antoine, in the eleventh arrondissement. On the left, in the background, a small workshop where an upholsterer worked on period armchairs. Full frame. 28–50-mm zoom set to 28 mm.

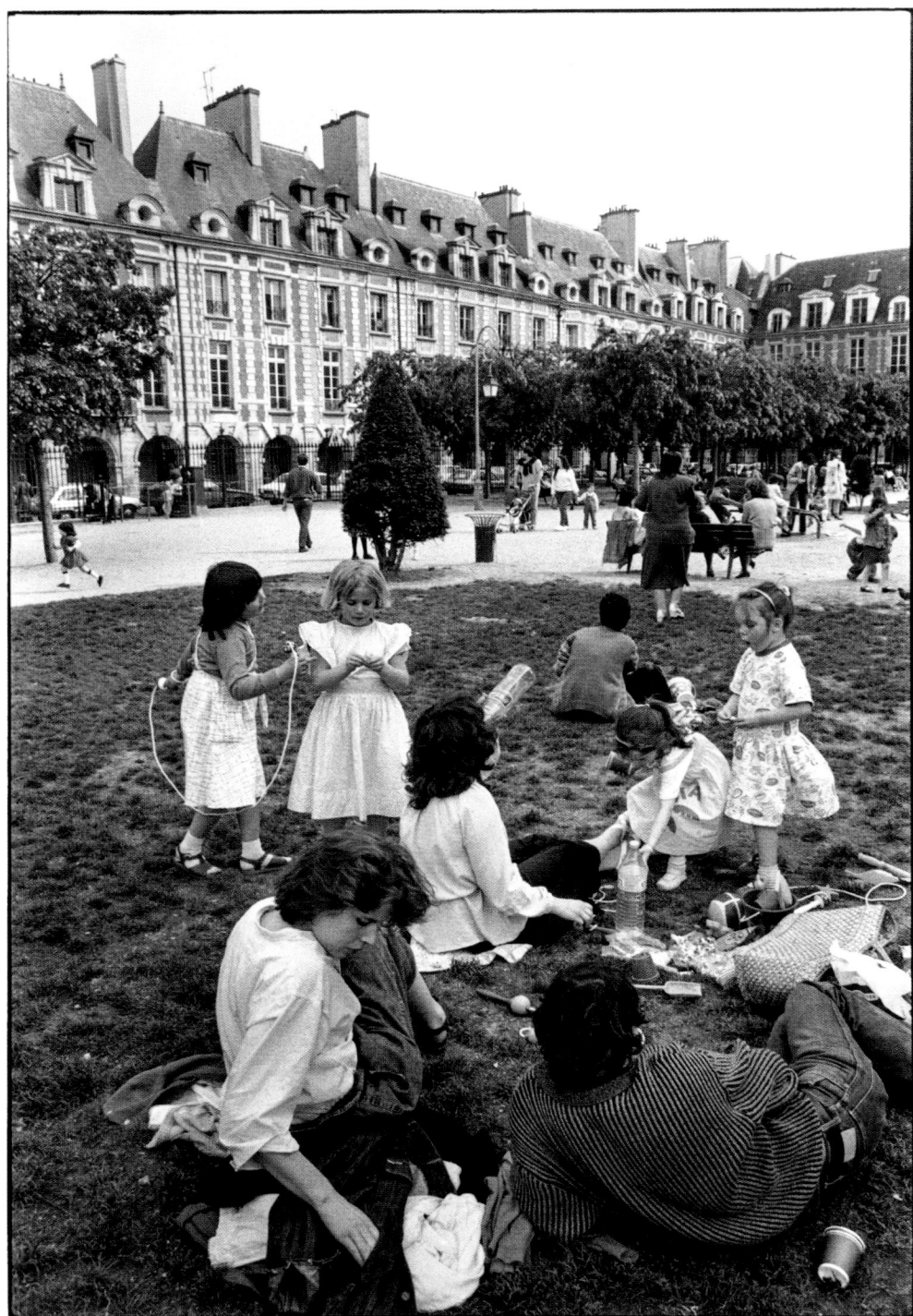

Place des Vosges, Paris, 1985
NEGATIVE: 24×36 MM _ P224/4500
___ 446

End of April. I was actively working on collecting the last photos for my book *Mon Paris* that Denoël would soon be laying out. Plagued by the feeling that I was still missing some fundamental images, I wandered restlessly through Paris, bringing back some pictures that gradually soothed my anxiety. On this Saturday the weather was beautiful, and the lawns of the place des Vosges provided me with some informal scenes. This one, framed vertically in successive planes, would be included in the book and, later, in my exhibitions. 28–50-mm zoom, probably set to about 35 mm. Full frame.

Café terrace in front of the Centre Georges Pompidou, Paris, 1985
NEGATIVE: 24×36 MM _ P224/5034
___ 447

Early June. On this day of constantly changing light, at the corner of rue Saint-Martin and rue Saint-Merri, I managed to capture the teeming activity around the Centre Georges Pompidou in microcosm. Starting with the hair of the mermaid in the foreground, I waited for the young girl on the left to turn her head and for the waiter to enter the frame. This photo, like the previous one, was included in my forthcoming book. 28–50-mm zoom. Full frame.

Self-portrait in the twentieth arrondissement, Paris, 1985
NEGATIVE: 24×36 MM _ P226/0902
___ 448

On this late-December morning, my walk took me down rue des Couronnes in the twentieth arrondissement, where a large window presented me with the surreal picture of an incongruously abandoned mannequin and, successively reflected in the window and in a mirror in the background, my own double reflection. Click: we'll see if it's a sucess.
28–50-mm zoom. Full frame.

Centre Georges Pompidou, Paris, 1986
NEGATIVE: 24×36 MM _ P227/4832
___ 449

I had just acquired a Minox, a lightweight camera that could be carried in my pocket, like a notebook, whenever it seemed inappropriate to load myself down with my satchel with its zoom lenses (which weighed over four pounds). It was July, and the crowds had gathered in the square and inside the Centre Pompidou. I was drawn to the somewhat theatrical pose of the young man with his hand placed against the window. I framed with haste, because everything can change very quickly.
I released the shutter, aware that a person arriving on the right could spoil everything. It was a calculated risk: only their profile appears in the image and, luckily, it balances out the two characters on the left.

Le Crotoy, Somme, 1986
NEGATIVE: 24×36 MM _ F229/2528
— 450

Saturday, August 16. A trip to Le Crotoy, in the Bay of the Somme, with a couple who are friends of ours. The afternoon was getting on and, after a break in this café on the seawall, we began to go back to the car. I got up last; Marie-Anne and our friends had already walked out the door. My gaze moved up and down, because at the table I had had the vague sensation that something was taking shape in my head. From the constantly changing sky, an astonishing light suddenly enveloped the scene. I mechanically adjusted my Pentax focus to two meters, aperture set to f/16. I zoomed out to 28 mm and released the shutter in a trance, conscious of the fact, in my usual state of anxiety, that my friends were waiting impatiently, in the wind, and I had no time for a second or third frame. I tore myself away from my composition, furious at not having taken the time to master the overall subject matter and the distribution of objects on the table. Afterward, our conversations helped to soothe my distress, which I put into perspective in the context of my professional life at that time. In fact, after developing the image I observed with satisfaction that any intervention after my single frame might have messed things up, and that it was this unique, very unstable moment that mattered above all else, and the framing that is perfect just as it is.

Pushkin Palace, Leningrad, USSR, 1986
NEGATIVE: 24×36 MM _ 230/3215
— 451

Moscow had just put on an exhibition of my donations to the French State, organized by the French department of photographic heritage with the assistance of the France–USSR association. The day after the opening, we had been invited to Leningrad for several days, where I was to conduct a presentation and a Q&A with the press association. On the morning of October 19, a car took us to the sumptuous Pushkin Palace where, during the visit, I captured this little scene. From the outset, the photo reminded me of one that I had taken in the Louvre eighteen years earlier (photo 295). This is the phenomenon of the "eternal return" that I referred to earlier, and that connects photo 347 from 1982 (the girl against the Alfa Romeo in Greece) with photo 145 from 1954 (the little farmer girl against the cart). To enhance the magnificence of the location, I used the full angle of my zoom lens. Full frame.

Villa des Boers, Paris, 1987
NEGATIVE: 24×36 MM _ P232/0229
___ 452

On March 12, I was once again exploring the many "villas" that connect rue de Bellevue to rue de Mouzaïa, near place des Fêtes in the nineteenth arrondissement. Here, we are even lower down, in the Villa des Boers. In the background is the steeple of the church of Saint-François d'Assise. 75–150-mm zoom set to around 85 mm. Full frame.

Rue Ordener, Paris, 1987
NEGATIVE: 24×36 MM _ P233/3614
___ 453

For a long time I had heard about the picturesque qualities of the small market on rue Duhesme in the eighteenth arrondissement, which set up every day in the late afternoon. I had already been twice, but I had not got what I wanted. On this July 3, a little disappointed, I was heading home via rue Ordener when I was struck by the sight of this old man standing near a boy seated in a state of profound boredom. Just as I was wondering how to position myself, a man with his hand trolley came darting out in front of me, with the expression of someone who enjoyed startling me. As he pulled his vehicle to change direction, I opened my zoom up to 28 mm and arranged my framing to capture the scene.

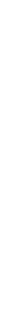

From the bus, at the corner of boulevard Saint-Michel and rue des Écoles, Paris, 1987
NEGATIVE: 24×36 MM _ P233/3939
— 454

The next day we took the 86 bus to visit the Corbusier exhibition on rue de Tournon. I sat on the left, on the side near the center of the road, to better observe the traffic. In rue des Écoles, we were overtaken by a convertible full of high-spirited young people, as if on vacation in Saint-Tropez. A red light brought us in line. I quickly took out my Minox and captured the scene full frame, just as the light turned green, and we all drove across boulevard Saint-Michel. I photographed from behind the window, which explains the reflections to the left and bottom of the image.

Quai de Montebello, Paris, 1987
NEGATIVE: 24×36 MM _ P233/5010
— 455

Libération had asked me and a few other photographers for images of Paris on vacation. For this album I selected the current picture: probably a family of tourists visiting Paris, taken on quai de Montebello on July 25. I had also noticed a couple lying face down on the parapet, hands theatrically linked, heads touching. I had plenty of time to capture this image of passionate love, in a vertical composition with Notre-Dame in the background.

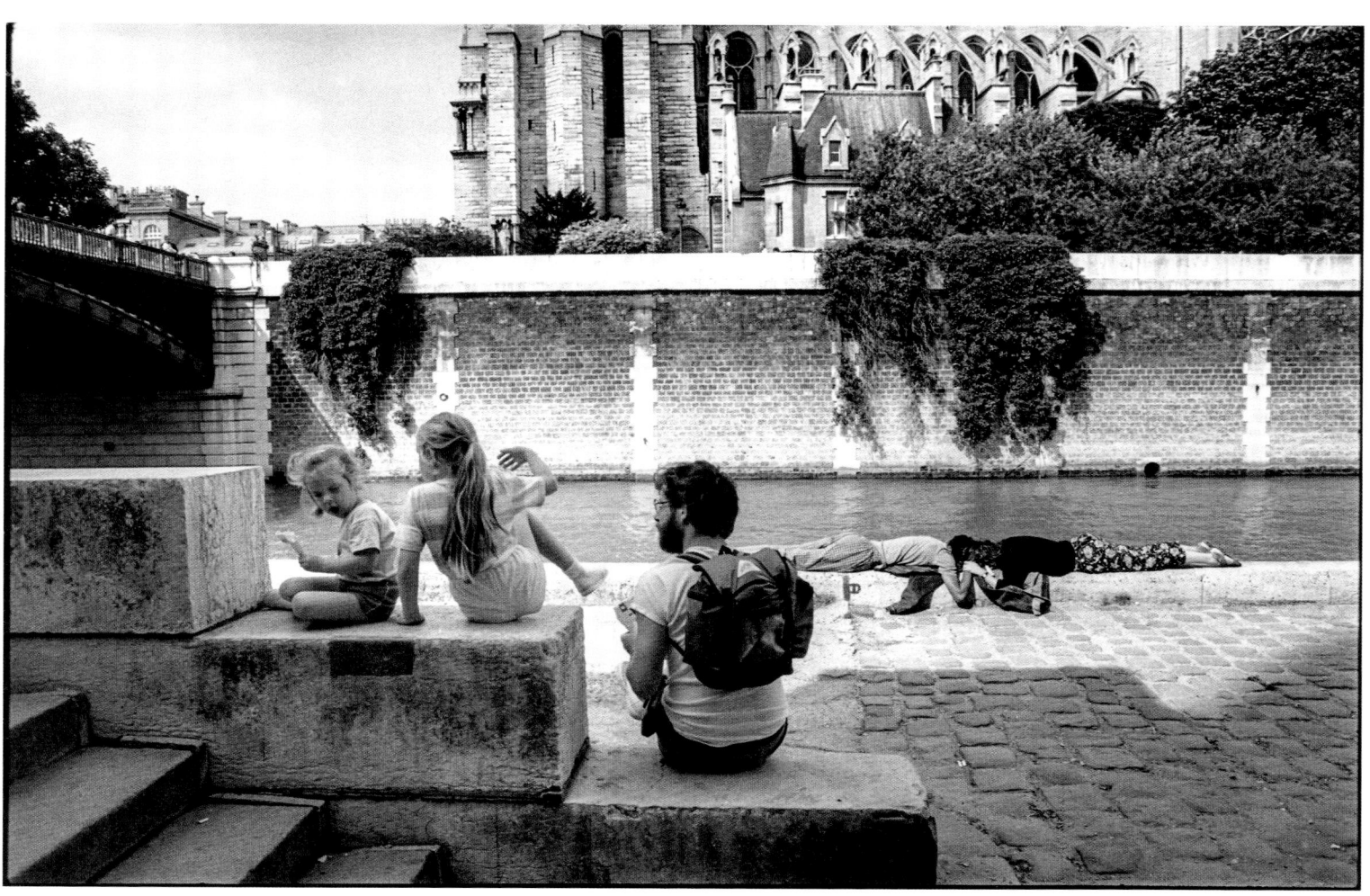

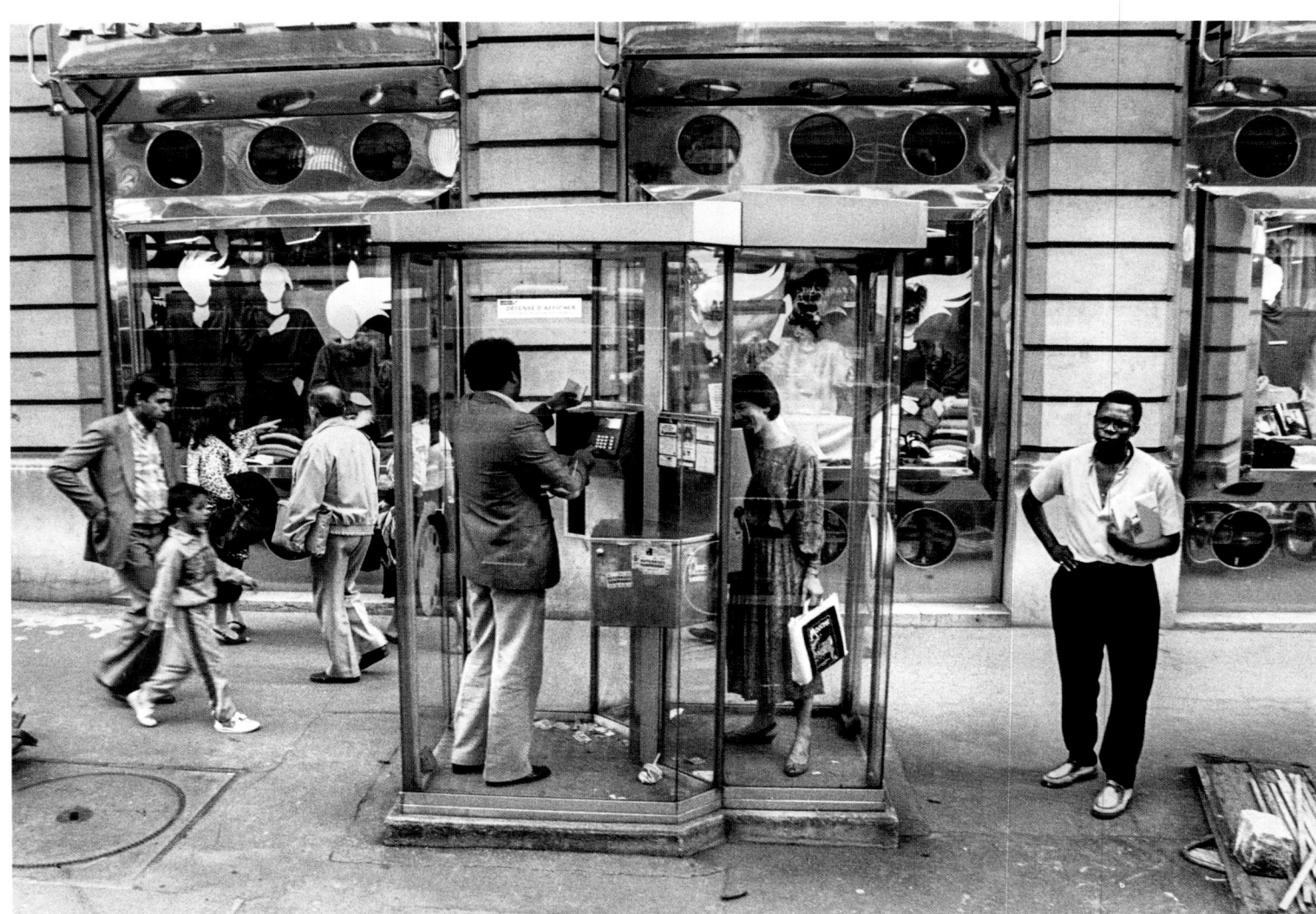

From the bus, rue Réaumur, Paris, 1987
NEGATIVE: 24×36 MM _ P234/2530
__ 456

In my comment on photo 454, I referred to the idea of using the randomness of a bus route to capture new images. I started this research on buses featuring a rear deck, which are the exception. The 29 bus followed an interesting route near my home at the time. It was a highly fanciful project because shooting is possible only at very slow speeds or during stops (traffic lights, traffic). And even then, it isn't possible to choose the viewpoint, which is extremely frustrating. But still, it is pretty exciting and, despite some disappointing attempts, I intend to try again. The photo above was made during a stop on rue Réaumur. 28–50-mm zoom.

Blind musician, boulevard Haussmann, Paris, 1987
NEGATIVE: 24×36 MM _ P235/2017
__ 457

December on boulevard Haussmann. It was raining and windy. The musician's dog was sheltering under his blanket, but the musician played anyway. People were hurrying to cross. This somewhat ungenerous day made me select a 1/15-second shutter speed, as I had narrowed the aperture to provide some depth of field. The relative slowness of my snapshot gave a motion blur to the pedestrians in the foreground: an effect specific to the language of photography that one must know how to use without turning it into a habit. 28–50-mm zoom set to around 40 mm.

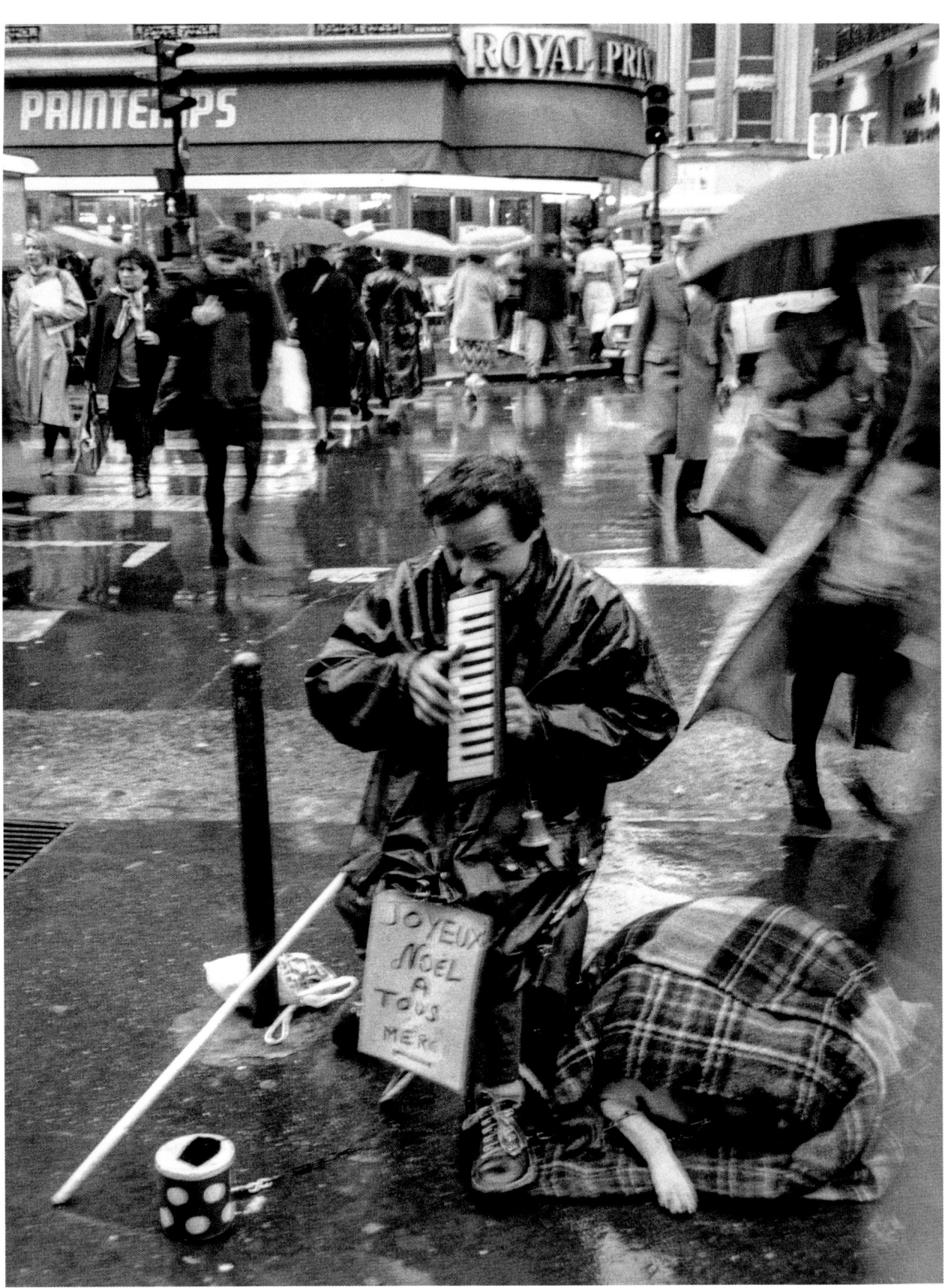

Rain, Mogador–Haussmann intersection, Paris, 1987
NEGATIVE: 24×36 MM _ P235/2439
___ 458

Same type of weather as the previous photo. Same technical characteristics. The negative is very difficult to print because of the very uneven lighting in the different planes. For preference use a variable-contrast paper. Full frame with a 28–50-mm zoom. It is not always possible to specify the setting of the zoom lens. As I have mentioned several times, first of all I *position myself*; only then, depending on how the subject presents itself, do I decide which angle I think is best to capture it from.

Christmas week, boulevard Haussmann, Paris, 1987
NEGATIVE: 24×36 MM _ P236/0107
___ 459

A few days later. I had just taken some pictures inside and around the department stores on boulevard Haussmann before Christmas, and I was crossing the road to take the metro home. Chance made me look to the left, and I saw two girls about to step onto the pedestrian crossing. It was their balloons that captured my imagination. I ran to catch up with them and, without stopping (is it possible to stop in the middle of the flow of people crossing the road?), I grabbed this snapshot, just as I drew level. This first shot was good, the next two were hopeless. This picture was my New Year's greeting card for 1988.

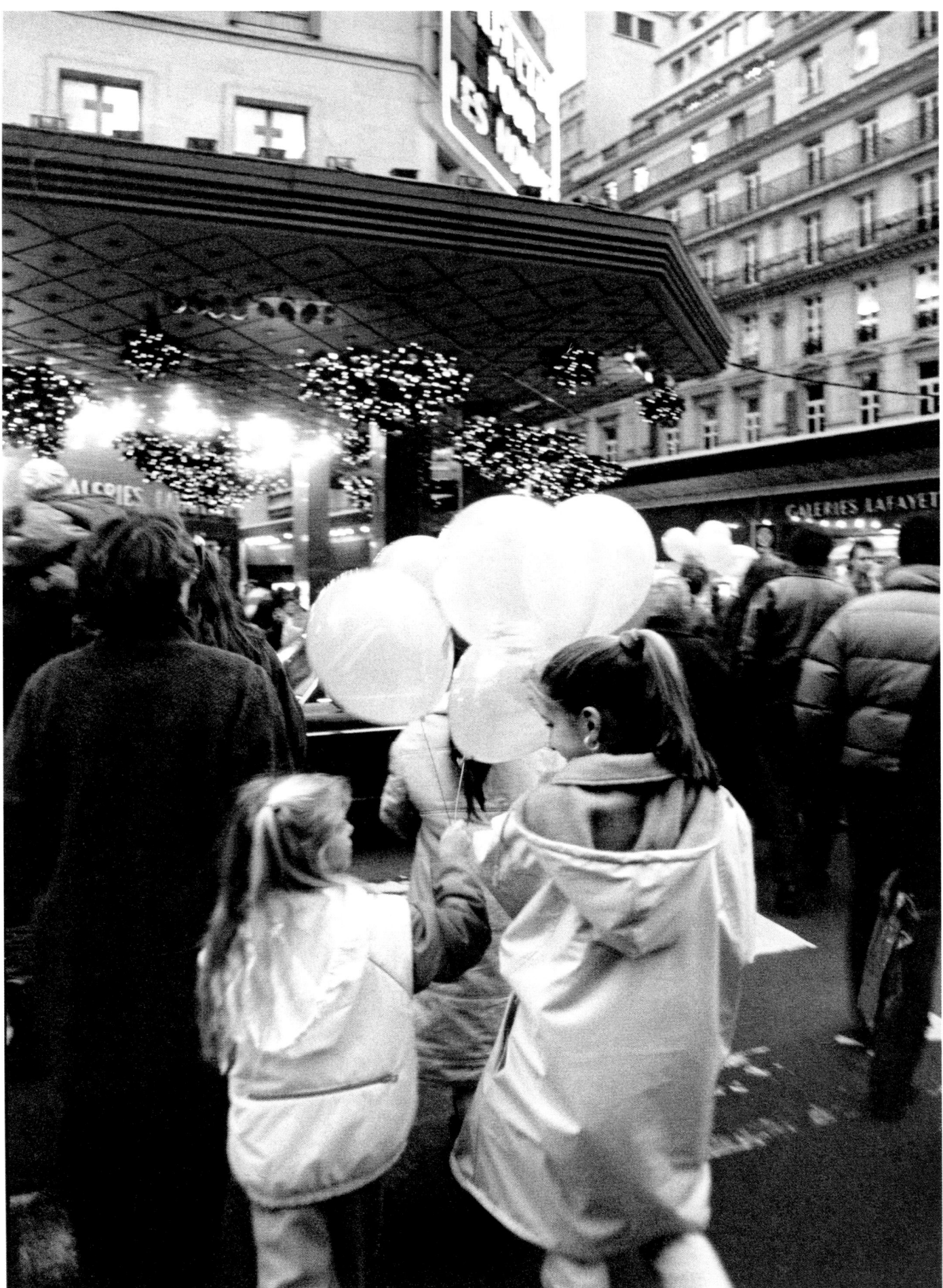

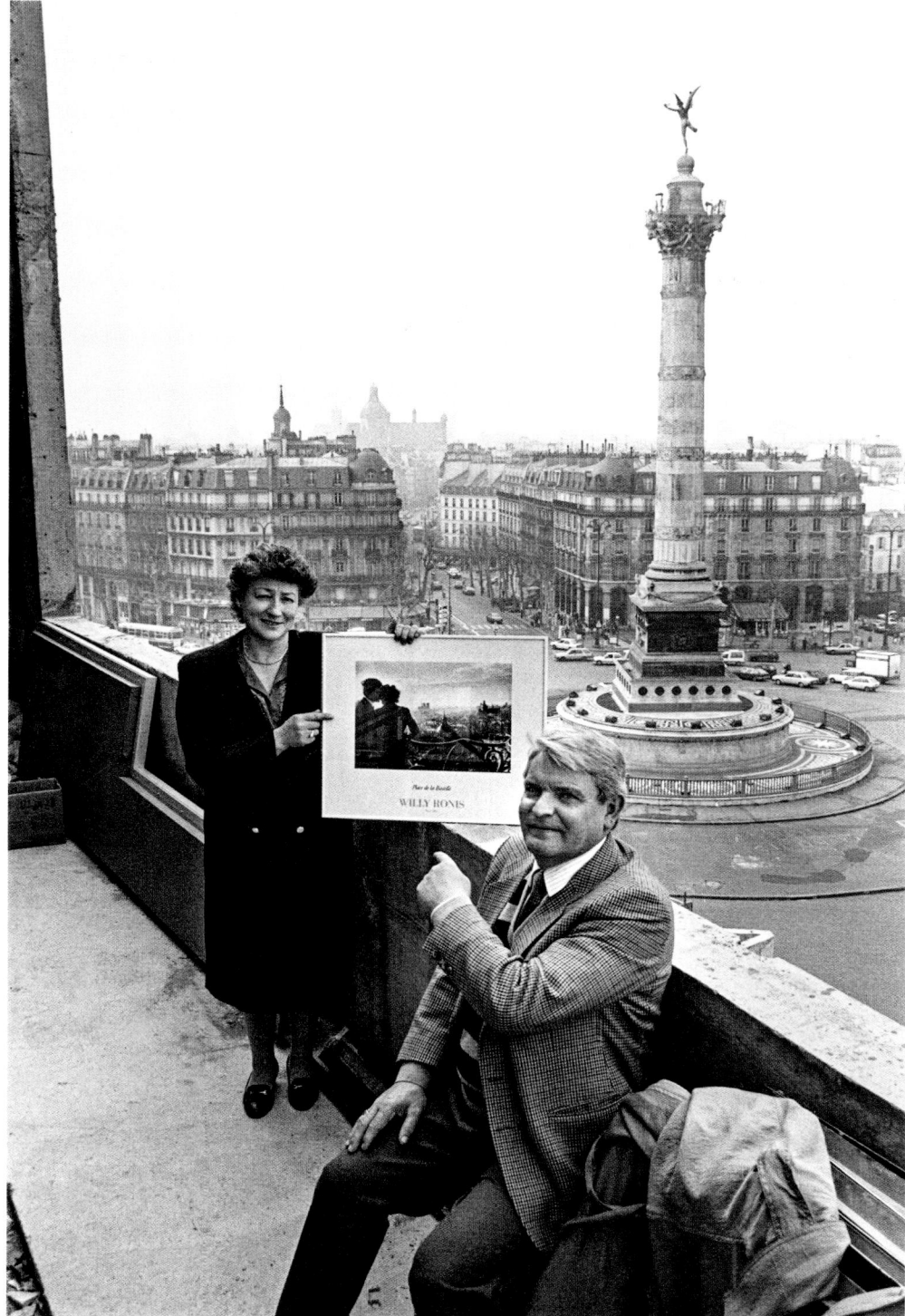

Riton and Marinette, the lovers of the Bastille, the sequel, Paris, 1988
NEGATIVE: 24×36 MM _ P236/3710
___ 460

On December 8, 1987, I had met Carlos Ott, the architect of the Bastille Opera House, at the opening of my exhibition at the Comptoir de la Photographie gallery. He kindly offered to show me the Opera's construction site. Two months later, in February 1988, back at the Comptoir for the group exhibition *Le baiser* (The Kiss), a man came up to me with my book *Mon Paris*, which he asked me to sign. "Did you know, Mr. Ronis, that I know your 'lovers of the Bastille' very well? You can meet them at the café and tobacconist at 10 rue Saint-Antoine, which they run." That is how I met Riton and Marinette, thirty-one years after the photo. Remembering Carlos Ott's offer, I took my couple up to a balcony on the site to take the photo on the left. The early April light was very bad, and I had armed myself with a tripod to cope with it better. Before we went up to our lookout, we were made to wear safety helmets, which I had then placed on the ground. As I turned my back to make a final adjustment to the camera, our guide, thinking that I was being careless, removed the helmets and placed them out of frame. What a disappointment when, after development, I noticed they were not there! An unforgivable lapse in my vigilance. Nevertheless, this is a good souvenir. The following summer, during the making of Patrice Noïa's film about me, we reconstructed the photo from 1957 (picture 209) at the top of the Bastille Column. 28–50-mm zoom. Full frame.

Saint-Germain-des-Prés church, from rue de Rennes, Paris, 1988
NEGATIVE: 24×36 MM _ P236/4043
___ 461

I was leaving an appointment on rue de Rennes, on an April morning. Down the street, people were sitting. Unfortunately for my composition, a bench was empty, but I waited, just in case. It wasn't long: a bearded and booted fellow came to sit down. Just as the pedestrian on the left appeared in the viewfinder of my Minox, I pressed the shutter. Nobody noticed anything, even though I wasn't hidden. But I had been standing in the same place for a long time, as if I were expecting someone. In short, nobody was interested in me.

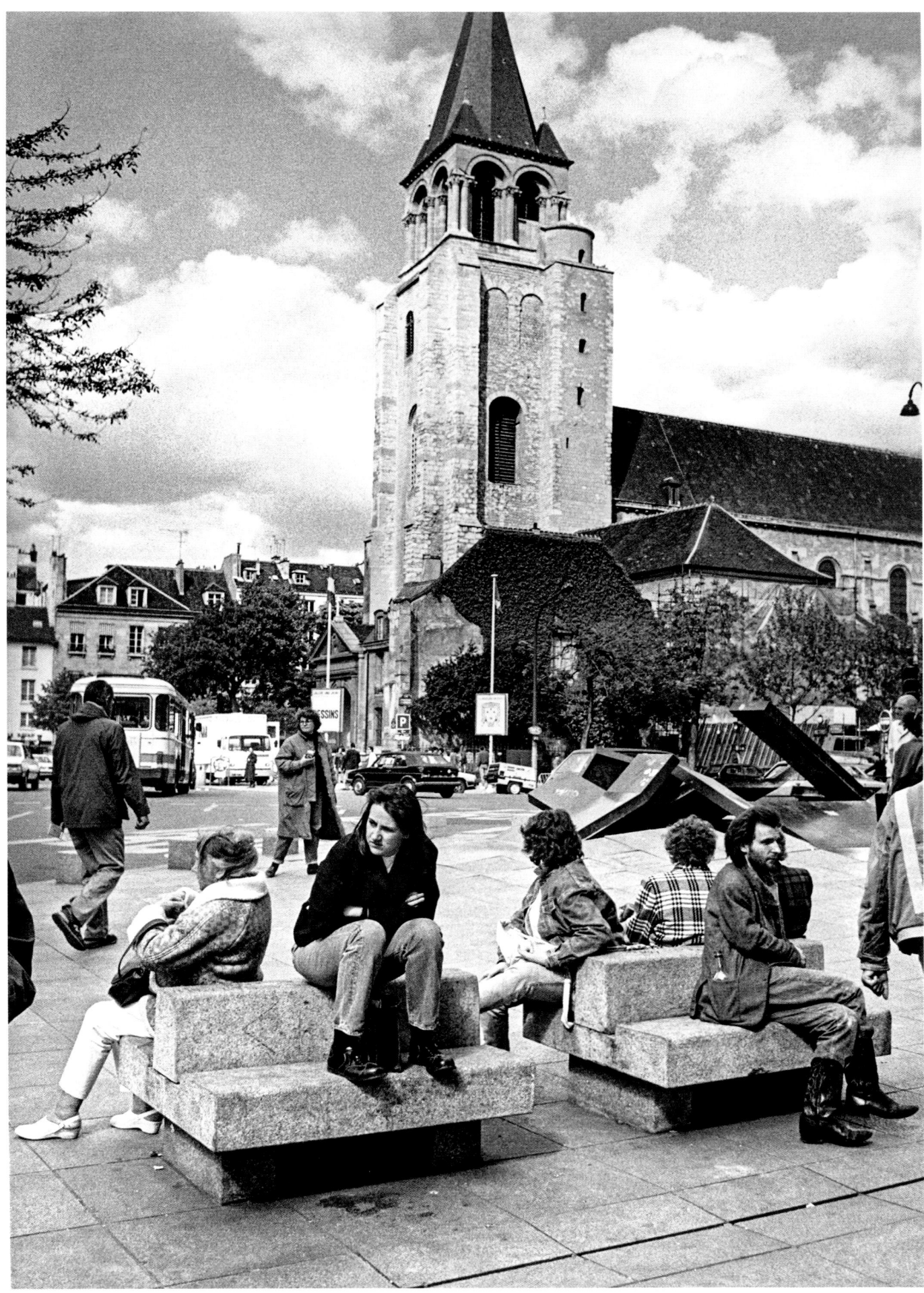

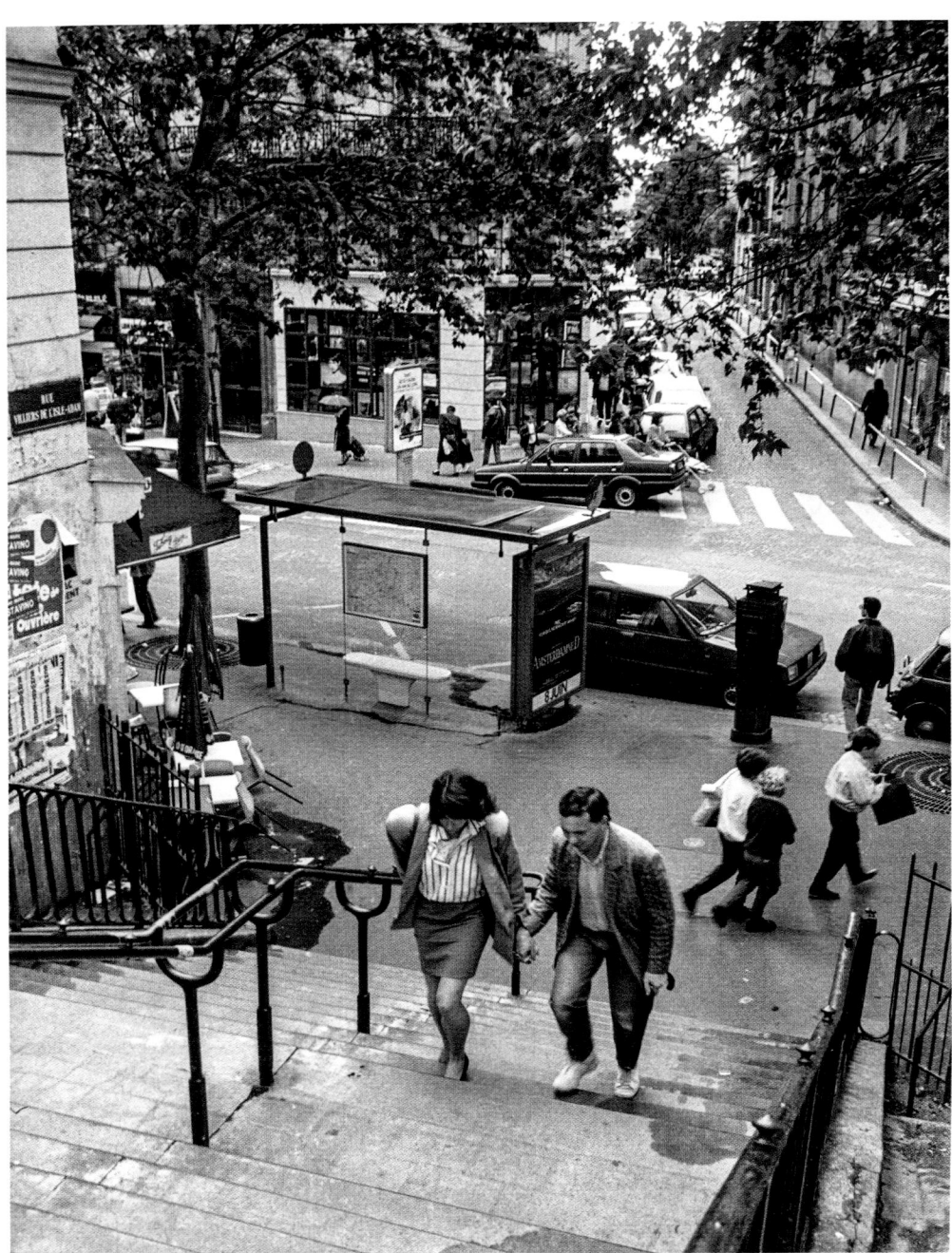

Rue des Pyrénées from the staircase on rue Villiers-de-L'Isle-Adam, Paris, 1988
NEGATIVE: 24×36 MM _ P237/1407
___ 462

For three or four years, I had been taking up my post on the landing halfway down the stairs leading to rue des Pyrénées. I had not yet quite gotten the picture I wanted: people on the stairs, busy sidewalks, and a few cars on the road (but not a bus, which takes up too much space). What high standards! Why this doggedness? Because this was the price to pay if I wanted the bustling cityscape to take on its full significance for me. These conditions are certainly all met from time to time, but thus far in my absence. Too bad; I will return. 28–50-mm zoom, slight cropping.

School, rue de la Victoire, Paris, 28 June, 1988
NEGATIVE: 24×36 MM _ P237/3840
___ 463

The filmmaker Patrice Noïa had started shooting a documentary about me for the series *Océaniques*, which he directed for the FR3 TV channel. It was a morning in June, during recess in a municipal school in the ninth arrondissement. For this clip, I was to photograph the children playing. I find "pretending" very hard, so I tried to take a few photos while keeping the director, the school principal, the sound technician, the camera operator, or several of them at once out of the frame. I stole a few nice moments *for myself, i*ncluding this one. 28–50-mm zoom set to about 35 mm. Full frame.

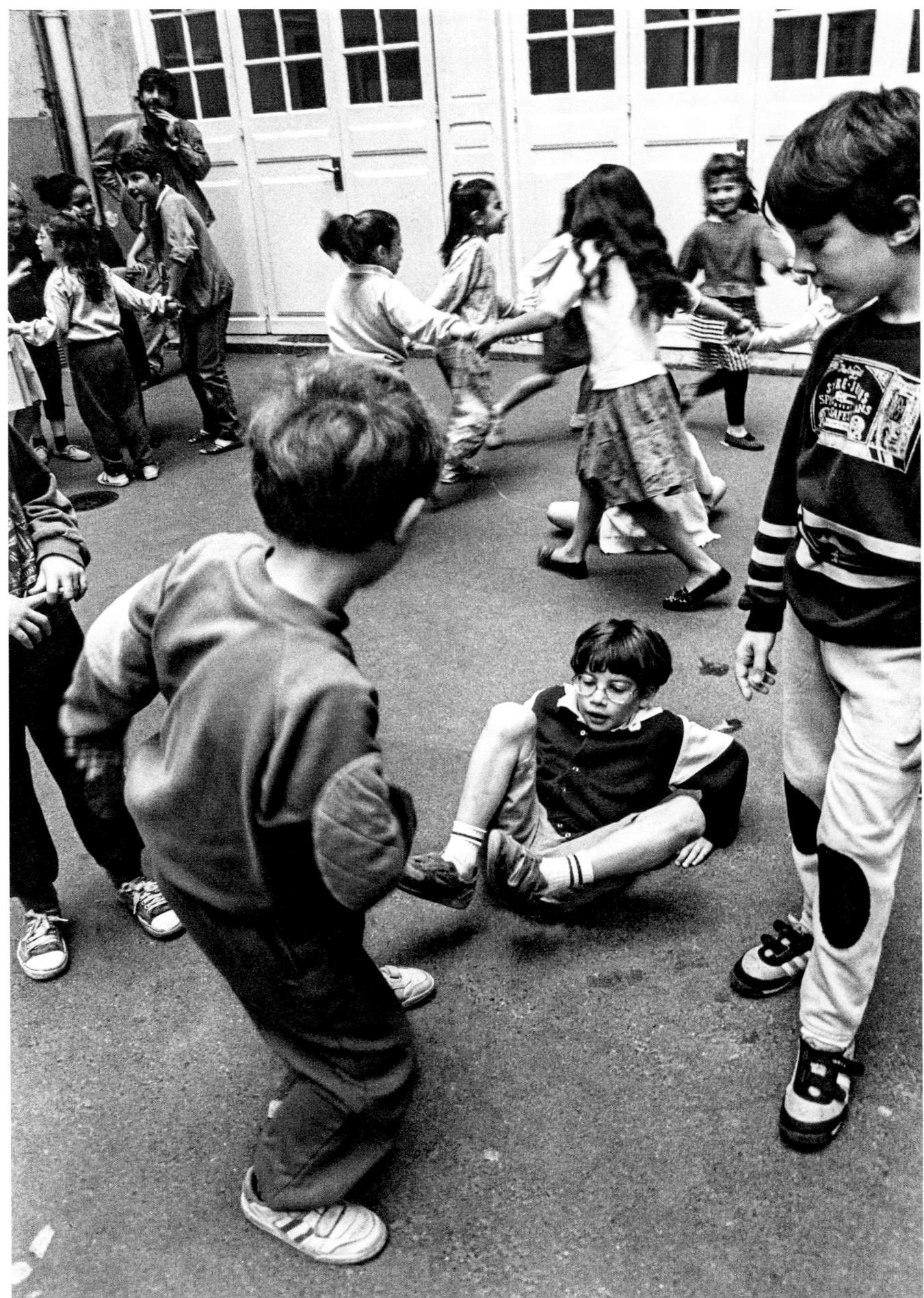

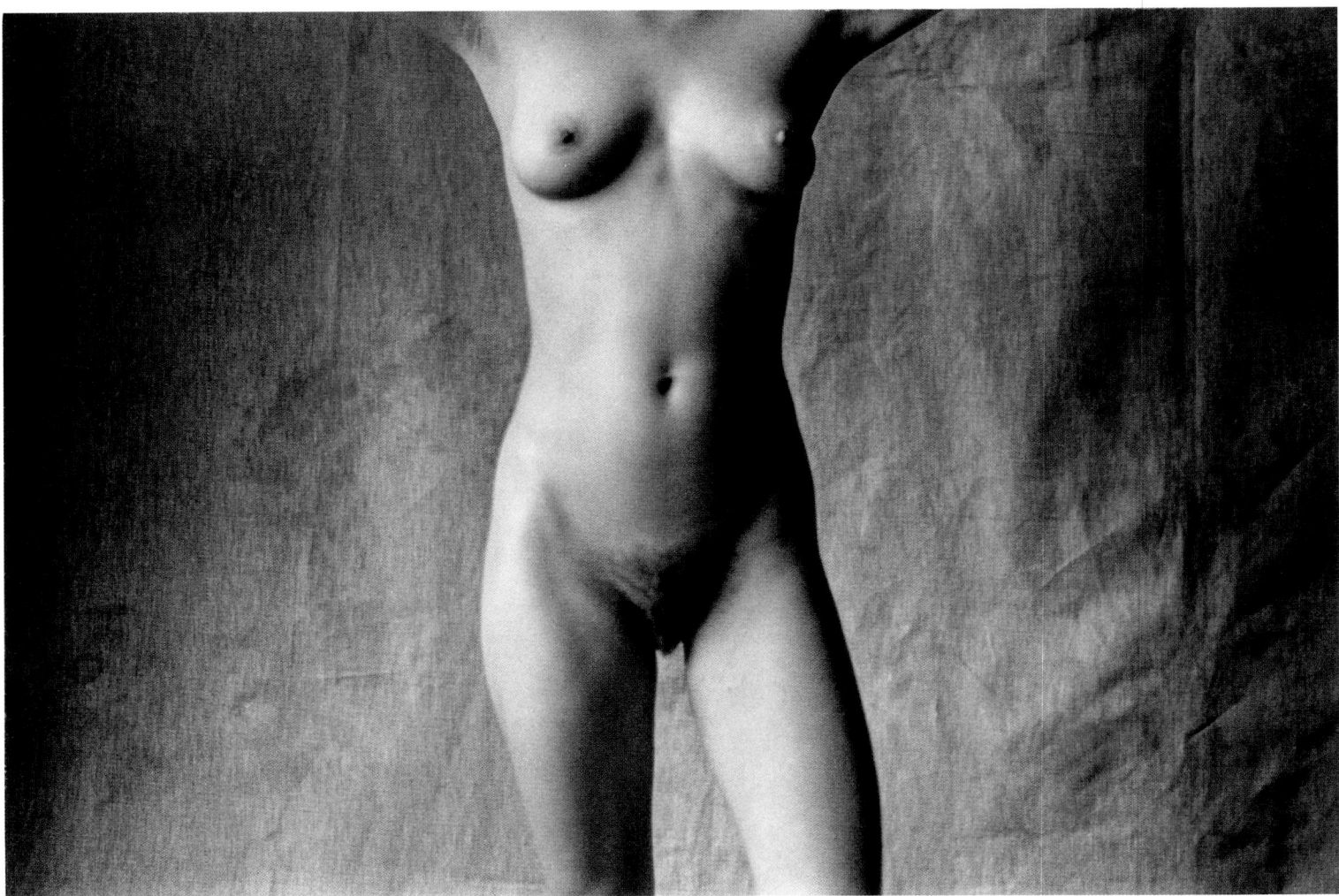

Nude, Paris, 1988
NEGATIVE: 24×36 MM _ 238/4128
___ 464

I was able to devote one room in my apartment to photography. I stretched out a large piece of cloth, not properly ironed on purpose, which I used as a backdrop in this room that benefited from good light from the north. A young woman who was not a professional asked to pose for me, as she did with other photographers, in the hope of building a portfolio. I chose this photo in natural light, taken during the first few minutes of the session. 50-mm lens. Almost full frame.

The nude with a linen cloth, Paris, 1988
NEGATIVE: 24×36 MM _ 239/1312
___ 465

The designer Agnès B. wanted to bring together one hundred unpublished photographs by one hundred photographers. The exhibition was planned in her gallery on rue du Jour, near Saint-Eustache church. The title was *Le nu au chiffon de lin* (The Nude with a Linen Cloth). We all received a thin piece of linen that measured 7 ¾ in. (20 cm) by 3 ft. 11 in. (120 cm). We were free to use it as we wished in our images. I called a woman from Guadeloupe, whose complexion contrasted with the light color of the fabric. By mutual agreement, this is the picture that the gallery director and I chose. The model was lying on a mattress covered with a dark bedspread. Backlit, with natural light. 50-mm lens. Full frame.

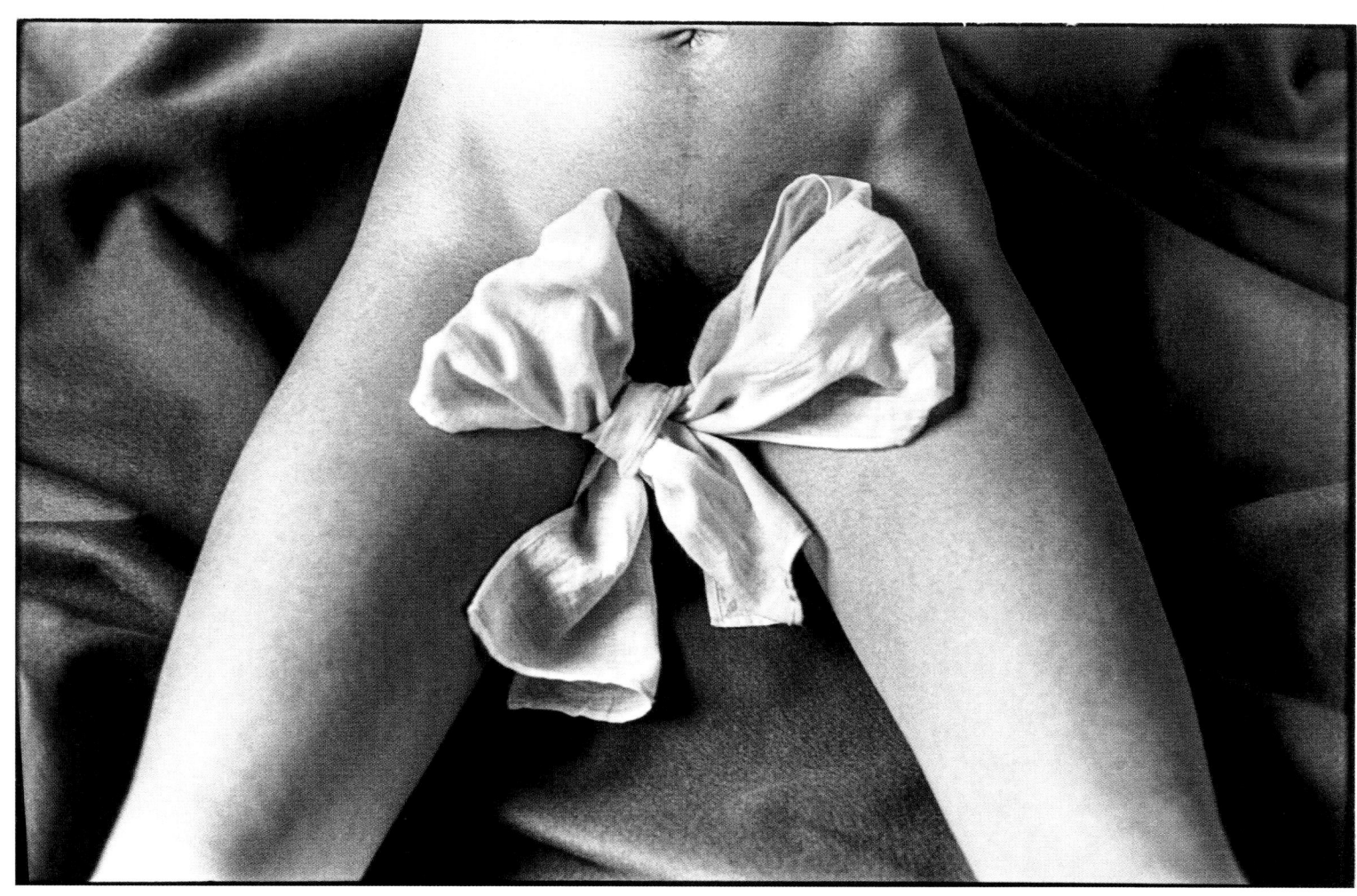

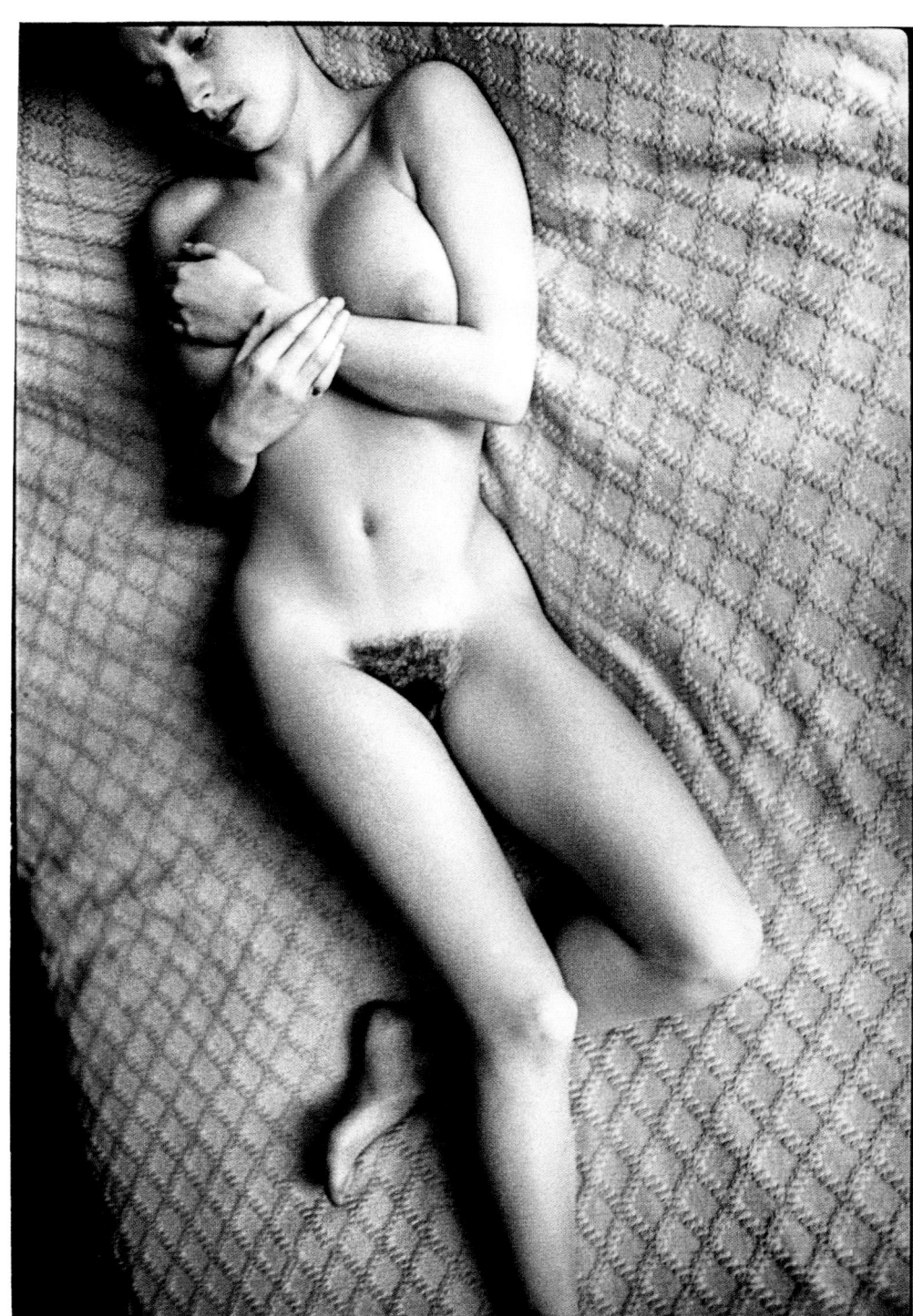

Marie-Anne, Nogent-sur-Marne, Val-de-Marne, 1988
NEGATIVE: 24×36 MM _ F240/1610
—— 466
One Sunday in November, in the public grounds of the Maison Nationale des Artistes in Nogent-sur-Marne. The morning light was emanating from a slightly overcast sky. The ground was carpeted with dead leaves, shed by the trees with each breath of wind. During the walk, I had found the best viewpoint on the third floor of the building. I asked Marie-Anne to sit on the stone bench and showed her the windows where she would be able to see me, so that she could face toward me. 75–150-mm. Full frame.

Nude, Paris, 1988
NEGATIVE: 24×36 MM _ 240/3415
—— 467
Nude shoot in the same room as in photo 465. Here too the model was lying on a mattress on which a light bedspread had been thrown. For this photograph I used my Minox and stood on a stool. Full frame.

**La Défense,
Hauts-de-Seine, 1989**
NEGATIVE: 24×36 MM _ P242/0144
___ 468

Project for a book that was being published for the opening of the Grande Arche. The subject: the pedestrians of La Défense. Request: the characters must appear relaxed. Given the production time, I started shooting a little too early, in March, and the weather was pretty cool. The photo above left was taken in the passage that connects place de la Défense to the Coupole area (home to the Tour Fiat, Tour Elf, etc.). Backlit image with complex shadows owing to reflections on the glass buildings. 28–50-mm zoom. Full frame.

**Lunch break, La Défense,
Hauts-de-Seine, 1989**
NEGATIVE: 24×36 MM _ P242/3329
___ 469

Lunch break, three weeks later. The sun was out, and there was no wind. Workers and tourists rubbed shoulders, so the photographer sought out the best viewpoint to obtain a satisfactory balance between static and dynamic elements. 28–50-mm zoom. Framing a little cropped to the left.

**La Défense,
Hauts-de-Seine, 1989**

NEGATIVE: 24×36 MM _ P243/3935

___ 470

This passerby was hurrying toward the Crédit Lyonnais and Atlantique towers. There was a harsh backlight, and I had run to catch up with my subject and capture her at a moment when her feet were close together, which accentuates the tapered shape of her silhouette. 28–50-mm used at 28 mm. Full frame.

DONATION 3
2006

ALBUM_06 _ VOL.1: PHOTOGRAPHS 471 > 510

ALBUM_06 _ VOL.2: PHOTOGRAPHS 511 > 550

ALBUM_06 _ VOL.3: PHOTOGRAPHS 551 > 590

This page opens the sixth and final album, since the author put away his cameras in 2002 when he was forced to use two canes when venturing outside. The album contains 120 photographs, half of which were taken before the final image in album 5, because, on reflection, it was unfair not to include what might help people understand my story better. I thus awarded myself the right to reconsider, which will, I hope, be forgiven.
The six albums include 590 photographs in total. This selection is the photographer's own, and is therefore subjective, which determines both its merits and its limitations.

The beginning, in the Trocadéro gardens, Paris, 1927
NEGATIVE: 2½ × 4¼ IN. (6.5 × 11 CM) _ P07/1
__ 471

My father had given me my first camera the previous year. I had already taken photos of the family and of vacations. I was sixteen and a half. This is probably one of my first photos of Paris, made with my 2 ½ × 4 ¼-in. (6.5 × 11-cm) Kodak with bellows.

Quai de Bercy, Paris, 1935
NEGATIVE: 2¼ × 3¼ IN. (6 × 9 CM) _ P5/46
__ 472

Kodak camera. Three years earlier, I had joined my father's portrait studio. When he began to suffer from incurable cancer, he came less and less often. I hated this studio and compensated by photographing Paris on Fridays, when the studio was closed. The quays were one of my favorite places: here, I encountered some workmen on quai de Bercy, at the site where coal was loaded.

Gare de l'Est, Paris, 1937
NEGATIVE: 1¾ × 2¼ IN. (4.5 × 6 CM) _ P7/4
__ 473

Rolleiflex. Train stations are photogenic. This is rue d'Alsace, overlooking the departures and arrivals at Gare de l'Est. Steam engines would be ubiquitous for a long time yet. A train leaving Paris lets off jets of steam.

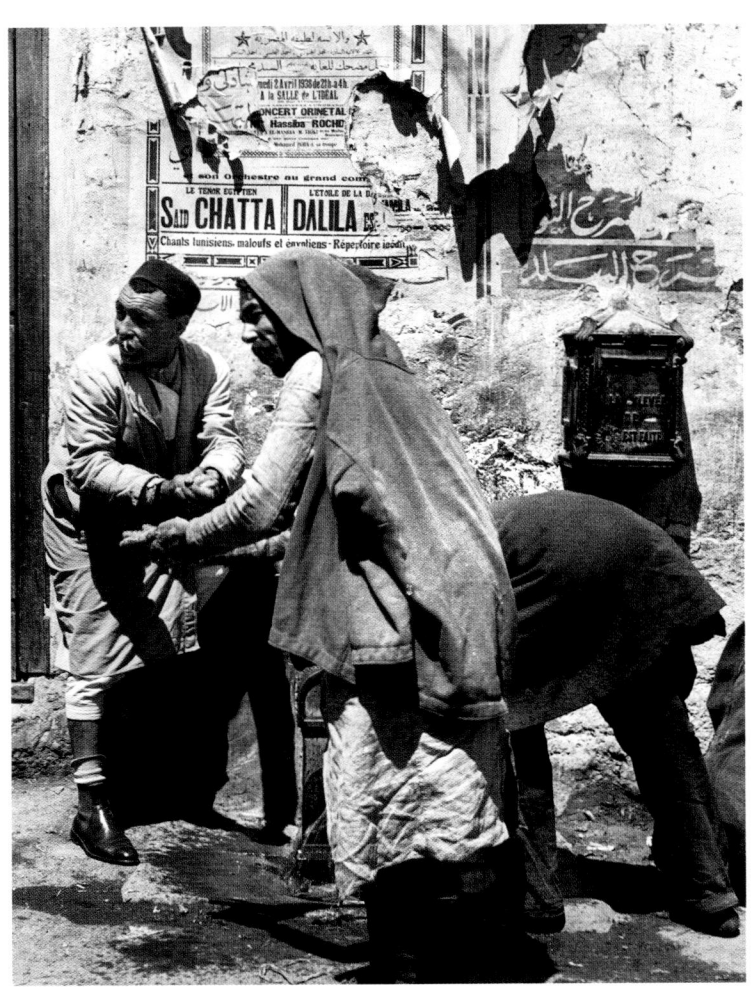

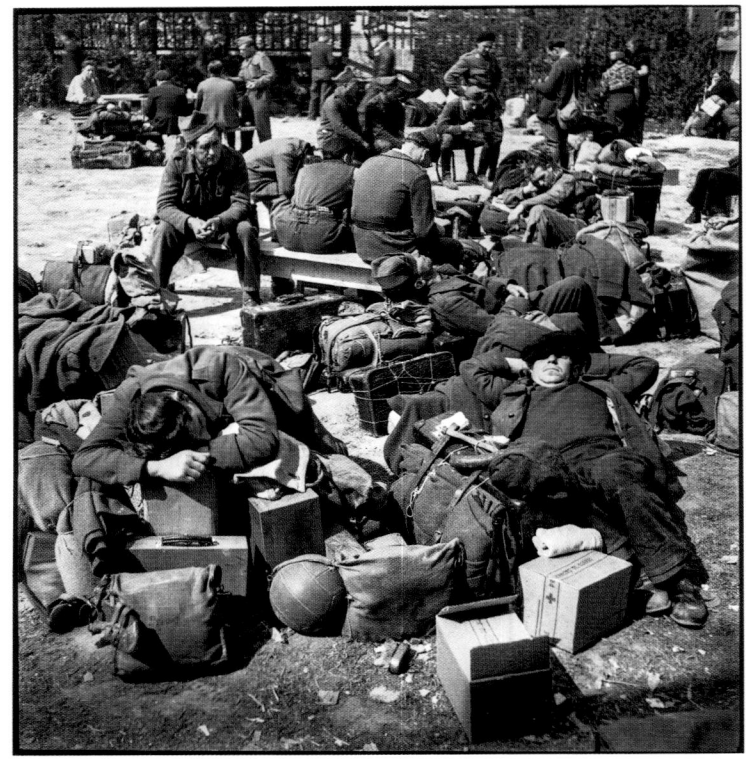

Tunis, Tunisia, 1938
NEGATIVE: 2¼×2¼ IN. (6×6 CM) _ C8/83
___ 474

An enterprising army friend had just created a travel agency and took me on two Mediterranean cruises in exchange for work. I had to photograph life on board ship and picturesque stopovers for his advertisements. This photo was taken in a working-class district of Tunis. Photo 21 was taken in Durrës, Albania. We also dropped anchor in Yugoslavia and Greece. On our return, Robert Capa, with whom I had become close over the last two years, proposed choosing five (or six) series of twenty pictures from the mass of images I had brought back. Without fanfare, he dictated an article to his secretary, "The Balkans at Risk Again," crediting "Our Special Correspondent Willy Ronis, etc." The series was sent to five European capitals and New York. But war broke out, disrupting this admirable plan. Capa had already foreseen what would become the prestigious Magnum agency after the war, in 1947.

Prisoners at rest, Revigny-sur-Ornain, Meuse, 1945
NEGATIVE: 2¼×2¼ IN. (6×6 CM) _ R15/3/90
___ 475

The repatriation of prisoners. In April that year, the French state railroad assigned me a major story about the repatriation of prisoners (photo 27). The report was divided into two round trips between Paris and the German border, interspersed with multiple stops throughout.

Tree surgeons on boulevard Richard-Lenoir, Paris, 1945
NEGATIVE: 2¼×2¼ IN. (6×6 CM) _ P15/4
___ 476

At this time we were living on boulevard Richard-Lenoir, near rue Oberkampf. The tree surgeons were under my fifth-floor windows. It is taken from the same perspective as the photos of the busker (photo 42) and the fall landscape (photo 356).

**Locksmith in Cavignac,
Gironde, 1945**

NEGATIVE: 2¼×2¼ IN. (6×6 CM) _ F15/4

___ 477

During our summer vacation in Cavignac, at my in-laws, I became acquainted with the locksmith and the jovial winemaker from whom my father-in-law got his supplies, and, the following year, the farmer from photo 38.

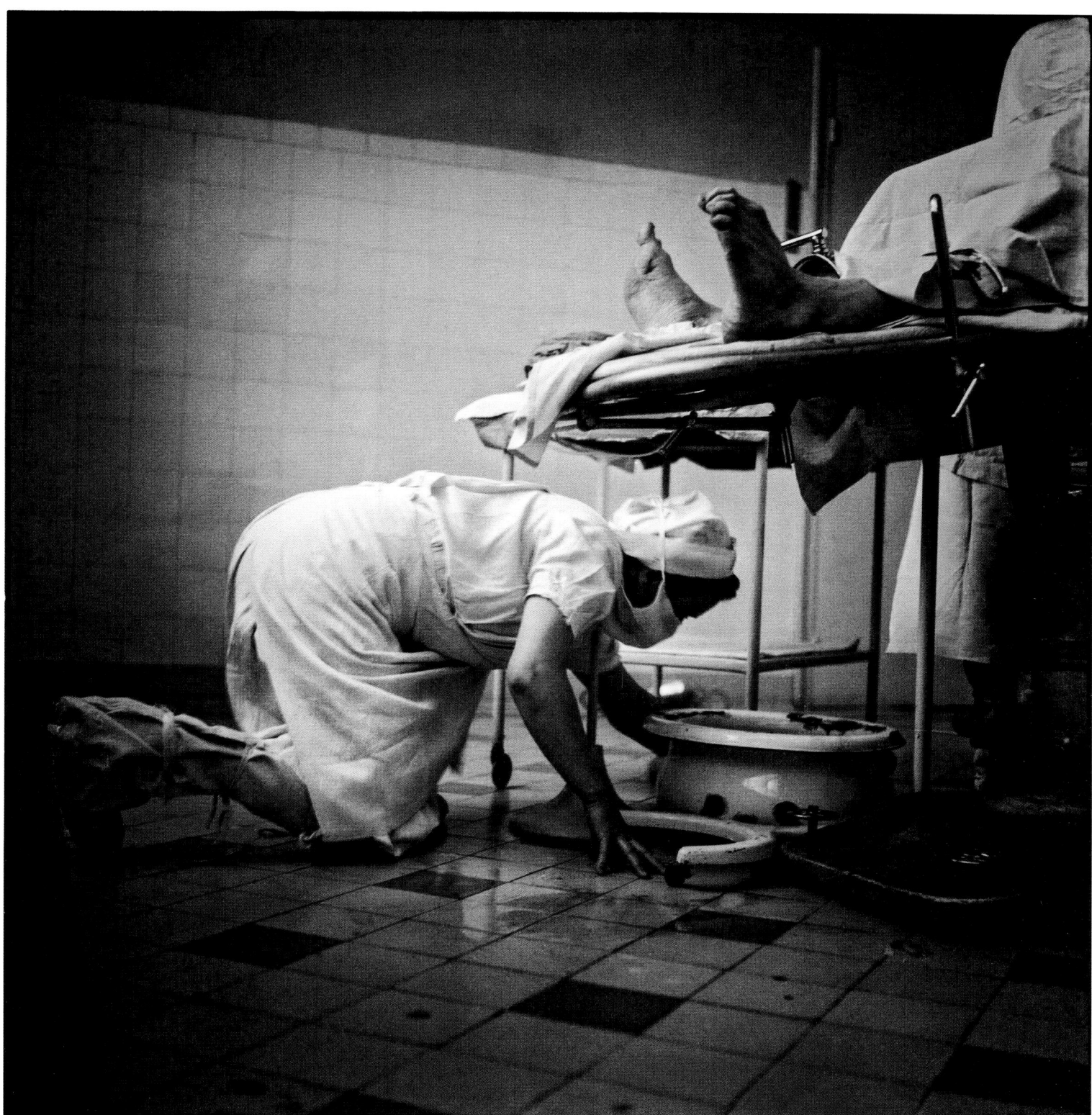

Bichat hospital, Paris, 1946
NEGATIVE: 2¼×2¼ IN. (6×6 CM) _ R16/9/54
— 478

In March, a weekly commissioned me to do a report on a surgeon at the Bichat hospital. I was allowed to work during the operation. This photo was taken shortly before leaving the premises. I rarely print the entire 2¼ × 2¼-in. (6 × 6-cm) negative when working with the Rolleiflex. The general composition of this scene made it necessary.

Fairground, boulevard Garibaldi, Paris, 1947
NEGATIVE: 2¼×2¼ IN. (6×6 CM) _ R17/20/15
___ 479

The traveling carnival came to boulevard Garibaldi twice a year, at Easter and in the fall. Living from 1947 to 1964 in a little house with an artist's studio (my wife was a painter) on passage des Charbonniers, near the Sèvres-Lecourbe metro station, I was often drawn to the fair's attractions and rides. This was the case that October, when Raymond Grosset, who had founded the Rapho agency the previous year, had brought back an electronic flash, which was a novelty at that time, from either England or the United States. The instrument was carried across the shoulder and weighed twenty-two pounds (ten kilos). Furthermore, in wet weather it would sometimes honor its user with a violent jolt. (Doisneau, my colleague at the agency, had once experienced this.) Within two years the electronic flash became lighter and more user-friendly. On this particular evening, I used it after spotting a packed (mostly male) crowd under the swings, where the adventurous were doing loop-the-loops.

The local journalist, Montsalier, Basses-Alpes, 1948
NEGATIVE: 2¼×2¼ IN. (6×6 CM) _ R18/21/102
___ 480

At Easter, the agency sent me to do a report on caving in the Alpes-de-Haute-Provence. Near the chasm, my attention was drawn to this local journalist writing his article in the cool of the morning (photo 378, *The speleologist's goodbye*). After this adventure, I joined Marie-Anne who was waiting for me in Gordes, where the year before I had photographed the painter André Lhote (photo 51) and his summer school. I was impressed by the village's beauty and urged by the painter to acquire a ruin there (as some of his students had, it being very cheap then). During my days underground, my wife managed to find something that, after some much needed work, became our vacation haven. As well as André Lhote in an empty frame, I would photograph *The Provençal nude* in 1949 (photo 94) and *Vincent and the model aircraft* in 1952 (photo 129) in this village.

Homework time, family in need, Paris, 1949

NEGATIVE: 2¼×2¼ IN. (6×6 CM) _ R19/2/13

—— 481

A report on those families in need supported by charities. Note that in this kitchen, a small space is devoted to children for their homework, the rest serving as a kitchen counter on which to set out the dishes. It was in an equally poor family that I hired the elder daughter for a modeling session in the attic room adjoining the kitchen (photo 89), having discovered that she posed for sculptors.

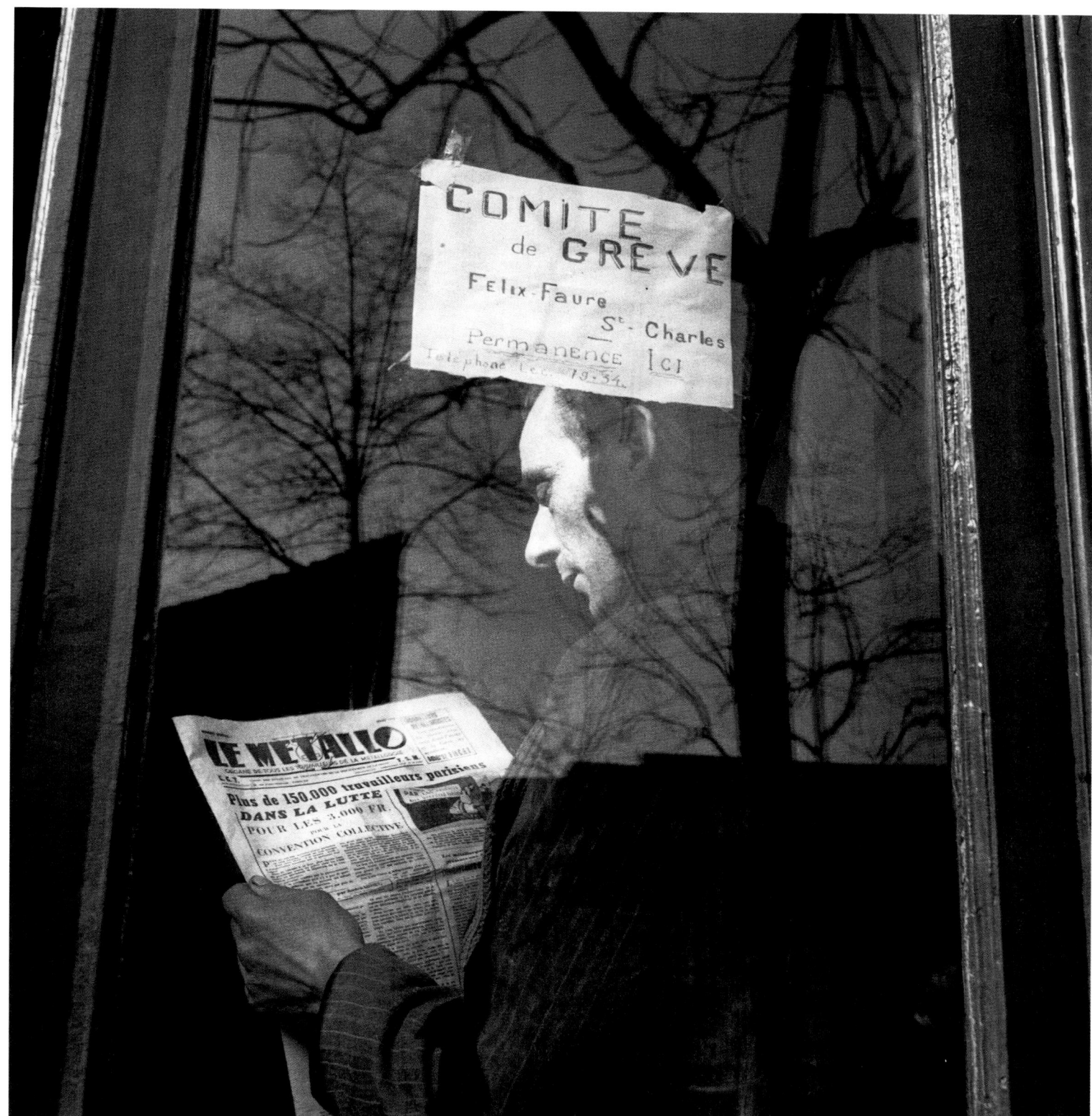

Strike at Citroën-Javel, Paris, 1950

NEGATIVE: 2¼ × 2¼ IN. (6 × 6 CM) _ R20/3/24
— 482

In the early 1950s there was a period of strikes. I traveled around Paris by motorbike, stopping in front of appropriate subjects, such as this café in which a Citroën striker was reading the news. It was at this time that I took *The delegate* (photo 101).

The children of Aubervilliers, Seine, 1950
NEGATIVE: 2¼×2¼ IN. (6×6 CM) _ R20/8/60
___ 483
Soon after, social services in Aubervilliers sent me to a poor neighborhood. Hence this photo (and photo 104).

Place Vendôme, automobile gala, Paris, 1950
NEGATIVE: 2¼×2¼ IN. (6×6 CM) _ R20/14/53
___ 484
My activities spanned different worlds, hence this image, taken from a nighttime report in June, at place Vendôme during an automobile gala. On June 15, at L'Isle-Adam swimming pool, I photographed a throng of dancers from the Paris Opéra during a closed session (photo 105).

Nightclub, Megève, Haute-Savoie, 1952
NEGATIVE: 2¼×2¼ IN. (6×6 CM) _ R22/5/56
___ 485

Air France had introduced quick connections to Megève (among other destinations) for busy skiers who wanted to practice their favorite sport at the weekend. I hired a pretty young athlete from a modeling agency. The story was published in *Air France* magazine. Take-off on the afternoon of Saturday, February 2. We left the plane 1 hour and 10 minutes later for the bus, which got us to Megève early enough to enjoy the slopes before dinner. Around 10 p.m., we were in a nightclub during the election of the local homecoming queen. My model was the winner! I took this picture soon after, at a table shared with new friends. Chance, that reliable accomplice, had led me to run into Paul Éluard at Orly, on his way to Geneva for a conference. We knew each other. During the flight, I waited for the moment when, as the plane was turning, the sunlight would fall on Paul and Dominique. That was photo 117.

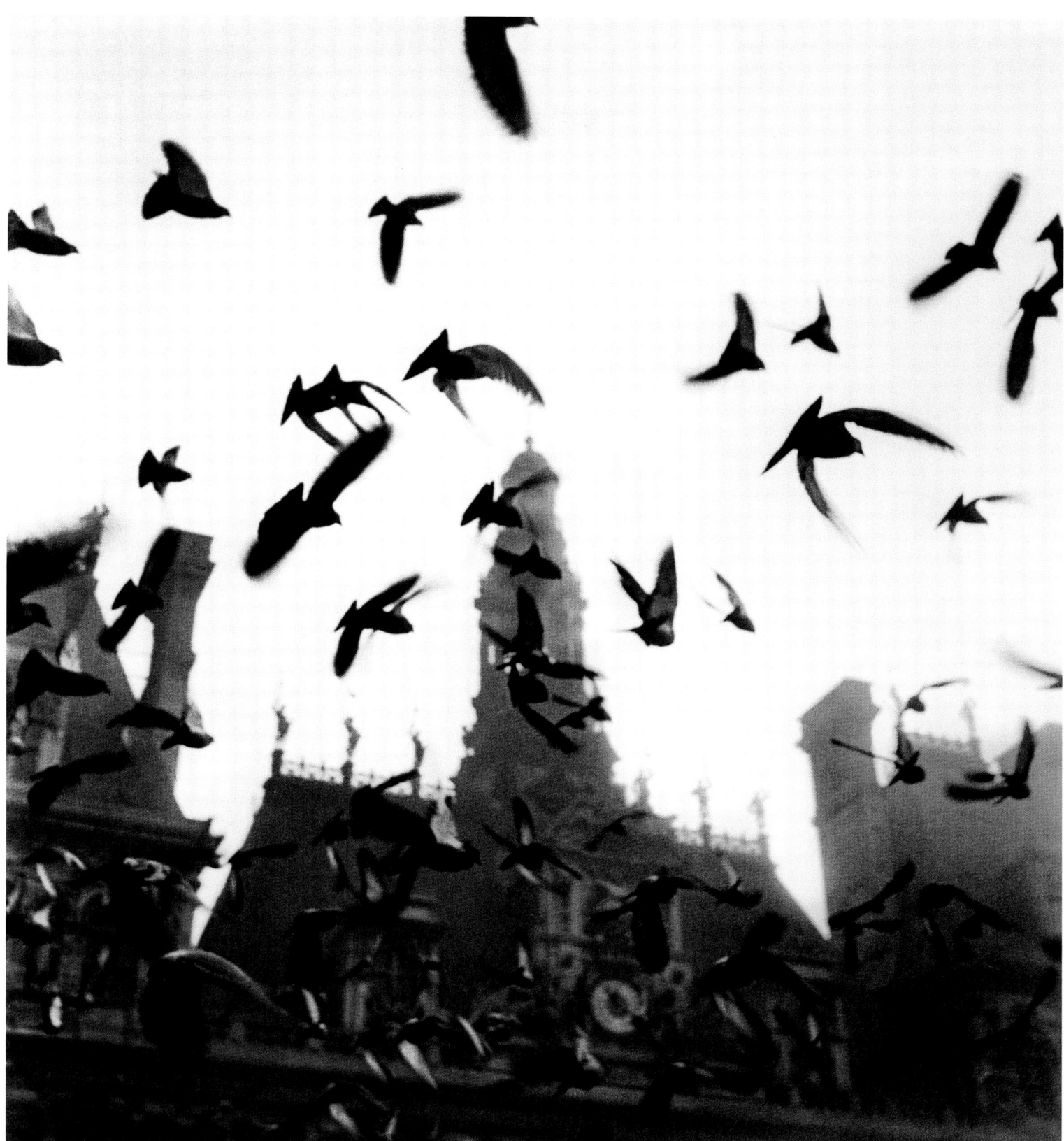

**Place de l'Hôtel-de-Ville,
Paris, 1952**
NEGATIVE: 2¼×2¼ IN. (6×6 CM) _ P22/80

That same winter, passing through
the place de l'Hôtel-de-Ville.

**Weekend in Seine-et-Marne
with Marie-Anne and Vincent,
Chambry, Seine-et-Marne, 1952**
NEGATIVE: 2¼×2¼ IN. (6×6 CM) _ R22/7/6BIS
___ 487

In my book *Derrière l'objectif* (Behind the Lens) is photo 118—*Marie-Anne and Vincent playing in the snow*, taken on a Sunday in February near Meaux—which appears on page 53. The facing photo is from the same roll. I usually present it fully square, for the sake of the composition. I print it inverted left-to-right, so that Marie-Anne's movement is more apparent, perhaps because we Westerners read from left to right.

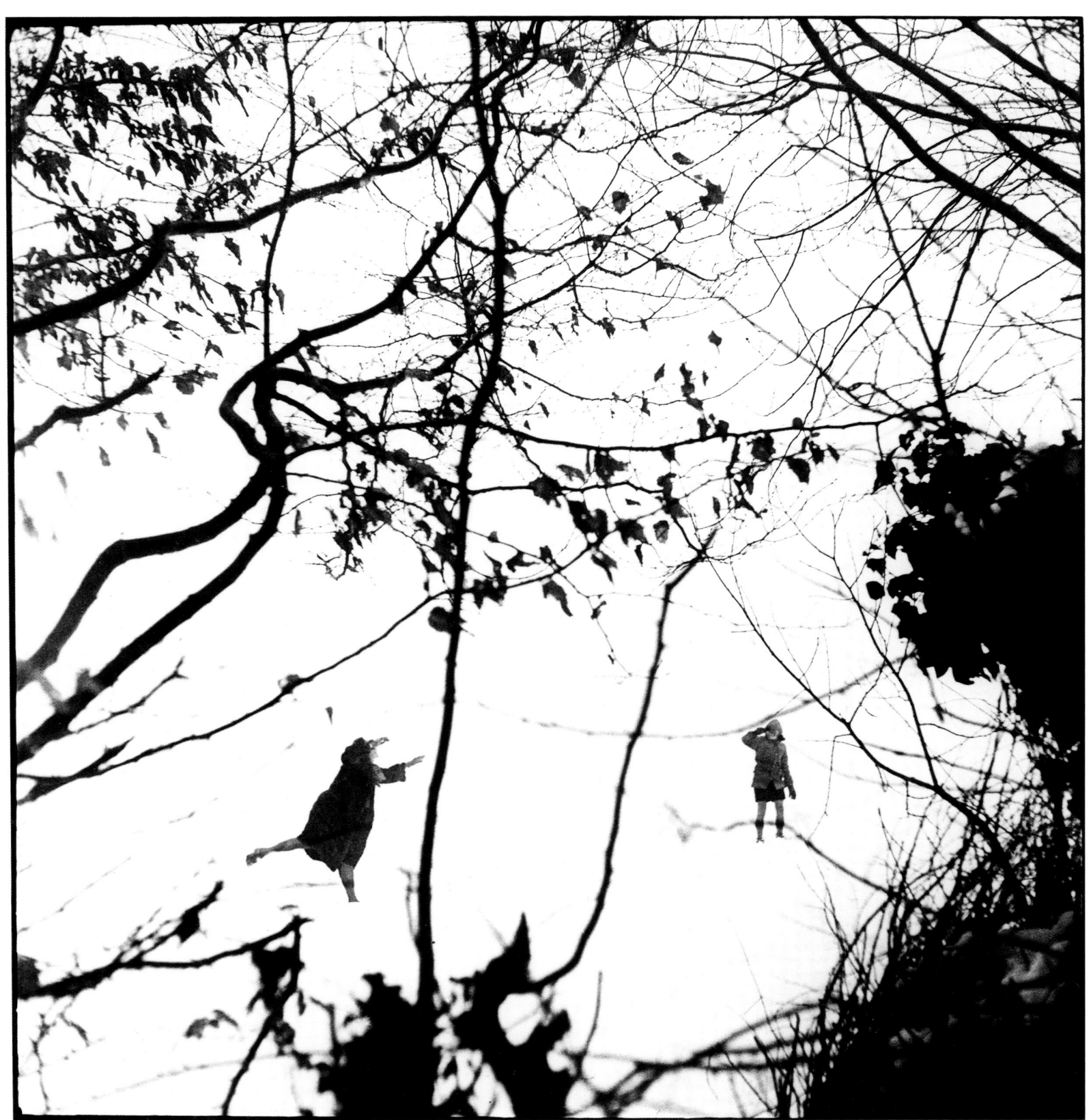

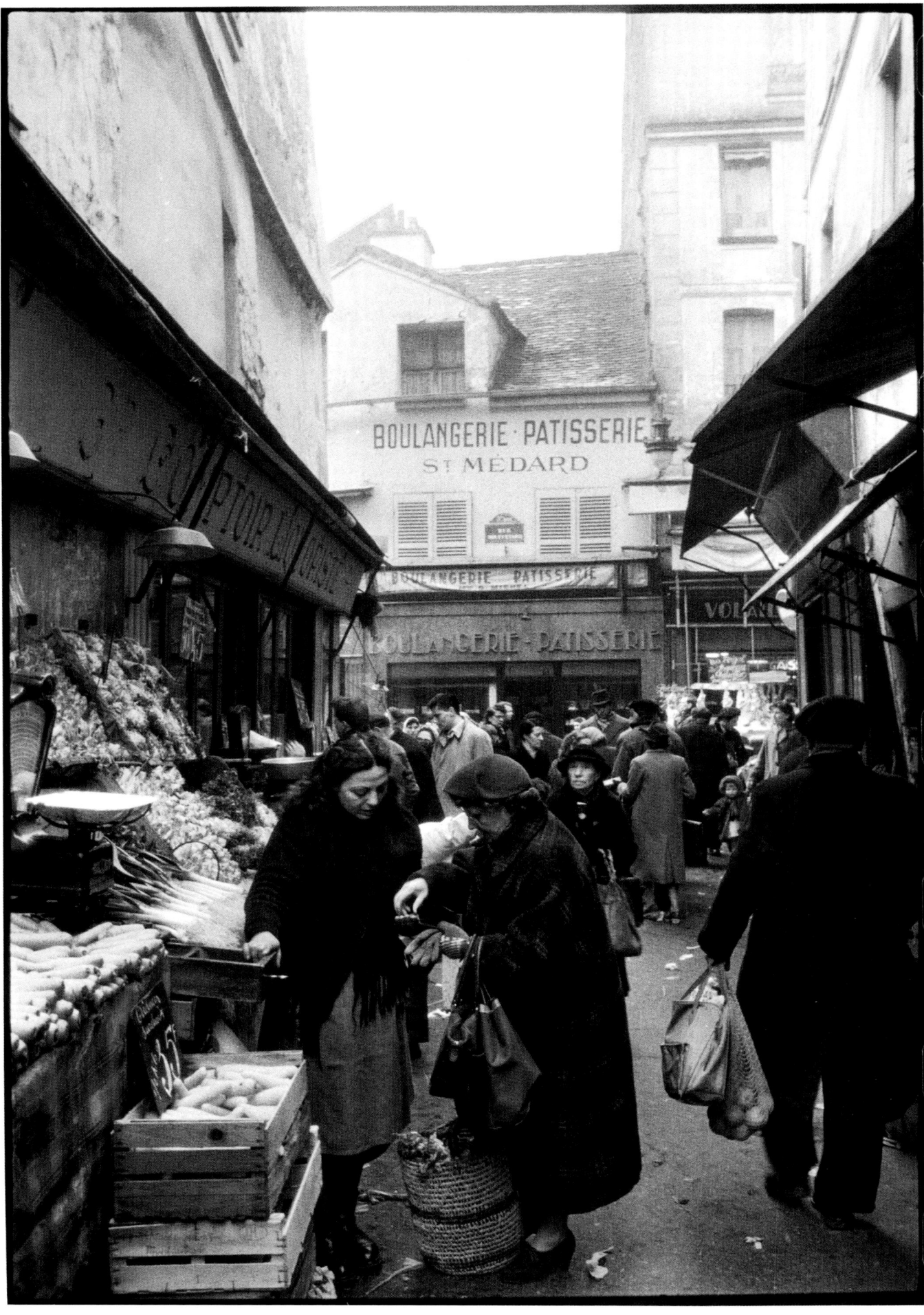

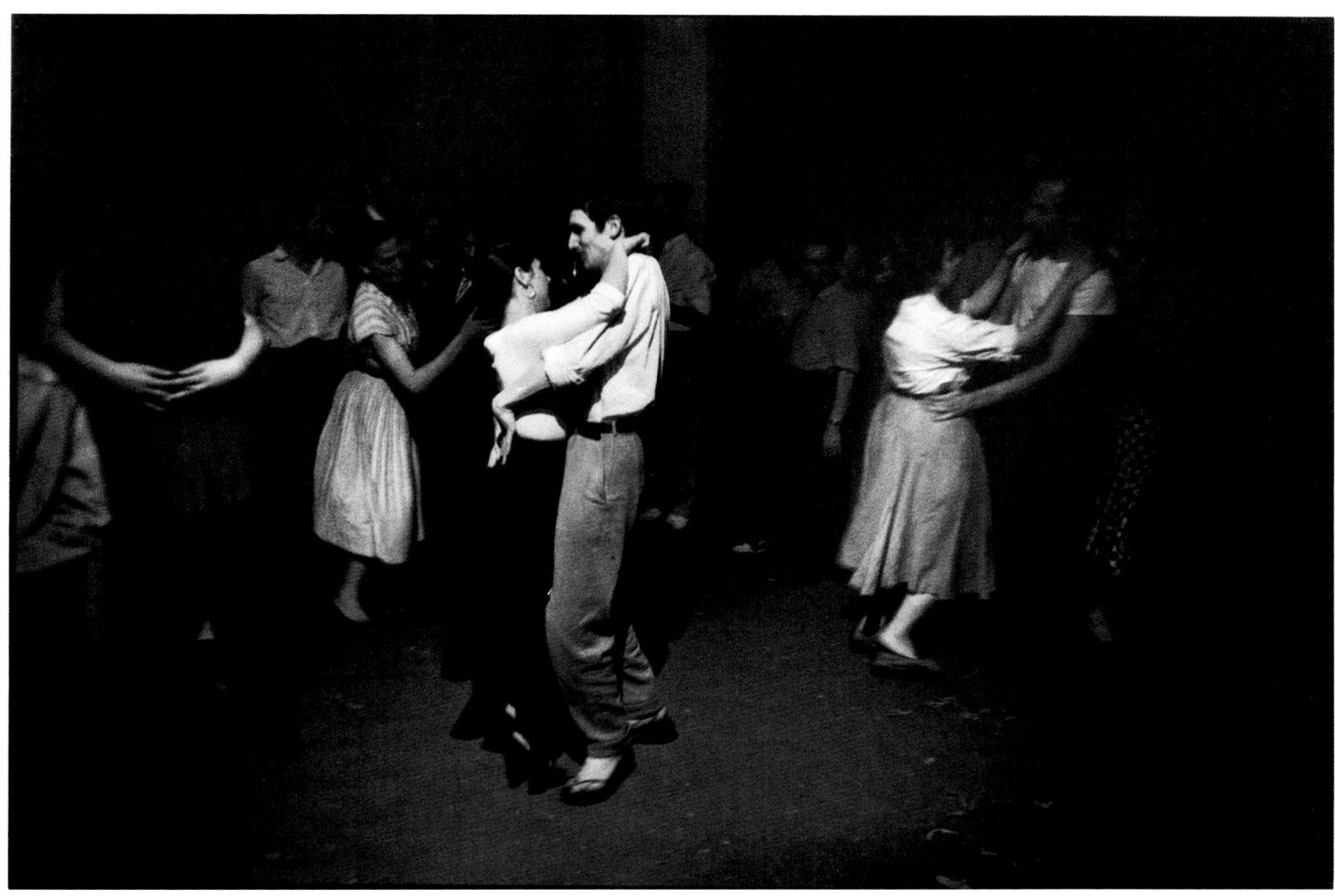

**Rue Mouffetard from
rue Daubenton, Paris, 1955**
NEGATIVE: 24×36 MM _ P4/1408
___ 488

Foca camera (no cropping). I had started
my story on Christmas week 1954 with my
Rolleiflex, bought in 1937 and of which
I had acquired a double in 1949 for safety
reasons. But I finished my story with a
24 × 36-mm (photos 157 to 162), a format
I stuck to (with a few rare exceptions) until
I put my equipment away in 2002. In winter
1955, I found myself in the Mouffetard
area, on rue Daubenton, where I took
this scene on the morning of March 8.

**The night of July 14,
rue des Canettes, Paris, 1955**
NEGATIVE: 24×36 MM _ R12/1723
___ 489

I spent part of the evening of July 14
roaming through Saint-Germain-des-Prés.
It was quieter in a little bistro on rue des
Canettes. The interior was cramped, and a
few couples went outside to dance on the
pavement, lit only by the lights of the café.

Gallantry, Saint-Germain-des-Prés, Paris, 1956
NEGATIVE: 24×36 MM _ P29/1139
—— 490

Parisian smooth talk. Springtime in May. I was in my car on rue de Grenelle, stopped at a red light. On my left, some rather heavy banter; the traffic light turned to green at the right moment, saving the unfortunate driver.

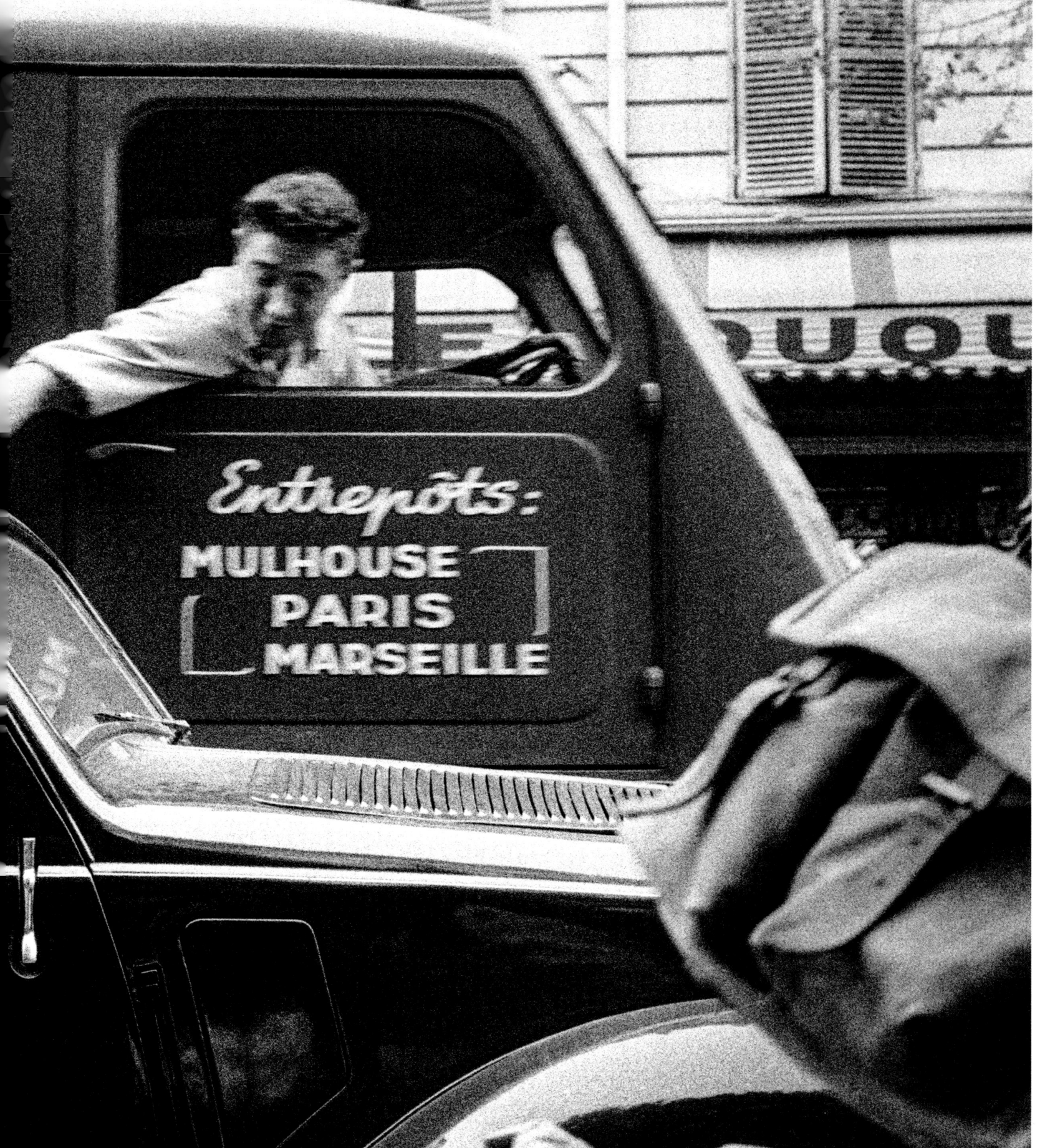

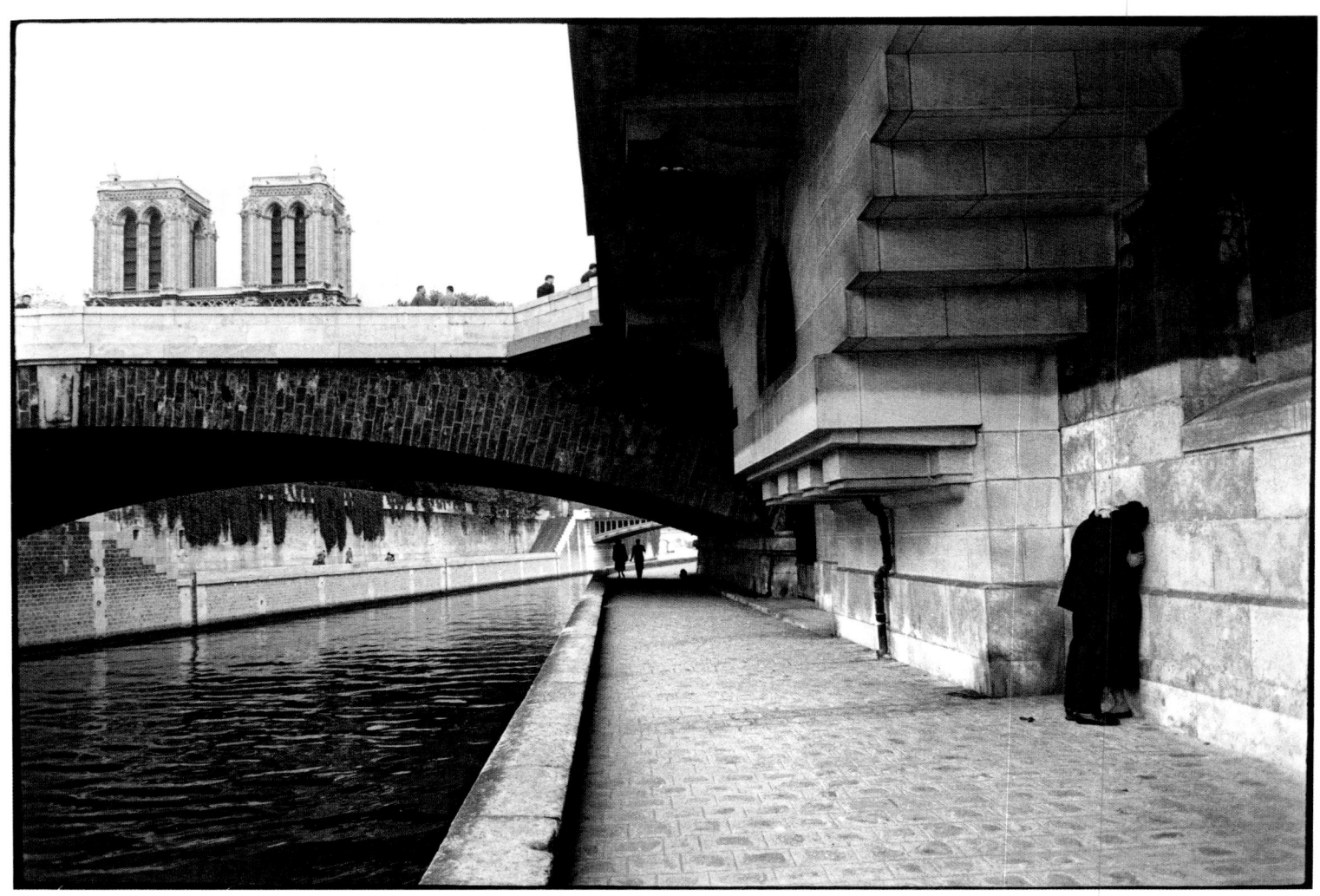

**The lovers of the
Petit-Pont, Paris, 1957**
NEGATIVE: 24×36 MM _ P50/0543
___ 491

For photo 220, *The lovers of the Pont Royal*, I mentioned my work on the bridges of Paris, done alongside my project on the youth of rue de la Huchette. In May, I spent a lot of time on the quays. Here, I was standing on the Left Bank, at the Petit-Pont. There is a contrast between the weight of the architecture and the poetry of the embracing couple.

**Dockworkers, quai Ivry,
Paris, 1957**
NEGATIVE: 24×36 MM _ P51/0442
___ 492

I continued my journey along the Seine in April and May. Upstream from the Pont de Tolbiac, I was attracted by the cheerful voices of a group of longshoremen resting at the bottom of a barge. On May 19 I returned to rue de la Huchette. For a long time it would be my favorite hunting ground (see photo 221).

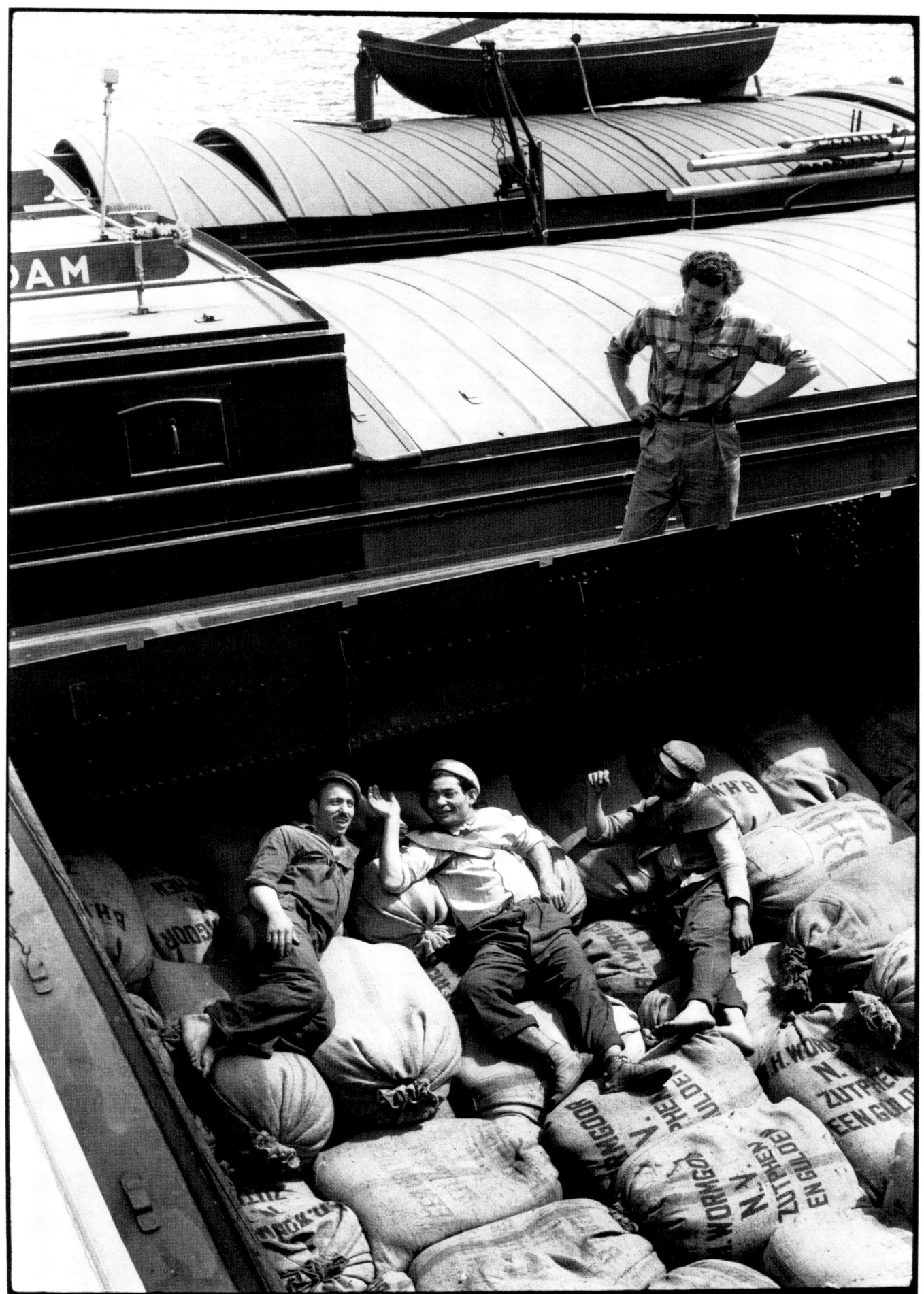

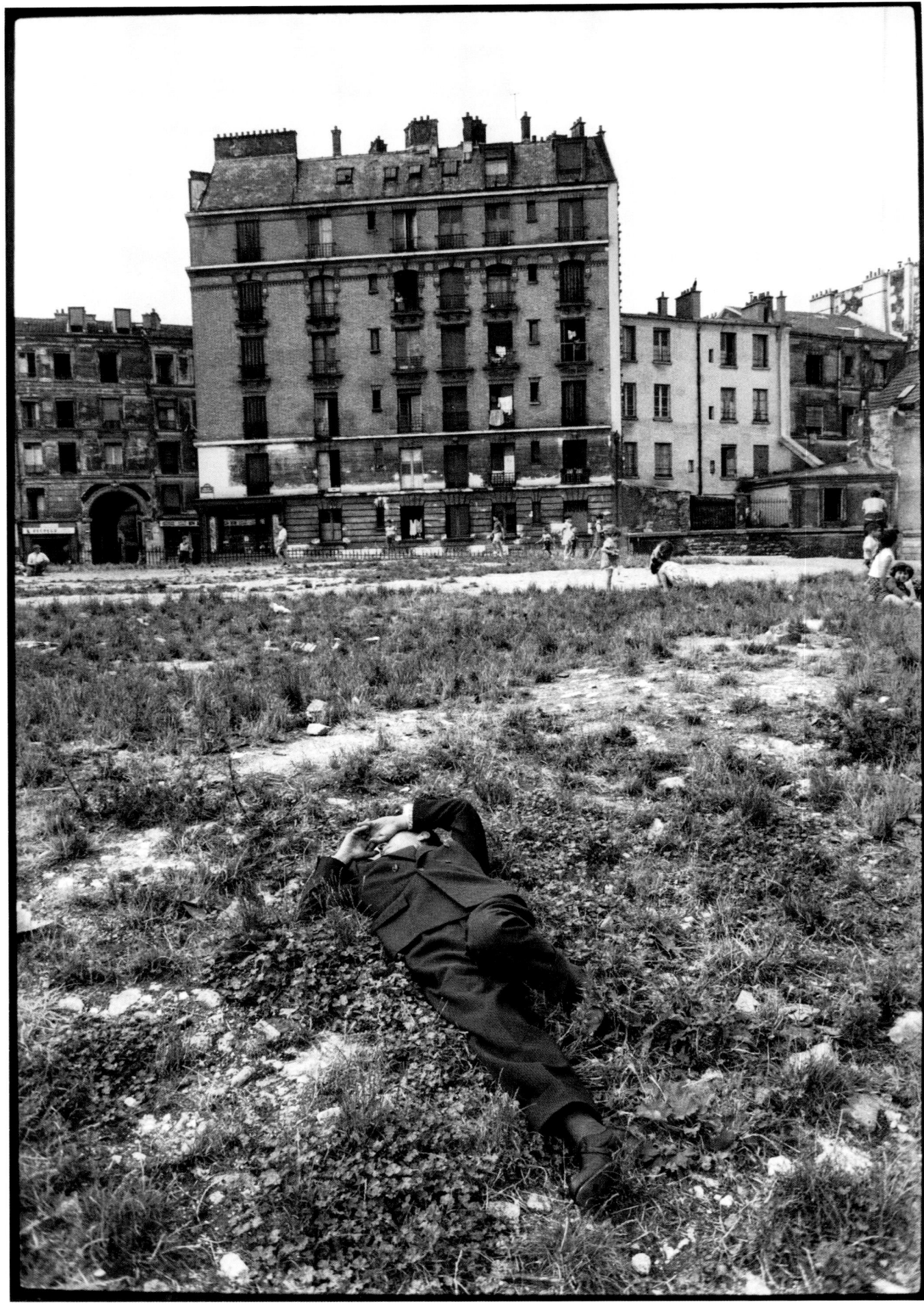

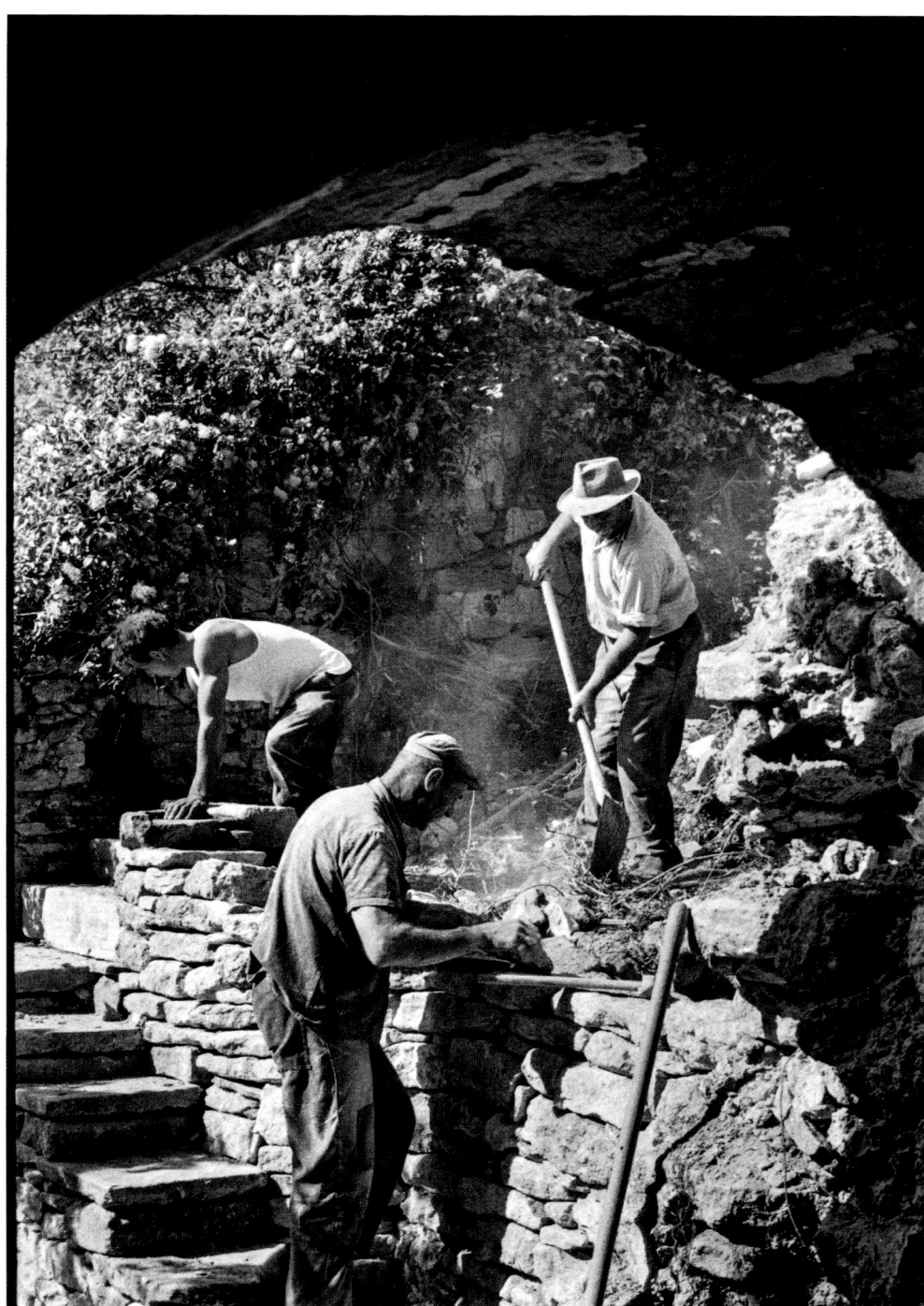

**Vacant lot on rue Botha,
Paris, 1957**
NEGATIVE: 24×36 MM _ P53/3717
___ 493

Focagraphie was a magazine founded by OPL (Optique et Précision de Levallois), which, among other things, designed the Foca camera whose top-of-the-range model equipped many travelers and explorers. Foca gave me their equipment in exchange for articles, which I supplied in the form of a commentary on my stories taken with this camera. On July 9, I was in the twentieth arrondissement for the "Back to Belleville" story, for which this photo was taken. I used this camera up until 1980, under the surprised, even contemptuous, gaze of my colleagues, almost all of whom were "Leicaists." Apart from the silence of the shutter, unique to Leica, I never regretted my choice.

Masons, Gordes, Vaucluse, 1958
NEGATIVE: 24×36 MM _ F63/4628
___ 494

During our vacation in Gordes, we had begun rudimentary work on the small building we had just acquired to accommodate visiting friends, and especially ourselves if we came at Easter or Christmas, because it would be much easier to heat.

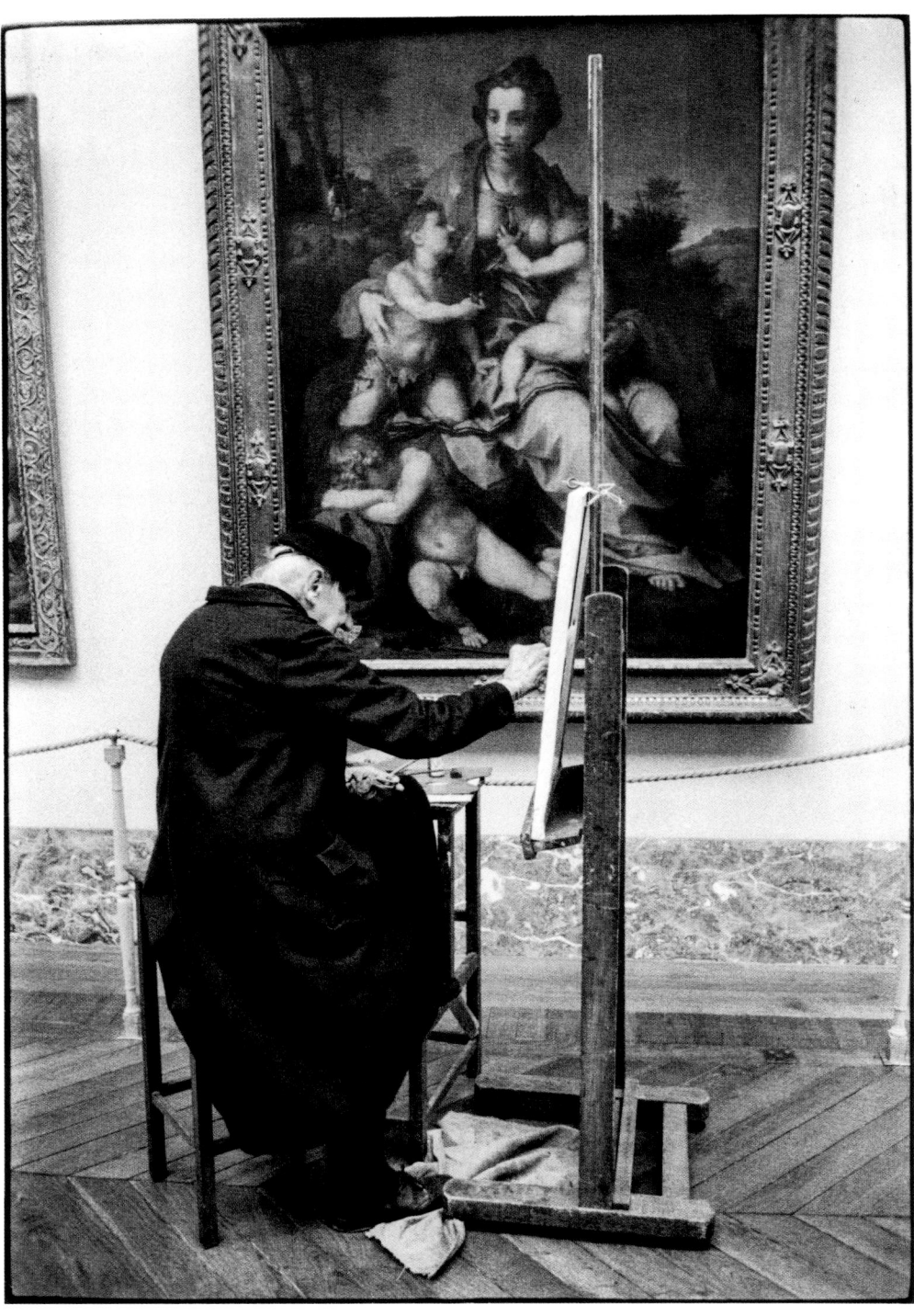

The old copyist, the Louvre, Paris, 1960
NEGATIVE: 24×36 MM _ P81/1205
— 495
June 12, an afternoon at the Louvre.

Borax warehouse, Coudekerque-Branche, Nord, 1960
NEGATIVE: 24×36 MM _ R82/1429
— 496
In July, a communications agency commissioned me to do an industrial story on borax near Dunkirk. We watched the product being transported from a warehouse to a freight-train platform.

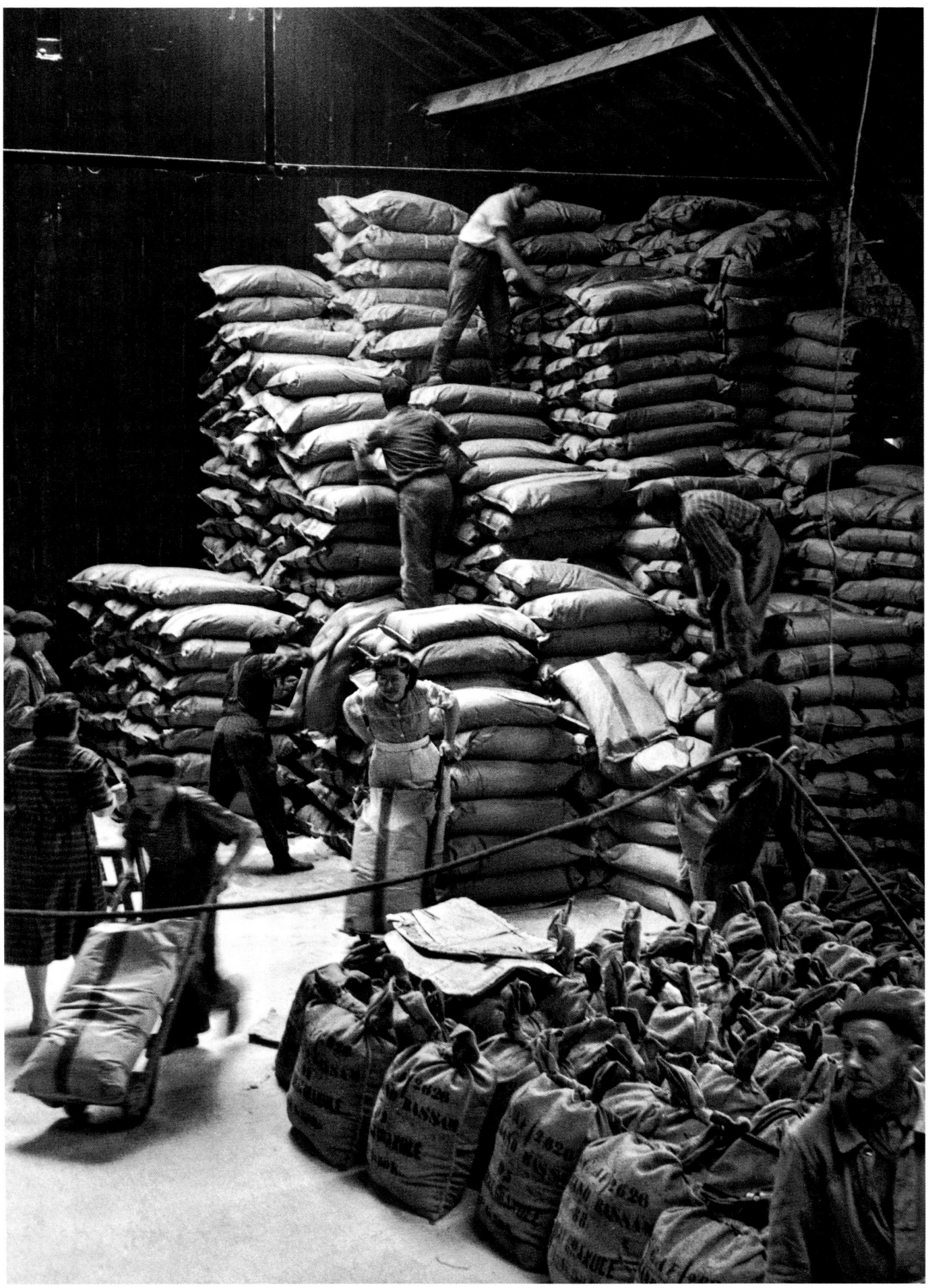

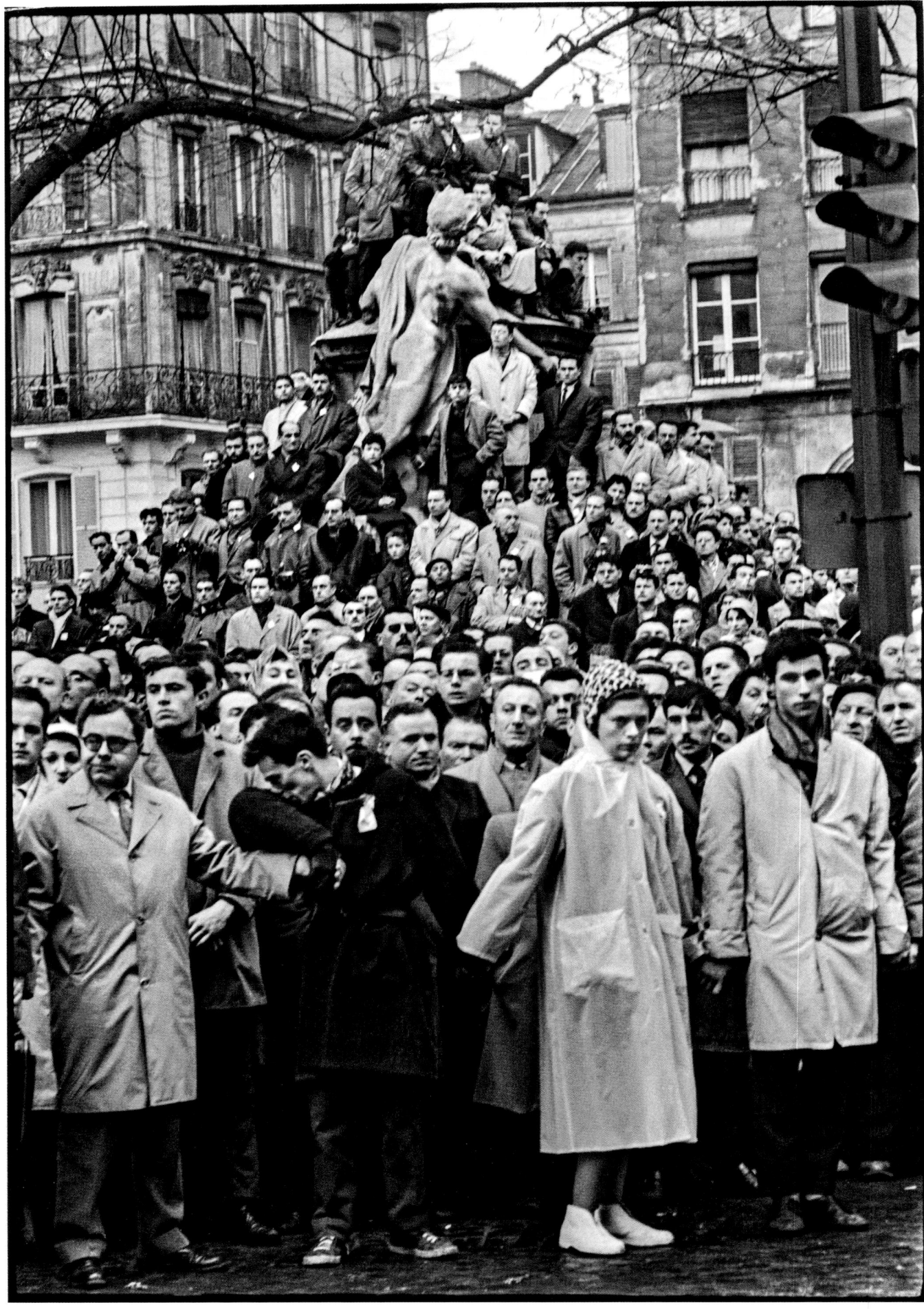

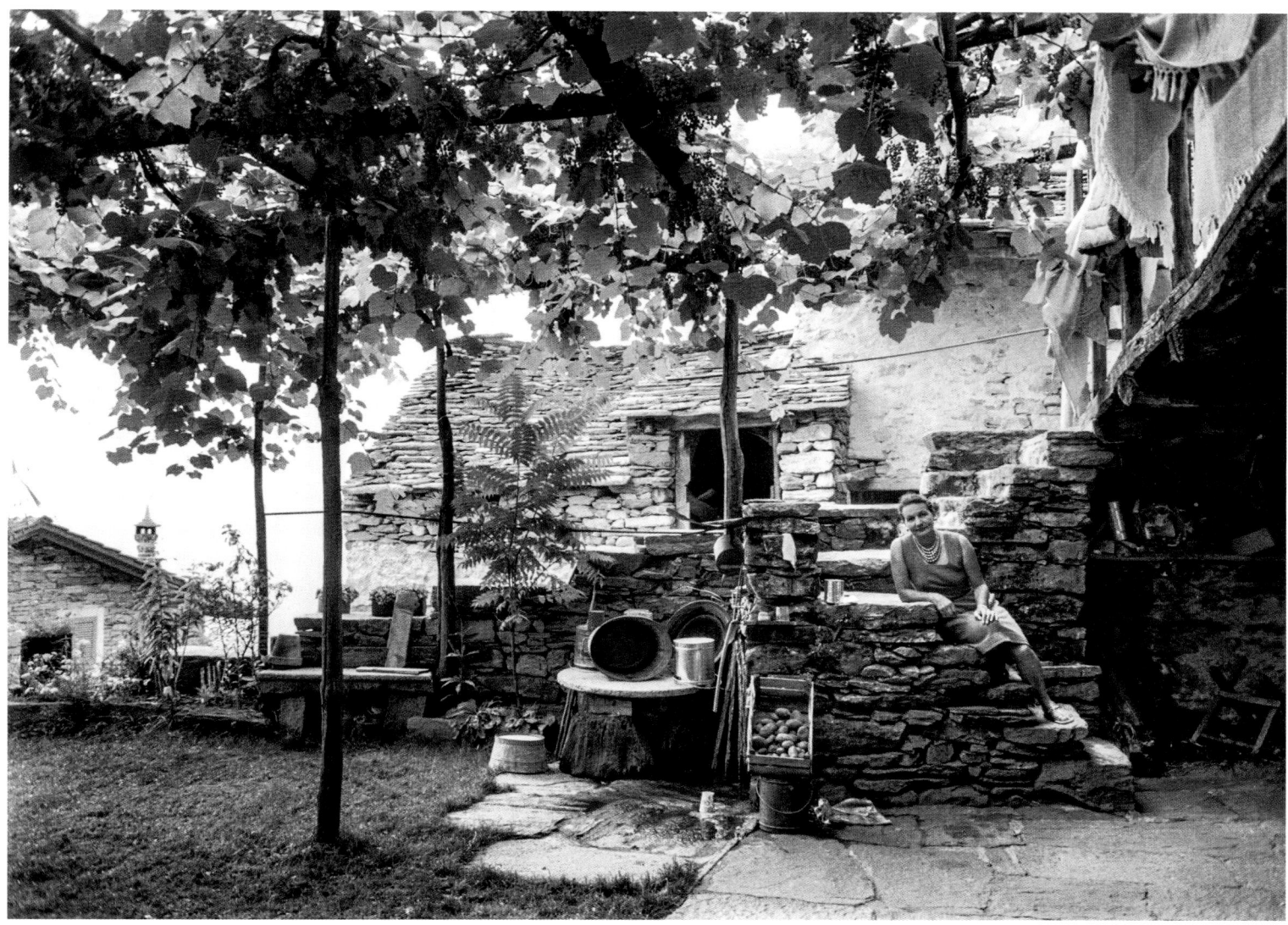

Funeral of the victims of Charonne, Paris, 1962
NEGATIVE: 24×36 MM _ R92/4103
__ 497

The OAS, a right-wing organization nostalgic for French colonial Algeria, had committed ten attacks in Paris, targeting, among others, André Malraux, and disfiguring a young girl. The next day, February 8, the Left organized a demonstration. The worst of the police crackdown occurred on boulevard Voltaire and near Charonne metro station, causing eight deaths. This picture was taken on the day of the funeral service, which brought together between five hundred thousand and one million people.

Marie-Anne in Mergoscia, Ticino, Switzerland, 1962
NEGATIVE: 24×36 MM _ 96/4501
__ 498

Summer vacation in Switzerland and Italy. This photo was taken in Mergoscia, a mountain village in the Swiss canton of Ticino, not far from Ascona. Marie-Anne is pictured here in the yard of a farmhouse where we stayed for two days.

Avenue de Breteuil, Paris, 1962
NEGATIVE: 24×36 MM _ P97/2828
—— 499
The market of avenue de Breteuil was not far from our home. This photo was taken against the light on the morning of September 15.

Strike at the Bull factory, Saint-Quentin, Aisne, 1964
NEGATIVE: 24×36 MM _ R111/3727
—— 500
A weekly, *La vie ouvrière* (The Workers' Life), sent me to Saint-Quentin for a report on the strike at the Bull plants. This photo demonstrates the solidarity of the trade unions during the dispute.

Café de la Paix, boulevard des Capucines, Paris, 1964
NEGATIVE: 24×36 MM _ P114/3709
— 501
I exited Opéra metro station and found myself, on this morning of June 9, on boulevard des Capucines. Suddenly, this beautiful young woman appeared, hurrying past the Café de la Paix; I captured her among the passersby.

A Parisian walk, the Eiffel Tower from Trocadéro, Paris, 1966
NEGATIVE: 24×36 MM _ P130/1440
— 502
October 30. Extract from a series on the Eiffel Tower and the Trocadéro for a client whose name is illegible in my diary. Three chic amblers, typical of the sixteenth arrondissement.

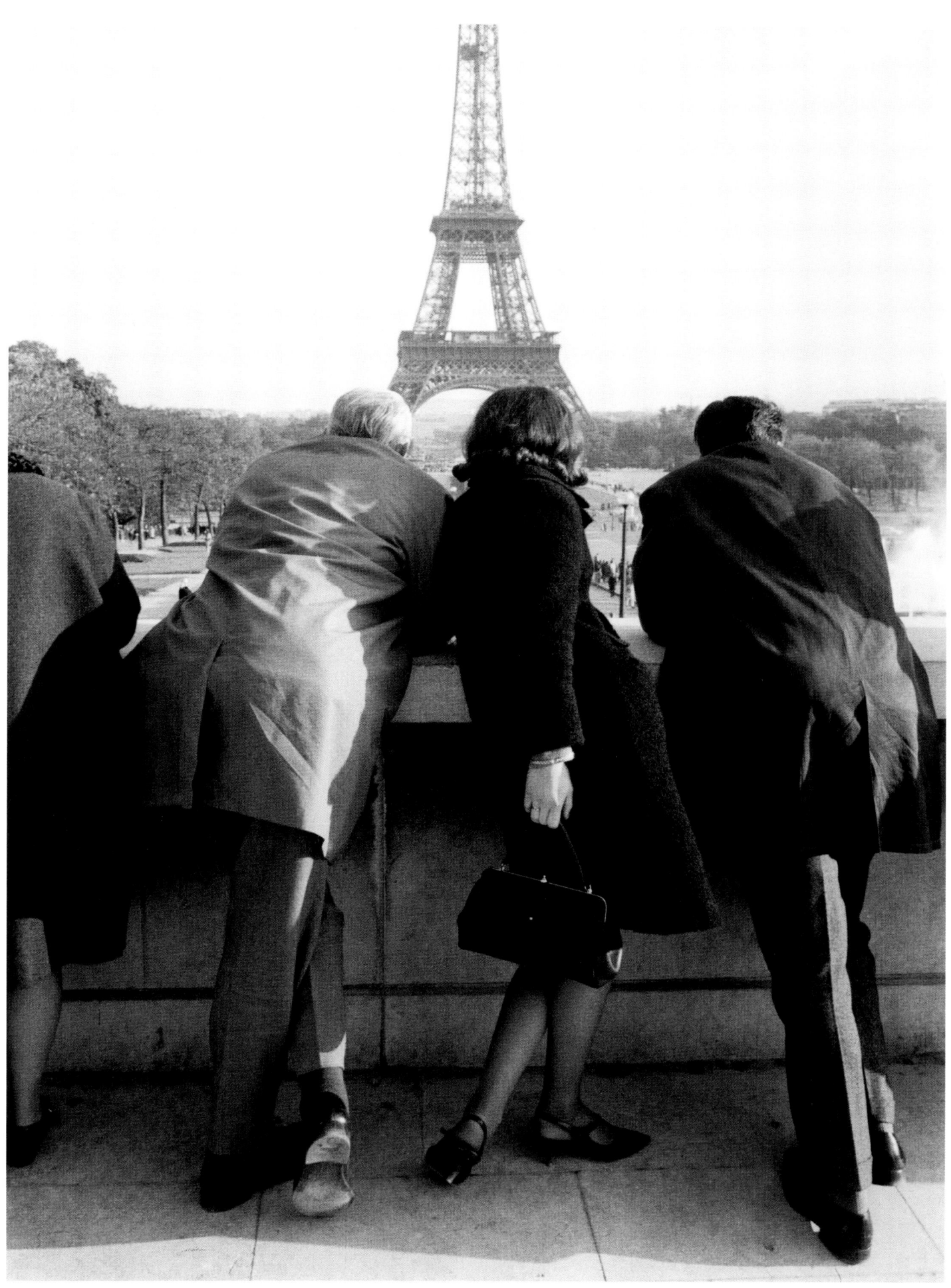

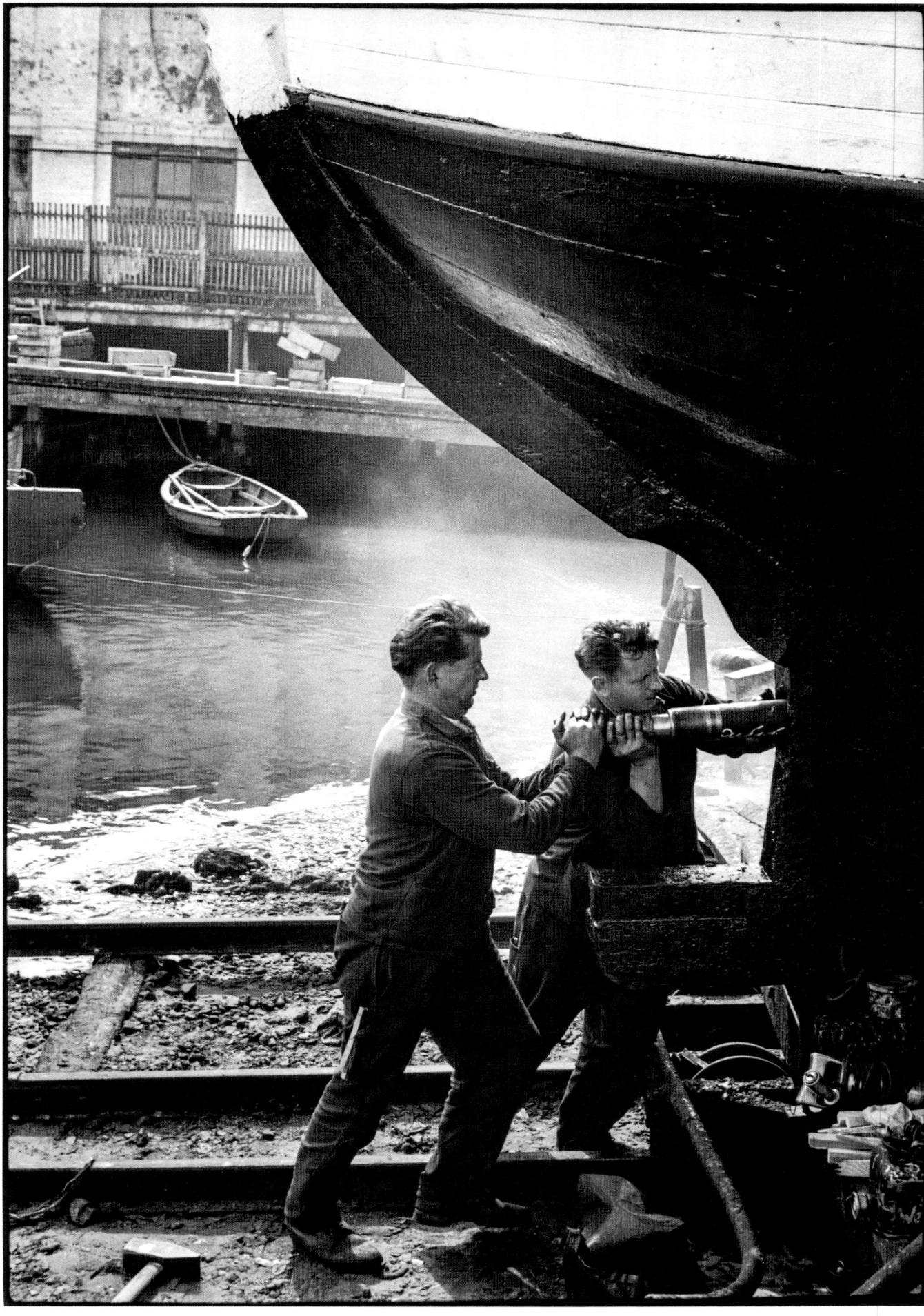

Annot, Basses-Alpes, 1969
NEGATIVE: 24×36 MM _ F151/0101
___ 504

This is Annot, a village in Haute-Provence. I was on a long road trip for a project on the mountains of Provence for an exhibition traveling to French embassies abroad. The light of an April morning. I was struck by the alternating areas of shade and sun, and I waited (for quite some time) for some characters to come and bring this theatrical setting to life.

Shipyard, Sassnitz, East Germany, 1967
NEGATIVE: 24×36 MM _ 134/2418
___ 503

That year, I did a major story on East Germany. On July 7, I was in Sassnitz, a port on the island of Rügen on the Baltic. Two construction workers were installing a propeller camshaft on a fishing boat.

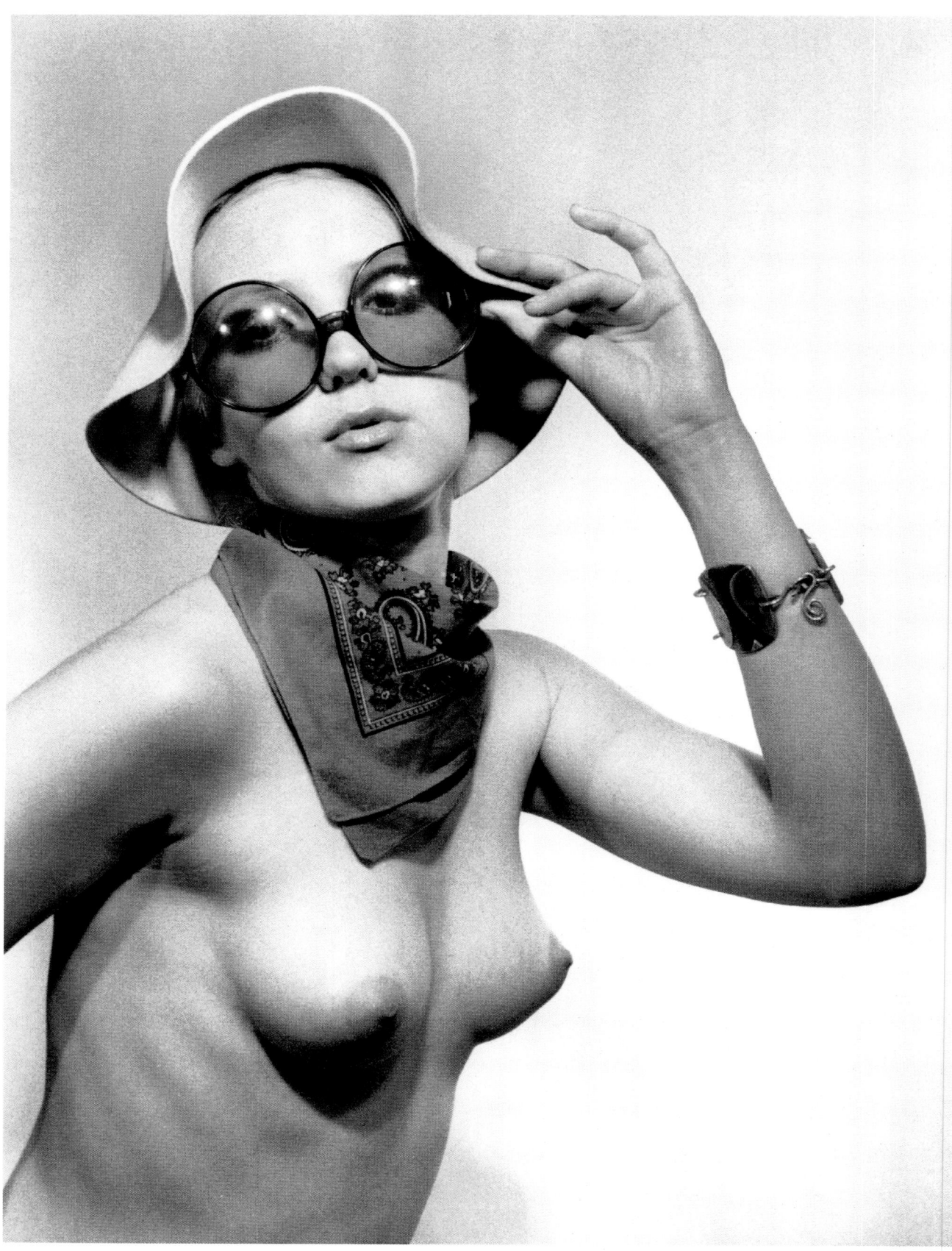

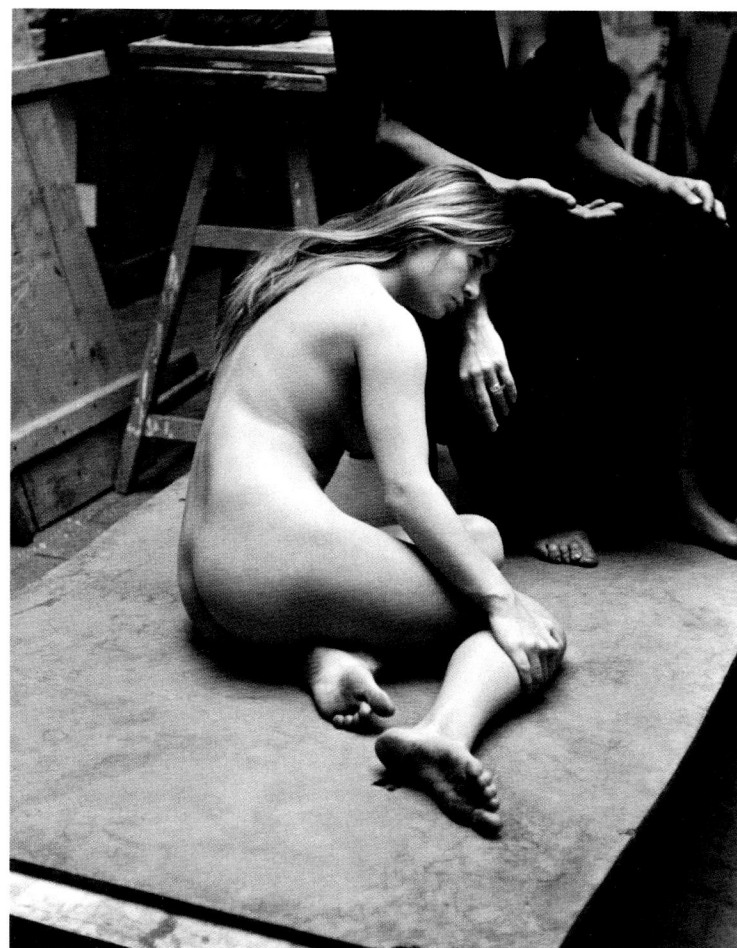

The monokini, Paris, 1969
NEGATIVE: 24×36 MM _ 152/1220
__ 505

In early July, I was commissioned by a photography school to do something on the theme of the studio nude. The premises I then occupied on rue Bargue allowed me to equip a studio with artificial lighting. At the time, there was talk of a new trend on the French Riviera: the "monokini." This photo—although a little stereotypical—was successful.

Nude, École des Beaux-Arts, Avignon, Vaucluse, 1971
NEGATIVE: 24×36 MM _ 165/1407
__ 506

Between October 1971 and July 1972, I traveled to the École des Beaux-Arts of Avignon on two consecutive days, twice a month, for classes on the history of photography and technique. They became weekly from October 1972, when we left Paris to settle in our house in Gordes, which we had extended so we could live there permanently. These classes took place until 1977, between 1972 and 1976 in parallel with weekly classes at the Faculty of Arts at Aix-en-Provence. This picture was taken during a drawing class.

Fontaine-de-Vaucluse, Vaucluse, 1974
NEGATIVE: 24×36 MM _ F182/3117
__ 507

A July afternoon in Fontaine-de-Vaucluse. We were visiting in the company of a young friend, whom I photographed on the fly on the banks of the Sorgue river.

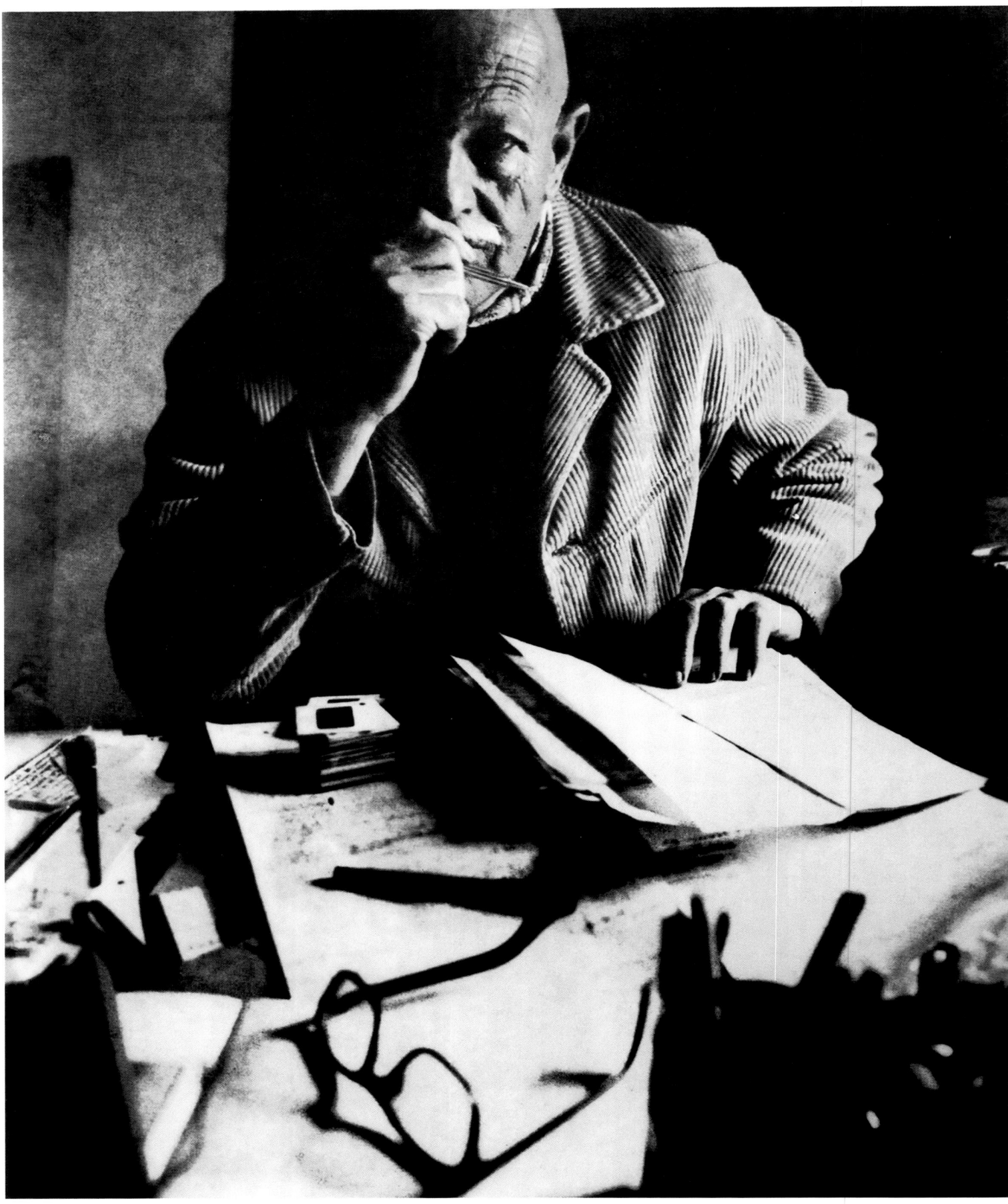

Self-portrait, calotype, L'Isle-sur-la-Sorgue, Vaucluse, 1976
NEGATIVE: 4×5 IN. (10×12.5 CM) _ NO NUMBER
___ 508

This self-portrait was taken using the calotype process, which dates back to the beginning of photography (employed by Talbot, Bayard, etc.), using my 4 × 5-in. (10 × 12.5-cm) camera. Instead of the 4 × 5-in. (10 × 12.5-cm) sheet film, I slipped a sheet of extra-thin light-sensitive paper into the chassis. I created an eight-second exposure to obtain a paper negative, which gave me, under the light of my enlarger, a positive image. It is this picture that I rephotographed to obtain a traditional 4 × 5-in. (10 × 12.5-cm) negative.

Beaucaire, Gard, 1976
NEGATIVE: 24×36 MM _ F188/0510
___ 509

Among my students at the École des Beaux-Arts in Avignon, there were two sisters who lived in Beaucaire. In 1976 they were elected beauty queens of their town. On the morning of July 26, they invited me to lunch at their parents' home. I photographed them as they dressed in traditional costume to make their (noteworthy) entrance on horseback at 5 p.m. in the town's amphitheater.

Centre Georges Pompidou, Paris, 1977
NEGATIVE: 24×36 MM _ FP190/4725
___ 510

This particular afternoon, I had gone to the Centre Pompidou after stopping by at my agency. Walking around the large sculpture by Henry Moore, I saw a girl sitting behind it, against the light. I felt that, by outlining her black silhouette, I would associate her with the artwork, which I did when she raised her right arm, creating a complicity between the two subjects.

Vallon des Auffes, Marseille, Bouches-du-Rhône, 1979
NEGATIVE: 24×36 MM _ DUPLICATE _ F196/2017
___ 511

I gave a series of lectures at the Saint-Charles Faculty of Science in Marseille. On this beautiful April afternoon, I met Marie-Anne in the Old Port and we went to one of our favorite places: the Vallon des Auffes. I selected this image of two teenagers fishing in the channel that connects the small harbor to the sea. At the top we can see the tip of the Monument aux Morts des Armées d'Orient that stands on the corniche. In 1980, I took a major decision. My faithful Foca had served me consistently and effectively for twenty-five years. But it yearned for retirement. I had reached seventy myself, and was looking for simplification. I acquired a Pentax camera. The reflex system allowed a zoom to be used. The Pentax 28–50-mm replaced my old 28-mm, 35-mm, and 50-mm lenses. How easy it was to use! It was with this lens that I took almost all of my work until I stopped shooting in 2002.

**Greenwich Village,
New York, NY, 1981**
NEGATIVE: 24×36 MM _ 209/4244
__ 512

I had been in New York since April 20 for the opening of my exhibition at the French Cultural Center. When not there, I roamed across Manhattan (on foot, of course) to fill my archives with the many images that I acquired through my random encounters. This picture was taken in Greenwich Village.

**Washington Square,
New York, NY, 1981**
NEGATIVE: 24×36 MM _ 210/0225
__ 513

The next day in Washington Square. In the background, the Twin Towers. To enliven the subject, I waited for this hurrying young woman to appear in the background. See the six pictures of New York and Philadelphia (photos 336–41) and photo 439.

Piazza Navona, Rome, Italy, 1981
NEGATIVE: 24×36 MM _ 212/2132
— 514

Having returned to Paris on Friday, May 1, I flew to Toulouse May 5, where I was exhibiting at the Château d'Eau. After returning to Paris again, I then left on May 15 for Rome, where we were invited to the Villa Medici by Bernard Richebé, the first photographer to be appointed resident. This is where photos 342 and 343 were taken, and the one above, on Piazza Navona.

Self-portrait, Venice, Italy, 1981
NEGATIVE: 24×36 MM _ 213/4934
— 515

Impossible to return to France without stopping in Venice where, in the entrance of a souvenir store on June 13, I made this self-portrait between two mirrors, a *mise en abyme*.

**Self-portrait, Giudecca,
Venice, Italy, 1981**
NEGATIVE: 24×36 MM _ 215/0231
—— 516

The next day on Giudecca, I took this discreet self-portrait in front of an upholstery workshop. I brought twelve students from the ten-day workshop I was running at the Palazzo Fortuny, organized by the local council, to the island.

Impatience, Centre Georges Pompidou, Paris, 1981
NEGATIVE: 24×36 MM _ 216/2134
—— 517

On September 18 at Beaubourg, I captured this little scene on the fly. It was during the summer of 1983 that, for various reasons, we ended our Vaucluse period—thirteen wonderful years—and returned to Paris. The photos dating from 1974 to 1981 on the previous pages were taken during trips made at this time, all for professional reasons.

Nude, Paris, 1984
NEGATIVE: 24×36 MM _ 222/2226
—— 518

Barbara. February. The female half of a couple I was very close to suggested doing a nude shoot as a surprise for her husband when he returned from a business trip. The gift was appreciated.

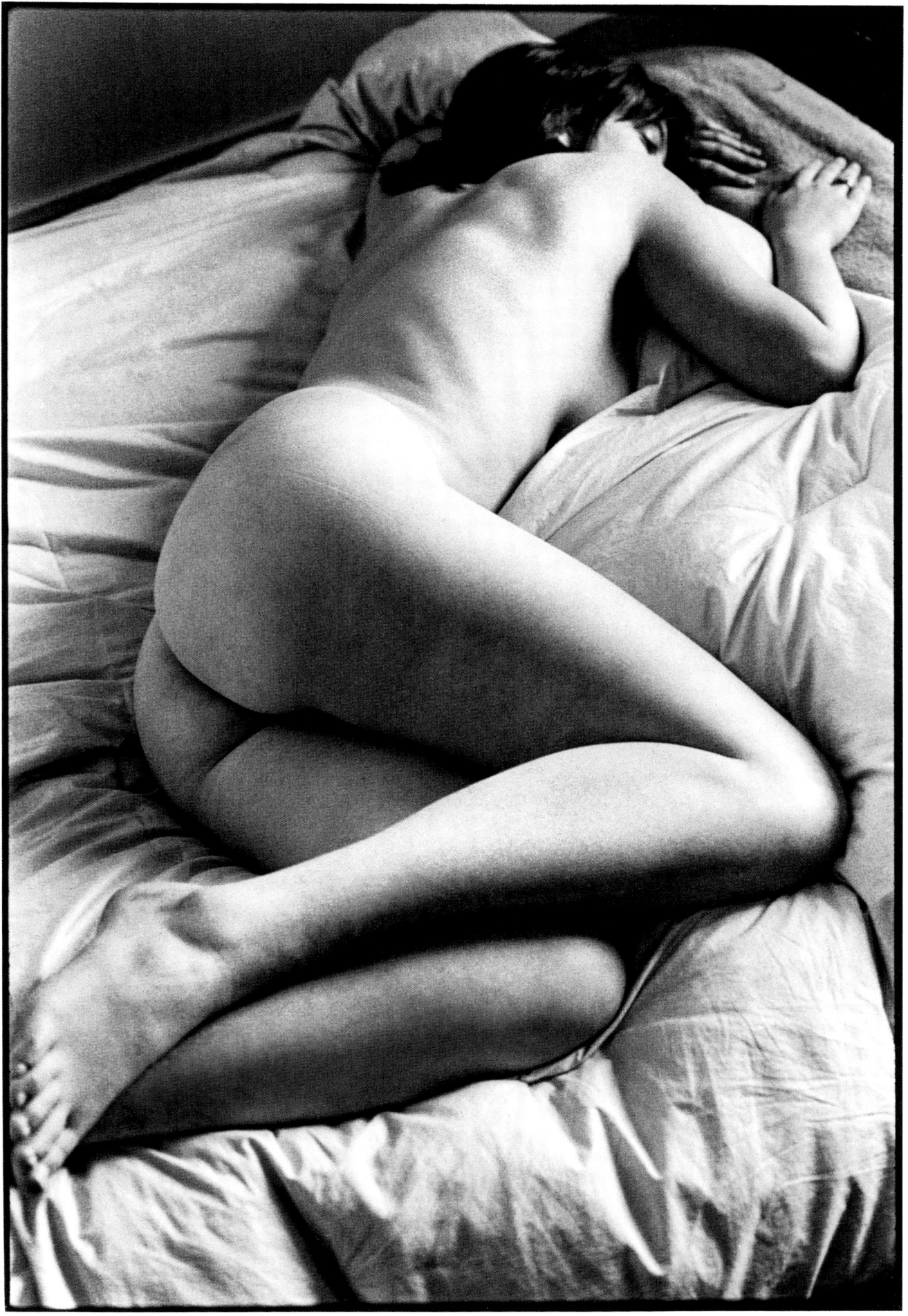

**La Défense,
Hauts-de-Seine, 1984**

NEGATIVE: 24×36 MM _ P223/2136

—— 519

From time to time, I went to La Défense
to capture some typical scenes (July 29).

The Seine riverfront, seen from Trocadéro, Paris, 1986
NEGATIVE: 24×36 MM _ P226/2132
___ 520
January 25. Once again, we were visiting the Musée des Monuments Français at the Trocadéro. It was almost dusk. A shot of the Seine riverfront through a plate-glass window.

Boulevard Garibaldi seen from the Tour Montparnasse, Paris, 1986
NEGATIVE: 24×36 MM _ P229/1635
___ 521
On the afternoon of August 5, my activities took me to boulevard de Vaugirard. The Tour Montparnasse is unavoidable. I went in and found myself on the top floor. From there, my eye was drawn to the elevated metro. Line 6 was in my line of sight. I recognized the nearest station, Sèvres-Lecourbe, which had been my station between 1947 and 1965, when we lived on passage des Charbonniers at the beginning of rue Lecourbe. It is followed by Cambronne, La Motte-Piquet, and Dupleix; Bir-Hakeim (what a shame) is invisible, hidden by a building.

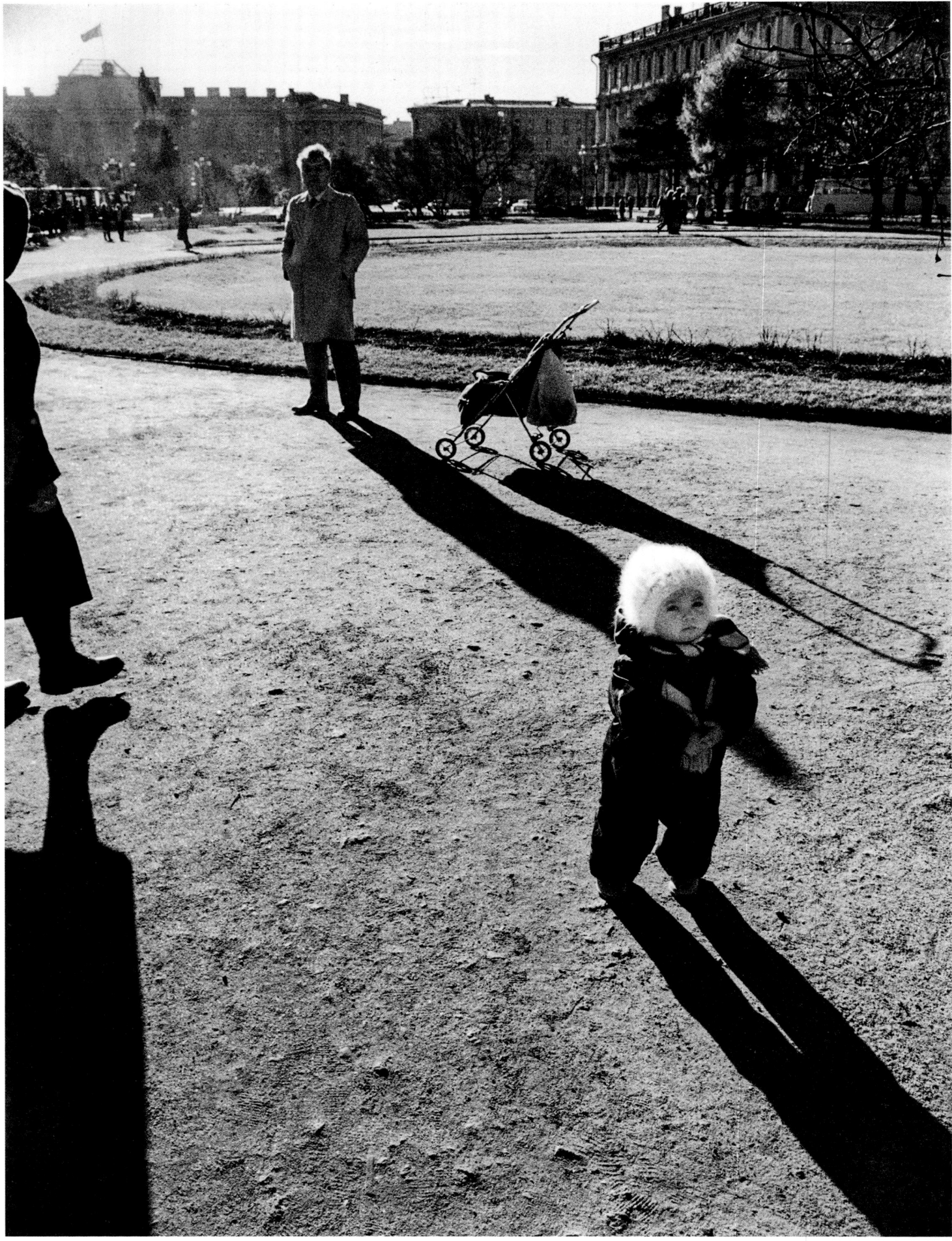

Leningrad, USSR, 1986
NEGATIVE: 24×36 MM _ 230/1909
— 522
October 18. Radiant sun. Two days before, we had attended the opening of my exhibition, shown the previous year at the Palais de Tokyo in Paris as part of the Year of Heritage, and which was now on display in Moscow, in the Kirov district. We were in Leningrad. From among all my images, I selected this one, taken in Arts Square.

Self-portrait, Leningrad, USSR, 1986
NEGATIVE: 24×36 MM _ 230/2225
— 523
October 20, from our apartment, no. 659, in the Leningrad Hotel. The morning sun allowed me to take this self-portrait in the room's big mirror. I half-opened the window and climbed onto a stool for a bird's-eye view of the Neva. I waited until I could include the bus and two cars on the embankment.

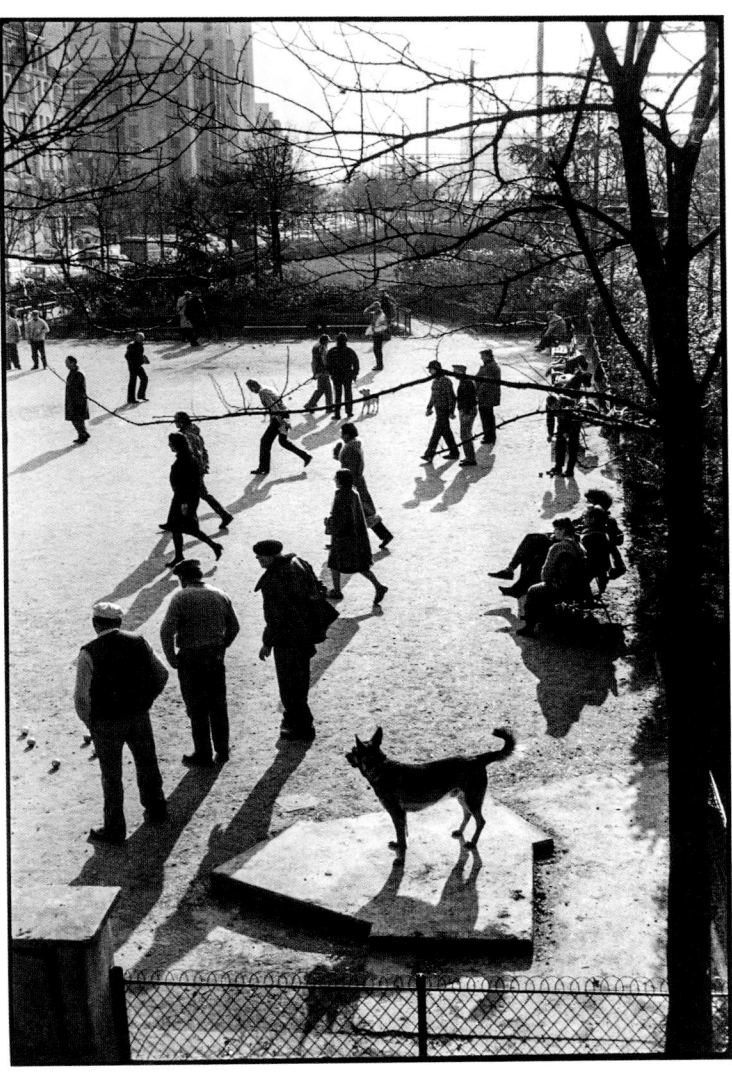

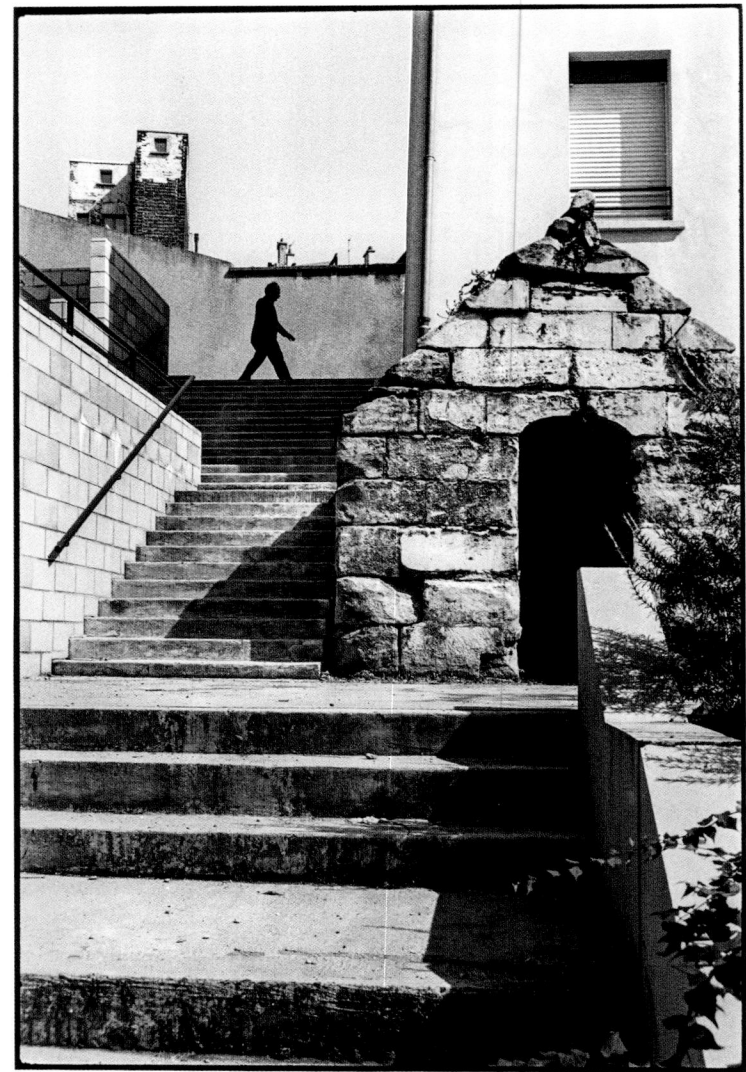

Rue Vercingétorix, Paris, 1987
NEGATIVE: 24×36 MM _ P231/4837
__ 524
March 10. A cool afternoon on rue Vercingétorix. The street, greatly enlarged by the major building works of the 1970s, was in those days largely devoted to pedestrians and fans of pétanque.

Rue des Cascades, Paris, 1987
NEGATIVE: 24×36 MM _ P234/1428
__ 525
August 28. Having recently returned from Volvic, where I had a major exhibition, I hiked back up to Belleville (a ritual I frequently carried out). This is rue des Cascades, on the reconstructed side, where this little edifice—an inspection chamber—was somehow luckily preserved in this neighborhood with other watery-themed street names (rue de la Mare, rue du Pressoir, etc.).

Christmas week, boulevard Haussmann, Paris, 1987
NEGATIVE: 24×36 MM _ P236/0211
__ 526
Another ritual that I happily follow almost every year: watching people rushing around the big department stores. This dad perched his little girl on his shoulders so that she could have a better view of the magical toy displays in the window.

Rue des Partants, Paris, 1988
NEGATIVE: 24×36 MM _ P238/1019
__ 527

Belleville. My friend the filmmaker Patrice Noïa was making a documentary about me that would be shown in the fall on the TV channel Arte. One part took place in Belleville (of course), and here we were on rue des Partants, where some of the dilapidated homes used as squats had had their running water turned off.

Arts and crafts school, avenue de La Bourdonnais, Paris, 1988
NEGATIVE: 24×36 MM _ P239/4633
__ 528

Part of the documentary takes place in various schools. It was June, during an arts and crafts class. I climbed onto a chair for a bird's-eye view. This is the seventh arrondissement; the children are dressed differently from those on rue des Partants.

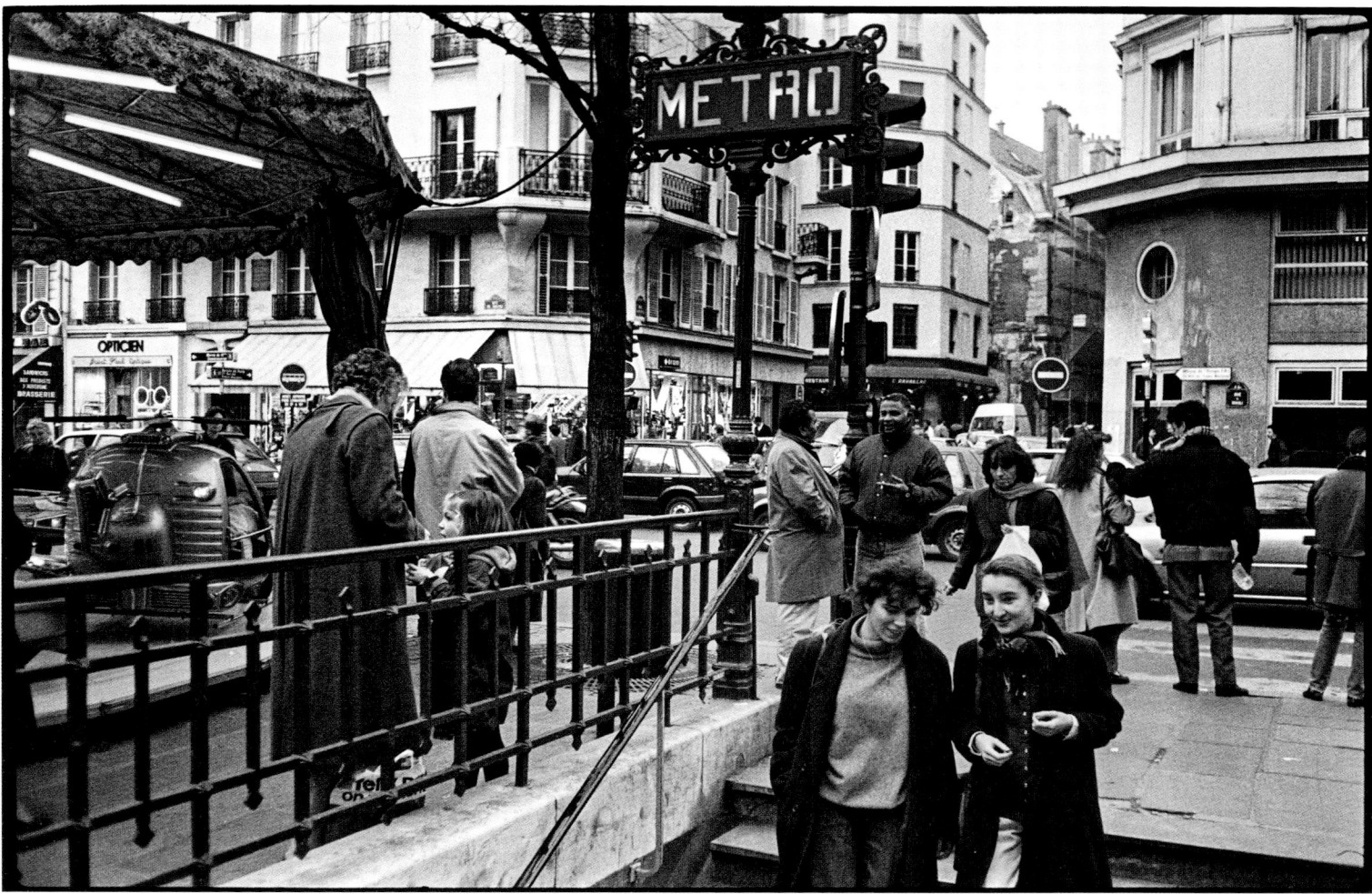

The Louvre, Paris, 1988
NEGATIVE: 24×36 MM _ P240/0716
—— 529

When my work took me to certain neighborhoods, I did not always burden myself with my Pentax, with its 28–50-mm zoom. In such cases I had my Minox in my pocket, which had the advantage of being lightweight. I used it to take the previous photo, and I also had it on October 15, when, passing by, I took this backlit scene in one of the passages connecting rue de Rivoli to place du Carrousel.

Saint-Paul, Paris, 1988
NEGATIVE: 24×36 MM _ P240/2928
—— 530

End of December, Saint-Paul metro station. This is the station I would take to get to my usual laboratory on rue du Roi-de-Sicile, which can be seen giving onto rue Malher, on the other side of rue de Rivoli.

Nude, Paris, 1988
NEGATIVE: 24×36 MM _ 240/3943
— 531
Agnès. She was tall and beautiful, with a smile that was a little sad (photo 467). She wasn't born from "the foam and the wind," she didn't arrive floating on a sea shell. More simply, I'd heard through my open window, eight floors down, the door of her 2CV slamming shut.

**La Défense,
Hauts-de-Seine, 1989**
NEGATIVE: 24×36 MM _ P242/3536
___ 532

A special issue of a glossy magazine was to be devoted to La Défense, and to the imminent opening of the Grande Arche. The proposed title for my contribution was "The pedestrians of La Défense." This photo, as well as photos 469 and 470, were part of my story.

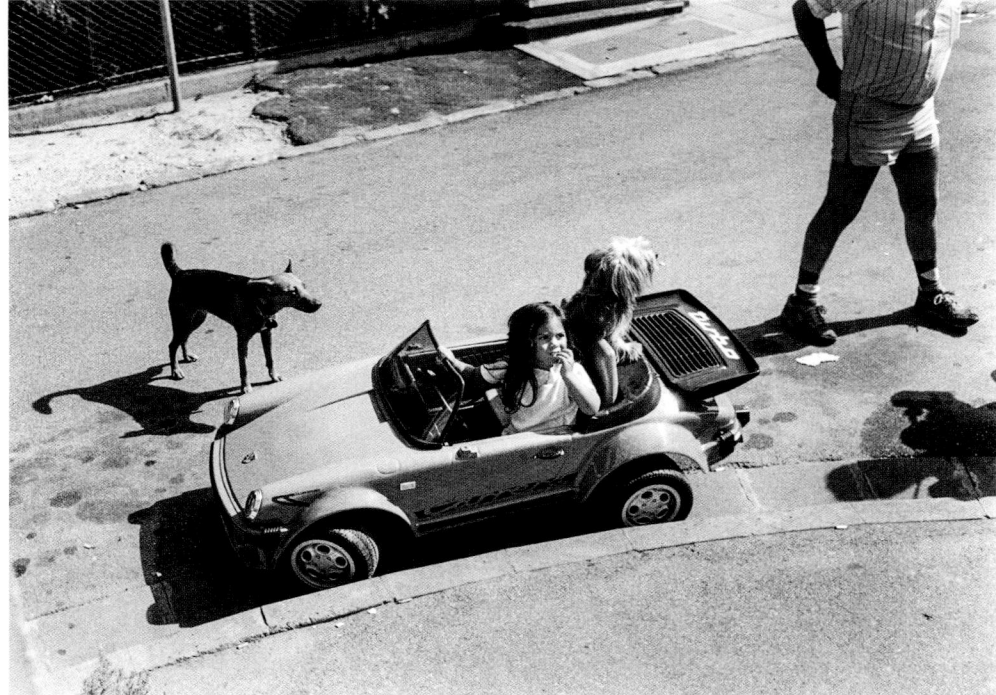

Parc de Belleville, Paris, 1989
NEGATIVE: 24×36 MM _ P243/2734
— 533
May 12. A walk in Belleville with Marie-Anne. I positioned myself on the spot where, in 1948, I photographed the old staircase from rue Piat (cover of the second and third editions of my book *Belleville Ménilmontant*). The dilapidated houses and vacant lots had given way to the park, built in 1970. No ill-founded nostalgia.

Joinville-le-Pont, Val-de-Marne, 1989
NEGATIVE: 24×36 MM _ F244/1211
— 534
Marie-Anne, who was suffering from Alzheimer's, had been living for the past few months at the Maison des Artistes in Nogent (she was a painter). She remained an excellent walker, and every weekend we would walk along the banks of the Marne. On this particular day, this little girl was celebrating her birthday, hence the snapshot in Joinville.

Bry-sur-Marne, Val-de-Marne, 1989
NEGATIVE: 24×36 MM _ F244/1918
— 535
September, during a walk in Bry-sur-Marne, in the late afternoon.

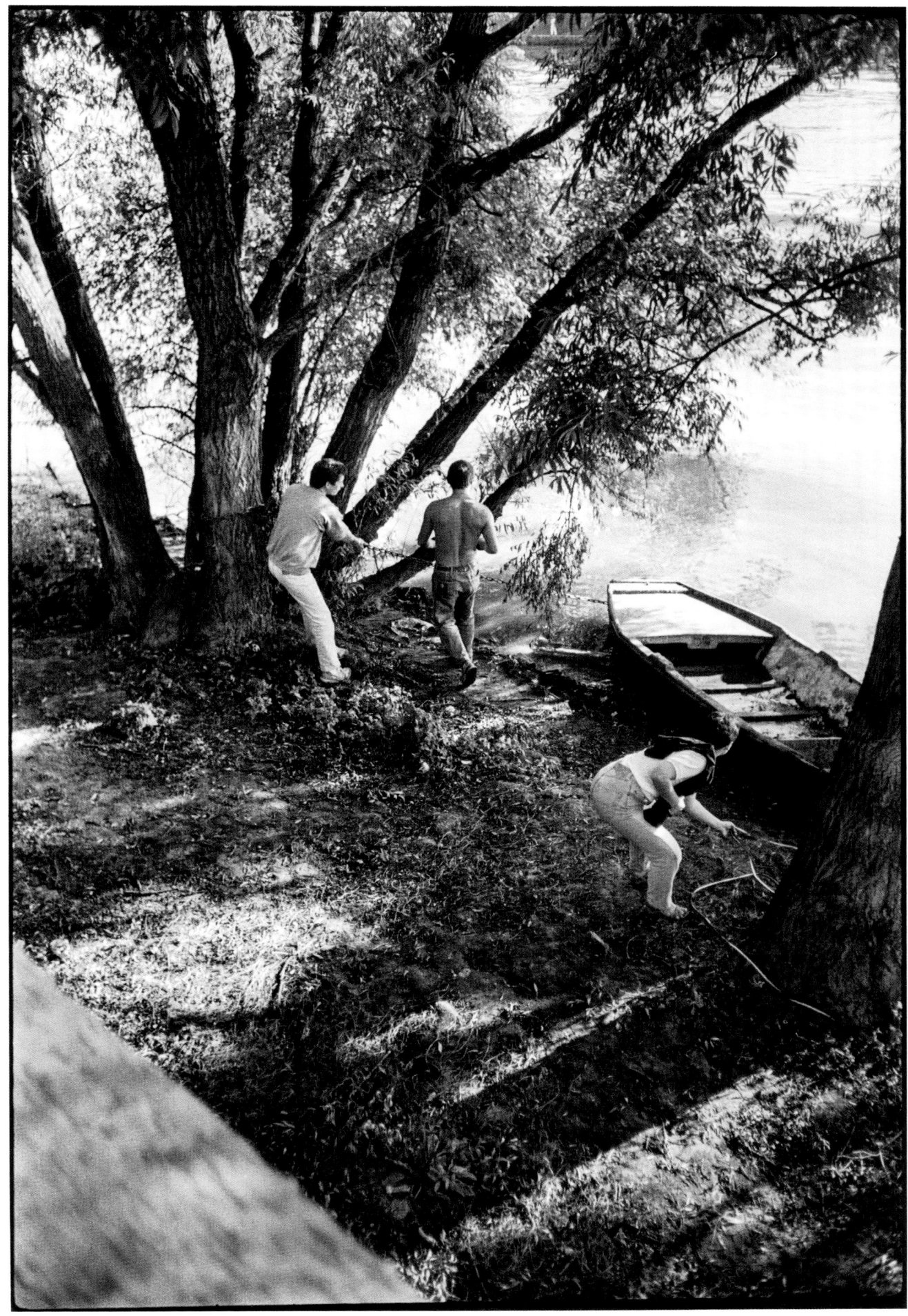

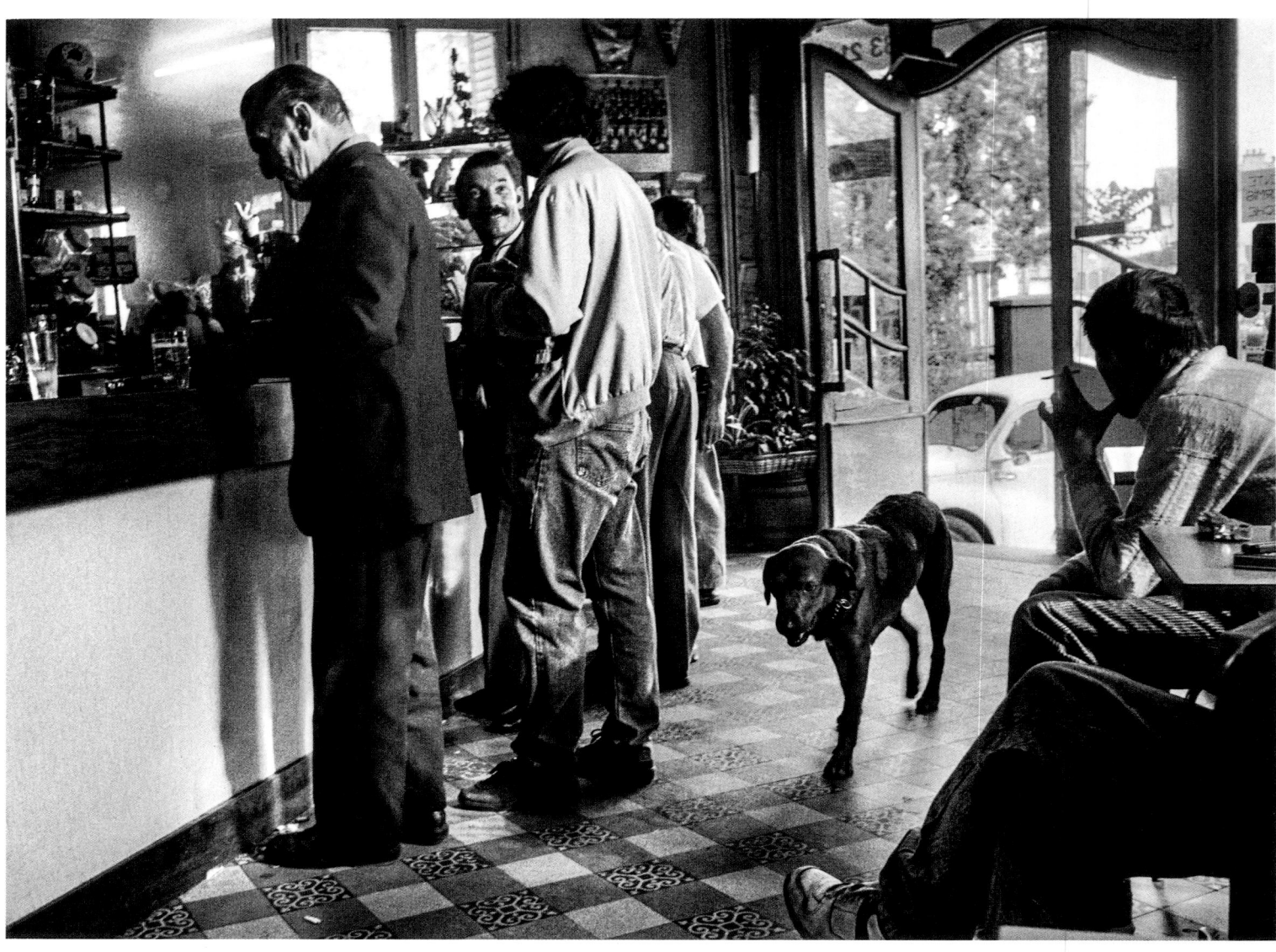

**Joinville-le-Pont,
Val-de-Marne, 1990**
NEGATIVE: 24×36 MM _ F245/3724
__ 536

May 12. The Joinville bistro where we rested at the end of our weekend walks. A local dog was making his usual visit.

**From the bus,
rue Rambuteau, Paris, 1990**
NEGATIVE: 24×36 MM _ P245/4406
__ 537

My activities had brought me downtown. I took the 29 bus home, a line that I particularly liked because of the open-air platform at the rear of the bus. I had my Minox ready for the unexpected, just in case. I pressed the shutter when the bus left rue Beaubourg and turned into rue Rambuteau.

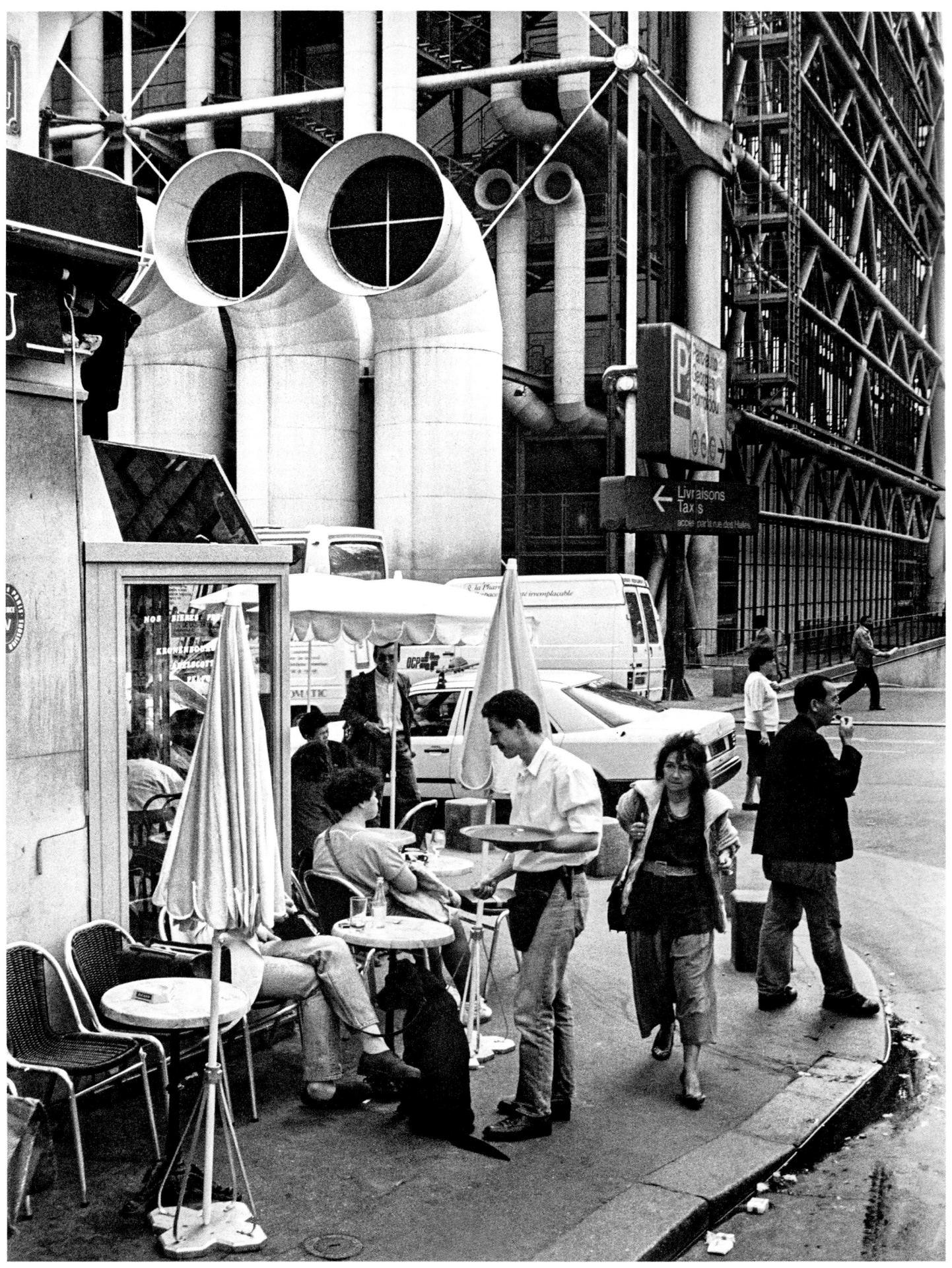

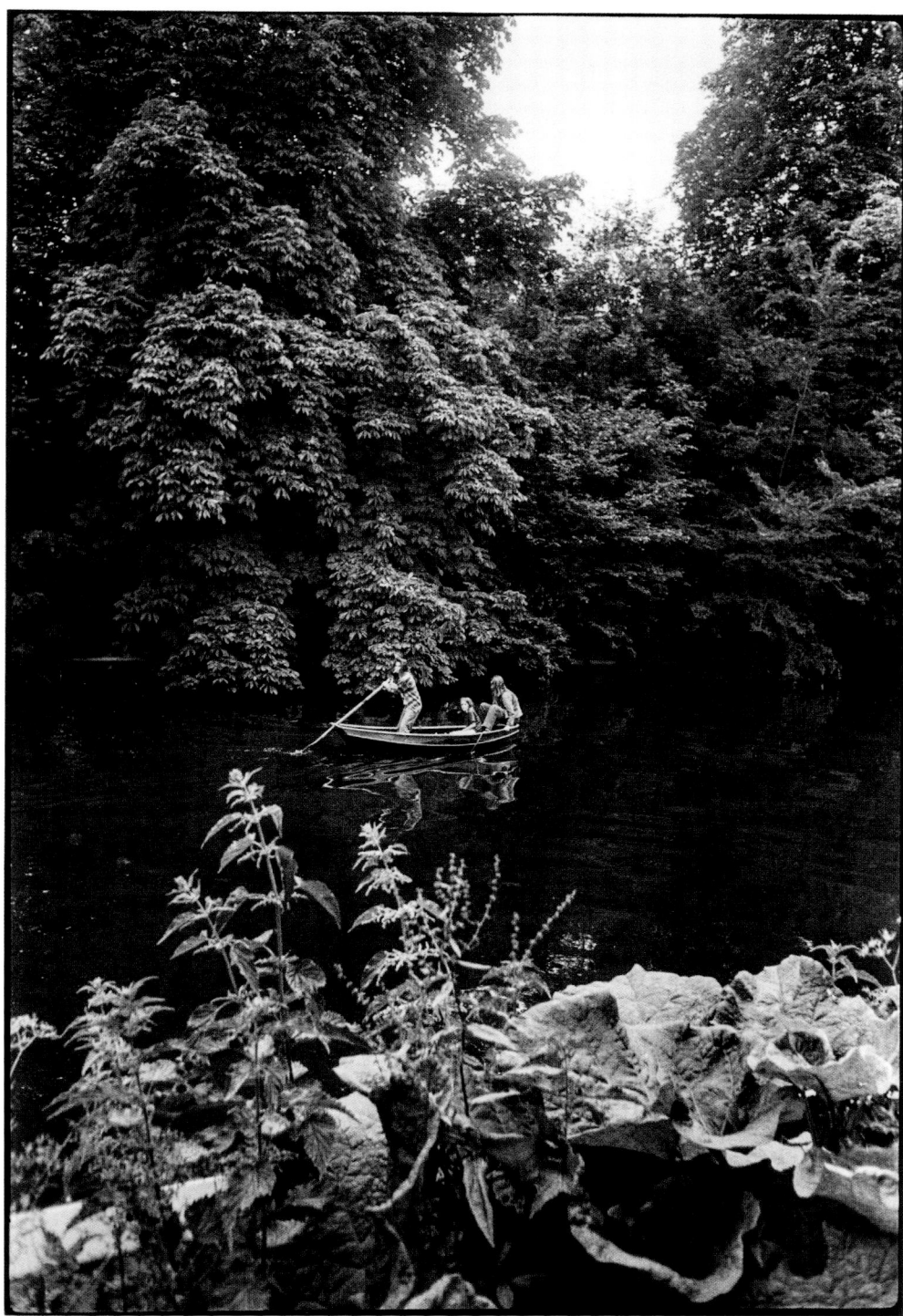

The Marne near Chennevières-sur-Marne, Val-de-Marne, 1990
NEGATIVE: 24×36 MM _ F246/0732
___ 538
On Saturday, June 15, we were walking along the pretty path that leads from Champigny to Chennevières. This is where we saw the three young girls, rowing along Île Casenave.

Neuilly-sur-Marne, Val-de-Marne, 1990
NEGATIVE: 24×36 MM _ F246/1511
___ 539
At the port of Neuilly-sur-Marne, a heat wave had encouraged some diving.

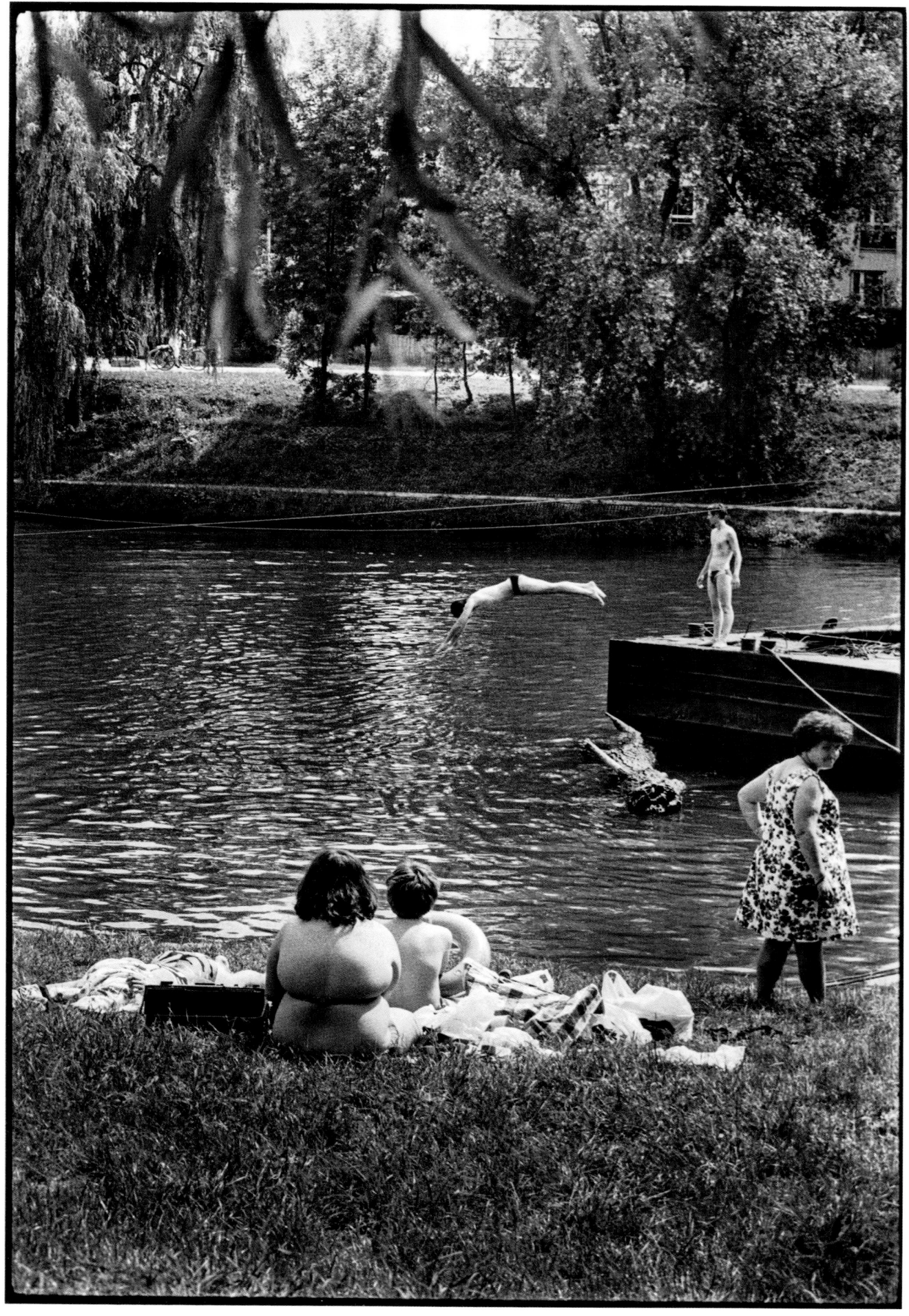

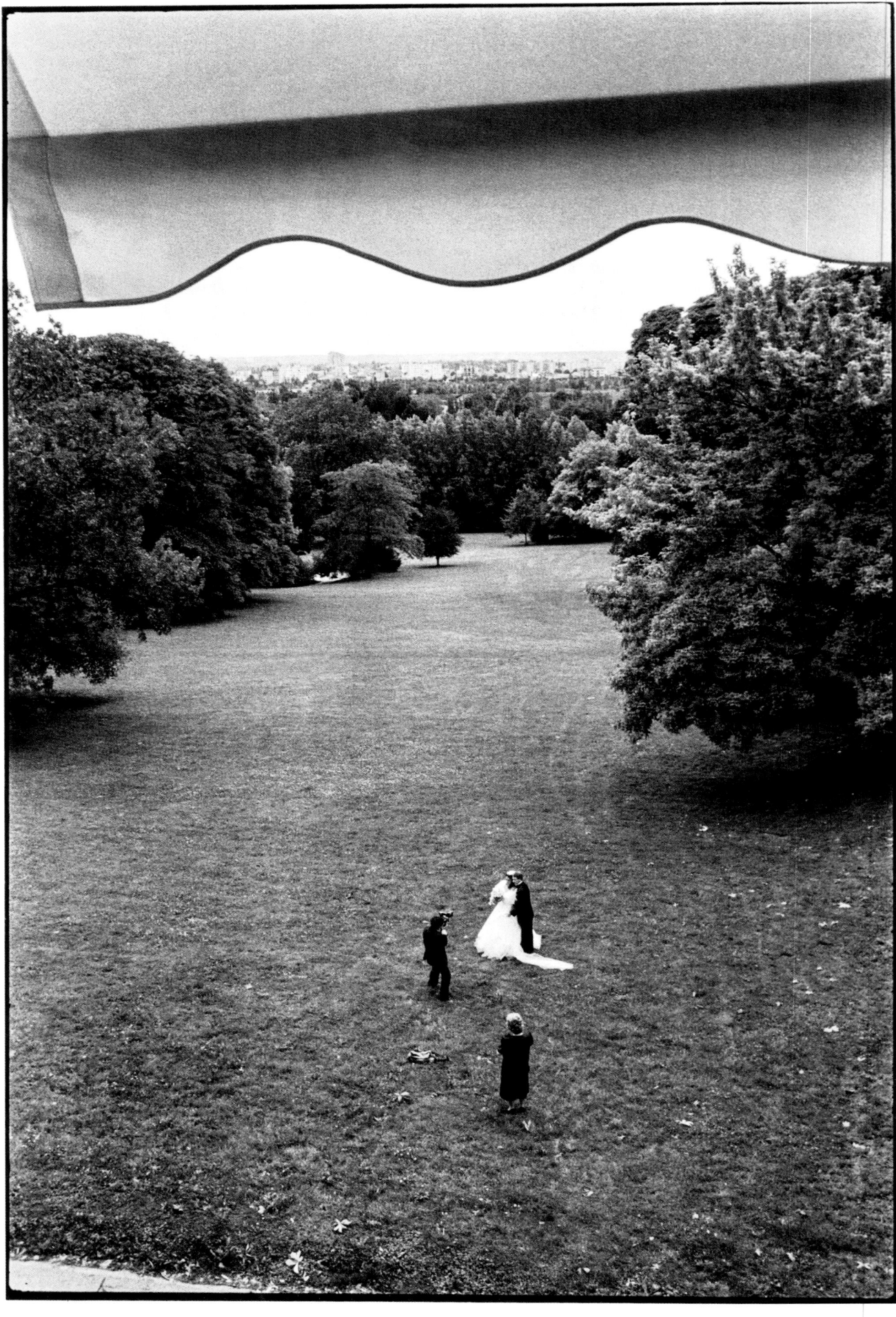

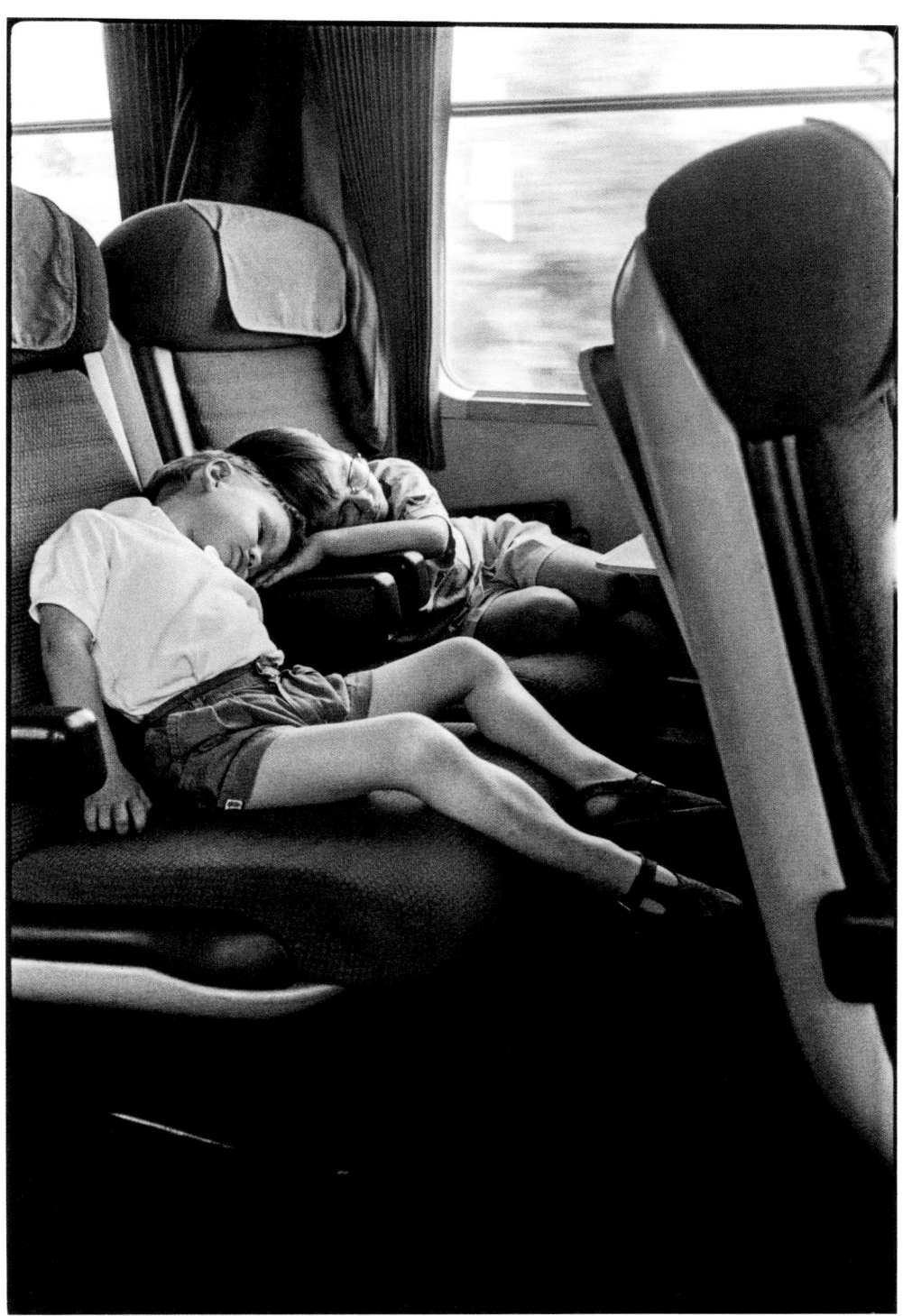

**Nogent-sur-Marne,
Val-de-Marne, 1990**
NEGATIVE: 24×36 MM _ F246/1724
— 540

The apartment in the Maison des Artistes, where I came to see my wife every weekend, overlooked the park that descended toward the Marne. This Saturday, a photographer from Nogent took a photo that might be sitting proudly on the sideboard in the couple's dining room.

Corail train, 1990
NEGATIVE: 24×36 MM _ F246/4139
— 541

I was on the Corail train taking me back home from Lapalisse, where I was exhibiting a retrospective of my work. It was July 20. Taking a break from a long read, I looked to my left. Without getting up, I took my Minox out of my pocket. A new image to be filed in the "Childhood" box.

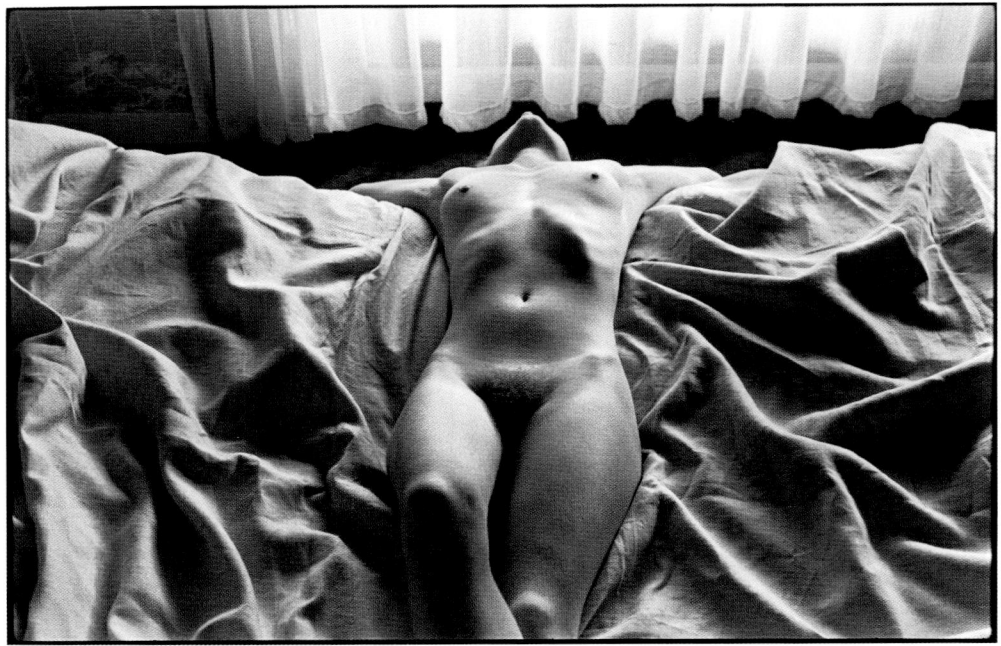

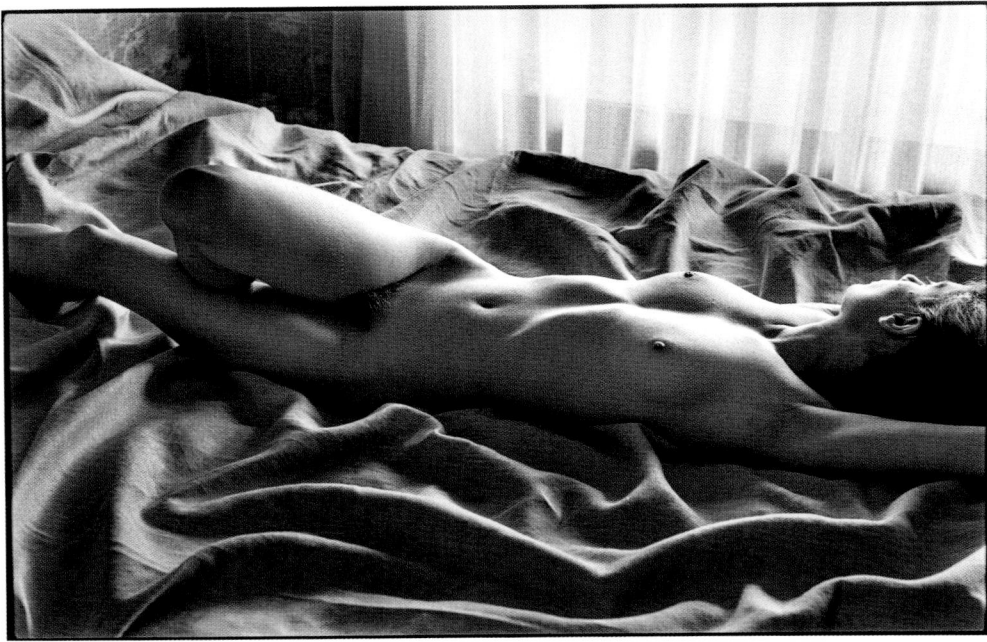

Nude, Paris, 1990
NEGATIVE: 24×36 MM _ 247/2517
__ 542

Isabelle. September 5. I had already done several nude sessions with Isabelle, since she had decided to be photographed in this way by those whose vision she admired, in France and elsewhere. This would lead to a video with sound.

Nude, Paris, 1990
NEGATIVE: 24×36 MM _ 247/2623
__ 543

Isabelle. A few minutes later, a change of pose and a slight change of viewpoint.

The head of hair, Paris, 1990
NEGATIVE: 24×36 MM _ 247/2728
__ 544

Photo from the end of the session. Same location.

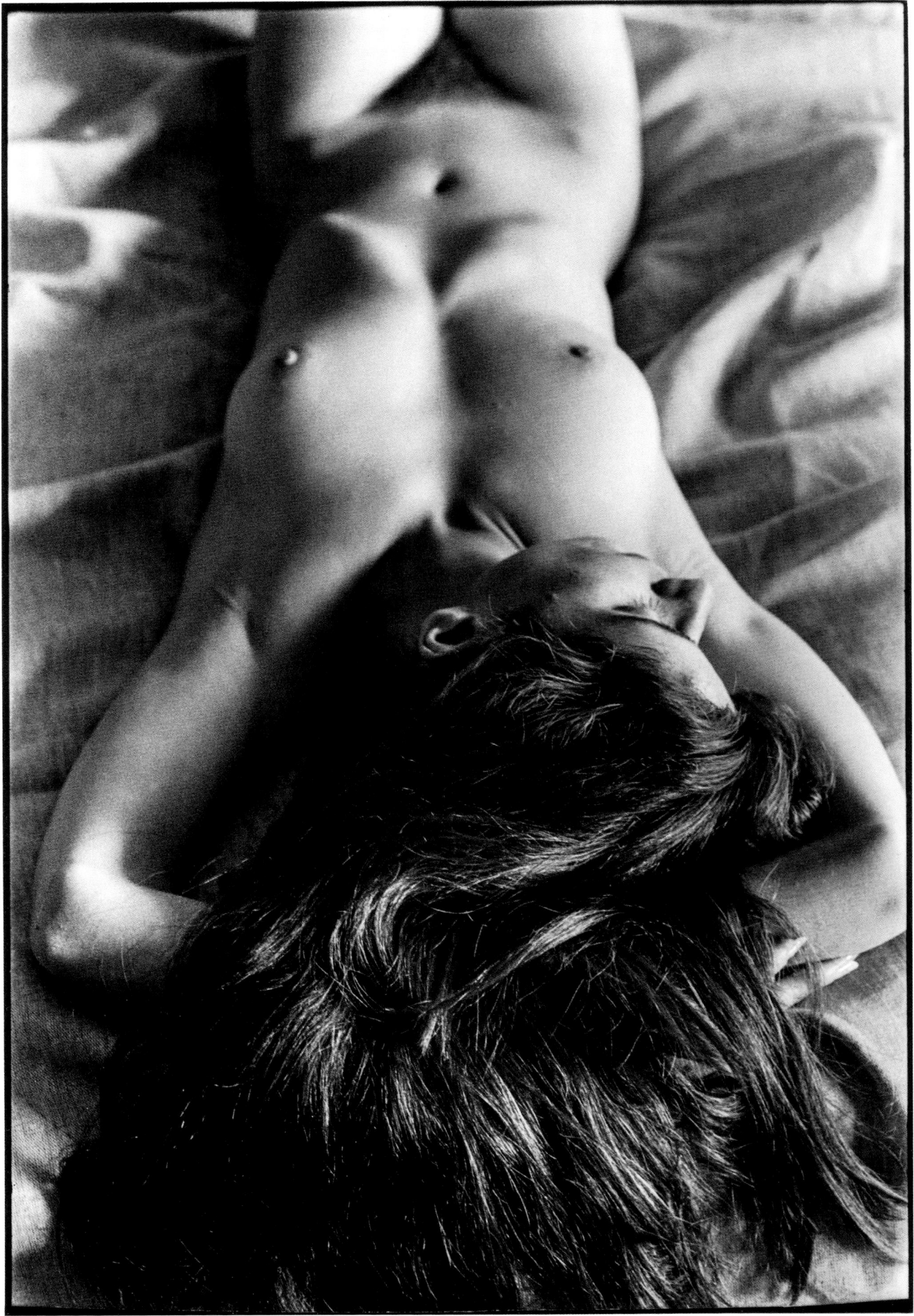

Cilaos, Réunion, 1990
NEGATIVE: 24×36 MM _ 249/2606
___ 545

A communications agency had organized a photo exhibition on Réunion, in the town of Le Port. I had also been commissioned to do two stories on subjects of my choice. November. During this trip, I was taken to the village of Cilaos, where many embroiderers worked.

Les Roches, Réunion, 1990
NEGATIVE: 24×36 MM _ 249/4503
___ 546

December 1, in a place known as Les Roches, not far from Saint-Paul: a bit of laundry in a backwater.

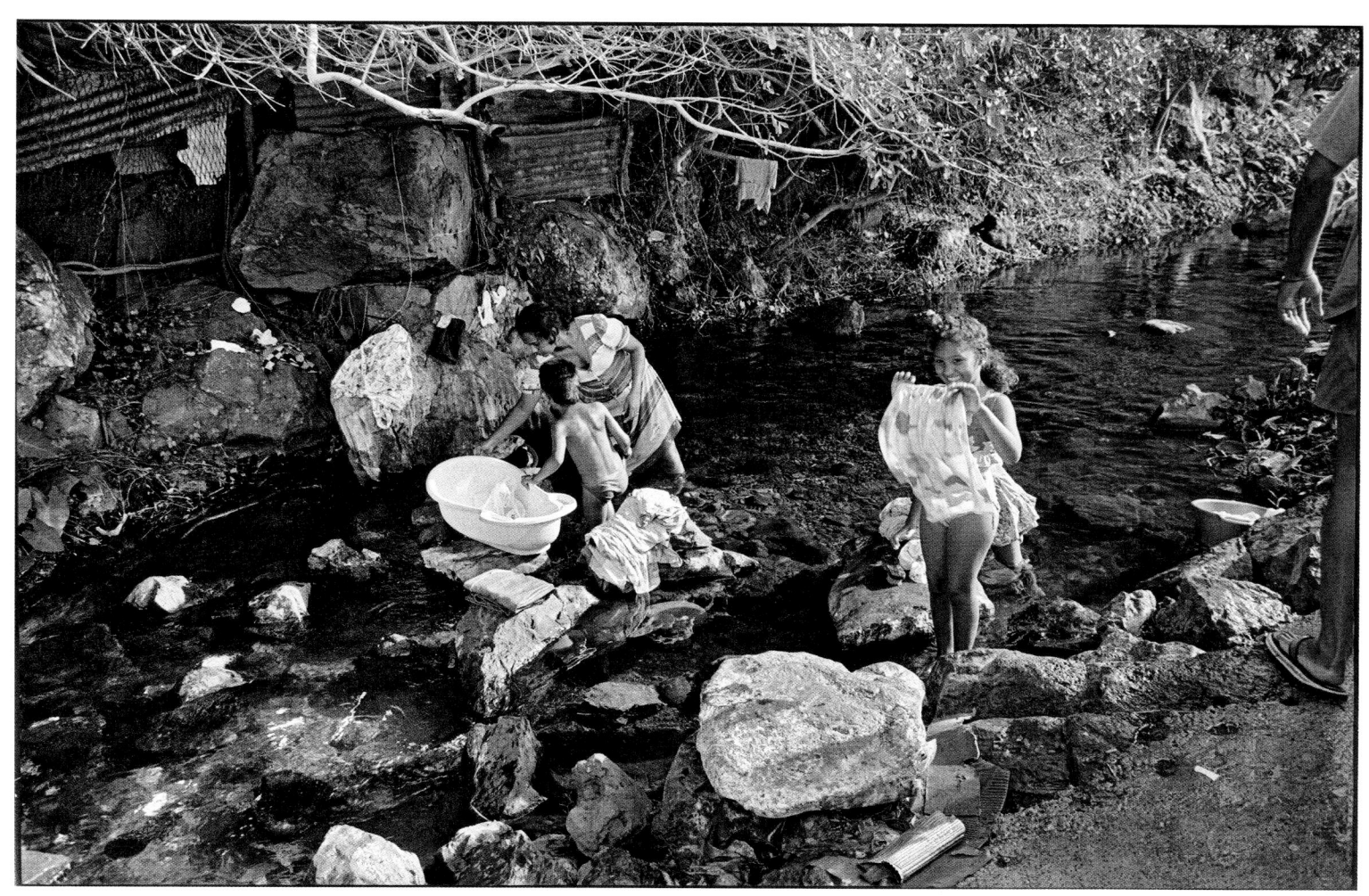

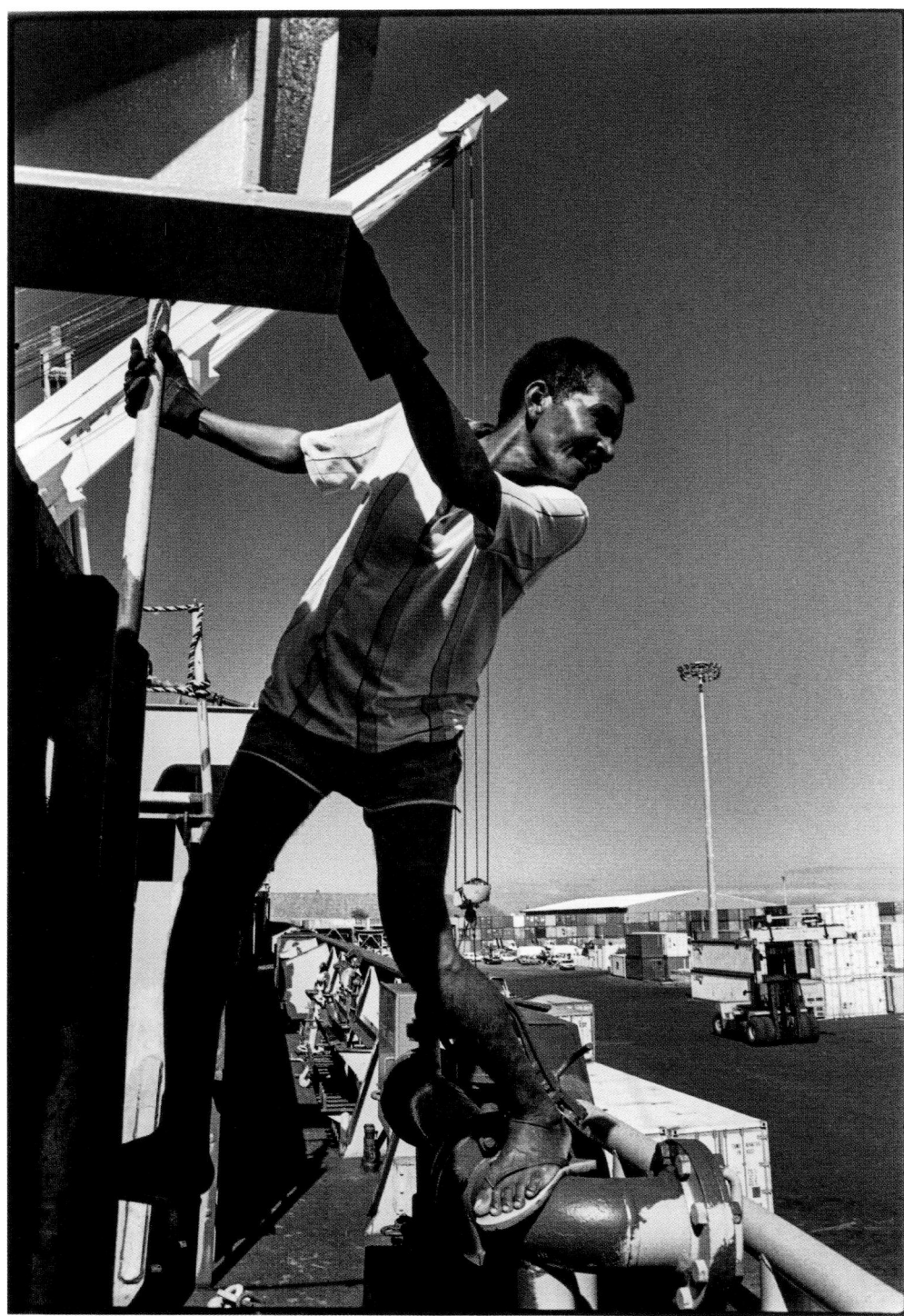

Le Port, Réunion, 1990
NEGATIVE: 24×36 MM _ 249/5034
__ 547

At the port of Le Port, a dockworker monitoring the arrival of the shipping containers.

Blind musician, Boulevard Haussmann, Paris, 1990
NEGATIVE: 24×36 MM _ P250/2434
__ 548

Christmas week. Since 1987, almost every December, I had taken a picture of the blind musician Stéphane Comnène on boulevard Haussmann, near the corner of rue du Havre (my book *Derrière l'objectif* [Behind the Lens] shows six of these images, up until 1999). Through these encounters we had got to know him (despite the dog, which was annoyed by my pestering). He passed away in January 2001.

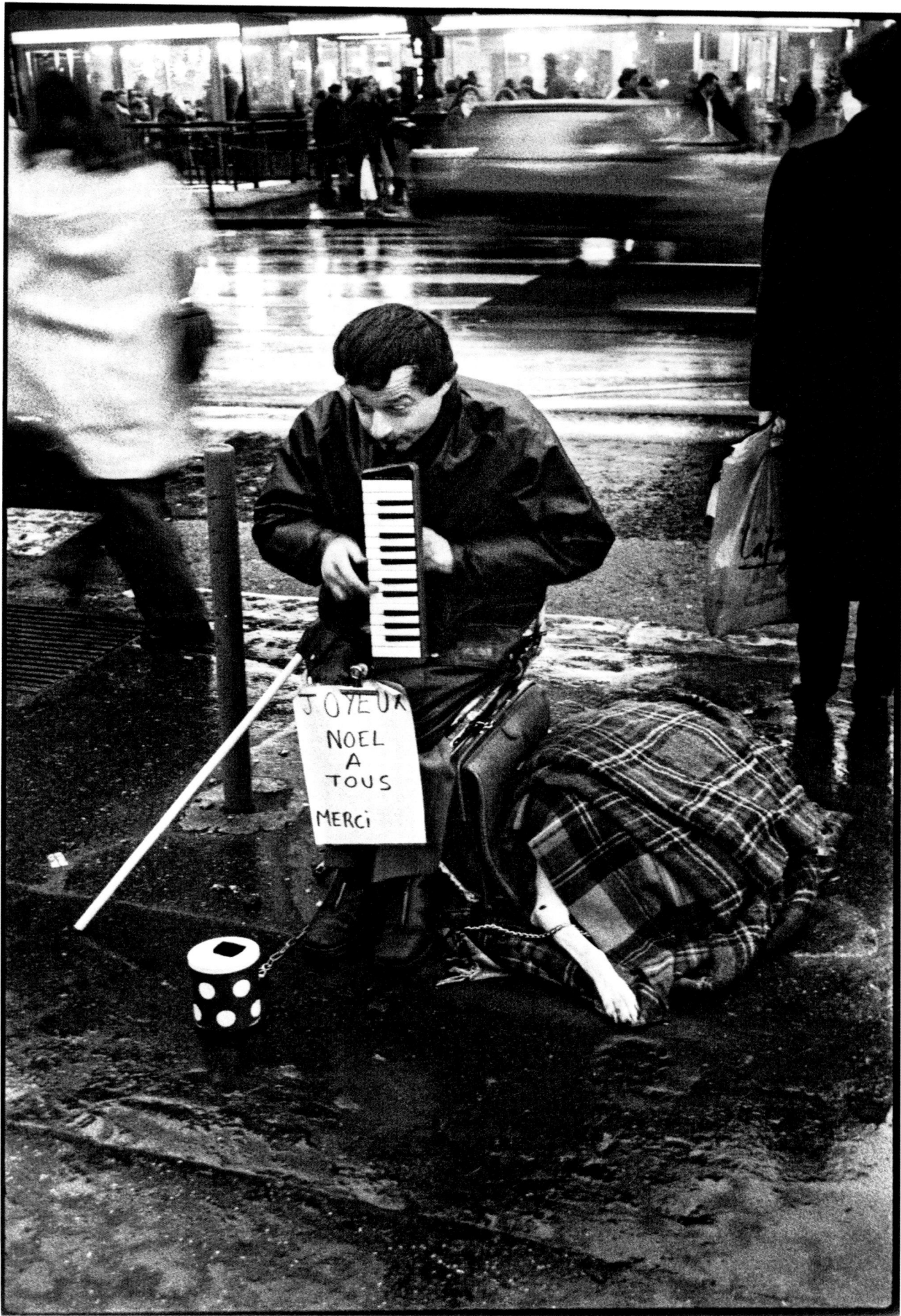

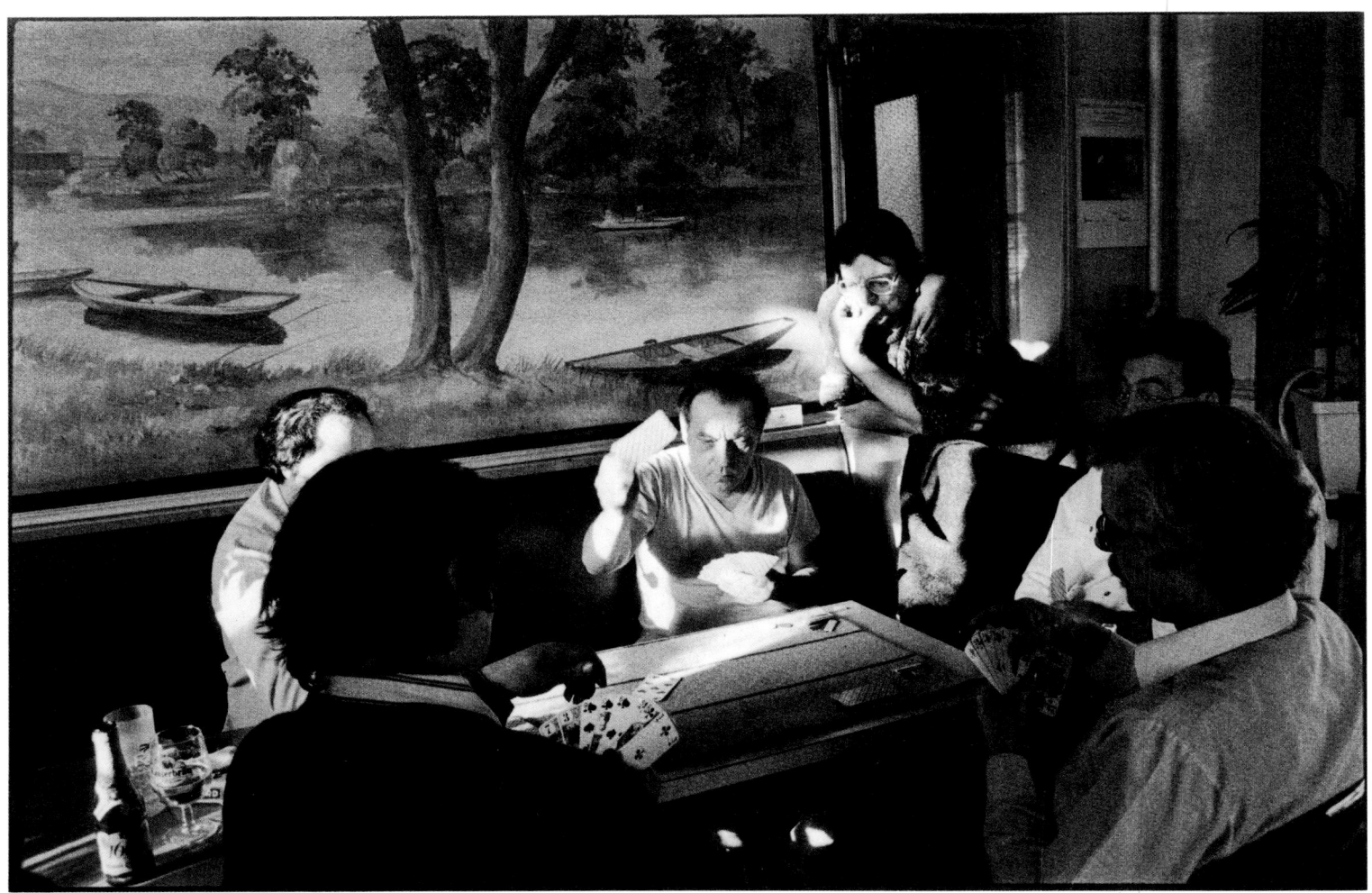

The game of tarot, Joinville-le-Pont, Val-de-Marne, 1991
NEGATIVE: 24×36 MM _ 250/3036
___ 549
February 6. Returning from a walk. We were once again in our Joinville bistro. The sun, already low on the horizon, shone its slanting rays onto the group that was there each time, unchanged. But this was the first time I had seen this light. I waited for the right moment. Christian (the owner's husband) raised his card. Click.

At the upstream tip of the Île Saint-Louis, Paris, 1991
NEGATIVE: 24×36 MM _ 251/4226
___ 550
Marie-Anne had passed away in April, and I abandoned the banks of the Marne for a time. On Sunday, July 21, I was at the upstream tip of the Île Saint-Louis. It was hot. The embankment where, on November 19, I captured the three swans, three lamps, and three teenagers (photo 350) was now covered with people in a state of undress—even a woman with bare breasts. I waited for a tourist boat to pass, to occupy the river.

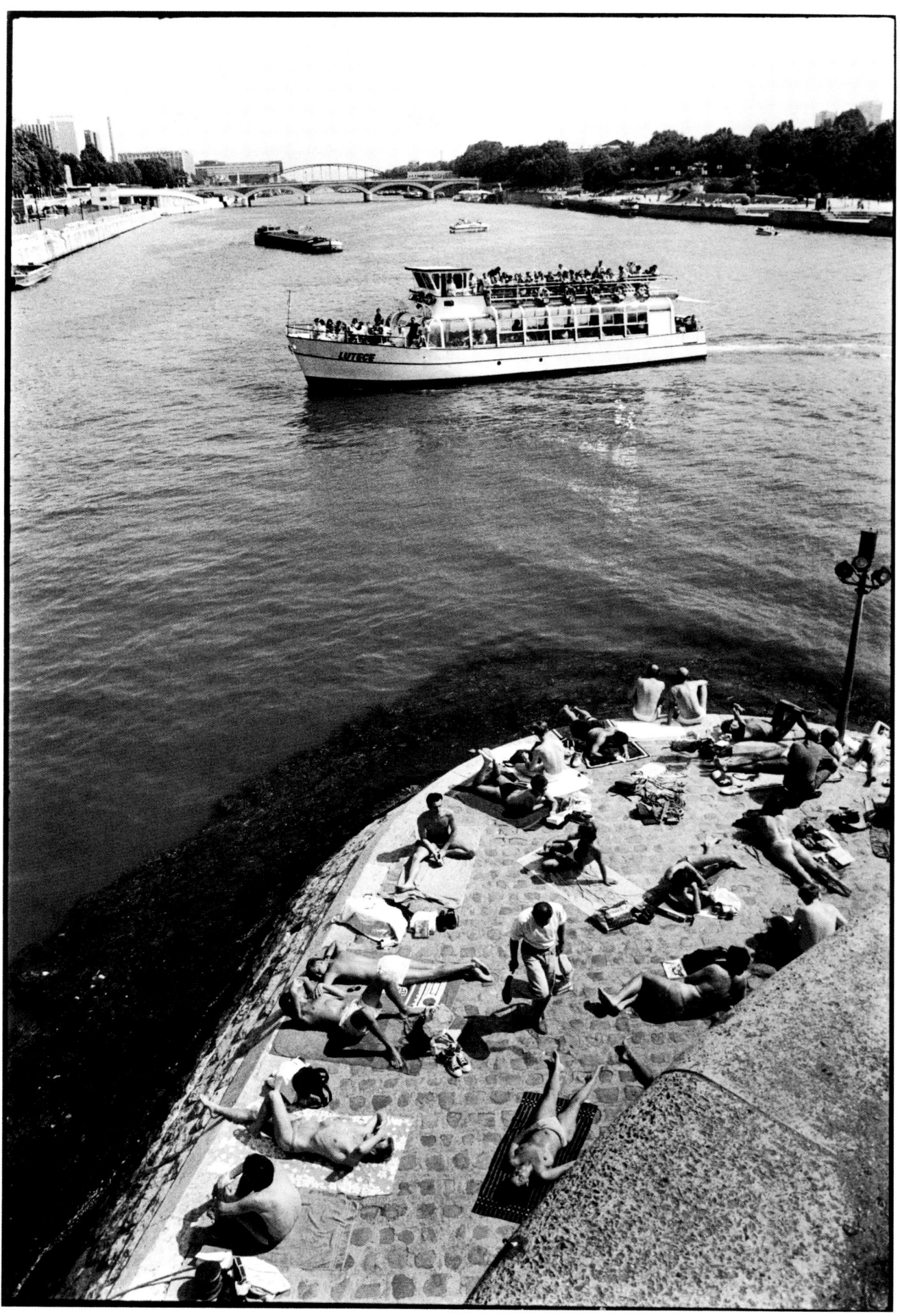

Traveling theater, Saint-Benoît-du-Sault, Indre, 1991
NEGATIVE: 24×36 MM _ F253/0131
___ 551

Since August 1, I had been in the beautiful village of Saint-Benoît-du-Sault in the Indre in central France, whose mayor, Jean Chatelut, had commissioned a book from me. I stayed until September 2, without having finished. This photo was taken in the improvised dressing room of a traveling theater company, L'Ours funambule (The Tightrope-Walking Bear), while two of the actresses were busying themselves before the performance.

The sheep fair, Saint-Benoît-du-Sault, Indre, 1991
NEGATIVE: 24×36 MM _ F254/1220
___ 552

During the sheep fair, waiting for the competition winner to be announced.

Playa de Gandía, south of Valencia, Spain, 1991
NEGATIVE: 24×36 MM _ 255/1727
___ 553

I had to interrupt my work to join some dear friends on a Spanish beach south of Valencia, Playa de Gandía. This photo was taken around August 15, one morning when the sun was still low.

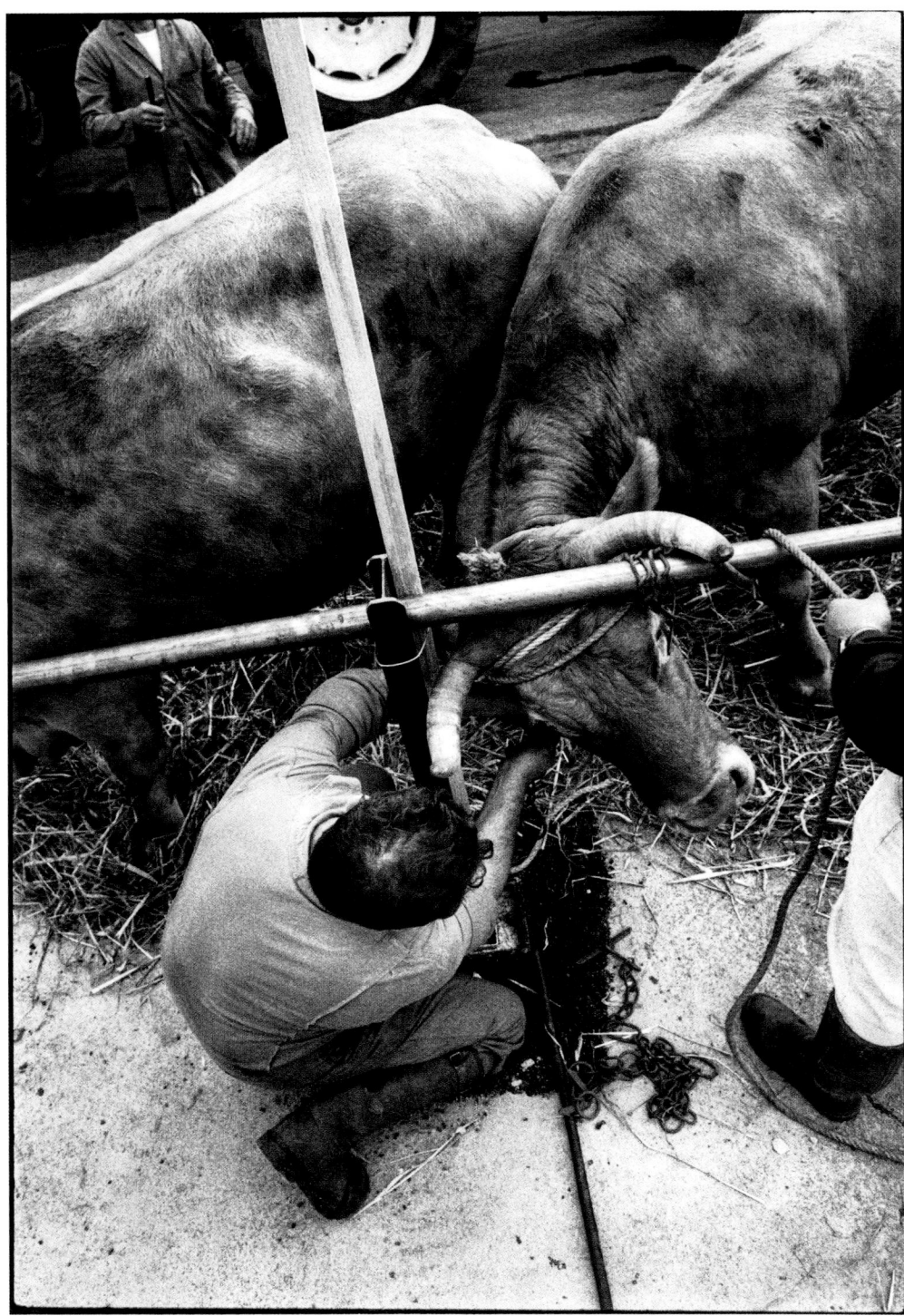

The cattle fair, Saint-Benoît-du-Sault, Indre, 1991
NEGATIVE: 24×36 MM _ F255/3422
—— 554
Back in my Limousin village on August 31, the cattle fair was now on. Perched on a cart, I got this bird's-eye view of a breeder tying one of his steers. The image itself is not that effective, except in terms of the composition, which pleases me.

At the fairground café, Saint-Benoît-du-Sault, Indre, 1991
NEGATIVE: 24×36 MM _ F256/0136
—— 555
On the morning of the cattle fair competition, a moment of relaxation in the café on the square. I had probably climbed onto a chair to separate the planes. The significant differences in light make this photo very difficult to print.

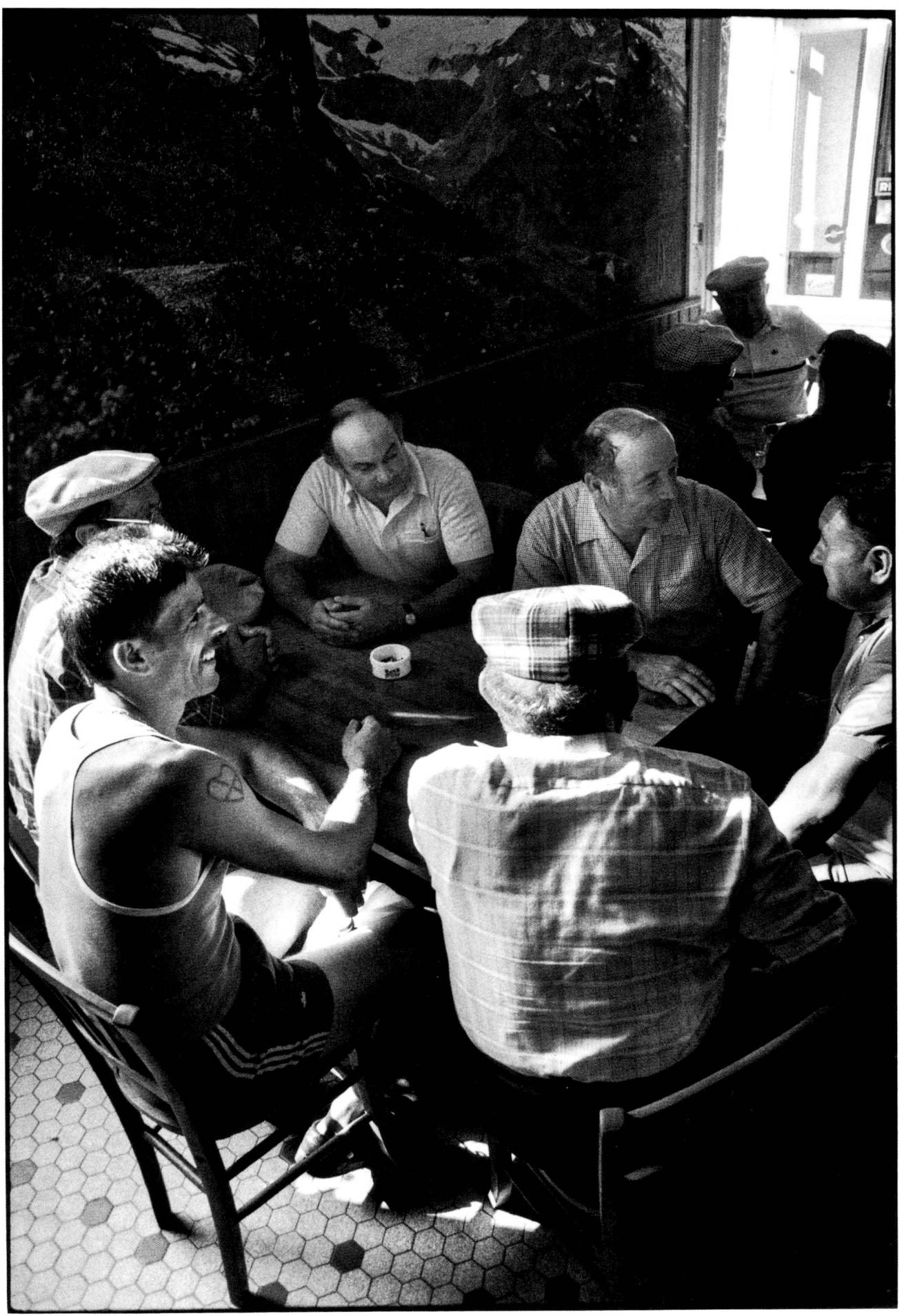

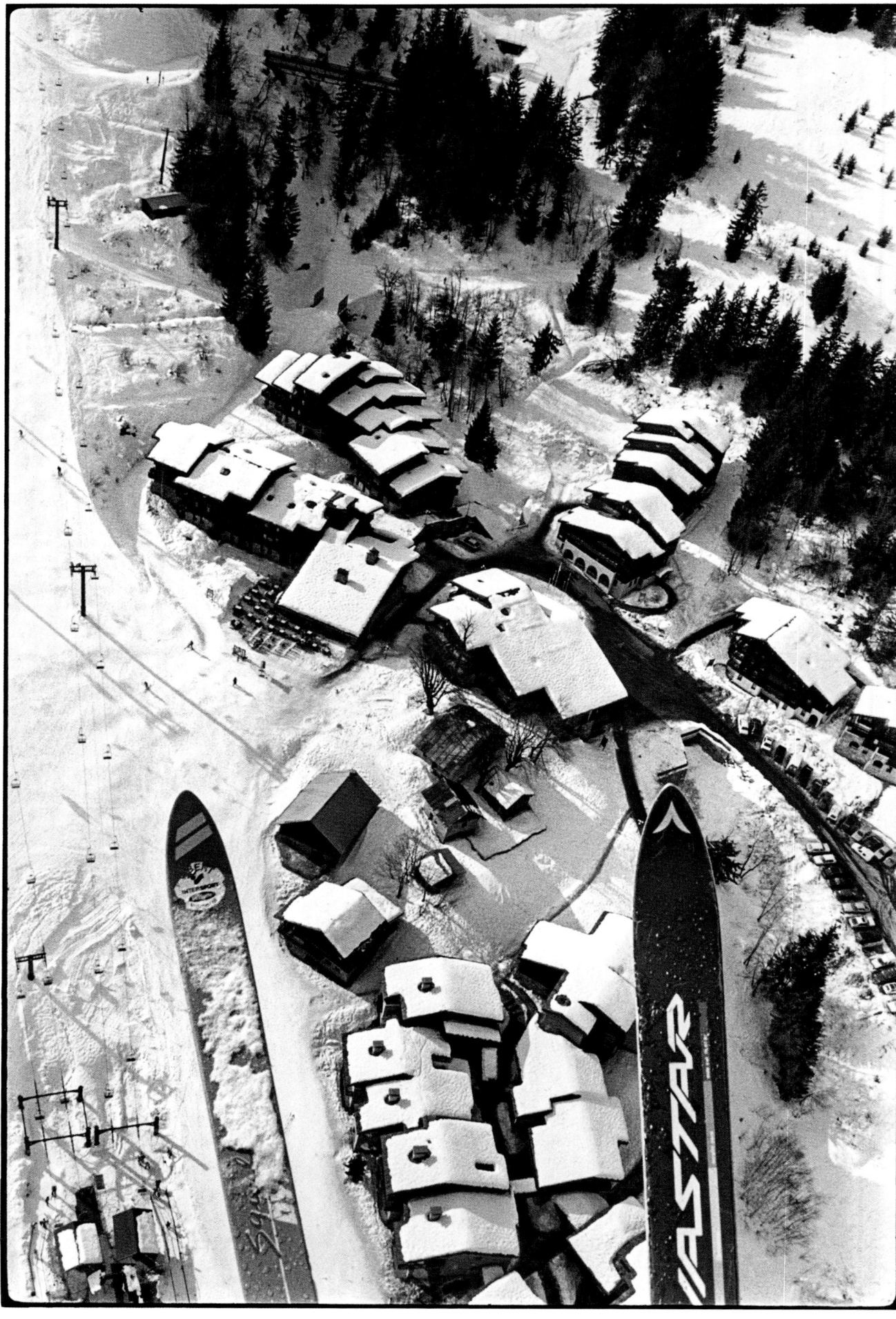

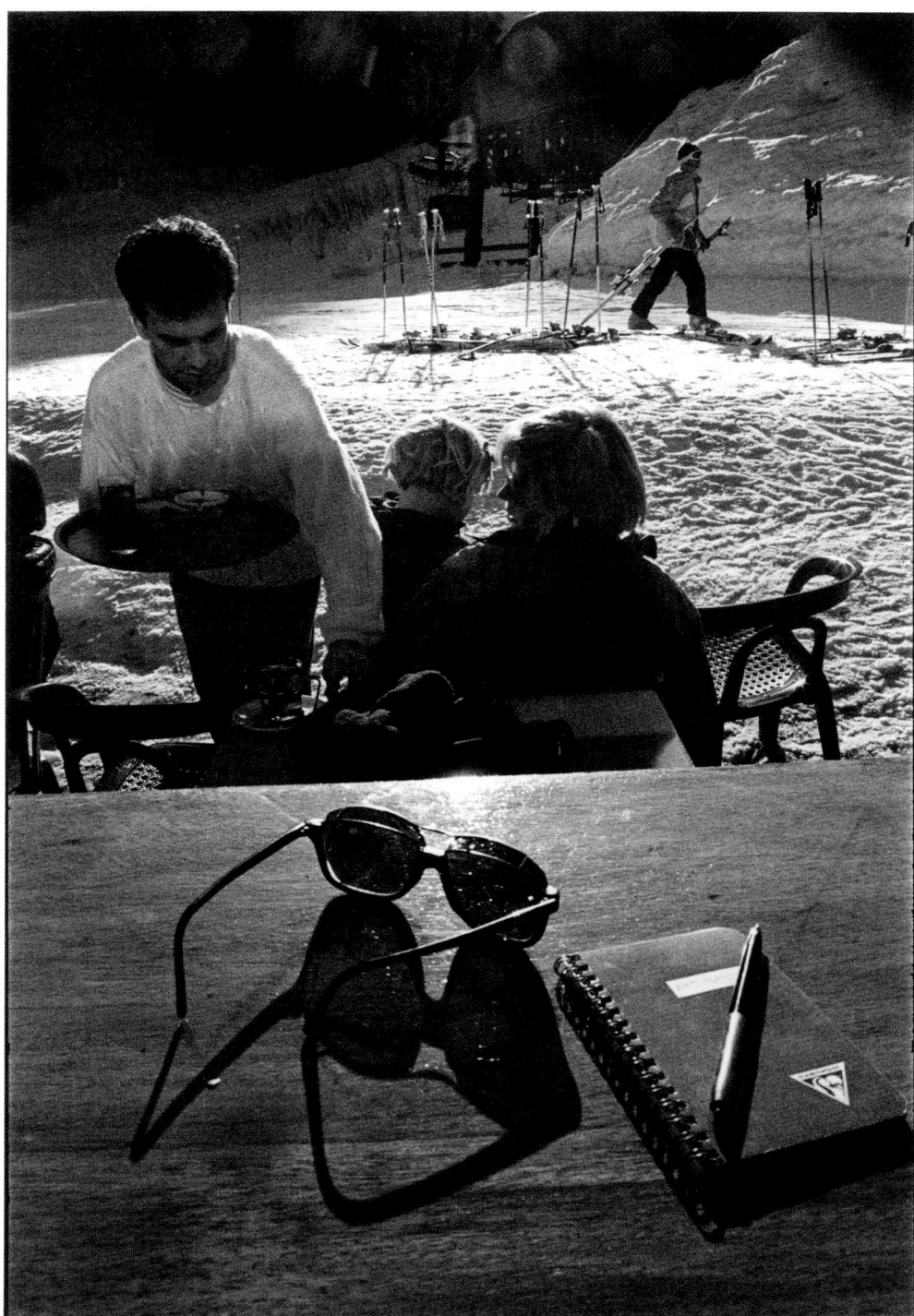

**Tandem paragliding
over Valmorel, Savoie, 1992**
NEGATIVE: 24×36 MM _ F258/2111
___ 556

I had decided to go skiing for a week in Valmorel, no doubt for the last time in view of my eighty-two years. It was January 25. Returning to the offices of the ski school, I saw three paragliders in the sky, each carrying two people. The school told me that it was possible to sign up, and the next day I was up in the air. Naturally, I took my Minox. I was firmly attached to my instructor; my back to his body, my skis between his. I photographed a part of the village. My viewpoint had veered slightly to my right, which explains the disparity between the two skis—his right ski on the right, mine on the left. Our two left skis are out of shot, to the left of the frame. It was Tuesday 28. I would do two more jumps during my stay.

Valmorel, Savoie, 1992
NEGATIVE: 24×36 MM _ F258/4115
___ 557

A little tired from too many descents that morning, I took the cable car up to a chalet-restaurant with a terrace, for a restorative mulled wine. This woman and her child caught my interest. She ordered drinks. I quickly placed items on the table in front of me. When the waiter put the drinks down and the skier I had noticed appeared in the right spot, I had my picture: a combination of preparation and seizing the moment of truth.

**Modiano market,
Thessaloniki, Greece, 1992**

NEGATIVE: 24×36 MM _ 259/2206

—— 558

I took advantage of my trip to Thessaloniki, where I was attending the opening of my exhibition, and visited the old town. I was (February 13) in a small restaurant in the covered market of Modiano, where I had lunch. Suddenly, two musicians entered, whose lively tunes roused the customers to dance. Climbing onto a chair, I took this photo with the wide angle of my Pentax zoom.

Place de la République, Paris, 1992
NEGATIVE: 24×36 MM _ P260/4706
— 559
May 18. On this morning, I took a new series of photos from the platform of the 29 bus. At place de la République, I took this photo of the animated crowd on the sidewalk near rue de Turbigo.

La Défense, Hauts-de-Seine, 1992
NEGATIVE: 24×36 MM _ P261/1309
— 560
A pretty hectic year. Between Valmorel and Thessaloniki, the summer in Vitré for my exhibition, three days in Saint-Benoît-du-Sault for additional images, then a few days in the Vaucluse, and various projects in Paris. New images at La Défense, this one taken at the beginning of May.

Brest, Finistère, 1992
NEGATIVE: 24×36 MM _ F261/4217
— 561
In August, I went to Brest for my exhibition. Few photos. I selected this one.

Île de Molène, Finistère, 1992
NEGATIVE: 24×36 MM _ F261/4909
___ 562

From Brest, I embarked for Île de Molène, where friends were expecting me. As I skirted the island, the strangeness of the landscape made me press the shutter (August 13).

Musicians near the Centre Georges Pompidou, Paris, 1992
NEGATIVE: 24×36 MM _ P263/2921
—— 563
November 21. As I was on my way to the Centre Pompidou, with my Minox I quickly captured these four musicians in action in front of the Stravinsky fountain.

Women's 15-km race, La Courneuve, Seine-Saint-Denis, 1993
NEGATIVE: 24×36 MM _ P265/2417
—— 564
For May 30, the city council of La Courneuve had organized races in the large park. They invited a number of photographers to cover the event, so that they could put up a giant poster in metro stations showing a typical moment from each race. The men's was a 30-km (18.6-mile) run. The above photo of the women's 15-km (9.3-mile) race was not the one that was chosen, but it appears here because I prefer it.

Aubenas, Ardèche, 1993
NEGATIVE: 24×36 MM _ F266/3819
___ 565
On Friday, July 16, I attended the opening of my exhibition at the château in Aubenas. The next day was market day. I took this image against the background of the château (short tele-zoom lens set to a focal length of 75 mm).

Château Lafite Rothschild, Pauillac, Gironde, 1994
NEGATIVE: 24×36 MM _ F268/4225
___ 566
Rapho assigned me a story on the famous Château Lafite vineyard in the Gironde. I went accompanied by the owner, Baron Eric de Rothschild. This photo was taken on October 2 under difficult conditions (frequent showers). I took the shot above during a sunny spell while perched on a tractor.

Isabelle Huppert, Paris, 1994
NEGATIVE: 24×36 MM _ 271/0323
__ 567

In January, *Cahiers du Cinéma* magazine invited Isabelle Huppert to edit their next issue. She asked me, along with a few other colleagues, to take her portrait. On the beautiful morning of January 20, I found myself at her home near the Luxembourg gardens. From this session, which took place in good spirits, both indoors and outdoors, I selected this photo, which was published several times. This led to a lasting friendship.

Memorial to the unknown Jewish martyr, Paris, 1994
NEGATIVE: 24×36 MM _ P271/2628
__ 568

I had to encapsulate, by means of a posed photograph, the idea of the memory of the Holocaust. I was introduced to an elderly couple, former deportees, and a teenager, their granddaughter. I asked them to pose in front of the memorial on the morning of February 4, the girl placing her hand on the old woman's shoulder.

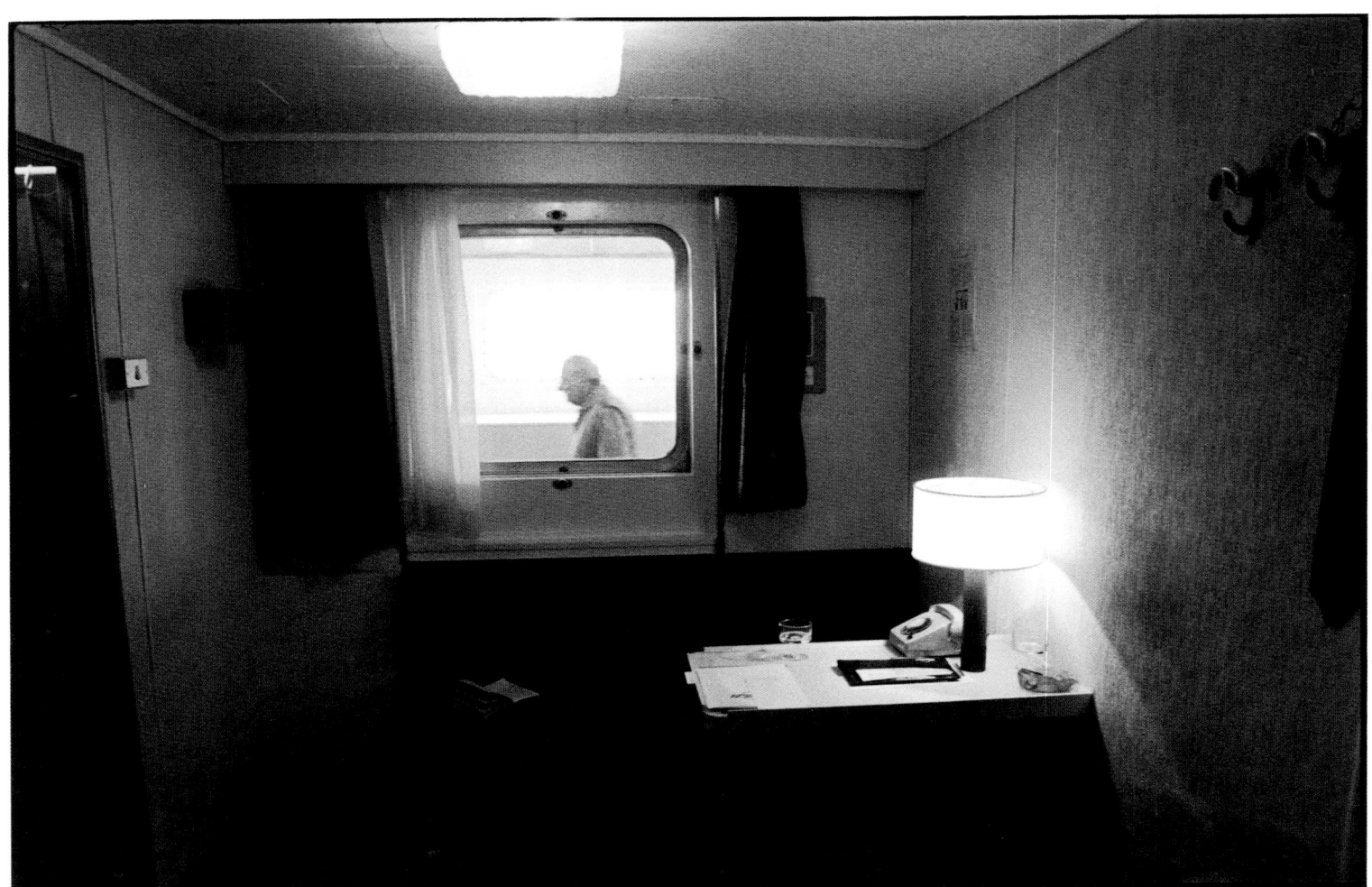

Mediterranean cruise, 1994
NEGATIVE: 24×36 MM _ 271/3204
__ 569
I was invited to go on a Mediterranean cruise, during which I would comment on a slide show of one hundred of my photographs, representing seventy years of activity. On board and during stopovers, my Pentax would be used a lot. It was mid-April, and on this morning I captured this character walking along the corridor in front of my cabin.

La Vucciria, Palermo, Italy, 1994
NEGATIVE: 24×36 MM _ 271/4118
__ 570
April 11. I asked to see La Vucciria, the colorful neighborhood Edmonde Charles-Roux had spoken of so highly to me. Its location was announced by a large number of bare electric light bulbs, starkly illuminating, in broad daylight, the fishmongers' stalls on this little square. I arrived a little late, but I still managed to capture the hurried pace of this tardy housewife.

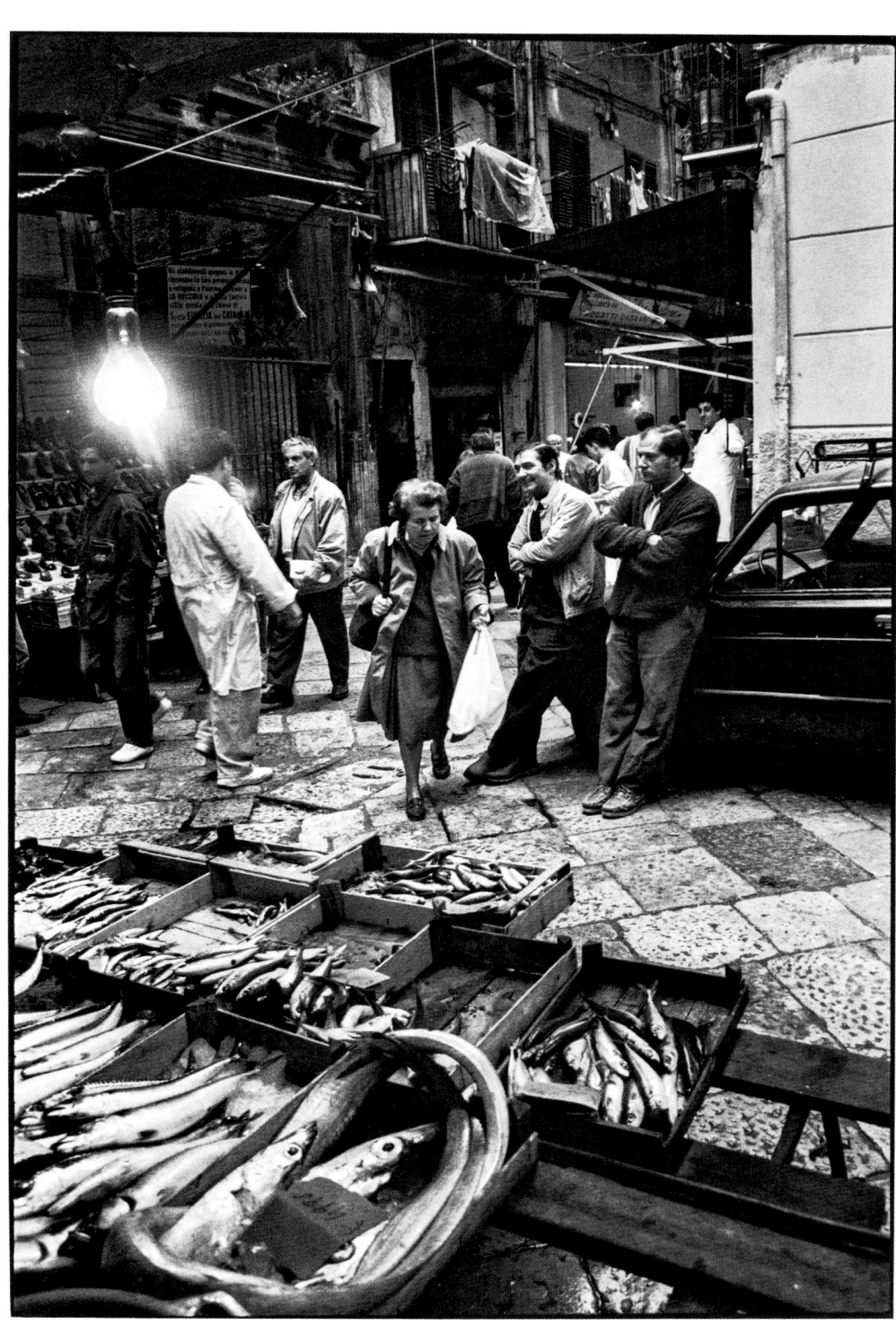

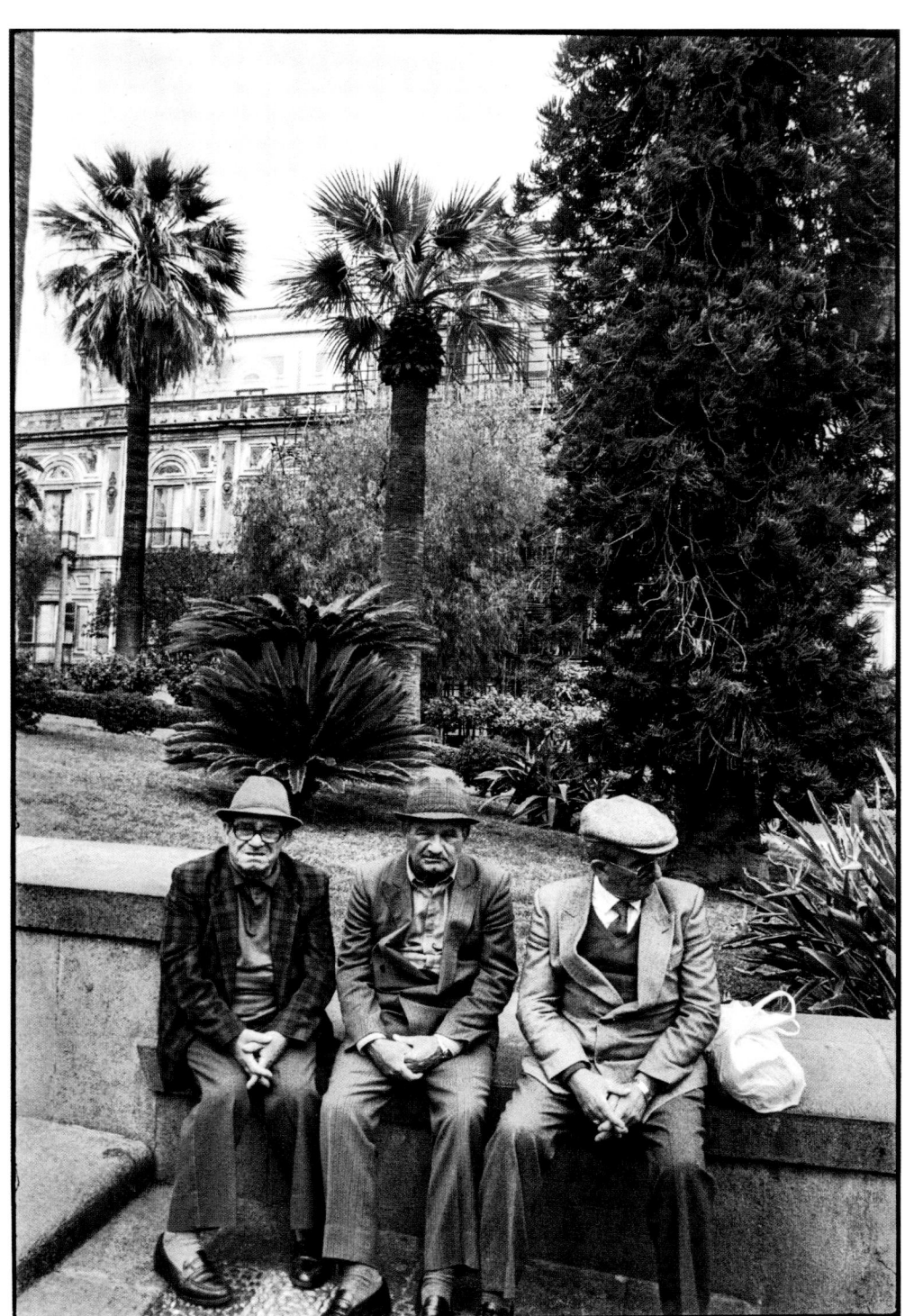

Naples, Italy, 1994
NEGATIVE: 24×36 MM _ 271/4818
___ 571
Two days later in Naples, in a park, these three pensioners. Curiously, none of them smoked.

Pantheon district, Rome, Italy, 1994
NEGATIVE: 24×36 MM _ 272/1610
___ 572
On April 14, in Rome, near the Pantheon, I noticed this group of students chatting enthusiastically among their scooters. I waited for the two pedestrians and the cyclist with her partner, because the place was otherwise too quiet.

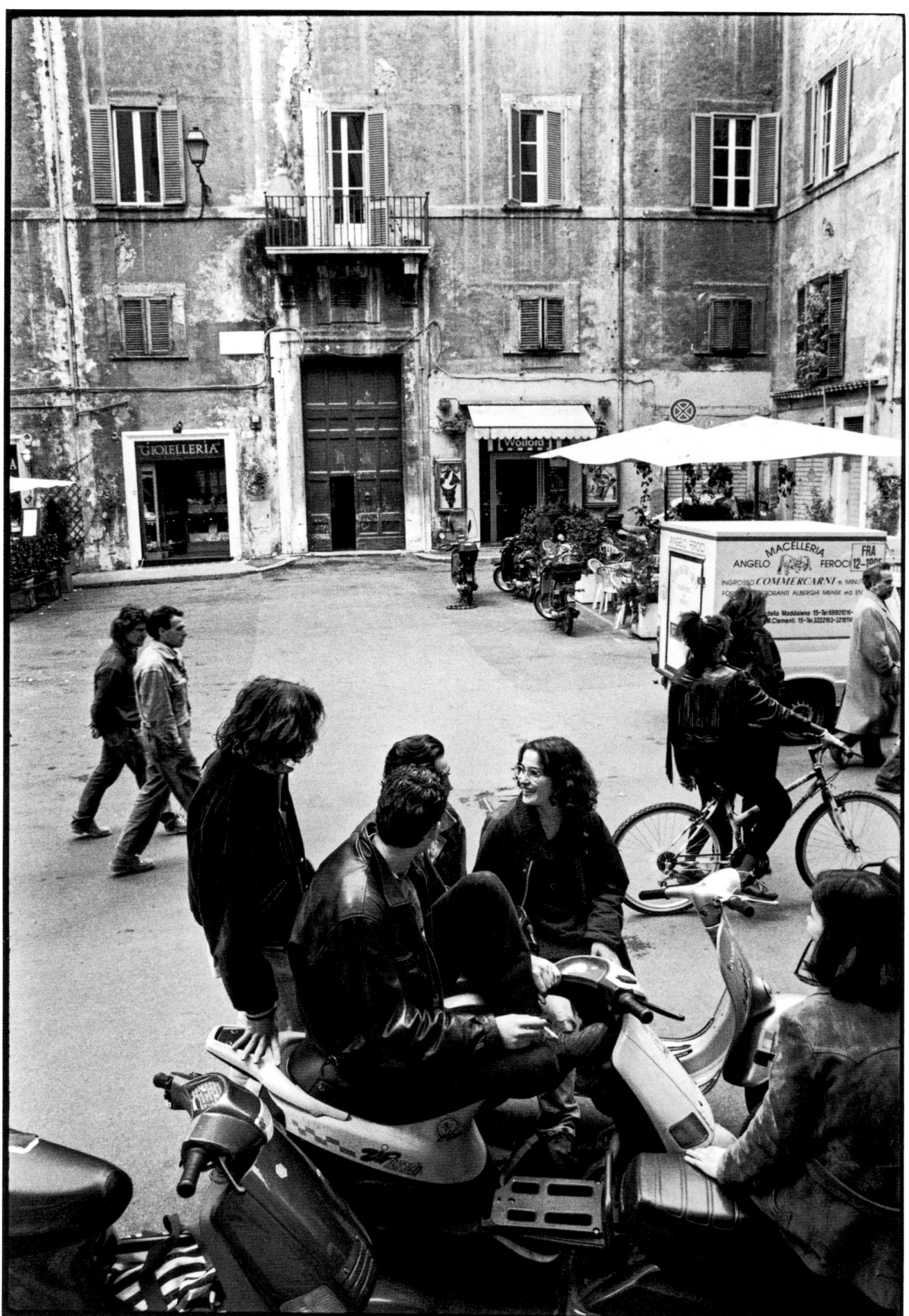

Spanish Steps, Rome, Italy, 1994
NEGATIVE: 24×36 MM _ 272/1819
— 573
On the same day, around noon; tourists buying paper cones of chestnuts. In the background, on either side of the thick vegetation, the stairs leading to the Trinità dei Monti church.

Piazza Navona, Rome, Italy, 1994
NEGATIVE: 24×36 MM _ 272/2032
— 574
Afternoon of the same day, a mixture of young Romans and tourists on Piazza Navona, the Bernini fountain as backdrop.

**Quai des Belges, Marseille,
Bouches-du-Rhône, 1994**
NEGATIVE: 24×36 MM _ F272/3907
—— 575

May 24. Quai des Belges, which I could
see from my hotel, as well as the Old
Port. Photo of this colorful fishmonger,
who was listening to a colleague on her
left. Four years later, my book *Provence*
was published. I received a letter from
the merchant who, arguing that I had not
spoken to her, rebuked me and issued
threats unless I gave her a copy of the
book she loved very much. I sent it to her
immediately. Everybody was happy.

**Vallon des Auffes, Marseille,
Bouches-du-Rhône, 1994**
NEGATIVE: 24×36 MM _ F272/4929
—— 576

The next morning, at the Vallon des Auffes,
not far from the place shown in photo
511 from April 1979. Some children were
having fun at the bottom of a small cove,
in the water, and on the small seawall.

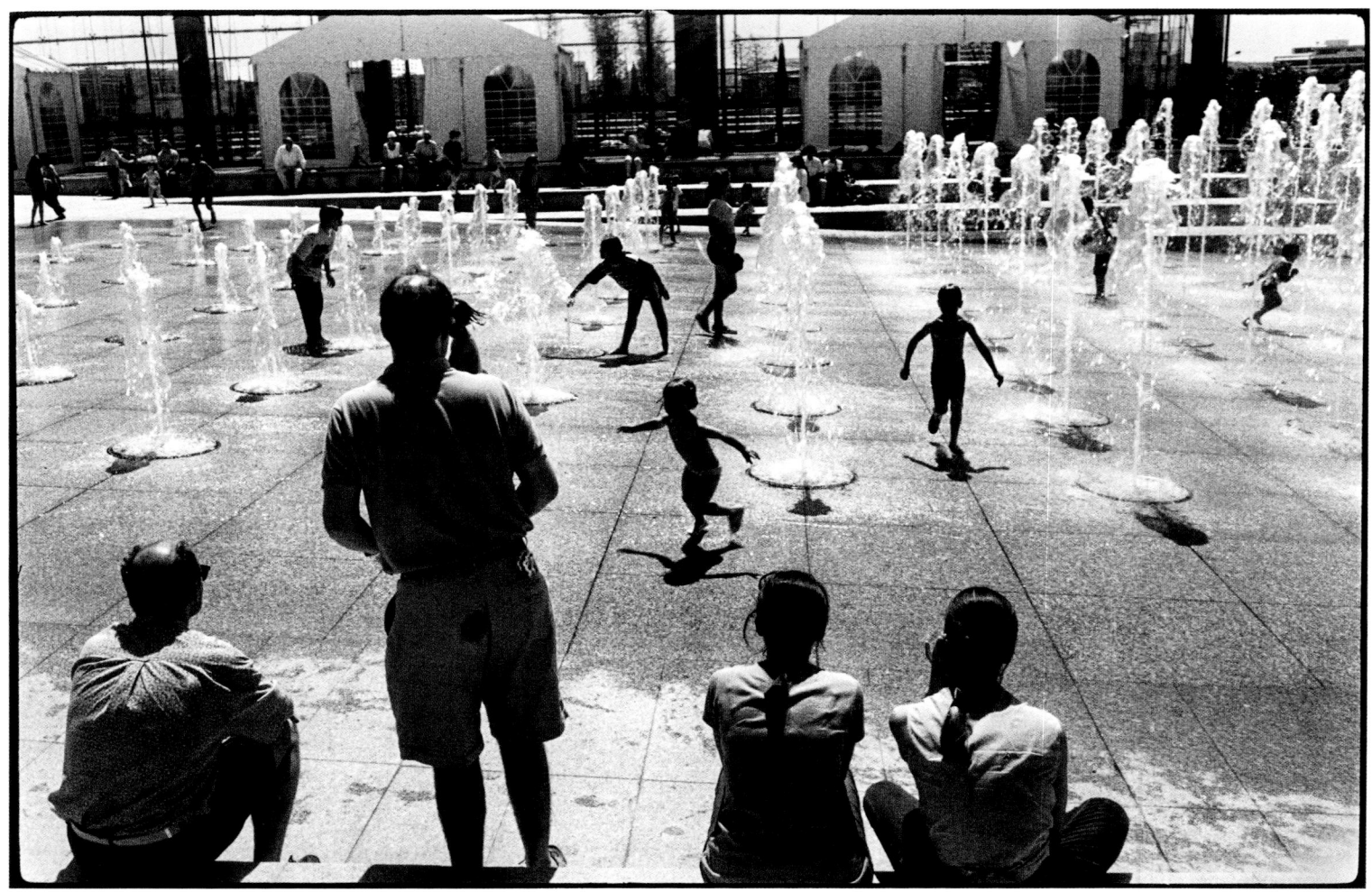

Parc André-Citroën, Paris, 1994
NEGATIVE: 24×36 MM _ P273/1501
___ 577
On June 15, my exhibition *Mes années 80* (My 1980s) opened, organized by the French department of photographic heritage at the Hôtel de Sully. Three days later, I was in the Parc André-Citroën, where I photographed some children who were very excited by the intermittent jets of water.

Christmas week, boulevard Haussmann, Paris, 1994
NEGATIVE: 24×36 MM _ P274/4021
___ 578
Once again, during Christmas week I mingled with the crowd of buyers rushing to acquire final gifts *in extremis* in front of their dazzled children.

Parachute self-portrait, La Ferté-Gaucher, Seine-et-Marne, 1995
NEGATIVE: 24×36 MM _ F276/3109
___ 579

Horizont panoramic camera. My appetite whetted by my paragliding flights at the end of January 1992 (photo 556 in Valmorel), on September 6, 1995, I went, clutching my medical certificate from a parachuting doctor, to La Ferté-Gaucher parachuting center in the company of a young friend who had decided to jump from the same plane. This was not my first jump: that took place on August 8, 1994, during which I took, after the chute had opened, a self-portrait with my Minox, which was published a few days later in *Libération*. For the jump shown here, I had equipped myself with a panoramic (Horizont) 1 × 2¼-in. (24 × 58-mm) camera. Once again, I took the shot during the canopy ride following the 5,000-ft. (1,500-m) free fall. My instructor, Bob Martinez, to whom I was firmly attached, can be seen behind me.

Lac de Charpal, near Rieutort-de-Randon, Lozère, 1996
NEGATIVE: 24×36 MM _ F278/2201
___ 580

In early June, I was invited by Didier Brousse to the village in Lozère where his parents lived. He and Kyoko, his wife, ran the Camera Obscura gallery where I was showing vintage prints and current photographs. Didier had been my student at the Saint-Charles Faculty of Science in Marseille, where I lectured in the early 1980s as part of the continuing education program. That day we stopped for a moment on the shore of Lac de Charpal.

The Coulée Verte elevated gardens, Paris, 1998
NEGATIVE: 24×36 MM _ P281/2907
___ 581
I often went for a walk along the Coulée Verte elevated gardens, which are quite close to my home. May 8, a public holiday, good weather. From the suspended footbridge, I contemplated the people lounging on the Pelouse de Reuilly, which had recently opened to the public.

Fête de la Musique, place des Vosges, Paris, 1998
NEGATIVE: 24×36 MM _ P281/3622
___ 582
The Ministry of Culture commissioned me to take a series of photos on the Fête de la Musique. So it was on June 21 that these photos were made. This one was taken on place des Vosges, under the arcades, near rue de Turenne.

**Fête de la Musique,
place des Vosges, Paris, 1998**
NEGATIVE: 24×36 MM _ P281/3727
__ 583
This photo, from the same day as the previous one, was taken in the same arcade, a little closer to the center. These beginners—that much was patently obvious—were putting their heart and soul into it, and for the time being that was what counted.

**Fête de la Musique,
rue de la Butte-aux-Cailles,
Paris, 1998**
NEGATIVE: 24×36 MM _ P281/4535
__ 584
On the sidelines of the party, rue de la Butte-aux-Cailles. The customers were relaxed; the two girls may have been meeting friends; two men were in conversation.

**Fête de la Musique,
rue de la Butte-aux-Cailles,
Paris, 1998**
NEGATIVE: 24×36 MM _ P281/4637
__ 585
Still on rue de la Butte-aux-Cailles, the hustle and bustle of the terrace is completely overflowing into the street.

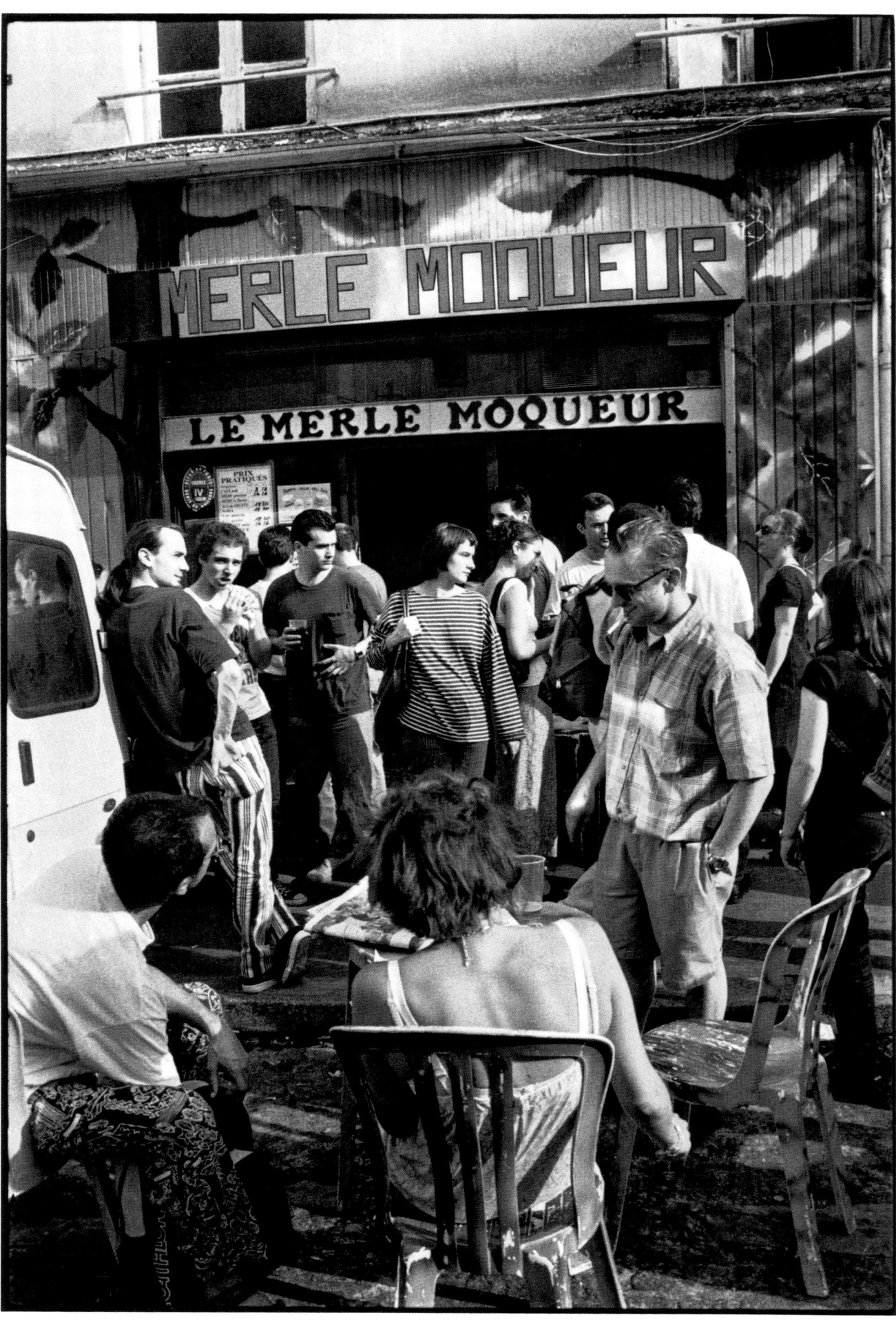

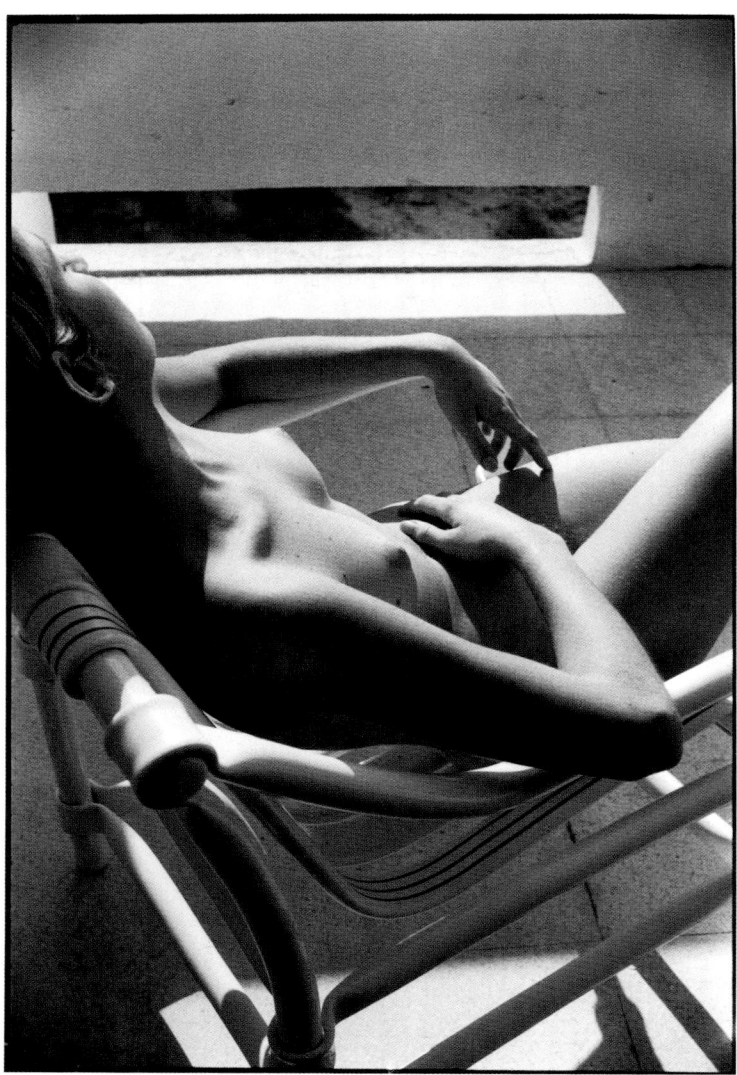

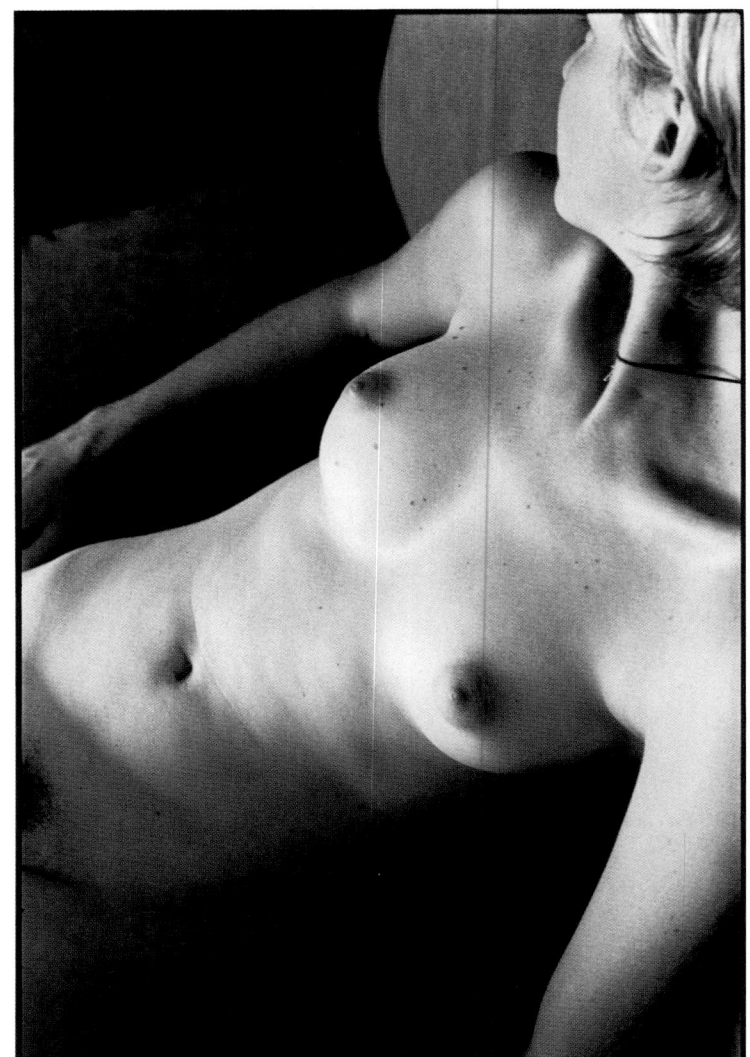

Nude, Djerba, Tunisia, 1998
NEGATIVE: 24×36 MM _ 283/0510
___ 586

I was invited by Club Méditerranée to a week-long stay in Djerba, where I took part in an exhibition, on the theme of emotion, that included my photo of the night in a mountain chalet from 1935 (photo 10). I met a young friend there who agreed to pose naked for me. The picture was taken on the terrace of my room.

Nude in Paris, 1999
NEGATIVE: 24×36 MM _ 285/1408
___ 587
Nude in an interior.
Natural light. August 25.

Nude, Paris, 1999
NEGATIVE: 24×36 MM _ 285/3109
___ 588
The same model, in another room with the blind two-thirds down.

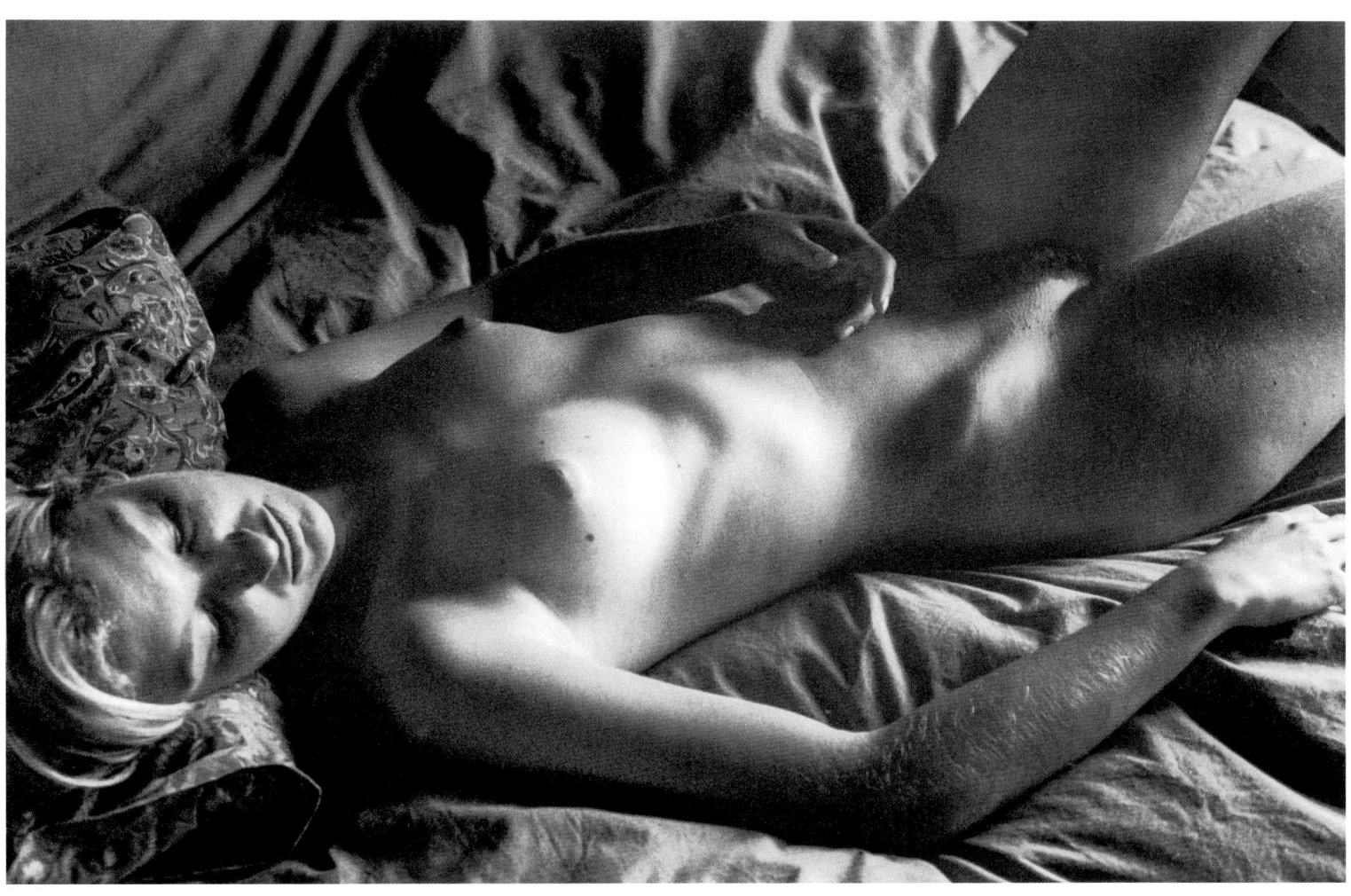

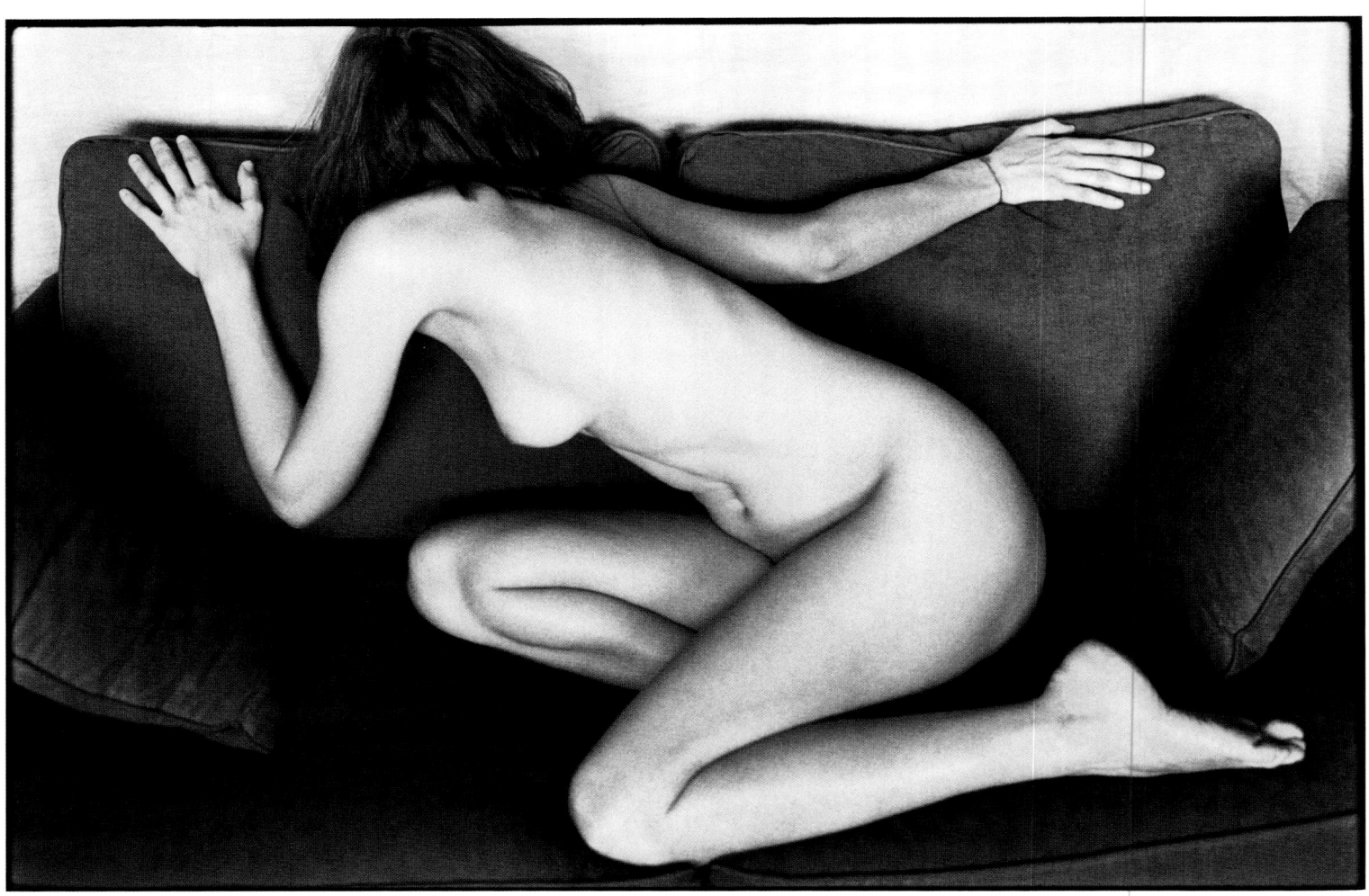

Nude, Paris, 2001
NEGATIVE: 24×36 MM _ 287/0713
___ 589

Rebecca. This picture was taken on a couch, in natural light, on September 1.

Nude, Paris, 2002
NEGATIVE: 24×36 MM _ 287/3505
___ 590

Pascale. Suffering from arthritis in my legs, I could no longer walk, except around my apartment and with the aid of two canes. No more pictures while running through the streets. My last photos were nudes, taken at home. Living on the eighth floor, I have lots of light. A friend asked me to photograph his wife. I accepted, knowing that this would be my last session, because my lack of stability and the fact that I hate working with a tripod meant I could no longer continue in this exercise.

I remove the batteries from my equipment and put it in the closet. No drama. I've taken pictures for seventy years! And one gains a certain wisdom from that. But I am not giving up on photography, just as photography isn't giving up on me: there are magazines, books, exhibitions in France and abroad—enough to keep me busy all week and often at weekends. And I have many friends. I am very thankful.

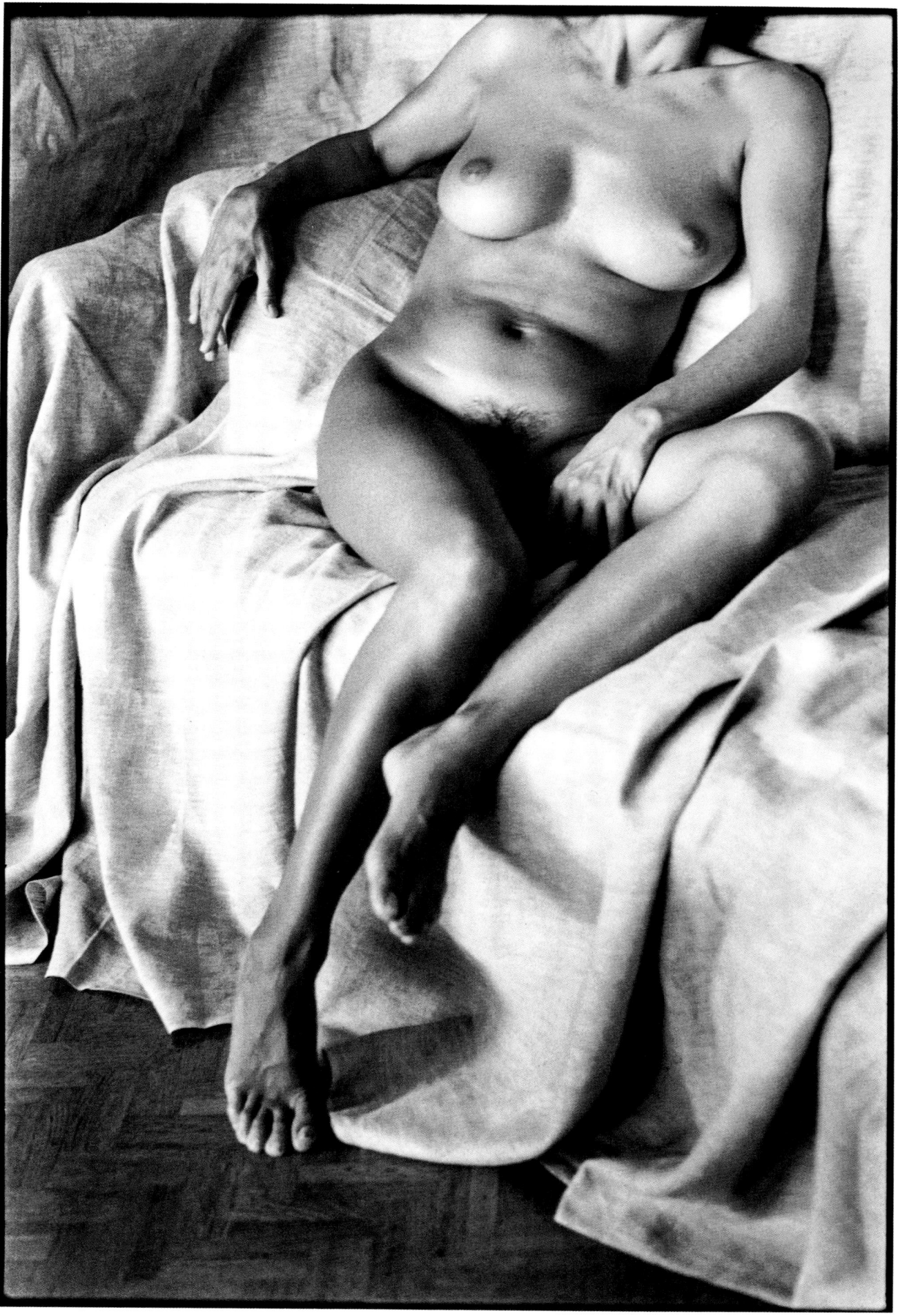

APPENDIXES

GLOSSARY
BIBLIOGRAPHY
BIOGRAPHICAL NOTES

Ronan Guinée, Head of Collections, Willy Ronis archive,
Médiathèque de l'Architecture et du Patrimoine, Charenton-le-Pont

GLOSSARY

To understand Ronis's work, the reader should also consider the vocabulary he used. The texts in his albums are based as much on anecdote as on photographic technique, and are aimed primarily at tradespeople and amateurs. The clarifications below, based on his own writings, are designed to throw more light on this singular body of work.

Note:
For abbreviated references used here (e.g. "WR1," "WR40"), please refer to the Bibliography.

ACCESSORIES

The names of some photographic accessories appear in some of the texts. As a good practitioner of black-and-white, Willy Ronis recommended the use of color filters to render better tonal values, particularly for skies (orange filter, photo 198). As for the shutter speed and aperture, these readings are to be taken as a guide only, since significant differences have been noted.

In the commentary for photo 310, the author discussed the acquisition of auxiliary lenses to change the focus of his panoramic camera, allowing him to create an image that surprises through the proximity of the subject and its vertical framing.

APERTURE
See shutter speed

CAMERAS: FOCA 24 × 36 MM

Aside from the Rolleiflex, the Foca was Ronis's other principal professional camera. His adoption of the small format at the end of 1954 came relatively late. He recounts the acquisition of three Focas following a correspondence with the manufacturer OPL (see photo 157). He justified this number thus: "If, during reportage, one must operate successively indoors and outdoors, it is advisable to have two cameras, one loaded with sensitive film (Tri X), the other with a slower and finer grain film (Plus X or FP3). Let's add ... a third camera for color(!), and our 'small-format' photographer is transformed into a porter."[1]

This camera is a rangefinder. A turret of rotating optics, placed above the camera, allows for framing according to the brand's five focal lengths. Ronis mentioned another important framing accessory, the "micro-Foca SLR body" (photo 230); it is positioned between the lens and the camera to allow framing and focusing when using long lenses (105-mm macro, 200-mm, and 500-mm).

CAMERAS: PENTAX

With his Focas nearing the end of their life, in 1981 Ronis chose a Pentax ME Super, with three lenses including two—highly appreciated—zooms (photo 438). He mentioned only one body: the demanding professional had given way to the free image-hunter. The big break occurred during the transition from 2 1/4 × 2 1/4-in. (6 × 6-cm) to 24 × 36-mm film, and the new requirement, now the format was no longer square, to choose between a vertical or a horizontal framing. The transition from Foca to Pentax was a modern choice, considering its reflex finder, the integrated photocell, and the zoom lenses: "Same possibilities as before (a few more) and similar weight. Greater maneuverability;"[2] "What I like about the SLR is to have the real image, whereas with a rangefinder ... when I worked with very close foregrounds, I had constantly to think of the corrections I had to make."[3] However, Ronis downplayed the importance of the equipment in his production: "For the year and a half that I have been using an automatic, I have never had the impression that the equipment was thinking for me and bringing me the image on a tray while wearing white gloves. My torment before the subject remains unchanged; besides, the equipment (mine, at least) is stupid and I often have to correct it."[4]

1 "La technique dans le reportage sur le vif," *Photographie nouvelle*, no. 33 (May–June 1968).

2 "Histoire d'une photo célèbre," *Photo-Magazine*, no. 214 (July 1985).

3 Olivier Delhoume, *Mises au point, Paroles de photographes* (Paris: Alternatives, 2006). Interview conducted in August 1986.

4 Letter from Willy Ronis to Robert Doisneau, January 9, 1982.

CAMERAS: ROLLEIFLEX 6 × 6

The Rolleiflex, or Rollei, was the first big camera used by Ronis. He chose it in 1937, when he began his career, and explained how he came to acquire it (see photo 14). He tended to remain loyal to his choice of equipment, using each camera body for around twenty years. This loyalty to his tools, which he mastered perfectly, was based above all on economics: "If I never wanted to acquire all the 'up-to-date' equipment, it is because I was too sure of never being able to pay it off."[5]

The Rolleiflex is a 2 1/4 × 2 1/4-in. (6 × 6-cm) twin-lens (non-interchangeable, 75-mm) camera; the lower lens is used for shooting, the upper for framing. Focusing is done either on a ground-glass focusing screen, which allows the image from the upper lens to be reflected through a mirror (normal view), or by guesswork, through the frame of the hood (sports viewfinder, photo 114). "The ground-glass screen ... is not used to focus (a moderately trained eye no longer makes mistakes in the appreciation of distances beyond two meters [six feet]). Everything is then done through the iconometric viewfinder, which alone allows the subject to be observed in its full extent."[6]

Ronis said that he owned two Rolleiflexes (photo 408), one for black-and-white, the other for color (postwar); he went on to acquire others following losses and breakages.

CAMERAS: OTHER

While Ronis was not a worshipper of photographic equipment, he was nonetheless careful to specify the various cameras he used and their origin. His first camera, given to him by his father, was a 2 1/2 × 4 1/4-in. (6.5 × 11-cm) folding Kodak. The cameras borrowed from the store were folding Ikontas, from the Zeiss-Ikon brand, 1 5/8 × 2 1/4 in. (4.5 × 6 cm) and 2 1/4 × 3 1/4 in. (6 × 9 cm). As the family store went bankrupt, he said: "From this shipwreck, I was able to save only one 11 3/4 × 15 3/4-in. (30 × 40-cm) drying plate, but not the dryer, a large-format 5 × 7-in. (13 × 18-cm) wooden camera, and the 2 1/4 × 3 1/4-in. (6 × 9-cm) Ikonta."[7] The Ronis archive holds 2 1/4 × 3 1/4-in. (6 × 9-cm) views from after the war; Ronis mentioned this in his commentary on photo 275, but in connection to a folding MPP 4 × 5-in. (10 × 12.5-cm) camera, acquired in the 1960s, with a "reducer 2 1/4 × 3 1/4-in. (6 × 9-cm) back that I used a lot for industrial work."[8] This camera played an important part in his commissioned work, which he does not illustrate here (with the exception of his reproductions and duplicates, photos 22 and 278).

Ronis mentions cameras that he borrowed: a Contax before the war (photo 6), a Canon before he chose the Pentax (photo 438), an Edixa camera with a hunting-style viewfinder (photo 426), and the panoramic Widelux and Horizont (photo 306) cameras, which he "fell in love with"[9] and acquired. He did not mention his experiments with the Leica, before the war and in 1954; he only discussed his Foca and the "surprised, even contemptuous, gaze of my colleagues, almost all of whom were 'Leicaists'" (photo 493).

Finally, Ronis's choice of Minox in 1986 was a matter of simplification and of that fact that it complemented his Pentax SLR. He appreciated its size and light weight, and the freedom it offered to go out without a camera bag (photo 449). He used these two cameras side by side until he finished practicing photography.

CANDID PHOTOGRAPHY, PREVISUALIZED IMAGE, GLOBAL VISION

These are concepts put forward by Willy Ronis and used on several occasions in his writings and lectures. "Candid photography" refers to the hunt for images and resulting moments of tension when the photographer is handling chance events. The title of Ronis's first monograph, *Sur le fil du hasard* (On Chance's Edge, WR7a), makes a poetic reference to this idea. The French expression "sur le vif" (on the spot) is mentioned nine times in the albums, and the word "chance" thirty-one times, including a notable "Chance was truly on my side" (photo 339).

The "previsualized image," constructed in the photographer's mind before it is taken, is apparently the opposite. The hunter becomes fisherman, patiently waiting for the elements to align in a predefined setting. The term is mentioned six times. The two approaches can be combined: "There is no contradiction between candid photographs and previsualization" (photo 64).

"Global vision" is another one of Ronis's major principles. If the first two are attitudes in the field, this is a skill developed through experience. It allowed him to track, in complex environments, several moving elements in order to capture, at the optimal moment, a composition in equilibrium. He wrote: "The good photos that we published were the result of an acquired skillfulness, a heightened attention, and a certain ability to master the unexpected."[10] Surprisingly, the term is mentioned only once (photo 159).

5 Letter from Willy Ronis to Herman Craeybeckx, February 10, 1970.
6 "Ne tirez pas sur le photographe," *Photorama*, no. 3 (May–June 1952).
7 "Le troisième œil de Willy Ronis," *Cyclope*, no. 2 (Spring 1990).
8 Ibid.
9 Ibid.
10 "Oeil, Objectif, Vision globale," *Photographie nouvelle*, no. 30 (November 1967).

COLOR PHOTOGRAPHY

Color photography constitutes the biggest gap in the albums. It was, however, mentioned twenty-one times in Ronis's texts, and it should be noted that photo 419 is a color slide, reproduced in black-and-white. The author tailored his account of his career. Like many of his peers he worked in color, through economic necessity but also through personal choice, from as early as 1946. Ronis exhibited color photographs at the Salon National Photographique in 1954, and in 1959 wrote an article entitled "Et vive la couleur!" (Long live color!).[11]

As soon as Ronis had attained a certain status as a photographer, he excluded his book *Paris* (WR5), in color, from his biography; he had cited it up until that point since it had been translated into several languages and had received a special international award in Vienna for the most beautiful illustrations in a tourist book. For him, the practice of color became a source of tension, not pleasure: "I noted with a certain dread that color had fooled me and that I looked at everything through a range of colors. I will need to react."[12]

CROPPING

Ronis provided the State, which would manage his archive, with printing instructions to be followed. They relate above all to 24 × 36-mm images, in a late reading of his work. Ronis's medium-format practice from the 1930s to the 1950s was quite free and by no means dogmatic, as he explains in *Sur le fil du hasard* (On Chance's Edge), published in 1980: "I was too unsure of myself ... and the 2 ¼ × 2 ¼-in. (6 × 6-cm) format seemed to me like a reasonable compromise.... Its format allowed enlargement ratios that 24 × 36 mm ... made uncertain."[13] Cropping during printing is determined on the baseboard, during the positioning of the sheet; the latter is rectangular, the projected image square. Reframing is therefore a natural act, not a shameful one. "When shooting, the need to operate quickly rules out careful framing during the hunt for images ... In short, compose rather widely" (WR1, page 41).

Strict full frame implies a white margin on the print, not used by Willy Ronis on his 7 x 9 ½-in. (18 × 24-cm) press prints; visually it is marked by a black border around the image. The negative is then printed with its technical edges and is referred to as "full." In the same text from 1980, the author recognizes that a certain "mutilation" results,[14] but denounces the "snobbery of full-frame printing, which is visible by the black border around the image. But not everyone can compose full frame, except proponents of nonsense, by pure provocation. So there are smart-asses who crop on the sly: their black border is post-veiling ... or the felt pen."[15] For the most part, the prints of the first five albums are without borders; the mat "eats" into the image. Ronis significantly changed his position in the 2000s and gave instructions for the sixth album that crop marks should be left; he intentionally includes this technical border for images that have not been cropped or straightened.

DARKROOM PRINTING

Darkroom work remains the hidden facet of the photographer's job. Even if professional laboratories began to appear after World War II—Ronis mentions the Duffort laboratories in the 1950s (photo 81) and Pictorial in the 1980s (photo 22)—he mostly handled the development of his black-and-white negatives, contact sheets, and prints. The decision to undertake the work himself or outsource it was made according to considerations of urgency, safety, and the client's means. Ronis admitted that he was not a good printer: "I do not know if you're very good at printing. Me? Not at all. I know (thankfully) what a *good* print is. But to achieve it, I spoil, I get angry, I start again, and, almost always, the final print leaves me dissatisfied. I have the same admiration for good printers as for good musical virtuosos. The negative is the score; the print is the rendition. As in music still, it is rare that the photographer (the composer) is also a great performer."[16] Nonetheless, Ronis insisted on the need for photographers to be able to print themselves, in order to develop their critical senses (photo 121) and to improve their practice: "The laboratory, the place where our desires, our strength, and our weaknesses are ruthlessly revealed. This impact encourages us to think better, to make calculations when in the throes of shooting, and to go over our errors in order to improve the results of future experiments."[17]

In his successive residences, in Paris and Provence, Ronis was adamant about setting up an office and a darkroom in addition to a painting workshop for Marie-Anne Lansiaux.

11 "Et vive la couleur!," *Photo Cinéma* (July 1959).

12 Letter from Willy Ronis to Robert Doisneau, December 29, 1976.

13 Unpaginated introduction to WR7, "Apprentissages" text; WR40, p. 23; WR47, p. 142.

14 Ibid., WR40, p. 25; WR47, p. 144.

15 Ibid., "Bouts d'essai" text; WR47, p. 159.

16 Letter from Willy Ronis to Robert Doisneau, April 28, 1976.

17 "Ne tirez pas sur le photographe."

DARKROOM TECHNIQUES

For photo 305, Ronis wrote that he was "not fond of laboratory contrivances but, from time to time, it's fun to go out of one's comfort zone." These excursions led him, in the 1960s, to try abstract photography, examples of which do not appear in the albums. Some singular laboratory techniques appear here and there.

Posterization, described in relation to the portrait of Picasso, is the voluntary reduction of shades of gray. To achieve the desired effect, Ronis superimposed two negatives.

To achieve a graphic effect with photo 259, Ronis chose to move away from a photographic finish. Choosing the hardness of the paper and the developer was no longer sufficient, so he resorted to an intermediary duplicate in which the contrast has been pushed to an extreme.

The "arsenal of photographic design" evoked for photo 278 includes, among other things, solarization and photomontage. Solarization is the inversion of certain values obtained during development—blacks in particular—which thus become lighter. Photomontage is the inclusion of several images to form one visual whole, in order to create a more expressive result or, as in photo 511, to improve the image and achieve a balanced, considered form not captured during the shooting. This example, in which Ronis did not reveal his use of photomontage, is special but without doubt not unique, because he fully mastered the technique. The author chose to emphasize "the shooting—and it alone—which is the work of creation."[18] To his amateur readers, he recommended, ironically: "The hunt for images is Life. If Life does not interest you, devote yourself to photograms, solarizations, and other free games. It's easier" (WR1, p. 20).

DUPLICATES

The term "duplicate" had two meanings for Ronis. The first is a corrective copy, on a 1:1 scale, of a negative that caused printing problems (problems of exposure and/or development), made by contact. In his text for photo 298, Ronis mentioned Kodak's Kodatone film, a self-toning emulsion designed for printing work; the resulting image was inverted right-to-left.

The word also refers to new negatives made from reproductions of paper prints. Made optically, they are enlarged. Ronis used this method in the case of lost original negatives (photo 100), when there were problems of excessive retouching or spotting (photo 22), for photomontages (photo 511), or in laboratory experimentation (photo 259).

EXPOSURE

Ronis's first integrated cell unit arrived late, in 1980, with the Pentax ME Super. In the past, light measurement was carried out using a hand-held photocell or simple exposure tables combined with a dose of empiricism. Ronis played on the exposure latitude of black-and-white films, with the risk of overexposing (too much light) or underexposing his film (not enough light). He deplored the difficulties in printing his work: "My best images ... come mostly from over- or underexposed negatives. This was the result of an instinctive trigger, even if the cerebral computer worked very well, except for calculating shutter speeds. If I'd had to get out the Lunasix [photocell] and think as well ... "[19]

18 "Universalité du Foca Universel," *Focagraphie*, no. 33 (May 1957).

19 Letter from Willy Ronis to Robert Doisneau, December 29, 1976.

FILM FORMATS

Ronis was careful to specify systematically the format of his negatives for albums 1 to 5. Linking this information to the year in which they made allows us to locate original negatives in his archives. The two main formats are 2 1/4 × 2 1/4 in. (6 × 6 cm) and 24 × 36 mm.

These denominations are standard. The 2 1/4 × 2 1/4 in. (6 × 6 cm) designation refers to square negatives (or slides) made on 2 1/4-inch-wide (60-mm) film; the size of the image is approximately 2 1/4 × 2 1/4 in (5.6 × 5.6 cm). On the other hand, the 24 × 36 mm indication corresponds to the size of the camera's actual frame, in mm; the film is 35 mm wide. The pictures taken with the Minox and Horizont cameras are made with these same films. For the latter, the indication "24 × 58-mm negative on 24 × 36-mm film" is used only in informal speech; it should in fact refer to a "24 × 58-mm negative on 35-mm film."

The other formats mentioned by Ronis are, in order of appearance: 2 1/2 × 4 1/4 in. (6.5 × 11 cm; film width 6.9 cm); 1 1/8 × 1 5/8 in. (3 × 4 cm; film width 4.5 cm); 1 5/8 × 2 1/4 in. (4.5 × 6 cm; film width 6 cm); 2 1/4 × 3 1/4 in. (6 × 9 cm; film width 6 cm); and 4 × 5 in. (10 × 12.5 cm; sheet film, not on rolls). All his films are flexible.

FILM SPEED

The sensitivity of film to light is the third component that determines the exposure of the image. Ronis does not dwell on this issue; nonetheless, in photo 6—to take an example—he cites the use of 40 ASA film for a frame taken in 1931. This American standard (the equivalent of the current international ISO scale) was prevalent at the time of writing (1984). In 1931 the scale of reference was German, the DIN degrees. In his original texts, Ronis refers almost exclusively to this system. He mentioned it without naming it in his commentary for photo 169, by describing the film as Ferrania 32 (32 DIN = 1280 ASA/ISO).

The industrial progress of the 1950s contrasted with a very long period of stagnation where the sensitivity of emulsions was concerned. "I dream of emulsions a hundred times faster," he wrote.[20] At the time, Ronis promoted a chemical soaking technique to increase sensitivity; he later no longer made the case for it, since it had become obsolete, but it revealed his work in the laboratory, a part of his practice for which he felt little fondness but that was necessary for his work as a photographer.

FILTERS
See accessories

GLOBAL VISION
See candid photography

LENS HOOD
See accessories

20 Typescript article for *Photo Cinéma*, dated March 30, 1950.

LENSES

Ronis did not indicate his choice of lenses until after 1954, when he adopted the Foca camera with interchangeable lenses. Previously, his Rolleiflexes had fixed 75-mm lenses, a standard focal length for the 2 ¼ × 2 ¼-in. (6 × 6-cm) format.

For photo 202, he referred to five focal lengths without specifying them; these are 28-mm, 35-mm, 50-mm (the standard focal length), 90-mm, and 135-mm. The focal lengths are similar to the lens's angle of view: the smaller the number of the lens in millimeters, the wider the angle of view. Inversely, long focal lengths capture only a narrow angle of the scene but allow distant objects to be brought into view (as with telephoto lenses, for example).

In 1980, Ronis began using a Pentax camera with a fixed 50-mm and two zoom lenses (28–50 mm and 75–150 mm). The zooms are sliding lenses that allow the focal length to be continuously adjusted. Regarding photo 450, he wrote: "I mechanically adjusted my Pentax focus to two meters.... I zoomed out to 28 mm."

LIGHTING

As a photojournalist and photo-illustrator, Ronis needed to be able to master light in all situations. Floodlights are incandescent lamps with a continuous light, supercharged to increase their power (photo 206). As for flashes, there were many. In a 1968 article,[21] he listed them and revisited his initial training in igniting magnesium powder. After the liberation, the technique moved to closed, single-use magnesium flash bulbs (photo 111) and the first electric flashes (photo 54). While the latter were heavy, in the context of reportage photography they compensated for a bag full of spare flash bulbs. They found favor with Ronis thanks to their flexibility, variable intensity (achieved by changing distance and/or their electric charge; types PF14, 25, 56 or 110; WR1) and the different lighting effects they offered (by distancing the lamp using a cable or multiplying synchronized light sources).

A remarkable technician in this regard, Ronis published many interesting texts on the subject. In WR1, he laid out the advantages of mechanical and electromagnetic synchronized flashes, and of the electric flash that "absolutely dries out the contours of the fastest models, which impedes the impression of movement" (WR1, pp. 62–66). However, flashes are limiting; he later confessed to hating the whims of this equipment, thereby according greater value, by contrast, to his work in natural light, for which he is recognized. His hatred of artificial light should not be misinterpreted (photo 111); the album texts allow us to better appreciate his nuanced view on the subject. Ronis's conclusion still applies: "In short, use the synchro-flash in cases where it is essential; natural lighting as often as possible" (WR1, p. 66).

PHOTOMONTAGE
See darkroom techniques

POSTERIZATION
See darkroom techniques

PREVISUALIZED IMAGE
See candid photography

21 "La technique dans le reportage sur le vif."

SHUTTER SPEED

As was the case in his technical publications of 1951 and 1953 (WR1 and WR2), Ronis liked to be instructive; the same applies to his writings intended for the State, which reveal a host of shutter speed and aperture data. These two parameters are decisive in exposing film to light: the diameter of the diaphragm makes it possible to control the quantity of light entering the apparatus, while the shutter speed is the time, expressed in fractions of a second, during which the film is exposed. However, these technical data are specified mainly in the albums donated in 1985 (albums 1 to 4).

Controlling the exposure time is a fundamental element of Ronis's job. "Shutter speed? Aperture. Focus!"[22] Through careful choice of punctuation, Ronis defined the order of his priorities, which he nevertheless puts into perspective: "One of the great difficulties of hunting for images resides in the fact that the strict observance of the rules would have us believe in the *impossibility of taking a photograph correctly in the most interesting cases*. The will to disregard them is then a function of our appetite for risk and our taste."[23]

In the albums, the term "photographic language" appears three times, always in relation to motion blur, a result of slow shutter speeds (see photos 114, 281 and 457). The other means of arriving at the "Expressive Truth"[24] are: blur, through a reduced depth of field (open diaphragm, f/5.6; see photo 354); the complete opposite, extreme sharpness (closed diaphragm, f/22; see photo 125); and, finally, gradation during printing (enhanced contrast; see photo 118). Ronis recommends "three gradations: normal, vigorous, contrasted" (WR1, p. 12).

The aperture settings and shutter speeds given in the book are to be considered indications. Ronis did not keep a technical log at the time of shooting. Small variations may appear in different publications, but his remarks and the overall measurements are what count.

SPOTTING AND RETOUCHING

In photography, spotting indicates the process of correcting small white defects on the print resulting from dust on the negative or other imperfections. Ronis mentions it in some texts (photo 42); his first amateur negatives require particularly heavy, time-consuming spotting. This is done on the print, when it is finalized, using black ink applied with the tip of a fine brush.

Black spots, on the other hand, derive from the development of silver metal, are consequences of defects on the negative, or result from masking during shooting. "Black defects (spots, etc.) are scratched with a scalpel or with a mechanical razor blade" (WR1, p. 12). They were generally not retouched during this "pre-digital" period, or only during the preparation of reproductions.

Retouching, such in the case of the photocell mentioned in the text of photo 430, differs because it is more complex. It is about the modification of the image and requires both know-how and physical and chemical tools. The retoucher's job requires real skill, one mastered by Ronis and his father, a portrait photographer. A print of this nude in which the photocell has disappeared exists in the collection.

22 "Rêveries d'un chasseur d'images," *Photo Cinéma*, no. 598 (August 1951).

23 "Ne tirez pas sur le photographe."

24 "La seconde de vérité," two-part typescript, undated but published following a talk.

BIBLIOGRAPHY

The bibliographical information contained in the notes is based on Ronis's works published in French, principally his monographs. The only foreign-language titles that appear here are original editions; note, however, that WR25 (1997) is preferred to its first (Italian) edition, *Lungo il fiume delle domeniche* (Sundays along the River) (Milan: Motta Fotografia, 1994).

Two books that Ronis did not wish to see reproduced in his bibliographies (WR4 and WR5) are included here for the sake of completeness; one of them is in color and forms only a fringe entry in the references. They are collective publications in which the majority of illustrations are by Ronis; the other collective books referenced here are WR6, WR13, WR24, and WR28. As a matter of principle, we have selected only works in which Ronis's participation makes up more than 30 percent of the images. However, this principle is not respected for WR6, because this pivotal book is beginning to return to the fore, and because it was a commission from the Ministry of Culture, the MAP's supervisory authority.

Although the decision is debatable, three books produced in close collaboration with the MAP after the photographer's death are also taken into account (WR47–49).

Photographic portfolios or reproductions of portfolios, published mainly by galleries, are outside the scope of this study. On the other hand, Ronis's bound albums are kept in the Department of Prints and Photography in the Bibliothèque Nationale and are obviously closely linked to the six albums published here. These two sets belong to the public collections of the State. One entered the Bibliothèque Nationale by legal submission in 1968 (one hundred exhibition prints bound in three albums, supplemented by fifteen smaller vintage prints), and the other was donated to the Ministry of Culture, and successively to the department of photographic heritage, the AFDPP (Association Française pour la Diffusion du Patrimoine Photographique), and the MAP.

In total, fifty books have been taken into consideration, sixty-five if one includes revised editions. Reprints are excluded, although there is a fine line between revised edition and reprint in some cases (WR3d, WR22, WR33).

Overall, we have tried to take an exhaustive approach to Ronis's publishing activity, with all the possible referencing errors inherent in this exercise. The scope of the exercise could in the future be extended to Ronis's solo and group exhibitions—a colossal (but relevant) job that would be more complicated to carry out and that would require a complete overview of his exhibition career.

WR1
Ronis, Willy. *Photo-reportage et chasse aux images*. Paris: Paul Montel, 1951.

WR2
Ronis, Willy. *Belles photos à la mer*. Paris: Paul Montel, 1953.

WR3a
Ronis, Willy, and Pierre Mac Orlan. *Belleville Ménilmontant*. Paris : Arthaud, 1954.

WR3b
Ronis, Willy, and Pierre Mac Orlan. *Belleville Ménilmontant*. Paris: Arthaud, 1984.

WR3c
Ronis, Willy, and Pierre Mac Orlan. *Belleville Ménilmontant*. Paris: Arthaud, 1989.

WR3d
Ronis, Willy, and Didier Daeninckx. *Belleville Ménilmontant*. Paris: Hoëbeke, 1999.

WR4
Prasteau, Jean, Willy Ronis, Roger Henrard, et al. *Îles de Paris*. Paris: Arthaud, 1957.

WR5
Brion, Marcel, Willy Ronis, and Roger Henrard. *Paris*. Paris: Arthaud, 1962.

BN1
Willy Ronis. Paris: Bibliothèque Nationale, 1968: EP-35 (1)-FOL, album volume 1, Paris.

BN2
Willy Ronis. Paris: Bibliothèque Nationale, 1968: EP-35 (2)-FOL, album volume 2 ("France–Province, Étranger").

BN3
Willy Ronis. Paris: Bibliothèque Nationale, 1968: EP-35 (3)-FOL, album volume 3 ("Moeurs, Portraits, Nus").

WR6
Gautrand, Jean-Claude, ed. *10 Photographes pour le patrimoine* (exh. cat.). [Paris]: Ministère de la Culture et de la Communication [1980].

WR7a
Ronis, Willy. *Photographies, Sur le fil du hasard*. Paris: Contrejour, 1980.

WR7b
Ronis, Willy. *Sur le fil du hasard*. Paris: Contrejour, 1986.

WR7c
Ronis, Willy. *Sur le fil du hasard*. Paris: Contrejour, 1991.

WR8
Éveno, Bertrand. *Willy Ronis*. Paris: Pierre Belfond, 1983.

WR9
Ronis, Willy, Romeo Martinez, and Bryn Campbell. *Willy Ronis*. I grandi fotografi. Milan: Fabbri, 1983.

WR10a
Ronis, Willy, and Henri Raczymow. *Mon Paris*. Paris: Denoël, 1985.

WR10b
Ronis, Willy, and Henri Raczymow. *Mon Paris*. Paris: Denoël, 1991.

WR11
Ronis, Willy, and Pierre Barbin. *Willy Ronis par Willy Ronis* (exh. cat.). Paris: Association Française pour la Diffusion du Patrimoine Photographique, 1985.

WR12
Ronis, Willy, Pierre Borhan, and Jean-Claude Gautrand. *Photographies*. Paris: Éditions du Désastre, 1989.

WR13
Ronis, Willy, Le Bar Floréal, and Dominique Gaessler. *La Traversée de Belleville* (exh. cat.). Paris: Le Bar Floréal, 1990.

WR14a
Ronis, Willy, and Bertrand Éveno. *Willy Ronis Photo Poche no. 46*. [Paris]: Centre National de la Photographie, 1991.

WR14b
Ronis, Willy, and Bertrand Éveno. *Willy Ronis Photo Poche n° 46*. [Paris]: Nathan, 2000.

WR14c
Ronis, Willy, and Bertrand Éveno. *Willy Ronis*. Photo Poche n° 46. [Arles]: Actes Sud, 2005.

WR15
Ronis, Willy, and Hiromi Nakamura. *Willy Ronis 1934–1987*. Tokyo: Treville, 1991.

WR16
Ronis, Willy, and Régine Deforges. *Toutes belles*. Paris: Hoëbeke, 1992.

WR17a
Ronis, Willy, and Jean Chatelut. *Portrait de Saint-Benoît-du-Sault*. [Paris]: Calmann-Lévy & P.O., 1992.

WR17b
Ronis, Willy, Didier Daeninckx, and Jean Chatelut. *Un Village en France*. [Saint-Benoît-du-Sault]: Les Cahiers de la photographie de Saint-Benoît-du-Sault, 1998.

WR18
Ronis, Willy. *Quand je serai grand...* [Paris]: Presses de la Cité, 1993.

WR19
Ronis, Willy, Gérard Macé, and Sylvie Bonnet. *Le Retour des prisonniers* (exh. cat.). Caen: Conseil Régional de Basse-Normandie, [1995].

WR20
Ronis, Willy, Peter Hamilton, and David Helliott. *Willy Ronis, Photographs 1926–1995* (exh. cat.). Oxford: The Museum of Modern Art, Oxford, 1995.

WR21
Ronis, Willy, and Dominique Grandmont. *70 ans de déclics* (exh. cat.). Paris: Paris-Musées, 1996.

WR22
Ronis, Willy, Didier Daeninckx, and Françoise Wasserman. *À nous la vie! 1936–1958*. Paris: Hoëbeke, 1996.

WR23
Ronis, Willy. *Autoportrait*. [Saint-Clément-de-Rivière]: Fata Morgana, 1996.

WR24
Picouly, Daniel, Willy Ronis, Robert Doisneau, et al. *Vivement Noël!* Paris: Hoëbeke, 1996.

WR25
Ronis, Willy, and Noël Simsolo. *Les Sorties du Dimanche*. Paris: Nathan, 1997.

WR26a
Ronis, Willy, and Edmonde Charles-Roux. *Provence*. Paris: Hoëbeke, 1998.

WR26b
Ronis, Willy, and Edmonde Charles-Roux. *Provence*. Paris: Hoëbeke, 2008.

WR27
Ronis, Willy, Bertrand Éveno, and Pierre-Jean Amar. *Marie-Anne, Vincent et moi* (exh. cat.). Trézélan: Filigranes—La Photographie à Aix-en-Provence, 1999.

WR28
Ronis, Willy, Régis Debray, Christine Charbonnier, et al.. *Mémoire textile* (exh. cat.). Strasbourg: La Nuée Bleue, 2000.

WR29
Ronis, Willy, and Yoshimoto Kajikawa. *Willy Ronis* (exh. cat.). Kyoto: Kahitsukan—Kyoto Museum of Contemporary Art, 2000.

WR30
Ronis, Willy, Claude Moisy, and Bertrand Poirot-Delpech. *Willy Ronis pour la liberté de la presse*. Paris: Reporters sans Frontières, 2001.

WR31a
Ronis, Willy. *Derrière l'objectif de Willy Ronis, Photos et propos*. Paris: Hoëbeke, 2001.

WR31b
Ronis, Willy. *Derrière l'objectif de Willy Ronis, Photos et propos*. Paris: Hoëbeke, 2010.

WR32
Ronis, Willy, and Paul Ryan. *Willy Ronis*. 55 series. Paris: Phaidon, 2002.

WR33a
Ronis, Willy, and Christian Sorg. *Le Val et les bords de Marne*. Paris: Terre Bleue, 2004.

WR33b
Ronis, Willy, and Christian Sorg. *Le Val et les bords de Marne*. Paris: Terre Bleue [2010].

WR34
Ronis, Willy, Sylvia Böhmer, Matthias Harder, et al. *Willy Ronis, La Vie en passant*. Munich: Prestel, 2004. Also published in a bilingual edition (English and German) as *Willy Ronis: C'est La Vie*. Munich: Prestel, 2004.

WR35a
Ronis, Willy, and Daniel Karlin. *Paris, éternellement*. Paris: Hoëbeke, 2005.

WR35b
Ronis, Willy, and Daniel Karlin. *Paris, éternellement*. Paris: Hoëbeke, 2014.

WR36
Ronis, Willy, and Jean-Claude Gautrand. *Willy Ronis, Instants dérobés*. Cologne: Taschen, 2005.

WR37a
Ronis, Willy. *Ce jour-là*. [Paris]: Mercure de France, 2006

WR37b
Ronis, Willy. *Ce jour-là*. [Paris]: Mercure de France, 2016.

WR38
Ronis, Willy, and Christian Sorg. *La Montagne de Willy Ronis*. Paris: Terre Bleue, 2006.

WR39
Ronis, Willy, and Marcel Boujut. *Paris-couleurs*. Cognac: Le Temps qu'il fait, 2006.

WR40
Ronis, Willy, Marta Gili, and Virginie Chardin. *Willy Ronis* (exh. cat.). Barcelona: Fundación La Caixa, 2006.

WR41
Ronis, Willy, Choi Mi-Li, Kathleen Grosset, et al. *La Vie, Grande inconnue* (exh. cat.). Seoul: Gallery Lumière, 2007.

WR42a
Ronis, Willy, and Colette Fellous. *Les Chats de Willy Ronis*. Paris: Flammarion, 2007.

WR42b
Ronis, Willy, and Colette Fellous. *Les Chats de Willy Ronis*. Paris: Flammarion, 2016.

WR43
Onfray, Michel. *Fixer des vertiges, Les Photographies de Willy Ronis*. Paris: Galilée, 2007.

WR44
Ronis, Willy, Bao Kun, Wang Baoguo, et al. *Willy Ronis à Paris* (exh. cat.). Beijing: China Photographic Publishing House, 2007.

WR45
Ronis, Willy, and Philippe Sollers. *Nues*. Paris: Terre Bleue, 2008.

WR46
Ronis, Willy, Federico García Lorca, Pedro Salinas, et al. *Amor*. [Spain]: Debolsillo, 2008.

WR47
Ronis, Willy, Marta Gili, and Nathalie Neumann. *Willy Ronis, Une poétique de l'engagement* (exh. cat.). Paris: Democratic Books/Jeu de Paume, 2010.

WR48
Denoyelle, Françoise. *Le Siècle de Willy Ronis*. Paris: Terre Bleue, 2012.

WR49
Müller, Markus, Jean-Claude Gautrand, and Alexander Gaude. *Willy Ronis* (exh. cat.). Berlin: Kehrer, 2013.

BIOGRAPHICAL NOTES

Note:
Biographical context for Ronis's work is essential, since his photographs are a reflection of his commissions and illustrative endeavors, but also of his personal life.

Under each year, brief biographical details of Ronis's life and career are given, followed by the photographs taken that year, and references to the publication(s) in which each photograph appeared. The 590 photographs are here arranged in chronological order rather than the order in which they appear in the albums, since each album has its own chronology. In order to find the bibliographic references relating to an image, the reader should look up first the year and then the number of the work in question. Note that Ronis's photographs of Belleville and Ménilmontant, which for the most part lack precise dates, have been grouped together. The book used to determine the work's title is underlined.

Willy Ronis was born on August 14, 1910, in Paris, into a family of immigrants, of Russian origin on his father's side and Lithuanian on his mother's. The family was called Roness owing to an incorrect transcription of their name upon their arrival in France. Ronis's quotes that introduce the major dates from 1926 to 1948 are taken from a 1951 biography that he wrote for a Japanese directory.[1] The later years are treated in the same spirit, introduced by quotes from the period.

1926

YOUTHFUL ENTHUSIASM

Authors looking to describe Ronis's work recognize a particular sensitivity in his photographs, rooted in his education and artistic interests. Indeed, in these albums Ronis regularly mentions the arts. He wrote in 1951: "Drawing, music, that was my entire childhood as the son of a retoucher [of photographs] and a musician.... On Thursdays, I loved to go to the Louvre to wander through the sculpture gallery, and on Sunday afternoons I stood in line for the gallery of the Colonne Orchestra concerts.... I wanted to be a composer."[2] His photographic beginnings were those of an amateur recording his vacations and his city, stage-directing himself and his vocation.

1
WR7, p. 2; WR21, p. 13; WR29, ill. 1; WR48, p. 19

2
WR9, p. 5; WR11, ill. 1; WR36, p. 20; WR38, p. 77

1927

471
WR10, ill. 2; WR20, ill. 34

1928

3
WR7a-b, p. 6; WR7c, p. 4; WR11, ill. 2; WR20, ill. 35; WR21, p. 16; WR29, ill. 2; WR31, p. 136; WR32, p. 17; WR34, p. 17; WR36, p. 21

1929

4
WR7, p. 5; WR11, ill. 118a; WR23, p. 15; WR29, p. 92; WR48, pp. 8–9 and 11

351
WR20, ill. 6; WR23, p. 13; WR48, p. 400

1930

5
WR35, p. 35; WR48, p. 38

1931

6
WR44, p. 32; WR47, p. 68

1932

THE STORE: DUTY AND ESCAPE

"1932. The economic crisis. My father's severe illness. Little by little, I had to replace him in his photography store. To me were entrusted passport photos, amateur snaps, wedding photos, and little children lying face-down on a goat skin. This work bored me to tears. But I started to become interested in photography. Inspired, I went to see exhibitions and kept a respectful distance from my elders: Kertész, Brassaï, Germaine Krull, Man Ray were a revelation. With my meager savings I bought a used 2¼ × 3¼-in. (6 × 9-cm) Ikonta and went outside to shoot.... Every year, in February, the quietest month, I went for a winter sports detox, where I split my time between skiing as a form of escape and the delights of snow photography."[3] A cloistered young man, Ronis thus managed to break away and to expose himself to other forms of photography. He reveals his first themes and his first spontaneous photo stories. Through them, we glimpse a snapshot of his political commitments, his forays into the outside world, his love of the moment, and his stylistic aspirations.

1934

7
WR7a–b, p. 6; WR7c, p. 5; WR10, ill. 93; WR14, ill. 2; WR15, cover and ill. 56; WR20, ill. 7; WR21, p. 20; WR29, ill. 4; WR36, p. 19; WR37a, p. 158; WR37b, p. 168; WR41, p. 129; WR44, p. 64; WR46, p. 61; WR47, p. 13; WR49, p. 79

8
WR7, p. 118; WR10, ill. 46; WR11, ill. 3; WR14, ill. 3; WR29, ill. 3; WR35, p. 36; WR44, p. 30

352
WR22, ill. 58; WR30, p. 89; WR35, p. 27; WR43, ill. 1

1935

10
WR11, ill. 20; WR12, ill. 19; WR16, p. 83; WR20, ill. 38; WR21, p. 15; WR31, p. 109; WR32, p. 19; WR36, p. 31; WR38, p. 10; WR41, p. 83; WR46, p. 189; WR48, pp. 42-43

9
WR1, ill. 38; WR7, p. 100; WR40, p. 50; WR46, p. 69; WR48, pp. 36–37

11
WR11, ill. 9; WR20, ill. 41; WR21, p. 18; WR35, p. 11

472
WR35, p. 19

1. Typescript biography dated 1951, inserted into *Photography of the World* (Tokyo: Heibonsha, 1956). A selection of French and Italian photographers, this directory was designed as a "bridge between Eastern and Western cultures, [promoting] international understanding through photography."
2. Ibid.
3. Ibid.

1936

PRECARIOUS FREEDOM AND EARLY SUCCESS

"1936. My father died after a long and cruel illness. The crisis had ruined us. To make matters worse, I was not business-minded. I avoided the store.... After a few awful months, I sold two large groups of photos of winter sports to the railroad and tourist offices. And so, until 1939, I earned my living with industrial and advertising photos, but especially with snow photographs, which I would build on each winter in my beloved mountains.... Few photo stories; I was too shy."[4] It was freedom, even though it was precarious, and Ronis dated his true beginnings to that year. Even if that is not strictly true, in a later letter to his former partner Naf, he wrote: "Careful: my real name is RONIS. Roness died in 1936."[5] His selection highlights his illustrative work and his spontaneous series. Ronis began using a new, professional camera, and spoke about his experiences and his friendships, which were also sometimes professional.

12
WR7, p. 115; WR11, ill. 5;
WR15, ill. 46; WR20, ill. 44;
WR22, cover and ill. 46;
WR30, pp. 80–81; WR31, p. 153;
WR32, p. 21; WR34, p. 12;
WR35, p. 29; WR36, p. 27;
WR41, p. 116; WR43, ill. 7;
WR44, p. 23; WR47, p. 15;
WR48, p. 53; WR49, pp. 120–21

353
WR36, p. 30; WR41, p. 154

1937

13
WR7a–b, p. 7; WR7c, p. 6;
WR20, ill. 39; WR21, p. 14;
WR29, ill. 5; WR36, p. 32; WR38, p. 21

355
WR35, p. 39; WR48, p. 81

473
WR35, p. 14; WR48, p. 77

14
WR7, p. 119; WR22, ill. 71;
WR30, p. 90

354
WR9, p. 6; WR22, ill. 67 and back cover; WR48, p. 64

1938

15
WR7, p. 93; WR15, ill. 34; WR29, ill. 7;
WR36, p. 33; WR38, cover and p. 47;
WR41, p. 152; WR48, p. 61

17
WR7, p. 113; WR9, p. 27;
WR10, ill. 103; WR11, ill. 112;
WR14, ill. 1; WR15, ill. 47;
WR20, ill. 11; WR22, ill. 24;
WR29, ill. 6; WR30, cover and
p. 75; WR31, p. 150; WR32, p. 23;
WR34, p. 18; WR35, p. 30;
WR36, p. 24; WR40, pp. 4–5 and
95; WR41, p. 80; WR43, ill. 8;
WR44, p. 24; WR47, p. 65;
WR48, pp. 44–45 and 47;
WR49, p. 12

18
WR20, ill. 42; WR22, ill. 34;
WR29, ill. 8; WR34, p. 9; WR35, p. 31;
WR41, p. 81; WR47, p. 69;
WR48, p. 50; WR49, p. 119

16
WR10, ill. 100; WR22, ill. 14;
WR35, p. 15; WR36, p. 22;
WR48, p. 76

356
WR29, ill. 9; WR35, p. 38;
WR48, p. 40

19
WR8, ill. 2; WR9, p. 13; WR10, ill. 33;
WR11, ill. 4; WR29, ill. 10;
WR34, p. 27; WR35, p. 20;
WR41, p. 82; WR47, p. 14

20
WR21, p. 19; WR33, p. 18

357
WR14, ill. 14; WR34, p. 2; WR47, p. 91

474
WR36, p. 147

21
WR7a–b, p. 10; WR7c, p. 9

358
WR36, p. 146

4. Ibid.
5. Letter from Willy Ronis to Naf, January 5, 1975.

1939

22
WR7a–b, p. 8; WR7c, p. 6;
WR11, ill. 143; WR20, ill. 12;
WR36, p. 168; WR40, p. 24;
WR47, p. 177; WR48, p. 57

360
WR1, ill. 7; WR21, p. 21; WR31, p. 76;
WR32, p. 25; WR35, p. 37;
WR36, p. 23; WR37a, pp. 30–31;
WR37b, pp. 32–33; WR44, p. 76;
WR49, p. 28

23
WR11, ill. 6

359
WR36, p. 29

1941

WARTIME

"The war.... I left the occupied zone and crossed the demarcation line at night, pursued by the gunfire of a German patrol. To escape more quickly through the fields, I abandoned my bike and backpack that contained my cameras. No more photography for a long time. I became a stage manager for a traveling theater troupe, assistant decorator in a film studio, and then I painted on jewelry."[6] Because of his Jewish origins and the anti-Semitic measures imposed by the occupying authorities, Ronis fled to the Free Zone. These years were also ones of solidarity and significant encounters, notably that with his future wife. He does not mention it and does not yet reveal her, but he made costume jewelry with the painter Marie-Anne Lansiaux (married name Kaldor), mother, by her first husband, of a young child, Vincent. Their career choices were closely linked throughout their entire life: "The woman I married a few years ago is a painter. Happily, we agree: she on my conception of photography, I on her way of painting."[7]

24
WR1, ill. 25a; WR11, ill. 135;
WR36, p. 171; WR47, p. 174;
WR48, pp. 84–85 and 87

1942

361

1945

MEDIA SUCCESS

"Back to Paris at the liberation. I had a profound craving to take photographs. I had lost my shyness. I received a major commission on the return of the prisoners. I also did fashion photos for fashion houses. But I was increasingly passionate about reportage photography. I was freelance. The period 1945–48 was full of great professional successes: I sometimes did up to four photo stories in one week."[8] While he saw these years as ones of reportage assignments, Ronis also actively pursued his photo archives. At thirty-five years of age, he was a photojournalist and, through his many projects, mastered his craft and consolidated his approach.

363
WR1, ill. 88; WR36, p. 170

26
WR11, ill. 136; WR48, p. 126

475
WR19, p. 28

27
WR7, p. 49; WR8, ill. 3; WR11, ill. 7;
WR15, ill. 33; WR19, p. 45 and cover; WR20, ill. 14; WR21, p. 24;
WR29, ill. 11; WR32, p. 27;
WR35, p. 46; WR36, p. 37;
WR37a, p. 49; WR37b, p. 55;
WR40, p. 47; WR41, p. 42;
WR47, p. 21; WR48, pp. 106–07 and 109; WR49, p. 144

28
WR7, p. 10; WR10, ill. 105;
WR11, ill. 8; WR21, p. 25;
WR29, ill. 12; WR31, p. 137;
WR32, p. 29; WR36, p. 35;
WR48, p. 113; WR49, p. 82

29
WR1, ill. 30; WR7, p. 66; WR16, p. 69;
WR20, ill. 46; WR21, p. 27;
WR32, p. 31; WR34, p. 35;
WR37a, p. 115; WR37b, p. 125;
WR41, p. 71; WR44, p. 57;
WR48, p. 138

33
WR1, ill. 18; WR7, p. 65; WR37a, p. 91;
WR37b, p. 99; WR40, p. 51;
WR46, p. 35; WR47, p. 18

34
WR9, p. 35

362

476
WR35, p. 69

25
WR7, p. 57; WR15, ill. 49; WR20, ill. 50

477
BN3; WR48, p. 117

32
WR1, ill. 107; WR7c, p. 25;
WR9, p. 10; WR26a, p. 106;
WR26b, p. 104; WR31, p. 100;
WR40, p. 25; WR41, p. 140;
WR49, pp. 40–41

30
WR1, ill. 68; BN3; WR7, p. 77;
WR11, ill. 121; WR14, ill. 7;
WR15, ill. 18; WR20, ill. 4;
WR29, ill. 13; WR34, p. 33;
WR36, p. 117; WR37a, p. 140;
WR37b, p. 150; WR40, p. 53;
WR41, p. 121; WR47, p. 19;
WR48, p. 142

31
WR48, pp. 123 and 125

364
WR1, ill. 8; WR7c, p. 163;
WR12, ill. 13; WR18, ill. 52;
WR27, p. 10; WR29, ill. 14;
WR41, p. 74; WR49, p. 65

6. Typescript biography (n. 1).
7. Ibid.
8. Ibid.

1946

478
WR20, ill. 61; WR31, p. 102;
WR36, p. 134; WR48, p. 140

365
WR36, p. 105

41
WR1, ill. 24b; WR11, ill. 139

366
WR22, ill. 9; WR36, p. 135

368
WR10, ill. 25

36
WR1, ill. 23; WR10, ill. 6;
WR22, ill. 70; WR25, ill. 30;
WR35, p. 107

367

40
WR1, ill. 73; WR7, p. 138; WR9, p. 56;
WR10, ill. 58; WR11, ill. 87;
WR15, ill. 17; WR16, p. 76;
WR21, p. 26; WR29, ill. 18;
WR32, p. 35; WR34, p. 29;
WR35, p. 55; WR36, cover and p. 38;
WR37a, p. 101; WR37b, p. 111;
WR41, p. 111; WR44, p. 54;
WR48, p. 134; WR49, p. 107

42
WR1, ill. 43; WR8, ill. 8; WR9, p. 33;
WR10, ill. 52; WR11, ill. 75;
WR29, ill. 15; WR36, p. 63;
WR43, ill. 13; WR44, p. 78;
WR47, p. 36; WR49, p. 110

38
BN3

39

43
WR11, ill. 84; WR20, ill. 47;
WR26a, p. 102; WR26b, p. 100;
WR29, ill. 19; WR31, p. 38;
WR34, p. 32

44
WR1, ill. 59; BN2; WR46, pp. 79 and 160

35
BN3; WR7, p. 70; WR15, ill. 7;
WR18, ill. 47; WR20, ill. 15;
WR27, p. 11; WR32, p. 33;
WR36, p. 76; WR40, p. 133;
WR41, p. 75; WR44, p. 49;
WR47, p. 163

37
BN3; WR7a–b, p. 24; WR7c, p. 22;
WR15, ill. 2; WR18, ill. 2; WR21, p. 30;
WR29, ill. 17; WR31, p. 74;
WR40, p. 36; WR41, p. 85;
WR44, p. 48; WR49, p. 64

1947

48
WR21, p. 23; WR27, p. 14;
WR31, p. 136; WR36, p. 74

369
WR1, ill. 24c

50
WR7, p. 74

49
WR1, ill. 4; WR30, p. 68;
WR36, p. 122; WR40, p. 60;
WR47, p. 20

54
WR7, cover and p. 79; WR7b–c, p. 79;
WR11, ill. 124; WR15, ill. 15;
WR40, p. 57; WR44, p. 69;
WR46, p. 129; WR47, p. 22

479
WR1, ill. 86; WR7, p. 44; WR30, p. 87

55
WR1, ill. 40; BN2; WR7, p. 78;
WR9, p. 15; WR11, ill. 127;
WR15, ill. 20; WR20, ill. 59;
WR25, ill. 5; WR31, pp. 106 and 107; WR33, p. 75; WR34, p. 28;
WR36, p. 88; WR37a, p. 6;
WR37b, p. 8; WR41, p. 73;
WR44, pp. 18 and 72; WR48, p. 133

372
WR22, ill. 69; WR25, ill. 47;
WR31, p. 124; WR33, p. 26;
WR43, ill. 2

56
WR4, ill. 30; WR7, p. 52; WR15, ill. 19;
WR22, ill. 61; WR25, ill. 3;
WR31, p. 102; WR33, p. 73;
WR36, p. 89; WR40, p. 141;
WR43, ill. 10

371
WR33, p. 78

373
WR1, ill. 74

57
WR1, ill. 89; WR16, p. 68

58
BN3; WR10, ill. 71; WR20, ill. 45;
WR21, p. 28; WR29, ill. 30;
WR44, p. 56; WR49, p. 86

59
WR22, ill. 39; WR30, pp. 76–77;
WR36, p. 129; WR44, p. 26;
WR48, pp. 156–57

60
WR7, p. 110; WR9, p. 42;
WR22, ill. 33; WR36, p. 128;
WR40, p. 93; WR44, p. 29;
WR47, p. 66

45
WR1, ill. 5; BN3; WR7, p. 101;
WR9, p. 49; WR10a, ill. 67;
WR10b, cover and ill. 67;
WR11, ill. 81; WR14, ill. 5;
WR15, ill. 35; WR20, ill. 49;
WR29, ill. 16; WR31, p. 55;
WR32, p. 37; WR34, p. 34;
WR36, p. 62; WR37a, p. 14;
WR37b, p. 16; WR40, p. 55;
WR41, p. 54; WR44, p. 52;
WR46, p. 133; WR47, p. 32;
WR48, p. 351; WR49, p. 84

46
WR10, ill. 31

47
WR1, ill. 69; WR10, ill. 128;
WR35, p. 115; WR37a, p. 96;
WR37b, p. 106; WR41, p. 134;
WR49, p. 67

370
WR18, ill. 56; WR26a, p. 31; WR26b, p. 29; WR38, p. 157; WR49, p. 42

51
WR1, ill. 44; WR7, p. 132;
WR20, ill. 48; WR26a, p. 5;
WR26b, p. 3; WR31, p. 101;
WR32, p. 41; WR36, p. 167;
WR40, p. 139; WR41, p. 39;
WR43, ill. 4; WR48, p. 244

52
WR7c, p. 172; WR9, p. 12;
WR11, ill. 128; WR25, ill. 17;
WR26a, cover and pp. 48–49;
WR26b, p. 24; WR29, ill. 22;
WR32, p. 39; WR34, pp. 38–39;
WR36, p. 109; WR40, p. 56;
WR41, pp. 32–33; WR43, ill. 11;
WR47, p. 16; WR49, pp. 50–51

53
WR2, ill. 24; WR7, p. 120;
WR11, ill. 106; WR14, ill. 6;
WR18, ill. 67; WR26a, p. 103; WR26b, p. 101; WR29, ill. 20; WR31, pp. 48 and 49; WR34, p. 37; WR36, p. 115;
WR40, p. 65; WR41, p. 40;
WR47, p. 29; WR48, p. 334

1947-50

BELLEVILLE MÉNILMONTANT

The book *Belleville Ménilmontant*, unique in Ronis's bibliography, was the result of a genuine professional urge and, thereafter, the source of bitter disappointment. Pierre Mac Orlan accepted Ronis's proposal that he should write the text as early as 1948, but the project stagnated, and publishers' rejections discouraged the photographer. In 1953, the publisher Arthaud launched a new collection, "Les Imaginaires,"[9] and agreed to publish the project. The results were successful, and the publisher was delighted: "The reproduction is very good in my opinion and the atmosphere that you managed to create, without any false poetry or false realism, is all the more exciting, because many books have been published in this genre, none of which had in them this true sensitivity, not only of the mind but of the heart."[10] The neighborhoods of Belleville and Ménilmontant became landmarks in Ronis's career, and the book was reprinted three times (in 1984, 1989, and 1999). Ronis marked this success—not just a critical, but also a personal, achievement—by selecting twenty-one 2 ¼ × 2 ¼-in. (6 × 6-cm) frames (a total of thirty, if one includes the 24 × 36-mm images) to include in the albums, making it the largest homogeneous group of images. Some photographs never appeared in any of the book's four editions.

74
WR12, cover and ill. 1; WR15, ill. 29; WR16, p. 60; WR41, p. 107; WR46, p.179; WR49, p. 132

61
WR3a, p. 1; WR3b–c, ill. 1; WR3d1 and 3, p. 13; WR3d2, p. 12

62
WR3a, p. 3; WR3b–c, ill. 3; WR3d, p. 32; WR11, ill. 97; WR13, p. 7 and 43; WR20, ill. 65; WR29, ill. 29; WR35, p. 124; WR36, p. 48; WR41, p. 53; WR46, p. 107; WR47, p. 27

63
WR3a, p. 5; WR3b–c, ill. 4; WR3d, p. 82; WR11, ill. 88; WR46, p. 89

64
WR3a, p. 9; WR3b–c: ill. 25; WR3d, p. 41; WR8, ill. 11; WR10, ill. 152; WR13, p. 8 and 55; WR14, ill. 13; WR29, ill. 21; WR31, p. 50; WR34, p. 15; WR40, p. 63; WR44, p. 74; WR49, p. 130

65
WR3a, p. 20; WR3b–c, ill. 38; WR3d, p. 66; WR49, p. 102

66
WR3a, p. 25; WR3b–c, ill. 9; WR3d, p. 29; WR25, ill. 2

67
WR3a, p. 33; WR3b, ill. 31; WR3c, ill. 33; WR3d, p. 73

68
WR1, ill. 63; WR3a, p. 38–39; WR3b–c, ill. 37; WR3d, p. 59; WR7, p. 87; WR11, ill. 83; WR13, pp. 6 and 20; WR14, ill. 20; WR15, ill. 51; WR29, ill. 24; WR31, p. 140; WR34, p. 21; WR36, p. 41; WR41, p. 131; WR44, p. 35

377
WR10, ill. 150

69
WR3a, p. 42–43; WR3b–c, ill. 35; WR13, p. 15

70
WR3a, p. 44; WR3b–c, ill. 8; WR3d, p. 45; WR35, p. 120

71
WR3a, p. 50; WR3b–c, ill. 45; WR3d, p. 91; WR13, p. 45; WR41, p. 133

72
WR3a, p. 53; WR3b–c, ill. 49; WR3d, p. 84

73
WR3a, p. 68–69; WR3b–c, ill. 66; WR30, p. 23

74
WR3a, p. 75; WR3b–c, ill. 58; WR3d, p. 68

75
WR3a, p. 79; WR3b–c, ill. 75; WR3d, p. 71; WR11, ill. 117; WR30, p. 46; WR32, p. 43

76
WR3a, p. 82; WR3b–c, ill. 22; WR3d, p. 63; WR10, ill. 50; WR13, p. 27; WR29, ill. 26; WR30, p. 35; WR36, p. 52; WR40, p. 17; WR44, p. 33; WR49, p. 128

77
WR3a, p. 83; WR3b–c, ill. 79; WR3d, p. 47; WR11, ill. 13; WR12, ill. 16; WR14, ill. 10; WR15, ill. 41; WR29, ill. 27; WR36, p. 51; WR41, p. 52; WR47, p. 26

78
WR3b–c, ill. 21; WR3d, p. 56; WR7, p. 109; WR11, ill. 35; WR14, ill. 4; WR47, p. 41

79
WR3b–c, ill. 77; WR3d, p. 51; WR7, p. 59; WR8, ill. 1; WR11, ill. 108; WR14, ill. 17; WR15, ill. 42; WR20, ill. 19; WR21, p. 53; WR29, ill. 36; WR31, p. 142; WR34, p. 43; WR35, p. 121; WR36, p. 49; WR41, p. 132; WR42a, p. 63; WR42b, p. 58; WR44, pp. 19 and 75; WR47, p. 38; WR48, p. 353; WR49, p. 137

9. François Cali, *France aux visages* (Paris: Arthaud, 1953), and François Cali, *Dictionnaire pittoresque de la France* (Paris: Arthaud, 1955), were multi-contributor photography books in which Ronis's work was in a minority.
10. Letter from Claude Arthaud to Willy Ronis, August 12, 1954.

1948

PROFESSIONAL RECOGNITION AND DIVERSIFICATION

"Publishing crisis in late 1948. Many publications disappeared.... I split my activity between magazine projects, advertising photography, and industrial photo stories. In 1949, I was invited to join the Groupe des XV. I always refused to become a 'staff reporter.' Independence, which I hold so dear, allows me to refuse subjects that displease me, freedom of expression being one of the fundamental pillars of professional honesty in my eyes. I also wrote articles on different aspects of my job and had just published a book for advanced amateurs, *Photo-reportage et chasse aux images*."[11] In 1951, Ronis summed up, quite simply, his professional activity during this period. He did not mention the Rapho agency; his independence came first. He published texts, many more than he would later highlight. These were his richest years. In retrospect, he justified them: "No need to go on and on. Of course, I have good things later on, even after 1970. But the choice lies in [this] very limited production. I have thought a lot, for a long time, about the decisive moment and the most significant image.... The foolish joy that accompanies the recording of the crucial moment, in a composition balanced both on the surface *and* in depth ... is strictly attached to the work of journalistic reporting, to a small number of pictures, and where dramatic distillation in a coherent form is the photojournalist's constant quest."[12]

80
WR1, ill. 11; WR9, p. 55; WR10, ill. 140

378

480
WR1, ill. 15

82

83

84
BN3; WR7, p. 55; WR11, ill. 116; WR14, ill. 16; WR15, ill. 52; WR29, ill. 23; WR30, p. 71; WR36, p. 143; WR40, p. 105; WR48, p. 298

86

87
WR7, p. 104; WR22, ill. 30; WR40, p. 104

88
WR11, ill. 110; WR31, p. 103

379
WR36, p. 50. Similar photograph: WR10, ill. 51; WR14, ill. 19; WR49, p. 87

375
WR10, ill. 170; WR23, p. 23

81
WR8, ill. 4; WR9, p. 48; WR10, ill. 62; WR11, ill. 80; WR14, ill. 15; WR15, ill. 36; WR20, ill. 56; WR29, cover and ill. 25; WR30, p. 64; WR31, p. 26 and 27; WR32, p. 45; WR34, p. 36; WR35a, p. 49; WR35b, cover and p. 49; WR36, p. 53; WR40, p. 58; WR41, p. 55; WR44, pp. 15 and 53; WR46, p. 93; WR47, p. 34; WR48, p. 263; WR49, p. 85

376
WR1, ill. 96; WR20, ill. 16; WR30, p. 31; WR31, pp. 16 and 17; WR32, p. 47; WR40, p. 107; WR44, p. 45; WR47, p. 31

85
WR18, ill. 48; WR26a, p. 61; WR26b, p. 59; WR27, p. 15; WR40, p. 134; WR48, p. 171; WR49, p. 47

1949

481
WR22, ill. 62; WR30, p. 24

383
WR20, ill. 60; WR31, p. 129; WR34, p. 49; WR35, p. 93; WR41, p. 120; WR47, p. 23

91
WR7, p. 82

384
WR37a, p. 110; WR37b, p. 120

92
WR1, ill. 1; WR25, cover and ill. 28; WR31, p. 103; WR34, p. 31; WR41, p. 45; WR46, p. 247

93
BN3; WR11, ill. 138; WR20, ill. 18

98
BN2; WR7, p. 34; WR11, ill. 123; WR14, ill. 21; WR15, ill. 16; WR20, ill. 64; WR29, ill. 32; WR30, p. 93; WR31, p. 65; WR34, p. 30; WR36, p. 86; WR40, p. 61; WR41, p. 103; WR44, p. 55; WR48, p. 259

97
WR1, ill. 83; WR7, p. 75; WR14, ill. 18; WR30, p. 92; WR31, p. 102; WR36, p. 75

99
BN3; WR7, p. 107; WR11, ill. 105; WR15, ill. 32; WR20, ill. 63; WR29, ill. 33; WR40, p. 62 and back cover; WR41, p. 43; WR47, p. 28

11. Typescript biography (n. 1).
12. Letter from Willy Ronis to Robert Doisneau, April 28, 1976.

90
WR1, ill. 2; BN3; WR36, p. 118

380

95
WR12, ill. 15; WR15, ill. 23; WR16, p. 20; WR26a, p. 63; WR26b, p. 61; WR27, p. 16; WR37a, p. 102; WR37b, p. 112; WR40, p. 135; WR42a, p. 21; WR42b, p. 31; WR49, p. 46

381
WR18, ill. 54; WR42a, p. 19; WR42b, p. 53

94
WR1, ill. 13; BN2; WR7a, p. 131; WR7b–c, cover and p. 131; WR8, back cover; WR9, p. 39; WR11, ill. 131; WR14, ill. 22; WR15, ill. 24; WR16, p. 41; WR20, ill. 25; WR21, p. 31; WR26, p. 1; WR27, p. 13; WR29, ill. 31; WR31a, pp. 96 and 97; WR31b, cover, pp. 96 and 97; WR32, cover and p. 51; WR34, cover and p. 41; WR36, p. 181; WR40, p. 143; WR41, p. 37; WR42a, p. 7; WR42b, p. 8; WR43, ill. 15; WR45, p. 19; WR46, p. 101; WR47, p. 136; WR48, p. 169; WR49, pp. 35 and 59

89
WR7, p. 67; WR11, ill. 130; WR20, ill. 62; WR32, p. 49; WR36, p. 186; WR37a, pp. 78–79; WR37b, pp. 86–87; WR40, p. 144; WR41, p. 142; WR45, p. 17

100
BN2; WR7, p. 90

382

96
WR7, p. 116; WR11, ill. 113

1950

482
BN3; WR22, ill. 21; WR30, p. 76

101
WR1, ill. 51; WR7, p. 105; WR9, p. 43; WR11, ill. 111; WR14, ill. 24; WR20, ill. 28; WR22, ill. 23; WR29, ill. 34; WR31, p. 47; WR36, p. 127; WR40, p. 113; WR44, pp. 16 and 25; WR47, p. 67

104
WR7, p. 63; WR40, p. 52; WR41, p. 74; WR47, p. 45

385
WR12, ill. 17; WR22, ill. 64; WR36, p. 83; WR41, p. 118

483
WR30, p. 22; WR40, p. 48

105
WR7, p. 99; WR14, ill. 23; WR16, p. 81; WR25, ill. 18; WR29, ill. 35; WR36, p. 123; WR41, p. 98; WR43, ill. 14; WR46, p. 207

484
WR16, p. 73; WR35, p. 51; WR41, p. 102; WR48, p. 179

107
WR11, ill. 140; WR36, p. 172; WR41, p. 78; WR47, p. 175

106
WR11, ill. 82; WR41, p. 135

386
WR36, p. 142; WR48, p. 261

102
WR7a–b, p. 27; WR28, cover, pp. 34 and 81; WR37a, p. 23; WR37b, p. 25; WR40, p. 99; WR47, p. 85

103
WR7, p. 112; WR11, ill. 114; WR20, ill. 71; WR22, ill. 2; WR32, p. 53; WR34, p. 55; WR36, p. 141; WR37a, p. 130; WR37b, p. 140; WR40, p. 108; WR47, p. 70; WR48, p. 205

1951

387
WR14, ill. 25; WR20, ill. 69; WR22, ill. 18; WR30, p. 73; WR34, p. 20; WR36, p. 133; WR37a, p. 132; WR37b, p. 142; WR40, p. 115; WR41, p. 87; WR43, ill. 6; WR44, p. 37; WR48, p. 161

109
BN3

108
WR7, p. 33; WR11, ill. 115; WR14, ill. 27; WR15, ill. 11; WR20, ill. 68; WR21, p. 42; WR29, ill. 39; WR30, p. 29; WR36, p. 132; WR41, p. 59; WR47, p. 73; WR48, p. 165

110
BN2; WR7, p. 125; WR11, ill. 54; WR15, ill. 53; WR20, ill. 76; WR29, ill. 37; WR36, p. 145; WR41, p. 127; WR47, p. 104

115
WR11, ill. 39; WR22, ill. 50; WR30, pp. 72–73; WR36, p. 130; WR41, p. 138; WR48, pp. 274–75

114
WR11, ill. 56

388
WR7a–b, p. 26; WR7c, p. 24; WR18, ill. 40; WR44, p. 67

112
BN2; WR7, p. 128; WR11, ill. 57; WR29, ill. 38; WR37a, p. 107; WR37b, p. 117; WR40, p. 137; WR41, p. 86; WR42a, p. 33; WR42b, p. 29; WR47, p. 164

113
WR36, p. 107

111
WR7, back cover; WR11, ill. 118–b; WR14, ill. 26; WR20, ill. 73; WR23, p. 25; WR31, p. 128; WR36, p. 2; WR40, p. 21; WR41, p. 157; WR44, pp. 1 and 3; WR47, p. 6; WR48, p. 404; WR49, p. 21

1952

116
WR7, p. 53; WR14, ill. 30; WR30, p. 67

117
WR48, p. 190

485
WR16, p. 59; WR31, p. 122; WR48, p. 272

118
WR7, p. 129; WR11, ill. 74; WR27, p. 17; WR29, ill. 41; WR31, pp. 52 and 53; WR47, p. 167

487
WR31, p. 52; WR36, p. 95; WR37a, p. 172; WR37b, p. 184; WR40, p. 66; WR41, p. 95; WR44, p. 79

389
BN3; WR38, p. 83

120
WR7a–b, p. 13; WR11, ill. 19; WR16, p. 70; WR35, p. 50

121
WR9, p. 17; WR10, ill. 59; WR11, ill. 43; WR40, p. 16; WR47, p. 43; WR48, p. 295

124
WR10, ill. 111

125
WR8, ill. 5; WR9, p. 54; WR10, ill. 29; WR11, ill. 52; WR14, ill. 28; WR20, ill. 79; WR21, p. 38; WR30, p. 60; WR31, p. 35

390
WR10, ill. 41

391

126
BN3; WR10, ill. 127; WR14, ill. 29; WR18, cover and ill. 31; WR30, p. 6; WR34, p. 53 and back cover; WR35, p. 62 and back cover; WR36, p. 81; WR37a, p. 177; WR37b, cover and p. 189; WR40, p. 64; WR41, p. 25 and back cover; WR44, back cover; WR49, p. 69

127
WR7a–b, p. 12; WR7c, p. 11; WR11, ill. 144

392

395

131
WR7, p. 50; WR11, ill. 24; WR15, ill. 13; WR32, p. 57; WR34, p. 47; WR36, p. 100; WR41, p. 94

132
WR7, p. 51; WR41, p. 117

133
WR16, p. 14

134
WR11, ill. 120; WR12, ill. 14; WR16, p. 15; WR36, p. 101; WR37a, p. 13; WR37b, p. 15; WR41, p. 117; WR44, p. 51; WR47, p. 59

119
WR8, ill. 6; WR9, p. 23; WR10, ill. 36; WR11, ill. 10; WR15, ill. 50; WR41, p. 133

122
WR11, ill. 48; WR12, ill. 6; WR21, p. 52; WR35, p. 78; WR41, p. 66; WR47, p. 33; WR48, p. 280

486
WR10, ill. 82; WR35, p. 117

130
WR35, p. 80

407

128
BN2; WR7, p. 141; WR11, ill. 96; WR15, ill. 55; WR21, p. 46; WR26a, p. 105; WR26b, p. 103; WR36, p. 103; WR37a, p. 18; WR37b, p. 20

129
BN2; WR7, p. 35; WR9, p. 47; WR11, ill. 89; WR14, cover and ill. 31; WR15, ill. 4; WR18, ill. 50; WR20, cover and ill. 74; WR21, p. 51; WR26a, p. 65; WR26b, p. 63; WR29, ill. 40; WR30, p. 94; WR31, p. 57; WR32, p. 55; WR34, p. 40; WR36, p. 114 and back cover; WR40, p. 136; WR41, p. 31; WR47, p. 165; WR48, p. 248; WR49, p. 14

123
BN2; WR7, p. 154; WR11, ill. 94; WR15, ill. 44; WR41, p. 100

393
WR31, p. 58 and 59

394
WR30, p. 30

1953

137

139
WR7, p. 45; WR10, ill. 106; WR11, ill. 21; WR14, ill. 8; WR15, ill. 14; WR21, p. 37; WR31, p. 85; WR32, p. 59; WR34, p. 51; WR35, p. 83; WR36, p. 45; WR40, p. 28; WR44, p. 71; WR47, p. 25

140
WR11, ill. 38; WR24, p. 62; WR30, p. 69; WR38, pp. 160–161

396
WR4, ill. 9; WR10, ill. 17; WR25, ill. 21; WR35, p. 94

135
WR10, ill. 166; WR16, p. 51; WR25, ill. 20; WR41, p. 148

136
BN1; WR10, ill. 157; WR12, ill. 2; WR25, ill. 46; WR31, p. 75; WR44, p. 80

138
BN2; WR11, ill. 55

397
WR25, ill. 9; WR33, p. 27

1954

398
WR10, ill. 120; WR34, p. 60;
WR36, p. 94; WR40, p. 67;
WR48, p. 253; WR49, p. 97

399

400

141
WR34, p. 64

146
WR11, ill. 137; WR36, p. 175

406

401
WR10, ill. 38; WR21, p. 48;
WR30, p. 61; WR31, p. 79;
WR35, p. 58

402
WR10, ill. 14; WR35, p. 103

147
BN3; WR10, ill. 18

148

142
BN2; WR7, p. 89; WR11, ill. 63;
WR14, ill. 34; WR15, ill. 9; WR18, ill. 5;
WR20, ill. 21; WR29, ill. 45;
WR31, p. 87; WR34, p. 52;
WR36, p. 124; WR40, p. 71;
WR41, p. 115; WR47, p. 35;
WR49, p. 71

143
WR7, p. 94; WR20, ill. 77

144
WR7, p. 126; WR40, p. 70;
WR41, p. 97

145
WR11, ill. 67; WR16, p. 12;
WR29, ill. 44; WR31, p. 144;
WR36, p. 120; WR37a, p. 138;
WR37b, p. 148; WR38, p. 123

403

404
WR21, p. 40; WR29, ill. 43

405

153

154
WR11, ill. 90; WR41, p. 155;
WR42a, p. 39; WR42b, p. 17

155

156
WR10, ill. 134; WR11, ill. 64;
WR25, ill. 11; WR36, p. 84;
WR44, p. 46; WR49, p. 70

149
BN2; WR7, p. 140; WR11, ill. 95;
WR31, p. 82; WR34, p. 56;
WR40, p. 119; WR41, p. 150;
WR47, p. 105; WR48, p. 240

150
BN2; WR7, p. 61; WR11, ill. 92;
WR20, ill. 80; WR31, p. 19;
WR34, p. 57; WR40, p. 121

151
WR9, p. 50; WR47, p. 98

152
BN2; WR7, p. 38; WR36, p. 150;
WR37a, p. 65; WR37b, p. 71;
WR40, p. 12; WR43, ill. 12;
WR47, p. 100

1954: 24 × 36 mm

BREAKS AND CONTINUITY

"My best pictures date between 1948 and 1956, with a (small) change from the end of 1954, when I gave up the Rollei for 24 × 36-mm film. This is to be expected, as the frequency of in-depth photo stories had steadily declined since 1955."[13] Ronis does not seem to be going through a crisis but, rather, noting breaks in his career, whether brought about by choice or circumstance. First of all, his relatively late shift to 24 × 36-mm film was a conscious decision for greater technical freedom. He also left the Rapho agency,[14] without rancor, in order to make his own choices. His constantly updated archives and network of clients allowed him to move forward. He claimed to be working too much: "I calculated that I worked on average eighty hours a week this year."[15] His body was weakening: "It's probably always having my camera bag hanging on the same shoulder that gave me the stinking sciatica of my forty-five summers (the culmination of three or four annual 'preambular' lumbagos). I thought I was going to be bedridden…. I slowly came out of it, and with almost no lasting effects. But this scare left me at simultaneously stunned, then fatalistic, and finally quite indifferent."[16] However, Ronis was still fully committed to his profession; alongside his remunerative commissions, he pursued long-term projects that he hoped to publish.

13. Letter from Willy Ronis to Robert Doisneau, October 28, 1976.
14. From this point on, Willy Ronis managed his illustrations and reportage assignments himself. The envelope containing the duplicates of his assignments bears the following legend: "Rapho ends 12/54 (resumed summer 1972)."
15. Letter from Willy Ronis to Herman Craeybeckx, July 31, 1955.
16. Letter from Willy Ronis to Robert Doisneau, April 28, 1976.

157
WR10, ill. 141; WR18, ill. 39; WR24, p. 23

158
WR10, ill. 34; WR11, ill. 51; WR31, p. 62; WR41, p. 108

159
BN1; WR7, p. 43; WR8, ill. 13; WR9, pp. 1 and 2–3; WR11, ill. 102; WR14, ill. 33; WR15, ill. 45; WR20, ill. 92; WR21, p. 39; WR29, ill. 42; WR30, p. 50; WR31, p. 63; WR34, p. 46; WR36, p. 98; WR40, p. 79; WR41, p. 49; WR44, p. 40; WR47, p. 46; WR48, pp. 300–01

160
WR10, ill. 110; WR11, ill. 46; WR24, p. 31; WR31, p. 84

161
WR9, p. 8; WR10, ill. 48

162
WR10, ill. 109; WR11, ill. 44

163
WR7a–b, p. 12; WR7c, p. 11; WR11, ill. 145; WR20, ill. 86; WR36, p. 173

164
WR9, p. 20; WR10, ill. 89; WR11, ill. 47; WR47, p. 42; WR48, pp. 282–83

1955

165
WR3d, p. 98; WR7, p. 111; WR11, ill. 40; WR40, p. 116; WR41, p. 94; WR47, p. 58; WR48, p. 273

166
WR3d, p. 58 and back cover; BN1; WR10, ill. 143; WR11, ill. 36; WR13, p. 4; WR14, ill. 32; WR20, ill. 66; WR30, p. 34; WR36, p. 40; WR44, p. 34; WR48, p. 302

167
WR10, ill. 145; WR35, p. 53

168
WR30, p. 44; WR35, p. 76; WR40, p. 72

488
WR16, p. 78; WR36, p. 58

169
BN1; WR35, p. 56; WR48, p. 279

170

171
BN3; WR10, ill. 149

172
BN2; WR11, ill. 60; WR26a, pp. 92–93; WR26b, pp. 90–91; WR41, p. 38; WR42b, pp. 14–15

173
BN3; WR10, ill. 121; WR21, p. 36; WR36, p. 44; WR48, p. 276

174
WR10, ill. 137; WR40, p. 37

408
WR10, ill. 144; WR49, p. 103

175

176
WR7, p. 69; WR11, ill. 133; WR14, ill. 36; WR20, ill. 85; WR21, p. 33; WR29, ill. 46; WR32, p. 61; WR34, p. 102; WR36, p. 187; WR40, p. 145; WR41, p. 50; WR44, p. 59; WR45, p. 25; WR46, p.115; WR47, p. 169; WR48, p. 391; WR49, p. 61

409
WR16, p. 35; WR36, p. 180; WR45, p. 27

177

178
WR9, p. 28; WR10, ill. 86; WR11, ill. 53; WR20, ill. 29; WR21, p. 49; WR35, p. 59; WR36, p. 72; WR41, p. 141; WR49, p. 113

179
WR16, p. 57; WR30, p. 45; WR35, p. 90; WR40, p. 73; WR41, p. 112; WR47, p. 24; WR49, p. 105

180
WR10, ill. 124

489
WR35, p. 82; WR37a, pp. 74–75; WR37b, pp. 80–81

181
WR7c, p. 162; WR16, p. 10; WR20, ill. 75; WR31, p. 148

182

183
WR7, p. 142; WR22, ill. 10; WR41, p. 139; WR47, p. 84

184
WR11, ill. 71; WR18, ill. 30; WR29, ill. 47

185
WR35, p. 64

186
WR9, p. 24

187
BN2; WR7, p. 46; WR9, p. 8; WR11, ill. 85; WR15, ill. 39; WR20, ill. 72; WR30, p. 49; WR31, p. 149; WR34, p. 54; WR36, p. 155; WR40, p. 124; WR41, p. 113; WR47, p. 112; WR48, pp. 232–33

1956

188

189
WR7, p. 56; WR9, pp. 24–25;
WR11, ill. 16; WR15, ill. 48;
WR20, ill. 70; WR21, p. 41;
WR31a, cover and p. 80;
WR31b, p. 80; WR32, pp. 62–63;
WR35, p. 77; WR36, p. 57;
WR40, pp. 18–19; WR44, p. 36;
WR47, p. 47; WR48, p. 303

190
BN2; WR7, p. 88; WR11, ill. 61;
WR12, ill. 18; WR15, ill. 8;
WR31, p. 83; WR36, p. 125;
WR41, p. 114; WR47, p. 40;
WR48, p. 250

191

192
WR7c, p. 167

490
WR10, ill. 94; WR35, p. 52;
WR36, p. 46; WR48, p. 278

410
WR10, ill. 90

193

194

195
WR11, ill. 142; WR36, p. 174;
WR47, p. 176

411
BN1; WR10, ill. 69; WR35, p. 118

196
WR7, p. 36; WR11, ill. 73;
WR14, ill. 41; WR20, ill. 78;
WR25, ill. 12; WR29, ill. 48;
WR30, pp. 84–85; WR34, p. 65;
WR36, p. 85; WR40, p. 75;
WR44, p. 47; WR47, p. 37;
WR48, p. 249; WR49, pp. 72–73

197
WR7, p. 97; WR11, ill. 65;
WR14, ill. 38; WR20, ill. 94;
WR41, p. 41

198
WR10, ill. 138; WR11, ill. 72

199
BN2; WR7, p. 121; WR8, ill. 9;
WR9, p. 11; WR11, ill. 15;
WR14, ill. 39; WR20, ill. 81;
WR25, ill. 48; WR31, p. 21;
WR33, p. 61; WR34, p. 68;
WR36, p. 90; WR41, p. 96;
WR44, p. 39; WR47, p. 53;
WR48, p. 255

200
WR33, p. 32

201
BN2; WR9, p. 14; WR14, ill. 40;
WR33, p. 33

202
WR10, ill. 167; WR11, ill. 76;
WR20, ill. 22; WR31, p. 90;
WR35, p. 117; WR36, p. 47;
WR40, p. 74; WR41, p. 91

412
WR18, ill. 20

203
WR7, p. 153; WR36, p. 119

413
WR10, ill. 21

204
WR9, p. 31; WR11, ill. 26;
WR14, ill. 42; WR21, p. 35;
WR31, p. 77; WR35, p. 119;
WR36, p. 65; WR40, p. 77;
WR41, p. 35; WR44, p. 89

205
WR7, p. 157; WR14, ill. 35

206
WR16, p. 47

1957

207
WR9, p. 30; WR10, ill. 7; WR11, ill. 11;
WR30, p. 65; WR31a, cover and
p. 13; WR31b, p. 13; WR36, p. 64;
WR41, p. 56

414
WR15, ill. 26; WR16, p. 49;
WR31, p. 20; WR32, p. 65;
WR36, p. 67; WR41, p. 44;
WR44, p. 88

415
WR29, ill. 50; WR36, p. 61;
WR37a, p. 157; WR37b, p. 167;
WR41, p. 26

208
BN1; WR7, p. 122; WR20, ill. 95;
WR48, pp. 348–49

209
WR7c, p. 166; WR9, p. 32;
WR10, ill. 168; WR11, ill. 30;
WR14, ill. 37; WR15, ill. 31;
WR20, ill. 93; WR21, p. 34;
WR29, ill. 49; WR31, p. 146;
WR32, p. 67; WR34, p. 45;
WR35, p. 63; WR36, p. 60;
WR40, pp. 2–3 and 80–81;
WR41, p. 27; WR44, cover and
pp. 94–95; WR46, cover and p. 277;
WR47, p. 52; WR48, pp. 346–47;
WR49, cover and pp. 108–09

210
WR7, p. 96; WR11, ill. 66;
WR25, ill. 42; WR31, p. 11;
WR34, p. 61; WR41, p. 126

211
WR10, ill. 3; WR20, ill. 90;
WR34, p. 66; WR35, p. 106;
WR43, p. 6

212
WR7, p. 147; WR40, p. 78; WR47, p. 44

213
WR7, p. 85; WR11, ill. 129;
WR31, p. 129; WR35, p. 92;
WR41, p. 72

214
BN1; WR30, p. 48; WR34, p. 48;
WR36, p. 42; WR44, p. 70

215
WR10, ill. 162; WR11, ill. 22;
WR12, ill. 20; WR15, ill. 30;
WR30, p. 32; WR36, p. 54;
WR41, p. 106; WR47, p. 51;
WR49, pp. 100–01

216
WR20, ill. 87; WR47, p. 48

217
WR9, p. 45; WR10, ill. 8; WR11, ill. 27;
WR20, ill. 3; WR31, p. 120;
WR34, p. 62; WR40, p. 69;
WR44, p. 90; WR47, p. 55

218
BN1. Similar photograph:
WR16, p. 52; WR35a, cover and
p. 101; WR35b, p. 101; WR37a, p. 52;
WR37b, p. 58; WR46, p. 229

219

220
WR10, ill. 155; WR49, p. 96

491
WR10, ill. 156; WR40, p. 83;
WR41, p. 108; WR46, p.77

221
WR7, p. 83; WR11, ill. 126;
WR35, p. 85; WR37a, p. 167;
WR37b, p. 178

492
WR35, p. 104; WR47, p. 75

222
WR16, p. 66; WR35, p. 88; WR46,
p.181 and 183

223
WR7, p. 95; WR11, ill. 62; WR21, p. 47;
WR25, ill. 41; WR33, cover and
p. 21; WR34, p. 70; WR36, p. 91;
WR37a, p. 44; WR37b, p. 48;
WR40, p. 140; WR44, p. 81;
WR46, pp. 9 and 11; WR47, p. 54;
WR48, p. 254

493
WR3d, p. 35

224
WR3b–c, ill. 56; WR3d, p. 61;
WR11, ill. 33; WR14, ill. 11;
WR35, p. 123; WR37a, pp. 34–35;
WR37b, pp. 36–37; WR38, pp. 170–71; WR41, p. 105

225
BN2; WR7, p. 62; WR8, ill. 14;
WR9, p. 46; WR11, ill. 12;
WR18, ill. 19; WR20, ill. 89;
WR21, p. 45; WR31, p. 104;
WR32, p. 69; WR34, p. 67;
WR36, p. 152; WR37a, p. 129;
WR37b, p. 139; WR40, pp. 82 and 160; WR41, p. 89; WR47, p. 99

226
WR7, p. 91

227

228
BN2; WR7, p. 135; WR11, ill. 34;
WR26a, pp. 22–23; WR26b, pp. 20–21; WR49, p. 53

229
BN1; WR12, ill. 4; WR41, p. 29;
WR49, pp. 98–99

416
WR41, p. 47; WR42a, p. 23;
WR42b, p. 57

419
WR10, ill. 158; WR41, p. 130

1958

230
WR11, ill. 70; WR21, p. 50

417
WR10, ill. 78; WR31, p. 131

231

232
BN1; WR10, ill. 77; WR11, ill. 29;
WR42b, pp. 54–55; WR49, p. 111

233
WR9, p. 22; WR10, ill. 95

234

235
WR7a–b, p. 13

236
WR48, p. 185

494
WR26a, p. 83; WR26b, p. 81

237
BN1

238
BN1; WR10, ill. 96; WR44, p. 77

239
WR7, p. 106; WR11, ill. 109;
WR14, ill. 44; WR20, ill. 82;
WR21, p. 44; WR30, pp. 26–27;
WR34, p. 69; WR37a, pp. 164–65;
WR37b, pp. 174–75; WR40, p. 111;
WR44, p. 38; WR47, p. 49

240
WR11, ill. 146

1959

241
BN1; WR10, ill. 74; WR11, ill. 31;
WR31, p. 94; WR34, p. 44;
WR41, p. 34

242
BN1; WR7, p. 159; WR8, ill. 16;
WR9, p. 51; WR10, ill. 24;
WR11, ill. 28; WR14, ill. 43;
WR15, ill. 6; WR20, ill. 98;
WR21, p. 43; WR25, ill. 40;
WR30, p. 19 and back cover;
WR31, p. 95; WR32, p. 71;
WR34, p. 63; WR35, p. 105;
WR36, p. 69; WR40, p. 84; WR41,
cover and p. 147; WR44, pp. 17
and 91; WR47, p. 56; WR48, p. 335;
WR49, p. 92

243
BN2; WR31, p. 40; WR36, p. 139;
WR47, p. 76; WR48, p. 206

244
WR20, ill. 91; WR22, ill. 13;
WR43, ill. 5

245
BN1

418
WR16, p. 82; WR41, p. 151;
WR46, p. 225

246
WR7, p. 139; WR8, ill. 10; WR9, p. 34;
WR11, ill. 104; WR15, ill. 54;
WR29, ill. 52; WR31a, cover and
p. 67; WR31b, p. 67; WR34, p. 58;
WR40, p. 122; WR41, p. 76;
WR47, p. 92; WR48, pp. 336–37

247
WR7, p. 80

248
WR7, p. 146; WR20, ill. 100;
WR31, p. 88; WR32, p. 73;
WR34, p. 59; WR36, p. 154;
WR41, p. 76; WR47, p. 93

249
WR11, ill. 45; WR15, ill. 21;
WR16, p. 74; WR29, ill. 53;
WR31, p. 93; WR41, p. 90;
WR47, p. 97; WR48, p. 225

250
WR11, ill. 93; WR15, ill. 43; WR16, p. 21; WR31, p. 61; WR36, p. 151; WR47, p. 95

251
BN2; WR7, p. 37; WR11, ill. 69; WR14, ill. 45; WR15, ill. 10; WR18, ill. 68; WR20, ill. 99; WR21, cover; WR29, ill. 51; WR31, p. 41; WR32, p. 75; WR34, p. 71; WR36, p. 157; WR40, p. 1 (detail) and 126; WR41, p. 119; WR46, p.47; WR47, cover and p. 94; WR48, p. 227

420
WR10, ill. 80; WR49, p. 90

252
WR10, ill. 129; WR36, p. 87

253
WR3c, ill. 19; WR3d, p. 17; WR7, p. 155; WR10, ill. 136; WR11, ill. 14; WR13, pp. 5 and 12; WR14, ill. 46; WR15, ill. 5; WR18, ill. 27; WR20, ill. 96; WR30, p. 20; WR34, p. 42; WR35, p. 125; WR36, p. 80; WR40, p. 85; WR41, p. 130; WR44, p. 43; WR47, p. 39; WR48, p. 333; WR49, p. 136

254

255
BN1

256
WR7, p. 102; WR22, ill. 11; WR36, p. 136; WR40, p. 114; WR47, p. 77

257
WR7, p. 103; WR31, p. 29; WR40, p. 87; WR47, p. 57

258
WR11, ill. 141

1960

PHOTOGRAPHER, GENERALIST, PLUMBER, ZINC-WORKER

"During my first few successes, I thought that fame was important to me, but gradually this concern (an honorable one for those who believe in its uniqueness) left me. I stopped sending photos to the annuals (*US Camera, Photography Year Book*, etc.) and exhibitions."[17] "To avoid having to laugh at myself with every evening's assessment of the previous day, I (lazily?) preferred to practice my job like a conscientious plumber, and it is almost accidentally that, sometimes, what I produced for pleasure and for the files appeared on the surface of a printed page."[18] Ronis began this new decade with application and a sense of detachment. The Groupe des XV and group exhibitions were no more. Society was changing, and what was expected of his images was changing, too. The generalist adapted and got used to advertising and illustration jobs, in black-and-white and in color. His difficulties with writing made him abandon a new project on candid photography with the publisher Paul Montel. Family obligations played a role in his choices: "I would not care if I were single, because worries about approaching old age wake me up at night to such an extent that I know that I am accompanied, for better or for worse, by a wife whose sensitivity and fragility make me apprehensive about times—no longer so far away—where the worst may be the daily lot. *Nitchevo!*"[19]

259
BN2

260

262
WR18, ill. 10; WR30, p. 21

421
WR18, ill. 9. Similar photograph: BN3

261

495
WR16, p. 86; WR20, ill. 101

263
BN1; WR10, ill. 159; WR21, p. 56; WR32, p. 77; WR40, pp. 14–15; WR46, p.17

496
WR22, ill. 16; WR30, p. 83

422
BN1; WR21, p. 59; WR31, p. 116

264
WR10, ill. 116; WR35, p. 62; WR49, p. 88

17. Letter from Willy Ronis to Robert Doisneau, November 6, 1975.
18. Letter from Willy Ronis to Jean Lattès, September 16, 1979. These assessments are retrospective, addressed to active colleagues when he had withdrawn to Provence.
19. Letter from Willy Ronis to Herman Craeybeckx, May 18, 1960.

1961

265
WR10, ill. 73; WR11, ill. 25

266
WR10, ill. 151; WR35, p. 77; WR36, p. 56; WR49, p. 104

267
WR7, p. 84; WR21, p. 61; WR36, p. 43; WR37a, p. 70; WR37b, p. 76; WR49, p. 27

423
Similar photograph: WR35, p. 80; WR41, p. 48

268
WR10, ill. 160

1962

497
WR36, p. 131

498
WR21, p. 67; WR27, p. 24; WR37a, pp. 56–57; WR37b, pp. 62–63

499

269

270
WR11, ill. 119; WR16, p. 85; WR20, ill. 31; WR27, p. 22

1963

271
WR7, p. 137; WR11, ill. 91; WR12, ill. 9; WR14, ill. 47; WR15, ill. 28; WR16, p. 61; WR20, ill. 103; WR21, p. 57; WR30, p. 41; WR31, p. 81; WR32, p. 79; WR36, p. 39; WR37a, p. 152; WR37b, p. 162; WR40, p. 11; WR41, p. 88; WR44, p. 82; WR46, p. 7; WR47, p. 50; WR48, p. 293

272
WR10, ill. 66

273
WR16, p. 56

274
BN3; WR7, p. 144; WR36, p. 138

1964

500

275
WR21, p. 60

276

501
WR35, p. 54

277
WR7a–b, p. 29; WR10a, cover and ill. 1; WR10b, ill. 63; WR29, ill. 54; WR41, p. 28; WR44, p. 92

278
WR10, endpapers

424
WR35, p. 79

425
BN1; WR10, ill. 55

1965

279
BN1; WR7, p. 151; WR35, p. 99

1966

280
WR11, ill. 59

426
WR10, ill. 20; WR36, p. 64; WR49, p. 91

427
WR35, p. 144

281
BN3; WR7, p. 150; WR11, ill. 49; WR31a, cover and p. 10; WR31b, p. 10; WR48, p. 281

502
WR35, p. 57; WR41, p. 65; WR44, p. 93

1967

ANGUISHED PHILOSOPHER, EXHIBITIONS, TEACHING

"For some time, a significant part of my heart has 'atrophied.' Not that I reject the whole century; technical progress delights me, and space travel (which Marie-Anne does not even want to hear about) fascinates me. But, little by little, I managed to lose interest in myself, and I accept philosophically that I am almost nothing."[20] Ronis's approach to life was counterbalanced by deep anxiety about material needs: "I work, without great satisfaction, to live; because life was given to me, because I took on responsibilities."[21] Ronis described himself as moved by "a kind of religion of effort … and the visceral need to work, avoiding doubt as much as possible."[22] He found two new interesting opportunities: commissioned exhibitions (he now refused to participate in group exhibitions dedicated to the beauty of art) and teaching, "because, unfortunately, at the moment I have time for that."[23]

20. Letter from Willy Ronis to Herman Craeybeckx, December 12, 1968.
21. Letter from Willy Ronis to Herman Craeybeckx, November 8, 1968.
22. Letter from Willy Ronis to Robert Doisneau, November 6, 1975.
23. Letter from Willy Ronis to Herman Craeybeckx, January 15, 1968.

282
BN1

283
BN2; WR9, p. 9; WR18, ill. 23;
WR30, p. 86; WR34, p. 72

428
BN2; WR23, p. 47; WR29, p. 89;
WR36, p. 188; WR41, p. 156;
WR49, p. 145

284
WR7, p. 47; WR14, ill. 48;
WR15, ill. 40; WR31, p. 141

503
WR47, p. 122

429
WR14, ill. 49; WR21, p. 58;
WR31, p. 123

285
BN2; WR16, p. 62; WR31, p. 112;
WR47, p. 88

286
WR7, p. 73; WR11, ill. 122;
WR18, ill. 18; WR21, p. 62;
WR30, p. 88; WR31, p. 69

287
WR18, ill. 12

288
BN2; WR7, p. 149; WR31, p. 33;
WR34, p. 73; WR40, p. 123

289
BN2; WR7, p. 143; WR31, p. 45

290
WR7, p. 60; WR41, p. 124;
WR47, p. 121

291
BN2; WR11, ill. 107; WR31, p. 143;
WR34, p. 87; WR36, p. 158;
WR47, p. 126

292
WR7, p. 58; WR11, ill. 18; WR12, ill. 3;
WR15, ill. 1; WR31, p. 24;
WR32, p. 81; WR34, p. 74;
WR36, p. 159; WR40, pp. 125 and
158–59; WR41, p. 29; WR47, p. 127;
WR48, p. 235

293
WR11, ill. 58; WR41, p. 149

1968

294
WR9, p. 29; WR10, ill. 88;
WR11, ill. 42; WR14, ill. 50;
WR21, p. 63; WR30, p. 55;
WR31, p. 71; WR36, p. 73;
WR43, ill. 3; WR44, p. 87; WR47, p. 61;
WR49, p. 112

295
BN1; WR37a, p. 86; WR37b, p. 94;
WR40, p. 88

296
BN1

297
BN1; WR10, ill. 15; WR36, p. 66;
WR41, p. 64; WR49, p. 94

1969

504
WR26a, p. 29; WR26b, p. 27;
WR38, p. 158

505
WR7, p. 117; WR8, ill. 12; WR11, ill. 86;
WR31, p. 39; WR32, p. 83;
WR34, p. 75; WR36, p. 153

299
WR11, ill. 23

1970

300

301
WR7a–b, p. 15; WR7c, p. 14;
WR9, p. 38; WR11, ill. 132;
WR16, p. 28; WR20, ill. 104;
WR21, p. 69; WR29, ill. 55;
WR32, p. 85; WR36, p. 184;
WR40, p. 146; WR41, p. 144;
WR45, cover and p. 45; WR46, p. 121;
WR47, p. 173; WR48, pp. 386–87

302
WR45, p. 51

303
WR7, p. 123; WR11, ill. 100;
WR35, p. 129

304
WR34, p. 78

1971

506
WR45, p. 59

430
WR7c, p. 171; WR45, p. 55

305

1972

ACTIVE RETIREMENT, IN THE SUN

"Paris was no longer possible, and it was better to 'recycle' ourselves while our strength was still (almost) intact.... Our choice to live here does not represent the crowning achievement of a hardworking life continuing into the tranquility of a well-deserved retirement. We must continue to work, until our strength fails us."[24] Gordes, their vacation spot since 1947, became their new home. In addition to his passions and hobbies, Ronis devoted his professional time to a few illustration commissions, made prints for the Rapho agency and galleries, and, most of all, put a lot of effort into teaching: "It is now the contact with my students that brings me the greatest joys and gives me balance."[25] For convenience, the couple settled in L'Isle-sur-la-Sorgue in 1975.

306
WR20, ill. 106

1974

507
WR21, p. 70

431
WR7c, p. 165

24. Letter from Willy Ronis to Herman Craeybeckx, December 27, 1972.
25. Letter from Willy Ronis to Herman Craeybeckx, August 19, 1972.

1975

307
WR7, p. 39; WR18, ill. 53;
WR26a, p. 28; WR26b, p. 26;
WR31, p. 22; WR41, p. 58

1976

508
WR23, p. 33

509
WR16, p. 71; WR21, p. 72;
WR36, p. 112; WR37a, p. 119;
WR37b, p. 132

308
WR7, p. 133; WR14, ill. 53;
WR31, p. 104; WR38, p. 169;
WR46, p. 269

1977

309
WR9, p. 61; WR10, ill. 119;
WR21, p. 74; WR24, p. 45

510

1978

310
WR9, p. 4; WR11, ill. 118-c;
WR23, p. 37; WR29, p. 5; WR32, p. 2;
WR42a, p. 10; WR42b, p. 1

1979

RECOGNITION AND RETURN TO PARIS
Various issues coincided, and with that Ronis at last achieved fresh recognition. It seemed deserved: "I saw this part of my life with great detachment, but with the awareness that it was deserved and that it was a due that could have come to fruition ten years earlier."[26] It is clear from reading the album texts that Ronis did not dwell on prizes, exhibitions, and honors. He is not shy of acknowledging his professional friendships: Brassaï, Herman Craeybeckx, Romeo Martinez, Lucien Vogel, Izis, Robert Capa, Dennis Stock. And he quoted, without illustrating them, Robert Doisneau, Guy Le Querrec, Jean-Claude Gautrand, and rare members of the Groupe des XV. Many others were missing. In exchange for his first donation to the State, he returned in 1983 to "Paris, the (adored) slut,"[27] and came to grips with a new schedule while managing his family life.

311
WR7, p. 145; WR10, ill. 99;
WR11, ill. 101; WR14, ill. 60;
WR21, p. 75; WR30, p. 39;
WR31, p. 31; WR34, p. 79;
WR35, p. 136; WR36, p. 70;
WR40, pp. 90–91; WR41, p. 67;
WR48, p. 322–23

511
WR7, p. 134; WR14, ill. 58;
WR37a, p. 142; WR37b, p. 152

313
WR6, ill. 4; WR7, p. 40; WR26a, p. 45;
WR26b, p. 43

312
WR9, p. 37; WR21, p. 73;
WR26a, p. 50; WR26b, p. 48;
WR29, ill. 58; WR31, p. 111;
WR32, p. 87; WR34, p. 89

314
WR9, p. 57; WR15, ill. 22;
WR16, p. 77; WR20, ill. 32;
WR21, p. 71; WR26a, p. 21;
WR26b, p. 19; WR31, p. 15;
WR32, p. 89; WR34, p. 76;
WR40, p. 89; WR41, p. 122;
WR49, p. 55

315
WR6, ill. 8; WR7, p. 41; WR8, ill. 7;
WR9, cover; WR11, ill. 37;
WR14, ill. 57; WR29, ill. 56;
WR31a, cover and p. 118;
WR31b, p. 118; WR32, p. 91;
WR34, p. 77; WR36, p. 111;
WR41, p. 112; WR48, p. 317;
WR49, p. 54

432
WR14, ill. 52; WR31, p. 105

316
Similar photograph: WR6, ill. 1;
WR18, ill. 60. Also WR16, p. 26.

317
WR6, ill. 3; WR7, p. 81; WR11, ill. 103

433
WR41, p. 123

318
WR11, ill. 147

26. Letter from Willy Ronis to Brassaï, July 4, 1980.
27. Letter from Willy Ronis to Robert Doisneau, March 19, 1979.

1980

434
WR6, ill. 7; WR16, p. 87; WR26a, p. 71; WR26b, p. 69; WR31, p. 108; WR36, p. 110; WR38, p. 156

319
WR11, ill. 148

320

321
WR10, ill. 83

435
WR10, ill. 131

322

436

323
WR31, p. 86; WR32, p. 93; WR34, p. 83; WR36, p. 156

324

325
WR9, p. 36; WR10, ill. 122; WR11, ill. 125; WR13, cover and pp. 58–59; WR31, p. 110; WR32, p. 95; WR34, p. 80; WR35a, p. 154; WR41, p. 33; WR49, pp. 138–39

326
WR10, ill. 61; WR11, ill. 32; WR20, ill. 108; WR41, p. 48

1981

327
WR9, p. 16; WR10, ill. 44; WR11, ill. 41; WR21, p. 79; WR30, p. 40; WR31, p. 92; WR32, p. 97

437

328
WR11, ill. 98; WR31, p. 30

329
WR9, p. 18; WR10, ill. 130; WR14, ill. 59

330
WR9, p. 19

331

332
WR9, p. 53; WR14, ill. 61; WR21, p. 83; WR29, ill. 59; WR31, p. 23; WR34, p. 93; WR44, p. 83; WR46, p. 143

438
WR10, ill. 165

333
WR10, ill. 84

334
WR9, p. 52; WR10a, ill. 63; WR10b, ill. 64

335
WR10a, ill. 64; WR10b, ill. 87; WR11, ill. 99; WR31, p. 68; WR35, p. 136; WR41, p. 136; WR47, p. 63

336
WR9, pp. 40–41; WR11, ill. 50; WR14, ill. 55; WR21, p. 77; WR36, p. 165; WR47, p. 130; WR48, pp. 368–69

337

338
WR9, p. 40; WR20, ill. 112; WR47, p. 131; WR48, p. 367

512
WR36, p. 164

513

339
WR11, ill. 149

439
WR14, ill. 56; WR40, p. 131

340
WR31, p. 148

341
WR8, ill. 15; WR45, p. 61

342
WR9, p. 58; WR11, ill. 78; WR14, ill. 51; WR31, p. 89; WR36, p. 162

514

343
WR11, ill. 134; WR14, ill. 54; WR16, p. 38; WR20, ill. 110; WR29, ill. 57; WR32, p. 99; WR34, p. 97; WR36, p. 179; WR40, p. 147; WR41, p. 145; WR45, p. 71; WR46, p. 57; WR47, p. 171

515
WR23, p. 39; WR28, p. 6; WR49, p. 147

516
WR37a, pp. 124–25; WR37b, pp. 134–35; WR47, p. 96

344
WR15, ill. 37; WR35, p. 132

517

440
WR13, p. 32–33; WR35, pp. 156–57

441
WR30, p. 47; WR34, p. 82; WR47, p. 62

345
WR10, ill. 169; WR11, ill. 79

346
WR9, p. 44

1982

347
WR11, ill. 68; WR16, p. 13; WR31, p. 145; WR36, p. 121; WR37a, p. 137; WR37b, p. 147

442
WR26a, p. 97; WR26b, p. 95

348
WR9, p. 21; WR11, ill. 17; WR30, p. 38; WR31, p. 37

1983

349
WR11, ill. 150; WR40, p. 26

443
WR10, ill. 54

444
WR10, ill. 9

445
WR10, ill. 53

350
WR10, ill. 22; WR11, ill. 77; WR31, p. 91; WR34, p. 86; WR41, p. 61

1984

518
WR16, p. 30; WR45, p. 73

519
WR35, p. 134

1985

446
WR10, ill. 132; WR25, ill. 34; WR34, p. 22; WR37a, p. 60; WR37b, p. 66

447
WR10, ill. 154; WR30, p. 79; WR44, p. 86

448
WR23, p. 41; WR48, pp. 408–09

1986

520

449

521

450
WR7c, p. 174; WR15, ill. 25; WR31, p. 105; WR32, p. 101

522

523
WR23, p. 42; WR31, p. 60

451
WR7c, p. 156; WR21, p. 92; WR32, p. 103; WR36, p. 163; WR37a, p. 85; WR37b, p. 91; WR40, cover and p. 129; WR41, p. 125; WR48, pp. 324–25 and 327

1987

524
WR34, p. 81; WR35, p. 147

452
WR13, p. 31

453
WR21, p. 78; WR34, p. 84

454
WR35, p. 142

455
WR31, p. 114

525
WR31, p. 40; WR35, p. 148

456
WR40, pp. 40–41

457
WR20, ill. 113; WR31, p. 139

458
WR7c, p. 164; WR15, ill. 12; WR21, p. 85; WR31, p. 34; WR47, p. 60

459

526
WR36, p. 100

1988

PERSONAL DIFFICULTIES AND A FRESH IMPETUS

Ronis's two chief occupations were moving in different directions: his professional life occupied him more and more as his reputation grew, but his personal life was contracting: Vincent died in an accident and Marie-Anne was placed in a nursing home. He presented nothing of his lightning trips and selected only views of Paris. From 1991, he opened up again, with a stated need to be active: "I am far from retired and I work, one would say, an unreasonable amount."[28] He accepted a number of exhibitions, in small French cities and on distant continents (Asia, North America); he would publish another thirty-six books, not to mention the reprints—that is to say, three times more than during his entire career up until that point. He revealed his need to keep the flame alive and was not satisfied with his achievements: "This will restore a taste for life that gradually threatened to dry up, which will seem contradictory to you, with the joys I should be feeling after a certain roll of the dice of fortune."[29]

460
WR31, p. 147

461

462

528

463

527
WR35, p. 152

464
WR45, pp. 78–79

465
WR41, p. 144

529
WR35, p. 133; WR41, p. 128

466
WR16, p. 88; WR20, ill. 119; WR29, ill. 60; WR33, p. 47; WR36, p. 93; WR37, p. 151; WR41, p. 93; WR43, ill. 16; WR47, p. 166

530

28. Letter from Willy Ronis to Hélène Nivault, March 18, 1994.
29. Letter from Willy Ronis to Robert Mallet, March 30, 1995.

1989

467
WR45, p. 85

531
WR45, pp. 90–91

468
WR35, p. 134

469
WR20, ill. 109; WR31, p. 117; WR44, p. 85

532
WR35, p. 135

470
WR31, p. 108; WR34, p. 92

533
WR35, p. 153

534
WR21, p. 93; WR32, p. 105; WR33, pp. 38–39; WR34, pp. 90–91; WR48, p. 362

535
WR33, p. 22; WR36, p. 92

1990

536
WR33, pp. 76–77

537
WR35, p. 131; WR36, p. 71; WR37a, p. 162; WR37b, p. 172; WR41, p. 137

538
WR16, p. 27; WR33, p. 23

539
WR25, ill. 7

540
WR16, p. 64; WR33, p. 37; WR41, p. 92; WR46, p. 215

541
WR36, p. 77; WR49, p. 75

542
WR45, pp. 100–01; WR48, pp. 388–89

543
WR16, p. 39; WR34, pp. 100–01; WR44, pp. 62–63; WR45, p. 99; WR46, p. 201

544
WR16, p. 37; WR31, p. 108; WR32, p. 107; WR34, p. 109; WR36, p. 183; WR40, p. 149; WR41, p. 145; WR44, p. 61; WR45, p. 107; WR46, p. 151; WR47, p. 172

545
WR21, p. 90

546
WR16, pp. 24–25; WR32, p. 109; WR36, p. 149; WR37a, pp. 26–27; WR37b, pp. 28–29; WR40, p. 128; WR41, p. 150; WR47, p. 134

547
WR31, p. 28

548
WR20, ill. 114; WR30, p. 51; WR31, p. 139; WR32, p. 111; WR34, p. 95; WR36, p. 99; WR41, p. 57

1991

549
WR21, p. 81; WR25, ill. 1; WR31, p. 78; WR32, p. 113; WR33, pp. 80–81; WR36, p. 55; WR37a, pp. 146–47; WR37b, pp. 156–57; WR41, p. 62

550
WR25, ill. 24; WR35, p. 141

551
WR17a, p. 75; WR32, p. 115; WR37a, pp. 120–21; WR37b, pp. 130–31

552
WR17b, p. 23

553
WR40, p. 127

554
WR17a, p. 69; WR31, p. 121; WR32, p. 117

555
WR17a, p. 71

1992

PROFESSIONAL FULFILLMENT

Ronis is much in demand and works on projects continuously, having gained full recognition for his photography. In 1992, he expresses his contentment in an interview: "I'm a Parisian who is happy to be infatuated with his city. I'm working a lot, I'm exhibiting in France and abroad. Two new books should be coming out in 1992. I'm traveling. I have many friends. I can imagine ending my days taking photographs like a simple amateur. Without doubt, that's the best thing that could happen to me."[30]

556
WR20, ill. 5; WR37a, p. 40; WR37b, p. 44; WR38, p. 17; WR41, p. 153

557
WR21, p. 80; WR31, p. 104; WR32, p. 119; WR38, p. 16

558
WR20, ill. 118; WR21, p. 87; WR36, p. 161; WR37a, pp. 38–39; WR37b, pp. 40–41; WR41, p. 63

559
WR35, p. 127

560
WR25, ill. 37; WR44, p. 84

561

562
WR21, p. 95

563
WR35, p. 142

1993

564
WR48, p. 360

565

1994

566
WR32, p. 121; WR36, p. 116

567
WR20, ill. 117; WR36, p. 176

568
WR48, p. 291

569
WR48, pp. 370–71

570
WR14b–c, ill. 63; WR30, p. 56; WR31, p. 25; WR34, p. 85

571

572
WR14b–c, ill. 62; WR21, p. 84; WR31, p. 46

573

574

575
WR21, p. 89; WR26a, pp. 98–99; WR26b, pp. 96–97; WR36, p. 108; WR40, p. 43; WR41, p. 101

576

577

578
WR41, p. 117

1995

579
WR23, pp. 44–45; WR38, p. 13; WR49, p. 151

1996

580

1998

581
WR35, p. 139

582
WR34, p. 94; WR35, p. 143; WR44, p. 73

583
WR32, p. 123

584

585

586
WR32, p. 125; WR40, p. 148; WR45, p. 111; WR47, p. 170

1999

587
WR34, p. 99; WR36, p. 185; WR45, p. 115

588

2001

589
WR36, p. 178; WR45, p. 123; WR48, p. 390

2002

590
WR36, p. 182; WR45, p. 125
Willy Ronis still had a few years to live; between 2002 and 2009, he published another sixteen books, plus reprints. The dedication kept him awake; his mind remained sharp. His biographer described at this point as "Firm in his choices and his decisions after many worries, always available, friendly, and open to new proposals" (WR48, p. 392). Willy Ronis died on September 11, 2009, in Paris.

30. Patrick Roegiers, "Willy Ronis, le moissonneur du hazard," in *Façons de voir* (Pantin: Le Castor Astral, 1992).

ACKNOWLEDGMENTS

The publisher would like to thank Willy Ronis's rights holders, Jean Guerry, Daniel Karlin, Roland Rappaport, and Gérard Uféras; and, at the Médiathèque de l'Architecture et du Patrimoine (MAP), Gilles Désiré dit Gosset, General Curator of Heritage and Director, Matthieu Rivallin, Head of Collections in the Photography Department, and Ronan Guinée, Head of Collections, Willy Ronis archive.

A department of the French Ministry of Culture, the MAP is concerned with safeguarding, cataloging, and promoting the archives in its holdings. It encourages in-depth study of the Willy Ronis archive and has delegated the management of its commercial interests to RMN-Grand Palais, thus complying with the photographer's wishes as expressed at the time of his donations to the French State.

Editorial Directors
Gaëlle Lassée
and **Kate Mascaro**

Editorial Assistant
Estelle Hamm

Editors
Helen Adedotun
and **Sam Wythe**

Translated from the French
by **Marc Feustel**

Design and Typesetting
Studio B49

Copyediting
Lindsay Porter

Proofreading
Nicole Foster

Production
Corinne Trovarelli

High-Resolution Scans
Bruno Plouidy
and **Christophe Frontera, MAP**

Color Separation
Les Artisans du Regard,
Paris

Printed in Barcelona, Spain
by **Indice**

Simultaneously published
in French as *Willy Ronis
par Willy Ronis*

© Flammarion, S.A.,
Paris, 2018

English-language edition
© Flammarion, S.A.,
Paris, 2018

All rights reserved.
No part of this publication may
be reproduced in any form or
by any means, electronic,
photocopy, information
retrieval system,
or otherwise, without written
permission from
Flammarion, S.A.
87, quai Panhard et Levassor
75647 Paris Cedex 13

editions.flammarion.com
18 19 20 3 2 1

ISBN: 978-2-08-020372-4
Legal Deposit: 10/2018

© RMN-Grand Palais -
Collective rights management
for Willy Ronis
Location: Médiathèque
de l'Architecture
et du Patrimoine (MAP),
Charenton-le-Pont.
Photos © Ministère de
la Culture – Médiathèque
de l'Architecture et du
Patrimoine, dist. RMN-Grand
Palais/donation Willy Ronis.